Strategic Management in the Arts

GW00776189

Lidia Varbanova

Routledge
Taylor & Francis Group

NEW YORK AND LONDON

First published 2013
by Routledge
711 Third Avenue, New York, NY 10017

Simultaneously published in the UK
by Routledge
2 Park Square, Milton Park, Abingdon, Oxon OX14 4RN

Routledge is an imprint of the Taylor & Francis Group, an informa business

Library of Congress Cataloging in Publication Data
Varbanova, Lidia.
Strategic management in the arts / Lidia Varbanova. — 1 [edition].
 pages cm
 Includes bibliographical references and index.
 1. Arts—Management—Textbooks. 2. Strategic planning—Textbooks. I. Title.
 NX760.V37 2012
 700.68—dc23
 2012018326

ISBN: 978-0-415-53002-6 (hbk)
ISBN: 978-0-415-53003-3 (phk)
ISBN: 978-0-203-11717-0 (ebk)

Typeset in ApexBembo
by Apex CoVantage, LLC

To my beloved parents Nikolinka and Dimitar

Contents

Foreword

Writing about strategic management in the arts and culture is still a relatively young phenomenon. It is only since the 1990s that books on culture management and university courses in this field have progressively started to profile a new generation of leaders and managers in arts organisations. Culture professionals will probably always maintain a certain hesitation and caution towards wholeheartedly embracing methods and ideas derived from business administration in their predominantly nonprofit environment. Nevertheless, today strategic management for organisations in the arts and culture (whether in the world of profit-oriented creative industries, publicly funded institutions or nongovernmental organisations) has become a widely acknowledged standard of operation in this sector. Only a handful of scholars from around the world, however, have so far published complete volumes on culture management theory. Books and practical manuals on strategic management concepts and hands-on methods for arts organisations are an even rarer phenomenon.

The book you hold in your hands is written by one of the worldwide leading experts in the field of organisational capacity-building and education for arts managers and culture administrators. Dr. Lidia Varbanova looks back at countless profound and varied working experiences in this field which have shaped her conceptual thinking on arts management training and cultural development across many countries in Europe, Asia and North America. Over the past 20 years, literally hundreds of cultural operators, artists, public administrators and policy-makers have taken part in her master classes, academic lectures and workshops. Many of these trainings were realised in the framework of cultural development programmes offered by the European Cultural Foundation (Amsterdam), the Soros Foundation and its local foundation spin-offs across Eastern Europe as well as many other international institutions, universities and training centres. The birth of entirely new scenes of culture organisations in the countries of Central and Eastern Europe, the former Soviet Union and other neighbouring regions of the European Union is closely connected to the educational work of the author of this book. The practical insights gained through this hands-on capacity-building work in combination with her methodological reflection and writing have made Dr. Varbanova one of the most requested teachers in arts management all over Europe.

This book now makes available the vast experience and knowledge pooled by her and the many training participants, professionals and partners involved with her work. It is based on knowledge gathered from her consulting work, training sessions and involvement in practical collaboration projects. This publication does not propose just another theoretical framework for dealing with issues of arts management or another hypothetical view on learning in the arts sector. It is meant for both academic education and professional training in arts management, and even more for 'heavy-duty' usage in field practice. While it draws from a large number of different academic sources and refers to theory and standard business management methods, it is strongly based on the use of a variety of these concepts in the practice of arts management. The numerous case studies and examples introduced in this book illustrate the application of theoretical concepts in concrete cultural work in the field. The experiences arts managers and their organisations have acquired while successfully (or less successfully) applying the theory and concepts in their day-to-day work, while engineering lasting change in their cultural

environment, are at the core of this book. A central goal of this publication is hence to provide its readers with solid resources for elaborating their own strategic plans and concepts.

The book focuses on innovative thinking and entrepreneurial actions in the arts sector as two primary vectors in strategic management. It emphasizes the necessity to cultivate a more intrapreneurial climate in the arts. The author stresses that in a situation of overall scarcity of funding for arts organisations and projects worldwide, strategic management practices are successful only if based on the generation, development and realisation of innovative ideas for achieving a sustainable mode of operations with a long-term perspective.

Some of the key elements of the methodology introduced in this book were previously presented in a publication commissioned to the author by the European Cultural Foundation. This handbook, published in the Romanian and Russian languages in 2010, was part of a targeted capacity-building training programme for arts managers and local administrators in the eastern European Union neighbourhood countries. Financially supported by the Social Transformation Program of the Netherlands' Ministry of Foreign Affairs, the book targeted the very specific and challenging conditions of cultural development in postsocialist countries—a key feature of the European integration and cultural policy development agenda of the European Cultural Foundation. Following the method proposed by Dr. Varbanova several dozen cultural managers elaborated innovative strategic development plans which led their young culture organisations back on the road to success. Testing the method proposed in this first publication in the cultural practice aided the discovery and conceptualisation of the new practical instruments and tools for the strategic management process described in the publication at hand. *Strategic Management in the Arts* hence reflects and incorporates feedback received from numerous experts, consultants, scholars, policy-makers and practitioners from many countries inside and outside Europe.

We believe that *Strategic Management in the Arts* is a very useful textbook for teaching classes and running training modules on arts management and culture administration worldwide and will be well received by university professors, trainers, students and peers in the field. It contains an easy-to-adapt methodology and answers the needs of a variety of academic education programmes but also hands-on training workshops. Another important goal of the book is to inspire managers, leaders, producers and entrepreneurs in the arts and culture and to enable them to apply new ways of learning, working, thinking and creating strategies for change. The contents of the book are easily applicable to the world of subsidized, nonprofit and business arts organisations. In times of critical need for systemic innovation and entrepreneurial actions in the arts and culture all over the world, tools for realising new strategic approaches to successfully realise long-term goals in a sustainable way are more important than ever before.

This book will also appeal to city cultural administrators and policy-makers, as well as researchers and consultants, and anyone else who is interested in the concepts and practicalities of strategic management. The variety of backgrounds of the potential readers is reflected in the number of methods, topics, tools, cases and examples introduced in this book.

We are certain that the content presented in the book will further evolve and take on new dimensions with each subsequent edition. In this way, *Strategic Management in the Arts* will become an ongoing learning tool itself. It will certainly reinforce arts management theory and practice worldwide.

Isabelle Schwarz
Head of Programs & Advocacy

Philipp Dietachmair
Program Manager EU Neighbourhood

European Cultural Foundation
www.culturalfoundation.eu

Preface

WHY I WROTE THIS BOOK

This book is a result of my more than 20 years of professional experience in the arts and culture sector as a consultant, researcher, university professor and manager in over 50 countries. I realised that as a theoretical subject, strategic management is becoming more popular and widely discussed worldwide. Its practical applications have been gradually increasing in the last 20 years in many areas beyond the business sector. There are numerous resources on strategic management and planning, but actually very few of them have made an attempt to focus on the specificities of the arts and culture sector. On the other hand, there are plenty of publications on arts management, cultural policy, arts entrepreneurship, innovations and functional management areas in the arts. However, there is no comprehensive book adapted for the learning environment about the concepts, specificities and practices of strategic management and planning in the arts and culture sector, considering innovation and entrepreneurship as important vectors for sustainable development.

I wrote this book driven by my strong wish to enrich and refresh arts management theory and practice by exploring the complex triangle 'strategy-innovations-entrepreneurship' in all phases of the strategic management process. The book connects theoretical approaches to strategic management with practices in the arts sector from different countries. The arts world is immensely diverse, and the examples given in the book vary a lot—from tiny nonprofit organisations and sole entrepreneurships to very large and well-established ones. The book deals with general strategic management concepts and methods, and their adaptation and implementation in various arts organisations—theatres, orchestras, museums, galleries, libraries, music companies, cultural and community centres, arts venues, cultural networks, online platforms and others.

In the global situation of ongoing scarcity and decreases in financial support for the arts at all levels—from local to international—in which the majority of arts organisations operate today, it becomes more important than ever to understand and apply strategic management concepts and practices from the angle of innovation and entrepreneurship. The book gives an answer why. Strategic management might not be that passionate of a subject, but it is a much-needed one—not only for survival but for a healthy and sustainable future for our arts organisations, projects and initiatives.

I have realised, as probably many of you have too, that strategic planning is not a recipe for everyone in all circumstances. I propose a framework for strategic management and planning which is not a ready-to-use model. It needs adaptation to each specific case, considering its uniqueness and context. This is why strategic management in the arts is an art in itself and is 'situation specific'.

This book is a reminder for all of us that the people in an organisation are the ones who make the plans and implement them. This is why the active involvement and motivation of the board, stakeholders, managers and teams in the strategic management process are of utmost importance for success. Strategic plans and concepts are dynamic and not static—once elaborated, they should be flexible and adaptable to ongoing changes.

WHO THIS BOOK IS FOR

I strongly believe that the book will assist university professors, instructors, lecturers and students from arts management and culture administration programmes worldwide to better apply to a learning environment the theoretical concepts of strategic management and planning in the arts and culture sector, also using cases, examples and practical recommendations from the practice of arts management worldwide.

The book is useful reading for arts managers, cultural administrators, arts entrepreneurs, board members, project leaders and business managers in the arts who need step-by-step guidance in the process of strategic management and a fresh approach in elaboration of a strategic plan. It will also be of help to arts management consultants and experts who need to validate their experience and practice in the field.

The book could assist policy-makers at all levels in the development of government support for strategic planning initiatives in the arts as part of a country's cultural policy framework. The book might be valuable reading for cultural researchers as it discusses diverse theoretical approaches to strategic management concepts and analyses their practical applications in an international context.

And, finally, artists could also benefit from reading the book, as it would help them to shift their minds from creative processes to the pragmatic language of management and economy in order to learn how to run their organisations and projects in the long term and consider the importance of money and markets in the field of the arts today.

WHY YOU SHOULD READ THE BOOK

This book will help you find answers to the following main questions:

- Why does successful strategic management in the arts nowadays require innovative thinking and entrepreneurial actions in order to achieve long-term objectives?
- What are the main phases of the strategic management process and their specificities in the arts sector?
- What are the characteristics of an intrapreneurial arts organisation, and why is *intrapreneurship* important for the elaboration and implementation of strategic plans in a financially sustainable mode?
- Why do arts organisations need strategic planning, and how is it specific in the arts and culture sector?
- How does one elaborate a strategic plan for an arts organisation using the approach which is the most suited to a specific case?
- Why are innovative ideas and 'thinking beyond the box' both vital ingredients of a well-elaborated strategic document?
- How does one analyse external and internal factors and choose an appropriate strategy?
- How does one design the functional strategies and the part of the strategic plan related to managing people, markets, the creative production process and money?
- What should be considered when implementing the strategic plan?

The book emphasizes that strategic management in the arts requires strategic thinking, analysis, planning and reflection, as well as entrepreneurial talent and the ability to innovate. An effective strategy is one that constantly responds to dynamic external changes, preparing the organisation to act accordingly by utilising its full capacity and resources. This is why arts managers should possess entrepreneurial traits to be able to exploit new opportunities, find unmet customers' needs, create future wants and solve social problems through the arts. On the other hand, successful arts entrepreneurs are those who are visionary leaders and apply strategic approaches in their actions.

HOW I WROTE THE BOOK

Key elements of this book's methodology were previously used in a publication commissioned by the European Cultural Foundation in 2010 for targeted capacity-building training sessions with arts managers and cultural administrators in Europe. As a result of implementing the methodology, more than several dozen innovative strategic plans and concepts were successfully elaborated and are currently in the process of being realised. The practical implementation of this publication helped to discover and conceptualise new practical instruments and tools in the process of strategic management. The current book reflects and implements constructive feedback from more than 90 arts and culture managers, experts, consultants, policy-makers, university professors and students from many countries.

The book is a result of the following research methods:

- Review and analysis of over 350 theoretical resources on the topics of strategic business management, strategic management of nonprofit organisations, arts management, cultural entrepreneurship, innovations, arts marketing, human resource management strategies in the arts, financial and fundraising strategies, cultural policy and cultural industries.
- Targeted qualitative research on cases, examples and arts practices. The book contains 16 case studies and over 40 short examples from the practice of arts organisations and projects across the globe, selected from an initial sample of 80. The qualitative research forms the backbone of the book's findings and is based on a series of questionnaires and interviews with 90 arts managers, experts, scholars and cultural professionals from Europe, Canada and Asia.
- Content analysis of strategic plans, management documents and promotional materials of arts organisations and online research on relevant sources.
- Experience and personal observations in the arts and culture sector in an international context from many diverse countries, arts organisations and projects.

HOW TO READ AND USE THIS BOOK

The book is carefully structured to be used as a textbook for university classes and training seminars and as an academic resource, as well as a practical guide on strategic management and planning. The content is intended to serve professors, lecturers, trainers and students from academic programmes and practical courses in arts management. It is also suitable to assist arts managers, directors and consultants in acquiring competence in strategic management and in becoming more efficient in their daily actions. The book's chapters are logically connected, while each is also constructed to stand on its own and be used separately. Every chapter starts with 'learning objectives', and most of the chapters end with cases, questions and assignments.

The book has five main pillars:

- **Theoretical Concepts**

The book discusses the theories and concepts of other scholars on strategic management and planning, and their development over the years. The review of academic literature goes back 100 years in the history of strategic management and planning and highlights classical theories as well as the contemporary viewpoints of diverse authors. The book also gives a comprehensive list with suggestions for further reading in the field of strategic management in the arts and related topics.

- **Case Studies**

The 16 cases in the book demonstrate how elements of strategic management have been applied in practice in different types of arts organisations. The cases come from 12 countries in Europe (France, Spain, Sweden, Italy, Turkey, Russia, Slovenia, Serbia, Macedonia, Kosovo), North America (Canada) and Central Asia (Mongolia). These cases illustrate the complexity of managing arts organisations strategically by applying elements of innovation and intrapreneurship. The cases are elaborated on

the basis of primary data resulting from targeted qualitative research and secondary data from strategic plans, management documents, promotional materials and the online presence of these organisations. The cases complement Chapters 4 to 11, while the first three chapters have mainly theoretical aspects. Each case starts with *learning points* and ends with *questions and assignments* for students and trainees. Cases are suitable for class discussions, group and individual assignments, midterm and final exams.

- **Examples**

The theory is animated and illustrated throughout the text by over 40 short practical examples, elaborated from authentic arts organisations and projects. They help readers to understand the application of the theoretical concepts, terminology and models in arts management practice.

- **Practical Recommendations**

Practical recommendations throughout the book target mainly managers, directors and entrepreneurs in the arts sector who wish to advance their skills and competence in applying strategic management methods and tools. These tips result from summarising numerous experiences and shared practices in the arts, gathered through targeted interviews, training, seminars and informal conversations with arts and cultural professionals worldwide.

- **Visual Materials**

There are 84 figures and tables throughout the text which assist learners to visualise the theory and the diverse concepts and practices in strategic management in the arts.

Before starting to read each chapter of the book, carefully evaluate your knowledge in the respective field and your competence in applying the concepts to the arts and culture sector. If you are new to the subject matter, read the whole chapter. If you have a good theoretical knowledge but you lack practical experience, you might wish to pay special attention to the tips and examples. If you already have knowledge and experience in the respective area of strategic management, look carefully at the sections with examples of strategic plans and the cases given at the end of chapter—compare with your own practical experience.

WHAT'S NEXT

I look forward to receiving your suggestions, feedback and opinions on the book, as well as your stories, cases, successes and lessons learned in the process of strategic management. I will discuss them with you and consider for the next edition of the book. Creating tomorrow today is not an easy process, but if we do not envisage where we want to be, why and how to get there, tomorrow may not be the one we dream about. In the arts sector, this is possible only by collective efforts, sharing, ongoing learning and mutual inspiration.

Dr. Lidia Varbanova
www.lidiavarbanova.ca

Acknowledgements

I consider myself a professionally fortunate person. My treasure is the vast network of colleagues and friends across the globe which I have built up throughout my years of working in the arts and culture sector. They are too many to list them by name. I devote this book to all of them—those who believed in me, supported me, helped me, advised me and shared with me throughout the many years of professional exchanges, gatherings and meetings. Many of them have contributed directly or indirectly to discussing the ideas and concepts elaborated in the book and their practical applications.

I would like to sincerely thank all my students and colleagues from numerous universities, training centres and research institutes in Europe, North America and Asia. This book wouldn't be possible without their ongoing provocation, curiosity and critical reflections.

I am grateful to all 90 professionals from 25 countries who responded to my research inquiries in the process of writing the book. They were so kind to share their experience and spend time helping me select cases and examples and complete the qualitative research. Again, the list is too long. My colleagues and friends from the 16 organisations who worked with me on the elaboration of the case studies deserve very special appreciation as well.

My very special thanks go to my colleagues from the European Cultural Foundation in Amsterdam for supporting a 2010 publication on the same subject as this book: on facilitating capacity-building programmes in several European countries and organising seminars and training sessions around it. All the European organisations that applied key elements of the methodology in their practice of strategic management and planning, and submitted helpful feedback, deserve my sincere thanks as well.

The biggest thanks of all go to my immediate and extended family in Sofia and Montreal for their unconditional love and ongoing support. My father, Prof. Dr. Dimitar Kamenov, deserves special recognition and sincere thanks for his valuable feedback on the final draft of the book.

Finally, I would like to thank Sharon Golan, acquisitions editor at Routledge, for her editorial feedback and for giving me this unique opportunity.

1 Innovation and Entrepreneurship in the Arts

A Strategic Approach

LEARNING OBJECTIVES

Upon completing this chapter you should be able to:

1. *Explain different types of organisations in the arts and culture sector.*
2. *Demonstrate how an arts organisation functions and transforms resources into outcomes.*
3. *Differentiate positions and roles of arts managers.*
4. *Summarise why innovation is important and what different types of innovations are.*
5. *Analyse the profile of entrepreneurs in the arts.*
6. *Describe the characteristics of an intrapreneurial arts organisation and the phases of an intrapreneurial process.*

This book focuses on strategic management in an arts organisation as a process to manage changes through innovative thinking and entrepreneurial actions in order to reach long-term objectives in an open system of interaction between an organisation and its environment. It regards planning as an essential function in management practice. The book offers a methodological framework and a step-by-step guide on how to elaborate a strategic document to run an organisation in the arts and culture sector over a long-term period. It emphasises the importance of innovation and entrepreneurship in the arts as two basic vectors in the strategic management process.

The philosophical notions of *culture, arts, heritage* and *creativity* differ a lot. In a broader sense, the word *culture* usually reflects the system of shared values, beliefs, customs, behaviours, and so on, which members of a society develop and transmit to the next generations, and means the ways of living together. As written in the UNESCO Universal Declaration on Cultural Diversity: 'Culture takes diverse forms across time and space. It encompasses the knowledge, belief, art, law, morals, custom and any other capabilities and habits acquired by man as a member of society'[1]. In a narrower sense *culture* refers primarily to creative artistic expressions and is associated mainly with the *arts:* the visual, performing, literary arts, and so on. Creative activities and organisations which are based on a creative process but are also related to the mass production, commercialisation and distribution of cultural products with the aim of gaining profit in return are associated mainly with the term *creative* (or *cultural*) *industries.* This term becomes very important in light of policy objectives: for example creation of jobs, revitalisation of cities through the arts, development of new media industries, improvement of the local economy as a result of large cultural events, economic activities in the cultural sector as a result of which organisations pay taxes and contribute to the national budget, and so on. Cultural industries are an immense source of added value in the society from an economic viewpoint.

The term *arts and culture sector* as used in this book refers to all types of organisations, as well as activities, projects and initiatives in the field of arts and culture in a particular country. This includes art forms such as the visual and plastic arts, the performing arts and music, literature and publishing, cultural heritage and multidisciplinary art forms. They are institutionalised in the form of museums, galleries, theatres, opera

companies, dance companies, cultural centres, music companies, and others. The book also refers to arts sector organisations and projects which include artistic elements, or are based on artistic creativity, or have an indirect affiliation with the arts, for example associations and networks, cultural research institutes and observatories, nonprofit organisations that operate internationally in the field of arts and culture, and others.

1. TYPES OF ORGANISATIONS IN THE ARTS AND CULTURE SECTOR

Culture, arts and entertainment exist in diverse institutionalised and organised forms. Management processes, functions and methods differ based on the ways organisations are structured and function. These are related mainly to their legal status, mission and objectives, organisational structure, financial structure, and so on. Two main variables are important for the choice of an overall strategic management and planning framework: the size of the organisation and the proportion of self-generated income versus external financial support.

According to the most commonly used typology in arts management theory and practice, organisations in the arts and culture sector can be divided into three main groups: nonprofit organisations, business (commercial, profit-making) and state-subsidized (state or public).[2]

1.1. Nonprofit Organisations

Nonprofit (non-commercial) organisations (NPOs) provide services and programmes that benefit society. They exist to contribute to the solution of diverse educational, environmental, cultural, health, youth or social problems. Their financial structure is different compared with business organisations, as they do not aim to generate profit. NPOs can, however, have a 'financial surplus' at the end of the financial year as long as it is used for the organisation's future activities and not for the individual benefit of the management body or the founders. Based on legislation in different countries, these organisations may also have tax-exempt status or receive tax benefits. If their primary mission and activities are related to fundraising for social causes, they can also acquire a special charitable status[3].

NPOs are independent and are institutionally separate from government and businesses. They have flexible organisational structures and small operational teams and often use volunteers for their programmes and activities. NPOs should be accessible, and their activities should be transparent, because they are based on using public funds. Most of their funding comes from external support—foundations, government programmes, individual donors or commercial sponsors. In limited cases, nonprofit organisations are allowed to perform commercial activities, but this depends on the national legislation in the respective country.

NPOs are also called *nongovernmental organisations* (NGOs). The subtle difference in name emphasises that they are legally constituted with no interference from (participation by or representation of) the government, and therefore they operate *independently*. Many NGOs rely on their members' involvement and support: this is the case for associations, unions, networks and social clubs. Theatres, galleries, festival organisations, multimedia organisations, community centres and other educational and cultural organisations that do not aim primarily to generate profit can be registered as nonprofit organisations as well.

The term *grass-roots organisation* is used to emphasise the fact that the initiative or movement comes from peoples' needs and that the mission is to help provide a specific social, cultural, educational, environmental and/or health-related initiative in a neighbourhood. In the theory and practice, several other terms are also used to refer to NPOs and NGOs as distinct from other institutions and organisations in a society; these include *independent sector, volunteer sector, charitable sector* and *third sector*[4].

1.2. Business Organisations

In most cases these organisations are registered under a trade law. They are also called art-based business companies or arts businesses. They rely entirely on sales revenues from selling goods and/or services (tickets for performances, CDs, books, art objects, paintings, online services, etc.) or other peripheral

sources of revenue (such as merchandising, selling souvenirs and commercial products, selling food and drinks, renting spaces and equipment). Their revenues could be generated in other ways as well, for example by receiving copyright and other royalties. Business organisations distribute the gained profit among the owners and/or the shareholders and/or reinvest part of it for future activities and programmes. Their financial structure is mixed. They function entirely in a market environment, and their artistic programming is driven mainly by consumers' and audiences' needs, tastes and preferences. These organisations can be of different forms and types, depending on a country's legislation[5]. Business companies in the field of arts and culture, which pursue commercial activities and are based on mass production and distribution, are generally considered as functioning in the creative or cultural (or entertainment/leisure) industries.

1.3. State-subsidized Organisations

Depending on the level at which they operate, as well as their scope and budgeting structure, arts organisations can be national, regional or local:

- **National.** For these organisations, the main portion of their income usually comes from the national budget (the Ministry of Culture, Arts Council or other government programmes). The main aim of these organisations is to preserve cultural heritage, develop classical and traditional forms of art, safeguard the quality of artistic productions and programmes and, in some cases, support contemporary artistic production. In every country there is at least one, or more than one, national cultural organisation in each arts category, for example a national drama theatre, national opera, national museum of fine arts, national symphonic orchestra, and so on.
- **Regional.** These arts organisations are subsidized mainly by the budgets of regional government authorities or specially designed regional programmes or funds. Cultural policies or regionalisation and decentralisation aim at providing higher autonomy for the regional authorities to decide on funding and creative programming related to organisations in the cultural sector.
- **Local and municipal.** These are arts organisations that receive their primary funding (or in some cases patronage and support in other means, not necessarily financial) from a municipality or a city council.

The term *cultural institution* is used for formal organisations of the government and public services. Institutions follow certain rules and fulfil government expectations. They are directly or indirectly part of a government structure.

1.4. Mixed (Public-Private Partnership)

There are increasing examples in cultural practice of mixed ownership support for culture organisations. In many cases, private donors and government bodies collaborate to set up an organisation or long-term project which could not be developed with only state support or solely by private investments. These organisations usually have nonprofit legal status, with clearly defined public-private partnership and funding models. Partnership schemes are set up within the governance structure and reflected in the operational management of the organisation.

1.5. Other Criteria

Another typology of arts organisations is to split them into *subsidized* and *commercial*[6], based on their *main sources of income*—self-earned revenues or external financial support.

- **Subsidized organisations** receive most of their incomes from external sources—mainly from different levels of government support in the form of subsidies but also from foundations, funding institutions and donors. The subsidies are used to lower the price of the product and/or services offered in order to increase the level of participation and/or consumption. These organisations

aim at broadening access to culture, presenting high-quality artistic programmes, and focusing on education, community support, and other societal matters. They often connect cultural and artistic activities with environmental, social, health and other causes. Organisations supported by government funding, as well as some types of NPOs which are primarily funded by state sources, are called *subsidized organisations*. Their strategic management is heavily influenced by the overall cultural policy framework in a country.

- **Business (commercial) organisations** receive most (or all) of their income from commercial types of activities. They function on market principles and through trading transactions. This is why they need to attract, keep and develop ongoing relationships with buyers and clients. Examples of such organisations are publishing companies, recording studios, private galleries, private dance studios, commercial theatres, private multimedia companies and film corporations. Their strategic management and planning are influenced by the overall analysis and trends of the cultural (creative) industries[7].

Another possible criterion for grouping arts organisations could be their *scope of autonomy and independence*. From this angle, they can be divided into the following types:

- **Independent organisations.** These are registered as a separate legal entity and make independent decisions regarding their operations.
- **Part of another entity.** These organisations are attached to a university, college, corporation, foundation or another institution.
- **Collaborative entities.** In some countries these are called *artists' collectives*. They have shared aims, for example to share equipment, materials or spaces or to organise joint marketing campaigns. Artists' collectives are also organised for lobbying and advocacy purposes. These collaborative gatherings could also be called *artist-run organisations*. Their aim is to provide alternative spaces for exhibition for emerging and contemporary artists outside of the conventional commercial galleries.

Depending on the balance between *stability* (creating and presenting programming mainly in one place) and *mobility* (touring, diversifying artistic programming, changing locations and interacting with audiences), arts organisations could also be classified as follows:

- **Permanent.** These are, for example, conventional museums, national art galleries, repertory drama theatres and cultural and community centres.
- **Temporary.** These organisations work on a project basis and are gathered for only one show, one set of programmes or one event. After completing their objectives, they dissolve.
- **Touring and mobile.** These organisations do not have a permanent home place but are constantly on the move. Examples include private theatre companies, touring gallery exhibitions, circuses, street art forms, and others[8].
- **Mixed.** These organisations have both a permanent creative team and external programming. For example, a regional symphonic orchestra may have a permanent team of musicians and staff while at the same time organising international festivals and inviting other orchestras and music events to perform in the orchestra's building.

The digitalisation trend and the impact of new technologies and global connectivity on the cultural sector are moving the activities of many organisations, either partially or entirely, from the conventional 'offline' physical spaces to 'online' creation, presentation, marketing, distribution and sales[9]:

- **Offline organisations and projects.** These use Internet and online communications, and part of their work could be digitalised, but their activities and interactions with audiences primarily occur offline—in physical spaces and places, either indoors or outdoors.
- **Online organisations, projects and platforms.** These might have a physical office or premises, but most of their activities and programmes happen online. Examples are social networking sites specialising in arts and culture, virtual resource centres, virtual galleries, new media projects, online shops for selling artistic objects, live streaming of artistic events, and more.

Arts organisations can have their own buildings, rent the spaces they need or operate in a more flexible and 'nomadic' style, consisting only of teams, without buildings, and constantly finding new spaces in which to create, produce and present. The use of the term *organisation* in this book refers to a type of social arrangement, a gathering of people who pursue collective goals, and is not related to the building itself. Throughout the book, the term *arts organisation* is used broadly and refers to different types of organisations in the arts and culture sector—operas, theatres, and ballet companies; symphonic orchestras; museums and galleries; libraries; music studios; cultural and community centres; arts networks; international nonprofit organisations; and more.

2. ARTS ORGANISATION: RESOURCES, PROCESSES AND RESULTS

Management and planning activities in an arts organisation require a rational approach. Economics and management studies often regard an organisation as a complex system of elements which are in transformation from the input(s) through process(es) to a final output(s) (see Figure 1.1). Seeking and managing resources, understanding and organising internal processes, reaching the desired outcomes and evaluating results are key milestones in the process of strategic management and planning.

2.1. Resources

Identifying and using resources in an efficient manner is an important aspect of the strategic management process. Limited resources can be a constraint for achieving future strategic goals, while developing new resources can be a driving force. Resources can be divided into two main categories:

- **Tangible resources.** These can be financial or physical.
- **Intangible resources.** These can be intellectual property, reputation, good will, and so on.

Human resources are the core of every arts organisation, irrespective of its size, type, objectives or outcomes. Of all the resources needed to start a cultural activity, the most important is human resources. The creativity, ideas, knowledge, experience, skills and competence of the people involved in the process are the key to the success of any organisation. Cultural organisations are generally labour-intensive, as most of the key processes could not be performed if people were replaced by technical or electronic equipment. The limitations of a human's productivity and labour intensity predetermine the unique economic characteristics of cultural organisations, in comparison with production companies or businesses.

Creative teams are at the core of any arts organisation. They may include actors, choreographers, musicians, dancers, singers, writers, designers, painters, curators and many others. The success of any cultural production or artistic work is predetermined to a great extent by the creativity, talent and professionalism of the artists. The configuration and size of a creative team depend on the artistic field, the nature of the artwork and the type of organisation. Bill Ryan (2002)[10] considers that within a professional project team organised to deal with cultural production, various people perform different functions. Categories of personnel include

- primary creative personnel, such as musicians, screenwriters and authors;
- technical workers, such as sound engineers, camera operators, copy editors and floor managers;
- creative managers who act as brokers or mediators between the interests of owners and executives and those of the creative personnel;
- marketing personnel who aim to match the work of the primary creative personnel to audiences;
- owners and executives; and
- unskilled and semi-skilled labour.

The uniqueness of any arts organisation is that all activities are undertaken for the preparation and presentation of a final artistic product or production. Managerial, technical, production, marketing, financial and supporting activities all contain creative elements—in one way or another. Coordination, synchronisation, motivation and development of all teams are important functions of arts managers.

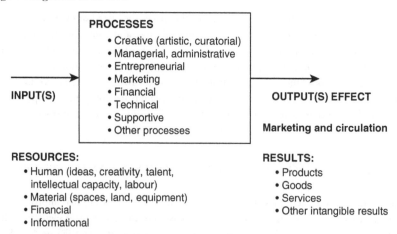

Figure 1.1 Arts organisation: input-process-output

Chapter 8 emphasises the strategic approach to evaluation, planning, recruitment and development of human resources in an arts organisation, as well as other labour-related issues.

Irrespective of the size and aims of an organisation, *financial resources* are needed to start up and run any activity. In the arts, they can be generated from diverse external and internal sources, for example from

- sales of core cultural products and artistic works;
- royalties from copyrights;
- sales of peripheral commercial products;
- provision of additional services (food, drinks, online and offline services, etc.); or
- external support from governments, foundations, corporations, individual donors, banks and other financial institutions.

Strategic approaches to management and planning of financial resources in an arts organisation are discussed in Chapter 10.

Material resources in an arts organisation include musical instruments, written notes, scenery and equipment, theatre props, lighting and sound equipment, materials for painting and sculpturing, spaces, land, buildings and other premises. They are an important ingredient for starting up and running an arts organisation. Projections of the quality and quantity of material resources available certainly matter and are an inevitable part of the strategic planning process. Planning material resources in the overall production process is discussed in Chapter 9.

Informational resources are becoming an immense part of the daily life of arts managers. The ability of management teams to gather data, analyse facts and figures, and seek and implement feedback in the overall decision-making process is becoming more important in the current world of globalization and connectivity. Informational resources are very important for defining strategic goals and elaborating alternative strategies to reach them. Informational resources in the strategic management process are discussed further in Chapters 5 and 9.

2.2. Processes

In some arts organisations, the creative process is mixed with the final result and cannot exist without an audience. This is the case for the live performing arts—stage performances, dance shows and opera performances. In other organisations, the actual artistic creation does not happen within the organisational setting. In these cases, the interpretation of the artistic products and/or their exhibition to the audience is an important part of the overall organisational processes. Such organisations are, for example, museums, public galleries or public libraries, whose main goals are orientated towards education and wider public participation.

Arts products and projects can be created in an individual or collective manner. The performing arts are a perfect example of a *collective creation*—by a music ensemble, orchestra or dance company. Other forms of art are individual by the nature of their creation, for example writing, painting or designing.

For a better understanding of the overall management and planning process, it is useful to divide the main creative process within an arts organisation into phases, or stages. For example, the theatre process in a repertory drama theatre could be split into

- a preparatory period (conceptualising, designing the idea, casting, seeking initial resources);
- rehearsals (static—reading—and dynamic—on the stage, including technical and sound rehearsals);
- a premiere (first-night show in front of an audience);
- performances (presentation of the theatre production in front of an audience); and
- multiplication of the final production (repeating the performances, touring and broadcasting in order to increase audience attendance).

In this example all managerial, technical, marketing, financial and supportive processes are complementary as they help to promote smooth and efficient functioning of the creative teams and to achieve successful results.

The charm and the difficulty in managing an arts organisation in a strategic framework are the ongoing liaison, interaction and interdependency between the core creative processes and all other managerial and supplementary processes. The dilemma between the long-term creative goals and the marketing goal of reaching a larger audience stays in the foundation of a strategy for further development[11].

This is why, in the majority of arts organisations, especially middle-scale and large ones, there are two equally important top management positions: an artistic director (i.e. a chief curator, theatre director, chief conductor, etc.) and a manager (i.e. an executive director, general manager, managing director or executive manager)[12]. Their innovative and entrepreneurial competences are of utmost importance for any arts organisation in the contemporary world.

2.3. Results

As a result of its efforts, an arts organisation offers its clients, audiences or buyers, and the society at large, tangible products (goods) or intangible services. Chapter 7 of the book is dedicated to marketing planning, audience development and communication and gives tips for understanding clients' needs and elaborating efficient promotion of arts products and services. Arts marketing campaigns deal with the results of the creative processes, although the marketing planning process starts at the very beginning of setting up an art project or event. A major dilemma in arts marketing is that between the goal of attracting audiences while satisfying their tastes and the goal of developing, educating and engaging audiences, because art should be accessible to all. The two approaches, as shown in many examples and cases throughout the book, can be combined to achieve financial sustainability.

At the end of all the efforts performed by an organisation, the final results need to be measured and analysed so that the new planning cycle can begin. Measuring and reporting results, both internally (presenting them to the board and the staff) and externally (making them publicly visible for stakeholders and funding institutions), is a very important phase in the strategic management process. It is usually related to the plan's implementation. There are a variety of ways to formulate expected results in a planning document.

The results of an arts organisation's activities can be divided into the following two categories:

- **Tangible** (material). These are the artistic products, which become goods when they appear on the market and are subject to market transactions.
- **Intangible** (non-material). These are services and other intangible results, such as recognition, joy and entertainment, applause, education, trust, aesthetic value, and so on.

Results can also be divided into two other categories:

- **Quantitative** (measurable). These are based on data, numbers, figures, percentages and ratios which can be measured, for example the number of people attending an event, percentage of box-office increase, number of performances presented in a certain period of time, number of unique users of the organisation's website or profit gained as a result of an activity.
- **Qualitative.** These aim at gaining an in-depth understanding of why and how certain outcomes were achieved and what their wider impact is.

Another option for planning, recording and analysing the results is to group them as follows:

- **Creative results.** These are related to the quality, evaluation and attitudes shown towards the artwork or creative product.
- **Marketing results.** These are related to the media coverage, marketing budget spent versus increase in the audience, percentage of new audience members participating in an event, or the ratio of online versus offline communication and promotion.
- **Financial results.** These include increased sales revenues; enlarged number of supporters, donors and sponsors; percentage of earned income versus outside support; and the profit or financial surplus generated. Financial results also measure an arts organisation's ability to function in an entrepreneurial mode and to implement elements in its activities which increase the potential sources of revenue.
- **Organisational results.** These are about changes in the management competences and skills of the staff or the board, improved team-building, faster decision-making or advanced organisational capacity.
- **Innovative results.** These show the new programmes, models or techniques implemented in a certain period of time.

Setting up specific indicators is necessary to measure interim and final results and to monitor the overall implementation process[13]. Measuring the interconnections between inputs (resources) and outputs (outcomes, effects) is another way to register the level of success in the strategic management process. For this reason, the terms *effectiveness, efficiency* and *efficacy* are also commonly used in arts management practice:

- *Effectiveness* is the degree to which a goal is achieved and is connected to the ability to produce the expected result.
- *Efficiency* refers to the time and efforts spent on an activity and the ability to accomplish a job in the best possible manner, to do things in the most economical way and to establish a good ratio between outputs and inputs.
- *Efficacy* places emphasis on the capacity to achieve a final result; it refers to the success in achieving a goal rather than focusing only on resources spent.

In the practice of arts management, these three terms are sometimes used interchangeably.

3. INNOVATIONS IN THE ARTS: CATEGORIES OF INNOVATIONS

3.1. Creativity and Innovation

By their very nature, arts organisations have unique characteristics and are focused mainly on creativity. Creativity is an immense part of every artistic organisation or project. Creative processes and results make arts organisations unique. On the other hand, creativity has increasingly become an important element of business management, too, as it is a key to unlocking a competitive advantage in crowded

markets. Chris Bilton (2007)[14] points out that creativity is at the core of any innovation and that both are interrelated. Creativity is fundamental to innovation and is a necessary but not sufficient condition for innovation (Fitzroy, Hulbert & Ghobadian, 2012)[15]. Theodore Levitt, an American professor and economist, coined the famous phrase that 'Creativity is thinking up new things. Innovation is doing new things'. Creativity is having a new idea. Innovation means actually doing something with that idea, like creating a new product. Creativity can lead to innovation, but the two are not necessarily the same (Meyer & Heppard, 2000)[16].

Creativity and innovation are connected, and in management theory and practice both usually refer to the competence and capacity of doing things differently by adding value to an existing product, service or method or creating a completely new value. The value of innovation, in both financial and social aspects, is what differentiates it from the pure creative process in an arts organisation. Innovation is about uniqueness, newness and the different ways in which we do things. Innovation brings efficiency and effectiveness as a result. Therefore, not every new thing is innovative—only those which help attain a higher level of efficiency as a result.

Creativity is more about internal processes and operations and to some extent is a subjective matter, while innovations are about things that have been tested and are connected with the real world. By default artists always experiment, pioneer and create. Artists' creation is different to innovation: the latter is related to matching the creative ideas and results to the constant changes in the external environment, responding to the external needs of clients, communities and stakeholders. Arts organisations are open systems: many of them cannot even exist without their audiences and supporters. Working in such an open environment requires ongoing innovation.

3.2. Characteristics of Innovation

Innovations always imply *newness,* and they bring differences in the input, process or output of a system. Joseph Shumpeter, an economist and political scientist, popularised the term *creative destruction* to describe how innovations destroy the established order and the 'old way' of doing things. Peter Drucker's important conclusion is that innovation is an economic or social, rather than technical term. His five principles of innovation emphasise the need for an innovation to start by analysing the opportunities, to be both conceptual and perceptual, to be focused, to start small and do one specific thing and, finally, to aim at leadership[17].

Innovations are related to

- transformation and restructuring;
- change: in an organisation, in a process, in a model and in the society as a whole;
- generation of new value; and
- thinking that goes 'beyond the box': thinking and acting differently.

In *arts-based businesses,* innovations are important for creating new market opportunities, responding to the changing needs of customers and clients and looking at new ways to be better than the competitors. Business organisations need to constantly innovate in order to keep their competitive advantage on the market, to be constantly better than their competitors and to find new market gaps and new areas of growth and expansion. In their book *Blue Ocean Strategy* Chan Kim and Renee Mauborgne argue that the companies who will be tomorrow's leaders will succeed by creating 'blue oceans' of uncontested market space. The authors call such strategic moves *value innovation* and show its power for unleashing new demands[18]. The 'blue ocean strategy' creates uncontested market space, makes the competition irrelevant and creates and captures new demand.

Innovations are equally important for *nonprofit and public-service organisations,* because they help an organisation manage changes in a turbulent environment and to respond to constantly changing external factors. Philip Kotler and Alan Andreasen (1975) emphasise that to be successful in today's nonprofit environment, organisations must learn to effectively and efficiently develop and launch new offerings. These may involve new or existing offerings in combination with new or existing markets[19].

Public-service institutions face obstacles to innovation, because they are based on a budget rather than focused on results and their aim is to 'do good' rather than to concentrate on a cost-benefit analysis (Drucker, 1985). Also, they are dependent on a multitude of constituents, and they aim at satisfying everyone. Therefore, it is difficult to start something new that will be equally supported by everyone in the organisation[20]. Drucker points out that despite the obstacles, nonprofit institutions need innovation as much as businesses or governments do. He emphasises the need for an *innovative strategy*—a way to bring the new products to the marketplace[21].

The term *social innovations* refers to new ideas that resolve existing social, cultural, economic and environmental challenges for the benefit of people and the planet[22]. These new ideas work for the public good and can be elaborated in any type of an organisation: public, profit-making or nonprofit. In many cases social innovations occur in cooperation and collaboration between diverse organisations, stakeholders and individuals.

Arts organisations today operate in a changing, uncertain and unpredictable environment where the offers to consumers and audiences, coming from many service providers, are numerous and appealing. Arts organisations need to constantly elaborate new ideas and to be innovative for two main reasons:

- To keep or improve their competitive advantage on an ongoing basis in order to be better than others;
- To look constantly for new ideas, new projects, new management and financial models, new audiences and new supporters in order to be different to the others and maintain their uniqueness on an ongoing basis.

Arts organisations nowadays need to constantly implement 'newness' in their programming, marketing and operational strategies so that they can attain sustainability in the future. 'To be different' and/or 'to be better' is a key to success in arts management practice. These two vectors are the core of elaborating strategic choices.

3.3. Categories of Innovations

A widely used and quoted classification of innovations is that of Joseph Shumpeter. He categorises innovation into five types: introduction of new products, introduction of new methods of production, opening of new markets, introduction of new materials or sources of supply, and development of new organisational structures.

Henry Chesbrough (2007) uses the term *open innovation* and distinguishes between *outside-in* innovation, which occurs when an organisation brings external ideas, technology or intellectual property into its development and commercialisation process, and *inside-out* innovation, which occurs when an organisation licenses or sells its intellectual property or technologies, particularly unused assets. He emphasises that today innovation must include business models, rather than just technology and research and development, because a better business model will often beat a better idea or technology[23].

Alexander Osterwalder and Yves Pigneur (2010) regard the following types of innovations as being at the epicentre of their unique business model innovation[24]:

- Resource-driven innovations originate from an organisation's existing infrastructure or partnership to expand or transform the business model.
- Offer-driven innovations create new value propositions that affect other business model building blocks.
- Customer-driven innovations are based on customer needs, facilitated access or increased convenience.
- Finance-driven innovations are provoked by new revenue streams, pricing mechanisms or reduced cost structures.

Chris Bilton and Stephen Cumming (2010) identify six main ways in which innovation can be sought, using the 'value chain' and calling them the 'six degrees of strategic innovation'[25]:

- *Value innovation:* discovering something new of greater value to customers or constituents.
- *Cost innovation:* producing products, services or experiences at significantly lower costs than had previously been thought practical by thinking differently about what really needs to be in the chain of production.
- *Volume innovation:* discovering and creating ways to produce, provide, sell and move products and services in far greater quantities than previously thought possible.
- *Marketing innovation:* focusing on redefining markets in order to change the way people think about or use the product and inviting consumers to create or discover new sources of value in products, through innovative approaches to marketing and mediation.
- *Boundary innovation:* mixing up different stages along the value chain, from production to consumption, in order to discover or create what are in effect entirely new products and experiences in the mind's eye of the consumer.
- *Learning innovation:* emphasising learning during the process of developing an innovation and bringing it to market in order to develop further innovations.

Bakhshi and Throsby (2010)[26] analyse what innovation means for cultural organisations and observe that a major driver of change in the behaviour of these institutions has been the revolution in information and communication technologies. They identify four broad categories of innovation that are common to cultural institutions across the creative arts:

- innovation in extended audience reach
- innovation in art-form development
- innovation in value creation
- innovation in business management.

The two authors discuss the importance of the digital technologies in opening new opportunities for artistic creation, audience reach, and the implementation of new business models in the arts.

Another commonly used typology of innovations divides them into two main groups: breakthrough and incremental innovations. *Breakthrough* innovations bring radical changes in a product, service, process or method. They could be riskier and require large investments in research and development. *Incremental* innovations are related to gradual improvement of an existing product, service, process or method. They build on past experience and knowledge applied to something new.

3.4. Innovations in Arts Organisations

Considering the *input-process-output model,* the stages in the cultural production process (creation, reproduction and circulation) and the strategic planning stages, innovations in arts organisations could be categorised as follows:

- **Programme innovations.** These bring newness in the creative process and are related to a unique aspect of programming. These can be innovations in the design, creation, or interpretation of an artistic work, for example in the writing of a screenplay, the composition and improvisation of a song, or a performance in front of an audience. The most common practice for arts organisations implementing innovation in their programming is to design separate artistic and creative projects with diverse innovative elements.
- **Innovation in the process.** As discussed earlier, there are different processes happening in an arts organisation: creative, managerial and supportive. The main aims of process innovations are to improve ways of doing things. Innovations in the reproduction process is mainly related to the process or making multiple copies from a 'master piece'. These types of innovations are common to the creative industry as they help to reach the economy of scale and to decrease the costs for a single unit because of the need for mass production.
- **Marketing innovations or innovations in the methods of circulating final art products and services.** These could be new methods of audience engagement, new channels of distri-

bution of an art product, innovative branding, the offering of unique additional and peripheral services or products, new promotion techniques, and innovative online and digital marketing elements. Marketing innovations are commonly used in arts organisations because of their basic nature, which involves communicating, educating, involving, engaging and developing audiences on an ongoing basis. Marketing innovations are always related to the value created for the audiences. These innovations and their importance in overall strategic planning are discussed in Chapter 7.

- **Innovation in the resources.** These are diverse new ways in which an arts organisation starts new activity and seeks money, material, human and informational resources. Innovations related to new methods of fundraising and new sources of financing are the most popular in this group. Arts organisations constantly seek outside financing because of the economic nature of the creative process. Online tools and technologies increase the level of creativity in the fundraising methods used by arts managers to gain money and supporters worldwide. Chapter 10 discusses both traditional and innovative methods and examples of fundraising as part of the overall strategic planning process.

- **Organisational and managerial innovations.** These lead to upgrades in the way of organising activities in an organisation, to more efficient workloads or to implementation of new management models. Managerial and organisational innovations can improve the process efficiency. They establish the necessary background for establishment of an intrapreneurial climate.

- **Technical innovations.** These are related to the implementation of new technologies, new equipment and online tools.

The preceding classifications are done from a theoretical viewpoint to better understand what innovations are about. In the arts practice, types of innovations are usually interrelated. Examples of programme, process, marketing, organisational and technical innovations are given in the following:

- Digital portals allow artists to network and also to upload, sell and exchange artwork, while they also allow audiences to vote for artworks[27].
- An online and mobile ticketing facility allows customers to purchase tickets through Internet and mobile applications. The applications use data to show the location of events nearby and allow users to share content via social media[28].
- New software technologies allow creative dialogue between performing artists and the public as artists are developing their artistic projects[29].
- Cross-connections between Web 2.0 tools and mobile applications lead to the development of systems to enable participants in an art event to discuss, interpret and share opinions via social media[30].
- Live streaming of events extends audiences and makes the art much more accessible. It is applied by music clubs, opera houses, theatres and other performing arts venues.

An important role of arts managers in the strategic management process is to foster an organisational climate of generating ideas, experimenting and transforming the ideas into successful opportunities. Innovators are the ones who help in exploiting an arts organisation's full potential, bringing new programmes and projects and reaching new audiences. Fostering innovations in the arts is much more than just organising team brainstorming sessions once in a while. It is an ongoing purposeful process of setting up a proper environment for developing and implementing ideas in a collaborative manner.

3.5. Innovations in Strategic Management

Innovations are an important element of successful management strategies. The connection between strategies, innovations and entrepreneurship becomes more and more important for the long-term success of any organisation. Constantinos Markides (2000) defines strategic innovation as a fundamentally different way of competing in an industry by breaking the rules of the game and implementing new ways to compete[31]. Giep Hagoort (2000) looks at the interrelations between arts management and entrepreneurship, outlining that innovation is not an organic and separate part of the management process

but a strategic choice as to where and how to modernise the organisation[32]. Allen C. Amason (2011) emphasises the importance of innovation and change as keys to long-term success and imperatives of any successful strategy[33].

To be successful and sustainable, an arts organisation needs to develop new ideas on an ongoing basis and at all management levels, as well as to elaborate mechanisms to implement these ideas and transform them into opportunities. Innovations are the seeds for the long-term success, sustainability and adaptability of an arts organisation. Irrespective of their types, size or other characteristics, arts organisations today need to be innovative in order to survive in the competitive world, meet the challenges of the external environment and constantly improve their creative results.

Successful strategies and innovations are well connected. On one hand, successful innovations are strategic, because they aim at newness, change and economic effectiveness in a long-term period. On the other hand, to be able to reflect the ongoing changes, an effective strategy should inevitably contain innovative elements.

Innovations as a core element of successful strategies in the arts are not just about improved productivity or implementation of a new technology or new business model. They cover almost all aspects of an organisation's development. Innovation could be implemented in the production and technological processes, in the structuring and utilising of various resources, in the fundraising strategy and tools or in the marketing and communication process. Today's digital era and market context require that arts organisations constantly invest in innovations, further research and development[34]. Innovations in business arts organisations aim at maintaining a sustainable competitive advantage, while in nonprofit and subsidized organisations they aim at increasing visibility, audience participation, educational programmes or access to the arts. In the latter case, innovations have 'social' aspects—benefits to the society and societal value. In today's world there is no strict separation between the two, as the social and economic aspects of every innovation are tightly connected.

This book regards innovations and innovative elements as a very important vector in the process of strategic management and planning. There is no successful strategic concept, framework or plan without elements of innovation in it because every organisation elaborates strategies in order to be either different from others or better than others or both.

4. ARTS MANAGERS: PROFILES AND FUNCTIONS

The roles, functions and daily responsibilities of managers and administrators in the cultural sector vary significantly. It is almost impossible to cover and analyse all existing positions and functions of managers, administrators, entrepreneurs and mediators engaged in different cultural organisations and countries. They vary depending on the

- art category (performing arts, visual arts, cultural heritage, multidisciplinary art);
- sector (state, private or nonprofit);
- size of the organisation, its organisational structure and its managerial levels; and
- primary responsibilities and functions of the managers.

In theory, *arts and cultural managers* are those who work mainly in the business and third sectors, while *arts and cultural administrators* are primarily public servants working for government institutions (ministries of culture, arts councils, municipal cultural departments) or for subsidized arts organisations—national, international, regional or local. *Cultural mediators* cover a broad spectrum of competences and skills, such as audience development, enabling of mutual understanding between artists and communities, cultural interpretation, organisation of educational programmes, and much more. *Cultural animators* are usually those working with people and groups, especially with children and youth, stimulating their mental, physical and emotional life and moving them to experiences and actions through which they attain higher self-realisation, self-expression and awareness of belonging to a certain community.

Table 1.1 Profiles of Cultural Managers and Administrators

Arts managers and artistic leaders	Arts administrators	Others
Top-level managers of large, medium and small arts and culture organisations (business, public and nonprofit)	Officials in the ministries of culture, arts councils and other national and international bodies dealing with culture	Arts and cultural entrepreneurs
		Arts and cultural mediators
Managers at different levels and functional areas in an arts organisation (e.g., financial managers, marketing managers, audience development managers, human resource managers, stage managers, production managers, etc.)	Directors at different levels and administrators in regional and local authorities dealing with culture	Arts and cultural animators
		Consultants and freelancers
	Directors at different levels and officers of state-subsidized (national, regional and municipal) cultural organisations	Trainers and educators
Project managers		

An important difference between these various positions and professions is that managers and administrators usually work with teams and staff and are part of a permanent organisational structure. Cultural mediators and animators also work with groups and teams but not necessarily in a permanent organisational setting. Table 1.1 illustrates examples of arts managers and administrators, depending on the sector in which they are engaged and other variables.

Arts organisations are regarded as open systems, and therefore arts managers and administrators need to constantly communicate with the outside environment—with policy-makers, financial institutions, sponsors, critics, experts, journalists, professionals and volunteers from other cultural, social and business organisations, as well as with different communities[35]. Art is always a subject of social evaluation and criticism, and therefore these outside groups and supporters in many cases have different or even opposite opinions and influences on the quality of artworks and artistic productions. One of the main tasks of arts managers in the overall strategic management and planning process is to identify and consider the needs and preferences of, and to treat with priority, three very important groups: artists, audiences and supporters.

Therefore, arts managers have a difficult role to play in constantly trying to decrease the tensions between all internal and external groups influencing artistic quality, the image and visibility of an organisation and its overall financial situation. The ongoing scarcity of funding in the arts and culture sector and the need to strive for competitive advantage and differentiation in order to attract audiences and buyers, make the *arts manager* a profession which requires balancing the tensions between the priorities, needs and attitudes of different external and internal groups and key people (see Figure 1.2). The strategic planning process therefore helps improve the coordination, interrelations and partnership between all these external and internal influencing groups.

5. ENTREPRENEURSHIP IN THE ARTS

While managers work within the framework of an existing organisation, entrepreneurs are the ones who start from an idea and organise it to a successful end. At a certain growth stage in the organisational development, entrepreneurs become managers as they set up internal procedures and systems; they delegate, motivate, coordinate, control and perform all other management functions. On the other hand, effective managers are the ones who create an entrepreneurial climate within the organisation, facilitate constant generation of new ideas and transform them into opportunities.

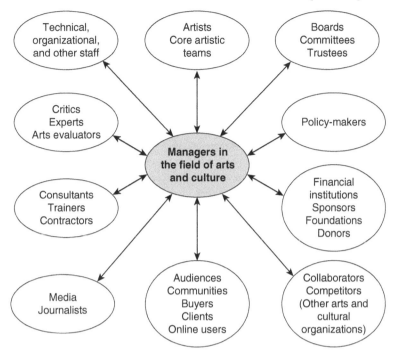

Figure 1.2 Arts and culture managers: balancing the tensions

5.1. Concepts of Entrepreneurship

There are numerous studies and theories that attempt to answer the questions 'What is entrepreneurship?' and 'Who is the entrepreneur?'[36]. There is no general definition of this complex phenomenon—different authors and researchers offer diverse concepts, which could be grouped as follows.

The first group of concepts and theoretical thoughts stresses the risk-taking nature of entrepreneurs. Richard Cantillon (1680–1734) was the first to recognise the importance of entrepreneurs for the development of the economy and the market. He defined the entrepreneur as a person who is ready to risk in order to receive future profit and is prepared to accept the consequences of risky decisions.

The second group of concepts emphasises the role of entrepreneurship in economic development and the effective utilisation of limited resources. Jean-Baptiste Say (1767–1832) described entrepreneurs as those who transfer economic resources to areas with higher productivity and organise production process by combining diverse factors of production with information and experience. Entrepreneurs focus on the organisation of production and are responsible for achieving productivity due to renewed allocation of resources. Austrian economist and philosopher Friedrich Hayek (1899–1992) defined entrepreneurs as people who work in competitive situations aiming at higher effectiveness and combining their unique skills and competences with the market situation. He believed that market conditions and entrepreneurship activities are the background of economic development.

The third group of concepts is related to innovation and creativity as a focus in entrepreneurial activities and profile. Joseph Shumpeter (1883–1950) defined the entrepreneur as someone who creates new combinations of factors of production aiming at new products; new processes, methods and technologies; new markets and market segments; and/or new resources. He connected entrepreneurship with innovation and emphasised that entrepreneurs have special skills for dealing with uncertainty.

The fourth group of concepts emphasises the personal characteristics of entrepreneurs, mainly related to their high need for achievement, motivation to excel, strong self-confidence and independent problem-solving skills[37]. William B. Gartner and other scholars identify three main traits of entrepreneurs: need for achievement, locus of control and risk-taking propensity[38]. Other key traits have been

added to the list, such as being optimistic, innovative, creative, imaginative, restless and proactive (Chell et al., 1991)[39]. Bilton and Cummings (2010)[40], as a result of a series of interviews and previous studies, recognise seven entrepreneurial traits: risk taker, lifelong learner, swift action and experimentation, thrill seeker, self-efficiency and confidence, and venture and industry experience.

The fifth group of concepts considers mainly external factors as the ones that primarily shape entrepreneurs. They can have a positive or negative influence on the person's decision to become an entrepreneur. External factors include family background, employment history, education, social networks, culture and prior management experience[41].

The sixth group of concepts connects entrepreneurship with management and leadership. Drucker (1985) emphasises that the entrepreneur always searches for change, responds to it and exploits it as an opportunity[42]. His research shows that not every small business is entrepreneurial: entrepreneurs are the ones who create something new and different; they change or transmute values. Vipin Gupta and Ian Macmillan (2002)[43] attempt to clarify what *entrepreneurial leadership* is—leadership that creates visionary scenarios, motivating and committing a cast of characters for the discovery and exploitation of strategic value creation in an organisational setting.

The ability of entrepreneurs to think and act strategically is less covered by the literature and studies on entrepreneurship. Bilton and Cummings (2010) make a good attempt to connect strategy with creativity, innovation and entrepreneurship, emphasising that 'if innovation is the heart of creative strategy, then entrepreneurship is the legs'[44]. John Thompson (1999) concludes that entrepreneurs have the qualities of successful strategic leaders because they evaluate the external environment in a systematic way and then position their companies strategically. He emphasises that entrepreneurship is a relevant and vital process for all types and sizes of organisations because it stresses the winning of a strategic position[45]. Dale Meyer and Kurt Heppard (2000)[46] prove that strategic and entrepreneurial thinking are inseparable. Rita McGrath and Ian MacMillan (2000)[47] suppose that business strategies must use entrepreneurial thinking and propose a new type of business leader who should mobilise resources, exploit opportunities and lead organisations in the current state of increased competitiveness and ongoing uncertainty. They define these new types of business leaders as *entrepreneurial leaders* and point out that the boundaries between entrepreneurship and strategy are blurred.

Strategic thinking and actions are important in the entrepreneurial practice because entrepreneurs have to not only recognise and make use of a current opportunity but also forecast the future, create new opportunities and sense and exploit things in a way that other people do not. Entrepreneurs are the ones who look at problems as solutions and implement new business ideas around them.

5.2. Entrepreneurs in the Arts

Studies and literature on entrepreneurship in the field of arts and culture are scarce. Entrepreneurship, innovations and the business aspects of the arts are little explored in the academic literature. Some publications on entrepreneurship in the arts use the term *artpreneurship,* covering the competences, tools and practical tips which individual artists need to sell their work of art. Giep Hagoort (2000) is one of the few authors trying to implement some elements of strategy and entrepreneurship in the management of organisations in the cultural sector[48]. He regards strategic management as a process of opening the organisation to its external environment and developing competences and abilities to keep the process functioning at a professional level. He stresses that in some cases cultural programming is presented as a strategy for the development of an arts organisation. Hagoort considers three core elements of cultural entrepreneurship, emphasising that it is based on passion and affection around a clear cultural vision, an external (market) orientation with an emphasis on innovation, and a societal responsibility, which is principally intended for the cultural sector to stimulate a vital cultural climate. Hagoort looks at the *life-cycle process* of traditional strategy-making in a cultural organisation: from an 'ad hoc' phase (project planning and development) to 'programming' (elaboration of a longer-term strategic creative direction) and then 'annual planning' (the formal process of strategic planning).

Other authors on arts entrepreneurship emphasise the importance of this process for the overall economic development and the fostering of innovations, as well as for exploring additional sources of revenues in the arts sector and the cultural industries.

- Marian Fitzgibbon (2001)[49] discusses the importance of the innovation process in arts organisations and the need to encourage experimentation and innovation. The author concludes that innovation in the arts requires dedication, persistence and sacrifice.
- Dragan Klaic (2007)[50] emphasises the importance of cultural entrepreneurs for seeking additional sources of income in the realisation of international projects. He defines the traits required for the profile of a *cultural entrepreneur of international orientation* and emphasises the entrepreneur's role in income generation and money-making activities in the realisation of cross-border projects and initiatives.
- Giep Hagoort and Rene Kooyman (2009)[51] discuss cultural entrepreneurship as the ability of art managers to explore cultural opportunities in their own environment, to formulate cultural innovations, to strike a balance between cultural and economic values and to show an entrepreneurial leadership style. They emphasise that cultural entrepreneurship is the most obvious approach to functioning in the creative industries as it focuses on both cultural content and commercial possibilities as a basis for cultural innovation and success.
- Ronnie Philips (2011)[52] examines the role of entrepreneurship in the overall economic development and provides an overview of the characteristics of arts entrepreneurs. He examines the role of government versus the private sector in promoting arts entrepreneurship.
- The relationship between leadership, innovation and entrepreneurial practices in the cultural sector is also worthy of mention here, not least because of the prevailing argument that 'since leadership is vital to improving innovation and productivity, investment in leadership development has the potential to support growth and jobs' (Kay, 2011)[53].

The review of literature shows that *arts entrepreneur* is a term which covers all types of entrepreneurs operating in the arts and culture sector—producers, impresarios, art dealers, arts agents, artists' agents, independent project managers, and others. Arts entrepreneurs are usually freelancers who are not attached to an organisation, structure or a team. They take a certain degree of risk in their operations and activities and have traits and competences like entrepreneurs in other sectors of the economy. Arts entrepreneurs are those who play an intermediate role between artistic ideas (products, services) and audiences. They usually start from an idea, then seek investments and financial support, organise all the resources and processes and lead the team to a successful implementation of this idea, either in the form of a project or by starting up a new organisation.

Arts entrepreneurship is about 'activating' an innovative aspect of an organisation's or project's development—bringing an idea from the initial incubation and testing phase to the commercial one while taking a risk. Strategic arts entrepreneurs are doers but also analytical thinkers and visionary people. They are the ones who generate an idea which has an innovative potential or who set up a climate for innovative thinking. Then they organise resources around the implementation of this idea—people, money and material and informational resources—while at the same time seeking options for long-term development and sustainability.

> Arts entrepreneurship is an economic as well as sociocultural activity, based on innovations, exploitation of opportunities and risk-taking behaviour. It is a visionary, strategic, innovative and social activity.

Working as an entrepreneur in the arts sector requires similar traits and competences to those described in the preceding. There are several main characteristics which define the uniqueness of arts entrepreneurs:

- **Social and cultural aspects of their work.** Entrepreneurs in the arts are both business and also social entrepreneurs. They aim not only to increase the revenues and the profit but also to bring more audiences, supporters and media attention to arts projects and initiatives.
- **Love for the arts and/or positive attitude to the arts.** As already discussed, creativity is the essence of every arts organisation. Entrepreneurs in the arts need to understand creative processes and outcomes to be able to match them with relevant audiences and supporters.

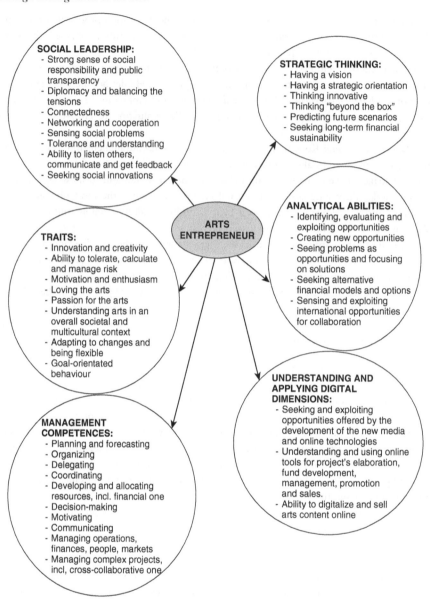

Figure 1.3 Traits and competences of arts entrepreneurs

- **Ability to balance the tensions.** Arts entrepreneurs need to reflect on the needs of many internal and external groups and stakeholders which sometimes have controversial viewpoints on what art quality is about and how to measure success.
- **The need for social responsibility and public transparency.** This is required especially for projects funded by public money. Art is always a subject of social judgement, approval and discussions and arts entrepreneurs are sometimes more visible than the one in other areas.
- **Social leadership abilities.** Arts entrepreneurs are the one who care not only about the business matters, but about social values and social causes. They encourage others to get involved and grow the communities around an art project or an event. Arts entrepreneurs understand well that artistic creativity is a tool for social change and contribute to positive societal changes through the arts.
- **Networking, communication, and collaboration.** Arts entrepreneurs need to be connectors, to understand the importance of networking and cooperation in the arts. Most of the successful

strategies in the field of arts and culture are based on collaboration. Seeking ways to expand internationally, to cross borders and collaborate with others are important aspects of any entrepreneurial practice in the arts.

- **Understanding of the multicultural context.** Entrepreneurs in the arts usually deal with diverse audiences' groups. They need cross-cultural communication skills to develop projects especially related to widening audiences' participation, using art means to solve social issues and operating in a multicultural environment.
- **Understanding and application of digital dimensions.** Managing projects in the arts nowadays is not anymore closed within an institutional or local context. Arts entrepreneurs need to constantly seek and implement new technologies and online tools to create artistic work online, to make the events and projects visible, to attract global audiences and users, and to promote the art works much cheaper and faster.

Figure 1.3 gives an overview of the traits and competences of a successful entrepreneur in the arts.

Successful arts entrepreneurs are visionary social leaders, strategic managers and social innovators who have strong motivation and are not afraid to take risks while at the same time forecasting and planning the future steps in the realisation of their idea. They peer at long-term goals and achieve creative, economic, and social results. Arts entrepreneurs aim as a minimum to break even[54], or to expand the organisation and make future profits, while at the same time seeking innovative solutions to social and cultural problems in a sustainable mode. On the other hand, successful managers of arts organisations are the ones who run them in an entrepreneurial mode, who facilitate an entrepreneurial climate where innovative ideas are constantly generated, developed and realized for the benefit of the organisation, as well as the society as a whole.

6. INTRAPRENEURIAL ARTS ORGANISATION: MAIN CHARACTERISTICS

Attempts to combine entrepreneurship with management aspects within an organisation lead to elaboration of the term *intrapreneurship,* or *corporate entrepreneurship* (or *internal entrepreneurship*). A review of the literature shows that authors on intrapreneurship look at this relatively new phenomenon from two main aspects—individual and organisational:

- *Intrapreneurs* are individuals who have the traits and competences of entrepreneurs but prefer to work within an organisational environment. Intrapreneurs focus on innovation and creativity and work not only to generate a new idea but also to transform it into a profitable project. Together with the usual entrepreneurial traits mentioned earlier, such as a propensity to take risks, self-motivation, an action-orientation and initiative, intrapreneurs have an ability to persuade management teams and boards, to play an intermediate role between the organisation and the business environment. Their skills in negotiation, diplomacy and networking, building coalitions of supporters, are also very important to bring an idea to a successful realisation. Intrapreneurs need to be able to take responsibility and risk in the whole process of realising an innovative idea. Possession of entrepreneurial traits by key figures in the management team—the general manager, artistic director and board members—is an important factor for an organisation to be classified as intrapreneurial.
- The second aspect of intrapreneurship is organisational. It relates to the type of organisational culture and management style required to create a climate for intrapreneurship in an organisation. An intrapreneurial climate is usually described in the management literature as one where employees are given ongoing freedom, encouragement and support, including financially, to create and develop new ideas. Enhancing an intrapreneurial climate depends on the organisational structure, management style, size of organisation, system of motivation and personnel development, as well as the overall strategy of an organisation. The more rigid, hierarchical and inflexible an organisation is, the more difficult intrapreneurship becomes.

Developing an intrapreneurial climate in a large organisation is important, because it helps an organisation to quickly take advantage of an opportunity, keep a dynamic working spirit and, in the long run, improve the competitive positioning or the unique features of an organisation because of the successful and profitable realisation of an innovative idea.

Intrapreneurship in arts organisations has still not been explored in the arts management literature. This is an important subject, especially in the changing external environment, where financial support for the arts is decreasing in many countries, and audiences have many more choices for spending their time and money in their free time. Strategic thinking and actions in the arts nowadays need to be tightly connected with elements of innovation and entrepreneurship in the business-oriented organisations as well as in the subsidized and nonprofit organisations. This is one of the sustainable ways to survive in the competitive environment of the rapidly growing entertainment industries and the context of limited public funding for the arts.

An intrapreneurial arts organisation is the one where elements of both innovation and entrepreneurship are embedded in its strategic management process. The following are eight main characteristics of an intrapreneurial arts organisation.

- **Evidence for elements of innovation or projects with innovative features.** Every arts organisation is creative, but not every arts organisation is both creative and innovative. Innovations in the arts, as already discussed, bring both economic and social effects as a result. Their project-based activities are important not only for increasing visibility and bringing in audiences but also for generating additional sources of income in the long run. An intrapreneurial arts organisation focuses on strategic innovations which bring value to audiences and clients.
- **Establishment of teams or units to work on generation and implementation of innovative ideas.** Intrapreneurial arts organisations are ones where internal project teams are not only established but supported on an ongoing basis. These teams generate an idea, take calculated risks and are responsible for the development and implementation of the idea to reach a successful end. They take responsibility for delivering the final results.
- **Experimental, 'laboratory' climate.** Intrapreneurial arts organisations are not hesitant to experiment and try new ideas on an ongoing basis and to pass through a process of trial and error. Usually, large organisations can afford to spend money for experimental development, while smaller organisations need to develop projects which are backed up by certain risk-mitigation strategies. Investing in a permanent fund for research and development (R&D) to support ongoing innovative ideas is one of the prerequisites for an arts organisation to be intrapreneurial.
- **Securing of ongoing financial support for innovative projects.** Ad hoc support for innovative ideas is important, but to be defined as intrapreneurial, an arts organisation should include financial support for research and development on an ongoing basis as part of the strategic plan. Intrapreneurial organisations are the ones that do not expect fast and immediate results but are prepared to spend a sufficient amount of time and efforts in development of an innovative idea. Supporting an innovative idea with resources, such as space, free time for creation, financial support and informational and infrastructural support, is an important characteristic of an intrapreneurial arts organisation.
- **Commercial aspects: generating revenues as a result.** Intrapreneurial arts organisations not only elaborate new ideas but complete the whole cycle from idea to implementation. The implementation phase aims at bringing revenues and exploring new funding sources. Intrapreneurial arts organisations are financially stable over time.
- **Flexible organisational structure.** Intrapreneurial arts organisations have internal structures which support innovation and risk-taking. There are no strict boundaries between management levels and different departments. Teams are created in a fluid and matrix-type structure manner. Creating an environment where people can generate and share ideas in a free and open way is an important factor in creating an intrapreneurial climate, for example having regular organised brainstorming sessions, focused groups, cultural retreats, and so on.
- **Adaptability to changes.** Strategic management in intrapreneurial arts organisations is a process to manage changes. The ability of an arts organisation to change the course of its actions based on

ongoing responses from the internal and external environments, to respond to problems quickly and innovatively, is also a symptom of having an intrapreneurial climate.

- **Ability to connect and network.** Intrapreneurial arts organisations are open systems that work in a synergetic mode by collaborating and communicating with others. Networking has become a key strategy for many arts organisations, especially those that seek international expansion and growth.

Strategies and intrapreneurship in the arts should be connected, because effective strategies result in long-term sustainability. Intrapreneurial organisations make possible constant generation and implementation of ideas which bring more audience members, supporters and public attention to the arts.

7. INTRAPRENEURIAL PROCESS IN AN ARTS ORGANISATION

Figure 1.4 presents a theoretical model of an intrapreneurial process in an arts organisation, consisting of five main phases.

Phase one: Establishment of an intrapreneurial climate. As mentioned earlier, an intrapreneurial climate requires certain characteristics. The management team needs to re-evaluate internal procedures, rules and structures in order to give space for elaboration of new ideas. One of the ways to prepare an organisation to start being intrapreneurial is to elaborate a strategic plan where human resource management is devoted to setting up such internal separate units (see Chapter 8).

Phase two: Generation of innovative ideas. Ideas can be generated in different ways and from different sources. There are no universal rules and recommendations on where to find an innovative idea in the arts. Approaches for generating ideas depend on various circumstances, such as

- the previous experience of the intrapreneur as an arts manager, artist or member of the staff of an arts organisation;
- the creative skills and direct involvement of the intrapreneur in an art form (writing, performing, singing, etc.) and the elaboration of an artwork (e.g. a poem, song, painting or book);
- other involvement by the intrapreneur in the arts, for example as a volunteer, member of a family of artists, board member, audience member or arts consultant; and
- the country, region or city where the arts organisation is based and the quality as well as the quantity of arts and organisations there.

Sources of new entrepreneurial ideas within an organisational setting can be grouped into internal and external:

- *External methods* include feedback from audiences and clients, feedback from stakeholders, targeted research (both online and offline) and focus groups with external experts.
- *Internal methods* include board discussions, feedback from the staff, cultural retreats and formation of special units to elaborate new ideas.

Very popular methods for generating ideas are the creative group methods, such as focus groups and brainstorming.

Phase three: Evaluation and selection of rational ideas. The ideas generated have to be evaluated so that only the ones which fit certain criteria go on to the realisation stage. There are five main criteria

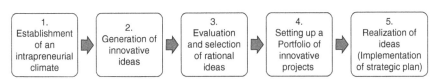

Figure 1.4 The intrapreneurial process in an arts organisation

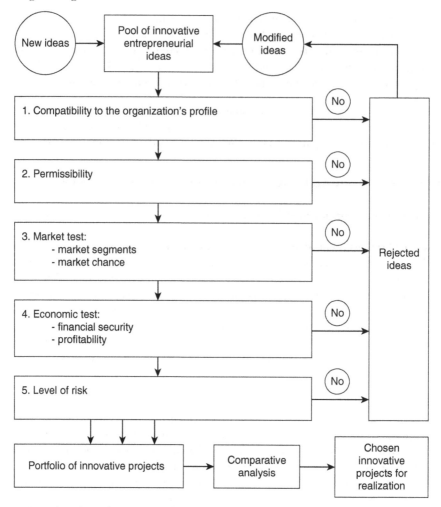

Figure 1.5 Procedure for evaluation and selection of innovative entrepreneurial ideas

for filtering of ideas (see Figure 1.5). The filtering phase aims to select the ideas which fit certain criteria and indicators; it also prioritises them in accordance with long-term plans. These criteria are as follows:

- Is the idea compatible with the organisation's vision, mission and long-term objectives?
- Is the idea permissible? Are there any legal or other restrictions on its realisation?
- What are the market chances of the new idea? What are the potential market segments when it is commercialised?
- What is the expected degree of profitability? Can the idea bring financial security in the future?
- What is the calculated level of risk if the idea is implemented? How can risks be mitigated?

If, as a result of the filtering, an idea is rejected because it does not fit one of these five criteria, it has to be modified and to pass through the filtering process again. If this is not possible, another idea is picked from the pool of innovative ideas to be evaluated through the filtering process. If an idea fits all the criteria, it becomes part of the organisation's 'portfolio of innovative projects'. Among all the accepted ideas, the one which offers higher expected incomes and lower risks in the comparative analysis is the one to be realized.

Phase four: Development of a portfolio of innovative projects. This portfolio is formed as a result of the selection process. Selected ideas become planned projects for further realisation and are included in the strategic plan. Elaborating ideas as projects is the way to more precisely characterise the aims, activities, resources, people in charge, time frame and expected results of implementing innovative ideas.

Phase five: Realisation of ideas. This phase is part of the implementation of the strategic plan.

The ongoing process of generating ideas and transforming them into innovative opportunities is the backbone of a successful arts organisation having a strategic approach and working in an intrapreneurial mode. Arts managers nowadays need both strategic vision and entrepreneurial behaviour to lead their projects and organisations in a constantly changing and demanding environment.

PRACTICAL RECOMMENDATIONS

When elaborating a pool of innovative ideas, answer the following key questions:

- Is our idea adequately original and innovative? How is it different from all other offers in the arts and culture sector?
- How does the idea fit the overall strategic management in our organisation? Does it correspond to our vision, mission and long-term objectives?
- What are we good at? What are our strengths that would help us successfully realize this idea?
- What are our weaknesses which might increase the level of risk in the realisation of the idea?
- What are our current assets, organisational capacity and available resources?
- What are the opportunities and resources in the region and the community where we live?
- What is the art and cultural potential in the region? Is there any external support for innovative art projects?
- Who are the potential audiences and clients for the innovative products or services?
- Does the innovative idea have a potential for long-term financial sustainability and growth?

2 Strategic Management

Essence, Role and Phases

LEARNING OBJECTIVES

Upon completing this chapter you should be able to:

1. *Understand strategic management in light of the historical phases of its development and current theories.*
2. *Elaborate reasons why strategic management is important in the arts sector.*
3. *Recognise the main phases in a strategic management process.*
4. *Analyse reasons why implementing strategic management in the arts is special as well as challenging.*
5. *Explain the main terminology used in the strategic management process.*

This book regards planning as an essential function in management practice, one that enables managers to understand clearly where their organisation is going and how. Planning is about setting the right direction, evaluating capacity and resources, recognising hidden opportunities, avoiding mistakes (as far as possible) and then guiding the organisation along the chosen road. To a certain extent planning helps make the future visible and as far as possible predictable.

1. STRATEGIC MANAGEMENT AND PLANNING: HISTORICAL DEVELOPMENT

In business practice, the term *strategic management* is used interchangeably with the terms *corporate strategy, business policy* and *strategic planning*. In the course of more than 100 years, the evolution of management and planning theory and practice has passed through several main stages until very recently reaching the arts and culture sector.

1.1. Early Management Theories: The Model of Organisations as Closed Systems

As already discussed in Chapter 1, the roles, functions and daily responsibilities of managers and administrators in the cultural practice vary significantly. From a theoretical point of view, well-known management functions include forecasting and planning, organising, commanding, coordinating and controlling, described for the first time by Henri Fayol (1841–1925)[1]. Throughout centuries of development of the management theory and practice worldwide, many other management functions have been added to this initial 'bouquet', such as delegation, decision-making, motivation, management of changes, management of conflicts, management of communication, ability to allocate resources, and others. The 'father of scientific management', Frederick W. Taylor (1856–1915), believed that

management is the '*art of knowing what you want to do and then seeing that it is done in the best and cheapest way*'[2]. This definition is related to the importance of the planning function in every management practice. He regarded scientific management as an ongoing collaboration between workers and managers and emphasized that planning, scheduling, organising and training are important functions of every manager.

This first period in the evolution of management theories was characterised by internal organisational management and planning. The main characteristics of the model were as follows:

- Organisations were regarded as a 'closed systems', and the planning process dealt mainly with internal resources and their efficient implementation.
- Management goals and objectives were set up internally, without considering ongoing feedback from clients, buyers and external groups.
- Emphasis was placed on management and planning of the internal processes, without implementing tools for communication between an organisation and its environment.
- The principle of planning was based on 'extrapolation'—from the past to the present and then the future.

The lack of a competitive environment and a poorly developed business sector in these early years were some of the reasons why management theories did not consider the importance of the external environment, such as industry trends, competitors and markets.

1.2. Strategic Management as a Discipline:
The Model of Organisations as Open Systems

In the 1950s–1960s authors in management and related disciplines introduced the importance of matching the organisation's internal factors with external circumstances (Philip Selznik, 1957)[3]. Later, this idea was elaborated as SWOT analysis—a method to evaluate the Strengths and Weaknesses of an organisation against the Opportunities and Threats in the environment. This concept is widely used in the practice of strategic management today.

Igor Ansoff (1918–2002), known as 'the father of strategic management', elaborated in 1957 a matrix to help an organisation choose a strategy of growth in order to be prepared for future opportunities and challenges[4]. He suggested four main strategies: market penetration, market development, product development and diversification. In the last 60 years, Ansoff's matrix became widely used in the practice of strategic business management[5].

The 'creator and inventor of modern management', Peter Drucker (1909–2005), introduced plenty of new ideas in management theory: the idea of decentralisation, the importance of workers as 'assets' in an organisation, the view of the corporation as a human community, the importance of customers for business development, the concept of 'knowledge worker', the theory of management by objectives (MBO), and many more. Alfred Chandler (1918–2007) recognised that a long-term strategy was necessary to give a company structure, direction and focus[6]. He wrote extensively about the management structure of modern corporations.

Michael Porter's widely applied book *Competitive Strategy* (1980)[7] offers three generic strategies for achieving and maintaining a competitive advantage for a company: cost leadership, differentiation and market segmentation (or focusing). Porter emphasizes that every business would need to specialise in one of these strategies in order to keep a distinctive competitive position. Porter's concept is discussed by many authors on strategic planning and is applied by millions of organisations worldwide. It is especially important for business-type organisations looking at competing and positioning themselves best on the market.

Towards the end of the 20th century, it was clear that management theory emphasized the importance of external economic, social, political, technical and market forces for organisations' development. It became a necessity for a successful company to look at the relations between the internal management and changes in the outside environment. Management theories started to consider two main levels in management of organisations: strategic and operational. The operational level covers all functional

management areas, such as human resource management, operations management, production management, marketing management, financial management, and so on. This model of management and planning regards organisations as open systems. Its main characteristics are the following:

- The focus of planning shifts from internal to external factors and increasingly relates to outside factors, especially markets, competitors, stakeholders and collaborators.
- Seeking a competitive advantage becomes an important focus in business strategies. Many authors stress that strategic management is about creating and sustaining a competitive advantage.
- The 'marketing-mix' concept becomes a focus point in the overall planning process—offering the right product, at the right time, to the right customer at the right price, using the right communication tools[8].
- Plans are based on in-depth market research, prognoses of sales and profits, analysis of competitors and better understanding of customers' needs and preferences.
- Organisations constantly compete for customers' time and money because of increased choices in the market.

In its early stages of development, strategic management was mainly used by companies in the business sector and focused on strategies, tools and models to generate profit, expand in new markets, increase revenues and grow the company,

1.3. Strategic Management and Planning in the Nonprofit Sector

Most research work and publications in strategic management and planning have focused on business organisations. In the 1970s–1990s the general management theories began to gradually influence the service sector, and then the nonprofit organisations. In many countries organisations in the third sector were appearing and developing rapidly in that period. Managers in the nonprofit sector started to recognise the need to implement marketing strategies and thus to find methods and tools to attract audiences, sell products and improve the organisation's image and visibility, as well as find supporters.

The first attempts to apply strategic planning in the public sector began in the late 1960s to early 1970s. Anthony Catanese and Alan Walter Steiss (1970)[9] emphasize the need for a more systematic approach to public decision-making and state that planning is a prerequisite for effective management, whether in the private or public sector.

John Bryson (1995)[10] was a pioneer in introducing planning models and techniques for the nonprofit organisations. He proves that strategic planning can be applied to public agencies and their departments, nonprofit organisations that provide public services, organisations providing specific services (transportation, health, education), and interorganisational networks in the public and nonprofit sectors. Bryson emphasizes that the key to success for public and nonprofit organisations (and for communities as well) is the satisfaction of key stakeholders. Therefore, analysis of stakeholders, as well as the involvement of citizens in the overall strategic planning process of a nonprofit organisation, is of utmost importance. He points out that the attention and commitment of key decision-makers are the resources most needed to undertake strategic planning in a nonprofit organisation.

1.4. Modern Approaches to Strategic Management and Planning: Focus on Leadership, Innovation and Entrepreneurship

The latest theories on strategic management look not only at strategies for competitive advantage but also at how strategic management helps an organisation be a leader, constantly innovate and be entrepreneurial. Despite many attempts by diverse authors, connections between strategic management, entrepreneurship and innovation are not thoroughly elaborated in the academic literature, especially in relation to the nonprofit and, arts and culture sectors. Theories in strategic management mainly relate to large, well-established companies, while entrepreneurship is considered an independent activity, starting

with an idea and bringing this idea to a successful end. The following is a selection of authors who devote their research work in all three areas of strategy, innovations, and entrepreneurship.

Back in 1978, Dan Schendler and Charles Hofer[11] regarded strategic management as a process that deals with the entrepreneurial work of the organisation, with organisational renewal and growth and, more particularly, with the development and utilisation of the strategy which is to guide the organisation's operations. Dale Meyer and Kurt Heppard (2000)[12] stress the connection between entrepreneurship and strategy and discuss the importance of having a strategy in the entrepreneurial process, as both are about finding something new, innovative, adaptable and unique.

Derrick Palmer and Soren Kaplan (2007)[13] describe a holistic, multidisciplinary framework that enables organisations to take a strategic approach to innovation. The framework is a combination of non-traditional and creative approaches to business innovation with conventional strategy development models. The authors also offer a 'mini-diagnostic' for an organisation to determine whether the organisation is innovating strategically.

Chris Bilton and Stephen Cummings (2010)[14] discuss the connection between creativity and strategy, using the term *creative strategy*. Authors emphasize the importance of integrating innovation and entrepreneurship, as well as leadership and organisation in the creative strategy. They outline that creative strategy is also built on an approach to leadership and being able to envisage the big picture for the future while interacting in the present.

Allen C. Amason (2011)[15] regards strategic management as a process which, together with integrating the firm's functions into patterns of actions, is designed to fit the constraints and demands of the market, creates value for the customers, owners and stakeholders of the firm. He defines strategic management as an essential framework for analysing the environment, for learning and adapting to change and for creating value both in the present and into the future. Mark Sniukas (2011) attempts to summarise and structure the theories on strategy and strategic innovation and to provide a practical framework and advice to help managers think about how to develop and implement innovative strategies.

Many authors analyse and implement the terms *strategic innovation* and *innovative strategy,* emphasising strategies that create new products, new services or new business models that generate significant value for the customers over a long period of time. Strategic innovations become a core element of strategic management in many companies, emphasising the need to have an ongoing management innovation process and to look beyond the obvious while forecasting the future. Strategic innovations require forming strategic alignments among stakeholders.

A review of the literature on the topic shows that the main characteristics of modern approaches to strategic management and planning are the following:

- The starting point is in the future, not the past or the present, and it takes the form of vision and mission. Strategic innovative thinking is a crucial aspect of strategic management.
- The overall organisational behaviour is influenced by unpredictable external factors. A turbulent environment puts ongoing pressure on organisations, including financial concerns. Strategic management and management of changes become inevitably connected: rapid and ongoing changes in the environment force an organisation to be flexible and constantly look for ways to adapt to these changes.
- Successful business strategies are based on innovations and differences. Managers constantly seek new ways of doing things, non-traditional approaches to satisfy customers' unmet needs. Organisations look at how to do things differently, not only at how to be better than their competitors in the field.
- An ability to see the 'bigger picture' becomes an important trait of successful managers at all levels. 'Thinking beyond the box' becomes a vital part of the organisational culture.

It has become clearer in recent years that strategic management is an approach that is not applicable only to large companies. Successful entrepreneurs also require strategic thinking and actions. They use strategies and planning to decrease the level of the foreseen risks and to achieve their long-term business and societal objectives. They are not only doers but also strategic thinkers.

1.5. Strategic Management in the Arts and Culture Sector

Art management appeared as a discipline and as a separate area of research several decades ago[16]. From the first publication on arts administration, written by John Pick (1980)[17], until today, researchers and writers have stressed the use of business and management models in managing different types of organisations in almost all fields of arts and culture: visual arts, performing arts, music, literary arts, and so on. The literature on arts management is divided into functional areas as well, for example marketing in the arts, public relations and audience development, fundraising, financing and sponsorship in the arts, legal aspects in the arts, and so on[18]. Most publications that explore theories on arts management and cultural administration deal with the nonprofit and subsidized organisations in the culture sector and the importance of knowing how to manage internal operations, people, markets, finances and other aspects of organisational development. Another group of authors looks at a macro-level and deals with the essence and development of cultural policy tools and mechanisms in different countries, matters of cultural economics, and the importance of the cultural and creative industries in today's world[19].

There is certainly a lack of publications on strategic management and planning in the arts. Michael Kaiser (1995)[20] offers a practical guide for considering key issues when preparing a strategic document for a nonprofit arts organisation and describes a practical approach to developing a strategy. He divides the strategic planning process into three main areas: analysing, strategising and actual planning and emphasizes the difficulties between taking both creative, managerial and entrepreneurial decisions when elaborating strategies in the arts. Milena Dragićević Šešić and Sanjin Dragojević (2005)[21] discuss elaborate conceptual issues and challenges facing arts management in turbulent circumstances and introduce a series of strategic development concepts as well as practical management tools for the operational management of arts organisations. The authors elaborate a methodological framework for capacity-building and strategic planning in arts organisations in regions with unstable and constantly changing external environments (Central and Eastern Europe, Central Asia, the Caucasus, etc.) and analyse specific cases of arts organisations.

This book considers the main characteristics of modern approaches to strategic management and investigates their applications to the arts and culture sector. Elaborated cases throughout the book illustrate that sustainable strategies in arts organisations require development of an intrapreneurial climate, related to elements of innovation and entrepreneurship.

2. STRATEGIC MANAGEMENT AS A PROCESS TO MANAGE CHANGES IN ARTS ORGANISATIONS

Strategic management is a process directed towards solving strategic problems and achieving strategic aims. It requires making strategic decisions. Strategic management process helps the organisation adjust to a changed environment and move toward well-defined and agreed long-term objectives. Strategic management processes in an arts organisation answer the following questions:

- Where does the organisation want to be after a certain period of time (in most cases up to four years)?
- Where is the organisation now—what does it do, and why? Where is the starting point for the journey? What is its potential for innovation? What is the entrepreneurial climate within the organisation?
- What are the trends in the outside environment, and how is the organisation positioned with respect to its competitors, collaborators and stakeholders?
- What are the possible sources of innovation?
- What are the organisation's internal capacity and resources? Where are the elements of innovation and entrepreneurship (if any)?
- How could the organisation change and reach the final destination?

Strategic management is both an analytical and practical process in which an arts organization: 1) sets up its mission, vision and long-term objectives; 2) makes a profound diagnosis of its current state in terms of available resources and potential for long-term development; 3) analyses all possible strategies and alternative actions for achieving the desired future state; 4) chooses those which are the most effective considering the changing external factors; and 5) implements them while constantly monitoring and controlling the whole process, undertaking ongoing corrective measures where required, and considering feedback for the next cycle of strategic planning.

There are conceptual differences in the strategic planning process for a business organization as compared to a nonprofit arts organisation. In a business organisation strategic management and planning focus on defining the competitive advantage, current and future market segments and the competitive positioning of the organisation over a long period. Growth and expansion based on generating higher profits stay at the core of the strategic objectives. This does not exclude social goals for a business organisation, for example the implementation or support of a social innovation or a corporate social responsibility programme. In a nonprofit or state-subsidized organisation, strategic management is a process that focuses mainly on the core artistic objectives, audience engagement and education, advocacy for a social cause, preservation of cultural heritage or ways to use a more participative approach in communication strategies. Nevertheless, nonprofit organisations also need to seek innovative and entrepreneurial elements in their strategic concepts in order to grow their audiences and communities and expand their sources of income beyond the traditional support from governments, foundations, corporations and individual donors.

Visually, the strategic management process is similar to a road map—a way to draw the road within a time frame and space, with a view to determining and evaluating various options to reach the final destination (Figure 2.1). The strategic management process is a combination of past, present and future: it involves anticipating the future organisational objectives and changes in the environment, while making management decisions in the present, based on a thorough analysis of the current situation and a consideration of the results of past activity.

In order to answer the key question 'Where do we want to be?' an organisation needs to decide on the mission and vision and the set of long-term objectives that define its desired future. The question

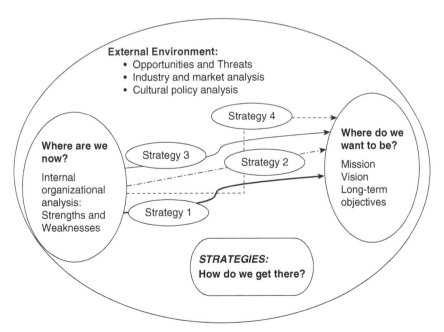

Figure 2.1 Strategic management: mapping the road

'Where are we now?' requires conducting an internal analysis of the organisation's strengths and weaknesses in areas such as management structure and performance indicators, programming, the financial state of the art, the entrepreneurial and innovative climate, and others. This is the first half of a SWOT analysis: the strengths and weaknesses. This question also requires a thorough analysis of the major external factors in light of how they help or disturb the organisation's activities and results. This is the second part of the SWOT analysis: the opportunities and threats. Answers to these four areas of analysis change over time, giving an impression of uncertainty and unpredictability. This is why art managers and entrepreneurs sometimes argue that there is no need for strategic planning, because it is impossible to predict the changing reality anyhow and the strategic plan is more a myth than a reality. Nevertheless, SWOT analysis is very popular and widely used as a tool to prepare an organisation to counter potential threats as well as capitalise on future opportunities. The question 'How do we get there?' requires a systematic analysis of possible strategies and selection of the most effective one(s) given concrete circumstances, the one that will help fulfil the organisation's mission and achieve its aims[22].

3. PHASES OF THE STRATEGIC MANAGEMENT PROCESS

Literature on strategic planning does not give a universal framework for the phases in the strategic management process. Selected opinions of authors on the subject are given below[23].

Fred David (1993)[24] suggests that the strategic management process consists of three main stages:

- Strategy formulation. This includes developing a mission statement, identifying external opportunities and threats, determining internal strengths and weaknesses, establishing long-term objectives, formulating alternative strategies and selecting particular strategies to pursue.
- Strategy implementation. This stage is related to establishing annual programme objectives and policies and allocating resources to ensure the successful execution of formulated strategies. Motivating employees, creating an effective organisational structure, preparing budgets and developing and utilising information management systems are also part of this stage.
- Strategy evaluation. This stage is related to reviewing external and internal factors and taking corrective actions.

Arthur Thomson and A. J. (Lonnie) Strickland (1996)[25] identify the five tasks of strategic management as

- formulating a strategic vision;
- converting the strategic vision and mission into measurable objectives and performance targets;
- developing and testing strategies to achieve the desired results;
- implementing and executing the chosen strategy efficiently and effectively; and
- evaluating performance and initiating corrective adjustments.

Roger Kaufman, Hugh Oakley-Browne, Ryan Watkins and Doug Leigh (2003)[26] differentiate the mega, macro and micro levels in strategic planning, emphasising that strategic thinking and planning are related and that together they can lead to accomplishment of high results. Alan Walter Steiss (2003)[27] regards strategic management as the development of strategies and formulation of policies to achieve organisational goals and objectives, paying attention to both external strategies and internal capabilities. He stresses that strategic management is concerned with relating organisational resources to challenges and opportunities in the larger environment and determining a long-range direction relative to these resources and opportunities.

Rudolf Grünig and Richard Kühn (2011)[28] divide strategic management into strategic planning, implementation of strategies, and strategic control. These authors emphasize the key role of strategic planning within strategic management as a process which determines the daily business but is run independently of it, while the other two tasks—strategy implementation and control—are part of

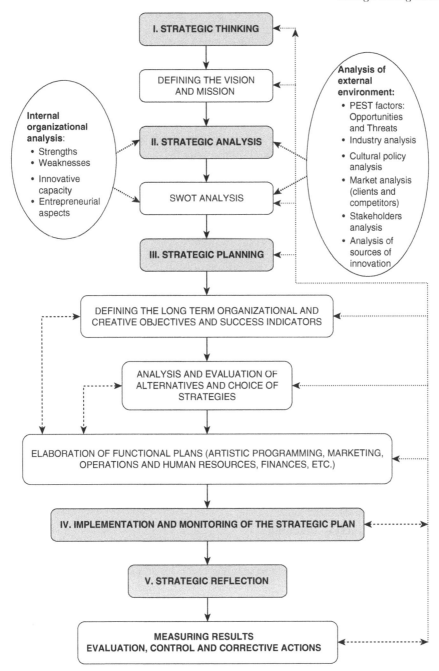

Figure 2.2 The strategic management process: an overview

[1] PEST factors are macro-environmental *p*olitical, *e*conomic, *s*ocial and *t*echnological factors that affect organization's performance.

[2] SWOT analysis is a method to evaluate the strengths and weaknesses of an organization against the opportunities and threats in the environment. This concept is widely used in the practice of strategic management today.

the ongoing daily management process. They conclude that strategic management is the product of strategic planning.

Considering the literature reviewed, arts management practice, and the cases elaborated in this book, strategic management in an arts organisation can be regarded as a spiral process having five main phases (see Figure 2.2)[29].

3.1. Phase I: Strategic Thinking

This phase includes understanding the main need to elaborate a strategic plan, gathering as much information as possible and identifying approaches for developing the plan and determining the people (team) responsible for it. It also includes envisaging possible obstacles and risks. In his book *The Rise and Fall of Strategic Planning* Henry Mintzberg (1994)[30] differentiates strategic planning from strategic thinking and emphasizes that strategic thinking is about synthesis; it involves intuition and creativity. The outcome of strategic thinking is the articulated vision of direction.

Defining the organisation's mission and vision, and its overall organisational identity, has a fundamental role in the long-term development. It is important for the organisation's image, organisational culture, communication with audiences, communities, stakeholders and the media. Defining the set of strategic objectives, prioritising them and breaking them down within a time frame is the next step in strategic thinking after formulating the vision and the mission, as well as working out the overall organisational identity. This process is elaborated further in Chapter 4.

Strategic thinking is the start-up phase of the strategic management process but is also embedded in all the phases. It means constantly asking questions such as: Are we doing the right thing? Are we going in the right direction? How do we see our organisation in 5, 10 or 15 years from now? Do we understand the environment, the driving and restraining forces and the organisation's response to it? Can we adapt, and how, using diverse strategies to achieve our mission?

3.2. Phase II: Strategic Analysis (Analysis of the External and Internal Environment)

Strategic analysis is done by diverse methods which aim at identifying where the organisation is at in terms of its internal operation, capacity, resources, overall performance and other factors, and what the main trends and changes in the external environment are. The most used method is SWOT analysis, which answers the questions 'Where are we now?' and 'What is our position in relation to the outside economic, political, social, environmental and other factors?' Depending on the type of the organisation (business, nonprofit or subsidized), this analysis looks at different external groups influencing the organisation's performance, for example competitors and stakeholders. Analysis of the external and internal environment is elaborated in detail in Chapter 5.

3.3. Phase III: Strategic Planning

This is the actual work of elaborating the strategic document (a plan, concept, framework or set of strategic programmes). This phase could be split into two main subsections which also reflect the two levels in the management structure:

- **The strategic level:** evaluation of potential strategies and selection of the right set of strategies, considering the results of the analysis as well as the organisation's mission, vision and objectives. Chapter 6, as well as the cases elaborated in the book, discusses the choice of various strategies in arts organisations.
- **The functional level:** developing the functional parts of the plan. Their implementation considers the overall strategy of the organisation and makes it more concrete, emphasising various aspects of the organisation's development, such as programming and creativity, marketing, human resources development and plans for financing and fundraising. Chapters 7, 8, 9 and 10 discuss functional sections of the strategic plan.

Strategic management theories emphasize the strategic level more than the functional level. There should be a strong correlation between the two, because functional strategies result from the general organisational strategy. On the other hand, organisational strategy considers the capacities and resources in all management areas. David (2011)[31] defines strategic management as the art and science of formulating, implementing and evaluating cross-functional decisions that enable an organisation to achieve

its objectives. He stresses the importance of the functional areas and the need for strategic management to focus on integrating management, marketing, finance/accounting, production/operations, research and development and information systems to achieve organisational success. Chapter 3 discusses in more detail the need for collaboration between the top managers and the functional managers in the process of elaborating the strategic plan.

3.4. Phase IV: Implementation and Monitoring of the Strategic Plan

This is one of the core management function, along with other management functions such as organising, coordinating, motivating and decision-making. It is important to constantly monitor current activities, resources, staff and deadlines. One of the main difficulties related to arts organisations is achieving a balance between the creative process and all other processes happening 'backstage' such as creative, operational, financial, marketing and managerial.

During the implementation of the strategic plan it is important to constantly motivate all people involved—the staff, board members, executive director, artistic director, management body, volunteers and stakeholders. Motivation creates a sense of belonging to an organisation and an ongoing engagement which is an important basic factor for achieving the desired goals. The role of motivation in the strategic management process is discussed in Chapter 8.

3.5. Phase V: Strategic Reflection: Measuring Results—Evaluation, Control and Corrective Actions

This phase is the last in the overall strategic management process. It is equally important, as it provides feedback, records diversions from the planned aims and provides success indicators that will help in the next strategic planning process. Corrective actions should be undertaken throughout the overall process of a plan's implementation as in many cases the reality is different from the planned actions. Implementation and strategic reflections are the subject of discussion in Chapter 11 of the book.

Figure 2.2 shows that strategic management is an ongoing, multilayered and complex process which involves all departments, teams and management levels in an organisation. All phases and stages are logically connected with one another, and they repeat constantly in a cycle. As discussed further in Chapter 3, there is an ongoing spiral communication between the strategic level and the operational level in the process of elaborating and implementing a strategic document. From a practical perspective, and considering the angle of innovation and entrepreneurship, the key phases in the strategic management process answer a particular set of questions, listed in Table 2.1.

Table 2.1 Understanding the Phases of the Strategic Management Process

Phase/stage	Questions
(A) Strategic questions	
Mission	Why do we exist? Why are we undertaking the journey? How are we different from others?
Vision	How do we see ourselves in the long-term future? How do our organisation and programs influence society?
Strategic objectives	What do we want to achieve? What are our long-term priorities? What are our criteria to determine whether we have reached the set-up (initial) objectives?
Analysis of internal and external environment	Where are we now? What are the trends and changes in the creative industries and cultural policies? Who are our potential audiences, and how will they change in the future? How are external factors influencing our organisation: which ones are driving forces and which ones are restraining forces with respect to our future development? Who are our stakeholders and supporters? How will they change in the future?

Table 2.1 (Continued)

Phase/stage	Questions
Strategies	How do we undertake the journey? How do we get there? How do we foster innovation? How do the chosen strategies facilitate an intrapreneurial climate in the long term?

(B) Questions concerning internal operations and management functions

Creative programming	What shall we offer to the public? What are the elements of innovation in the artistic programming? Where will our focus and priorities be in the next three to four years? For example do we plan to engage audiences and communities, sell products and services, increase profits, attract young people, increase participation, diversify our programs, stress the quality of our creative work, or fulfil the expectations of our supporters and donors?
Evaluation of resources	With what means shall we undertake the journey? What are our capacities and resources? What are the potential resources in the future, and how do we exploit them? How can innovations help us use resources effectively?
Marketing plan	How can we be better than others in the field? What are our unique features? What is our competitive advantage? Who are our audiences (clients, customers, buyers, users)[a]? How can we communicate with them and engage them in the most efficient way? How can we balance the creative program strategy with the marketing strategy? What are the elements of innovation in our marketing strategy and tools?
Organisational plan (plan for operations and human resources)	How is the creative process synchronised with the management and technical processes? Do we have the right people for the right jobs? How would our organisational structure change to handle the chosen strategy? How should we recruit, motivate, develop and educate our personnel in the future? How can we improve internal coordination and communication? What kind of material, technical and informational resources do we need to back up the chosen strategy for the organisation's development? What is the role of the board in the overall strategic process?
Financial and fundraising plan	What is the result of the cost-benefit analysis for our key programs? How much money do we need in the long term, and for what? How shall we evaluate our resources, processes and outcomes in money-related indicators? How can we balance self-generated incomes with external funding? What kinds of innovative fundraising and financial models could we elaborate?
Innovations and research and development	What can we improve in our performance? How can we generate and implement innovative ideas in our organisation? Is our organisation intrapreneurial? Do we need to invest in research and development (R&D), and, if yes, in which areas?
Contingency plan	What might stop or prevent us from reaching our objectives? What could be the risks during the journey? How can we mitigate risks through management methods?

(C) Implementation of the plan

Evaluation and control, feedback and measurement of the results	Are we undertaking the journey in the right direction? Did we reach the desired destination? What do our clients, audiences, stakeholders and funders think about our performance and results? What went wrong along the road? Why? What are the lessons learned? How could we improve our performance and results in the next planning cycle? What should we correct?

[a] Differences between audiences, clients, customers, users and buyers are discussed further in Chapter 7.

4. REASONS FOR STRATEGIC MANAGEMENT IN THE ARTS

The strategic management process in arts organisations is based on the commonly accepted key planning principles; however, at the same time it is specific because of their unique nature. There are many reasons why strategic management in the arts is becoming more and more important. Practice shows that strategic thinking, analysis and planning can help an arts organisation to

- define its mission, vision and goals clearly and communicate them well to key internal and external groups and audiences that are involved in or influence organisation's performance;
- see the bigger picture and confront issues beyond the daily problems;
- understand well its uniqueness and competitive advantage;
- prioritise and focus programmes and activities;
- develop and implement innovative projects, tools or methods;
- choose the optimum way to balance creative programming with management actions, marketing approaches and fundraising methods within a specific external context, including a cultural policy model;
- predict to a certain extent unexpected circumstances and risk factors;
- increase the overall organisational efficiency and productivity; and
- become self-sustaining in the future.

Table 2.2 elaborates the reasons for applying strategic thinking, analysis and planning in the functional levels of management—financial, marketing and operational.

This book emphasizes the role of the strategic management process in the achievement of long-term sustainability, especially financially, for an arts organisation. It stresses the importance to arts

Table 2.2 Reasons for Strategic Management in the Arts

Reasons	The strategic management process helps an arts organisation:
Financial and fundraising	analyse, rationally utilise and increase resources needed to implement programs in the long term.seek innovative programs which increase the revenues in the long term.fundraise successfully from various external sources. The strategic plan is the main document used for writing of diverse project proposals and applications for funding and/or designing sponsorship packages.
Marketing and communications	evaluate the potential to start new programs, enter new markets and implement new methods of marketing and communication.attract and keep future audiences and communities and engage the current ones.identify and maintain healthy relationships with funding institutions, donors, supporters, audiences, government institutions, unions, networks, associations and the media.improve visibility of creative products and services, both online and offline.
Organisational and managerial	analyse and evaluate the capacities and resources of the organisation versus established goals.increase organisational capacity and resources for implementation of strategic decisions.increase management competences and improve *rational decision-making*.[a]strengthen the capacities and professionalism of key staff members and the board.identify elements of innovation and intrapreneurship in internal operations and processes.improve staff motivation and internal communication.set up specific performance indicators.

[a] Rational decision-making means making decisions considering the future possible consequences. It relies on the results and information drawn from a SWOT (strengths, weaknesses, opportunities and threats) analysis and other research methods.

organisations of being intrapreneurial and—through the whole strategic management process—of developing and implementing innovative strategies, tools and projects which help them to break even, decrease their ongoing dependency on external funding or become profitable and grow in the future.

5. WHY IS STRATEGIC MANAGEMENT FOR ARTS ORGANISATIONS SPECIAL?

Strategic management in arts organisations is a process which in principle follows the same phases and methods as the strategic management process applied in other sectors, but it is distinctive because of the following unique characteristics of arts, creativity and creative processes:

- Every arts organisation is a combination of artistic creativity, management actions and other supporting processes. This is why a typical arts organisation is usually headed by two key figures—an artistic leader and a manager (i.e., executive director, general manager). Synchronising the strategic decisions, as well as daily actions, between these two key figures is sometimes difficult, because the rationale and arguments for decision-making could be different from the angle of creativity and artistic quality on the one side, and on the other the need for financial and managerial sustainability in the long term. Programme-market strategies help solve this tension.
- Organisations in the arts and culture sector usually have an experimental character: many of them constantly try new projects and initiatives, which increases the level of risk and uncertainty compared to organisations in other sectors. Even the most effective economic and market analysis and prognosis cannot entirely estimate the degree of success or failure of a theatre play, an exhibition or a new music piece. Risk analysis and management actions to decrease risks are a crucial part of strategic management in the arts.
- Financial resources for the functioning of an arts organisation in the long term might not be entirely predictable. For example, in the case of a nonprofit organisation, where funding from foundations, sponsors or donors is expected, it might be difficult to predict the changes in external donors' policies and priorities in the future, as they change over time. Business-oriented companies, such as private galleries, recording studios or private theatres, are focused mainly on the clients' interests and involvement, which might also be unpredictable, because of consumers' rapidly changing choices for how to spend their time and money on diverse and increased amounts of leisure and entertainment offers. This unpredictability makes it difficult to elaborate a strategy for promoting and selling works of art especially on the so-called *primary markets,* where emerging artists and not-well-known authors are present.
- Nonprofit and subsidized organisations seek external financial support to perform their activities, because their self-generated revenues are insufficient to cover the costs of operation, and there is an increasing gap between revenues and costs, especially in the live performing arts[32]. Business organisations in the arts function differently—they rely on sales revenues based on mass production and consumption of cultural products, as well as extended commercial offers. Due to the creative nature of their products and services, the unpredictability of creative processes and the unique characteristics of products which cannot always be produced and disseminated in huge quantities, many business companies operating in branches of the creative (cultural) industry also seek external funding. This is why innovative approaches to fundraising strategies are very important for all types of arts organisations.
- Arts organisations focus on individual and group creativity. Most of them are more labour-intensive than capital-intensive. The restrictions on human productivity and intensity limit the volume of the final creative production in a certain time and therefore limit the eventual benefits from the economy of scale—the reduction in cost per unit. This is one of several important reasons why arts should be subsidized and supported[33].
- In some types of arts organisations—e.g., opera, symphonic orchestra, classical ballet, museums—investment as well as production costs are very high. Capital subsidies in these cases are necessary to increase the public benefits much beyond the economic return on the investment.

- Despite many attempts by researchers, the final results of cultural and artistic activities cannot always be measured precisely, especially using quantitative indicators. Yet quality indicators are also difficult to work with, as it is challenging to evaluate what exactly is good-quality art and what is not. For one and the same artistic product or creative work, there could be many different opinions and evaluation given by curators, experts, journalists, audiences, artists and funding bodies.
- Arts organisations function as open systems with ongoing public involvement. They are constantly dependent on their stakeholders[34]. Satisfying the diverse expectations and needs of stakeholders in the long term is not an easy task and requires ongoing monitoring of the implementation of the strategic document, as well as flexibility in the overall strategic management process.
- Business strategies usually focus on the competitive advantage of a company, although this is not always the core of the strategies for business-oriented organisations in the arts[35]. This is because, together with the strategic goals of being profitable and growing, they offer public goods and services which are consumed collectively or have a societal value, and all members of the society theoretically benefit from the provision of these goods or services.
- Finally, it is not always easy to obtain information about changes and trends in external factors for a long time period. This is especially true for countries in transition or countries with a turbulent economic and political environment. National and regional databases and statistics are scarce in these countries, which makes such analysis difficult[36].

6. REASONS FOR RESISTANCE TO IMPLEMENTING STRATEGIC MANAGEMENT IN THE ARTS

Many arts organisations today, from small to large ones, do not implement strategic management framework and methods. In small arts organisations, strategic management is usually based on improvisation and intuition on 'how to do things' rather than on profound knowledge and management competences. It is an informal rather than formal process. This is because organisations want to act quickly and achieve fast results, and the results of strategic management always come after a certain period of time. Small arts organisations might resist implementing strategic planning because they might not have sufficient resources to elaborate strategic documents, and this is why they prefer ad hoc project-based planning. The practice shows that arts organisations are much better at defining their missions and visions than at rationally evaluating their resources and capacity, areas where they experience difficulty.

Large arts organisations may not implement strategic management because they do their business 'as usual'—they rely on their regular audiences and clients, receive sufficient financial support from external sources and 'feel good'. They might not see the need to 'think beyond the box' and be innovative or might be too ossified to do so. If their intrapreneurial capacity is low, even if they are currently successful, they might collapse in the long term because they do not adapt and innovate.

In some cases key managers and board members do not see the practical need for implementing strategic management and elaborating plans, arguing that the plan is just paper and that creativity cannot be planned. Such psychological resistance could also be a burden, making the creative and management teams unable to think and act strategically. Many managers of arts organisations are preoccupied with daily matters, emerging issues and urgent decisions to be made. Therefore, they may never find the time and resources to elaborate a strategic document. The strategic planning process requires patience, time, resources and efforts.

Certain arts organisations are based on membership, for example networks, associations or federations. Their strategic plan has to be elaborated based on feedback from and the opinions of members. This sometimes makes the elaboration of strategic documents slower. The inability of members to agree on the strategic direction might lead to inefficiency and lack of strategy.

Arts organisations are even more resistant when considering strategies for their online presence, visibility, programming, fund development or communications. Even if application of online tools is popular in the arts, not many organisations consider digitalisation and online tools as a key focus in their marketing, operational and fundraising strategies.

7. KEY TERMINOLOGY IN STRATEGIC MANAGEMENT

The practical need to elaborate strategic documents in the culture sector has risen significantly in the last few years, driven by a growing dynamic between arts organisations and their external environment. Arts organisations today function as open systems that care very much about their audiences, communities, clients and competitors. They need to better understand and adapt to a constantly changing environment and to find ways to overcome threats and take advantage of opportunities. In order to understand the strategic management process, its components and its phases, it is necessary to briefly review the main terminology used throughout the book. In the remainder of the book, these terms are a subject of discussion and analysis, considering also opinions of other authors.

- **Strategy.** A fundamental working definition in this book is that a *strategy* is the most effective chosen set of actions in a specific situation for achieving the organisation's long-term objectives. Strategy formulation is a result of considering all key internal and external factors and evaluating different alternatives. Selected definitions of *strategy* and diverse authors' viewpoints on strategies are discussed in Chapter 6.
- **Strategic issues.** *Strategic issues* are fundamental questions, policy-related matters and critical challenges that affect an organisation's long-term objectives, performance, products, services, clients and users, financial structure and management. Bryson (1995)[37] distinguishes three different kinds of strategic issues: (1) issues where no action is required at present, but the issue must be continuously monitored; (2) issues that can be handled as part of the organisation's regular strategic planning cycle; and (3) issues that require an immediate response and therefore cannot be handled in a more routine way. Identifying strategic issues is an important part of the external analysis and is discussed in Chapter 5.
- **Mission and vision.** The *mission* is a brief statement of the organisation's purpose for existence (the reason for being), a message about its historical role and vocation. The mission is expressed often in a *mission statement*, or *organisation's purpose*, which could include (in differing sequences) the purpose and values of the organisation, its competitive advantage and uniqueness, its main responsibilities to audiences, communities and clients, and its basic guiding principles. The *vision* is an imaginary picture providing an idea of the desired future of an organisation and its global and/ or main aspirations and ambitions. Chapter 4 discusses the elaboration of an organisation's vision and mission statement as part of the strategic planning process.
- **Objectives.** Organisational *objectives* are well-formulated, desirable and concrete goals that an organisation seeks to reach. Objectives are challenging but achievable. They are also measurable so that the organisation can monitor its progress and make corrections where needed. The importance of objectives in the strategic planning process and the opinions of diverse authors on the hierarchy of objectives are discussed further in Chapter 4.
- **External environment and PEST factors.** External factors could be grouped into the terms macro- and micro-external environment. The *macro-external environment* includes the so-called PEST factors (political, economic, social and technological) that affect an organisation's performance. Macro-environmental factors include the global, digital, natural and ecological ones. Understanding future trends in cultural policy development and specific cultural policy instruments is an important part of this analysis. The *micro-external environment* includes factors and groups that directly influence the organisation, such as competitors, audiences, stakeholders, financial institutions and funders. Analysing the trends in creative (cultural) industries' development is part of analysing the competitive environment. It is important to emphasize that changes in these external factors can be threats or opportunities for an organisation's future development. These changes can also be a source of an innovative idea or a new entrepreneurial opportunity in the arts.
- **Internal environment.** The *internal environment* is related mainly to resources, systems, processes and people. Internal factors influence organisational development, performance and results. Internal analysis aims at identifying strengths and weaknesses in an organisation's capacity and development and

elaborating strategies to use the strengths and decrease the weaknesses over a longer period. Analysing the potential of an arts organisation to be innovative and intrapreneurial is an important focus of internal analysis.

- **SWOT analysis.** *SWOT* (strengths, weaknesses, opportunities and threats) analysis is a widely used strategic planning method[38]. In the last 50 years it has helped business, nonprofit and government organisations to conduct a situational analysis and choose strategic alternatives based on it. The aim of SWOT analysis is to identify both key internal and external factors that are important to achieving the organisation's mission and long-term objectives. It also helps in identifying the innovative potential of an organisation and its capacity to become financially sustainable. External and internal factors, PEST and SWOT analysis in strategic planning in the arts are discussed in detail in Chapter 5.
- **Competitor analysis and competitive advantage.** Constant analysis of competitors is a vital focus in the strategic management process. It is especially important in business organisations in the arts whose strategies emphasize having a competitive advantage. The aim of this analysis is to look at how an arts organisation can perform better than its competitors and achieve better results. This leads to elaboration of the organisation's competitive advantage. Chapter 5 deals with analysis of competitors as part of the micro-external environmental analysis.
- **Stakeholder analysis.** *Stakeholder analysis* is especially important in nonprofit and subsidized arts organisations because they do not operate in a competitive environment but rather in a collaborative one. Their strategies are directed towards satisfying the expectations of diverse stakeholders. A *stakeholder* is defined in this book as a person, group or organisation who influences (or might influence in the future) and/or can be affected by the organisation's policies, actions, performance, resources or outcomes. Chapter 5 discusses further the analysis of stakeholders in an arts organisation.

It is important to emphasize again that strategic management is closely associated with managing changes. The starting point in the overall strategic planning process is from a desired future to the current state where the vision and mission should correspond to (or reflect) the capacities and resources of an arts organisation.

Strategic management in the arts focuses on achieving the best balance and fit between the unique, innovative and creative characteristics of an arts organisation and the ongoing changes in the external environment in the long term. In this process, an arts organisation needs to meet the expectations of diverse stakeholders and audiences, while at the same time elaborating innovative programmes to create future needs and also fill market gaps in a competitive environment.

Strategic management in the arts requires strategic thinking and analysis, as well as entrepreneurial talent and ability to innovate. An effective strategy is one which constantly responds to external changes and predicts the dynamics of external factors, preparing the organisation to act accordingly by utilizing its full capacity and resources for achieving maximum result with minimum efforts in the long-term. This is why arts managers should possess entrepreneurial traits to be able to exploit new opportunities, find unmet customers' needs and solve social problems through the arts.

3 Strategic Planning Process, Methods and Types of Plans

LEARNING OBJECTIVES

Upon completing this chapter you should be able to:

1. *Understand strategic planning as a key phase in the overall strategic management process.*
2. *Identify the main reasons for elaboration of strategic plans in the arts.*
3. *Articulate diverse approaches to and methods of strategic planning used in arts organisations.*
4. *Discuss the similarities and differences between various plans and projects.*
5. *Realize what intrapreneurial and collaborative projects in the arts are about.*
6. *Design the skeleton of a strategic plan for an arts organisation.*
7. *Understand the importance of the board and external consultants in the strategic planning process.*

1. STRATEGIC PLANNING: AN OVERVIEW

Strategic planning is an essential part of the overall strategic management process. It is closely related to strategic thinking, analysis and reflection. The end result is the elaboration of a strategic document, programme, plan, concept or framework which serves as the 'organisation's Bible' and is a key for all management actions. Throughout the historical development of strategic planning as an important branch of management theories, many scholars have elaborated their view and ideas on what planning means as a key management function and what the strategic planning process is about. The following are a few highlights in the evolution of theories of strategic planning until their application in the arts and culture sector today.

The *Harvard policy model,* elaborated by the Harvard Business School in the 1920s, was one of the first methodologies for strategic planning for private business companies. The organizational and managerial viewpoint on strategic planning originated in the 1950s and was especially widespread from the 1960s to the mid-1970s. It became a standard management tool for running a business company. The emphasis in that period was on understanding how an organisation functions in a market environment and what its strengths are in comparison with its competitors. Quantitative methods in planning became very popular. General Electric Company was a pioneer in using corporate strategic planning techniques. In 1963 the Boston Consulting Group pioneered the *growth and market-share matrix,* which became a very popular approach to strategic planning, used to perform business portfolio analysis as an important step in the overall planning process.

In the last 40–50 years many researchers and authors have attempted to define strategic planning, but there is no single agreed definition. Several selected viewpoints are given here. Fremont Kast and James Rosenzweig (1979)[1] define planning as the processes of deciding in advance what is to be done and how. They emphasize that planning provides a framework for integrating complex systems of interrelated future decisions.

Roger Kaufman, Hugh Oakley-Browne, Ryan Watkins and Doug Leigh (2003)[2] regard strategic planning as a formal process of defining the requirements for delivering high-payoff results, identifying what is needed to get from the current realities to future ones that add value to the society, and how to do that. Rudolf Grünig and Richard Kühn (2011)[3] define strategic planning as the process by which strategies are produced and emphasize six main characteristics:

- A systematic process
- A long-term orientation
- An approach which looks at the company as a whole or at important parts of the company
- A concentration on determining the potential for future success
- Emphasis on the need to involve the management team in this process
- Contribution to the long-term accomplishment of the company's objectives and values.

These definitions emphasize that strategic planning is a complex but also pragmatic and systematic process for determining the future, as far as possible. Planning is a tool of management and facilitates future decision-making.

At the end of the 1980s and in the early 1990s strategic planning became widely used in sectors outside of business—mainly in public organisations. Public administrators started to consider and deal with issues related to clients, services, risk mitigation, meeting objectives and managing by results. It became obvious that strategic planning techniques which originated from the business sector could help public organisations to manage in the constantly changing external environment. Public sector management required a useful framework to emphasize effectiveness and efficiency more, and strategic planning provided useful tools for that.

Gradually, together with management techniques, strategic planning also entered the nonprofit sector. In the last 30 years there have been many publications on the topic of how strategic plans can be applicable to the nonprofit field. These publications focus on foundations, associations, health-care service organisations, political bodies, social organisations and environmental organisations. Arts and culture organisations are rarely taken as cases and examples in books on nonprofit management.

John Bryson (1995)[4] defines strategic planning in public and nonprofit organisations as a disciplined effort to produce fundamental decisions and actions that shape and guide what an organisation is, what it does and why it does it. He reaches an important conclusion: that strategic planning in nonprofit organisations can help facilitate communication and participation, accommodate divergent interests and values, foster wise and reasonably analytic decision-making and promote successful implementation. Bryson separates the planning methods into 'outside in', where attention is paid to the external environment, and 'inside out', stressing the organisational values, mission and goals. He summarizes the main benefits of using strategic planning in the nonprofit sector as

- promotion of strategic thoughts and actions;
- improved decision-making;
- improved performance; and
- organisation of people so that they better fulfil their roles as well as meet responsibilities.

John Bryson and Farnum Alston (2004)[5] offer a step-by-step guide to implement strategic planning in public and nonprofit organisations, together with clear instructions and worksheets on how to elaborate a strategic plan tailored to the needs of the individual organisation. Michael Allison and Jude Kaye (1997)[6] consider strategic planning in nonprofit organisations as a systematic process through which an organisation builds commitment among key stakeholders while at the same time agreeing on which of them are essential to its mission and goals. They conclude that the similarities between strategic planning in nonprofit, business and government organisations are its essence—deciding what to accomplish, and how, in response to a dynamic operating environment. The difference is in the nature of the internal and external forces which influence an organisation.

Using strategic planning methods in the arts is a relatively new phenomenon, and publications on this subject matter are scarce. Michael Kaiser (1995)[7] offers a practical guide on developing a strategic plan for nonprofit arts organisations. He emphasizes that arts organisations that maintain an entrepreneurial perspective on management find planning most useful. Kaiser observes that maintaining an entrepreneurial perspective is difficult because of the ongoing tension between planners and entrepreneurs, as planners expect to follow a predetermined course of action while entrepreneurs demand the flexibility to change.

The current book tries to fill the gap in the implementation of planning methods and techniques in the arts sector. It emphasizes strategic planning for intrapreneurial arts organisations where the characteristics of entrepreneurship and innovative actions are essential for their further survival and growth.

2. MAIN STRATEGIC PLANNING PRINCIPLES IN THE ARTS

A review of the academic literature and targeted qualitative research, as well as analyses of cases, confirm that, to be successful, strategic planning in an arts organisation has to follow some main principles:

- **Balance aims with resources.** Planning processes require rationality and analytical skills to find the right balance between striving to achieve the desired status and using the resources available, as well as seeking new resources and opportunities within the changing market environment.
- **Balance creative programming with all other areas of strategic planning.** The core of any arts organisation is the creative process. Therefore, artistic programmes and projects are the main guideline for further advancement. All other functional areas of the strategic plan have to match the artistic programming well.
- **Maintain flexibility and openness.** As already discussed, strategic management in the arts is about an organisation's adaptation to its external environment. It regards organisations as *open systems* which have plenty of potential opportunities in the process of change. The relation between the organisation and the environment constantly changes; therefore, the strategic planning process requires a huge degree of flexibility.
- **Reflect the complexity of the organisation.** Strategic planning covers all aspects of an organisation's activities and includes all levels of management, functions and departments. It is a complex process in large arts organisations. In small nonprofits, the process is in the hands of a few people who are responsible for the plan's elaboration and implementation in all aspects.
- **Coordinate activities in an organisation horizontally as well as vertically.** Writing and implementing a strategic document requires an ongoing *spiral* of coordination between different levels of management, departments and units. In nonprofit and subsidized organisations, the strategic document is transparent to fund-providers, stakeholders, audiences and communities.
- **Apply systematic approach.** A strategic plan is a document whereby all phases, stages and elements are interrelated and logically connected.
- **Aim for long-term results.** Implementation of the strategic plan is directed towards achieving results in a minimum of three to four years. Intangible and qualitative results are more common in the arts sector.
- **Maintain continuity in a loop.** Strategic planning consists of repetition of activities in a cycle of three to four years—from drafting a plan, through implementing it, to monitoring, taking corrective actions and evaluating results. Strategic reflections at the end of one planning cycle are a starting point for the next planning cycle.
- **Use online tools.** Strategic planning is almost impossible today without using the power of the Internet and online tools in all stages to assist the development and implementation of the plan. New technologies in the arts are applied especially in the areas of creative programming, marketing and fundraising.
- **Incorporate elements of intrapreneurship.** As already discussed, innovation is essential to an effective strategy in the arts today. The strategic plan of an intrapreneurial arts organisation aims to

initiate, test, develop and implement new ideas which generate revenues and draw in alternative funding sources.

- **Use a participatory approach.** Planning in the arts is always about people. Arts organisations are not just buildings but creative teams, and therefore the involvement of the staff in the strategic planning process is a must—not only in the plan's implementation but also in the collective creation of the planning document. Artistic leadership is a very important factor in the overall planning process, especially when it is backed up by an effective management approach and is supported by the board.

3. PREPARING FOR STRATEGIC PLANNING

As emphasized in Chapter 2, the elaboration and implementation of a strategic plan (concept, document or programme) form the backbone of the strategic management process. Before one starts to work on the strategic plan, it is necessary to make sure that the team members and key stakeholders understand the principles of strategic thinking and orientation and are aware of the time and effort needed versus the benefits of elaborating a strategic plan. Strategic thinking, strategic analysis and strategic orientation are more important than just having the strategic plan as a static document.

An arts organisation has a *strategic orientation* if the following are present:

- The organisation's long-term purpose of existence, vision and objectives are clarified.
- An appropriate strategy or strategies is chosen for achieving long-term objectives.
- The organization is adaptable to factors from the external and internal environment that influence it.
- The organization's competitive advantage and unique characteristics are sustainable over a certain period of time.
- The organization constantly seeks to improve by generating and implementing innovative ideas.
- The organization analyses and considers not only current but also future audiences, clients, stakeholders, potential sources of funding and financing, as well as revenues from sales.
- Main critical zones and possible risks, as well as mitigation strategies, are considered well in advance.

PRACTICAL RECOMMENDATIONS

Be aware that strategic planning is not appropriate in all situations. However, here are several examples when you will certainly need to develop a strategic plan:

- Your organisation is operating well but does not know what its priorities would be in the next four to five years.
- There are major economic, political or social changes in your region, city or country which will affect your organisation's future.
- You and your team are constantly striving to find financial support and struggling to maintain operations.
- You are constantly losing members, supporters or clients, or your audience levels are decreasing.
- You sense decreased levels of motivation among your staff, board members and/or volunteers.
- You are uncertain how to balance creative programming with marketing and fundraising.

Strategic planning may not work for you if you have one (or more) of the following symptoms:

- Your organisation lacks leadership.
- Your management team does not have the necessary skills to elaborate a strategic plan nor the financial means to hire an outside consultant.

- The staff, key managers or stakeholders do not support the idea of elaborating a strategic plan.
- There is a lack of commitment to strategic planning by the majority of the management team and staff.
- You are squeezed by daily tasks and cannot find the time or resources to start and carry out a strategic planning process.
- You intend to write a strategic plan for presentation purposes only but never intend to implement it.

Understanding the key terminology and stages in the planning process is the first step to start the actual drafting of the strategic document. It is also important to find out the rationale behind the need to write a strategic plan.

4. APPROACHES AND METHODS OF STRATEGIC PLANNING: THE PEOPLE FACTOR

Diverse approaches and methods are discussed in the theory and practice of strategic planning. The choice of a method for elaboration of a strategic plan for an arts organisation depends on several key factors:

- **The type of organisation** (business-oriented, nonprofit, subsidized, public). Organisational structure and culture predetermine how the strategic process is handled.
- **The field of art in which the organisation operates** (performing arts, visual arts, literature, music, and so on).
- **The size of the organisation.** Small organisations have less capacity and fewer resources to pass through a comprehensive strategic planning process, while large organisations in principle can afford it.
- **The leadership capacities of key managers in the organisation.** Leadership is important in both strategy formulation and implementation. Managing changes requires strategic leaders, and the leadership capacity of top managers and the board is different in different organisations.
- **Previous experience in planning.** Some arts organisations undertake a strategic planning exercise for the first time, while others have already elaborated strategic plans many times in their evolution.
- **The level of partnership and collaboration.** The majority of arts organisations are dependent on external stakeholders, and they elaborate projects and plans in cooperation with other stakeholders and partners.

The most commonly used methods of strategic planning in the arts are the following:

- **Goal-oriented planning: 'Inside-out planning'.** This method emphasizes the formulation of long- and short-term goals and ways to achieve them. It is 'action-oriented' planning because goals are achieved by putting in place activities and separating the tasks between people.
- **Extravert planning: 'Outside-in' planning.** This planning model is based on feedback received from customers, clients, stakeholders and external groups. It is especially popular for networks and associations in the arts which have to consider members' feedback throughout the planning process.
- **Problem-based planning.** This method starts with a profound diagnosis of issues and problems which the organisation faces. Strategies and actions aim at finding solutions to these problems, in both the long and short term.
- **Project-based planning.** This model is very popular among nonprofit and small arts organisations which rely mainly on projects to seek external funding.
- **Business portfolio planning.** This model emphasizes understanding the positioning of a company's products in relation to their market attractiveness and competitive strength. The portfolio

model in planning stresses managing markets, managing risks and managing growth. This model is of limited use in the nonprofit sector because it targets future growth, market expansion and generation of higher profits.

Strategic planning is created by people and for people. The people factor in the overall management process is very important. This is because people are creating organisations, making them work, managing the process of change, creating problems and solving problems. As already discussed, in the arts sector, labour capacity is very high due to creative processes (more people than machines are required). It is therefore important during the very first steps of the strategic planning process to reach a general agreement among key internal and external decision-makers and stakeholders about the overall strategic framework. Support and commitment from all personnel are also very important to secure their involvement in the implementation of the plan.

There are several ways to elaborate a strategic document—it can be done by a specially formed team within the organisation, by the board or selected board members, by the artistic director or the executive manager or by an external consultant. In the practice of large arts organisations, the artistic leader, the general manager and the chair of the board are usually included in the planning group, because they are the key figures who will drive the implementation of the plan and analyse the feedback for the next planning cycle. It is important to identify well in advance who will be the key person behind the plan's elaboration, what kind of method and approach will be chosen (e.g., top-down, bottom-up or other) and who will be the person responsible for finalizing the strategic document. It is also important to think about whether it is necessary to involve external experts and consultants in the process and what resources would be available to do so.

PRACTICAL RECOMMENDATIONS

Before starting the process of elaborating a strategic plan:

- You need to ensure that everyone in the organisation, as well as the board and stakeholders, understands that this process is an open and shared activity. The time investment in elaborating a plan is, of course, always a challenge as other urgent priorities preoccupy the organisation's management.
- You need to secure strong leadership that is able to follow through with the whole process of drafting, elaborating and implementing the plan.
- You need to communicate to the staff that the strategic planning process will help them to be more effective, creative and proactive in their own work and encourage them to invest efforts into formulating the shared mission and goals.
- You have to be prepared to invest time and resources in training key personnel to be involved in the strategic planning process.
- You need to ensure that you have planned sufficient time for elaboration of the plan, as the process takes several months to complete.
- Everyone involved needs to understand that the strategic plan will be written not just to have another document but to meet specific needs and help in the overall future progress.

4.1. Involving the Board

In the cases of nonprofit and state-subsidized arts organisations, the organisational structure contains a top management body, which depending on its exact functions and tasks could have different names such as board of directors, creative committee, management committee or board of trustees (among other options). For the purpose of this book, all of these will be referred to as the *board*. The main responsibilities and tasks of the board usually include the following:

- **Policy-making.** The board makes general creative, marketing, financial and personnel-related decisions, agrees on the policy directions and oversees the organisation's performance.
- **Organisational supervision.** The board deals with governance, budgeting, planning, auditing, legal issues, and recruitment of new board members.
- **Specific operational involvement.** These tasks are performed by the board in specific cases, for example involvement in fundraising, public relations, special events or initiation of new strategic programmes and projects.

Members of the board can be

- professionals, whose services are of benefit to the organisation, for example curators, art critics, arts and business consultants, key accountants, directors of financial institutions, managers of business companies, marketing managers and lawyers;
- wealthy individuals or representatives of corporations, business companies or banks, who help mainly with financing and fundraising issues and the overall organisation's image;
- friends of the organisation and volunteers who believe in its mission and actively help in diverse areas; and
- key members of the staff.

Strategic planning methodology differs based on the level and scope of involvement that the board and the personnel have in the process. The *top-down approach* is a directive, authoritarian style of management, where the board, the artistic director and the key manager(s) decide on the plan while the staff implements it. As a result, the staff motivation is decreased as the plan is not a shared document but an obligation they are required to implement. The *bottom-up approach* is a democratic management style involving the whole personnel in the strategic as well as functional parts of the plan. The board, the artistic director and the key manager(s) have mainly monitoring, coordinating and facilitating functions in the process. The *mixed approach* is a combination of the two, where some sort of overall strategic guidance is given from the top by the general manager, artistic director or board or by a hired consultant. Then the personnel participate in a consultation process to provide comments, ideas and suggestions on the draft of the strategy. This feedback is repeated during the whole process of formulating the mission, vision, strategies and functional areas of the plan. The mixed approach is widely used by arts organisations. The *matrix approach* is applicable to small and emerging nonprofit organisations where a small team is involved in all stages of strategic planning, and there is no subordination but horizontal and networking-type relations between team members.

One of the most difficult tasks is to make everyone in the organisation understand why strategic thinking and actions are important. Strategic planning is essential for the organisation internally, as it is a guide for its future. It is also a fundamental document for external stakeholders—funding organisations, financial institutions and government bodies.

4.2. Involving an External Consultant

There are many benefits to involving an external consultant in the strategic planning process. The most important one is that the consultant can see, sense and identify issues which it is impossible to see 'from inside'. Another key benefit is that the consultant plays a neutral role in the strategic planning process, providing an objective opinion on the organisation's future development, and such a viewpoint is often difficult to achieve internally. Consultants can help in several key areas of strategic planning, such as

- defining the key strategic issues;
- gathering and analysing data;
- looking at the overall context in which the organisation operates;

- meeting key stakeholders, listening and summarizing diverse, sometimes contradictory, opinions;
- providing alternative solutions to problems that are identified;
- conducting strategic planning sessions with the board, key personnel and external experts;
- securing feedback from the staff, members, subscribers and external stakeholders; and
- elaborating the draft of the plan, presenting it to the management team or the board and finalizing it considering their feedback.

External professional consultants use a variety of methods in the strategic planning process: desk research into relevant documents, online research, personal interviews, online surveys, focus groups, individual meetings with key parties involved and direct observation. Together with these methods, they contribute with their own knowledge, competence and experience in the field. Carefully combining quantitative with qualitative methods of research and analysis is important to achieve efficiency in the process and end up with a well-elaborated strategic plan.

PRACTICAL RECOMMENDATIONS

When working with an external consultant, mind the following:

- Consider the value which a consultant might bring in elaboration of the strategic document versus the required resources (e.g., recruitment process and consultant's fee).
- Elaborate well the terms and conditions of the assignment, expected deliverables and the time frame. Do not forget to include a confidentiality clause in the contract.
- Assign only one person from the organisation to be the direct contact point for the external consultant.
- Prepare well for the first meeting with the consultant. The 'kick-off' phase is very important for the success of elaborating the strategic plan.
- Provide your consultant as much information as possible. Do not forget to share key documents and issues related to the organisation's past and current performance.
- Trust your consultant and work with him/her in a collaborative manner. Discuss complicated issues carefully.
- Inform your consultant promptly about changes, when they occur.
- Do not try to manipulate the opinion of your consultant by imposing your viewpoint. His/her role is to provide an objective view of the long-term development of your organisation and the problems you might face, as well as giving you alternative solutions and options.
- If your organisation has members or subscribers, convey to them the importance of the overall strategic planning process and help the consultant to get their feedback.

5. THE PLAN: AN OVERVIEW

Strategic documents are hypothetical guidebooks, maps for travelling into the future. They are desirable predictions of what is expected to happen along the road, based on an analysis of the current situation and a vision of future achievements. Strategic documents are the starting point for all other management functions: organisation, personnel structure and motivation, coordination, delegation, control and evaluation. Different types of strategic documents are used in the arts sector, for example a strategic plan, strategic framework, strategic concept or strategic programme. Plans take a priority position among all other management documents. In many cases they serve as a basis for all other management tools and instruments, such as procedures, internal regulations, working instructions, agendas and schedules, norms, standards and budgets. The plan is a set of diverse but logically arranged managerial decisions, which has to be followed up, monitored and amended where necessary throughout the duration of the plan's implementation.

PRACTICAL RECOMMENDATIONS

A well-elaborated plan usually answers the following key questions:

- **What?** What are we going to do? What are our aims and objectives? What kind of activities are we planning? What kind of programmes and services shall we offer?
- **How much, at what quality level and quantity?** What is our capacity to create and produce? How do we set up quality standards and according to whose criteria—those of the management, decision-makers, internal teams, board members or stakeholders? Which of our programmes and projects have innovative characteristics and are unique? Which can bring additional revenues?
- **Why?** What is the reason and the rationale for choosing these concrete projects and activities? What are the competitive advantages and uniqueness of our programmes and working methods? Would our programmes fit to the expectations of diverse shareholders? What kind of social problems would our projects solve, if any?
- **For whom?** Who are our direct and indirect target groups? Do we know our audiences, communities and stakeholders well? What is our relationship with each of them, and how will they be influenced by our activities?
- **Where?** Where do we plan to undertake the creative production process? What are our distribution channels? Where do we plan to meet our audiences on a repeated basis?
- **How?** What are the concrete processes which we plan? How do we coordinate and synchronize activities and programmes in a smooth way?
- **With what means?** What kind of resources do we need—material, human, financial, non-material, informational?
- **Who?** Who is responsible for what throughout the whole process? What are the capacities of people to perform the planned activities? Are there any additional needs for personnel considering future programmes and growth? How do we plan to recruit and to work with contractors and volunteers?
- **When?** What is the time frame, the internal phases, stages, schedules and deadlines?
- **What results?** What kind of qualitative and quantitative results would we like to achieve? How can we measure these results?

6. TYPES OF PLANS

Plans in arts organisations are classified by the purpose for which they are developed, the timescale they are expected to cover, the levels and scale of the management hierarchy and the organisation type. Table 3.1 summarizes the variety of plans used in arts management practice.

- **Entrepreneurial Plans**

 These plans are usually written by those who would like to start their own business in the field of arts or the creative (entertainment) industries. They are based on a well-defined business idea and exploit a market opportunity. As discussed in Chapter 1, entrepreneurs are those who take risks, deal with uncertainties and are able to organize the whole process from the idea to a successful end. Before being accepted for realization, an entrepreneurial idea has to pass through several levels of filtering, such as permissibility, compatibility, market chances, financial backup, potential for sufficient revenues and risk evaluation. Entrepreneurial plans usually have the following structure:

 - Elaboration of the idea, its uniqueness and market chances.
 - Profile of the manager/team behind the idea and his/her capacities and competences.
 - Industry and market analysis providing evidence for the window of opportunity and future trends.
 - Marketing section.

Table 3.1 Types of Plans

Criteria	Types of plans
Purpose	Creative plan Entrepreneurial plan Business plan Organisational/managerial plan Plans for partnership Action plan Investment plan
Time frame	Short-term plan (one year or less) Mid-term plan (one to three years) Long-term plan (three to four years or more)
Management level	Strategic plan Operational (tactical) plan Plan for a department or unit Plan for a team Individual plan
Organisation type	Business plan Plan for a nonprofit organisation Plan for a state-subsidized organisation
Functionality	Creative plan Artistic program Repertoire plan Marketing plan Financial plan Plan for fund development Organisational plan Operational plan Human resource management plan Plan for innovations
Approach in the planning process	Centralized plan (top-down approach) Decentralized plan (bottom-up approach) Mixed/interactive approach

- Other functional sections showing how all initial resources—material, financial, human and others—will be secured and developed further to realize the idea and grow the enterprise.
- Evidence for long-term sustainability.

Entrepreneurial plans are special, because they contain elements of innovation which contribute to the future growth and expansion of the business.

- **Business Plans**

A business plan aims at improving the company's competitiveness, conquering new market niches, attracting more clients and buyers and/or implementing innovative ideas. This is the main document for growth and expansion of a company. Business plans have an innovative character as they look for better opportunities, efficient management and possible improvements in all areas. They usually cover all functional areas of management—marketing, finances, operations, the technical and production side and organisational structure. Business plans are always oriented towards generating profits and a return on initial investments. In some cases, a business plan can be elaborated for a specific product, service or programme. Business plans are key documents for arts businesses, such as private theatres, commercial galleries, commercial festival organisations, record labels, publishing houses, and others. Business plans can also be very helpful if the company is in a crisis as they help to stabilize the business.

Nonprofit and state-subsidized organisations rarely elaborate business plans. They could, however, occasionally create a business plan for some of their programmes or projects, mainly for seeking additional revenues and alternative financial models[8].

- **Managerial Plans**

 These are the main instrument for starting up a new organisation or effectively managing an existing one. Managerial plans are particularly useful in a major restructuring process for an organisation or for key changes in its activities. Depending on the level of management, the scope and the time frame, these plans can be strategic plans (three to four years or more), operational (usually around one year) or specific functional plans for concrete departments or units. Managerial plans emphasize the need to maximize results through a more effective utilization of resources.

- **Action Plans**

 Action plans are usually created to identify and elaborate activities and results, as well as responsible individuals, interim results and the deadlines required to complete a certain task or set of tasks. Action plans are short-term plans and are part of projects or more complex plans.

This book deals with issues related to the strategic plan, as this is the basic document which can be further modified to form other plans—functional, operational, investment, creative, and so on. The book discusses strategies for a period of up to three to four years, as this is a relatively manageable scope for arts organisations to position themselves and interact effectively with the constantly changing environment.

Strategic planning in the arts is different from *cultural planning,* a term used in the arts administration practice to refer to the elaboration of strategic documents by a government institution on a local, regional or national level. This could be the ministry of culture, arts council or a cultural department of a municipality. Cultural planning is part of the overall development of a cultural policy, and these strategic documents deal with the general directions, trends and instruments of cultural policy and cultural development within a specific country, region or city.

7. PROJECTS AND PLANS IN THE ARTS

In the daily practice of arts management the word *projects* has become very popular as a means to develop an idea in a more comprehensive, logical and understandable way in order to apply to a foundation or government programme for grants, attract partners, convince supporters or present what a team plans to do. A *project* in the field of arts and culture has the following characteristics:

- A sequence of well-defined and logically connected activities, conducted over a certain period of time, targeted well and generating concrete final results.
- A *problem-solving* technique. Projects are generated to solve concrete social problems, educate audiences, increase visibility, improve cooperation and use innovation and creativity to support environmental, social, educational or charitable causes.
- A way to improve an organisation's performance and reorganize its workflow. Projects help people to improve their competence, learn by doing and analyse mistakes, and be more organized and logical in their daily actions.

A typical project in arts and culture:

- starts from an inspiring idea;
- involves people and defines responsibilities clearly;
- has creative characteristics;

- has deadlines and exists within a limited period of time;
- has well-defined outcomes (results, deliverables);
- uses a variety of funding sources; and
- takes risk factors into consideration.

Multiple projects, or a portfolio of projects that are combined under one theme and/or are managed as one unit with the objective of achieving benefits for the organisation as a whole, are called a *programme*. Creative programming is a core activity in arts organisations[9].

Projects also require planning activities, and that is why they are sometimes confused with plans. Projects can be considered as short-term operational plans. They differ from the strategic plan in the following ways:

- Projects are always short-term, while strategic plans have a long-term character.
- Projects are elaborated to be implemented and terminated, while strategic plans aim to help the organisation to survive and develop continuously.
- In many cases, projects are an element of a strategic plan—they are its content and 'flavour'.
- Strategic plans help identify the organisation's capacity and resources, necessary for implementing projects in the long term.
- Strategic plans envisage concrete results and success indicators to evaluate the implementation of projects in the long term.
- Strategic plans are complex documents and have both a strategic and a functional part, while projects reflect one concrete area of the organisation's activities.
- The skeleton of a project consists of aims, activities, target groups, an action plan and expected results, while a strategic plan has a much more complex structure.
- Strategic plans reflect the complex interactions between the organisation and its environment, whereas projects consider the environment as an important context within which the activities take place.
- The outcomes of a project are well defined, unique and closely related to the implementation of an idea. Strategic plans concentrate on achieving long-term objectives.

There are several similarities between a project and a strategic plan in the arts. Both documents are elaborated to help with the overall management and decision-making process. Both projects and plans have three main phases:

- The preparation phase: conceptualization and analysis;
- The implementation phase: implementation, development and monitoring;
- The evaluation phase: control and feedback, and undertaking of corrective measures.

Both documents answer the basic questions: *What? Why? How? For whom? Where? When? How much?* The emphasis in a strategic plan is on the *Why?* and *How?* And, finally, both documents would be useless if they are not implemented.

- **Intrapreneurial Projects**

 These projects are elaborated within an organisation's setting[10]. Many arts organisations develop projects to foster creativity, apply for external funding, attract new audiences, collaborate with other organisations or seek international expansion. Living on a project basis is a usual scenario in the practice of nonprofit arts organisations, because external funders are keener to provide support for tangible results, rather than intangible processes, and projects are about delivering concrete results in a short time period. Intrapreneurial projects in the arts have several main characteristics:

 - They are elaborated and implemented within the organisation, by a person (a unit or a team) who works in the organisation.

- They focus on innovation, newness and differences.
- The main aim of these projects is to bring revenues for the organisation, based on implementation of an innovative idea.
- These projects look at the market adaptation of artistic creation and creative products. They also look for opportunities to create future needs and lead audiences' tastes, and not only to follow trends.
- They are the result of brainstorming, focus groups and 'thinking beyond the box' exercises with the employees, the management team and/or the board.
- These projects motivate and inspire, as they give the team, or the unit which elaborates them, a sufficient amount of freedom and responsibility.
- These projects have a much higher degree of risk than others.
- Intrapreneurial projects increase staff's motivation as they allow greater freedom in the generation and flow of ideas. They require an intrapreneurial climate within the organisation and strong strategic leadership.

- **International Collaborative Projects**

 These projects are very popular and widely used in the arts world. They stimulate professional development, creativity, exchange, learning experiences and active networking in the arts sector. Dragan Klaic (2007)[11] gives a comprehensive overview of the reasons for international cultural co-operation, the forms collaboration can take and the steps in developing a collaborative cross-border project from the concept to the end result. He stresses that international bilateral and multilateral cooperation is important from the cultural policy and economic perspective. Cross-border projects in the arts have several distinguishing characteristics:

 - They are conceptualized and realized by organisations and individuals coming from different countries.
 - Most international arts projects are organized in the form of a consortium between partners, where the roles and responsibilities are clearly distributed between partners from different countries and one of them is the project coordinator.
 - These projects have a mobile, 'nomadic' character, happening in several places—in many cases, in different countries.
 - The motivation and ambitions of the core project team are usually very high as they have a unique opportunity to travel, meet colleagues and audiences from different countries and enlarge their professional and personal perspectives.
 - They are multicultural and should consider cultural differences between project team members, as well as country differences.
 - They have the potential to reach larger audiences if marketed and promoted well.
 - Funding for these projects usually comes from a variety of sources at the local, national and international levels (e.g., government support, foundations, sponsors and self-generated incomes).

 Arts organisations nowadays seek more opportunities to expand their activities internationally due to many factors. Among them are the trend towards globalization, the need to increase audiences and visibility and the collaborative nature of art, where good ideas and creativity are born as a result of interactions, exchange, collaboration and exploration of different realities.

8. RATIONALE AND STRUCTURE OF A STRATEGIC PLAN

There are several main reasons for an arts organisation to elaborate a strategic plan:

- To help a newly registered arts organisation start activities and envisage its existence in the long term;
- To conceptualize the start-up of a new organisation;

- To help an existing organisation to evaluate its activities, to restruct[...] long-term management strategies;
- To assist further growth and expansion;
- To stabilize or improve an organisation's health and performance, including when it is on the verge of collapse;
- To assist fundraising from a variety of external sources (In most cases, writing a project proposal to apply for institutional support is based on elements of an elaborated strategic plan.);
- To attract collaborators, investors and partners;
- To explore ways to increase revenues from diverse programmes and activities and maintain the organisation in a sustainable mode in the future by achieving lower dependency on external funding.

The proposed methodology and structure of a strategic plan for an arts organisation in this book is based on a thorough review of the literature on strategic planning in the business sector, as well as applications in the nonprofit sector[12]. It also considers management practice in the arts in many countries worldwide.

Table 3.2 gives a general overview of the basic structure of a strategic plan for an arts organisation. This structure provides the methodological background and serves as a guide throughout the book. This is not a universal model but a flexible framework which can be easily modified, restructured and adapted to specific situations and needs of diverse arts organisations. The following chapters of the book (Chapters 4–10) provide a deeper understanding, analytical discourse, examples and step-by-step guidance for effective elaboration of each section of the strategic plan.

Table 3.2 Basic Structure of a Strategic Plan for an Arts Organisation

A. INTRODUCTION

1. Cover page
2. Contents page
3. Résumé (executive summary)
4. Organisational profile

B. STRATEGIC PART

Section I: Mission (purpose), Vision and Strategic Objectives (Organisational identity)

Section II: Analysis of External and Internal Environment (SWOT Analysis) (Results and conclusions from the industry analysis, market analysis, stakeholder analysis, analysis of opportunities and sources of innovative ideas)

Section III: Main Strategies: Options and Choices (Evaluation and choice of strategies for growth, innovative strategies, program-market strategies, competitive strategies, strategies for survival and stabilization, strategies for partnership and networking, and others

C. FUNCTIONAL PART

Section IV: Strategic Directions in Creative Programming (Strategic objectives in artistic programmes, key programmes and projects)

Section V: Marketing, Creative Programming and Audience Development Plan (Strategic objectives for marketing; competitive advantage; marketing research and audience development; segmentation and positioning; marketing mix: product, place, price, promotion and communication strategies; necessary resources)

Section VI: Human Resource Management Plan (Strategic objectives for human resource management, evaluation of personnel's capacity, plans for the process of recruitment and promotion, schemes and methods of motivation, professional development and training)

Section VII: Technological and Production Plan (Strategic objectives in production and technology, flow chart, plan for equipment and materials, plan for spaces and capacity, plan for innovations, research and development)

Section VIII: Financial and Fundraising Plan (Strategic objectives for finances and fundraising, cost structure, analysis and strategies for increasing self-generated revenues and external sources of funding, elaboration of budgets and pro-forma financial statements, financial ratios and indicators)

Section IX: Contingency and Risk Plan (Anticipation of risks and possible mitigation strategies)

D. APPENDICES

1. Legal documents
2. Media coverage and visual materials
3. Financial documents
4. Supporting documents
5. Any other important and relevant documents

8.1. Introduction

The *cover page* usually includes the name of the organisation and its logo, the title of the strategic plan and its duration, the organisation's contact details (postal address, website, email), the team (or the person) who worked on it and the date when it was finalized and approved. If relevant, the signature of the artistic director or the general manager should also be included. If the strategic plan is being used to find investors, or financial support, the requested amount could also be included on the cover page. If the strategic plan is for internal use only and not for public visibility or distribution, this also has to be clear.

The *contents page(s)* present the whole structure of the plan logically and in detail.

The *résumé (executive summary)* is a crucial part of the plan and should be written once the whole plan is completed. It has to be clear, comprehensive, attractive, convincing and concrete. If the plan will be used to attract partners or financial support, the résumé is the first point where the plan could be rejected. It includes

- the rationale for writing the plan (why it is needed, what its purpose is);
- the time frame;
- the organisation's mission and strategic objectives;
- the core team behind the organisation's development;
- a brief summary of the SWOT (strengths, weakness, opportunities and threats) analysis and the context in which the organisation operates;
- the chosen set of main strategies and the rationale behind the choice;
- main highlights from the functional parts of the plan: marketing, human resources and financing/fundraising;
- the expected results; and
- any sustainability issues.

The résumé is usually short—for a business plan of around 20 pages, it is up to 1–2 pages maximum
 Organisational profile usually includes the following elements:

- A brief history (highlights of the organisation's activities and the most important achievements, for example awards, participation in international festivals or special programmes).

- The legal status of the organisation.
- The main organisational principles and values.
- A brief overview of the people involved: the creative and managerial team, board members and key stakeholders.
- A general introduction to the current business model of the organisation—is it mainly subsidized, or does it rely on outside support from foundations and sponsors, or is it mainly based on self-generated incomes and other internal resources? Changes in the financial structure in recent years should also be pointed out.
- Possibly a short statement on the importance of the sector (cultural and artistic field in which the organisation operates) within the country, region or city.

The main sections of the proposed strategic plan content are divided into two main parts—strategic and functional.

8.2. Strategic Part

The strategic section of the plan focuses on answering the main strategic questions 'Where do we want to be?', 'Where are we now?' and 'How do we get there?' It elaborates the mission, vision, long-term objectives and an analysis of the external environment and the organisation's performance, as well as the main strategies chosen. In this book, it is suggested that the elaboration of the vision, mission and strategic objectives be placed before the situational analysis, but in practice there is no strict separation between strategic thinking, analysis and planning—the three phases are interrelated.

The strategic section of the plan (described in Table 3.2) is elaborated in detail in Chapters 4, 5 and 6. However, here are a few important highlights to start with:

- The arts organisation's *mission (purpose) and vision* can be effective only if they contain socially targeted messages as well as elements of uniqueness. The reason for the existence of an arts organisation has to be tightly linked with the external environment, the target audiences and the beneficiaries and not closed within the organisation's own creative or financial aims.
- *SWOT analysis* can be an effective tool for understanding where the organisation is at and what strategies to choose for further development. It is a *dynamic tool* and not a static description of strengths, weaknesses, opportunities and threats. This book suggests a practical approach to such a dynamic analysis: how to use the strengths and opportunities and to minimize the weaknesses and threats.
- *Objectives* should be arranged in a logical and hierarchically structured framework in order to prioritize them from the point of view of how urgent and important they are—which of them are long term and which are short term. Together with the chosen strategies, they reflect and synchronize all activities and processes in an arts organisation. In subsidized arts organisations, the core objectives are usually related to creativity, education and/or audience development and engagement. In business and commercial arts organisations the core objectives are focused on higher revenues and profits, growth and expansion, development of peripheral products and services, and diversification of offers. Irrespective of the type of organisation and its business model, the long-term objectives of any arts organisation should be to become sustainable, with as little dependency as possible on only one external source of funding or on funding coming entirely from public sources.

8.3. Functional Part

Functional sections of the plan help an arts organisation to elaborate specific functional areas of the organisation's management in the long term, such as artistic programming, planning of communications and marketing (including visibility, public relations and overall audience development and engagement), planning of human resources (including recruitment, motivation and personnel development) and, finally, financial planning (including fundraising campaigns, planning of relations with external funders and planning for revenue growth).

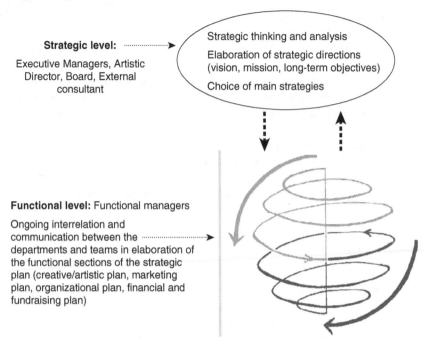

Figure 3.1 The spiral process of strategic planning within a large arts organisation

Elaboration of the functional sections of the strategic plan is discussed in detail in Chapters 7, 8, 9 and 10. Each chapter is logically designed to provide a brief overview of the main terminology and discuss priority aspects related to the planning of specific organisational elements, give practical tips and examples, discuss cases and, finally, suggest an overall skeleton and content frame for each section of the plan, as well as possible options and scenarios. All functional sections need synchronization with the strategic part of the plan, as their aim is to develop the practical aspects of management and make it more concrete in the long run.

There is a strong interdependence between the strategic and functional sections not only in terms of their content but also in the process of their elaboration and realization. Especially for large organisations, it is very important to maintain ongoing coordination and collaboration between the two levels: elaboration of the overall strategic directions and framework, and functional management planning (see Figure 3.1). This mixed method of strategic planning, as discussed in the preceding, includes elements of both 'top-down' and 'bottom-up' approaches and is very effective. As shown in the figure, the overall strategy is elaborated as a result of ongoing communication between the top managers and the functional managers, in a spiral shape. The top-level managers and the board elaborate the strategy as a result of ongoing feedback and suggestions from the functional managers and the staff. On the other hand, all functional sections result from the general organisational strategy. There is also an ongoing horizontal coordination between departments and teams in elaboration of the strategic plan.

8.4. Appendices

Appendices are not obligatory, but they certainly help in forming a better understanding of the strategic plan's content. Their role is to visualise, support, show facts, provide backup statements and make the plan more reliable and consistent.

• *Legal documents* could include an organisation's legal registration document, templates of major contracts, insurance documents, documents for working conditions, a detailed organisational chart,

internal rules and regulations, authorizations (for example for construction work) and quotations from legislation.

- *Media coverage and visual materials* include, for example, samples of brochures, leaflets, programmes, articles in the press and CDs and electronic press kits.
- *Financial documents* include balance sheets, income statements, budgets and other accounting documents from previous years.
- *Supporting documents* could be partnership agreements, project-approval agreements, reference letters, curricula vitae of key managers, and others.

PRACTICAL RECOMMENDATIONS

When creating a strategic plan for your arts organisation, have in mind the following:

- The recommended structure in this book is a general framework, and you will need to adapt it to your organisation's specificities and needs. There are no ready recopies, and strategic planning is situation specific.
- Keep in mind the nature and mission of your organisation and the reason you are developing the strategic plan. For example, a business or commercial organisation may aim to improve sales and marketing aspects, to provide evidence of economic viability, to ensure a return on investments and/or to generate profit. A nonprofit organisation may have very different primary reasons for writing a plan, such as to motivate people, to improve the quality of programming, to expand fundraising, to strengthen relations with stakeholders or to help in solving social problems.
- It is important to identify what kind of information you would need to elaborate the plan. Try to gather as much information as possible before beginning the planning process.
- Various online tools are available to facilitate the process of writing strategic plans. Evaluate how suitable they are for your organisation. Remember that it is better to invest time now and avoid wasting time learning to adapt to software that might be unsuitable later.
- Develop the strategic plan in a synchronized and coherent way. Make sure that there is a logical correlation between different aspects and that the aims, objectives, strategies, programmes and expected results are connected.
- Identify the internal work needed not only to elaborate the plan but also to implement it, monitor it and analyse the results. Remember that the ultimate goal of any strategic planning process is not the plan as a document but its implementation.
- Have a clear scenario for how you think the final version of the strategic plan will be presented, understood, accepted and adopted by all those who have to implement it.
- Write the plan as a dynamic tool which can constantly adapt and change. Do not consider it as a static text.

- Pay attention to the design and layout of the strategic plan:

 - Make sure that paragraphs have relevant headings.
 - Emphasize important sections.
 - Use diagrams, tables and figures wherever possible to improve understanding.
 - Try to avoid repetition.
 - Give arguments to support your statements.
 - Aim for a balance between quantitative and qualitative analysis. Use figures, statistics and numbers but also try to evaluate what is going on.
 - Use short sentences instead of long, confusing ones.
 - Try to be concrete and avoid general statements.
 - Be realistic and do not under-deliver or over-promise.
 - If you use specialized terms from a professional field, add a short glossary as an appendix.
 - Do not forget to double-check all legal documents and requirements mentioned in the plan.

4 Strategic Thinking

Vision, Mission and Objectives

LEARNING OBJECTIVES

Upon completing this chapter you should be able to:

1. *Describe the elements that make up an organisation's identity.*
2. *Understand and explain why defining an organisation's mission (purpose) and vision is so important.*
3. *Understand the three-dimensional framework for formulating objectives.*
4. *Elaborate how organisational objectives can be set up using the SMART approach.*
5. *Analyse the mission statements and objectives of diverse arts organisations.*
6. *Elaborate the section of the strategic plan related to the mission, vision and goals of an arts organisation.*
7. *Connect the theory on the strategic-thinking phase of the strategic management with practical case studies.*

1. THE IMPORTANCE OF ORGANISATIONAL IDENTITY

The start-up phase of the strategic management process is strategic thinking, which includes formulation of the organisation's mission statement (raison d'être, or the organisation's purpose), vision and long-term goals.

There is no agreed formula or common recipe on what would be a good mission statement as it is situation specific and different for every individual case. A mission statement is a unique, specific and positive message. The majority of authors place the elaboration of the mission and vision at the start of the strategic planning process, as it gives the general *vector* of the strategic objectives, operational activities and tasks. The following are several selected opinions of authors on strategies, in both the business and the nonprofit sectors, on what mission means and what would be the components of a mission statement:

- Peter Drucker (1974)[1] observes that a business's mission is the foundation for its priorities, strategies, plans and work assignments. He emphasizes that the answer to the question 'What is our business?' is the first responsibility of strategists.
- Patrick Burkhart and Suzanne Reuss (1993)[2] emphasize the connection between the mission statement and all other activities in the organisation, stating that every programme and activity should reflect the organisation's commitment to address central pressing problems, which are addressed in the organisation's mission.
- Michael Kaiser (1995)[3] emphasizes that an arts organisation's concrete mission statement is the foundation for the entire strategic planning process as it sets the standard to which the organisation aspires, now and in the future, and forces the board members and staff to align around a specific agenda. He suggests that the parameters of the mission statement may include product or service, quality, audience, geographical scope, repertoire and education of audiences.

- John Bryson (1995)[4] separates the vision and the mission in strategic planning for nonprofit organisations, elaborating that the mission clarifies an organisation's purpose, or why it should be doing what it does, while the vision clarifies what the organisation should look like and how it should behave as it fulfils its mission.
- Michael Allison and Jude Kaye (1997)[6] distinguish the vision from the mission statement, emphasizing that the vision statement answers the question 'What will success look like?' and is a shared image of success that inspires and motivates people to work together.
- Paul Joyce (1999)[5] suggests that the mission statement of an organisation in the public services is a statement of organisational purpose which sets out the intended beneficiaries, the main services to be provided, the geographical boundary of the organisation's operations, the desired consequences of the organisation's services and the desired consequences of the organisation's identity.
- Milena Dragićević Šešić and Sanjin Dragojević (2005)[7] discuss the importance of a mission statement for organisations where capacity-building strategies and programmes are implemented. They emphasize that the mission statement should succinctly describe what the organisation does, whom it serves and what it intends to accomplish. It should be broad enough not to need frequent revision and yet specific enough to provide clear objectives and guide programming. It should be understandable to the general public and should be brief.
- Rudolf Grünig and Richard Kühn (2011)[8] propose a possible outline for a mission statement, including: corporate identity, overriding objectives and values, areas of activity and principles addressed to specific stakeholder groups.
- Fred David (2011)[9] includes as components of a mission statement, together with the usual ones, also concern for survival, growth and profitability; the organisation's philosophy; concern for the organisation's public image and concern for its employees.

Creation of a mission statement is important, but not sufficient, for starting up the strategic management process. As discussed in Chapter 1, organisations in the arts and culture sector function as open systems: many of them cannot exist without their audiences and external supporters. Therefore, they need to know how to communicate and how to 'behave' with external groups, what messages to convey and how their external visual image fits with their internal core values and reason for existence. Therefore, one of the first things to do in the phase of strategic thinking is to evaluate and, if necessary, update or change the overall *organisational identity,* or to create an identity if it does not exist yet. It is important to underline what the organisation is and what it is not; to understand and demonstrate its values, uniqueness, originality, individuality and overall organisational culture and behaviour. The identity of an organisation expresses its individuality, as well as its visual image, behaviour and the way it communicates with the external world. The mission statement is the core of the organisation's identity but is not the only element.

PRACTICAL RECOMMENDATIONS

When elaborating the organisational identity, answer the following questions:

- Who are we, and what distinguishes us from others?
- Why do we exist as an organisation and as a team?
- What makes us different from all other arts organisations in the same field?
- What do we want to be, and what are our ambitions and aspirations?
- What are our basic organisational values and norms?
- What are the key programmes we are working on? What is their uniqueness?
- What is our message to society and to external groups, as well as to our personnel?
- How do we convey this message and communicate with our audiences?
- What kind of key messages do we convey: orally, design-wise and online?
- How do we communicate our differences through all forms of promotion?

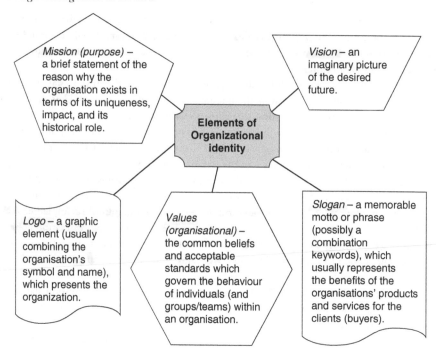

Figure 4.1 Elements of organisational identity

Organisational identity is a strategic issue because it is very much connected not only with the internal values and mission of an organisation but also with its reputation, image and public perception. These elements form the basis for developing audience strategies, seeking financial support, increasing sales, influencing clients and performing efficient work. The *public face* of the organisation is a key to its success and should be formed in a way to radiate trust, confidence and respect. The main elements of an organisation's identity are illustrated in Figure 4.1.

2. VISION, MISSION AND ORGANISATIONAL VALUES

In the practice of management, the terms *vision* and *mission* are considered synonyms, but there are key differences, even if both are interconnected. As discussed in the preceding, the *mission (purpose)* is the reason for existence, the fundamental value system of an organisation which expresses its essence and unique characteristics. Mission statements of arts organisations statement convey an important message, at the core of which are the organisational values. Mission statements target the following groups of recipients:

* Clients, customers and audiences, because of the need to not only satisfy but also create and lead audiences' needs.
* External stakeholders, as arts organisations rely on direct or indirect support from external parties.
* The society as a whole, because arts organisations function as open systems.
* People in the organisation—the staff, board, managers and volunteers—because organisational values have to be understood and shared by everyone working for the organisation's success.

The organisational mission mirrors the current situation and at the same time reflects the future. An organisation's *vision,* on the other hand, targets mainly the future, expressing the ideal desired portrait of the organisation. The vision is the 'guiding star' of the arts organisation in the future, and it can be a desire or a dream one wishes to have come true one day. The vision shows what an organisation could achieve in a much longer time period if it follows its mission. The vision should

- be imaginative, short and understandable;
- be passionate;
- match the mission; and
- draw a path to advancement and progress.

Surprisingly, many arts organisations operate without carefully defining their mission statements (statements of purpose). This is one of the reasons why over time they tend to lose their focus and effectiveness. Elements of a mission can sometimes be extracted from an organisation's legal documents of establishment (incorporation)—this is where the original intent of the founders is stated. These could provide ingredients for formulating the mission statement (if it is not created yet). The original intent might slightly shift over time, because of changes in the external or internal environment. Once formulated, the mission statement needs to be sustainable over time without the need for too many amendments. A well-formulated mission statement is neither too specific, as it should not change often, nor too general, as it might not be clear. It has to be attractive, short and agreed on by all people working in the organisation as well as by the main stakeholders.

It is important to emphasize that the mission statements of arts organisations are always open towards the external environment, not closed within the organisational context. The following gives some examples of mission statements of arts and culture networks. They contain active and positive verbs, expressing the ongoing relations between the network and its members, audiences, and users, as well as society as a whole[10]. Such verbs are, for example, *to encourage, to support, to influence, to promote, to contribute, to provide, to improve, to stimulate, to connect, to catalyse, to federate, to strengthen*. Keywords used in the networks' missions and visions also show the importance of art in the overall social, economic and political development of a country and the fact that art is part of the overall context, not an isolated area. Commonly used keywords and expressions in the mission statements of cultural association networks include some of the following:

- Facilitating a platform for debates and dialogue.
- Promoting access to arts and participation in the arts.
- Developing professional networking in the arts.
- Engaging in lobbying and advocacy.
- Supporting the identity and diversity of an art form.
- Exchanging experiences and generating ideas.
- Improving effectiveness at work.
- Conserving and protecting cultural goods.
- Building strategic partnership alliances.
- Acting as a catalyst for change.
- Promoting intercultural dialogue, communication and collaboration.
- Operating considering sustainability requirements and promoting sustainability.

Mission statements differ based on the status and the focus of an arts organisation:

- The mission statement of a *nonprofit arts organisation* usually addresses a specific type of problem in the society and the need to solve it. Every programme and activity in the organisation should reflect the organisation's commitment to addressing the central problem stated in the mission. The mission serves as a source of motivation for managers and staff, as well as for volunteers and stakeholders. It assists the feeling of involvement and the sense of a common purpose. Such a vector in the strategic management process in nonprofit organisations should not exclude elements of innovation, entrepreneurship and business-oriented behaviour.
- The mission statement of a *state-subsidized arts organisation* is closely connected with the overall cultural policy directions in the respective country, region or city. These organisations aim at the preservation of cultural heritage and traditions and the promotion of important artistic and cultural achievements from the past.
- The mission statement of a *business-oriented arts organisation* usually emphasizes the relationship between the organisation and its customers, and the competitive advantage of the products and

services offered. It focuses on the main directions of further expansion and growth. Business organisations could also incorporate broader social objectives in their mission with the aim of helping to solve societal problems. This part of their mission is closely related to their corporate social responsibility strategy.

It is important to emphasize that for certain arts organisations there are no clear boundaries between business-oriented and nonprofit angles in their mission statements. This is because creative aspects and business aspects are interrelated. There is a connection between the terms *mandate* and *mission*. The *mandate* of an arts organisation is about its social purpose for existence, about what the organisation *should do* because it is part of the society and has externally oriented values. Its *mission* is about the organisation's uniqueness, reason for existence and performance and is mainly focused on what the organisation *wants to do*.

EXAMPLE

Elements of a Mission Statement

- Fundamental reasons for its existence. What is our organisation about, and why do we exist?
- Core ideology: main values, ideas, beliefs or principles in organisational behaviour. What do we believe in?
- Key programmes, products or services and their uniqueness. What is the organisation doing? What is the core of its artistic activities? What are the elements of innovation and uniqueness in our activities and programmes, as well as our management and business approach?
- Key beneficiaries, clients, audiences, communities. For whom do we exist? For whom do we work?
- External responsibilities and attitude. What are our main responsibilities and attitude towards these beneficiaries (clients, audiences, users)? What is our commitment to education, community involvement, social innovation ands societal issues?
- Basic business model. Are we a profit-making, subsidized or nonprofit organisation? Are we financially stable for a long time period, how and why?

PRACTICAL RECOMMENDATIONS

Here are few suggestions to help you when drafting the vision and mission statement of your organisation:

- Your mission statement needs to be passionate, motivating and convincing.
- Do not use ready-made statements from other organisations, even if they sound attractive. Try to find your organisation's own beliefs, ideas and values.
- Your mission statements needs to be sincere and open, as it serves not only you but also all the people and groups with whom you cooperate. Therefore, do not promise more than you can offer and deliver.
- Base your vision and mission statement on long-term principles which will not change significantly over time and which cannot be influenced by occasional factors.
- Involve everyone in the organisation in the process of formulating the vision and the mission statement (through brainstorming, focus groups, social events, workshops, etc.). People who work with you need to understand and accept the mission statement.
- The internal draft of the mission statement may be revised over the course of writing the strategic plan.
- It is very important to reach a formal agreement by everyone on the final formulation of the mission statement and the vision before finalizing the plan.

The mission and vision could also include *organisational values*. Values (used in the framework of planning) are acceptable common beliefs, standards and norms on how people within an organisation should conduct themselves collectively and individually. Values are as important as the mission is, and both are tightly connected, because the values predetermine the way an organisation accomplishes its mission (purpose) and achieves its aims. If the values are not included in the mission or vision, they must be in line with it.

Formulating the values is a complex exercise, requiring a participatory approach and a deep understanding of the overall philosophy at work. Values are linked to, but at the same time different from, ethics, moral, principles, emotions and beliefs. They can be connected with different areas of an organisation's performance and behaviour, such as quality standards for the creative products and services, relations with audiences and clients, the organisation's image and the integrity of the teams and staff. In many cases formulations of value statements contain words such as *professionalism, integrity, excellence, originality, well-being, honesty, recognition, innovation, diversity* and many others. Values are cooperative, adaptable, reliable, sincere and trustworthy.

EXAMPLES

Vision and Mission Statements of Cultural and Artistic Networks

Culture Action Europe[11]

Culture Action Europe is an advocacy and lobby organisation promoting arts and culture as a building block of the European project. *Our aim* is to influence European policies for more and better access to culture across the continent and beyond. We provide customized information and analysis on the European Union, offer cultural actors a space to exchange and elaborate common positions, and develop advocacy actions towards European policymakers.

Our mission is to keep on providing EU cultural operators with a common arena in which they can reflect on the European project, identify their interests and organise their political representation with a long-term objective to strengthen the role of arts and culture in the development of Europe. Behind our mission is the belief that public investment in culture and the arts contributes to the development of a sustainable and more cohesive Europe. We are convinced that access to the arts and participation in cultural life is a fundamental right of every citizen.

Europa Nostra[12]

Europa Nostra represents some 250 non-governmental organisations, 150 associate organisations and 1500 individual members from more than 50 countries who are fully committed to safeguarding Europe's cultural heritage and landscapes. Together, we provide a powerful network for dialogue and debate, we celebrate the best heritage achievements; we campaign against threats to vulnerable heritage buildings, sites and landscapes, and we lobby for sustainable policies and high quality standards with regard to heritage.

Our mission: We are the Voice of Cultural Heritage in Europe.
The **three central themes** of Europa Nostra are:

- Celebrating the best of European cultural heritage.
- Campaigning in favour of Heritage at risk.
- Lobbying.

Europe Jazz Network[13]

Europe Jazz Network (EJN) is a Europe-wide association of producers, presenters and supporting organisations who specialise in creative music, contemporary jazz and improvised music created from

a distinctly European perspective. The membership includes 81 organisations (Festivals, clubs and concert venues, independent promoters, national organisations) in 25 countries.

EJN exists to support the identity and diversity of jazz in Europe and broaden awareness of this vital area of music as a cultural and educational force.

EJN's mission is to encourage, promote and support the development of the creative improvised musics of the European scene and to create opportunities for artists, organisers and audiences from the different countries to meet and communicate.

EJN believes that creative music contributes to social and emotional growth and economic prosperity. It is an invaluable channel for the process of inter-cultural dialogue, communication and collaboration. And music is a positive force for harmony and understanding between people from the diversity of cultures inherent in the European family.

International Network of Contemporary Performing Arts (IETM)[14]

IETM has over 400 subscribing member organisations from 45 countries. It includes organisations with many years' experience of working internationally, as well as those who wish to start.

Our mission is:

- To stimulate the quality, development and contexts of contemporary performing arts in a global environment. . . by initiating and facilitating:
- professional networking and communication
- the dynamic exchange of information
- know-how transfer and presentations of examples of good practice.

We aim to:

- **Anticipate:** new artistic tendencies and evolutions in the environment of the contemporary performing arts in Europe and around the world
- **Connect:** diverse organisations who share common interests in a cross-sector network
- **Catalyse:** international partnerships, exchanges, collaborations and knowledge transfer
- **Strengthen:** the contemporary performing arts sector by providing new arguments for the arts and by supporting professionals via informal learning experiences
- **Influence:** public policy through active participation in cultural policy debates, policy for and through direct advocacy
- **Federate:** different actors in the sector through IETM's neutral and international nature

International Federation of Arts Councils and Culture Agencies (IFACCA)[15]

IFACCA is the global network of arts councils and ministries of culture.

Vision

Our vision is a world in which the arts are valued in themselves and for their contribution to strengthening communities and enriching lives.

Mission

To improve the capacity and effectiveness of government arts funding agencies to benefit society through networking, advocacy and research.

Canadian Conference of the Arts (CCA)[16]

CCA is a not-for-profit, non-partisan member-based organisation that represents the interests of over 250,000 artists, cultural professionals from all disciplines of the nation's vast arts, culture and heritage community. As the national convener, the CCA provides support for collaborative leadership for the Canadian culture sector.

Mission

The Canadian Conference of the Arts is the national forum linking the arts, culture and heritage communities in Canada. Through research, analysis, and public discussion, we promote the adoption of cultural policies needed for the vitality of the Canadian culture sector.

Vision

The Canadian Conference of the Arts plays a unique role in the Canadian arts, culture and heritage sector. It is the focal point where issues relevant to the Canadian arts, culture and heritage sector are identified and debated and through which sound cultural policies are promoted. We build and support strategic partnerships and alliances, facilitate the identification of common priorities and act as a catalyst for change.

Association of Canadian Women Composers (ACWC)[17]

ACWC is the only professional association of women composers and musicians in Canada. It actively supports music written by Canadian women.

Mission statement

The ACWC/AFCC wishes to build on the achievements of the past, encourage women composers of the present and develop a body of well researched, catalogued and preserved archival material accessible to students, researchers and performers in the future. It would like to increase and broaden its membership base to reflect the varied cultures which have made their home here and to raise its profile in the Canadian and International Music scene.

Orchestras Canada[18]

Mission

Orchestras Canada is the united national voice of the Canadian orchestral community: furthering, enriching and celebrating the work of Canadian orchestras through programmes and services in both official languages.

Vision

Orchestras Canada will be at the forefront of advocacy for Canadian orchestras, taking informed action for the benefit of orchestras and the communities they serve. We champion the accomplishments and the potential of Canadian orchestras, and help to create the conditions in which:

- Canadian orchestras are recognised as resilient, collaborative, artistically vibrant organisations that actively contribute to the vitality of their communities.
- Canadian orchestras engage with enthusiastic audiences that reflect the diversity of their communities.
- Canadians can be proud of a distinctively "Canadian" orchestral style, repertoire and social commitment philosophy.

3. ORGANISATION'S NAME, LOGO AND SLOGAN

The *logo* is a memorable motto or phrase (possibly a combination of keywords), which usually represents the benefits of the organisations' products and services for the clients (buyers). The logo usually combines an organisation's name and a graphic image that will become a symbol of the organisation. If an organisation is yet to be registered and has not started operations, the choice of the name is an important part of the strategic plan.

PRACTICAL RECOMMENDATIONS

Keep in mind that the name of an organisation should be

- unique;
- short and expressive;
- connected with the organisation's scope of activities;
- easy to understand and pronounce;
- translatable into foreign languages;
- positive and open.

When choosing the name of your new organisation or project, consider also these questions:

- How does the name reflect the mission of the organisation?
- How will the name of the organisation and the domain name (the online URL) be connected[19]?
- Will the organisation operate primarily locally, regionally, nationally or internationally?
- Is someone else already using the same name?
- If the name consists of more than one word, how will it be abbreviated?

The organisation's logo is the visual expression of its identity. It could incorporate different designs consisting of different symbols, signs, texts, pictures, colours and other elements. It preferably should be simple and easy to recognise. The logo will provoke the imagination and perception of people and assist with recognition of the organisation. It is very important for it to tell a story, attract, and be memorable. The colours and form (vertical, horizontal, oval, round, etc.) used in the logo have an important impact and provoke various feelings and attitudes. An organisation's logo is designed to serve a long-term purpose. It forms an important part of all promotional and communicational materials, for example business cards, brochures, posters and letterhead. The logo is placed on all online promotional tools, such as the website, blogging space, organisational pages and profiles on social networks, and others.

The *slogan (corporate motto)* is a short, memorable phrase consisting of few words which aims to impress and stress important areas of the organisation's identity and the benefit of its products or services. It is directed towards customers, audiences or clients. A slogan is used most often by commercial and trade organisations as it aims primarily to attract clients and increase sales. Looking at the products and services from the clients' viewpoint is the basis for creating a powerful slogan.

EXAMPLE

Slogans of Foundations

European Cultural Foundation: 'Inspiring, engaging and empowering through arts and culture'[20]
David Suzuki Foundation: 'Solutions are in our nature'[21]
Vancouver Foundation: 'Working with you to build legacies in your BC community'[22]
oneVillage Foundation: 'Guiding the unity and transformation of the global village'[23]
Ford Foundation: 'Working with visionaries on the frontlines of social change worldwide'[24]

Slogans of Social Entrepreneurship Platforms

Ashoka Canada: 'Everyone is a changemaker'[25]
TakingITGLobal: 'Inspire. Inform. Involve'[26]
Cape Farewell: 'Climate is culture'[27]
Julie's Bicycle: 'Sustaining creativity'[28]
Tipping Point: 'Energising the creative response to climate change'[29]
Grameen Bank: 'Bank for the poor'[30]

Having a slogan is not a common practice in arts organisations. One of the reasons for this could be that the final outcome is not normally regarded as products 'for sale' and the main goals of arts and cultural organisations (even commercial ones) are multilayered, connected with, for example, artistic values, product quality and/or education of audiences and communities. Slogans in the arts and culture sector are popular when designing fundraising campaigns, connecting art with social causes or elaborating a social entrepreneurial project with artistic elements.

4. OBJECTIVES: THE THREE-DIMENSIONAL FRAMEWORK

An objective is a quantitative and/or qualitative expression of a desired outcome which an organisation or a person wants to achieve in a certain period of time. It usually answers the questions: *what, how much, by what means,* and by *when*? Objectives serve as guidelines at all levels and in all areas of an organisation's activities. Strategic objectives are tightly connected with the organisation's mission and vision. The objectives of arts organisations and projects are formulated based on

- analysis of the organisation's or project's potential (available resources and ability for growth);
- the results of market research (if any);
- the results of analyses of the external environment and external capacity and operations, and the fit of these results with the chosen strategies; and
- deep knowledge of all processes and units within the organisation or of all phases in a project's development.

Setting objectives involves a continuous process of research and decision-making. Setting the right objectives is critical for effective performance management, as well as motivating both personnel and the management team. Objectives also help internal coordination of different activities within an organisation (such as creative, managerial, financial, technical, supportive and marketing activities).

A common problem in arts practice is the existence of too many, badly structured or illogically connected objectives, as well as objectives that are formulated too broadly. Therefore, it is optimal in a strategic plan to elaborate objectives in a *three-dimensional framework* (see Figure 4.2), considering

- the hierarchy of objectives;
- whom they target; and
- the measurability of objectives.

The *first dimension* is the *hierarchy of objectives*. The main (strategic) organisational objectives result from the mission and need to be split into sub-objectives which are much more detailed and cover functional areas or specific activities[31]. Figure 4.3 gives an overview of the hierarchy of objectives.

- The *main organisational objectives* are based on the most important results that the organisation aims to achieve. Usually these objectives are long term; they serve as priority guidelines and are connected with the chosen *development strategies* (see Chapter 6). The basis for formulating these objectives results from the strategic analysis.
- *Functional objectives* are decompositions of the main objectives. They are sub-objectives and focus on the main functional areas of the organisation's activities. Depending on the type of organisation (state, nonprofit or business), they may be angled differently, for example

 - managing personnel development and building public trust (organisations in the public sector);
 - focused around increasing profit margins, developing commercial programmes or attracting investors (commercial organisations);
 - targeted towards improving capacity-building, attracting volunteers, raising funds, developing subscription and membership schemes, motivating volunteers, attracting and engaging diverse donors' programmes (nonprofit organisations); or
 - directed towards innovating and increasing revenues (intrapreneurial arts organisations), in the case of intrapreneurial arts organisations.

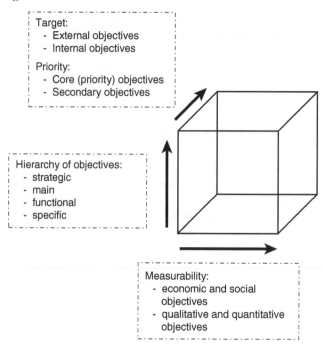

Figure 4.2 Three-dimensional framework for formulating objectives

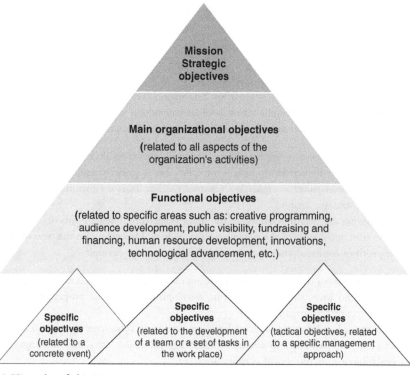

Figure 4.3 Hierarchy of objectives

- *Specific (operational, tactical) objectives* make the functional objectives 'down to earth' and help further the development of *action plans*. These are concrete plans for a specific period of time, emphasizing the sequences of activities, responsible persons, interim deadlines and interim results. They are also tightly connected with tasks.

The *second parameter* of formulating objectives is *whom they target*. They can be external or internal.

- *External objectives* are directed towards stakeholders, customer satisfaction, audience development, media coverage and visibility, expansion of website users, and so on. These objectives result from analysis of the external environment. They aim at exploiting opportunities for improving the organisation's performance and realizing new intrapreneurial ideas.
- *Internal objectives* are directed towards organisational development. They are important as they help the personnel to embrace organisational values and to work towards implementation of an agreed mission. Internal objectives are about the motivation of staff, improvement of internal processes, creation of more efficient management structures, improvement of elements of intrapreneurial culture and behaviour in the organisation, and so on.

Objectives can also be divided into important, or priority, objectives and less important, or peripheral, objectives.

The *third dimension* is *objectives' measurability*. Objectives can be divided into economic and social as well as quantitative and qualitative objectives.

- *Economic objectives* are usually measurable, related to figures, quantities and concrete parameters. They can be:
 - Financial—defining the necessity to achieve financial results, such as profits, turnover, return on investments, productivity and others. These objectives are related to the strategies of growth and expansion[32].
 - Non-financial—mainly connected with quality, innovation, general improvement of workflow and client relations

 Economic objectives are common for business organisations, although nonprofit and state subsidized one also formulate economic objectives in their strategies.
- *Social objectives* are usually not measured with quantity indicators and are directed towards organisational development and/or solving social problems. Social objectives in the arts are very important, especially in relation to developing educational programmes, contributing through art for social change, widening audiences' participation and accessibility, coping with a multicultural environment, and more. These objectives are common for nonprofit and subsidized arts organisations, although commercial art projects and organisations could also have social aspects, especially in relation to their corporate social responsibility strategy or social innovation projects.

EXAMPLE

Hierarchy of Objectives of a Private Art Gallery

- **Main long-term general objective:**

 Become the leading private art gallery in the region, arranging on average 10 art exhibitions of highly recognized artists annually.

- **Main long-term market-share objective:**

 Gain 5 per cent of the national art market by September 2013.

- Specific promotional objectives:

 - Set up an updated interactive website with the possibility for online sales by December 2012.
 - Open an online blog with viewpoints, news and interviews related to exhibitions.
 - Become a member of two international art dealer's associations by December 2012.

- Specific fundraising objectives:

 - Connect 20 per cent of art exhibitions with specific social causes important to the region and organise specific charity campaigns.
 - Increase involvement of sponsors by 10 per cent by the end of 2012 for exhibitions presenting young artists, emerging artists and art for social causes.

- Specific outreach and audience development objectives:

 - Set up a mailing list of minimum 400 people by December 2012.
 - Offer a targeted exhibition on the theme of arts and sustainability and invite relevant organisations and key stakeholders.

- Specific objectives (related to a concrete event):

 - Reach an attendance of at least 120 guests at the opening of the new major exhibition on January 31, 2012.
 - Increase sales related to this exhibition by 15 per cent above the average.
 - Increase the media coverage for this exhibition to one regional television station and two art journals.
 - Send press releases about the exhibition to 20 targeted online newsletters specializing in fine arts.
 - Recruit five volunteers (students in the field of fine art) for the overall publicity campaign related to the exhibition, by December 1, 2012.

5. HOW TO SET SMART OBJECTIVES

The act of writing objectives and collectively agreeing on and accepting them is a special kind of commitment. Being able to formulate exactly what the organisation wants to achieve is the first step towards a successful future. The most well-known method for setting objectives in the theory and practice of strategic management is the SMART approach. *SMART* refers to the words specific, measurable, achievable, realistic and timely:

- **Specific.** This means that the objective is concrete, detailed and oriented towards an action. It has to be straightforward and to express exactly what you would like to have happen. A well-formulated objective should answer the questions: What exactly are we going to do? With whom? For whom? and What will the outcome be?
- **Measurable.** There is a popular practical saying that 'if you cannot measure the objective, you cannot manage it'. Measuring objectives is important as it is the way to track progress throughout their implementation. This might be difficult in the arts, as many activities with qualitative results cannot be measured precisely. Therefore, in the strategic plan, the quantitative and qualitative objectives should be combined and synchronised.
- **Achievable and realistic.** Objectives are not just dreams but should be formulated in such a way that they can be reached. Therefore, it is important to evaluate an organisation's current performance and positioning and to choose strategies based on what is attainable. Objectives, strategies and resources should be well synchronised in the planning process.
- **Timely.** Well formulated objectives always have very concrete deadlines. Writing phrases such as *over a period of time* or *in a long-term perspective* is not effective. Each objective should have a precise time frame.

EXAMPLES

Analysis of SMART Objectives of Arts Organisations

Objective of an opera: To achieve 90 per cent attendance on average for the seven performances of *Barber of Seville* in March 2013 and to target mainly students from the university in the town.

- **Specific:** It says exactly what the staff of the opera plans to do.
- **Measurable:** It states the targeted attendance rate.
- **Achievable:** The opera has a subscribers' list and efficient contacts with the university's newsletters and other promotional media. The timing is sufficient to organise an effective promotional campaign.
- **Realistic:** The results of an initial analysis show that the objective can be achieved within the time frame with the resources available.
- **Timely:** The events will be held in March 2013.

Objective of a theatre company: To organise and disseminate five interviews or articles in high-profile specialized media (radio, television, press) in the period January–March 2013 concerning the new outreach programme of the theatre, attracting children and families (to be launched in early April 2013).

- **Specific:** It says what exactly the theatre will do, oriented towards action.
- **Measurable:** It states the number of interviews to be released.
- **Achievable:** The theatre has already established good connections with relevant journalists from the media.
- **Realistic:** Internal analysis shows that the theatre has the capacity to achieve this objective.
- **Timely:** The objective is to be achieved in the time period January–March 2013.

Objective of a private gallery: To increase sales of art objects by 15 per cent in 2013 in comparison with 2012 by introducing an innovative online sales application on the gallery's website.

- **Specific:** It is clear what exactly the gallery plans to do.
- **Measurable:** It states the targeted percentage of increase in sales.
- **Achievable:** The gallery already has a website and has the in-house expertise to include an application for online sales.
- **Realistic:** Online sales are becoming more and more popular in the arts world and such an objective matches the trends.
- **Timely:** The time period for achieving the objective is specified.

Objective of a library: To hire two highly motivated, innovative and knowledgeable individuals for the position of assistant librarian in digital assets and copyright by February 20, 2013. The deadline for elaboration of the job descriptions and vacancy announcement is December 1, 2012, and the deadline for applications is January 30, 2013.

- **Specific:** It is concrete and focuses on precise details.
- **Measurable:** It states the exact number of personnel required.
- **Achievable:** The library already has in-house expertise to hire new personnel, and the procedure for recruitment is well elaborated.
- **Realistic:** The new generation of educated librarians possesses knowledge of online technologies and library digitalization. At the same time, the library has in its budget sufficient resources to cover the expenses for these two positions.
- **Timely:** It specifies the time period for achieving the objective.

PRACTICAL RECOMMENDATIONS

Writing the objectives for your organisation or project seems an easy task, but it is not. Here are some tips to help you in the process:

- Consider your uniqueness and your innovative capacity. Objectives and strategies are the roadmap to your success. Remember that the indicators of success are unique and different for each organisation and each team.
- Arrange according to priorities. Think about which objectives are important and significant for the success of your organisation and which ones will help you to complete your mission. Apply the three-dimensional framework for formulating objectives.
- Synchronize your objectives. There needs to be a logical connection between the three dimensions when formulating objectives.
- Avoid contradictions between objectives. For example, if the main goal is to introduce an innovative creative programme which does not have the potential to break even, make sure that this matches a fundraising strategy directed towards fund-providers who are willing to undertake risk and support contemporary arts.
- Think positively when formulating your objectives. Keep in mind the future rather than the past or the present.
- Make sure that the objectives you elaborate are something you really want and wish to achieve, not just something which looks good on paper.
- Make sure that your objectives are not too 'down to earth' or too 'up in the air'—balance dreams with a rational approach. 'Think beyond the box' while at the same time minding the 'capacity of the box'.
- Keep in mind your organisation's capacity and resources, and evaluate how you plan to develop them further. This will make your objectives rational and achievable.
- Do not be afraid to include numbers and percentages. In the planning process, objectives are always 'expected', and you aim at achieving them, but throughout the implementation they could change.
- Do not under-deliver or over-promise if your objectives are related to external financing or fundraising.
- Use active verbs when formulating objectives, like *to increase, to establish, to reduce, to create* or *to achieve*. Avoid the future tense of the verbs.
- Be flexible. Be prepared for changes in the stated objectives throughout the plan's implementation.
- Finally, share with others. Formulating objectives is a team-building exercise. Involve your team (your staff), and make sure they participate in the process, because they will be the ones to help you along the road. Do not be afraid to be a 'buffer' and play a mediating role between your creative (conceptual) team and your financial and marketing team as they might have contradictory opinions on what your organisation's (or project's) common objectives should be.

6. EXAMPLE OF A 'MISSION, VISION AND OBJECTIVES' SECTION OF A STRATEGIC PLAN

Mission, Vision and Objectives

- Vision
- Mission (Purpose)
- Organisational values (if not included in the mission)
- Logo and slogan (optional)
- Strategic objectives:
 - Main
 - Functional
 - Specific and operational objectives (forming the action plan for the first year)
 - Values (optional)
 - Other key elements of organizational identity and culture (optional)

7. CASE: INTERNATIONAL COUNCIL OF MUSEUMS (ICOM): A STRATEGY FOR NETWORKING IN THE GLOBAL MUSEUM COMMUNITY

The case was created with the kind assistance of Julien Anfruns, director general of the International Council of Museums (ICOM)[33]. The case text is based on ICOM's strategic plan and online and offline documents as well as an analysis of primary data from targeted qualitative research.

STUDYING THIS CASE WILL HELP YOU TO:

- Understand organisational complexity and the concept of strategic planning for a global network.
- Discuss the importance of networking and collaboration in the field of arts and culture on a global scale.
- Articulate the common problems faced by museums in the era of globalization and increased cultural exchanges between countries.
- Analyse the mission, vision and strategic goals of a professional network

7.1. Brief History

ICOM was created in 1946 and is committed to the promotion and protection of natural and cultural heritage, present and future, tangible and intangible. With approximately 30,000 members in 137 countries, ICOM is a unique network of institutions and museum professionals. ICOM is officially associated with multilateral international conventions on heritage. Maintaining formal relations with UNESCO and a consultative status within the United Nations Economic and Social Council, ICOM has three official languages: English, French and Spanish.

For the first time in its history ICOM was part of the World Expo organised from May 1 to October 31, 2010, in Shanghai, China, on the theme 'Better city, better life'. ICOM's pavilion 'Museums, Heart of the City' represented the global museum community and offered a museum-related experience to visitors of the World Expo. This was a new way of communication for ICOM, giving it a very significant presence at a worldwide event. It raised ICOM's profile and acknowledgement and gave the organisation unprecedented visibility[34].

7.2. Current Programmes and Activities

ICOM Code of Ethics and Professional Standards

ICOM aims to define standards of excellence for museums around the world. In particular, as a leading force in ethical matters, ICOM adopted its *ICOM Code of Ethics for Museums* in 1986, a reference tool that sets standards of excellence to which all members of the organisation must adhere. The *ICOM Code of Ethics for Museums,* translated into 36 languages and revised in 2006, establishes values and principles shared by ICOM and the international museum community. These standards of self-regulation by museums include basic principles for museum governance, the acquisition and disposal of collections, and rules for professional conduct[35].

Red List Series

Illicit traffic in cultural goods causes significant damage to heritage, particularly in the regions of the world where cultural objects are most susceptible to theft and looting. Supporting the fight against illicit traffic in cultural goods is among ICOM's highest priorities. In this context, ICOM publishes its Red List series to raise awareness of smuggling and illicit trade in cultural objects[36].

Museums Emergency Program

ICOM is committed to providing cultural institutions with the necessary support and risk-prevention tools when they are faced with conflict situations or natural disasters. Through its Disaster Relief for

Museums Task Force, the Museums Emergency Program and ICOM's active role in the International Committee of the Blue Shield, ICOM assists museums worldwide by mobilizing its resources quickly and efficiently to provide support in both the prevention and the aftermath of disaster situations.

Mediation Program

ICOM's mediation programme, in collaboration with the World Intellectual Property Organisation (WIPO), is an alternative litigation-resolution method adapted to the arts and cultural heritage fields. Developed in response to an increase in ownership disputes between museums and other parties, the programme can overcome the statute of limitations and take into account customary laws for claims such as misuse of traditional cultural expressions. Specific ICOM-WIPO mediation rules guarantee mediator impartiality and independence, as well as compliance with the ethical standards embodied in the *ICOM Code of Ethics for Museums.*

International Museum Day

Every year since 1977, ICOM has organised International Museum Day, a worldwide event held around May 18. From America and Oceania to Europe, Asia and Africa, International Museum Day aims to increase public awareness of the role of museums in developing society. The event has increased steadily in visibility and popularity over the years, with more than 31,000 museums in some 120 countries participating in the event today. Participation in International Museum Day promotes greater diversity and intercultural dialogue among the international museum community.

Publications, Conferences and Information Dissemination

The ICOM network publishes more than a hundred books a year. In addition, *ICOM News,* created in 1948, is the magazine of the ICOM, designed for today's international museum community. The ICOM network organises annually approximately 250 conferences around the world. Held every three years, ICOM's General Conference is a unique opportunity for the international museum community to come together and engage in professional discussion on the issues facing museum professionals today. Finally, a UNESCO-ICOM Information Centre, created in 1946, has gathered the most comprehensive collection of ICOM publications with around 11,500 bibliographic records, more than 2,000 of which are presented in the publications database on ICOM's website[37].

7.3. Governance and Operations

ICOM is governed in an inclusive and hierarchical manner, on an international level.

- An elected president and an appointed director general head up the organisation and work closely with its institutional bodies.
- The General Assembly sets ICOM's statutory rules and adopts the strategic plan. It also elects a board of directors called the Executive Council.
- The Advisory Committee is ICOM's counselling and recommendation body, made up of the chairs of the ICOM's National and International Committees and Affiliated Organisations.

ICOM's National and International Committees, Regional Alliances and Affiliated Organisations strengthen the organisation's position within the international museum community. They contribute to the resources, energy and diversity of the programmes established by the organisation. ICOM counts

- 118 National Committees, ensuring that the interests of the organisation are managed in their respective countries;
- 31 International Committees, bringing together experts in a number of museum specialties and acting as global think tanks on museum- and heritage-related issues;

- 5 Regional Alliances, promoting dialogue and the sharing of information between the National Committees, museums and museum professionals in a given region;
- 18 Affiliated Organisations who participate in ICOM's activities and contribute to its network; and
- a small number of Technical Committees who carry out studies and draft reports on various essential aspects of ICOM and the museum world—ethics, legal affairs, finances, and so on.

ICOM's General Secretariat represents the organisation worldwide to institutions, museums and museum professionals but also to the contemporary society. The secretariat's international team, composed of 12 different nationalities, implements the decisions taken by the Executive Council, works in accordance with the strategic plan, coordinates the committees' activities, manages the programmes linked to ICOM's missions and provides services to the organisation's members. The secretariat's offices are located at the NGO house in the UNESCO building in Paris, France.

7.4. Profile of Members and Benefits

The majority of ICOM members come from Europe (82 per cent in 2009). The other 18 per cent are organisations located in Africa, the Arab states, Latin America and the Caribbean, North America and Asia/Pacific. The main types of ICOM members are individual members, institutional members, national committees, international committees, affiliated organisations and regional alliances. Members can be either individual museum professionals or institutional members (museums themselves).

To adapt to the variety of economic contexts in different countries, ICOM began to think in earnest about revising its scale of membership fees, and a new policy was approved in 2009, based on the twin principles of fairness and equity. The membership fees are currently divided into four categories of countries, according to the gross domestic product per capita by purchasing-power parity. For individual members, fees are different in each category depending on the profile of the member (active, student, etc.). For institutional members, fees are calculated on the basis of the institution's operational budget. The range of annual dues is therefore very large.

Members' benefits are also diversified[38]. Among them are the following:

- Enjoying advantages like the ICOM Card (free entrance to many museums worldwide), the magazine *ICOM News* and reductions and preferential rates for many services;
- Sharing and exchanging ideas with experts during international conferences, workshops, and so on;
- Developing a professional network;
- Contributing to discussions about museums and their future.

For institutional members, some additional benefits apply:

- Exchange of exhibitions;
- Discussions between museum directors;
- A network of peer museums (e.g., history museums, music museums and conservation institutes).

7.5. Basic Financial Figures

ICOM is a member-driven organisation and is mostly supported by the membership dues. The key figures from ICOM's 2011–2012 budget are presented in Table 4.1.

In terms of revenue, the figures take into account an increase of almost 5 per cent in membership, reflecting the overall trend noted in 2011 and the expected return to a higher level of membership in Spain and the Netherlands, and a reinforced fundraising policy based on contacts made over the last two years with potential institutional donors, including the renewed relationship with the Prince Claus Foundation and the unprecedented support received from the Getty Foundation.

In terms of expenses, both budgets reflect the orientations defined in the ICOM Strategic Plan 2011–2013 and their implementation, including the gradual introduction of the private collaborative

Table 4.1 ICOM's Budget for 2011–2012 (in Euros).

	Revised 2011 Budget	2012 Budget
Membership dues	2,393,000	2,509,840
Grants and donations	500,575	1,046,570
Other	86,145	20,000
Total income	2,979,720	3,576,410
Operating expenses	−1,329,597	−1,787,398
Salaries and social expenses	−1,474,142	−1,580,950
Depreciation expenses	−96,269	−128,350
Total expenses	2,900,008	3,496,698
Financial result, net	79,712	79,712
Financial surplus / (deficit)	0	0

Source: The figures are extracted from ICOM's internal management documents.

platform; the development of publishing activities, including the digital edition of *ICOM News;* a promotional campaign to increase the visibility of ICOM's activities; the publication of three Red Lists (Africa, Dominican Republic, Egypt); and the potential implementation of an International Observatory for the fight against the illicit traffic in cultural property and an updated version of the Museums Emergency Program.

The aim of the ICOM's new projects is not to earn income. Nevertheless, ICOM is very careful about its financial balance and expects therefore to create new sources of income:

- The range of projects consistent with the various aspects of ICOM's public interest missions is currently presented in order to generate interest and commitment from financial partners, with the aim of making projects understandable and raising value and awareness about them.
- The services to members are developed with the intention of increasing membership value and therefore generating membership renewals as well as new memberships. For instance, the digital collaborative platform called COMMUNITY, which will be implemented in 2012, will be an additional argument to promote membership.

In addition, ICOM committees regularly implement new actions—conferences, trainings, publications, workshops, and others—that generate income thanks to the participants' contributions.

7.6. Unique Features

ICOM is the only organisation of museums and museum professionals with a global scope, and it is active in a wide range of museum- and heritage-related disciplines. ICOM is a leading force in ethical matters and conducts advanced research on museum-and heritage-related issues through the international committees' actions.

ICOM is an inclusive international organisation, structured by levels of representatives, that looks beyond its membership to represent the global museum community as a whole. Its extensive network of museum professionals enables the organisation to exert an influence in all parts of the world by gathering, sharing and communicating information.

ICOM has a steadily growing membership base, which enables the organisation to have a strong international voice and to advocate for museums very pertinently. The organisation is well heard in a very wide range of interventions and is not only a network of experts but also an expert itself in fields like the fight against the illicit trafficking of cultural goods or the provision of assistance to museums in emergency situations.

7.7. Strategic Planning

Mission and Vision

Today more than ever, museums are at the heart of cultural, social and economic issues in contemporary societies. They face unique challenges related to their social, political and ecological environment. Museums play a key role in development through education and democratization while also serving as witnesses of the past and as guardians of humanity's treasures for future generations.

ICOM's vision is of a world where the natural and cultural heritage is universally valued. ICOM ensures the protection, conservation and transmission of cultural goods. The organisation shares with humanity the universal value of collections conserved in museums. ICOM contributes to the knowledge and transmission of identity and heritage values specific to each culture.

ICOM works for society and its development. It is committed to ensuring the conservation and protection of cultural goods. ICOM carries out its international missions thanks to international mandates in association with partners such as UNESCO, INTERPOL and the World Customs Organisation. ICOM's missions include

- the fight against the illicit traffic in cultural goods;
- risk management;
- culture and knowledge promotion; and
- protection of tangible and intangible heritage.

Main Strategic Goals, Directions and Programmes for the Next Three to Five Years

The ICOM Strategic Plan 2011–2013[39] was drafted within a view to facing the challenges and seizing the opportunities of a fast-changing museum landscape. ICOM's strategic objectives for 2011–2013 are to

- Increase membership value and transparency for ICOM members:
 - Offer differentiated services to address members' needs;
 - Encourage membership inclusiveness, diversity and participation in international committees.

- Develop museum and heritage expertise:
 - Strengthen compliance with museum ethics across the world;
 - Develop and support research and ICOM's publications;
 - Promote international guidelines for professional performance.

- Strengthen ICOM's global leadership in the heritage sector:
 - Advocate for museums and develop relations with official structures through international heritage projects;
 - Develop strategic partnerships with both traditional and non-traditional partners.

- Develop and manage resources to implement the strategic plan effectively:
 - Increase fundraising to enlarge ICOM's resource base;
 - Strengthen the transparency and reliability of all aspects of ICOM's financial reports.

ICOM's strategic plan outlines a set of precise tasks and operational steps for achieving each of the four strategic objectives.

Functional Strategies

Marketing, Audience Development and Public Relations. ICOM has boosted its technical and human resources and endeavours to improve and facilitate communication within the organisation and with the outside world. The aim is to communicate more coherently and professionally by modernizing the organisation's information and communication tools to keep up with new developments in

technology without losing sight of the network's multicultural nature and unique structure. Another goal is to develop and affirm ICOM's status as the primary spokesperson on international museum issues.

Financing and Fundraising. ICOM's objective is to expand the organisation's income to ensure that ICOM's activities can be implemented. A new position called 'Diversification of Resources' was therefore set up in 2009. The organisation develops new types of partnerships, including sponsorship and patronage. In addition, every possible effort is made at all levels to consolidate ICOM's resources: its financial resources are rationalized, and the financial management is modernized. Examples include providers that are systematically selected via tendering procedures to rationalize operating costs; a new work organisation at the secretariat, based on an outcome-oriented approach; and diversification of revenues, not based only on member subscriptions for a more modern and proactive way of securing its financial balance.

Partnership and Cooperation. Maintaining formal relations with UNESCO and a consultative status within the United Nations Economic and Social Council, ICOM also partners with entities such as WIPO, INTERPOL and the World Customs Organisation to carry out its international public service missions. ICOM also develops strategic partnerships to raise its profile and strengthen its global impact. ICOM also seeks to collaborate with institutions that share its values and with which synergies are possible, including nongovernmental, specialized and local organisations and development banks.

7.8. Elaboration and Support of New Projects

A General Assembly and an Advisory Committee meeting take place every year so that the leadership of the organisation can come together and participate in making decisions concerning the organisation's future. Every three years, these meetings take place during a General Conference which every ICOM member can attend. The ICOM International Museum Meeting takes place in Paris and includes not only the Advisory Committee and the General Assembly meetings but also working groups on hot topics for the organisation. For example, in 2011 three issues were discussed:

* Museums, the environment and sustainable development: making ICOM and museums actors for the development of society;
* Research, training and publications: enhancing the value of ICOM as the international research platform on museums;
* The ethics of museums, new perspectives: developing an ethical sensibility beyond the *ICOM Code of Ethics*.

ICOM meetings always facilitate the generation of new ideas and the exchange of experiences and good practices between members.

ICOM committees are encouraged to develop new projects that they can think of within the mission of ICOM. Every ICOM member is also welcome to make proposals. A working group on the strategic plan was organised in June 2011 to brainstorm on how to implement the global strategic plan at the level of the national and international committees. For other missions, every department of ICOM is encouraged to suggest new ideas that would be in line with the strategic plan, but the risk and the responsibility should be totally controlled before implementation.

ICOM has a strong policy regarding its support to the network. Four subprogrammes were created in order to allocate subventions to specific projects: annual subsidies for the International Committees, funding for national and international committees and regional alliances for the implementation of special projects related to the strategic plan, a grants programme designed to encourage ICOM members to participate in the annual meetings, and Getty Foundation subsidies for International Committees' activities. The projects that receive funding are selected prior to allocation on the basis of presentation files. Once the activities are under way, ICOM examines progress reports that include financial reports to make sure the funds are used properly.

QUESTIONS AND ASSIGNMENTS

- Evaluate ICOM's organisational identity and strategic directions, considering its current programmes and organisational structure.
- What are the main reasons for ICOM to elaborate its strategic plan? How does it help the network's performance?
- What are the main strategic challenges and dilemmas for ICOM in the future?
- What kind of approach/method would be most effective for ICOM to use for elaboration of its next strategic plan? What are the limitations and possible risks in its strategic planning process? (In your answer, refer to the methods discussed in Chapter 3 of the book.)
- Does ICOM's strategy and operations contain intrapreneurial elements? If yes, what are they? If not, why?

Note: You might need to perform additional online research to complete these assignments. In your answers, apply the theoretical models and methodology from Chapters 1, 2 and 3 as well as this chapter.

8. CASE: INTERARTS (BARCELONA, SPAIN): KNOWLEDGE-BASED APPROACH TO STRATEGIC MANAGEMENT AND PLANNING

The case was created with the kind assistance of Mercedes Giovinazzo, Director and Antonio Gucciardo, general manager of INTERARTS. The case text is derived from selected online and offline promotional materials and documents, as well as an analysis of primary data from qualitative research.

STUDYING THIS CASE WILL HELP YOU TO:

- Understand the importance of developing cultural policy research in a cross-collaborative framework.
- Discuss the mission and strategic goals of a nonprofit organisation supporting cultural policy development internationally and locally.
- Analyse the strategic orientation of an organisation working internationally as well as locally.
- Analyse innovative elements of a research-oriented organisation.
- Discuss the professional competence of the management team as an important factor in the process of strategic management.

8.1. Background

Founded in 1995, INTERARTS is a private agency[40] based in Barcelona, Spain, with international coverage and dimension of activities to support the design of cultural policies to contribute to the processes of development in the culture sector and to facilitate the transfer of knowledge and information in the field of culture.

INTERARTS's principal areas of activity are in the field of cultural policies and cultural cooperation. The organisation is active in innovative fields such as those concerned with cultural rights and with the creative and cultural economy. INTERARTS strives to include a cultural approach in projects concerning human development.

Activities are organised in the following the following activities:

- **Design.** As a laboratory of ideas and centre of applied investigation, INTERARTS focuses on emergent cultural issues of political relevance and contributes to the elaboration of proposals for the implementation of cultural policies.

- **Consultancy.** Culture is a key element in the process of development. With this end in mind, INTERARTS coordinates the management of international projects concerned with cooperation for development and acts as consultant in the organisation of creative industries.
- **Training and information.** Training is one of the core activities of INTERARTS, which organises short cycles of thematic seminars and initiatives such as the international campus for cultural cooperation, implemented in different geographical areas. Through its bulletin, *Cyberkaris,* and its website, INTERARTS continuously diffuses studies and information relevant to cultural cooperation.

8.2. Current Programmes and Activities[41]

• Applied research

INTERARTS initiates and partners in applied research and study work, generating new knowledge based on the observation and evaluation of projects, programmes and policies, along with participation in international research-action processes. Since December 2010, INTERARTS has coordinated, in cooperation with Culture Action Europe, the European Expert Network on Culture (EENC)[42] on behalf of the European Commission. The EENC involves a group of 17 experts and also includes the participation of the Institute for International Relations in Zagreb. Until the contract expires in late 2012, the EENC will contribute to the improvement of policy development in culture in Europe, through the provision of advice and support to the European Commission in the analysis of cultural policies and their implications at the national, regional and European levels. Rather than carrying out primary research, the EENC will provide expert advice to policy-makers by synthesizing current research and relevant issues in a way which is useful for policy development. Among the tasks that the EENC has been entrusted to perform is the launch and management of a website, which should provide comprehensive information both on the EENC's own activities and on other developments relevant to the fields in which the network operates.

Other research activities or projects currently under way or recently concluded include the following:
- INTERARTS performs (conducts, undertakes) a study of the creative clusters in the territory of the city of Cádiz (Spain), the aim of which was to identify strategies to increase the competitiveness of the sector.
- INTERARTS is one of the partners in the project European Arts Education Monitoring System[43], funded by the European Commission, which aims at implementing a sustainable European tool to compare information and resources on arts education between different European countries in order to facilitate learning processes as well as decision-making in the educational sector.
- INTERARTS coordinates the project "Social inclusion of marginalized young people in IberoAmerica" a spin-off of the study on "Access of young people to culture in Europe" which analyzes the role of culture as a vector for the social inclusion of young people in Argentina, Brazil, Chile, Colombia, Costa Rica, Mexico, Panama, Paraguay, Peru, Spain, Uruguay and Venezuela.

• Cultural cooperation

INTERARTS is an active collaborator with numerous organisations at the local and international levels on joint projects related to cultural processes and policies. The organisation participates actively in international debates on the values of culture and cultural cooperation and manages events for dissemination of knowledge in the culture sector.

In collaboration with the Organisation of Ibero-American States for Education, Science and Culture, INTERARTS has developed the Euro-American campus for cultural cooperation[44]. The first Campus took place in Barcelona in 2000; it has since been held in Cartagena de Indias (Colombia, 2001), Seville (Spain, 2003), São Salvador da Bahia (Brazil, 2005), Almada (Portugal, 2007), Buenos Aires (Argentina, 2009) and Las Palmas de Gran Canaria (Spain, 2010). The eighth edition will take place in Cuenca, Ecuador, in November 2012.

As a space for information exchange and debate, the campus is an opportunity for all professionals in the culture sector wishing to explore issues related to international cultural cooperation. Other campuses have taken place in the Euro-Mediterranean space (five editions) and in the Euro-African space (2009).

- **Advice**

INTERARTS supports the design of public cultural policies as well as initiatives coming from the business sector and the third sector. Two working strands have led to the setting up of two major programmes on the following:

 - Promotion of Cultural and Creative Industries (FOMECC), which is a management model that conceives of cultural production as a development tool. Its final aim is to create a sustainable system linking the sphere of art and culture with the economic, social and academic sectors. Specific projects have been implemented, since 2006, in Colombia, Guatemala, Honduras, Peru, Niger and Senegal.
 - Cultural Instruments for the Improvement of Women's Sexual and Reproductive Health, which interconnects the cultural dimension, including cultural rights, with sexual and reproductive health care in order to fight against maternal mortality and foster culturally appropriate care. Specific projects have been implemented, since 2007, in Bolivia, Ecuador, Peru and Mali.

- **Transfer of knowledge**

INTERARTS disseminates information to the general public and specific target audiences through publications, documentations and online tools, through the general website and specialized websites[45], and also through the upcoming new website for the Euro-American Campus for Cultural Cooperation. Its monthly newsletter, *Cyberkaris,* is sent to over 5,000 subscribers in four languages. All the project-related documents are available online.

8.3. Management Team and Governance

INTERARTS's organisational structure is as follows:

- **The board**, currently composed of 11 individual members who are highly competent and experienced in diverse ranges of complementary sectors (ranging from the cultural to the financial). The board takes all major strategic decisions, the approval of the annual accounts and operational budgets. It also discusses the future development of the organisation.
- **The Executive Committee**, composed of two board members (chair and vice-chair) and two staff members (director and general manager). The committee is mandated by the board to follow up on the implementation of the organisation's activities and to make the necessary ad hoc decisions.
- **The executive team**, consisting of 11 full-time staff members (10 in the headquarters in Barcelona and 1 in Dakar, Senegal). The team is composed of highly competent professionals coming from diverse cultural and professional backgrounds.
- **External collaborators**, recruited on a project basis, for short time periods.
- **Interns**, two to four of whom work with INTERARTS each quarter. They are selected on the basis of individual applications. For each intern there is a prior agreement with the university in the framework of their postgraduate studies. The period of the internship can be prolonged up to six months, and remuneration is foreseen. Selection is done on the basis of qualification and experience.

8.4. Facilities

INTERARTS rents an independent office (200 square meters) with meeting facilities (two meeting rooms holding 10 and 50 people respectively) in the center of Barcelona, on the top floor of an office building. The premises have two large terraces, one equipped for lunches and coffee breaks.

INTERARTS owns its own equipment:

- 19 independent work stations, each with a PC equipped with Windows 7, Office 2011, Navision Dynamics Nav specifically tailored to meet the needs of the organisation, and Microsoft Exchange;
- four laptops, three netbooks and one tablet;
- two servers with capacity for remote access, as well as a periodic backup system;
- digital telephones and smart phones;
- high-bandwidth Internet access (ADSL through optical fiber);
- a videoconferencing system;
- Skype premium and Go-to-meeting;
- flat mega screen for television, projections and other audiovisual support;
- a documentation centre.

8.5. Basic Financial Figures

INTERARTS's income is exclusively generated through participation in public tenders—external support from a diverse range of sources at the local, regional, national, European and international levels. The challenge for the organisation is the need to diversify its funding sources and to open up new ones, especially within Europe. The total operational budget of INTERARTS for the year 2011 was €1,262,303. The budget breakdown is given in Table 4.2.

Table 4.2. INTERARTS's Operational Budget in 2011

Income Sources	€	%
Sales and services (European Union, private foundations, other)	291,511	23.09
Public grants towards activities	970,792	76.91
TOTAL	1,262,303	100.00%

Expenses	€	%
Operating costs	405,648	32.14
Operational costs (costs linked to direct project implementation)	856,655	67.86
TOTAL	1,262,303	100.00

Source: Data are extracted from the estimated closing accounts of INTERARTS for 2011.

8.6. Targeted Groups and Partners

INTERARTS's principal beneficiaries are

- Cultural researchers;
- Educational and training institutions;
- Libraries and research centres;
- Cultural and arts organisations; and
- Decision-makers at the local, regional and European levels.

The main partners of INTERARTS are international organisations, state and local public administrations (in particular, all those departments which are directly or indirectly responsible for culture and cultural cooperation), private foundations, nongovernmental organisations, universities, etc.

INTERARTS's stakeholders are mainly the same as the partners already mentioned; to these may be added the culture sector's professionals in the large sense, which includes cultural entrepreneurs and other public entities such as chambers of commerce, ministerial departments responsible for education, labor, health, trade and industries, etc.

Cyberkaris, INTERARTS's newsletter, was first launched on paper in the year 2000. It is an important and well-known communication tool, and it is currently distributed electronically to over 5,000 subscribers on different continents (Europe, Latin America and Africa) in four languages (Catalan, Spanish, English and French).

8.7. Unique Features and Success Factors

- **The Team**

INTERARTS is a relatively small organisation, with a flexible internal structure and management. The team is highly competent—all team members have completed postgraduate studies in different areas. They are highly respected internationally for their professional competence. Language diversity is another benefit of INTERARTS. The team is quite young—the average age is around 35 years. The contracts with the staff are long term, and the turnover is very low. Team members have a certain degree of autonomy to initiate and elaborate specific projects. INTERARTS has proven its capacity to attract talented project managers and young researchers and to motivate them.

- **Know-how**

INTERARTS has 17 years of experience and is the only organisation of its type in Spain. It has a high knowledge of the sector, at both the international and national levels. It is the first nongovernmental organisation for development in Spain that is specialized in the management of cultural projects and initiatives. It is also recognized among the professional circles for its high-level advocacy and lobbying capacity. INTERARTS carries out specialized strategic consultancy in the field of cultural policies in the European Union. It also provides strategic support to organisations in developing countries.

- **Adaptability**

INTERARTS has proven that it has a high capacity to adapt to a changing external environment and a high capacity to respond to changing needs in the cultural field.

- **Networking**

INTERARTS has an extremely wide network of individuals and organisations from which it can pool high expertise for the implementation of its activities.

- **Reputation**

INTERARTS is highly respected among professional circles as an organisation working internationally, building bridges between cultural policy, research and practices; having a competent team; and delivering high-quality results.

8.8. Strategic Directions

INTERARTS has undertaken the revision of its five-year strategic plan. In this framework the organisation's mission and vision are currently being reworked. This process will be finalized by June 2012. Nevertheless, given that this process is being undertaken on the basis of the organisation's development over the last 17 years, the following are some important strategic directions, considering a situational analysis as a starting point of the new strategic plan.

- **Mission**

INTERARTS has a public service vocation. In particular, it strives to attain the following:
 - Foster the growth of the culture sector with the aim of contributing to social, economic and, in more general terms, human development;
 - Advise public administrations and international organisations in the definition and implementation of cultural policies;

- Facilitate international cooperation processes related to the culture sector;
- Propose strategic solutions for operators and cultural enterprises; and
- Promote the circulation of information (advocacy) for the culture sector.

- **Vision**

To include a cultural approach in projects concerning human development.

- **Organisational Values**

INTERARTS believes in the need to foster access to culture for all, inclusive education and respect for human rights and cultural diversity; strive for a sustainable economy; apply transparent and legal working methods; facilitate networking and the equality of partnerships in the field of cooperation; and so on.

- **Strategic Directions**
 - To maintain the organisation's high international reputation and positioning
 - in the management of cultural projects and programmes in the field of international cooperation towards development in Latin America and Africa;
 - in the organisation of cultural flagship events, such as the international Campus for Cultural Co-operation (Euro-Mediterranean, Euro-American, Euro-African); and
 - in the applied research on cultural policies geared towards the provision of specific recommendations for public administrations (local, national and international).
 - To become the leading European organisation in the above-mentioned areas of activity.

8.9. Innovative Aspects

- INTERARTS has done pioneering research, consulting and training work in areas such as cultural rights, international cooperation and development by introducing culture as a key factor, connections between culture and sexual and reproductive health, and more.
- INTERARTS sets up benchmarking in the culture sector, especially related to cultural policies. It does this in close collaboration with other key players in Europe and internationally.
- IINTERARTS adapts innovative instruments to its internal administration procedures and also to its internal as well as external communication policies. This has been done in close collaboration with specialized professionals in each of the specified areas. Examples of innovative tools include the following:
 - Enterprise Resource Planning specific to INTERARTS: the system was developed through the collaboration of INTERARTS, accountants, information technology staff, and so on.
 - Models for cross-checking the technical activities and management costs.
 - An internal control system for the expenditures and project activities.
 - Predictive models for the general budget and analytical budget.
 - Control and management systems for the activities carried out abroad.
 - A specialized portal for the cultural and creative industries sector, http://www.fomecc.org, which includes a social feature to facilitate contacts and the setting up of projects.
 - Work experience programme abroad for INTERARTS employees.
 - Visiting research fellow in INTERARTS: inviting renowned professionals, especially university professors.

These innovative aspects help INTERARTS to achieve its objectives and to maintain the organisation's international reputation and positioning in professional circles and among the general public. Innovative elements are intended to help the organisation's development and sustainability in the long run. Investing in developing the organisation's potential in international public relations is understood as crucially important given that this is considered as a major asset to ensure the organisation's capacity to adapt quickly to a fast-changing environment.

QUESTIONS AND ASSIGNMENTS

- Analyse the vision, mission and organisational identity of INTERARTS. What are their main strengths? Are there any weaknesses?
- Identify the strategic management process phases in this case. What approach would you recommend to INTERARTS for them to successfully complete their strategic planning process?
- What are the main reasons for INTERARTS to elaborate a strategic plan? Considering the current structure, who should finally approve the plan? Why?
- Identify the types of innovation in INTERARTS's operations and activities. Can INTERARTS become an intrapreneurial organisation? Why? Why not?

Note: You might need to perform additional online research to complete these assignments. In your answers, apply the theoretical concepts and the methodology from Chapters 1, 2 and 3 as well as this chapter.

5 Strategic Analysis

The Arts Organisation and Its Environment

LEARNING OBJECTIVES

Upon completing this chapter you should be able to:

1. *Demonstrate why strategic analysis is a key phase in the strategic management process.*
2. *Articulate the differences between macro- and micro-environmental factors and the influence they have on an arts organisation's performance.*
3. *Understand cultural policy and creative (entertainment) industries as key elements of the external environment.*
4. *Elaborate competitor analysis and stakeholder analysis.*
5. *Elaborate the SWOT matrix in preparation for selecting the right set of strategies.*
6. *Analyse driving and restraining forces as a result of interactions between various factors.*
7. *Elaborate a SWOT analysis section of a strategic plan.*

1. STRATEGIC ANALYSIS: AN OVERVIEW

Strategic analysis is an important phase in the overall strategic management process. In practice it is inseparable from strategic thinking because the formulation of the mission, vision and strategic goals should be in line with the results of the analysis of the present situation. As discussed in Chapter 2, strategic planning reflects the changing relations between an organisation and its environment over a long period of time and suggests ways of achieving an organization's mission and objectives by choosing the most appropriate strategies and action tools[1].

Like every other organization, an arts organisation does not operate in a vacuum and is surrounded by the outside world which in economics, management and marketing studies is called the *external environment* or *context*. The external environment includes all factors which are outside of an arts organization but influence its resources (input), processes and/or outcomes (results). Some of these factors have a closer influence and are part of the direct *(micro-)* external environment, while others form the *macro*-framework as their influence is indirect (see Figure 5.1). The analysis of an arts organisation's external environment consists of several main areas:

- **Analysis of macro-external environment.** These are factors which indirectly influence an arts organisation. These political, legislative, economic, social, technological, informational and global factors can create opportunities or restrict an organisation's future performance. Analysis of the macro-environment also includes analysis of the cultural policy framework in a country or a region where the arts organisation operates.
- **Analysis of micro-external environment.** These are factors influencing an arts organisation directly. They include analysis of industries as well as markets:

- Analyses of creative (cultural) industries focus on their structure, innovative potential, the likely changes in these industries in the future, and the arts organisation's possible responses to these changes. In the industry analysis Michael Kaiser & Paul Engler (1995)[2] also includes peer organisations—those organisations that offer the same level of product or service and therefore compete for resources, customers and patrons.
- Market analyses focus on the arts and culture market's size, growth and segmentation, and potential audiences as well as competitors. In nonprofit arts organisations, analysis of external partners and collaborators is of utmost importance.

An organization's *internal environment* includes all elements within the organization, such as artistic programmes, management methods, organizational culture, structures, policies, resources, capacity and others.

As already mentioned in the previous chapters, SWOT analysis (*SWOT* stands for strengths, weaknesses, opportunities and threats) is a widely used basic method for strategic situational analysis which helps to identify the positive and negative influences of the external environment on an organization, as well as the internal strengths and weaknesses of an organization. Using the external

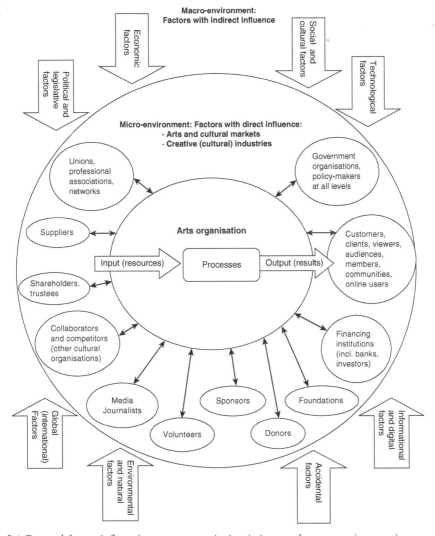

Figure 5.1 External factors influencing an arts organisation (micro- and macro-environment)

opportunities and strengths of an organisation to cope with weaknesses and counteract threats is an important result of the SWOT analysis. This is one of the fundamental ingredients to generate alternative strategies.

2. UNDERSTANDING AND ANALYSING THE MACRO-EXTERNAL ENVIRONMENT

Macro-environmental factors affect organisational strategies and decision-making in an indirect way—they cannot be controlled or changed by direct actions. They are covered with the umbrella term PEST factors (political, economic, social and technological)[3].

2.1. Economic Factors

Cultural and artistic development depends on the overall economic development in a country. Economic factors regulate to a certain extent cultural participation and consumption. They also facilitate (or restrict) philanthropy, sponsorship, individual spending and government support for the arts. Economic factors can help arts organisations become entrepreneurial and be able to cover their costs with self-generated revenues or earn profits, or they can prevent this. Some of the most important economic factors influencing the arts sector and cultural activities are

- the overall economic situation (economic growth, financial stability or instability, recession, deflation, inflation rate);
- the purchasing power of the population, which depends on salary levels, taxation policy, savings, bank loans and the structure of household income and expenditures (all of these influence to a certain extent the level of audiences' spending for different art forms);
- relationships with financial institutions (including bank loans, lines of credits and other debt instruments);
- currency exchange rates (especially for cross-border artistic activities, international touring, purchases of backstage equipment or materials from external suppliers and other activities which depend on imports and exports);
- the level of employment and unemployment (in the culture sector and in the respective country in general); and
- patterns of privatization and their reflection in the culture sector.

Cultural participation and overall economic development are not directly connected. This means that in some countries, during periods of economic crisis or instability, cultural event attendance may not drop significantly. There are examples when people tend to spend more money on entertainment and artistic events during periods of recession. This is especially valid for specific cultural products and services with *non-elastic* prices[4]—where increases or decreases in price do not significantly influence cultural participation.

An analysis of economic factors requires answers to questions such as the following:

- What are the overall long-term economic trends in the country (region)?
- What economic trends influence the specific artistic or cultural field?
- What is the long-term prognosis for the main economic parameters?
- What is the overall development forecast for cultural industries?
- How does consumption of cultural goods and services change over time, and how is it related to economic indicators in a country or region?
- How might the relationships between an arts organisation and its main external stakeholders and audiences change in the long term under the influence of economic factors?
- What are the capacities and attitudes of the business sector with respect to investing in the arts and supporting artistic projects and initiatives?

- What are the economic conditions facilitating (or preventing) international cultural cooperation, export and import of cultural goods and services or mobility of artists?
- What are the economic conditions facilitating (or preventing) innovations in the arts?

2.2. Political and Legislative Factors

Arts and culture are influenced to a great extent by the relevant political system and subsequent cultural policy model. Important political factors influencing the arts, culture and creative industries are general cultural policy trends, instruments and methods (national, regional and city cultural policies); taxation policy; labour legislation (general and specialized); and the overall political situation in the country that provides stability or instability. An important part of all political factors is legislation affecting the arts and culture sector:

- Specialized laws in different arts and culture categories. These include theatre laws, laws for preservation of cultural heritage, laws for regulation of cultural and community centres and audio-visual legislation.
- Copyright law and intellectual property law. Copyright is the principal source of revenues in the cultural (creative) entertainment industry.
- Legislation for establishment and functioning of nonprofit organizations. Development of the third sector in a country is largely dependent on these laws.
- Legislation for the establishment of various types of cultural foundations—corporate, community, family, regional and national. These laws facilitate external financial support for nonprofit initiatives and organisations.
- Legislation for sponsorship and donations from individuals and institutions. Such a legislative framework facilitates relations between the arts and the corporate sector.
- Legislation providing benefits for arts businesses. These laws make possible registration and operations of commercial arts organisations.
- Regulations for the export and import of cultural goods, services, people and material objects needed for artistic processes. These laws are especially important in light of improving international cultural cooperation and facilitating cross-border projects and international mobility of artists and cultural professionals. Supporting mobility of artists (artistic mobility) is an important direction of legislative changes in a country. Artists and cultural professionals have an essential need to travel internationally to find new inspirations, meet new audiences, exchange experiences and initiate new projects. They also need to travel to increase their economic status and have more opportunities to develop their careers.
- Support for arts education and training. These legislative instruments are about incorporation of arts subjects in the curriculum primary and secondary school programmes, development of programmes and departments of art in university and higher education systems, and facilitation of connections between arts organisations and educational institutions.
- Support mechanisms for cultural participation, including special government incentives at the local and regional levels for encouraging participation in artistic events and programmes, especially targeting young people.
- Protection of cultural heritage. Because of the uniqueness of cultural heritage[5] and the necessity to preserve past achievements for the benefit of future generations, governments at all levels, including international bodies, undertake special legislative initiatives for protection of cultural property and intangible and tangible cultural heritage, as well as natural cultural heritage.

2.3. Social Factors

Social factors that influence cultural organizations include demographic, cultural and educational matters; traditions; habits; ethnicity; religion; and others. The demographic structure of the population is one of the most important factors influencing trends in cultural participation and consumption, as well as the choice of marketing strategies for creating needs and developing tastes for quality

cultural programmes. Developing special strategies to attract particular social or marginalized groups or work with specific audiences such as children, youth, immigrants, the elderly or ethnic minorities is important. Traditional social structures including families, schools, community organizations, and so on play an important role in setting up basic social values in a society. Another important influencing factor is the media, which influence arts organizations much more directly and are part of the micro-environment.

Examples of what trends should be monitored and analysed in the strategic analysis include

- the socio-economic characteristics of the population (such as age, sex, education level, income level, occupation, marital status and religion);
- the geographical distribution of the population;
- the birth and death rates;
- literacy levels;
- the ethnic mix;
- the average family size;
- professional career attitudes;
- lifestyle trends;
- language(s) spoken;
- social networks;
- the level of development and usage of the Internet (generally and in the arts sector);
- the historical development of the arts sector;
- the main traditions and customs in society;
- consumption patterns of cultural goods and services;
- acceptable gender roles and occupations;
- intellectual, artistic and leisure-time pursuits; and
- immigrants and diaspora groups.

Social factors are important because they influence consumers' behaviour[6]. Family units are considered to be the most important 'buying unit' in the society and a key factor that influences the buying behaviour and patterns of individuals.

2.4. Technological, Digital and Informational Factors

The constant implementation of new technologies, online tools and Web 2.0 tools[7] changes the arts world very rapidly. Information and communication systems play an increasingly important role in the overall functioning of arts organisations and projects. Online technologies and new media provide a new virtual and digital context for arts organisations, initiatives and projects[8]. They offer plenty of options for free or low-cost promotion of artists, arts products and services. Audiences' behaviour also changes— from consumers of information they become active participants and collaborators involved in the artistic process. They can easily give feedback, share opinions with each other about an art product or change other consumers' behaviour. Content generated by users is, in many cases, the result of a collaborative effort—each subsequent user can contribute to what the previous one has said, uploaded or written.

New technologies change the understanding of what art is and who the artist is. Every user can create online and become a self-promoter—his/her voice, opinion or creative digital work could reach millions of other users, accumulating the accessibility effect through users' interest and rating. The phenomena of online technologies in the arts and user-driven content raise numerous discussions about the value, level of professionalism and quality of art offered online by users.

Arts organisations operate in a digital environment, not only in a physical one. Digital culture is one of the global phenomena of the twenty-first century. It is a fascinating trend because it is about access—to everybody by everybody; it has no limits and helps art products and artists overcome borders, and it offers users a 'second life' in virtual spaces. Digitalization is not just about another channel: it requires a new approach in arts management practice and in the overall strategic planning process[9].

When preparing a strategic plan, arts managers and entrepreneurs need to deeply consider digital, technical and information/communication opportunities and explore them to generate innovative ideas in the most effective way. These opportunities include

- free or low-cost promotion and offering of artistic products and services online;
- real-time communication with audiences: instant messaging, discussions online, group calendars, shared online encyclopaedias;
- ongoing involvement of users in the artistic process or feedback on the final product through social networks[10];
- fast communication through integrated applications: mobile devices, workflow integration, syndicated content, group emails, a common online workflow;
- personalized delivery of content: providing information specific to the needs and preferences of a user, filtering based on priorities;
- new ways of fundraising online for an artistic project or innovative initiative[11];
- the ease with which to raise awareness of a specific cause quickly and broadly;
- the ability to overcome the distance between artists and audiences by the power of social networks;
- promotion of artists or artworks based on users' rating; and
- e-commerce possibilities—selling artistic works and offering paid services online[12].

Online technologies are not by themselves a driving force for arts organisations: it is important how and for what purpose they are used by an arts organisation to help audiences spend less time on orienting or informing themselves or on buying and to allow them to buy faster and from different locations, to share opinions on their experiences and to feel involved.

New media and online technologies are used for the creation and realization of innovative and entrepreneurial projects in the arts, which contribute to a sustainable strategy. Examples include making artistic products more visible, enlarging distribution channels, connecting art with a social cause, attracting supporters and funders, increasing revenues from sales, financing a project, and many more.

PRACTICAL RECOMMENDATIONS

When analysing trends in technology and information development, important areas to consider include the following:

- Trends in the development of new technologies and online tools;
- The level of computerization and Internet usage in society;
- Users' capability to benefit from Web 2.0 tools (social networking, blogging, online forums, online participatory art projects, etc.);
- Future opportunities to use new technologies and mobile applications in the cultural production process, as well as in marketing, promotion and fundraising;
- Cultural policy instruments and government support for research and development, including in the culture sector;
- Technological development and social innovations in cultural industries;
- Opportunities for automation of certain technical, mechanical or service processes in culture (e.g., selling tickets online).

2.5. Global Factors

A review of the literature on strategic management shows that this is a relatively new dimension in analysing the external macro-environment. It is driven by increased globalization processes influencing all areas including the arts and culture sector. Globalization trends influence artistic processes: the production, circulation and consumption of cultural goods. They could be both driving and restraining forces in artistic practices. Global trends could raise the need for a new artistic project or could be a

problem for maintaining artistic uniqueness and preserving cultural heritage. For example, the free flow of goods, services and people between countries as a result of the expansion of European Union membership creates new marketing opportunities for arts organisations and artists. There are more opportunities for sharing of information and knowledge, for collaborations, co-productions, touring and mobility of artists across borders[13]. On the other hand, the issues around preservation of cultural heritage and the regulation of imports and exports of arts objects and products are becoming an important part of governments' cultural policies and might be a restraining force for international cultural exchange.

Connecting art products and services with global issues facing the planet becomes an important part of overall strategic management and strategic programming in the arts. These issues include concerns about the environment and a clean planet, climate change and global warming[14], world hunger and poverty, sustainable development, human rights, arms control and the fight against terrorism. Exploring issues of global concern opens a window of opportunity for many social entrepreneurship projects and organisations, social innovation initiatives in the arts which aim at using artistic concepts and artists to solve the burning problems of communities at risk, people living in isolated areas or underprivileged groups[15].

2.6. Environmental Natural Factors

With discussions around energy saving and global warming now part of everyday life, environmental and natural factors are an important part of a strategic analysis. Four main aspects could be considered:

* Scarcity of natural resources (water, metals, oil, etc.);
* Increased energy costs from traditional sources of energy (oil, coal, natural gas);
* Global warming and constantly increasing carbon emissions from burning fossil fuels;
* Pollution and the implementation of recycling programmes, ecologically friendly production technologies and ecologically clean packaging for materials and goods.

Bringing an environmental agenda into strategic planning in the arts and increasing awareness about the environment on the part of artists and arts managers are growing trends worldwide. Managing arts organisations and projects while reducing electricity and water consumption, recycling garbage or using organic materials in artistic projects is a growing concern in the arts sector[16].

2.7. Occasional (Accidental) Factors

These factors are difficult, or sometimes impossible, to predict—they are related to war, terrorism, weather effects and natural disasters such as earthquakes and floods. In some cases the contingency section of the strategic plan includes measures and preparations against possible disasters and risks, especially in zones and regions of the world which are much more influenced by such occasional factors.

3. CULTURAL POLICY AS AN ELEMENT OF THE EXTERNAL ENVIRONMENT

Applying a strategic approach in the process of planning in the arts requires a general understanding of how the overall cultural policy development influences the practice of managing a concrete arts organisation. Cultural policy[17] is part of the overall public policy in a country. In a narrow sense it refers to direct and indirect government measures, methods and instruments used to encourage, develop and protect cultural heritage, cultural and artistic organisations, activities, projects and individual artists.

Societies nowadays recognize more and more the beauty and the power of art and the need to support artists. Cultural policy instruments use a broad range of measures to foster, encourage, support and develop cultural life in a specific geographical location (country, region or city). They are needed for many reasons but mainly because culture is seen as a 'public good', and therefore there is a need for all to share it and protect it. It is also important to create a favourable environment in which cultural heritage and artistic achievements can be preserved for future generations.

The focus on strategic management in arts organisations regards cultural policy as one of the key factors of the macro-external environment (PEST factors). A review of key theoretical resources devoted to cultural policy and strategic management in the arts shows that there is little connection between the policy and the management levels[18]. This chapter of the book emphasizes that understanding and analysing the opportunities as well as threats which cultural policy decisions, documents and other direct and indirect methods pose for arts organisations and artists is important to the elaboration of proper strategies.

Analysing trends in cultural policy development and instruments is an important part of the strategic external analysis in an arts organisation. This is because the government's direct and indirect support sets up the general context in which the arts and culture sector operates. In the strategic planning process cultural policy analysis covers issues related to

- general principles, mechanisms and dilemmas of direct and indirect state support for the arts;
- international, national, regional and local cultural policies;
- government incentives for fostering innovation and entrepreneurship in the arts;
- encouragement of arts education;
- employment in the culture sector; and
- relationships between arts organisations and external financing and funding institutions.

It is important to keep in mind that policy decisions are always related to the distribution of taxpayers' money in a country among different arts organisations, activities and individual artists. There are several *key questions and dilemmas* which require consideration when elaborating strategies of arts organisations:

- Is the emphasis on direct or indirect government support for the arts or both?
- Are policy instruments targeting national-level (and federal-level) arts organisations or also high-quality and innovative nonprofit and commercial art forms through project subsidies?
- How is state funding distributed between the *centre* and the *periphery*—between larger cities and provinces, as well as isolated regions or towns?
- Is state support directed only to traditional and classical art forms, or are contemporary arts organisations also eligible for state funding?
- How are the state subsidies distributed between well-established arts organisations with a long history of existence and emerging artistic organisations?
- What is the form of direct state funding: provision of part of the budget of arts organisations, or subsidies based on project submissions, or support for individual artists?
- Is arts education well balanced with the demands of the labour market in the arts and cultural field, and how do policies help with that?
- How is it possible to foster artistic creativity through policy decisions?
- Is there any support for arts organisations that have an intrapreneurial profile?

The general directions, models and instruments of cultural policy vary a lot from country to country, depending on a mixture of historical, political, economic and social factors. Government intervention in the arts occurs in two main ways: directly, through subsidies, and indirectly, through legislative and regulatory mechanisms (as already mentioned). Depending on the level and the instruments of government support for the arts, and the correlation between the three economic sectors related to the arts,

there are three main *models of cultural policy,* elaborated in the following. They result from a thorough analysis of the vast literature on the topic, as well as experts' opinions gathered by conducting targeted qualitative research:

A. Model of Primarily Government Support for the Arts

The main characteristics of this model are the following:

- The state is the main financial source of funding for all, or most of, the cultural organisations' activities.
- Centralized administration and management leads to a danger of censorship and direct involvement of the state in the creative processes.
- Diversity, mobility and flexibility in the overall cultural life are minimal. The cultural infrastructure is well developed, and state capital subsidies are high.
- Nonprofit and business types of arts organizations do not exist or occupy a very small portion of the arts and culture sector.
- Arts organisations are relatively stable, enjoying ongoing annual financial support from the state. This provides opportunities for longer rehearsal, creative and conceptualization periods, and the capacity to engage creative teams for longer periods of time.
- There is no direct link between state subsidies and the final quantitative results from the cultural activities. Support is given irrespective of the number of participants in a cultural event.
- Arts markets are non-existent or underdeveloped. Other intermediaries in the arts, such as producers, impresarios or art dealers, are rarely present (or not at all).
- Artistic products and services are accessible to many people, due to the regular state subsidies which make it possible to decrease the prices and make art widely accessible. It also allows dissemination of artistic programmes to isolated geographical areas and small cities and towns.
- The size of the audience have very little influence on an organisation's development and on creative strategies.
- Strategic plans at the organizational level are often predetermined by the overall direction of the national cultural strategy.

B. Model of Arts and Culture Development Based on Market Principles

The main characteristics of this model are the following:

- State support for creative work is mainly indirect—through the legislative framework. Direct state subsidies are minimal.
- Arts organisations function in the three sectors of the economy—state, private and nonprofit. Commercial and business arts organisations prevail.
- The majority of revenues for arts organisations and projects come from self-generated revenues from selling products and services.
- Artistic mobility and exchange are very high—organisations need to tour to capture bigger audiences.
- Arts and cultural markets are well developed. Intermediaries, such as producers, entrepreneurs or art dealers, play important roles in linking artistic products with buyers and audiences.
- Consumer choices lead and predetermine creative policies and overall decision-making on the organisational level. This means that programming fits the tastes of the audiences who are ready to pay a sometimes high price to attend an event or buy an art object.
- Differences in the salary and income levels of individual artists are significant. Many of them have fluctuating incomes and are engaged via temporary contracts, rather than receiving stable salaries.
- Business plans for arts organisations are more common in this model, as they place a strong emphasis on marketing and consumer behaviour predetermines the creative production process.

C. Mixed Model

Theoretically, the mixed model keeps the pluses and diminishes the minuses of the two previous models. The main characteristics of this model are the following:

- The funding scheme for the majority of cultural organisations and projects is mixed—coming from the state, business companies, individual donors, foundations and other financial institutions, as well as from self-earned income.
- The state supports arts and culture with both direct subsidies and indirect instruments through legislative and other initiatives.
- Together with state-subsidized arts organisations, there is a well-developed art market, especially in larger cities.
- Creative (cultural) industries are well developed and contribute to the overall economic development of a country.
- The third sector in the arts and culture (civil society sector) is powerful and influences the decision-making process at all levels—national, regional, local and international—through lobbying and advocacy actions.
- The diversity of art forms and arts organisations is very high. The financial models of the majority of arts organisations are mixed—including both self-earned income and support from various institutions and individuals.
- The price levels of offered arts products and services vary between state-subsidized and business organisations. Prices are usually much higher in commercial arts projects organisations that rely mainly on sales, merchandising schemes and entrepreneurial projects.

When one is elaborating a strategic plan, it is important to understand the variety of cultural policy models and instruments, on both the national and local levels. Cultural policy, when well elaborated, could be a driving force for the arts. But when not set up well, or non-existent, it could be a restrictive force. The future development of any organisation is influenced by the overall policy model and further trends in the cultural policy in a country and a region. Cultural policy documents could be regarded as plans for the protection, promotion and development of culture and arts in a country. In Europe, a comprehensive reference on cultural policy instruments, measures and debates is the Compendium of Cultural Policies and Trends in Europe[19]—a web-based and continuously updated information and monitoring system for national cultural policies in Europe. It is a long-term project which aims to include all 49 member-states cooperating within the context of the European Cultural Convention. Each country's cultural policy profile covers key aspects such as a historical perspective on cultural policies and instruments, competences, decision-making and administration, international cultural cooperation, objectives and principles of the cultural policy, cultural policy issues and priorities, legislation (general and specific, such as tax law, labour law, copyright provision, financing culture (public cultural expenditures, allocation of responsibilities, direct and indirect state support), cultural consumption and participation and, finally, arts and cultural education. An important document that advocates for including culture in the development agenda of cities and local governments is Agenda 21 for Culture[20]. It was agreed on by cities and local governments from all over the world to enshrine their commitment to human rights, cultural diversity, sustainability, participatory democracy and creation of the conditions for peace.

4. UNDERSTANDING AND ANALYSING THE MICRO-EXTERNAL ENVIRONMENT: INDUSTRY AND MARKET ANALYSIS

As discussed in Chapter 1, arts organisations are open systems, and arts managers constantly interact with outside organizations, groups and individuals. On one hand they need to be in constant contact with suppliers, sponsors and funding and financial institutions to secure the necessary resources—materials, equipment, information, finances, and more. The ongoing scarcity of financial support

for the arts worldwide requires a special emphasis on building up long-term relations with business organizations, governments, foundations and individual donors that provide financial support or might provide it in the future. On the other hand, arts organisations offer products and services to audiences and clients on a paid basis and generate revenues as a result. This becomes very important not only for the art businesses but also for organisations having nonprofit status. To survive and grow further, an arts organisation needs to maintain and develop contacts with all groups which form its micro-environment. Some of them influence mainly the *input* of the system, such as creative labour, artists, suppliers, shareholders and financial institutions. Others are important at the *output* of the system, for example audiences, clients and buyers. There are external groups and organisations who are affiliated both with the internal processes and with the outcomes, for example the media, journalists, professional unions and associations, other arts organisations, and communities.

The general framework for analysing the micro-environment as part of the strategic planning process covers three main areas:

- Analysis of creative (cultural, entertainment, leisure) industries' development and trends;
- Analysis of market factors: competitors and audiences (clients);
- Stakeholder analysis.

4.1. Creative (Cultural) Industries, Entertainment Industries

Business and commercial arts organisations form a special sector in the economy which is often covered by the terms *creative (cultural) industry* and *entertainment industry*. The term *industry* is related to mass production (manufacturing, processing) of goods or services in large quantities, to be sold to generate profit in return. The definition that is most quoted and widely accepted by authors on creative industries is the one given by the Department of Culture, Media and Sport, United Kingdom[21], emphasizing that

> creative industries are those industries which have their origin in individual creativity, skill and talent and which have a potential for wealth and job creation through the generation and exploitation of intellectual property. This includes advertising, architecture, the art and antiques market, crafts, design, designer fashion, film and video, interactive leisure software, music, the performing arts, publishing, software and computer games, television and radio.

In addition, cultural heritage, tourism and museum industries are identified as being closely related to creative industries—particularly in the provision of services which often fall within the definition of creative industries.

According to the UNESCO Convention on the Protection and Promotion of the Diversity of Cultural Expressions (2005)[22], *cultural industries* refers to industries producing and distributing cultural goods or services. These industries are involved with one or another element of the processes of creation, production, distribution and dissemination of goods and services based on cultural or artistic activities and are usually protected by intellectual property rights. The processes and products in the creative industry branches contain creative elements and are based on collective or individual creativity. These industries are knowledge-based and labour-intensive and contribute much to the overall economic development of a country.

The review of vast theoretical resources on creative (cultural) industries[23] shows that this subject is becoming extremely important from the viewpoint of the new knowledge-based economy and information society we live in. The knowledge-based economy considers the production, distribution and use of knowledge. This term emphasizes that knowledge, information and education are the necessary 'human capital' for the production and dissemination of goods and services. Authors writing about the creative (cultural) industries stress the importance of these industries for the fulfilment of policy objectives such as job creation and employment in the culture sector, the importance of cultural

organisations and creative entrepreneurs as taxpayers, the role of culture in urban regeneration policies, and so on. Another group of researchers, among them Allen Scott and Dominic Power (2004)[24], analyses the main features of creative industries:

- They have an experimental character.
- They typically consist of small producers (with low entry and exit costs), complemented by large establishments (tending towards mass production).
- They stimulate experimental reactions by the consumers.
- They are subject to competitive and organisational pressures.

Analysis of the creative (cultural) or entertainment industries is important for the process of strategic planning as it helps to identify

- the potential chances for a new entrepreneurial idea in the arts sector to succeed;
- the level of difficulty in starting up a new organisation in a specific cultural industry branch;
- the capital, labour, knowledge and other resources required to start a new arts organisation or project;
- the driving and restraining industry forces which will influence an arts organisation or a long-term project in the next three to four years;
- the direct and indirect competitors in the sector;
- potential partners and collaborators;
- the potential sources of innovations; and
- options for partnership with other organisations.

There is no agreed framework on what exactly creative (cultural) industry branches include. For example, the term *culture and media industries* also includes broadcasting (radio, television, cable), digital media (including software and computer services), film and video, recorded music and publishing. Ken Roberts (2004)[25] also regards sport and tourism together with the cultural industries. Some authors, especially in the United States, prefer to use the term *entertainment industry*, emphasizing the element of enjoyment for audiences more than the cultural aspect of these industries. The term *entertainment industry* (in some sources also *leisure industry*, although there are differences between the two)[26] covers all companies and organisations that exist to offer goods and services related to pleasure, amusement and attraction in a passive way (by watching a concert or a movie) or in a dynamic/active way (gaming or cultural tourism). The entertainment industry's main aim is to fill people's free time; to help them to enjoy their after-work hours, weekends and holidays; to generate profit as a result of offering goods and services in mass quantities; or to attract numerous buyers and clients[27].

The entertainment industry is divided into several branches (subsections), depending on the nature of the goods and services offered, the use of artistic skills and creativity, distribution channels (media or otherwise) and the level of contact with audiences (see Figure 5.2) The proposed sub-structuring is one of the many ways of grouping different branches:

- Creative/artistic branches are the music business, the film industries, art market, antiques market, fashion, photography, architecture and design.
- Industry branches based on broadcasting or involving the media are the cinema, the video industry, television and radio, the recording industry and the publishing industry.
- Branches using online and digital entertainment are computer games, online publishing or Internet-based entertainment services.
- Another group is live entertainment and outdoor forms of entertainment, such as the show business, commercial theatres, stage shows, festivals and carnivals and circuses, as well as outdoor events.
- Finally, there are branches not directly connected to arts and creativity, such as gambling, sports, recreation, catering, and so on.

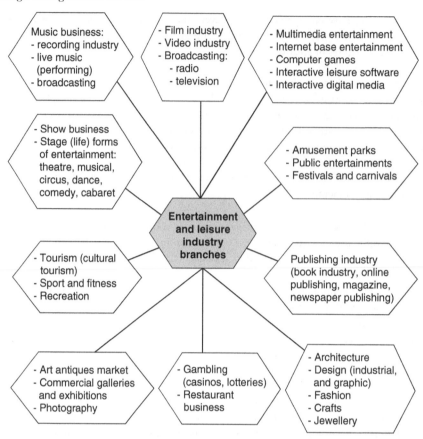

Figure 5.2 Entertainment and leisure industry branches

Analysing the creative (cultural) and entertainment industries' trends is important in the process of strategic planning in the arts. Kaiser & Kaiser (1995)[28] suggests that an analysis of industry structure and participants is an important part of the external analysis in an arts organisation; he separates industry participants into five key categories: peer companies, new entries, substitute products, buyers and suppliers. He defines peer companies as those organisations that offer the same level of product or service and therefore compete for resources, customers and patrons.

Those organisations in the arts that function as businesses are part of the creative (cultural) or entertainment industries. Their strategic plans require careful consideration of the overall process of creation, production, distribution and dissemination of goods or services in order to increase initial capital as well as projected revenues. The main objectives in the strategic planning process are to find out the possibilities for investment returns, the point when sales revenues would start generating profit, the use of intellectual property as a way to generate income in the form of royalties, and ways to grow and expand the business to also boost the overall economic development.

PRACTICAL RECOMMENDATIONS

When analysing the creative (cultural) or entertainment industries as part of micro-external environmental analysis for the objectives of strategic planning, perform targeted research, both online and offline, to answer the following questions:

- What is the branch of the creative (cultural) or entertainment industries to which your organisation belongs?
- Are there databases, statistical sources or media coverage at the national, regional and local levels in your country that can provide data and trends for this industry branch?

- What are the general trends in the development of this industry branch in the next years?
- What is the stage in the life cycle of development of this industry branch? Is it in the early stages, growth, maturity or decline?
- What is the level of concentration of companies and businesses in the industry? Mind that small organisations perform worse in highly concentrated industries and much better in fragmented industries.
- Is the industry structure capital-intensive? Does it require a relatively high level of capital investment compared to the labour cost? This is especially important for start-up projects.
- What is the level of current innovations and knowledge conditions in the industry branch?
- What are the main driving forces in the development of the creative industry in the next few years which your arts organisation can benefit from?
- What might be the restraining forces for your arts organisation to function effectively?

4.2. Market Analysis

Markets are a very important part of the micro-environment. Market analysis includes three main aspects: analysis of market size, growth and segmentation (potential audiences and clients); analysis of competitors; and analysis of suppliers and sources of support (including possible sources of financing, the labour market, and so on).

- *Market size* refers to potential audiences, as well as options for international expansion. This part of the analysis also includes options for international artistic exchange, mobility and cross-border collaboration. Globalization and new technologies, an important external factor, drastically increase market potential. Results of this analysis are further used in the marketing planning to identify specific marketing tools and techniques used by arts organisations to attract and engage audiences.
- The analysis of *market growth* concentrates on the trends in the changing demands of consumers for a particular product or service in the future. Creative and entertainment industry branches where markets are growing fast are very favourable for starting new entrepreneurial activities based on artistic elements.
- *Market segmentation* is an important part of this analysis as it helps an arts organisation to focus better on those audience segments which are more likely to attend performances, buy products or become engaged in supporting the organisation's projects. New entrepreneurial ideas in the arts have more chances to succeed in markets which are more segmented because the choices of consumers become more diverse.

Research on and analysis of the future demands of customers, clients and audiences are important as these influence artworks and cultural products, especially when the presentation or sale of an artistic product is impossible without an audience, for example in the case of the live performing arts.

Cultural, artistic and entertainment industry organisations could be *competitors* or *collaborators*. This depends greatly on the organisation's main mission and goals, the chosen set of strategies and other factors.

- *Direct competitors* are organisations that offer similar products or services. For example, the direct competitors of a commercial gallery could be other galleries in the same city.
- *Indirect competitors* are those organisations that compete for the free time and money of the public. For example, all other companies that fill the free time of audiences and attract their spending can be considered as indirect competitors of a commercial gallery—computer games companies, broadcasting organisations, live music events, the Internet, festivals, tourist agencies, sports organisations and so on. An important part of the strategic planning process is to research and analyse competitors' advantages and mistakes and to work out joint networking and collaborative strategies with other similar organizations by building cultural networks and professional associations[29].

Collaborative strategies in the arts are equally important to competitive strategies. Sometimes, transforming competitors into collaborators could be a powerful move for elaborating strategies of integration and networking.

The media are part of the micro-external factors and are particularly important because of their influence on public opinion. The media, both new media and traditional media[30], can indirectly regulate

demand and supply factors in the arts. The media can also create a public image and visibility, or they can destroy it. The marketing section of the strategic plan considers the results of the market analysis and emphasizes diverse communication and public relations tools to involve the media—broadcasting, print media, online tools and others[31].

PRACTICAL RECOMMENDATIONS

When performing a market analysis, keep the following questions in mind:

- Who are our main competitors (direct and indirect)? What are their unique features, strengths and weaknesses? These questions will help you to formulate the competitive advantage of your arts organisation or project.
- Who is our potential audience, and what are their consumer-behaviour trends, especially related to their free time and leisure activities? This question will help you to target your creative programming, to estimate your potential revenues, and to elaborate appropriate marketing strategies.
- Who are our main suppliers, and what is their importance in our organisation's programmes and activities? This question is related to all the technical and 'backstage' parts of your activities.
- Who are other important groups and key persons from the micro-external environment? How could we involve them in our programmes and projects? These questions will assist the elaboration of your communication strategies.

4.3. Stakeholder Analysis

Stakeholder analysis is an important focus of the micro-environmental analysis for public and non-profit arts organisations because their strategic objectives are open to external groups and one of their primary long-term goals is to satisfy key stakeholders. Patrick Burkhart and Suzanne Reuss (1993)[32] define a *stakeholder* as a person or group of people who have a stake in the organisation. This stake may refer to organisation's past, present or future. Bryson (1995)[33] understands a stakeholder as any person, group or organisation that can place a claim on an organisation's attention, resources or output or is affected by that output. Bryson gives as examples of a government's stakeholders the citizens, taxpayers, service recipients, the governing body, employees, unions, interest groups, political parties, the financial community, businesses and other governments. In his opinion, examples of a nonprofit organisation's stakeholders include clients or customers, third-party payers or funders, employees, the board of directors, volunteers and other nonprofit organisations. Michael Allison and Jude Kaye (1997)[34] include in the group of external stakeholders clients or recipients, funding sources, referral or cooperative organisations, organisations that serve the same population or seek resources from the same sources and community leaders from business, civic and private organisations.

A *stakeholder* is defined as any external or internal person, group or organization who influences (or might influence in the future) the organisation's performance and outcomes and/or who can be affected by the organisation's actions, resources or outcomes.

EXAMPLE

Stakeholders in Arts Organisations

- The stakeholders of a *city council department for culture* include citizens, taxpayers, unions, political parties, other government administrations, service recipients, businesses and government employees.

- The stakeholders of a *private gallery* include subscribers, buyers, sponsors, clients, commissioned and exhibiting artists, staff and contractors.
- The stakeholders of a *nonprofit organisation* include the board of directors, volunteers, leaders of other nonprofit organizations, funding institutions, staff and contractors.

Stakeholder analysis identifies key persons and groups and their relationships with the organisation. Bryson (1995)[35] suggests that the first few steps in such an analysis require identification of who the stakeholders are, what their criteria are for judging the organisation's performance (that is, what their 'stake' is in the organisation or its output) and how well the organisation performs according to those criteria from the stakeholder's point of view. Bryson emphasizes that stakeholder analysis will help clarify whether the organisation needs to have a different mission and perhaps different strategies for different stakeholders and whether it should seek to have its mandates changed. Paul Joyce (1999)[36] identifies five main steps in the stakeholder analysis: identification of stakeholders, identification of how stakeholders influence the organisation, identification of what the organisation needs from each stakeholder, identification of the criteria used by the stakeholders in evaluating the organisation, and ranking of stakeholders in a rough order of importance.

The concrete results of a stakeholder analysis include the following information:

- A list of key stakeholders;
- Their main competences and attitude;
- The level and scope of their influence on the arts organisation;
- Possible approaches to involve them in the long-term development of the arts organisation;
- Possible benefits for stakeholders in the long term.

An example of a stakeholder analysis of a nonprofit arts organisation is presented in Table 5.1.

5. UNDERSTANDING AND ANALYSING THE INTERNAL ENVIRONMENT

Strategic planning requires evaluation of all internal factors influencing organisation's current performance. Analysis of strengths and weaknesses of an organisation is the second part of the SWOT analysis.

Table 5.1 Example of Stakeholder Analysis in a Nonprofit Organisation

Stakeholder	Competence/abilities/ areas	Level and scope of influence on the organisation	Approaches to involve the stakeholder
Board of Directors (Organisational Committee)	Legal issues, fundraising matters, content and curatorial advise, financial and fundraising issues	Decision-making, high level of influence on resources, processes and outcomes	Ongoing communication, seek advice, involve at milestone points throughout the strategic planning process
Foundation	Provides financial stability	The main supporter and fund-provider. Influence high as provides 60% of the budget for the current year	Ongoing information, give evidences of smooth management and implementation of the granted projects
Group of young motivated volunteers: youth community leaders	Provides unpaid labour, invests efforts, participates in the organisations' activities	Involved in volunteering work, and have a high influence as connect to audiences of programmes and projects targeting young people	Involve in actions, ensure ongoing communication and motivation. Implement innovative marketing strategies to keep their attention at a high level
Municipal cultural department (director, staff)	Directing, decision-making, administrating programmes and policies related to the cultural development of the city/region	Medium level of indirect influence through policy decisions and legislative initiatives	Lobby, advocate, make programs and projects visible, give special personalized invitation to participate in key events

It helps to research and identify resources, capabilities, processes and other organizational elements that provide an organisation's uniqueness, core competences, competitive advantage and innovative methods of performance. The end result of an internal analysis (or *internal auditing, internal scanning*) is to indicate the organisation's capability and flexibility to cope with the changing external environment and to handle the chosen strategy. When performing an internal analysis, it is important to identify

- the internal strengths of an arts organisation which might be used in the future to lead audiences' tastes, cope with competitors, satisfy stakeholders' expectations or generate additional incomes;
- internal weaknesses which have to be diminished by implementing effective management methods in the future;
- the capacity of the team to undertake further programmes;
- the capability of the organisation to grow, expand or maintain its long-term stability;
- elements of an intrapreneurial climate and options to either create it, if it does not exist, or improve it; and
- sources and methods to generate and implement innovative ideas.

There are various practical approaches to analysing the internal organisational environment. It is important to underline that one and the same internal factor may be viewed as either a strength or a weakness, depending on its impact on the organisation's objectives and attitudes towards the external environment.

5.1. Functional Approach

This type of analysis is based on an evaluation of all functional areas of managing an arts organisation, as follows:

- Artistic and curatorial programmes and creative activities. The analysis includes methods of measuring the quality of artistic production, evaluation of artistic teams and their creativity, and internal synchronization between artistic processes.
- Human resource management. The analysis here includes the capability of managers and the board, relations between core artistic teams and others, opportunities for professional development, personnel motivation and appraisal systems, and the development of internal units to work on innovative projects.
- Technologies, information systems and operations. The analysis aims to identify weak points in the process and strategies to cope with risks. It also discovers the organisation's capacities to handle future strategies.
- Marketing and communication. The analysis in this area covers audience development and engagement, use of marketing research results in the decision-making process, communication strategies and tools, and more.
- Finances. Analysis in this area includes: the budget structure, evaluation of investment and operational costs, ratio of external subsidy versus self-generated revenues, cost-benefit analysis, main factors for future financial stability.

5.2. Resource-based Approach

This type of analysis is based on an evaluation of the strengths and weaknesses of all available resources needed to perform an organisation's activities, their quality and quantity, including

- human resources—the potential for creativity and implementation of innovative ideas;
- material resources, including technological and technical resources;
- financial resources—sales revenues, external support, and overall cost structure; and
- information and non-material resources—such as copyrights and intellectual property.

It is important to evaluate the potential of the organisation to seek innovative ways to increase current resources, especially in the case of expansion and growth.

5.3. Mixed Approach

This type of analysis combines the 'soft' (people, teams, behaviour, etc.) and 'hard' (structures, technologies, methods, etc.) aspects of management. Therefore, the evaluation is performed based on the following main elements:

- Resources
- Processes and activities
- Structure, people and management procedures
- Performance and visibility.

Figure 5.3 gives an overview of an internal environment in an arts organisation, based on the mixed approach. These four main areas form the basis for the analysis. In some cases audiences could also be considered part of the internal environment, for example in the field of the live performing arts.

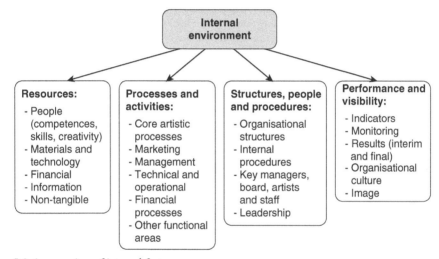

Figure 5.3 An overview of internal factors

PRACTICAL RECOMMENDATIONS

When performing an internal analysis in an arts organisation, try to answer systematically the following key questions:

- What do we do best?
- What are our strongest assets?
- What unique resources and capabilities do we have?
- What is our ability to adapt to changes?
- What are our available resources (assets, intellectual property and people), and how can we use them more efficiently?
- How could we seek new and alternative resources in the future?
- What are our organisational capabilities and capacity?
- Where are our weak points?
- What expertise and competencies do we lack?
- What areas of organisational performance do we need to improve, and how?

EXAMPLE

Analysis of Strengths and Weaknesses of a Nonprofit Theatre Organization Located in a Small City

Strengths

- High reputation among regular audiences
- Talented and motivated team of actors
- High-quality theatre performances, recognized by the theatre critics and the media
- Long history of existence of the theatre company
- Own building for rehearsals and performances
- Regular annual subsidy from a municipal fund, covering 70 per cent of the operational costs
- Audience and stakeholder trust and support, built up over a number of years

Weaknesses

- A weak brand name
- Increased cost in the budget structure in the last few years
- Lack of efficient access to key distribution channels for ticket sales
- Traditional marketing tools and inability to implement innovative marketing strategies
- Absence of specialists in the field of marketing and fundraising in the theatre
- No innovative aspects of work
- Geographical location not favourable for international cooperation and networking
- Municipal subsidy covering mainly operational costs and insufficient for innovative programming or attracting new audiences.

6. PREPARING TO DEFINE A STRATEGY: CRITICAL SUCCESS FACTORS

The result of the external and internal analysis is to identify the driving and restraining forces for the organisation's functioning and behaviour. *Driving forces* are opportunities provided through the external environment as well as by an organisation's strengths. *Restraining forces* are threats from the external environment and the organisation's weaknesses. As SWOT analysis is about analysing a real situation and not a hypothetical scenario, it is important to also analyse the risks and limitations. An overview of the interaction between internal and external factors in SWOT analysis is given in Figure 5.4.

PRACTICAL RECOMMENDATIONS

When performing SWOT analysis it is important to follow several rules:

- Work out first the analysis of the external environment and then the analysis of the internal environment (opportunities and threats before strengths and weaknesses). This is a simple rule to start from the general and gradually move to the more specific areas of analysis.
- Concentrate on the specific artistic field or industry branch where your organisation operates. External factors influencing a museum or a gallery would be quite different from those influencing a drama theatre or an opera company.
- Remember that one and the same factor, external or internal, could have either a negative or a positive influence, depending on the company's mission, capacity, resources and other variables. For example, a small and lean team in a nonprofit arts organisation can be a strength, as it gives a higher

degree of flexibility and autonomy, but can also be a weakness, because of the need to overlap functions and overload the staff members.

- Do not just list all factors. Try to rank and prioritize them in order of those that have a significant influence and those that have a weaker influence on the organisation's future performance.
- Evaluate all factors as an interrelated system and not in isolation, as each one depends on the others.

The results from the SWOT analysis results provide the background for choosing an appropriate strategy and are therefore an important part of every strategic plan. SWOT analysis is a widely used tool not only in business planning but also in the planning process for nonprofit organizations and government institutions such as municipal cultural departments, city or regional arts councils, community centres or departments at the ministry of culture. Elaboration of a SWOT analysis is also an important start-up phase for entrepreneurial projects and new organisations.

The results from the SWOT analysis are used for

- formulating an organization's mission and set of objectives;
- evaluating a business idea and/or starting a new business;
- identifying the most suitable organisational and functional strategies;
- developing and implementing innovative programmes, activities, products or services;
- managing changes in human resources;
- elaborating efficient financial strategies; and
- undertaking strategic changes in marketing tools and methods.

There are four main theoretical options resulting from the SWOT analysis, summarized in Table 5.2. These options provide the background for elaboration of the most appropriate strategies for an arts organisation to achieve its strategic objectives.

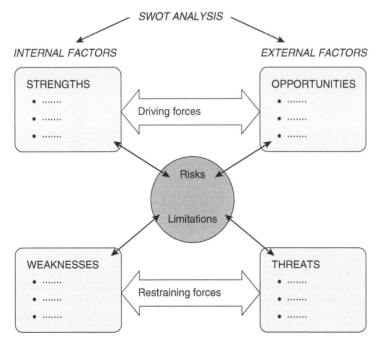

Figure 5.4 SWOT analysis: an overview

Table 5.2 SWOT Matrix: Preparing to Formulate a Strategy

Option 1 Strengths and opportunities prevail	**Option 2** Weaknesses and opportunities prevail
Option 3 Strengths and threats prevail	**Option 4** Weaknesses and threats prevail

EXAMPLES

Results of SWOT Analysis: Preparing to Formulate a Strategy

The following are four examples from diverse arts organisations matching the four options in the SWOT matrix in preparation for the formulation of a strategy.

Option 1: Strengths and Opportunities Prevail

This is the most favourable situation, almost near to an ideal scenario, and therefore it happens rarely. An example might be a situation in which a national puppet theatre has an efficient management team, an innovative marketing approach which increases audiences, and good-quality shows and is functioning in a country where the overall cultural policy framework contains a number of incentives for performing arts organisations.

Option 2: Weaknesses and Opportunities Prevail

In this case, the organization is not capable of fully utilizing existing external opportunities because of internal problems and weaknesses. An example is a situation where a new software programme for online sales and tracking of membership has just come onto the market. This could allow a private theatre company to introduce a new system of subscriptions, ticket sales and souvenir sales online. The cost-benefit analysis shows that such a system will increase self-generated revenues in the next years. The problem is that none of the current staff members of the small theatre team is capable of dealing with this new online tool. Also, the theatre does not have sufficient funds to purchase the new software, nor does it have the capacity to fundraise for technical advancement.

Option 3: Strengths and Threats Prevail

This situation occurs when an arts organisation has the required capacity, competence and resources, but the external environment prevents its development. An example is a music recording company that has invested significant resources into releasing a new series of CD albums of emerging musicians and the products are of a recognized high quality. The company has a high reputation in the country and has been in the business for 25 years. At the same time, regular clients of the company are turning their preferences to downloading online and digital music rather than buying CDs. There is serious competition in the music business, and new companies dealing with digital technologies appear constantly.

Option 4: Weaknesses and Threats Prevail

This is the most unfortunate case, whereby the opportunities for development are difficult, few or none. An example is a team of curators who have a strong desire and passion to open a new private art gallery. They do not have any managerial and marketing competences or any previous experience in arts sales. They also find it difficult to seek initial financing for opening the gallery. The legislation in the country does not provide incentives for private arts organizations. The arts market in the small city where the gallery would be located is underdeveloped because of a severe economic crisis and a drastic decrease in consumer spending on all types of leisure and entertainment. Also, there is no regional support for contemporary arts from private companies, foundations or individual donors.

The final part of a strategic analysis is to identify the *critical success factors*. These are related to the mission and strategic objectives, the results of the external and internal analysis, and the formulated strategy. Identification of success factors in the process of strategic planning is important because these are areas where management has to pay much higher attention so that the organisation performs successfully in a competitive environment. For example, critical success factors for a nonprofit arts organisation could be the ongoing engagement of stakeholders, the quality of exhibitions and the reputation of the artists presented, public transparency and accountability, community outreach, development of a circle of regular clients and visitors, the effectiveness of communication tools, staff motivation and ongoing implementation of innovative projects and tools. Critical success factors for a private theatre company could include for example: a strong brand image and awareness, an attractive theatre repertoire, understanding of why audiences buy tickets and attend, innovative responses to customers' needs, sensitivity to cooperation and collaboration, identification of competitive advantage, seeking profitable protects to increase revenues, knowledge on how to manage all resources in an effective way, and so on.

If objectives associated with the critical success factors are not achieved, there is a high probability that the organisation will fail. These factors vary across different industry branches and different organisations. This is why a good understanding of the industry branch, the competitors, the audiences, and the internal organizational environment is a must.

7. EXAMPLE OF A 'SWOT ANALYSIS' SECTION OF A STRATEGIC PLAN

1. Results of analysis of external factors influencing an arts organization and its activities (opportunities and threats):
 - Economic
 - Political/legislative (including analysis of cultural policy trends in a country/region/city)
 - Social
 - Technological
 - Informational and digital
 - Global
 - Other

Opportunities	Threats

2. Results of analysis of the micro-external environment of an arts organization:
 - Creative (cultural) or entertainment industry situational analysis and trends
 - Potential market (size, growth, segmentation)
 - Main consumer-behaviour trends including spending, preferences and needs, especially related to free time and leisure activities
 - Potential market and projected revenues
 - Competitors (direct and indirect), and their strengths and weaknesses
 - Stakeholders
 - Collaborators and other key organizations and groups

3. Results of the analysis of the internal environment: Main factors influencing an art organization's internal activities and performance (strengths and weaknesses):
 - Resources
 - Processes and activities
 - Structures, people and procedures
 - Performance and visibility

Strengths	Weaknesses

4. SWOT analysis: A summary overview (relationships between strengths, weaknesses, opportunities and threats):
 - Driving forces
 - Restraining forces
 - Limitations and risks

5. Basic rationale for further choice of a strategy (or set of strategies): Final conclusion of the SWOT analysis

8. CASE: VISHTYNETSKY ECOLOGICAL AND HISTORICAL MUSEUM (KALININGRAD REGION, RUSSIA): COMMUNITY OWNERSHIP AS A POWERFUL FACTOR FOR BREAKING ISOLATION AND ACHIEVING SUSTAINABILITY

This case has been created with the kind assistance of Alexey Sokolov, director of Vishtynetsky Ecological and Historical museum. The case text is based on the museum's first strategic plan, as well as analysis of primary data from targeted qualitative research.

STUDYING THIS CASE WILL HELP YOU TO:

- Understand the importance of strategic management and planning for capacity-building in a new organisation.
- Analyse the factors in the external and internal environment and how they influence an organisation's performance.
- Review a practical example of connections between territory, nature, culture and creativity in a nonprofit organisation.
- Recognize the need to involve communities, external stakeholders and partners in the realization of strategic goals.

8.1. Background

Vishtynetsky Ecological and Historical Museum is a nonprofit public organisation in the Kaliningrad region of Russia[37]. It was legally established in 2001 without having its own building as a museum. A series of exhibitions about the unique natural areas of the Kaliningrad region was organized in 2004. A mobile museum exhibition about the nature and history of Vishtynetsky Hills and Romintsky Forests was organized in 2004. In the period 2005–2011 the museum was transferred twice to different places, until the official opening of the museum as an environmental, educational and informational centre in the village of Krasnolesie in 2011.

- **Key Current Programmes and Activities**

 - New educational programme *Vishtynetsky's treasures of gnomes*. The project has won a prestigious national competition titled 'Changing Museum in a Changing World' organized by the Vladimir Potanin Foundation[38].
 - Museum Night. The programme, organized annually, consists of several elements: a research expedition to the Romintsky forest; educational activities for local residents and visitors, for example observation of the moon through a telescope; research and seminars for children and engaging children in research work; meetings and workshops with artisans; and organized museum tours.

- **Governance, Finances and Location**

 - The museum is managed by a council and the general assembly of the museum's founders.
 - The core museum team consists of two persons: the director and deputy director, who deal with a variety of functions, from reconstruction of the building, through decisions on management and financial issues, to the organisation of events, museum tours, promotional activities and maintenance of the website. The museum has numerous friends who help out on a volunteer basis.
 - The museum uses a building in Krasnolesie village, where the main exposition is located. The building also has an informational centre, a space for workshops and events with children, and a youth hostel with 20 beds.

- Financial activities started only in 2011, and the annual income was € 16,000. The main external sources of income include donations from charitable foundations and philanthropists for project activities. Not all museum programmes bring a direct financial return. The museum started providing paid services only in 2011, and they account for only 2 per cent of the overall budget, although the museum's team is confident that this figure will increase. Self-generated incomes come from educational services, guided tours, targeted workshops and educational programmes for children and schools, targeted guided excursions in the region, and horse-riding. The museum also offers a package of paid services for diverse audiences.

- **Target Audiences**
 The main target audiences of the museum are

 - tourists: groups and individuals;
 - children from the region; and
 - inhabitants from the village of Krasnolesie and the region of the Romintsky forest.

 The museum has not done any marketing research up until now. The museum keeps records of visitors and participants in the events. During 2011 the museum's visitors numbered around 1,000 people, and 35 per cent of them were children. Marketing activities are organized based on the experience and competences of the museum's staff and partners. These achievements have to be evaluated considering the fact that the museum has been operating in its new building for less than one year.

- **Partners and Collaborators**
 Vishtynetsky Ecological and Historical Museum works in close collaboration with other cultural organisations from the region and abroad:

 - Fridland Gates, Kaliningrad
 - Amber Museum, Kaliningrad
 - Insterburg Castle, Chernyakovsk
 - Transit Agency, Kaliningrad
 - Kaliningrad Regional Tourism Information Centre
 - Vystis, Lithuania
 - Landshaft Park, Romintsky Forests, Poland
 - Gdansk Independent Schools, Poland.

 Increasing the network of collaborators and partners is one of the main strategic goals of the museum for the next four years.

8.2. Unique Characteristics

Vishtynetsky Ecological and Historical Museum is the first public institution in the Kaliningrad region that has an environmental, historical and cultural mission and programmes. Its activities have been widely recognized and appreciated by citizens in the region and by tourists. This is the only museum in the region, established by the local residents in a unique natural environment. Museum programmes are set up in constant interaction between the people and the unique natural environment of the surroundings. This natural complex is located near the borders of three countries: Russia, Lithuania and Poland.

8.3. Mission, Vision and Slogan

- **Mission statement:** Vishtynetsky Ecological and Historical Museum is a nonprofit public institution, acting as a living 'Safeguard Certificate' of the cultural and natural heritage of Vishtynetsky Hills and carrying out the inspiring idea of harmony and sustainable relationships between nature and human culture.

- **Vision:** The museum will become an international scientific and cultural centre on the social ecology of Vishtynetsky Hills, maintaining, protecting and developing further Vishtynetsky Hills and promoting environmental education and awareness.
- **Slogan:** 'Our Earth is a reflection of our culture. Our Earth is our future.'

8.4. Main Strategic Goals and Programmes

Vishtynetsky Ecological and Historical Museum has set up the following *long-term goals:*

- Preservation of the natural and cultural heritage of Vishtynetsky Hills;
- Reasonable utilization of the whole natural complex for touristic and recreational purposes;
- Development of the social and cultural life of local communities and ongoing involvement of inhabitants in the museum's activities;
- Education of children and youth about the harmony between nature and humans, and the importance of caring about the sustainable development of this natural and cultural complex in a creative way.

The main *programmes* of the museum for the next four years are as follows:

- Educational programme enhancing learning and creativity;
- Research programme on the natural and cultural heritage of the region;
- Programme for tourism development;
- Programme for preservation of the natural and cultural heritage of Vishtynetsky Hills;
- Programme for support of community initiatives;
- Capacity-building programme for internal development of the staff and volunteers.

8.5. Main Results of the SWOT Analysis

The SWOT analysis was performed in 2007 by the museum team as the background for the elaboration of a strategic plan.

- **Strengths**

 - Professionalism of people involved in the museum and their high level of devotion to their work;
 - Team cohesion and focused actions;
 - Simple organisational structure;
 - Easy cycle of decision-making;
 - Easy flow of information within the organisation;
 - Use of modern communication technologies;
 - Established reputation among local inhabitants as well as in the Kaliningrad region;
 - Established cooperation with the Polish landscape park Romintsky Forest;
 - Computer equipment and equipment for mobile exhibitions;
 - Independence of the overall management of the organisation from government decision making.

- **Weaknesses**

 - Lack of management experience and competences in the museum practice;
 - Lack of personnel to perform certain activities, including entrepreneurial ones;
 - Lack of specialized units in the museum structure;
 - Museum team that works on a voluntary basis; with little or no renumeration;
 - Unstable internal and external sources of financing;
 - Insufficient promotion of the museum in the border areas of Lithuania and Poland.

- **Opportunities**

 - Presence of potential partners among state-subsidized and nonprofit organisations in Lithuania and Poland;
 - Presence of international cross-border cooperation programmes and funds for support of activities and organisations in the region;
 - Positive changes in the state policy, supporting the development of autonomous cultural organisations;
 - Collaboration and constructive discussions with the district administration in relation to the development of diverse programmes and initiatives;
 - Increased public attention to museums in the region as important institutions for preservation and development of the cultural heritage of the territory;
 - Well-trained, knowledgeable and competent museum professionals in the Kaliningrad region;
 - Gradual development of tourism in the region.

- **Threats**

 - Government policy directed towards reducing the social infrastructure in small villages;
 - Low standard of life in the rural areas of the Kaliningrad region and therefore low purchasing power;
 - Very limited opportunities for elaborating paid programmes and increasing self-generated incomes due to low income levels of the population in the rural areas;
 - Relatively low overall demand for cultural services;
 - Lack of expertise and material resources in the region for development of handicraft arts forms;
 - Poor communication network and infrastructure at the Vishtynetsky Hills;
 - Isolation of the region—located at a distance from the main big cities.

8.6. Main Strategies

As a result of the SWOT analysis, as well as the long-term goals it had elaborated, the museum has chosen three main strategies.

- **Strategy of partnership.** The museum aims at enlarging the circle of supporters, collaborators and stakeholders to achieve higher visibility as well as opportunities for joint projects.
- **Strategy of wide public participation and contribution to changes in the social sphere.** The museum realizes the importance of engaging audiences for future programmes and activities and plans to concentrate on promotional activities bringing wider public participation.
- **Strategy of increasing self-generated incomes from programmes and activities.** The museum understands the need for financial sustainability based on mixed fundraising and the importance of elaborating commercial programmes as part of its overall strategy.

8.7. Elements of Innovation

- **Creation of a unique and memorable image of the space**
 The museum concentrates on attracting audiences not only to its activities but also to the territory and nature. For this reason, the museum combines the most attractive and specific aspects and features of Romintsky forest and draws audiences' attention to them through diverse marketing and promotional methods, both on- and offline. Museum programmes are devoted to bringing educational, cultural, and pleasant experiences to audiences, exploring nature and history in a creative and memorable way.

- **Museum as a Learning Experience for Children and Youth**
 Special programmes are designed for children as the future generation that will care for and develop the region and preserve its nature. One of them is the 'Fairy-tale for Stones' programme, which is a powerful motivation for children and families as well as adults to attend the museum.

- **The Power of Collaboration**
 Collaboration with other organisations and external stakeholders helps the museum to elaborate programmes and projects based on mutual non-monetary benefits for all parties involved. The museum applies a synergetic approach in using resources. An example is the Traveling Museum Exhibition project, a series of thematic exhibitions to be held in large and small museums in the area, as well as in other cultural and scientific institutions, without paying rent. This project was of mutual benefit: the 'receiving' organisation gained additional incomes, while Vishtynetsky Ecological and Historical Museum enlarged its audience.

- **Promotion Through Partnership**
 To expand its audiences, the museum disseminates information to visitors and tourists about accommodation available in the region. In return, hosts direct visitors to the museum, where they can learn about the unique cultural and natural heritage of the region from the professional museum guides.

- **Community Ownership**
 Museum offers are free of charge for the inhabitants of Krasnolesie village and the surrounding area. The programme 'Museum Nights', as well as the museum's educational initiatives, also offer a wide free access. People living in the region have a sense of ownership of the museum and contribute by volunteering in diverse areas, such as collection of objects, caring for the museum's garden and premises, helping organize events, and more.

8.8. Open Space for Generation Ideas

Every idea, especially if it concerns interactions between the museum and the local communities and businesses, is considered and discussed in a collaborative mode. There are no procedures or rules for idea generation. Every idea is born spontaneously by a museum staff person or an audience member, and the realization of the idea is based on collaborative discussions and communication. The important aspect is that the author of the idea understands that its elaboration should benefit both the museum and its communities in the long term. The museum staff believes in the 'ideas multiplication effect': if one idea is realized successfully, it will lead to generation of new ideas and more people.

The museum also allows communities to develop their own ideas using the museum's facilities and resources. For example, people could make handicraft objects from wood and other natural materials and bring them to the museum for further sales to tourists. A further step is to organize handicraft workshops in the museum for training purposes, involving diverse target groups: tourists, families, children and young people, and so on.

8.9. Lessons Learned

Alexey Sokolov, director of the Vishtynetsky Ecological and Historical Museum, shares the main lessons learned as a result of his museum management practice and experience:

- 'Idea generation and realization in a cultural organisation requires strong wish to share joy, experiences, and wisdom with other people. This makes life more interesting and enjoyable.'
- 'Be close to communities: listen to them and involve them in your work on an ongoing basis.'
- 'Be creative to succeed. Creativity is born from communication with others and from collaborative work.'
- 'Care about the nature, about the place where you live, and invest efforts to make it enjoyable and attractive for the future generations. This is what sustainability is about.'

QUESTIONS AND ASSIGNMENTS

- Outline the main issues in the museum's overall strategic management. In your analysis, elaborate the driving and restraining forces influencing the museum, as well as the risks and limitations.
- Elaborate a stakeholder analysis for the museum, and discuss why it is important for the museum's current and future programming.
- Analyse the interactions between external and internal factors in a matrix way. Draw conclusions.
- Discuss the influence and importance of the regional cultural policy for the museum's future strategy.
- Discuss how the museum's innovative features could be better implemented in its strategies and further programmes. Elaborate concrete suggestions.

Note: To complete the assignments, use the theoretical background and the methodology given in Chapters 1 and 4 as well as this chapter.

9. CASE: MT SPACE (WATERLOO REGION, CANADA): ENGAGING CULTURALLY DIVERSE ARTISTS AND COMMUNITIES

This case was created with the kind assistance of Majdi Bou-Matar, director of MT Space. The case text is derived from the MT Space strategic plan, created with the assistance of consultant D'Arcy Farlow; from selected online and offline promotional materials and documents of MT Space; and through analysis of primary data from a targeted questionnaire and an interview conducted with the MT Space director.

STUDYING THIS CASE WILL HELP YOU TO:

- Analyse the factors needed for a theatre company to grow substantially, from a local grass-roots organisation to a reputable, internationally recognized organisation.
- Understand the importance of the ongoing engagement of culturally diverse communities and partners in the creative theatre processes.
- Analyse the social role of a theatre company in providing aboriginal and immigrant artists an opportunity to pursue their artistic careers and take part in shaping Canadian culture.
- Review a practical example of a strategic management process done on the basis of broad consultation with the board, staff and stakeholders.

9.1. Brief History

As Waterloo Region's first and only multicultural theatre company, founded in 2004 by artistic director Majdi Bou-Matar, MT Space[39] aims to increase interactions and activity between performing artists of many disciplines, cultural backgrounds and styles of practice. The company continues to fulfil its mandate by creating, producing and presenting high-quality artistic performances and cultural events reflective of the people who live and work in the area. It also offers educational programmes and professional development workshops, and provides mentoring and assistance to local artists. The company has toured across Canada and to the Middle East and has received various awards and rave reviews[40]. In eight years MT Space has grown from a local grass-roots organisation to one that has earned a national and international reputation.

9.2. Current Programmes

MT Space successfully runs three main programmes:

- **IMPACT International Theatre Festival.** The festival was launched in 2009 and presents cutting-edge theatre performances from around the world alongside the latest in Canadian inter-cultural theatre. It provides a unique platform to engage in meaningful activity and discussion with over 100 performing artists from the Waterloo region and abroad. The event has brought together a collaboration of local arts organisations from across the Waterloo region as well as theatre compa-nies from other parts of Canada, Lebanon, Colombia, China, Belgium and Hungary.
- **Theatre for Social Change.** MT Space works with schools and community organisations to cre-ate commissioned theatre productions which explore researched cultural, health and social issues within the community. As an example, MT Space realized a programme in partnership with the Waterloo Region Crime Prevention Council where MT Space artists have been working with eight 'youth at risk'. The young participants have created their own performances telling their stories about substance use. In addition to these activities, MT Space continues to provide mentors for young emerging artists and advice and information to immigrant artists on securing project fund-ing from various sources.
- **Creating, Producing and Touring a New Canadian Work.** MT Space continuously promotes the cultural richness of our community by providing a space for meaningful interaction through contemporary art forms. Some of these works are receiving widespread attention. *The Last 15 Seconds,* for example, has toured extensively to Jordon, Lebanon and Syria as well as to Victoria, Vancouver and Toronto and continues to have ongoing future bookings.

9.3. Management Team, Organisational Structure and Facilities

MT Space has a staff of five persons: one general manager and four artistic associates, and is governed by a volunteer board of directors and headed by the artistic director. The two full time positions are those of the general manager and artistic director. The four artistic associates are engaged in part-time contractual work. The associated artists are also engaged in marketing and public relations processes, as well as other activities. Each year MT Space engages over 60 individual artists and stage technicians on a project-by-project basis. Such flexibility in the organisational structure creates an opportunity but is also a challenge. On one hand, it allows the theatre to respond quickly to changing realities and to work in a flexible way. On the other hand, the challenge is the absence of a concrete structure at work, which is required by external funding organisations.

The selection of artists is based on auditions. Each project is assembled by engaging diverse artists who are paid on a commission basis according to the industry standards (per day or week). MT Space is conscious about the diversity of the creative team, led by the strong belief that differences create a better theatre. MT Space projects always start with clarifying the main idea and its social relevance first. The team then looks for elements that would engage the wider community—not only theatre audiences but also social service organisations, students, social interest groups, immigrants, and so on. The theatre pieces are always born on the stage in the studio, through physical interactions.

9.4. Budget

MT Space has mixed sources of funds. The main external sources of income are the Ontario Trillium Foundation; the Canada Council for the Arts; the Ontario Arts Council; the cities of Kitchener, Wa-terloo and Cambridge; the K-W Community Foundation; and the Region of Waterloo Arts Fund. The total external grant revenues for the financial year ending June 30, 2011, were Can\$154,937 (40% of which came from the Canada Council for the Arts).

Another source of income is self-earned revenues from ticket sales and other activities such as workshops, classes, events, membership, rental of facilities and equipment. Earned revenues amounted

to $72,736 for the financial year 2010–2011. A small portion of the budget is provided by spon-
sorships and individual support. The total revenues for the financial year ending June 30, 2011
are $245,584.

Total MT Space artistic expenditures, including artistic salaries and fees, as well as production costs,
amounted to $187,364, which is 76.3 per cent of all costs.

9.5. Target Audiences

One of the core programmes of MT Space—the IMPACT International Theatre Festival—targets five
key audiences:

- **Immigrant and Aboriginal Communities**
 MT Space develops partnerships and relationships with community organisations like the
 Kitchener-Waterloo Multicultural Centre[41], KW YMCA Cross Cultural Services, the Mennonite
 Coalition for Refugee Support, the Working Centre, the Multicultural Cinema Club in Kitch-
 ener[42], Focus for Ethnic Women[43] and many more. The company has good working relations to
 several key cultural groups like the Canadian Islamic Congress, Canadian Chinese Association,
 Canadian Caribbean Association and African Canadian Association. Experience has shown that
 direct face-to-face communication through the community agencies listed here is the most effec-
 tive way to reach these target groups.

- **University and High School Students**
 MT Space reaches out to university students through existing and new relationships with student
 clubs, social interest groups and associations. The company has established connections with groups
 like Waterloo Public Interest Research Group (WPIRG)[44], Engineers without Borders, Students for
 Palestinian Rights, Friends of Lebanon, and more. The company also has well-established relation-
 ships with many high schools and teachers through other educational and outreach programming,
 especially with programmes for English as a second language (ESL) and international languages.
 Direct phone and/or face-to-face communication with teachers and student leaders has proved to
 be an effective marketing tool. In addition, MT Space uses online social networks, such as Facebook,
 YouTube and Myspace.

- **Local, National and International Artists**
 IMPACT attracts the attention of local, national and international artists through several chan-
 nels that MT Space currently uses. The company implements co-marketing with the two leading
 Canadian contemporary festivals Open Ears and Contemporary Art Forum Kitchener and Area
 (CAFKA) and shares target audiences as well as communication tools with them.

- **Mainstream Theatregoers and Arts Supporters**
 MT Space engages the mainstream theatre audience through partnerships with established theatres
 like the Stratford Shakespeare Festival[45] and the Centre in the Square[46], as well as with other organi-
 sations such as the Kitchener-Waterloo Art Gallery[47] and the Perimeter Institute. The company uses
 mainstream forms of media and marketing outlets (print, television and radio ads and interviews;
 community posters; postcard mailings; calendar listings; e-blasts; personalized phone calls; and on-
 line listings in events calendars online, as well as word of mouth.

9.6. Unique Features

One of the most prominent unique features of MT Space is the ongoing community support and the
easy accessibility of the theatre premises. The MT Space has a black box studio used for rehearsals and
workshops. It is widely accessible to many immigrants and community arts organisations in the region.

MT Space receives numerous requests for help from new immigrant artists and students preparing to launch their careers in the arts. The staff members are always available to answer questions, provide information about funding opportunities and resources, review grant applications and act as a connection to the arts community. MT Space also provides letters of support and references for artists and volunteers. Since the inception of the company, MT Space has been creating work that fulfills a need in the regional community and that contributes significantly to the development of a culturally diverse Canadian theatre.

MT Space is renowned for its

- creativity and passion;
- originality and innovation;
- partnerships and cross-community collaborations;
- unique artistic approach engaging wider communities;
- willingness to take risks;
- push for inclusion, social justice and change;
- artistic director who demonstrates leadership, vision and professionalism; and
- positive impact on the local community.

9.7. Main Elements of the Strategic Plan (2012–2017)

The MT Space strategic planning process was made possible by grants from the Ontario Arts Council and the Flying Squad programme of the Canada Council for the Arts. The process was facilitated and supported by D'Arcy Farlow, who specializes in organisational and community capacity-building. The following are selected extracts from the strategic plan:

Purpose: MT Space uses theatre to explore cultural intersections amongst people, their histories and their forms of expressions.

Contribution: MT Space is a vital, community building agency committed to working with artists from aboriginal, immigrant and marginalized communities to create and produce culturally diverse and innovative performing-art projects of the highest quality. MT Space strives to develop forms and practices that talk to, draw upon, reflect, and finally, help to constitute the Canadian contemporary community.

Vision: A community of difference.

Guiding principles: MT Space:

- Brings together culturally diverse artists to share ideas and to collaborate in the development of new forms of theatrical expression;
- Gives professional aboriginal and immigrant artists an opportunity to pursue their careers and take part in shaping Canadian culture;
- Creates, produces and presents contemporary productions locally, nationally and internationally; and
- Contributes to the development of a vibrant and inclusive community.

Strategic planning process: A specialized strategic planning approach was used for the planning process, called 'appreciative inquiry'. It allowed MT Space's staff and board to identify and amplify the positive core of the organisation. Appreciative inquiry works with traditional strategic planning to better understand and leverage an organisation's strengths and energy. By discovering MT Space's 'positive core', it was possible to create a plan that is dynamic and responsive. As the environment changes, the

organisation will be more resilient and adaptive because the strengths, resources and assets have been recognized.

The process took about 18 months and included the following two phases:

- During the *discovery/Environmental Scan phase,* a Conversation Café with partners and stakeholders was followed by key informant interviews. A series of appreciative inquiry questions were developed to elicit stakeholders' views related to the strengths of MT Space, the environmental opportunities aligning with these strengths, and dreams for the organisation's future. These findings were documented and blended into one report. Board members also met for an afternoon to review the findings, discuss the future of the organisation and identify their governance role in the immediate context.
- During the *Strategic Design phase,* the board of directors, executive director, staff and community partners participated in a one-day retreat—a participatory planning day—to build on the findings from the discovery phase, confirm the organisation's purpose, identify aspirations for 2017 and design the strategic directions to move forward. As follow-up, subsequent meetings were held with the planning-day participants and with the executive director and board members to clarify the action steps for the organisation and the governance responsibilities for the board.

The final Strategic plan was submitted to the board and the artistic director.

Success factors and opportunities: A number of key stakeholders and Conversation Café participants claimed that MT Space is on the leading edge when it comes to redefining theatre and culture in the Waterloo region and beyond. The organisation is perceived as having a range of opportunities which could easily leverage its strengths and successes. In today's environment there are opportunities to

- continually recreate the concept of inclusion by working with diverse local, national and international partners in different contexts (e.g., universities, schools, funders, corporations, media and other artistic groups);
- generate a new conversation on innovative funding approaches for supporting artistic endeavours;
- tap into new and unrealized audiences;
- exploit social media technologies to further the organisation's reach (through devices such as 'Downloadable Theatre', as well as educational packages built into the school curriculum); and
- become a vibrant and fertile space, known for 'firebrand theatre', with a troupe of performers who are recognized and respected for their breadth of work locally, nationally and internationally. Create a lasting legacy of highly respected work.

Aspirations for 2017: Building on its strengths and opportunities, MT Space will have achieved the following by 2017:

- Three additional IMPACT Festivals;
- Widespread dissemination of its collaborative work;
- A well-defined touring repertoire and longer runs;
- A full staffing complement of 10 artists engaged continuously in all stages of creation and production. The artists will learn business skills and also, opening of these three positions will help gain business skills for the organisation through three FTE (full-time equivalent) shared administrative positions, one FTE general manager, and one FTE executive director;

- An 'ecology' of part-time professional artists associated with MT Space (through residencies, internships and other opportunities);
- A board membership (local, provincial and national) which reflects the community's diversity; a range of artists and connections, practical skills or assets; and functional committees as needed;
- Affiliation with funders who understand well the MT Space model and how the theatre works;
- An increase in 'Circle in the Space' donors to 50 annual members.

Strategic directions 2012–2017: To achieve these aspirations, MT Space will follow four strategic directions:

- **Strengthen the Organisational Capacity and Effectiveness**

 - Provide a strong voice/advocacy on behalf of MT Space's artists.
 - Develop a sustainable staffing structure that will ensure the ongoing operational efficiency of MT Space and allow the artistic director and artists to focus on their creative/ production roles.
 - Explore new strategic partnerships.
 - Enhance the board's ability to govern effectively.
 - Foster the organisation's ability to be nimble and resilient.

- **Develop and Expand MT Space's Audience**

 - Increase the company's audience by creating a season or rhythm people can count on.
 - Increase the company's exposure by including the public, the media, funders, and students in the creative process.
 - Engage the technology sector and experiment with different forms of social media.

- **Establish a New Model for Working with Artists**

 - Create the mechanism for 10 permanent artists to be continuously engaged in the cycle of creation and production with MT Space.
 - Attract an 'ecology' of part-time artists through internships and residencies.

- **Create a Comprehensive, Diverse and Sustainable Funding Strategy**

 - Maintain and grow a diversified funding base through donors, grants, sponsorships and earned revenue.
 - Expand and sustain the Circle in the Space programme to 50 annual members.
 - Generate new partnerships with corporations and foundations.
 - Provide leadership in the conversations on a new funding model for artists.

For each of these strategic directions, MT Space's strategic plan contains details about strategic objectives, people involved, actions required in the short and long term, resources required and outcome indicators of success.

QUESTIONS AND ASSIGNMENTS

- Outline the main reasons why MT Space elaborated a strategic plan for 2012–2017.
- Analyse MT Space's vision, purpose and guiding principles.
- Evaluate the strategic planning process implemented by MT Space. Does it follow the main theoretical principles of strategic planning? What kind of approach is chosen?

- Analyse MT Space's strengths and weaknesses related to internal operations, and discuss how they relate to MT Space's chosen strategic directions.
- Are there any elements of innovation in MT Space's current programmes and future strategy?

Note: You might need to perform additional online research to complete these assignments. In your answers, apply the theoretical concepts and methodology from Chapters 1, 3 and 4 as well as this chapter.

6 Choice of Strategies

LEARNING OBJECTIVES

Upon completing this chapter you should be able to:

1. *Understand the main organisational strategies and how they can be applied to organisations in the arts sector.*
2. *Analyse the main strategies in arts and culture organisations.*
3. *Comprehend the essence of product/programme-market strategies and competitive strategies and their specificities in the arts.*
4. *Analyse why strategies for integration, co-production and networking are very important for arts organisations.*
5. *Understand how to evaluate strategic alternatives to choose a strategy.*
6. *Elaborate the "Strategies: Options and Choices" part of a strategic plan.*

1. WHAT IS A STRATEGY, AND WHY IS IT IMPORTANT IN THE ARTS?

As already noted in many publications on strategic management, the origin of the word *strategy* comes from military operations and the deceiving of an enemy. Management theory and practice have adopted this term. The following are selected opinions of authors on strategic management on what a strategy is about:

- Benjamin Tregore and John Zimmerman (1980)[1] understand strategy as the framework which guides the choices that determine the nature and direction of an organisation.
- Roy Amara (1983)[2] regards strategy as an orchestrated set of decisions over time designed to achieve specific goals and objectives.
- Henry Mintzberg (1992)[3] formulates the 'five Ps for strategy': plan (strategy is about guidelines), ploy (strategy is a manoeuvre intended to outwit an opponent or competitor), pattern (results in behaviour and is a stream of actions), position (matching organisation's capabilities to a particular market niche) and perspective (as the strategy is about a company's way of looking at the business opportunities and changing markets).
- Michael Porter (1996)[4] emphasizes that whereas operational effectiveness can help a company catch up to or do things better than competitors, strategy focuses on doing things differently. Strategy means deliberately choosing a different set of activities to deliver a unique mix of value.
- John Bryson (1995)[5] defines a strategy as a pattern of an organisation's purpose, policies, programmes, actions, decisions or resource allocation that define what an organisation is, what it does and why it does it. He clarifies that an effective strategy for a nonprofit organisation should fit several criteria, among them being technically workable and politically acceptable to key stakeholders, fitting the organisation's philosophy and core values, and being ethical, moral and legal.

- Cornelis DeKluyver (2000)[6] states that strategy is about positioning an organisation for sustainable competitive advantage and involves making choices about which industries to participate in, what products and services to offer and how to allocate corporate resources to achieve such a sustainable advantage.
- Lloyd L. Byars (2002)[7] emphasizes that strategy is the determination and evaluation of alternatives available to an organisation in achieving its objectives and mission, and the selection of the alternative to be pursued.
- Mary Coulter (2002)[8] regards strategy as a series of goal-directed ~~~ match an organisation's skills and resources with the opportunities and ~~~
- Stephen Cummings and David Wilson (2003)[9] describe an organisation ~~~ onward movement in space and time, where it goes and where it does no ~~~ strategic frameworks can help people to orient themselves or think strategically by offering a language by which complex options can be simply understood, communicated, bounced around and debated, enabling a group to focus in order to learn about themselves and what they want to achieve, and locate themselves in relation to their environment. They analyse the term *creative strategy* and why it is important for fostering entrepreneurship and innovation.

There are many definitions from different authors in the academic literature on what a *strategy* is, but there is no one agreed definition of this important term. This is probably because this term is quite rich and has different connotations and interpretations in the theory, given by different authors, and their opinions are even sometimes contradictory. The majority of authors connect the strategy with the long-term objectives of an organisation and interpret it as a direction, an approach or a way by which these objectives should be reached. The existing rich palette of theoretical and methodological knowledge on strategy has its specific characteristics and limitations when applied in the field of arts. These specificities should be considered when formulating strategic alternatives and looking for the most appropriate one in a given set of circumstances.

Strategy for an arts organisation is a system of approaches, methods and tools for the evaluation of and choice between alternative(s) to achieve the mission and priority long-term goals in the most effective way, given external and internal influencing forces and considering the organisation's resources and capacity, as well as its innovative, entrepreneurial and creative potential. Strategy is important because it helps the team to achieve its primary goals and fully utilize its creative potential and resources, while at the same time seeking ways to implement intrapreneurial elements and become financially sustainable.

2. CLASSIFICATION OF STRATEGIES

Strategy formulation is the core of the whole strategic planning process. It results from the strategic analysis (discussed in Chapter 5) and the organisational values, mission and objectives (discussed in Chapter 4). Strategy formulation answers questions of the type 'How do we . . .' and is an effective way to cope with changes and the influences of the environment. An organisation's *strategic portfolio* consists of a set of chosen strategies that could respond to many existing possibilities[10]. The literature on economics and strategic planning offers a variety of options to classify, group and interpret different strategies for business, nonprofit, and public organisations. The adaptation of strategies to the specificities of an arts organisation is a complex task. Table 6.1 presents a classification of strategies applicable to arts organisations. This typology is a result of a comprehensive review of resources and publications on strategies. It considers the differences between main organisational strategies and functional ones, the uniqueness of the arts sector, the results of qualitative research, and analyses of cases.

Table 6.1. Classification of Strategies for an Arts Organisation

Main organisational strategies	Programme (product)-market strategies	Competitive strategies	Strategies for integration, cooperation and networking	Functional strategies
Intensive growth	Market penetration	Cost leadership	Integration: • Horizontal • Vertical	Strategies for human resource management
Stability	Market development	Differentiation	Partnership	Marketing strategies: distribution, price, promotional strategies
Innovations	Product (program) development	Product (programme) focus (specialization)	Networking	Technological and production strategies
Survival: • Increase in revenues • Decrease in expenditures • Liquidation (bankruptcy)	Diversification: • Concentric • Conglomerate		Co-production	Financial strategies
Privatization			Lobbying Advocacy	Fundraising strategies
Capacity building				
Spin-off				

- **Main organisational strategies.** These define ways to solve the main problems within an organisation and set up the main 'road map' in the organisation's development. These are
 - strategies for intensive growth or *ascending, advancing strategies*;
 - strategies for stability—keeping the organisation in a relatively stable situation over time;
 - strategies for survival—in case an organisation is not doing well and its activities are declining;
 - privatization strategies—aiming to change the ownership and the overall legal status of an organisation; and
 - capacity-building strategies—improving the overall management of an organisation.
- **Artistic programme strategies.** These strategies are the core of every arts organisation irrespective of its legal status or creative output. Programme strategies help to clarify what an arts organisation is going to change, and how, in its core processes and results, for example producing new artistic works, new repertoire in a theatre, or a curatorial concept in a gallery. Programme strategies guide an organisation on how to be more proactive in creating and promoting artistic programmes and help determine what resources will be required. These strategies also help for cultivating creative teams of excellent artists, performers, actors or musicians.

 It is important to understand that programme strategies in the arts are not isolated from the overall development of society as they often help in solving a social problem, contributing to a social cause, working with communities, making art accessible to wider audiences, facilitating intercultural dialogue, creating awareness and educating communities. These strategies are especially important for subsidized arts organisations and for those with nonprofit status. *Programme (product) development, concentrated and conglomerate diversification* and *focusing* are the most common product strategies. In the arts practice the term *product strategy* is often replaced with the term *programme strategy*, to emphasize the strategy's relation to the creative artistic process.
- **Market and competitive strategies.** These strategies help an arts organisation to concentrate on achieving a sustainable competitive advantage, increasing sales, satisfying audiences' tastes and improving the organisation's visibility. Some of the most popular market strategies are *market development, market penetration,* and *competitive strategies*.

 In business and commercial arts organisations the use of market and competitive strategies in the overall strategic portfolio usually prevails. However, nonprofit organisations and state-subsidized arts organisations also need to consider market strategies to achieve their strategic goals. In these cases, strategies aim to increase the organisation's public image, improve public relations and raise audience participation and involvement, rather than directly selling products and generating profit.

 The formulation and choice of market strategies requires a thorough analysis of overall market trends and market segments, as well as competitors' actions.

The programme (product) and market strategies in an arts organisation are very tightly connected, so that in some cases they are regarded as *product-marketing strategies*. Specific marketing and communication strategies that form the concrete 'marketing mix' are the subject of Chapter 7, for example distribution, price and promotional strategies.

- **Functional strategies.** These are about further development of important functional areas of management such as strategies for human resources, strategies for technological advancement, financial strategies, and marketing strategies (see Table 6.1).

Another approach is to group the strategies in relation to an organisation's level of adaptation to the external environment. For example, they could be grouped into:

- **Aggressive strategies.** These aim to implement changes quickly and widen market opportunities. The use of innovative methods and implementation of new programmes is also part of these strategies.
- **Protection strategies.** These strategies look at ways to stabilize the organisation against external threats.

- **Counter-attack strategies.** These consider the need to correct mistakes.
- **Perceptive strategies.** These strategies emphasize research into the external and internal environment and look for flexible adaptation of methods already used by other organisations.
- **Mixed strategies.** These combine the preceding strategies.

PRACTICAL RECOMMENDATIONS

When choosing the most appropriate strategy (or set of strategies) for your arts organisation, consider the following:

- Adapt the 'standard' strategies to your specific situation, and connect them closely with the results of analysis and the organisation's identity, mission and objectives.
- Consider the compatibility of the chosen strategies, if more than one, and make sure that they do not exclude or interfere with one another.
- Mind that the chosen strategies should fit into the planning time frame.
- Explain to your board, staff and stakeholders what the essence of the strategy is about. Elaborate this in understandable, simple and straightforward language, emphasizing the future benefits of implementing the strategy.
- Train your staff on how to implement the strategy—particularly if the implementation requires a new set of skills and competences.
- Develop a risk plan to predict possible burdens and barriers that might occur during the implementation of the strategy.

A well-chosen strategy is one which

- is dynamic and flexible;
- is objective and balanced;
- can supplement other strategies and does not contradict them;
- contains innovative and entrepreneurial elements; and
- can be understood and embraced by all people involved in its implementation..

3. MAIN ORGANISATIONAL STRATEGIES

The strategies chosen for an organisation's future should complement each other in a coherent way. The main strategies are the ones which determine the main direction that an organisation will follow over an extensive period of time. There are several possible options resulting from the SWOT (strengths, weaknesses, opportunities and threats) analysis:

- An organisation has lots of strengths and the external environment offers opportunities for development. In this case a possible general strategy to choose is **intensive growth.**
- If some factors with a negative influence prevail—either weaknesses in the organisation or threats from the external environment—the best way to proceed is to choose a **strategy of stability**. This strategy aims at helping to find ways to sustain current operations over a longer period of time, without planning drastic changes.
- Both the arts organisation and its environment show positive features of development, and there is a good potential to try something new. In such cases, the preference is to work towards **innovation strategies**.
- An arts organisation has lots of weaknesses, and the outside environment is quite turbulent, with plenty of risk factors. This worst-case scenario forces a **survival strategy**. This strategy results in drastic expenditure cuts, aggressive fundraising or 'spinning off' part of activities. If nothing works out, the only remaining strategy is to prepare the organisation for bankruptcy protection.

3.1. Innovation Strategies

As discussed in Chapter 1, the term *innovation* is applicable to many aspects of an organisation's resources, processes and outcomes. Innovation is about new products, new management models, new communication channels, and so on. If the focus of the future development, growth, expansion or improvement is primarily based on 'newness leading to effectiveness', the general strategy of an organisation is about innovation. Innovation strategies prevail in intrapreneurial arts organisations operating in a flexible management style[11]. Arts businesses are much more open to applying innovation in management and marketing, while nonprofit organisations use innovative strategies in artistic programming. This is in contrast to state-subsidized arts organisations, which often operate within more bureaucratic structures and constraints where it is harder to achieve innovative behaviour. In the case of external subsidies provided for contemporary and emerging artistic work, the implementation of innovative strategies is easier, because possible risks resulting from innovative actions are covered by public or other external funds.

EXAMPLES

Innovation Strategies

- **Artistic and creative programme innovations.** They are usually part of the creative programme strategies, in which new characteristics of existing artistic products are implemented or a product or a service is modified in an innovative way. Strategies of differentiation also include product innovations.
- **Process innovations.** This type of innovation is the core of human resource management strategies in intrapreneurial arts organisations. They result in more efficient organisation of internal processes and operations, more flexible structures and creation of an intrapreneurial climate for achieving efficiency.
- **Innovations in resource structure and use.** Examples include: application of new fundraising strategies, innovative ways of combining artistic teams, introduction of new technologies in stage productions and the use of alternative and non-conventional spaces for presenting programmes and/or selling products.
- **Innovations in marketing and communications.** These innovations are part of the marketing strategies, for example implementation of innovative marketing tools for audience development, image-building and broadening of public access, newness in the construction of the brand, and non-conventional spaces and places for distribution and presentation of artistic programmes.
- **Online innovations.** They are embedded in almost all general and functional strategies, for example the use of new technologies and Web 2.0 tools in the creative process, in diverse areas of marketing and fundraising, in resource-gathering and allocation, and in the internal management process.
- **Technical innovations.** They are about implementing new equipment and technology aimed at improving the quality of the programming and cultural infrastructure or at exploring new ways to attract audiences, especially young people.

3.2. Spin-off (Outsourcing) Strategies

These strategies are used in situations where preliminary analysis shows that part of the activities would be better positioned in a new entity which could be taken out of the larger organisation and registered separately, with its own organisational structure and operation. This is also the case when an organisation outsources its entire production and operations, or part of it, for example public relations, marketing, sales or distribution activities, to another organisation. A common case of outsourcing in the arts is when a foundation or another funding body sets up a nonprofit organisation, giving initial seed money for a limited start-up period or a testing phase. After this period, an evaluation shows the viability and capacity of the new entity to continue its operation independently.

3.3. Privatization Strategies

These strategies are predetermined by the overall cultural policy directions in a country. In the last 20 years there have been many discussions about the pros and cons of privatizing cultural organisations, as well as the methods and criteria for doing so. It is clear that in cultural industries such as publishing, music business and show productions, privatization is much easier than in traditional arts sectors preserved by government funding, such as cultural heritage, symphonic orchestras and opera companies. Depending on the cultural policy model, privatization strategies are usually applied with care using different methods, especially concerning those art sectors with substantial state subsidies aimed at increasing public accessibility[12]. Privatization in culture does not necessarily mean changing the whole ownership to private hands for the purpose of gaining profit. The aims of privatization could be different, such as to provide greater autonomy or a more flexible style of operations, to increase private funding via sponsorship or via raising entrance fees or to motivate entrepreneurial thinking and action in the arts.

Although offering benefits, privatization in the arts and culture sector also creates many fears, such as a possible commercial shift in the aims and objectives after privatization, disappearance of direct state control and loss of traditional art forms or cultural heritage sites because of lack of consumer interest. Therefore, privatization methods in the arts have to be applied carefully and in close cooperation and consultation with relevant stakeholders. Before starting the process, it is important to consider public opinion as well as to follow government regulations.

EXAMPLES

Privatization Strategies

- A museum has a souvenir shop which does not bring in sufficient sales revenues. The museum board decides to open a public tender to transfer the property into private hands, with an internal agreement outlining specific conditions and the requirement that a percentage of the profit from the souvenir shop should be returned to the museum on a quarterly basis.
- A book publishing and distribution company is fully subsidized by the ministry of culture as it publishes mainly emerging young authors. The new strategy for the next three years is that 25 percent of future titles will be based on marketing surveys and what people in the area might be willing to buy and read. The ministry decides to privatize part of the publishing and distribution activities to be operated by a private company under a specific agreement.

3.4. Capacity-building Strategies[13]

These strategies refer to an overall transformation in an organisation based on improving its own capacities and resources. This transformation results from a substantial process of training and learning, as the people in the organisation need to develop a set of competences and skills to gradually transform the organisation to a more efficient operational mode. Such transformation is especially important for countries in transition—for example in Central and Eastern Europe and other world regions. Many international organisations provide capacity-building support in developing countries and countries in transition to help them to cope with turbulent environments or adapt to changing economic and political systems. In other cases, national or regional governments use capacity-building strategies to empower the third sector, or a specific branch where substantial help is required, such as nature and the environment, health care, nonprofit organisations working with children and youth or communities in isolated areas.

Capacity-building is also a human resource management strategy, as it aims at changing people's skills, competences and knowledge and implementing new management tools to cope with a turbulent environment. As it often results in a substantial change in all areas of organisational development over a long period of time, it is considered one of the main organisational strategies.

3.5. Survival Strategies

These strategies are appropriate when there is a misfortunate situation of coincidence of organisational weaknesses and external threats. Some tendencies which predict a forthcoming crisis in an organisation are

- a significant drop in public attendance and sales;
- a large increase in indirect costs for administration, maintenance, and so on;
- constant complaints and negative feedback by clients and customers;
- large increases in taxes, rents, bank interest on loans, insurance policies and/or other financial instruments used by an organisation;
- inability to pay back debts (if any); or
- defaults and problems of payments on contracts.

The reasons for an organisation's difficulties could be internal or external:

- *Internal reasons* include inefficient management which gives negative results; serious difficulties in functional areas of management such as marketing, public relations or fundraising; absence of team motivation; and a long-term tendency towards crisis management, that is, solving urgent problems instead of important ones.
- *External reasons* include strong competitors, an economic recession, withdrawal of a regular annual subsidy by a key supporting institution, a high inflation rate in the country, unfavourable changes in national cultural legislation, government changes which worsen the overall stability in a country and national disasters. These factors are beyond the organisation's control, but strategic thinking and actions may nevertheless help to decrease the negative consequences and find possible ways to survive.

Strategies for survival include strategies for increasing revenues and strategies for decreasing expenditures.

- In strategies for urgent increases in revenues, the focus is on
 - implementation of new projects and initiatives for fast increases in sales in order to achieve higher revenues quickly;
 - persistent and focused fundraising from diverse sources;
 - sale of part of the organisation's assets which are not that important for the basic operations; or
 - innovative approaches towards self-generated income from peripheral and additional commercial activities.
- In strategies for urgent decreases in expenditures (economical way of operating and shrinkage), the focus is on
 - analysis of the whole cost structure for all programmes and operations and subsequent cuts of ineffective costs;
 - decreases in indirect costs for administration, maintenance of the building and others;
 - reduction of waste in every possible way (travel expenses, payments to suppliers, etc.);
 - cuts in staff benefits which exceed a certain level;
 - sales of properties, equipment or other assets that are not key to the main processes;
 - delays in payments due to creditors (if any); or
 - increases in 'in-kind' contributions[14]—finding out what the organisation could do with its own resources without purchasing or renting anything.

3.6. Liquidation (Bankruptcy) Strategies

This is the 'no-exit' case scenario, when an organisation has serious problems of all kinds such as huge amounts of unpaid debt to creditors, resulting in an inability to continue operations. In some cases, the bankruptcy occurs because of a personal problem of a key shareholder or manager or because of

a serious financial mistake or a sudden negative shift in the organisation's portfolio. The strategy for bankruptcy aims to secure a time period for returning some of the losses and debts and eventually finding a way to restart operations after a certain time.

In the case of nonprofits, bankruptcy is a theoretical option as well when there are severe economic difficulties. It is certainly not a good option, because usually nonprofit organisations do not have the ability to survive the long and expensive process that a bankruptcy requires. Also, closing a nonprofit organisation might cause harm to a local community, destroy relationships with grant-givers and other supporters and result in laying off employees. A way out might be to explore options for setting up risk funds or guarantee programmes as part of foundations or government institutions to refinance debts and help key nonprofit organisations to overcome a difficult time of economic recession.

4. STRATEGIES FOR INTEGRATION, COOPERATION AND NETWORKING

These strategies are classified as main organisational strategies. They are very important in the arts because they are directed towards the external environment, collaboration with other organisation, ongoing sharing and exchange.

4.1. Integration Strategies

An integration strategy is used when an organisation decides to conquer, buy, acquire, merge with or supervise other organisations in the same sector—either those that produce and offer similar products or those that act as suppliers or distributors in the economic chain.

- **Horizontal integration** occurs when an organisation expands by buying, acquiring or merging with other organisations that have similar processes and products.
- **Vertical integration** occurs when an organisation, dealing mainly with the creative production process merges with either the suppliers or the distribution company or both. A merger between a production company and its distributor occurs more often in the arts than a merger between a production company and its supplier, although both are possible.

EXAMPLES

Integration Strategies

- Horizontal integration. An example is the acquisition of several successfully operating private commercial galleries by one big commercial gallery in order to create a distribution chain, synchronize activities and generate higher revenues.
- Vertical integration. An example is the integration between a music publishing company and a distribution company responsible for selling CDs. Other examples are a book publishing company which acquires a distribution company, or a theatre company which acquires an atelier for production of stage properties.

4.2. Partnership Strategies

The main focus of these strategies could be combining efforts and expertise to achieve greater results, to enable the dissemination of good practices, to jointly increase the public image and audience interest or to develop a high-quality artistic programme. Partnership strategies supplement competences of partners and help them be more successful in fundraising and marketing campaigns. In the case of cross-border partnerships, the teams involved improve their international recognition and become more mobile and flexible. Partnerships can occur in many areas, for example in creative processes, fund development, marketing, advertising or audience development.

When one starts to develop a strategic plan, it is important to map all potential partners and to envisage opportunities for long-term partnerships. Partnership strategies are very popular in the arts and cultural field as they aim at building new strategic alliances that share knowledge, information and expertise and influence government policies in relation to the cultural, social and educational sector. Partnership strategies could occur:

- **Within one art sector:** This type of partnership occurs between arts organisations or professionals from one and the same branch, for example between theatres, between opera companies, between orchestras or between libraries.
- **Cross-sectoral:** This type of partnership is either devised between different arts and culture sectors or between cultural and other sectors such as tourism, education, social areas, the environment, and health care.

Consortiums are a type of partnership set up for joint work on a project, with the objective of pooling the resources of several organisations to achieve a common goal. Consortiums are common arrangements between nonprofit organisations when they apply for a public bid. Usually one of the partners is the lead organisation, and the others are co-partners.

Joint ventures are another form of partnership between two companies, usually in the business world, for setting up another company. Partners in the joint venture invest money, efforts and time and share roles and responsibilities on that basis. Commitment and trust between the parties involved are key ingredients for the success of the newly established organisation.

PRACTICAL RECOMMENDATIONS

When choosing an appropriate partnership strategy, answer the following questions:

- Do your potential partner's goals coincide with yours?
- What are your partner's past achievements, and what are their exact areas of expertise?
- What are the legal status, credibility and financial situation of your potential partner?
- How would your partner's competences match yours so that you achieve a more successful result?
- What is the public image and reputation of your potential partner?
- Does your partner target similar clients or audiences?

4.3. Creative Cluster Strategies

The term *business cluster* was first introduced by Michael Porter[15], and it was initially associated with geographical, sectoral or horizontal connections between companies with the aim of increasing their joint potential to face a competitive environment. The term *creative cluster* is relatively new. It refers mainly to the geographical concentration of organisations in the creative (entertainment) industries, such as music companies, publishing houses, design organisations and film studios. To form a cluster, organisations pool resources and look at ways to optimize the overall production and dissemination chain of creative works.

Creative clusters are important for the arts sector because, if well formed, they lead to a long-term partnership and ongoing networking between the teams involved, and contribute to the local development. These strategies strengthen the communities of people who think alike and share interests in one or more artistic fields in a certain city or region. Creative clusters create an open environment of ongoing exchange of innovative ideas, improve interpersonal relations, and boost people's creative capacities and uniqueness. This is why they are associated with initiation of intrapreneurial behaviour by local arts organisations. From a policy perspective, creative clusters are vital for the social and economic development of a region, or a city, as they boost local innovation, originality and uniqueness in the arts sector[16].

4.4. Co-production Strategies

Artistic co-production occurs when two or more organisations or groups of artists create an artistic work together. The level of partnership is different depending on how much each of the partners commits in terms of investing resources and efforts. This strategy is also popular in the arts sector as it helps to share risk and to use the strengths of each of the organisations involved, as well as to diminish the weaknesses. In the case of commercial artistic products, the distribution of profits depends on the signed agreement between the partners. Co-production strategies are also related to co-marketing and promotion, such as a joint campaign for selling a product, increasing the public image or attracting audiences. Other models of co-partnership are cultural exchanges, touring and artistic residencies[17].

4.5. Networking Strategies

Cultural and artistic networking is a phenomenon in the field of the arts, originating in the 1980s when cultural professionals from different countries and regions started to gather together in an informal way to share information and knowledge and develop ideas. Cultural and artistic networks are dynamic systems for communication, cooperation, exchange and partnership. Unlike hierarchical structures, networks are based on horizontal relationships between members. They have an informal nature and operate in a democratic and open way. Networks are flexible and can be easily formed.

There are differences between creative clusters and cultural networks. While creative clusters are strategies applied mainly in the creative industries and arts businesses, networks are very popular mainly in the nonprofit sector. Clusters aim at achieving higher effectiveness as a result, while networks are mainly formed for nonprofit aims. Another difference is that clusters are formed primarily on a local level, while networks can also be national or international.

Networking strategies help the arts sector by facilitating artistic mobility across borders, as well as creating platforms for sharing of information and knowledge between arts professionals and artists. These strategies result in the initiation and realization of innovative projects because well-functioning networks are spaces for laboratory and experimental thinking in the arts sector. In some cases they are related to the strategies of lobbying and advocacy, as they are formed because of the need to put culture on the political agenda, raise public awareness of the importance of the arts in daily life and in the society as a whole, and gain external financial support for arts projects and organisations. Professional networks help improve the status of artists and arts managers in the society, as well as the level of professionalism in the arts.

Despite its popularity and usefulness, *networking* can also raise practical problems. The following are some of them:

- *Entry barriers.* Membership fees may cause problems for organisations and individuals from disadvantaged and developing countries and prevent them from joining.
- *Internal networking competition.* Most networks are seeking external financial support in a situation of limited funding for the culture sector. Instead of cooperating, they might start competing when applying to foundations or government funds. The one that has existed longer or has a higher reputation might win amongst others with much more innovative programming.
- *Internal operations and management.* Many networks grow rapidly over time and face problems in managing their diverse and growing membership, as well as keeping their members engaged and motivated. Growth leads to a loss of focus and concerns about over-programming and limited staff. It also becomes difficult to match networking services with the constantly changing needs of members.
- *Sustainability.* Networks can be formed easily but can also disappear easily if they do not deliver benefits to their members or if members do not see a shared purpose for cooperation and become passive.
- *Long-term results.* Networking is a process and does not bring immediate results. As results usually come years later, it is a challenge for networks to attract ongoing financial support for their operational costs, even if these are minimal.

Effective elaboration and implementation of networking strategies requires an arts organisation to

- define well the 'added value' and expected results from networking;
- choose the geographical area of networking—local, regional, national or international—which fits its main strategy;
- focus on dynamic exchange and on establishment of a learning environment in the process of networking;
- stimulate cross-sectoral networking strategies, leading to implementation of projects beyond the arts and culture sector; and
- consider strategies and models for online networking.

Many artistic networks and platforms nowadays have an online presence and assist their members to exchange ideas, collaborate and share in virtual spaces. This is a way to save travel costs and make communication much faster. On the other hand, online networks can hardly replace the essential need for personal meetings and collaboration offline.

4.6. Lobbying Strategies

These strategies are aimed at expressing common interests and influencing decision-makers, usually government authorities, to make certain decisions in favour of the arts and culture sector, to change policy priorities and methods or to increase the transparency of their actions. It is commonly used in the nonprofit culture sector because of the historical influence that civil society actors have on policy decisions and on defending the public interest. Lobbying is a time-consuming strategy as it often takes many years to accomplish a goal. It also usually requires a broad international support. Organisations and groups who use this strategy are sometimes vertically integrated for a certain time period in order to achieve higher public visibility and media coverage for their actions. This means that they merge with public relations companies, advertising companies, or broadcasting companies. Lobbying strategies always have open agendas and are applied under a legal framework.

5. PRODUCT (PROGRAMME)-MARKET STRATEGIES

Product-market strategies in the arts aim to achieve high-quality standards in the professional domain while at the same time gaining wide audience participation. These strategies refer to creative programming as well as audiences' engagement, and this is why they are also called *programme-market strategies*. Quality development is the backbone of all departments and activity areas in an arts organisation. As discussed in Chapter 1, the difficulty is that in the arts sector diverse groups of people and individuals evaluate or influence artistic quality. Also, it is almost a 'mission impossible' to identify the exact requirements for the quality of a future artwork or cultural product, especially over a long time period. One of the reasons is that customer' choices and attitudes towards the arts change in an unpredictable manner. This is why market trends should constantly be considered in the elaboration of product strategies.

A widely used tool in management practice that helps businesses decide on their product and market growth strategy is *Ansoff's Matrix*[18] (see Figure 6.1). This matrix suggests that a business can grow in one of four ways that range from low risk to high risk. These four strategies are mainly applied for business-type organisations in the arts. The choice of a product-market strategy is based on

- identification of the types, quantity and quality of products (programmes) which an organisation will produce and offer (e.g., music concerts, theatre productions, exhibitions, educational programmes);
- their *marketability*: the sales possibilities (in the case of a commercial product) or the need to find support or subsidies (in the case of a nonprofit organisation);

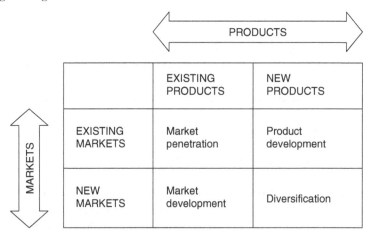

Figure 6.1 Ansoff's matrix

- results of research on and analysis of competitors—both direct and indirect; and
- results of market research, segmentation of audiences, the life cycle of the product and the overall marketing mix.

Figure 6.1 shows four possible strategic alternatives: market penetration, market development, product development and diversification.

5.1. Market Penetration Strategies

These are strategies for growth whereby an organisation focuses on producing and offering an existing product in existing markets. This is an *easily applicable* strategy, with no additional investment or specific market research required. It provides opportunities to increase the quality of the products and services and to work with regular clients. It is sometimes called 'business as usual'—focusing on well-known markets and products or services. A potential problem in implementing this strategy might be that it is related to offering one product, and when this product loses its markets for one reason or another, for example competitive attack, the organisation does not have an alternative, unless it changes the product or offers another one. This strategy uses conventional methods of production and distribution.

EXAMPLE

Market Penetration Strategies

- A library works with a regular circle of clients and would like to maintain the current level of attendance and borrowing and to also increase it. Therefore, the strategy would be to focus on the quality of services offered, client-relation training for personnel and/or digitalization of a certain percentage of library books in order to target young people.
- A nonprofit local theatre company is specialized in producing dramaturgy which is included in the secondary schools' curricula. The theatre is subsidized primarily by the municipality. The theatre repertoire is relatively stable over time, offered on a repetitive basis. The theatre has subscribers—pupils and teachers from the secondary schools in the region—and has relied on a regular audience in the last five years. The next strategy of the theatre is to focus on keeping the current programming and audiences, as well as the quality and educational aspects of the future repertoire.

5.2. Market Development Strategies

These strategies aim to seek new markets for existing products and services. Possible ways to implement such a strategy include

- seeking new geographical markets for the same creative programme—for example touring a theatre show in other regions or abroad; and
- searching for new market segments for the same creative programme.

Market development strategies usually require investment in new distribution channels, changes in pricing policies to attract different audience groups or the targeting of new market segments. The strategy might require a market survey to find out whether the programme would be attractive for the new market segments. The potential threat in this strategy is the same as for all strategies related to offering only one product—the absence of an alternative if the product loses its markets.

EXAMPLE

Market Development Strategies

- A symphonic orchestra has already designed a special programme for a series of thematic concerts. This programme is well accepted by the core audience. The orchestra decides to attract new groups, for example to target students and young people by offering special promotional offers, such as a price decrease, as well as changing the place or time of the concerts to be more adaptable to young people's leisure time.
- A private gallery decides to increase sales from their usual exhibitions by attracting tourists, who have not been targeted in the past. The gallery arranges a partnership with a travel agency to popularize the gallery among tourists.
- A music distribution company needs to increase the circle of buyers of a new CD album of a contemporary composer. Contemporary music is usually sold mainly among specialists, music critics and academics. The distribution company would like to try a new market segment for this CD and therefore targets sales at students studying music in universities and colleges.

5.3. Product (Programme) Development Strategies

These strategies are efficient in situations when an arts organisation aims to introduce new creative (core) programmes to existing audiences or customers. To do so, there is a need to first improve the product's quality and/or to provide additional advantages related to the product. It is also possible to develop modified products which could be well accepted by existing market segments. The benefit of this strategy is the possibility of keeping current regular audiences and at the same time attracting new market segments with similar tastes, needs and/or expectations. The investment and risk taken are not huge, as there is no need to drastically change the organisation's activities, although in some cases the budget for communications might increase.

There are different methods of developing new creative and artistic programmes within a long-term framework, depending on the involvement of different people and teams. For example, creative programmes can be elaborated by

- the key figure in the organisation who is responsible for developing artistic programming, such as the artistic director, chief choreographer, chief conductor or museum curator;
- an invited guest producer, conductor, curator, or the like;
- the artistic director, the board and the general manager working together in close cooperation;
- the whole creative team within the organisation in a collaborative mode (for example actors, dancers, musicians and artists);

- a cooperative project of several artistic organisations, and as a result of joint efforts; or
- a specially designed new creative team, combining selected artists and creative producers whose skills, creative concepts and abilities match.

EXAMPLES

Product (Programme) Development Strategies

- A museum would like to open a brand-new programme—a series of classical music evenings for the core permanent group of museum members (subscribers) every first Friday of the month. They plan to increase the number of subscribers with the same profile among the museum audiences.
- A cultural and community centre aims to focus next year on a new educational programme on media technology and the arts, consisting of series of workshops and targeted consulting. The centre plans to attract the regular circle of young people who are usually coming for the centre's other activities, such as nightclub events, thematic evenings and language and computer courses.

5.4. Diversification Strategies

These strategies aim to enrich the core activities of an organisation and/or increase the variety of offers (programmes and services). Diversification strategies seek to increase revenues and profit through the sale of new products to new market segments. If not implemented with attention, or if the organisation is not big enough to handle the diversification, these strategies could be dangerous for an arts organisation, as they could lead to a loss of focus through the production and distribution of too many products to diverse audiences. An arts organisation should not look like a supermarket, offering too many things without having a core creative concept.

Entering an unknown market with a new product also requires higher competence on the part of the staff, especially regarding marketing and communications, or the expansion of human and financial resources. It also involves a high percentage of uncertainty.

EXAMPLE

Diversification Strategy

A small-scale commercial gallery dealing mainly with the sale of art objects would like to start a series of training courses on business entrepreneurship in the arts, targeting arts students who recently graduated and are not regular clients at the gallery. The gallery plans to offer courses on many aspects of entrepreneurship and also to issue a handbook on how to run a commercial gallery. At the same time, the gallery plans to arrange a series of exhibitions on female entrepreneurs with the aim of presenting talented women in the region who are starting careers as artists. The gallery has limited resources (money and personnel) and has to prioritize these ideas in a timescale.

There are two main diversification strategies:

- **Concentric diversification.** This occurs when an organisation continues its core activities but at the same time develops new products and services which are closely connected with the main programme and targets them to new clients.
- **Conglomerate diversification.** This occurs when the new products, programmes or activities are not connected with the usual core product. This is a useful strategy when the organisation needs to increase its revenues through offering something attractive and new. At the same time, it could lead to distraction from the main programme and activities. It also needs substantial investment to prepare personnel and provide them with new marketing skills.

EXAMPLES

Diversification Strategies

- **Concentric diversification.** The text of a theatre play which has been dramatized in a repertoire drama theatre for a number of years is printed as a book and promoted among a special group of new audiences, such as students from secondary schools. One of the reasons for this is that the play was written by a famous playwright and is part of the educational programme in schools.
- **Conglomerate diversification.** A symphonic orchestra has its own building for rehearsals and concerts but decides to use part of the space to open its own permanent gallery for exhibitions of contemporary artists.

5.5. Defining the Product Portfolio: Background for Product-Market Strategies

An important focus of product-market strategies is evaluation of the market potential of a product and elaboration of the product portfolio. This is done based on an analysis of the product life cycle— evaluating which phase of the product life cycle each one of the products (programmes) is in. As a result of this portfolio analysis the company can make strategic choices regarding which product or service to continue to develop, which product to maintain and which product to stop producing or offering, and when.

This concept helps arts managers and entrepreneurs to better understand and plan changes in product sales and to plan revenues over a given time frame. It is a useful way to find out the quantity of products and services that should be produced and offered. Figure 6.2 shows a hypothetical life cycle of a product, consisting of four main stages.

- **Introduction.** This phase is when the sales commence. Usually there are financial losses at the start due to the initial investment required and the small audience that is attending or buying. The initial sales price could be higher. Marketing campaigns are directed towards building awareness, motivating customers to try the products and experience the benefits. There is a high percentage of risk due to the unpredictability of customers' behaviour. This phase is suitable for the market penetration strategy.
- **Growth.** In this phase, there is a rapid sales increase, cultivation of new market segments, consideration of new distribution channels, rapid increases in profit and the possibility of price-decrease strategies. In this phase the competition also begins to increase. The growth phase is suitable for implementing market development and product (programme) development strategies.

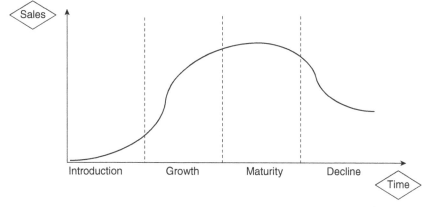

Figure 6.2 Phases in the life cycle of a product

- **Maturity.** The focus here is on prolongation of maturity as this is the point when one is reaching the targeted customers and thus stabilizing sales and prices. The competitive offers are usually increased, and the organisation could consider innovation or diversification strategies. This phase is suitable for strategies of innovation and integration. When the sales stabilize and the competition increases more and more, concentric and conglomerate strategies are also applicable.
- **Decline.** This could occur because of the appearance of better products, changing customer preferences and the need to implement new technologies. Most reasons for decline are usually objective, but it could also happen because of threats in the internal environment. In this phase, profitability diminishes as sales volumes decline. Marketing strategies try to forecast the future point of decline for certain products so that they envisage far in advance the design, production and implementation of a new product to replace the one receiving decreased audience attention.

Using the life-cycle concept to develop product (programme)-market strategies and tools in an arts organisation is certainly useful but should be implemented with care. This is because the product quantity and higher revenues are not the core element in the mission of many arts organisations. Also, as discussed in Chapter 1, it is difficult to fully predict the success of an artistic product and audiences' attitudes because of influencing risk factors, high uncertainty in the process that influences the outcomes, and the uniqueness of the artistic results which can not be precisely measured. However, the product life-cycle concept can help arts managers to plan marketing strategies that address the challenges and diminish the threats from the external environment. It is also a useful monitoring tool to foresee results over a period of time in a pragmatic way and to compare them with the one of the competitors.

6. COMPETITIVE STRATEGIES

Research on competitors aims to discover, collect and analyse information which would help to clearly secure an organisation's competitive advantage and thus provide a higher level of satisfaction for its audiences and clients. As discussed in Chapter 5, competitors can be direct or indirect, depending on how similar their activities and product areas are to the organisation's activities and products.

Competitive advantage is a term which is at the core of the majority of business strategies. It refers to an organisation's ability to perform at a higher level than others in the same industry or market. It covers key things which make an organisation better than its competitors. These advantages could be in the quality of the products or services, in the price policies, in the benefits offered to audiences, in the way a product or a service is offered, or in lower costs for operations. To elaborate its competitive advantage, an arts organisation needs to perform research and analysis on competitors which covers several main areas, described in Figure 6.3. The research on competitors usually covers two levels: strategic and operational.

Competitive strategies are based on thorough research on and analysis of key direct and indirect competitors who have different market positioning. An arts organisation does not need to compare itself with all competitors but only with those that are better positioned and perform better on most of the variables shown in Figure 6.3. This is why it is important to analyse an organisation's performance by comparing with the leaders in that branch of the creative (cultural) industry. This approach is known as *benchmarking*[19]. Benchmarking is a process of researching and applying the best practice which leads to the best results and of satisfying clients' needs in the best possible way. Leaders in a certain branch give the standard, the positive example for comparison, which helps an organisation to understand its weak points and strengths and to plan improvements. Benchmarking is an approach which is widely used in the business world, as well as in the public sector (such as in universities and hospitals), but it is less known and less commonly applied in the field of the arts, because it is not easy to define who is the actual market leader in the arts. Nevertheless, a benchmarking approach would help an arts organisation to improve its strategic actions through research and application of the best examples.

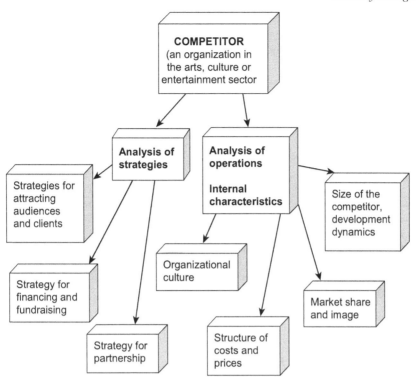

Figure 6.3 Factors in analysing a competitor

Competitive strategies are connected with Porter's well-known *generic strategies model*, widely applied in the business world[20]. The model provides a system for assessing and analysing the competitive strength and position of a business organisation. Elements of Porter's model is used in the following to identify how the three generic strategies—*cost leadership, differentiation* and *focus*—are applicable to arts organisations.

6.1. Cost Leadership Strategies

The main aims of these strategies are to secure a competitive advantage through lower costs (or higher subsidies, in the case of nonprofit organisations), which allow an organisation to offer programmes and products at much lower prices than those offered by the competitors. In a business company this could be done by re-evaluating the cost structure, especially related to the indirect costs which decrease when revenues increase. In a nonprofit or state-subsidized organisation it could be applied by successfully increasing external support and thus decreasing the price charged to consumers. Such an approach is justifiable only when related to the cultural policy priorities of a country. Three main areas to look at when re-evaluating and decreasing costs are:

- costs, related to purchasing materials and equipment needed to undertake activities;
- indirect costs (for maintenance, administration, etc.), and
- costs for marketing and distribution.

6.2. Differentiation Strategies

The essence of this strategy is to outline the unique and non-conventional characteristics of the product or service which are preferred by the target clients or customers and which distinguish it from those of the competitors. The emphasis is therefore on the comfort and satisfaction of audiences and

the product's usefulness to them. Clients have the feeling that they receive more than what they pay for. This is why they are ready to pay a higher price because they know they will obtain in return something which other similar organisations cannot offer.

EXAMPLE

Differentiation Strategies

A national contemporary ballet company is the only one of its kind in the country. Its new stage production requires increased costs to support multimedia and stage equipment which transforms the audience from passive viewers to active participants in the performance. A preliminary market survey indicates that the show would be accepted very well by the regular audiences and that they are ready to pay a higher price. The regional arts council also increases its subsidy for the company as they are aware of its importance, of the need to attract young people and of the increased costs involved in using new technologies on the stage. Utilizing the state subsidy to invest in the new technical requirements of the production is worthwhile, as the regular audience may contribute even more through increased ticket sales and generated revenues.

6.3. Product (Programme) Focus Strategies

These strategies aim to identify an area, activity, product or service which is most appropriate in relation to the organisation's expertise and resources. It requires deep research of the market niche and potential audiences that could be attracted by these specialized products or services. The emphasis in these strategies is on

- the unique characteristics of artistic programming, the way it is offered and the differences from all other programmes offered in the same field;
- a non-traditional approach to production and distribution; and
- the special offer(s) made to targeted groups.

Product focus strategies usually need narrow but specialized know-how in a specific production area. As in the majority of arts organisations the final outcome always has an impact on society or contributes to solving a societal problem, product focus strategies are based on profound research on how culture could be connected with other areas, and they are combined with strategies for integration, collaboration and partnership. In their non-commercial version, these strategies are very popular among subsidized and nonprofit arts organisations. Commercial arts organisations could apply product focusing strategies in all cases where they need to concentrate on satisfying the needs of a narrow market segment by offering them unique products in order to increase profits.

Specialization is a key element of programme (product) focusing strategies, and it is one of the main factors for creating a competitive advantage. Specialization can occur by

- hiring highly specialized and skilled actors, personnel or contractors;
- employing new and innovative technology or methods;
- pursuing a strong branding of products; or
- distribution methods engaging audiences.

Specific marketing strategies such as audience development, widening of accessibility and increases in public image and visibility, which are closely connected with the market research and marketing-mix techniques, are discussed in more detail in Chapter 7.

EXAMPLE

Product (Programme) Focusing Strategy

- A puppet theatre in a city offers specialized programmes for different age groups of children. The theatre has researched the needs of specific target segments (niches) and obtains the know-how on how to not only satisfy but also lead these needs. The program focusing strategy requires ongoing external support from the municipal council to preserve the quality repertoire and maintain low ticket prices for children and their families.
- An opera company is the only one in the country which offers a contemporary approach to performances of classical operas. They have been specializing for 10 years to connecting traditions and modernity. The theatre has regular subscribers and also constantly enlarges its audiences. It focuses on quality, creativity and innovation in the offered repertoire. The labour costs as part of the operational budget are very high, as the opera company has an ongoing casting approach of hiring the best opera singers as guests.

7. EVALUATION OF ALTERNATIVES AND CHOICE OF STRATEGIES

As discussed in Chapter 2, strategic management includes the elaboration of strategies, their implementation, and evaluation of the final results. The phase of analysis and evaluation of alternative and choice of strategies is based on the analysis of the external and internal environments, as well as on the organisation's mission, vision and long-term objectives. This phase has four substages:

- **Generation of strategic alternatives.** Each alternative is a practical approach for achieving a goal—what should be done in order to obtain the expected results. This is the practical way of elaborating a set of strategic alternatives to use the strengths and opportunities as well as diminish the threats and weaknesses.
- **Evaluation of alternatives.** This stage looks at possible barriers and risks for the realization of alternatives, for example limitations in resources, the skill levels, and knowledge of personnel.
- **Comparative analysis of alternatives and choice of strategy.** This step aims at choosing the most appropriate alternative which will bring the highest results with minimum efforts by utilization of resources and lowest level of risk.
- **Operational plan for implementation of the strategy.** This is the implementation of the plan which brings the strategy into a practical phase.

PRACTICAL RECOMMENDATIONS

The choice of a strategy, or set of strategies, is not an easy process. It requires a synchronized approach that is achievable by answering the following questions:

- How can we use existing opportunities?
- How can we avoid, or diminish, the expected negative influences of the environment?
- How can we use resources in the best way to achieve maximum effects?
- How can we create, produce, present and/or sell better than others in our field?
- How can we fully utilize our organisation's unique features?
- What are the most effective ways to nurture creativity and innovation?
- How can we increase audiences and supporters?
- How can we convince stakeholders and fund-givers?
- How can we organize the internal processes and workflow more efficiently?

One of the most popular methods for selection of a strategy is based on the results of the SWOT analysis. Table 6.2 gives an idea on how SWOT provides the necessary background for selecting a strategy.

Table 6.2 Grid for Selection of Strategies

Option 1: When strengths and opportunities prevail	**Option 2:** When weaknesses and opportunities prevail
Possible strategies: • Intensive growth • Product (programme) development • Product (programme) focusing • Market development • Innovations • Differentiation	**Possible strategies:** • Integration (vertical) • Diversification (conglomerate) • Co-production • Capacity building
Option 3: When strengths and threats prevail	**Option 4:** When weaknesses and threats prevail
Possible strategies: • Integration (horizontal) • Diversification (concentrated) • Market penetration • Networking	**Possible strategies:** • Decreases in costs • Increases in incomes • Bootstrapping • Liquidation • Bankruptcy

- **Option 1:** When strengths and opportunities prevail, the most appropriate strategies are usually intensive growth, product (programme) development and product (programme) focusing strategies, innovations and differentiation.
- **Option 2:** When weaknesses and opportunities prevail, organisations aim at collaborating, joining and integrating, to diminish their weaknesses and use external opportunities. Suitable strategies are vertical integration, conglomerate diversification, co-production and capacity-building.
- **Option 3:** When strengths and threats prevail, organisations feel strong and able to manage, but there are not that many positive trends and opportunities in the external environment. Strategies help organisations use all their strengths to cope with the negative factors and restraining forces in the environment. Useful strategies in this situation are horizontal integration, concentrated diversification, market penetration and networking.
- **Option 4:** When weaknesses and threats prevail, this is the most unfavourable situation, one in which organisations are at the edge of surviving because of the restraining forces from both the external and the internal environment. Suitable strategies in such cases are bootstrapping[21], decreases in costs and increases in incomes, or liquidation and bankruptcy.

There is no precise formula to determine which strategy to apply in which case. Every decision depends on the specific situation and on a combination of strengths, weaknesses, opportunities and threats as well as other factors. Combinations lead to the choice of one strategy or a set of strategies.

8. EXAMPLE OF A 'STRATEGIES: OPTIONS AND CHOICES' SECTION OF A STRATEGIC PLAN

Strategy	Rationale for the choice	Key elements	Objectives	Expected results
List the strategies you have chosen.	*List the main reasons for selecting the strategy (results of analysis).*	*Point out the main focus, key elements and priorities in each strategy (using time period, based on months or years).*	*List the key objectives as well as specific objectives for each strategy.*	*Envisage expected results from the implementation of each strategy. (Results are very tightly connected with objectives but have a more 'visible' format—quantitative and/or qualitative characteristics.)*

(Continued)

Strategy	Rationale for the choice	Key elements	Objectives	Expected results
Main strategies: • Strategy 1 (for example strategy for integration and partnership) • Strategy 2 (for example product–market strategy) • Strategy 3 (for example innovation strategy) Functional strategies[a]: • Marketing strategy • Human resources strategy • Financial strategy • Others				

[a] Detailed elaboration of these strategies is incorporated in the functional parts of the strategic plan.

9. CASE: ODA THEATRE (PRISTINA, KOSOVO): COMPETITIVE ADVANTAGE AND STRATEGIC CHOICES

The case was created with the kind assistance of Florent Mehmeti, the director of ODA Theatre. The case text is based on an analysis of primary data from targeted qualitative research and secondary data from materials provided by ODA Theatre.

> **STUDYING THIS CASE WILL HELP YOU TO:**
>
> • Analyse the connections between the results of the SWOT analysis, the choice of a general strategy and functional strategies in an arts organisation.
> • Discuss the application of product (programme)-market strategies and the dilemma between maintaining high artistic quality and making the art accessible to broader audiences.
> • Discuss the challenges of rapid audience development and managing organisational growth by maintaining the artistic quality of performances.
> • Analyse a practical example of a theatre company's competitive advantage.
> • Understand the concept of a 'set of strategies' for an organisation's development.

9.1. Background Information

The independent ODA Theatre[22] in Pristina, Kosovo, was founded at the end of the year 2002 as an artistic initiative of Lirak Çelaj, actor, and Florent Mehmeti, director. The first play of the theatre, the *Vagina Monologues* (author Eve Ensler), was performed on March 1, 2003, and since then that has been considered the birthday of the theatre. Since its opening, many artists and art-lovers have visited and supported the theatre. It is the only independent theatre in Kosovo that has its own place since January 2004. The theatre building had initially been a bowling club and was transformed into a disco club later on and then into a black box–type theatre with flexible usage for different alternative set-ups, convenient for a range of events from smaller, more intimate ones to large events.

In the period 2003–2011 ODA Theatre has produced around 30 theatre productions of its own, several exhibitions, over 70 concerts and around 100 guest performances. For several years now ODA has hosted several festivals, among them, the Pristina Jazz Festival, Rock for Rock Festival, SKENA UP Students Theatre and Film Festival. The theatre has gained national and European credibility as a leader in the independent culture sector in Kosovo.

- **Main Achievements**
 The theatre holds the record in the country in terms of audience attendance per show[23]. The theatre has pioneered several programming milestones, among them:

 - Elaborating (organizing) a laboratory for development of the theatre productions and putting new theatre dramaturgy on stage;
 - Organizing theatre performances and art events for young people;
 - Introducing cultural management methods in the contemporary arts organisations in the country through specialized projects and programmes;
 - Collaborating in initiatives devoted to cultural policy development in Kosovo;
 - Organizing projects in the field of arts and education.

- **Key Programme Areas**
 ODA Theatre currently works in five main programme areas:

 - Theatre productions: putting on stage two to three of its own productions per year in addition to one or two co-productions;
 - Artistic production in public space, in cooperation with the IN SITU network;
 - Local cultural policy development programme 'Culture from-for all' (in conjunction with PAC Multimedia);
 - Arts in Education Theatre Clubs for cultural debates in 20 primary schools around Kosovo;
 - Cultural Forum—ODA's initiative for creating a Network of Independent Cultural Organisations in Kosovo.

- **The Team**
 The theatre is governed by a board and run by its two directors and founders. ODA Theatre also has an advisory board of influential people, local and international, who provide consultation and advice. The advisory board is led by Ms. Vanessa Redgrave. Other team members are

 - one project manager;
 - two project assistants, who are also in charge of administration and management;
 - one bar and events manager;
 - three permanent technical staff;
 - an accounting company to which financial management has been outsourced; and
 - outsourced cleaning company.

In addition, the Theatre Clubs project employs four artistic coordinators and 20 teachers. This is a project for creation of 20 pilot theatre clubs in elementary schools in the country, each involving on average 20 pupils in each school working regularly two times a week throughout the school year. The end result is a performance by the end of the school year, which then continues to be presented at the municipal and national levels.

The theatre has currently 33 people on its monthly payroll and annually engages around 25–30 additional artists and other temporary contractors on projects.

The main sources of new ideas are the two founders/directors. Their frequent travels abroad have helped to enlarge their perspectives and helped them learn about theatre management and creative practices in other countries. There is no specially elaborated system for ongoing generation of ideas. The theatre does not have sufficient financial means to develop, on an ongoing basis, laboratory-type and risky projects and initiatives generated by the team members.

- **Operational and Technical Aspects**
 The theatre operates in public rented premises of 440 square meters in the central part of Pristina. The theatre has a flexible audience-stage system with an average capacity of 220 people. It is equipped with a solid lighting and sound system, improving from year to year based on the available

funds. The theatre has its own vehicle which is used for staff and artistic teams' daily business as well as for touring.

- **Sources of Income**

 ODA Theatre has a mixed financial structure with income coming from international donors, national organisations, corporate sponsorship and self-generated revenues. Table 6.3 gives an overview of the different sources of incomes and revenues as a percentage of the overall budget for the period 2008–2011.

 A few clarifications concerning sources of income are as follows:

 - The European Union office in Kosovo awarded ODA Theatre a grant for the Theatre Clubs project under the human rights/democracy grants programme.
 - International donors include the Swiss Cultural Program, Olof Palme International Centre and Rockefeller Brothers Fund, as well as grants from the U.S. embassy in Pristina in Kosovar-U.S. collaboration initiatives.
 - Subsidies from national institutions come from the Ministry of Culture of Kosovo, as well as occasionally from the Ministry of Education for the Theatre Clubs project. The support from the city of Pristina is relatively small: €5,000 for the period 2008–2011.
 - Corporate sponsorship includes €44,000 from the Post and Telecom Company in the country for a period of two years and €8,000 from Pristina Airport.
 - Self-generated revenues include income from core activities (ticket sales) and income from peripheral activities (renting spaces and services to third parties).
 - An innovative initiative that sells seats for premieres for the next five years to theatre supporters is called 'Your Seat in ODA'. The initiative raises funds for the telescoping (flexible) tribunes of the theatre hall where the seats will have the written names of the people and companies who supported the initiative.

- **Profile of Audiences**

 ODA Theatre's main audience (around 70 per cent of the audience) is relatively young, in the range of 25–35 years of age. The theatre has not done any marketing surveys, and this is based on observations only. It is estimated that in 2011 ODA Theatre had 28,000 visitors for its productions, as well as for visiting events. Together with the Theatre Clubs project ODA Theatre serves on a regular basis around 400 pupils from 20 pilot schools. The overall audience for the performances created in the clubs is around 24,000 pupils in total.

9.2. Uniqueness and Competitive Advantage of ODA Theatre

Artistic communities, theatre lovers and media identify ODA Theatre with the main unique characteristics which shape the theatre's competitive advantage:

- **'Lonely rider'.** The theatre remains the only independent theatre company in the country that has a regular repertoire and its own venue which is open daily.

Table 6.3 Sources of Incomes and Revenues for ODA Theatre (2008–2011)

Incomes/revenues	2008	2009	2010	2011
International donations	58%	65.6%	78.7%	58%
National (public) donations	14%	5.5%	5.9%	7%
Corporate sponsorship	–	16.4%	7.8%	–
Self-generated revenues	18%	12.5%	7.6%	35%
Revenues generated from the program 'Your Seat in ODA'	10%	–	–	–

- **Pioneer in new communication channels.** Since the very beginning the theatre has constantly implemented new channels of communication which did not previously exist in the arts field in Kosovo, such as regular emails and newsletters for events and programmes, which back in 2003 were not popular among arts organisations.
- **Strategy toward youth.** Another angle of innovativeness is *active work with and for young people*, introducing advanced tools in arts management.
- **Putting on stage quality artistic work.** The theatre produces new, provocative and unknown as well as quite popular pieces of dramaturgy which attract wide audiences. An example is the theatre play *Three Fat Germans*[24], a comedy first produced in 2004 as the collective creation of eight artists. Later, a national broadcasting company requested that the theatre transform the play into 63 episodes (written by Lirak Çelaj and directed by Florent Mehmeti), which then made it even more popular. The theatre continued to receive requests from audiences across the country to repeat it on stage. The second version of it, *Three Fat Germans II* (written by Lirak Çelaj and directed by Florent Mehmeti), is still on stage after 60 performances with almost 10,000 viewers. The song created for the play, 'Three Fat Germans II', became very popular, and the theatre had more than 800,000 viewings on YouTube in a period of only three to four weeks.
- **Well known venue.** The theatre venue is very much liked by audiences for evening concerts, music, and DJ events.
- **Lobbying actions.** ODA Theatre is engaged in projects and actions for improvement of cultural policy strategy and instruments on both the national and local level.
- **Active networking.** The theatre team maintains numerous fruitful contacts with colleagues from the theatrical and artistic fields on both the local and international level.

9.3. Strategic Directions

- **Mission Statement**
 ODA is an independent organisation committed to professional development of the theatrical arts, encouragement of interrelations with other arts, and the building up of a strong arts and culture foundation for the future generations. ODA is determined to play a key role in strengthening the culture sector in the society and to influence powerfully the building of a democratic and open Kosovo.

- **Vision Statement**
 ODA's vision is to become a strong and influencing institution within the civil society sector and among the artistic community. ODA will have a powerful influence on the development of the democratic processes in the country and beyond.

- **Strategic Goals**
 ODA Theatre has determined the following long-term strategic goals:

 - To build up and empower further leadership and professionalism in the independent cultural and artistic sector;
 - To improve on an ongoing basis the artistic quality of programming, especially by implementing international co-productions and cultural exchange programmes;
 - To increase the regional and international presence of its artistic work;
 - To influence cultural policy decision-makers in the country and to create a better financial climate for arts support in the country;
 - To carry out the newly elaborated programme Arts in Public Space by creating strong and powerful co-productions for the domestic and the international markets[25];
 - To consider a possible spin-off of the non-artistic projects into a future ODA Institute; and
 - To enhance the capacity-building of the staff for more efficient performance and management.

9.4. SWOT Analysis: Main Results

The SWOT analysis conducted for the ODA Theatre shows the following results:

- **Strengths**
 - Good public profile of the theatre in Kosovo and abroad;
 - Significant capacity on the part of the theatre staff to administer and implement projects;
 - Experience in managing artistic projects of all types;
 - Fundraising experience of the management and the staff in exploring ways to cover operational costs for diverse projects and to adapt project budgets to different external funders' priorities;
 - Efficient communication channels, among them: 15,000 subscribers on ODA Theatre's mailing list and free television advertising.
 - Flexible venue with a good location—suitable for diverse concerts, exhibitions, parties, use as a film studio, and more;
 - A faithful and passionate audience;
 - Efficient networking skills and good contacts with international partners.

- **Weaknesses**
 - Lack of internal management system to ensure maximal performance by and capacities of the staff;
 - Insufficient staff due to lack of funds—especially for technical and supportive processes and tasks;
 - Difficulties in finding staff member able to perform multiple tasks;
 - Mentality of work in the country, which tends to avoid precise planning of tasks;
 - Lack of time for research and contacts related to potential international funding resources and international networks;
 - Lack of storage space capacity in the venue.

- **Opportunities**
 - Lack of a strong competitive environment in the country;
 - Presence of international aid and development funds for the country and the region;
 - Lack of an overall culture of planning and management in the country, which creates opportunities for flexibility at work;
 - Small artistic community in the country, which allows creation of an informal and friendly atmosphere of collaboration and partnership with similar organisations and venues;
 - Dynamic society in transition, which often creates a climate of quicker achievement of objectives.

- **Threats**
 - Absence of recognition of cultural management as a specialized professional field, or a field of study in the country;
 - Absence of professional stage managers and technical theatre professions;
 - No clear future in terms of public properties in the country and therefore non-secure long-term contract for renting the space (the contract was recently signed for another two-year term);
 - Lack of specific resources to fundraise for artistic projects and products;
 - The cultural policy of the country, which focuses much more on public and state cultural organisations rather than supporting the independent culture sector;
 - Lack of external resources to cover operational costs and a need to undertake projects that do not entirely fit the mission of the organisations but take the time and the efforts of the staff;
 - Lack of a culture of planning in the society, which creates difficulties in programming and coordination of partnership and collaborative projects;
 - Difficulties in international cultural cooperation because of the existing visa regime.

9.5. Functional Strategies: Main Elements

- **Creative Process and Product/Service Development**
 - Designing the overall programming and creative projects from the viewpoint of the core organisational values;
 - Using international collaboration as a tool to ensure high-quality theatre programming;
 - Using Kosovo's rich history and mythology as a basis for new theatre pieces;
 - Putting on stage attractive pieces of work for the international audience and theatre professionals from other countries.

- **Communication and Marketing**
 - Communication: Implementing diverse communication tools, such as announcements in bars or through mobile devices and emails offering promotional codes for discounts or free tickets, as well as online communication tools and social networks;
 - Sales promotion: Offering group discounts for theatre attendance;
 - Public relations: Motivating media presence at theatre shows and follow-up interviews and press coverage;
 - Audience development: Concentrating on young people and creating clubs of ODA Theatre fans;
 - Location strategy: Achieving full utilization of a venue with suitable facilities not only for theatre but also for additional events, as well as television programmes.

- **Human Resources**
 - Developing a flexible organisational structure and style of work;
 - Aiming to develop an open, flexible and collaborative work climate;
 - Improving recruitment policy and procedures for searching and hiring creative and dynamic staff.

- **Financing and Fundraising**
 - Maintaining a diverse fundraising strategy in the next years;
 - Undertaking new initiatives funded by outside sources from the viewpoint of the organisation's mission and future benefits;
 - Matching the overall programming with sources of funding and their priorities;
 - Seeking alternative sources of funding for artistic programmes and creating opportunities for in-kind support for elements of artistic works.

- **Partnership and Cooperation**
 - Building long-term partnerships on the basis of shared beliefs and common values;
 - Establishment of good working relations with donors and subsidized institutions, emphasizing the quality of programming and avoiding patronization;
 - Balancing local and national cooperation with international cooperation.

9.6. Elements of Innovation

ODA Theatre has increased much its self-generated revenues in 2011 in comparison with the previous three years. Innovative elements are mainly related to their fundraising efforts and the attempt to enlarge the scope of the additional and peripheral products and services offered. The main innovative elements of the theatre, in comparison with the general arts management practice in Kosovo, are:

- The 'Your Seat in ODA' programme generated public and media attention. The programme allowed individuals and companies to 'buy' seats and have their names on them for the theatre premieres.

- The show *Three Fat Germans* was negotiated with the television broadcaster, giving them the rights for the story, the dramatic set-up and the characters, on the condition that SITICOM (the television production Situation Comedy) would be filmed in the theatre's location while paying rent, which provided a regular income for a certain period.
- The ODA Theatre Fan Club generates monthly donations as a source of ongoing sustainability.
- ODA Theatre offers peripheral services at the venue as sources of additional revenues: selling books, programmes, beverages at the bar, and snacks from a machine.

The long-term objective is to enlarge additional sources of revenues to secure financial sustainability.

9.7. Lessons Learned

Florent Mehmeti shares the lessons learned as a result of his entrepreneurial and management practice in the field of arts as follows:

- 'Always think long-term and believe that your current investments will provide a return, but not immediately, and in most cases, with no tangible results or benefits.'
- 'Do not be afraid to take a calculated risk, and it will pay back in the long-run.'
- 'Be professional and set up clear rules and procedures, especially when you work with friends or relatives. If possible, avoid involving them in your professional activities.'
- 'Check in advance the credibility of a company which you plan to contract for outsourcing part of the work. Read and understand well every contract with external parties before you sign it.'

QUESTIONS AND ASSIGNMENTS

- Elaborate the main driving and restraining internal and external forces in ODA Theatre's work, considering the results of the SWOT analysis and the internal theatre operations.
- What are the missing elements of the external analysis as part of a strategic plan? What kind of research, data and analysis should the theatre undertake to elaborate them?
- How would you define the optimal set of strategies for ODA Theatre? Why do you recommend these strategies? Give arguments, considering influencing external and internal factors.
- Is the theatre managing growth in the right direction? Is it a viable idea to implement a future strategy of spinning off a new organisation, the ODA Institute? What are the potential results, consequences, risks and limitations for such a project?
- How could the elements of innovation and entrepreneurship be embedded in the strategic development?

Note: You might need to perform additional online research to complete these assignments. In your answers, apply the theoretical concepts and the methodology from Chapters 4 and 5 as well as this chapter.

10. CASE: ARTS COUNCIL OF MONGOLIA: CAPACITY-BUILDING STRATEGY FOR PRESERVATION OF NATIONAL ARTS AND CULTURE IN THE ERA OF GLOBALIZATION

The case was created with the kind assistance of Ariunaa Tserenpil, Solongo Ukhnaa and Odgerel Odon-chimed. The case text is based on qualitative research using documents and personal viewpoints, elements of the Arts Council of Mongolia's strategic plan, and secondary data existing in the public domain.

STUDYING THIS CASE WILL HELP YOU TO:

- Analyse the phases of development of a nonprofit organisation from its inception until today.
- Understand the implementation of a capacity-building strategy for a nonprofit organisation in the field of arts and culture.
- Connect a general strategy of development with functional strategies, especially related to fundraising.
- Provide arguments for the importance of preserving cultural heritage in a country in the era of globalization, and ways this could be achieved through diverse partnership strategies.
- Understand the role of the board, committees and stakeholders in elaboration of a strategy for an arts organisation.

10.1. General Information

Mongolia has an extremely rich culture, full of skilled and creative people. The country's talented artists produce work as unique to Mongolia as Mongolia's cultural heritage is to the world. Currently there are more than 5,000 people working in Mongolia's culture sector, employed by 28 national as well as a number of private ones (theatres, ensembles, circuses and orchestras), 48 museums (including 9 national museums, 30 local museums and 9 branch museums) and more than 80 nongovernmental organisations, private studios and productions dealing with arts and cultural development[26].

The Arts Council of Mongolia (ACM)[27] exists to ensure that the arts and culture of Mongolia are sustainably developed, promoted and preserved. The organisation has a nonprofit status and was established in 2002, with initial support and funding from the Mongolian Foundation for Open Society (Soros Foundation[28]) as well as business, civic and arts leaders in Mongolia. It focuses primarily on supporting Mongolian arts institutions and individual artists in order to promote international interest in and awareness of Mongolian arts, enhance the skills of Mongolian arts administrators and artists and advocate for cooperation between the private and public sectors on arts issues.

Since its beginnings, ACM has each year expanded its capacity to serve the cultural interests of Mongolia in the most efficient ways and has earned visibility and respect, both in the arts and culture sector and among the broader communities. It has also built close relationships with the government of Mongolia and with local and international organisations in Mongolia and abroad.

To accomplish its mission of supporting the sustainable development of Mongolian arts and culture, ACM carries out activities in five main programme areas addressing issues currently faced by both the society and the cultural community:

- **Advocacy.** The programme focuses on providing a platform for public dialogue about the policy and legal environment surrounding the culture sector and on raising the profile of Mongolian arts and culture. Currently ACM is strengthening its partnership with the Ministry of Education, Culture and Science to assist the formulation of state cultural policies, a master plan for cultural development up to 2020 and tax benefits for charitable giving. The programme is the subject of an hour-long television programme named *Arts Network* to address broad issues of arts and culture within the country's social and human development
- **Artist development.** This programme supports and nurtures Mongolian artistic communities by providing a variety of national and international education and professional development opportunities for artists and managers. It also helps provide funding for arts and culture organisations to conduct specific programmes and projects. A special focus of the programme is artistic mobility which helps to raise the profile of the Mongolian arts and culture nationally as well as internationally. Capacity-building is an important angle that offers training and consulting opportunities on specific projects, including the Visual Arts Residency Program, ACM Fellowship Program, Modern Dance, Museum Collection Management and documentary film training sessions.

- **Arts education.** This programme promotes critical thinking, creativity, life skills development and self-confidence in young Mongolians. ACM believes that the energy and imagination of the creative process not only enriches personal lives but can also build a stronger nation by awakening confident self-expression in Mongolia's children. In 2011 the Arts Education Program implemented six arts education projects, involving 450 children in secondary schools to enhance their life skills and creativity through the visual arts, performing arts and music. Another important focus of the programme is building the capacities of teachers in creative teaching methodologies. Within this framework, ACM developed and published a visual arts teacher's handbooks for secondary school art teachers with funding from UNESCO's National Commission and Tuguldur Foundation[29]. Also, ACM initiated and conducted first-ever Mongolian survey on arts education with funding from UNESCO's National Commission to address current challenges and future solutions to offer access to the arts for every child of Mongolia through formal and informal arts education.
- **Cultural heritage.** This programme is an important tool to safeguard the nation's identity in this era of globalization. It focuses on increasing awareness of the importance of both tangible and intangible heritage and ensuring the preservation and transmission of cultural heritage to the next generations. Projects vary from cultural heritage site preservation to traveling museum-in-the-box projects. Since 2009 ACM has implemented a project to preserve the Amarbayasgalant Monastery, funded with US$672,000 from the U.S. Ambassador's Cultural Heritage Fund to install new electrical wiring and security systems.
- **Development.** This programme is one of the unique features of ACM and aims at increasing self-revenues by building ongoing relations with local and international partners, donors and business organisations (see later on).

During its nine years of operation (2002–2011), ACM has raised a cumulative total of US$3.5 million for support of the arts and culture sector through implementing 215 projects, which have served 88,000 people, including 25,000 youth and children, and have supported 5,500 artists and arts organisations. ACM has partnered with 180 local and international organisations.

10.2. Management Team and Organisational Structure

ACM's internal operations are organized around three main areas: programs, operations and development. The operations area provides the day-to-day work of the organisation: administration and financial management. ACM has a staff of 11 full-time professionals whose focus is on activities and projects which bring optimal impact in terms of both programme mission and fundraising[30]. ACM governance is supported by a board and committees on a volunteer basis. Members are some of the country's most respected artists, political leaders and business managers, as well as international experts and key professionals.

10.3 Fundraising and Financing

In the period 2002–2012 ACM was supported financially by the Open Society Institute and Soros Foundations network. Since then, the organisation has grown its own wings, and along with funding from the Open Society Institute, has developed other sources of financial support. Funding comes in the form of specific project funding through donations and sponsorships, membership fees, sales from the Red Ger Art Gallery and income from ACM services for businesses. Currently ACM has two main funding sources to ensure sustainability:

- International funding sources for specific projects. These include support from the Asia Europe Foundation, Arts Council of Mongolia—US (see the following), Turkish International Cooperation Agency and the embassies of Norway, the United States, Turkey and France.
- Local funding sources, mainly from local businesses and memberships. A special focus is the 'Arts and Business' service series offered for business organisations.

As of December 31, 2011, ACM had raised approximately US$753,967 for the 2011 fiscal year, which is around 10 per cent higher than the amount raised in 2010. ACM's planned budget for 2012 is US$627,858.

In 2011, 76 per cent of ACM's budget came from international funding resources. Of the international support, 69 per cent of the budget is supported by external funders located in Mongolia and 31 per cent by funding organisations outside of Mongolia. Fundraising from local sources, both external and internal, comes to 24 per cent of the overall budget and comes from the following sources:

- Support from business organisations (sponsorship and other): 48 per cent;
- Self-generated income from events and activities: 19 per cent;
- ACM memberships: 18 per cent;
- Subsidies from state institutions: 9 per cent;
- Nongovernmental organisations and others: 6 per cent.

In addition, the ACM-US, a counterpart organisation in the United States with 501(c)(3) status, was established in 2003 to provide residents there with an easy and tax-deductible means of supporting arts and culture in Mongolia. In some cases, ACM-US makes grants to ACM to benefit from its administrative capacity and expertise in Mongolian culture.

10.4. Mission and Vision

ACM's mission is to support the sustainable development of Mongolian arts and culture and to work for the preservation of Mongolian cultural heritage in a transparent and accountable mode. ACM's vision for the future is to become the leading Mongolian organisation which guides, advocates, and supports the sustainable development of Mongolian arts and culture.

10.5. Strategic Objectives (2011–2015)

The strategic objectives are closely related to the needs of ACM's main target groups:

- To advocate for greater public awareness in Mongolia about the importance of arts and culture for human and social development.
- To contribute to the preservation of the Mongolian cultural heritage and traditional as well as contemporary art forms.
- To build the capacity and competitiveness of Mongolian arts organisations, art groups and individual artists
- To provide opportunities for Mongolian artists to create and to develop their artistic skills, while maintaining a high level of artistic integrity and excellence.
- To support, encourage and motivate young artists and to promote arts education.
- To advocate for broader access by disadvantaged communities and individuals to a range of cultural services and arts productions.
- To expand creative international partnerships and collaborations among funders, business communities and key stakeholders.

10.6. Results of the SWOT Analysis

- **General Cultural Policy Context**
 Since 1990, several actions to formulate national policy on cultural development have taken place. The National Policy on Culture was ratified as a leading document by the Parliament of Mongolia in April 1996. The new version of the document is under consideration by Parliament. The policy that was elaborated promotes the significant role of culture in establishing and developing a humane society in Mongolia. It defines Mongolian culture as 'a guarantee of independence and safety,

a source of national pride and unity and an important lever for development and progress'[31]. This document defines the basic areas of Mongolia's cultural policy as 'safeguarding the nomadic culture while developing it in proper combination with sedentary culture, protecting against the eventual loss of Mongolian culture because of the globalization trends, and supporting the development of the national culture in all possible means'[32].

- **Opportunities**
 - Trends towards progressive cultural leadership and increased public funding in the country;
 - Growing public demand for preservation of Mongolian cultural heritage;
 - New cultural policy document elaborated at the national level;
 - Growing arts and culture sector: increasing number of state, nonprofit and business arts organisations;
 - Increasing investments and rapid development of the extractive industries (oil, gas, mining);
 - Unique Mongolian culture and heritage and talented artists;
 - International market demands and needs for Mongolian arts and culture products and artists;
 - Democracy and freedom of artistic expression.

- **Threats**
 Although the national agenda on cultural development has been formulated and its implementation is in progress, the arts and culture sector of Mongolia is still facing the following main obstacles and threats:

 - The growing economy's limited positive influence on making support and funding available for the arts.
 - Lack of alternative and independent investment sources for the arts.
 - Taxation and legal structures that do not function well to promote cultural philanthropy.
 - The effect of inflation, particularly increases in service costs associated with the mining supply chain, which has negatively impacted artists and independent arts organizations.
 - Limited competitive human resources to sustain arts activities in a market economy.
 - The large territory of Mongolia and unequal access to arts and culture in rural areas and among disadvantaged communities.
 - The threat of losing Mongolia's cultural heritage within the broader context of globalization and information technologies.
 - Lack of recognition within the traditional education system of creativity as a major factor in human and youth development.
 - Lack of awareness among policy-makers and the general public about the importance of arts and culture as part of everyday life and as an innovative source of economic and social development.

- **ACM's Strengths**
 - Transparency and accountable governance and operations.
 - Prominent, highly respected members on ACM's board.
 - The high national and international visibility of ACM's programmes, operations and achievements.
 - Creative programming elaborated in a flexible mode and collaborative manner, giving successful results.
 - Highly competent, goal-oriented and motivated staff.
 - Diversity in fundraising from different sources.
 - A wide range of partners and stakeholders who support ACM's activities and programmes and are engaged in brainstorming exercises for further development.
 - Innovative and proactive approach in the overall programming, operations and fundraising.
 - Developed know-how and expertise on national cultural policy instruments and tools, as well as the organisation of diverse events (conferences, workshops, seminars, etc.).

- **ACM's Weaknesses**
 - Limited capacity to reach all regions of the country and reflecting on the needs of different rural communities.
 - Limited staff capacity to meet all needs and all creative directions of programming and fundraising.
 - Limitations of time and money to pursue desired optimal programming.
 - Growing competition among art and culture organisations for the limited funding available on a national level, as well as applying to international donors.

10.7. Functional Strategies: Highlights

- **Creative Offers**

 The Red Ger Art Gallery was established in June 2003 with the aim of promoting Mongolian fine arts abroad and within the country and of supporting sustainability in Mongolian fine arts by providing a market platform for artists. A significant part of ACM's annual fundraising occurs through sales at the gallery.

- **Marketing, Audience Development, and Public Relations**

 Starting in 2011, ACM's marketing and communication division became a new component of the advocacy programme to promote ACM's activities and Mongolian arts and culture to a broader audience through different publications on local and international printed and online media, event calendars and targeted marketing for specific ACM projects.

- **Financing and Fundraising**

 Creative programming and marketing tools are tightly connected with a strategy of ongoing fundraising from diverse sources, and the elaboration of programmes to increase self-generated income. For all programme staff, 50 per cent of their overall workload is proposal development and relationship-building with potential partners and donors. As already mentioned, ACM's funding comes mainly from

 - project-based fundraising from international and local resources;
 - memberships; and
 - self-generated income from Red Ger Gallery sales and ACM's services for businesses.

In this regards, ACM's programme directors and coordinators are responsible for developing innovative and mission-relevant project proposals which could raise funds from local and international sources.

10.8. Innovative Aspects

ACM is the only organisation of its kind in Mongolia, and it works on the national as well as the international level. Since it began operation, ACM has gained extensive experience in project management including proposal development, fundraising, project implementation, partnership, marketing and communication, time and risk management and teamwork, which by itself is a very innovative project management and strategy-oriented approach for the Mongolian arts management practice. ACM staff consider two new programmes as innovative in their attempt to bring in individual and business supporters and funders:

- **Membership campaign.** In 2009 ACM launched 'Bringing the Arts to You!' This is an annual membership campaign to recruit individual and organisational members to support ACM. In 2011 ACM established a development programme with the goal of ensuring the sustainable development of ACM and Mongolian arts culture through building creative partnerships with local and

international businesses and increasing the organisation's earned revenues. To implement this programme, ACM set up an advisory committee consisting of 15 experts with the task to oversee and advise ACM's development and fundraising efforts. Membership in ACM provides members access to special events as well as a network of like-minded individuals and organisations. Different levels of membership offer unique benefits, including invitations to ACM's 'Creative Series'. These special events take place throughout the year and offer members the chance to see performances, meet artists, visit museums and attend creative art lectures.

- **Arts and Business.** Within the development program strategy, ACM initiated a new programme titled Arts and Business Services, consisting of events management, as well as arts and heritage consulting services for local businesses. The next step is the elaboration of a cultural adjustment program to help expatriates living and working in Mongolia to understand Mongolian people, society and culture.

Memberships in ACM bring in 18 per cent of the total income, and Arts and Business Services Programme generate income from local businesses. Both go to support ACM programmes and operations. The expectation is that ACM memberships and Arts and Business services will greatly contribute to ACM's long-term sustainability in both programmes and operations. They will strengthen partnerships between the arts and business sectors and will contribute to increased awareness about the arts and culture in society, and especially among business communities.

10.9. Lessons Learned

ACM's team shares the following lessons learned as a result of their arts management practice:

- 'The strategy of capacity building for an emerging organisation is a long process and takes a minimum of several years to bring results. To be successful, it has to attract a wide range of support from diverse external stakeholders: government authorities, international funders, key individuals and cultural communities as a whole.'
- 'Keep close relationships with your board members and use their capacity and skills. Make them feel recognized, needed, involved in the organisation's work. Respect their opinions and treat them with special care.'
- 'The focus of any programme or strategy in the arts is artists and their creative efforts. Arts creativity has to be nurtured from the very early school years, and this is why the connection between arts and education is crucially important for building up future audiences and supporters for the arts.'
- 'Creative partnership is the most important way of doing any programme initiative within the organisation. ACM tries to avoid any duplications or unnecessary competitions, especially with the arts and culture community. The team believes that creative partnership is a much better strategy than competition or duplications.'
- 'Transparency in programming, operation, financial management, decision making and communications are the most important factors to sustain ACM's activities in the long term. Annual audit of ACM's financial management is requested by ACM's board on a mandatory basis.'

QUESTIONS AND ASSIGNMENTS

- Elaborate the key elements of ACM's capacity-building strategy and discuss connections with the functional strategies.
- Discuss the types of strategies chosen by ACM for its next planning cycle. Give arguments for the strategic choices, connecting them with the results of the SWOT analysis.

- Help ACM to elaborate a strategy of collaboration with the Mongolian Tourism Board[33] and other touristic agencies for broader visibility of its programming and fundraising internationally. Keep in mind the current creative programmes and uniqueness of the organisation.
- Suggest ways to expand activities outside of the capital by using one of the programme-market strategies which is applicable in this case.
- Suggest a set of innovative online methods for fundraising, sponsorship and increasing of ACM's international visibility. Connect these methods with the current programmes and future strategic goals.

Note: You might need to perform additional online research to complete these assignments. In your answers, apply the theoretical concepts and the methodology from Chapters 1, 4 and 5 as well as this chapter.

7 Marketing, Creative Programming and Audience Development Plan

LEARNING OBJECTIVES

Upon completing this chapter you should be able to:

1. *Understand why marketing strategies and tools are needed and used in arts organisations.*
2. *Discuss how market research and audience segmentation help strategic decision-making.*
3. *Understand the balance between creative programming and diverse marketing tools in an arts organisation.*
4. *Prepare a 'marketing-mix' recipe for an arts organisation.*
5. *Analyse the opportunities and challenges when creating and managing an online space.*
6. *Elaborate the marketing section of a strategic plan for an arts organisation.*

1. WHY USE MARKETING IN ARTS ORGANISATIONS?

Elaboration of the marketing section of a strategic plan requires an understanding of the basic marketing terminology and how it is applicable to arts organisations. Strategic marketing objectives differ depending on the type and the size of the organisation, the general strategy for development, the directions in the creative programming, the marketing experience and competences of the team and many other factors. As discussed in Chapter 3, there is a strong interdependence between the main organisational strategy and functional strategies in an arts organisation. The marketing plan follows the chosen main organisational strategy and suggests concrete ways to attract and involve audiences, improve the efficiency of the distribution channels or improve the overall organisational image. Marketing in the arts is often well connected with fundraising and financial strategies, and it helps for increasing the revenues from diverse sources, attracting supporters and fund-givers, or implementing a new price policy.

This chapter is about how to plan marketing and communication with audiences in synchronization with creative programming in an arts organisation over the long term. It is about marketing thinking and strategies, backed up by the choice of the most appropriate marketing tools and methods. The chapter discusses basic marketing terminology, giving a rationale as to why marketing strategies are useful for arts organisations and what the options are. It provides at the end a skeleton for the content of the marketing section of a strategic plan.

Marketing is an essential management function and an important part of every strategic plan. There are hundreds of definitions of what is 'marketing'. Theoretical resources offer diverse viewpoints on marketing strategies and tools and their usefulness in the arts and culture sector[1]. A few widely used definitions are highlighted here:

- The American Marketing Association defines marketing as 'the process of planning and executing the conception, pricing, promotion and distribution of ideas, goods, and services to create exchanges that satisfy individual and organisational goals'[2].

- The Chartered Institute of Marketing in the United Kingdom emphasizes that 'marketing is the management process responsible for identifying, anticipating and satisfying customer requirements, profitably'[3].
- Marketing guru Philip Kotler defines marketing as 'a social and managerial process by which individuals and groups obtain what they need and want through creating, offering and exchanging products of value with others'[4].
- Renowned author and management expert Peter Drucker points out the importance of marketing and innovation for business companies, saying: 'Because the purpose of business is to create a customer, the business enterprise has two—and only these two—basic functions: marketing and innovation. Marketing and innovation produce results; all the rest are costs. Marketing is the distinguishing, unique function of the business'[5].

A review of specialized literature on the topic shows that the widely used definitions of marketing contain the following essential elements:

- Marketing is a process and not just a one-off transaction.
- This process should bring mutual satisfaction for both parties involved: the customers (clients, buyers) and the company (the organisation) which offers the goods and/or services.
- The aim for the organisation implementing marketing is normally (but not always) to increase profits, while the aim for customers is to satisfy their needs and expectations as a result of purchasing and using or consuming the product or experiencing the service.
- The centre of all marketing activities is the customer (the client).
- There is an ongoing communications exchange between the company and the customers in a way that not only sells but also informs, educates, motivates and builds a relationship over time.
- This process also aims to convey values and to influence, as well as change, customers' behaviour over time.

Marketing has a long history in business management theory and practice. It is a relatively young discipline (compared to economics, accounting and other business disciplines), emerging in the early 1900s. From identifying strategies and tactics for selling more products and services (before and around the 1950s), marketing gradually developed in the past several decades as a philosophy and practice suggesting that understanding the needs of customers and building long-term relationships and mutual trust are the keys to success. Starting from the business and commercial sector, around the 1960s–1970s marketing strategies and tools expanded into other fields such as services and infrastructure, the non-profit sector and, later, the arts and culture sector as well. It has become clearer that marketing tools are not applicable only to 'selling-buying' transactions but are about the whole palette of ongoing communications between an organisation and its external environment. Therefore, marketing as a concept became equally useful in non-commercial areas such as education, health care and other branches of the public and nonprofit sectors. Application of marketing to nonprofit organisations originates from the articles written by Kotler and Sidney Levy (1969)[6], Kotler and Gerald Zalman (1971)[7] and Benson Shapiro (1973)[8]. In the late 1980s to early 1990s, marketing tools entered the practice of organisations from the nonprofit and public sectors.

Kotler is a pioneer in raising marketing issues related to cultural organisations, pointing out that these organisations must compete for consumers' attention and for limited resources; therefore, they face a marketing problem[9]. Kotler and Levy (1969) regard marketing as a complex of exchanges in which the aesthetic product—a painting, story, song or performance—is offered to the audience for a price—a price of attention, emotion and action[10]. Michael Mokwa, William Dawson, and Arthur Prieve (1980)[11] as well as Joseph Melilo and Patricia Lavender (1983)[12] are also among the first authors who implemented marketing concepts for arts and cultural organisations. Mokwa et al. (1980) regard marketing as 'a process of exchange between individuals and groups, each of whom wants something and offers something'. They emphasize that the role of marketing is to match the artistic creations with an appropriate audience, not to tell an artist how to create a work of art. Francois

Colbert (1993)[13] regards cultural marketing as 'the art of reaching those market segments likely to be interested in the product while adjusting to the product the commercial variables—price, place and promotion—to put the product in contact with a sufficient number of consumers and to reach the objectives consistent with the mission of the cultural enterprise'. Milena Dragićević Šešić and Sanjin Dragojevi (2005)[14] define marketing as a set of specific actions which aim at successfully selling a product to a specific audience at a specified price, under certain conditions. They point out that the main aim of marketing is to increase the institution's own revenue, and this is the yardstick by which its success is measured. The two authors emphasize that, unlike business marketing, marketing of the arts should not be allowed to use this information to change the institution's organisational culture and programme policies. Arts marketing must try to develop new forms and methods of operation, as well as new services, to make the present programme more communicative and thus attract new audiences.

This review of prominent theoretical resources and commonly used definitions demonstrates that there are several important and unique aspects to consider when applying marketing to the arts. They are as follows:

- The leading role of artistic and creative programming in the arts.
- The importance of aesthetic and joyful experiences for the audiences.
- The importance of educational aspects of the arts.
- The need for social dimensions of artistic projects and programmes.
- The connections between arts and community engagement and development.
- The collaborative and networking environment in which arts organisations operate.
- The need to incorporate innovative elements in marketing strategies and tools, both online and offline.

Definitions of marketing in the arts stress the need to maintain long-term relationships with audiences, communities, supporters and stakeholders and not just use marketing tools to increase the number of consumers and generate profits. It is important to emphasize that marketing in the arts is about leading audiences and communities, shaping their tastes and creating new needs and wants and not simply satisfying existing ones.

Figure 7.1 describes in a simplified way the marketing process in an arts organisation whereby there is an ongoing mutual-exchange process in which both sides give something and receive something in return, in a way that satisfies their needs and expectations. This exchange process is also about shared experiences. The marketing process is a kind of interface between the organisation and its external environment.

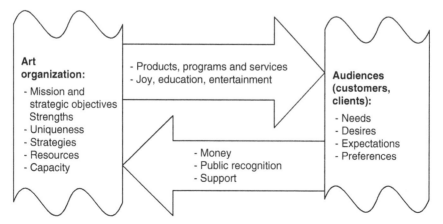

Figure 7.1 Marketing as a process between an arts organisation and its audiences

There are arts managers and artists who are doubtful about using marketing methods in the arts and culture sector and argue the need for elaboration of marketing strategies. Such resistance exists especially in countries with centralized systems of state support for the arts and in the subsidized culture sector. This resistance comes from prejudices and mindsets such as the following:

- 'Culture and arts should be supported primarily by the state and not dependent on commercial principles. Therefore marketing intervention in the arts is wrong as it aims to generate sales revenues and profit.'
- 'Marketing tools are always commercial, and they decrease the quality of the art.'
- 'The art is about creativity, inspiration and muse and can't be limited by pragmatic methods of sales and distribution.'
- 'If our team offers high-quality art, the audiences will come anyway.'
- 'The arts are about leading and opening audience tastes, while marketing fulfils existing needs. Therefore both are incompatible.'

As outlined in Chapter 1, arts managers and entrepreneurs are lodged between artists' creation and audiences' needs. They are the persons responsible for attracting and developing audiences, selling artistic programmes and products; sustaining ongoing contacts with the media and the general public; seeking sources of funding and ways to increase sales revenues; implementing diverse cooperation schemes; maintaining processes and keeping the organisation running as well as developing. These functions form part of the marketing portfolio of a manager. Marketing managers need to work in ongoing cooperation with artistic leaders in order to develop strategies that are in harmony with the nature and essence of the artistic products.

There are many arguments as to why marketing tools are appropriate for arts and cultural organisations and projects. The following are important ones:

- Marketing helps an organisation attract audiences in a competitive environment of many and constantly increasing choices and offers in the cultural and entertainment industries.
- Marketing communicates the organisational identity to external audiences and stakeholders and makes them understand better why the organisation exists and for whom.
- Marketing helps arts projects and initiatives to become more visible, both offline and online.
- Marketing helps to increase the external support and additional revenues, and this is why it is often connected with financial strategies, fundraising campaigns and sponsorship.

Marketing strategies and tools in the arts also help strengthen the internal capacity. They contribute to further improvements of the creative programmes, based on the constant feedback from audiences; assist the overall decision-making process by researching the changing external environment; and help in the elaboration of risk-mitigation strategies.

2. STRATEGIC MARKETING OBJECTIVES

The marketing section of the strategic plan has to be in line with the overall strategy of an arts organisation, as it 'translates' the long-term goals into specific marketing objectives, considering the market research as well as the organisation's internal capacity. The content of the marketing plan focuses on four main pillars:

- Identification of the *audience profile* and specific *audience needs and attitudes* towards the offered creative products and services through marketing research;
- Elaboration of the organisation's *competitive advantage and uniqueness,* as well as elements of innovation in both the creative programmes and the marketing tools;

- Elaboration of the *marketing mix* to find out the most appropriate ingredients related to the product, price, place and promotion to be offered to the target audiences;
- Outline of the *marketing budget*.

The marketing section of the strategic plan is critical for the long-term success of an arts organisation. This chapter provides an outline of the structure and content of the long-term marketing plan, although it could vary depending on the general structure and mission of the organisation, its size, its market positioning and many other factors. There is an ongoing tension in the arts between marketing strategies and programme (product) strategies. This is because it might look on the surface as if marketing is only about sales and profits, while creative programming is about concentrating on the quality of the products and the artistic creation. However, marketing strategies in the arts can have different directions and aims (as shown in Figure 7.2). The key for an effective marketing strategy is to assist and support the main creative process, irrespective of the organisation's type—business or nonprofit.

When elaborating creative programming strategies, it is important to connect them to the main strategic marketing objectives. As shown in Figure 7.2, these objectives could be

- To educate and engage audiences and communities and help them to understand better the core artistic products and services;
- To develop audiences' tastes and to involve them in diverse cultural experiences;
- To increase diverse audience segments' access to the core programmes (regionalization, touring, improvement of distribution channels, etc.);
- To create, improve or change the public image of the organisation (in cases where it does not exist, is low or is negative);
- To increase revenues as well as profits coming from offering paid programmes and activities; and
- To seek external support from different institutional and individual supporters.

Marketing strategies which help to increase revenues from paid programmes and activities are especially important for commercial organisations and arts-based businesses. Strategies to maintain high-quality artistic programming, increase audiences' access and participation and educate audiences are common among subsidized arts organisations and those having a nonprofit status.

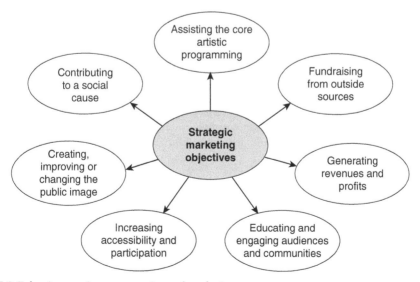

Figure 7.2 Balancing creative programming and marketing

It is important to note that a strong balance between creative programming and efficient marketing happens when there is close cooperation between the artistic leader/director and the marketing manager. The role of the board is to ensure that this balance is achieved and gradually implemented in a strategic framework. In small organisations these diverse roles can be performed by one person, combining an artistic vision with marketing skills and competences. These organisations might not have specialized marketing departments, as well as sufficient knowledge on how to implement marketing tools. In such cases low-cost marketing research and communication methods are very important. They often use *buzz-marketing*[15] and word-of-mouth marketing instead of paid advertising and other expensive promotional techniques.

PRACTICAL RECOMMENDATIONS

The marketing section of the strategic plan is a result of the chosen overall strategy. It is a logical continuation of the previous sections of the plan. When elaborating the marketing section, it is important to answer the following key questions:

- Do we know our audiences well? Why? Why not?
- How can we better know, attract, satisfy and educate our audiences (buyers, clients) in the future?
- What main methods should we use in the overall process of audience development and engagement in the creative programming?
- Are our artistic programmes and projects oriented towards the needs and expectations of our current and future audiences?
- How can we ensure that we are selling the right programmes and projects to the right people, in the right place, at the right time, using the right communication tools?
- How can we create and apply the most appropriate 'marketing mix' (product, price, place and promotional strategies)?
- What could be the most efficient ways to connect audiences' expectations and motivations with the right communication tools?
- How can we increase the public image of our organisation and the visibility of our programmes?
- Are there any elements of our programming that could generate profit and secure financial sustainability?

3. DIGITAL MARKETING

Practice in the arts sector shows that the marketing strategies of arts organisations nowadays are successful if they contain innovative elements. As discussed in Chapter 1, innovations are not limited to new products or services. They include thinking up and implementing new business and marketing models as well. Feedback from clients and customers is a powerful source of innovative ideas. Marketing innovations are in a constant state of evolution, especially considering the ongoing improvements in new technologies and online tools. Some of the current trends in marketing-related innovations influencing arts organisations are as follows:

- The rapidly expanding role of social media in all marketing communication strategies and tools;
- The changing role of audiences, from passive viewers to active participants in the creative process;
- Production and offers of more digital content for arts products and services;
- Mobile marketing—using mobile devices for marketing products and services;
- Co-marketing to boost returns and lower marketing costs;
- Consideration of customers' attitudes and opinions about the products and services, listening to their new ideas for changes and improvement.

The practice of promoting products and services in an innovative way, using primarily database-driven online distribution channels to reach consumers and customers in a timely, relevant, personal and cost-effective manner is known in the theory and practice as *digital marketing. Internet marketing*[16] is another commonly used term in arts management practice, referring to products and services offered via the Internet, as well as via email, wireless media and online devices.

A *user,* or *online visitor,* is a term applied to those people who browse websites and participate in on-line social networking sites and other online tools. Digital marketing strategies and tools are different from traditional marketing because of the following features:

- **Interactivity.** Online users choose when to initiate contact, and for how long.
- **Duration.** Online resources are usually permanently available and are not campaign-driven.
- **Active users approach.** The offered online content is offered to users on an ongoing basis, and they choose to consume it or not.
- **Dialogue with and among users.** Online marketing allows collaboration between users and open expression of their opinions and attitudes towards the product (service) offered.
- **Rich content.** Online marketing offers practically unlimited content and the flexibility to be updated on a regular basis.
- **Measurable.** Online technologies allow following up users' participation (active and passive) at any time.
- **Adaptable.** It is easy to change online content based on users' feedback.

Elaboration of the marketing part of a strategic plan requires a careful consideration of a targeted mix of traditional and non-traditional marketing tools which matches the organisation's strategic goals as well as the audience's profile very well.

PRACTICAL RECOMMENDATIONS

When dealing with digital marketing, keep the following tips in mind:

- Elaborate and demonstrate clearly the uniqueness of your organisation as well as the uniqueness in the way you deal with your online users.
- First build your organisation's overall credibility and image before starting to offer specific products or services via social networks.
- Remember that building an online community first is more important than implementing online sales methods and gaining revenues. Gaining general recognition and trust from users facilitates any future offers.
- Use an 'online language' to communicate the messages: they should be short, focused, catchy and inviting.
- Tie arts events to social causes, where relevant.

4. AUDIENCE DEVELOPMENT STRATEGY

The main focus of arts marketing strategies is the audience. In daily life, the words *customer, client, buyer, audience* and *user* are commonly used as near synonyms. Marketing theory, however, distinguishes between them:

- An *art buyer* (purchaser) is someone who enters market relations with the purpose of buying goods. In arts and culture, a buyer obtains CDs, books, paintings, sculptures and other art-related objects. Frequent buyers of fine art objects are called *art collectors.*

- A *customer* is a buyer or client who maintains a relationship with the organisation or place where he purchases his goods and goes there often.
- An *art client* is someone who pays money to acquire services.
- An *attendee* is a client who participates in and benefits from services, for example museum attendees, exhibition attendees or attendees of historical sites.
- An *audience* is a group of people who attend a live event or participate in an art experience such as theatre audiences, music audiences and opera audiences. *Audience* as a general term used in arts marketing usually replaces the more 'commercial' terms such as *buyers* and *customers*. Audiences are also the listeners and watchers of broadcast programmes. Less common, but also used in marketing practice, is the expression *museum audience.*
- A *community* is a group of interacting people, sustaining relationships and living in one location (or sharing an online space and common interests regardless of the location). *Community* is used mainly in nonprofit organisations' marketing strategies and tools, as well as in online marketing. In arts marketing theory and practice it has the meaning of an upper level of audience development where there is a higher level of interactions between audience members, shared values, as well as a specific purpose for gathering—social, educational, environmental, and so on—which goes much beyond just participating in an art event.

Nonprofit and subsidized arts organisations most commonly use the terms *audiences* and *communities,* while commercial organisations refer to *art buyers, customers* or *clients.*

4.1. Audience Development Process

The central figure in the arts is of course the artist. On the other hand, in many cases there can be no artistic production without an audience's participation and involvement, for example a live symphonic orchestra concert, opera performance, dramatic piece on stage or live music show. In other cases, organisations are unsuccessful without customers' purchases and the generation of profits, for example if an increase in revenues is a must. In subsidized arts organisations, a key factor in increasing audiences' participation and active engagement is the external financial support, which allows broader access to the art for vulnerable groups of the population, people living in isolated regions of a country or disadvantaged communities. Therefore, an important part of the marketing plan is to identify who the audiences are, what their main characteristics are, and what their attitudes towards the creative programming is.

Audience development is a term mainly associated with the arts and cultural field. It relates to methods, tools and activities to meet the needs of existing and potential audiences, to also create future needs, and to develop ongoing long-term relationships between the organisation and its audiences. Audience development is related to audience participation and active engagement in the creative processes. In the case of nonprofit or subsidized arts organisations, it usually also includes elements of education and then is called *audience outreach.*

Audience development requires as a first step an understanding of who the audiences are. One of the ways to group different audiences is based on the frequency of their attendance (participation) and their level of involvement in artistic processes. Figure 7.3 illustrates audience groups based on these criteria, as well as the stages in the audience development process.

Potential audiences are all those who may have an interest in engaging with the arts organisation's activities now or in the future. *Occasional audiences* are those who come to an art event not because they are familiar with the art form but because of sporadic factors. Their attendance rate is lower than the average rate of attendance for the year. *Regular audiences* attend (or come to the art venue) on a regular basis, and they form the overall average rate of attendance. *Frequent audiences'* rate of attendance is higher than the average. These are people who not only come to art events but are actively engaged in the organisation's activities. They are subscribers to seasonal concert series; members of the organisation, paying an annual fee to receive a package of services; or just informal friends to

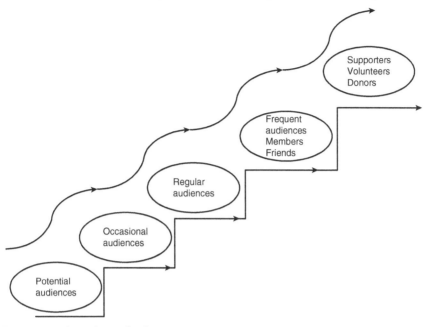

Figure 7.3 Stages in the audience development process

the organisation who support its development. The highest level of audience development are the *supporters*—volunteers, board members, donors and all others who devote time, money and/or efforts to the organisation's current programmes and further development.

One of the main objectives of an audience development strategy is to transform, step by step, potential audience members into regular audiences and then into devoted supporters and friends. The 'marketing-mix' process (discussed later on) aims to identify how to match the right programme (product) with the right audiences, at the right place, and how to communicate with them in the most efficient way. Therefore, for each one of these audience groups, different promotional and communication tools are used in the arts management practice.

4.2. Online Users

The Internet and digital marketing have changed the methods of researching and communicating with audiences, as well as the overall audience development process. Online users are global and not located in a specific physical place. Therefore, they create open markets and endless opportunities. Online users are quite critical as they can freely post their ratings, comments and opinions online (sometimes passing through a website's editorial control). They can be anonymous and might have unpredictable behaviour. In social networks, users are both consumers and also creators of online content: from passive viewers they become active participants. Figure 7.4 represents the stages in development of online users.

Passive users are the ones who read online content (websites, blogs and forums), watch videos and listen to podcasts, but they do not participate in it. *Online connectors* maintain a profile on a social networking site with the main goal of staying in contact with others and observing. They might or might not post content online, but they maintain a profile. *Online collectors* usually add tags to their photos or web pages, use bookmarking tools to easily collect or refer to content, and subscribe to RSS feeds for regular updates on preferred content. *Online contributors* give critical opinions, post ratings and reviews, comment on other blogs and contribute to online forums by posting opinions. The most engaged group of online users are the *creators of online content,* who publish their own blogs, open forums based on specific topics, or upload content (text, video or audio). They are also the ones actively involved in artistic creation online (in the case of multimedia art forms).

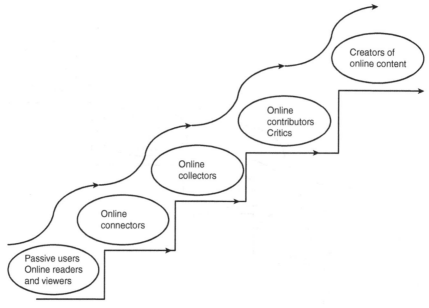

Figure 7.4 Stages in online users' involvement

The marketing section of the strategic plan focuses on understanding, engaging and keeping regular audiences and online users, as well as motivating them to stay engaged, participate and pay on an ongoing basis. It also focuses on reaching, attracting and involving new audiences and user segments, because contemporary art cannot exist without its audiences and supporters, both online and offline.

5. AUDIENCE RESEARCH

The commonly accepted definition in the theory of marketing is that *market research* is the systematic design of surveys and research tools, collection, analysis, reporting and interpretation of data and findings relevant to a specific market situation facing an organisation. Market research involves gathering, analysing and interpreting targeted information to help management's decision-making, especially over the long term. Therefore, each chosen method of research aims at decreasing the overall uncertainty as far as possible by bringing diverse concrete solutions to important marketing and other problems. As outlined in Chapter 5, the goal of the market analysis and research is to understand the potential clients (buyers) and competitors as well as the market trends.

On an organisational level, market research aims to help the overall strategic management process by suggesting which marketing strategies and tools would be the most efficient in relation to the organisation's strategic goals and capacity. In practice both terms—*marketing* and *market research*—are interconnected and in many cases are used as a synonyms. Their focus is on audiences.

5.1. Reasons for Audience Research

Audience research in the arts and cultural field is more important today than ever. Some of the reasons for this are the following trends in the external market environment:

- The marketing strategies of arts organisations nowadays have become more complex and focused, as well as more flexible and able to adapt to specific target groups. They need to be backed up by solid audience research.

- Competition among organisations in the entertainment and cultural industries has increased, as customers' time and money are limited, while the offers and their attractiveness have increased. It is important to know who the audiences are and how to keep them by conducting market research.
- Arts organisations experience a constant scarcity of funding which creates a need to develop marketing methods to help them generate revenues from their own programmes and projects. This can hardly happen without the interventions and participation of audiences.
- Audiences nowadays have a much more selective and demanding behaviour than before. Their choices change often because of the many offers available. Predicting their market responses is possible to a certain extent through frequent market research.
- Audiences reflect much more nowadays on the future programming by providing their feedback, responses and comments, including online. Their direct participation in artistic processes is much higher than before. This is why an important focus of market research is audiences' attitudes and suggestions for improvement of artistic programmes.

From a strategic perspective, there are several main reasons to plan and perform audience research:

- To understand how the audiences' profiles and motivations to attend an event, buy an art product or return to an art venue change over time;
- To find out which segments of the current audience are most important for specific artistic programmes offered and so should be given priority treatment;
- To research future audiences' needs, priorities and motivations in order to elaborate new creative programmes and projects in a strategic framework;
- To find out how much audiences are ready to pay for a product or a service and how their purchasing power as well as priorities are changing over time;
- To elaborate the most efficient ways to communicate with audiences and to engage them in the creative process, including via the use of online technologies.

PRACTICAL RECOMMENDATIONS

When planning audience research, it is important to consider the following key steps:

1. **Define the reason for undertaking research.** What are the current problems in your organisation? Why do you need to conduct audience research? How will the research results help in the decision-making process and revenue-generating strategy?
2. **Identify and evaluate the resources needed.** What is your current capacity? How much money and staff time do you have available to conduct the research process?
3. **Decide on your research methods.** What kinds of research methods do you intend to use? Why? How do they match your resources and expected outcomes?
4. **Prepare the questionnaire.** Keep in mind that questionnaires are different for quantitative versus qualitative methods of research. What kind of questions do you plan to ask? How do you intend to use the results of the research in your management operations, as well as in the strategic organisational development?
5. **Distribute the questionnaire.** Where and how do you plan to distribute the questionnaire?
6. **Collect primary data and data analysis.** What is your targeted feedback, and how do you plan to improve audiences' responses?
7. **Interpret the data and implement the results.** What are the main conclusions from the research, and how could they be useful in the strategic management and decision-making process?

5.2. Research Methods

Research methods are usually identified as techniques used to gather data. They are divided into two main groups:

- **Qualitative methods.** These are generally used for deeper exploration of feedback and opinions by a smaller number of respondents. Some of the most common methods in this group are the following:
 - *Focus groups.* These are small groups whose members are chosen to express opinions on specific issues. They are usually moderated in such a way that group members generate ideas and share open and sincere opinions.
 - *Personal in-depth interviews.* These are interviews conducted with selected targeted individuals in a one-on-one discussion. They contain open questions and require the interviewees to be familiar with the subject matter. In-depth interviews are more expensive in terms of time spent and the expertise required by the interviewee as well as the interviewer. They are very useful when the subject matter is sensitive or when a detailed understanding of a person's behaviour and opinion is needed.
 - *Observations.* These are about careful monitoring (in person or through video cameras) of what audiences do in the process of participating, attending, buying, and so on. Observation is a particularly useful method in situations where the required information includes an understanding of the actual behaviour of individuals in a natural setting (the environment).
 - *Expert evaluation.* In this case the organisation hires an outside consultant or expert to submit a report on specific problematic areas in the marketing process and to suggest possible solutions.
- **Quantitative methods.** These methods involve a large numbers of respondents and expect feedback that is easy to give and is less time consuming.
 - *Marketing survey.* This is a popular technique in which a relatively large sample of the potential or regular audiences is asked closed, short and easy-to-digest questions, related to the issue needing to be investigated. The way a marketing survey is arranged depends on the reasons for doing it, the budget and the time available, as well as the method of distributing the questionnaire. It is important to plan a method which gives maximum feedback.
 - *Experiment (test) marketing.* This is an experimental production offered to a small market segment to see how it would be accepted. This method is useful when launching new products, advanced productions and innovative or alternative programming.

Table 7.1 summarizes some of the quantitative audience research methods most commonly used by arts organisations.

An audience survey usually gathers information in the following key areas:

- Audience profile: examining characteristics such as age, educational level, professional affiliation, geographical location and others;
- Attitude towards the creative programmes, products or services. The questions in this group are related to
 - general evaluation and level of audience satisfaction with their cultural experience (participation in a programme, purchase of a product, attendance at an event);
 - motivations (reasons) for attendance or purchase; and
 - ideas for improvement of the programme, product or service.
- Attendance and accessibility. This group of questions is about
 - accessibility (the time to reach the art venue);
 - frequency of attendance; and
 - the manner of attendance (individually or in a group).

Table 7.1 Examples of Quantitative Research Methods in the Arts

Method	Specific features
Online survey[1]: • Via email • Via the organization's website • Via customised software for marketing research	Arranging feedback on an organisation's website yields limited responses by users, unless there is an incentive attached to the survey (e.g. a prize offer). Using ready-made software products for marketing surveys to facilitate distribution channels and provide easier, and faster, analysis of the results.
Regular mail	Sending letters or postcards to households in the region where the arts organisation operates, containing the questions to be answered.
Direct mail	Sending letters, postcards or emails to members, subscribers and supporters. The percentage of responses is usually high, as these audience members know the organization well and are ready to contribute.
Short interviews: • Via the telephone • In person	Asking short questions a of random people, either on the telephone or in person (e.g. on the street or during an event).
Questionnaire on the spot: • During an event • At other public places	Distributing the questionnaire either at the place where the product (programme) is offered or in other public places such as libraries, shops, hotels and public transport facilities.

[1] Online audience survey methods are quite popular. The feedback is higher if the questionnaire is distributed through email or another online method.

- Other areas. Questions can be asked also about
 - audiences' interests in other similar art forms;
 - audiences' preferences regarding things to do in their free time; and
 - sources of information about the event (product).

The choice of an audience research method depends on many factors, among them the expected results of the research and how they will be used in the decision-making process, the budget and the time available, the capacity of the team to conduct such research and the overall audiences' profile.

5.3. Segmentation, Targeting and Positioning

One of the important outcomes of audience research is *market segmentation*. This is a process of separating the *neutral market* into various pieces (segments) of audiences (buyers, clients) which have similar needs, preferences and models of market behaviour. Organisations usually perform segmentation to find out to what degree audiences' demands are similar and why.

Marketing literature identifies several basic requirements for defining a market segment:

- It must be significant—distinctive from other segments.
- It must have a certain size—have quantifiable characteristics.
- It must contain buyers (clients) who respond in similar ways to market offers, stimuli and pressure.
- It must be relatively stable over time—not change too often.

The segmentation variables most commonly used in arts marketing practice are age, gender, educational level, professional affiliation, annual income, family size and geographical location. The audience members in a particular segment respond to similar market fluctuations and require the provision of identical or similar products or services.

Theoretically, once the market segments are clear, the next step is the process of *targeting*. It is aimed at using specific marketing strategies and promotional schemes to fit the tastes, needs and expectations

of the audiences in the targeted segments. In arts marketing practice these segments are called *target groups*. Once the target groups are defined, marketing efforts are directed to *positioning* of the product. This process helps an arts organisation to create a perception of the products and is connected very much with branding and image-building.

6. MARKETING MIX RECIPE: THE FOUR PS OF MARKETING

The *marketing mix,* or *four Ps of marketing,* is probably the most commonly used concept in marketing strategies in the arts and is a focus in the marketing section of the strategic plan. The four Ps refer to the four variables product, place, price and promotion[17]. An efficient mix usually responds to the needs and expectations of the audiences (buyers) while at the same time maximizing the performance and financial results of the organisation, increasing the quality and the level of professionalism of its pro-grammes and products (services). The extended understanding of the marketing-mix concept includes three more Ps—*people* (all those involved directly or indirectly in the marketing activities, such as managers, staff and volunteers), *processes* (mechanisms and operations) and *physical* facilities (the space where the service or product is delivered).

 In the elaboration of the marketing-mix strategy of an arts organisation, it is important to consider the conventional four Ps and how they will change in the future, as well as their 'translation' into the Internet world as this is a very important trend nowadays. Online marketing uses the four Ps differently depending on the type and the usage of online space. In principle, online marketing relates to

- selling physical products (CDs, books, paintings, etc.) by using online tools (e-commerce);
- creating and selling virtual art products, for example digital photographs, artwork, music mash-ups, and more;
- selling services online, for example information, research results, databases, consulting services and/ or educational packages;
- engaging in online promotion and advertising—using online tools to make the programmes or organisation more visible;
- communicating, sharing and collaborating with audiences—using social networking sites and Web 2.0 tools, such as blogs, forums, tags, social bookmarking, and more; and
- connecting the online visibility of an arts organisation with opportunities to raise money for a specific art project or social cause[18].

 Elaboration of the marketing mix depends on the chosen organisational strategy (or set of strategies), such as programme-market strategies, competitive strategies, strategies for integration and partnership, and others, discussed in Chapter 6. The strategic approach to the four Ps requires a careful analysis of the current status of each one of them, and what the envisaged changes would be in terms of the future development.

6.1. The First P: Programme Strategy (Creative Programming)

The term *programme strategy* in an arts organisation refers to the elaboration of a strategy for further artistic programming—for creation of artistic repertoire and new offers and services. Creative teams in an arts organisation are essential in this process—dancers, actors, choreographers, conductors, musi-cians, and others. When elaborating an artistic programme from a marketing perspective, there are two main dimensions to discuss:

- The *quantity* of the products and programmes offered—the number and frequency of performances, productions or exhibitions;
- The *quality* of the programming.

Peripheral products and services

Figure 7.5 Extended product structure

The concept of extended products or services in an arts organisation, know in the marketing theory and widely implemented in the arts practice, considers three layers (see Figure 7.5.):

- **Core products and services.** These result from the organisation's mission and are the actual artistic programming. Examples of core products (services) are the repertoire in a theatre, educational programmes in a museum, book sales by a book distribution company, the series of exhibitions in a gallery, or a writers' union's defense of the copyrights of its members.
- **Additional products and services.** They are closely connected with the core products or services and supplement the core artistic or curatorial process. These products and services could be a source of additional revenues. Examples are a theatre workshop for kids put on by a puppet theatre company, the production and sale of catalogues in a museum or a book on jazz sold by a recording company for jazz music.
- **Peripheral products and services.** These are offered in order to generate profit, to offer diverse activities not directly connected to the core product, and to answer specific needs of the targeted audiences. These could be sales of food by cafés and restaurants located at an art venue, sales in a souvenir shops located at a museum sales of beverages and food during an event, parking charges, babysitters offered to families attending an event, and so on.

Additional and peripheral products in nonprofit and subsidized arts organisations are directed towards securing financial stability and providing comfort for the audience. A golden rule in arts marketing is that such an extension of the product strategy should not diminish the artistic quality. Marketing managers need to carefully balance additional and peripheral offers so that the art programming remains the main focus and an ongoing concern in the overall marketing strategy.

When elaborating the programme strategy for a nonprofit or state-subsidized arts organisation, it is important to consider *educational aspects*. There are several ways in which arts organisations could be connected with educational programmes:

- Curricular support: implementing art subjects as part of the educational system at all levels (e.g. classes in music, drawing or singing).
- Artists working with schools and universities on an ad hoc or regular basis (e.g. specialized workshops, courses or modules related to different art forms).
- Regular attendance by young people from universities and schools at art events. This requires adaptation of the artistic programming to the needs and expectations of the young audiences.
- Training of young talent through secondary art schools, colleges, and universities.

Branding is also part of the product strategies as it is about making the elements of the organisation's identity (such as the name, logo, slogan or design) recognizable by more and more people[19]. An identity can become a brand once when the verbal and visual associations a product conveys are transformed through the personal attitudes of the audiences. Increased competition and market choices demand creation of a brand because this is one of the ways in which an arts organisation can distinguish itself from others and make its image and personality stand out. Branding increases audiences' emotional attitude towards a product or a service and motivates them to return.

PRACTICAL RECOMMENDATIONS

When elaborating the creative programming strategy, address the following issues:

- How does the creative programme correspond to the organisation's mission and long-term goals?
- What are the innovative elements in your artistic programming?
- Is the programme attractive and appealing to the targeted market segments?
- How would the organisation's resources and capacities handle the future programming?
- What are the requirements of the new programmes in terms of technical specifications and people involved?
- How will the new programming impact on the cost structure of the organisation?
- Which programmes, if any, are attractive to external donors? In what way? How could they be connected with the fundraising strategy?
- Which programmes, if any, might generate revenues? Which of them contain entrepreneurial elements (if any)?

6.2. The Second P: Price Strategies

Price strategies are important as they can motivate or restrict demand and increase or decrease the profits and competitive advantage of an arts organisation. It is important to keep in mind that for many cultural and artistic products, the consumer pays not only the price required to purchase a product or attend an event but also the price for the attached peripheral or additional products as well as the costs of the efforts spent in accessing the product (e.g. the time spent on transportation to reach a theatre).

A well-elaborated price strategy of an arts organisation should

- motivate audiences;
- reflect the quality of the artistic programme or product;
- be more appealing than that of the competitors;
- offer price packages and deals in collaboration with other organisations; and
- offer promotional prices to regular audiences, members and subscribers to motivate them to attend frequently.

Many factors influence price strategies in cultural organisations. The most important are the following:

- **The type of organisation.** Subsidized and nonprofit arts organisations can afford to offer products and services at lower prices than commercial ones, as the subsidy helps to decrease the prices which the end consumers pay.
- **The quality of products and services.** High-quality art is usually sold at higher prices.
- **Demand.** This factor is important for commercial arts organisations where audiences' tastes and interest influence the price policy—higher customers' interests lead to higher prices.

- **Collaboration.** Arts organisations which offer price packages in partnerships are more successful in attracting audiences than ones working in isolation. Examples include seasonal subscriptions, one entry card for several museums in a city for a certain period of time or a number of prepaid theatre performances in several theatres.

There are five basic methods for planning the prices:

- **Cost-based.** This method requires a calculation of the direct and indirect costs. Direct costs are tightly connected with the production process, such as the fees and salaries of the artistic team and material costs for direct production. Indirect costs are not related to the production process, such as costs for administration, depreciation, insurance, security or communications. The elements and structure of direct and indirect costs vary depending on the concrete artistic product. Costs can also be divided into fixed and variable types. In a simplified accounting approach, the price is calculated based on total costs (direct and indirect), plus the expected profit[20].
- **Competition-based.** In this case, it is important to find out how the competitors are performing, and what their price strategies are, so that the offered prices for the same or similar products are better, or at least not higher, than those of the competitors. If the organisation is dominant in the market, it could be the price leader.
- **Demand-based (or consumer-based).** This method puts consumers' demand at the centre of calculating the price. It is very popular for commercial and business arts organisations, where prices increase when consumers' requests and attention increase.
- **Advanced.** This price method is based on the assumption that the programmes offered have unique characteristics and are very attractive and inviting. For this reason there will be good market demand, even if the price is a bit higher than usual. For example, inviting star guest singers in an opera performance or a concert could increase the ticket price.
- **Subsidized.** These prices are common for organisations receiving the majority of their budget from state subsidies (or other major funding sources). The subsidy helps to decrease the price which in no way could otherwise correspond to higher cost of production. Certain arts fields expect subsidies because their economic nature makes the production costs much higher than what a consumers could afford to pay (e.g. opera performances, symphonic orchestra concerts, museum exhibitions or puppet theatres for kids).

Table 7.2 gives an example of factors influencing the price calculation for a painting or a sculpture created by a contemporary artist, to be offered for sale in a commercial gallery.

Very often price reductions are offered for certain target groups. Usually these are for disadvantaged or economically vulnerable groups of the population, such as families with low incomes, families with multiple family members, students, children and retired or disabled persons. Discount strategies are important in the arts, as they increase audiences' and communities' participation and provide wider access to diverse art forms, which is one of the core objectives in most documents related to cultural policy at national and local levels.

The use of online marketing tools has changed the price strategies. As already mentioned, traditionally pricing is based on calculating the costs, considering competitors' prices, and researching how much the consumers are willing to pay. In online sales and marketing some costs are drastically decreased, for example labour costs. In addition, intermediaries are cut out as the consumer buys directly from the organisation. Internet offers have caused prices to become much more competitive. The Internet also allows consumers to compare prices in an easy way. Technology allows tracking of visitors to the site and targeting of repeat visitors, as well as the offering of rewards or discounts to loyal customers on an occasional basis. It also gives an opportunity for the clients to determine and dictate the price.

Table 7.2 Example of Factors Influencing the Price of a Painting (Sculpture) by a Contemporary Artist

Prestige (image)	Quality	Artwork characteristics	Costs	Conditions of sale	Other factors
• Of the artist	• Of the final artwork (certified in a professional manner)	• Art school and style used	• Material costs	• Geographic region	• Limited edition of an art object
• Of the art dealer who plays an intermediate role between the artist, the gallery and the buyer (or art collector)		• Size of the painting (or sculpture)	• Labour costs (artist's fee)	• Time of sale (season, month, day of the week)	• Limits on availability of the art objects because of artist's death
			• Costs for advertising and promotion		
• Of the collector who has previously bought artworks from the same artist	• Of the art technique used	• Subject of the painting (or sculpture)	• Transportation costs	• Economic factors (overall economic development in a country)	
• Of the place where the paintings (sculptures) are exhibited and offered for sale	• Of the materials used by the artist	• Authenticity	• Installation costs		
		• Signature of the artist	• Insurance costs	• Occasional factors	
• Of the media who write about the artist and the exhibition			• Administrative costs		

PRACTICAL RECOMMENDATIONS

When elaborating price strategies, answer the following questions:

- What exactly are your audiences (customers, clients) paying for? What do they get in return for the money spent?
- What are the factors influencing the prices of the products and services offered?
- Which method will you use to calculate the prices for the different programmes and products offered by your organisation? Why?
- How is it possible to connect the price with the production costs and the value-added benefits for the clients?
- How do the price strategies change for artistic and cultural offers during the weekends, for subscription schemes, seasonal tickets, and so on?
- How will you diversify the price policy depending on the profiles of different target groups?
- Could you offer some of the programmes or services for purchase online? What are the pros and cons? What are the options and the risk factors?

6.3. The Third P: Place (Distribution Strategies)

In arts marketing, the *place* as part of the marketing mix covers two main aspects:

- The physical location where the purchase of a product or participation in an event takes place (concert hall, theatre venue, gallery, cultural centre, etc.);
- The distribution channels, that is, the places where people can buy tickets for an event.

The term *commercial location* refers to the physical site where the product is bought or consumed. *Physical distribution* covers all logistics and transportation involved in the process of bringing a product to the market.

Distribution strategies aim to move products and services to the end customer in the most beneficial way, using the right distribution channels and providing products on time. Distribution channels are those that play an intermediary role in the flow of goods from the producer to the consumer. They are

- online and mobile channels—using Internet and online tools for offers and sales;
- offline channels—using intermediary agents, organisations or individuals;
- a telephone reservation system; and
- an existing distribution chain of a network, association or other organisation.

Distribution channels can also be divided into direct and indirect. In direct channels the organisation that produces the product is the one that sells it. Indirect channels are those where there are intermediaries (people, organisations or tools) between production and sales. In indirect distribution, the use of more channels for one transaction increases the retail price, as each intermediary usually requires a commission.

There are different scenarios for planning of the distribution channels. The choice of an appropriate channel depends on the following main factors:

- The type, size and capacity of the arts organisation;
- The nature of the creative processes and end results;
- The available resources for marketing and specifically for the distribution part of it;
- The involvement of audiences in the creation and presentation of a product (performance, book, CD, painting);
- Connections between the production and the distribution.

The choice of a distribution channel for an arts organisation also depends on the balance between stability and mobility. For example, a touring theatre which changes the location of its performances regularly needs to develop a diverse set of distribution channels. Another example could be a permanent repertoire theatre having its own building for productions and performances and relying permanently on two main channels for selling tickets: the box office at the venue and the theatre website. Examples of distribution channels for different types of arts organisations and products are shown in Figures 7.6, 7.7, 7.8 and 7.9.

PRACTICAL RECOMMENDATIONS

When elaborating distribution channels, answer the following questions:

- Where do your audiences usually look to find information and purchase your products? Do you know enough about their purchasing and participating behaviour?
- What are your primary online and offline locations? How would they change in relation to the long-term objectives of your organisation?
- What kinds of distribution channels do other arts and cultural organisations use? Can you develop a distribution strategy in partnership?
- Are your current distribution channels and locations efficient? Why? Why not?
- Which distribution channels are best suited for your marketing strategy—direct or indirect ones? What are the opportunities and risks for each of them?
- How do you plan to mix online and offline distribution channels? How does this influence the cost-benefit analysis? How much would the planned distribution channels cost?
- Do you have sufficient competences to implement innovative digital and online distribution channels?

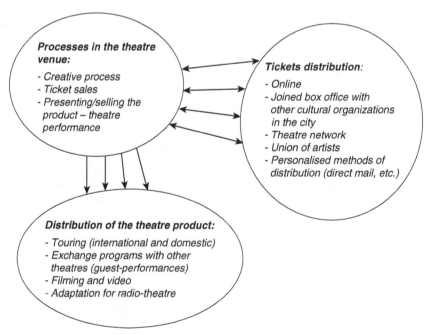

Figure 7.6 Distribution channels for a repertory theatre

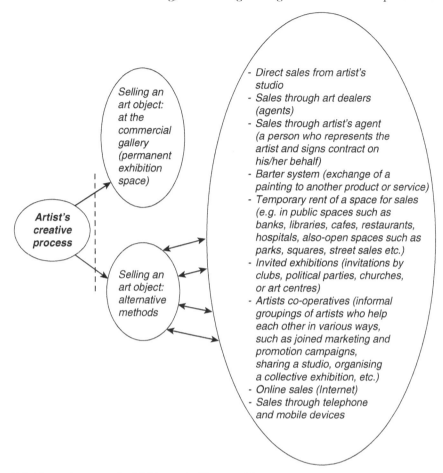

Figure 7.7 Alternative ways of exhibiting and selling art objects

6.4. The Fourth P: Promotion (Communication Strategies)

As emphasized, one of the main objectives of the marketing plan is to establish long-term relationships and trust between the audiences, communities and stakeholders that lead to further financial stability. Communication strategies result from the overall marketing strategy and help to achieve the long-term objectives of an arts organisation. A communication strategy aims to inform, attract attention, provoke interest, persuade, encourage, create desire and stimulate actions leading to purchasing of an art product and/or participation in a cultural event. Communication as part of marketing in an arts organisation is directed towards

- stimulating cultural demand;
- differentiating a product or a service from all others;
- creating or repositioning an organisation's image;
- involving and engaging audiences;
- increasing sales revenues;
- influencing and leading audiences' tastes; and
- advocating for the role of the arts and culture in the society.

In the arts marketing practice, *communication strategy* and *promotional strategy* are used as interchangeable terms, although promotion is part of the marketing mix, while *communication* is a much broader term, in many cases also used widely outside of the theory and practice of marketing. The overall communication strategy as part of marketing is called the *promotion mix* and involves

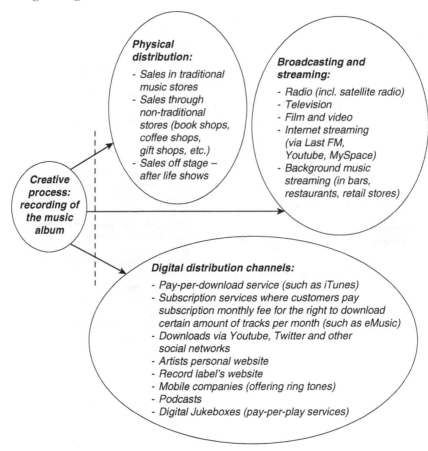

Figure 7.8 Distribution channels for a music album or a single

information, persuasion and influence over customers' behaviours and actions. Promotion includes techniques which not only help sell a product or service but also stimulate future demand. The promotion mix usually contains four main elements: advertising, public relations, sales promotions and direct sales.

- **Advertising**

 In a widely accepted definition, *advertising* is a paid form of non-personal communication and aims at presenting and promoting ideas, goods or services. The messages are communicated to potential audiences through impersonal media such as radio, television, newspapers, magazines and outdoor signs, as well as online methods. A commonly used checklist in marketing practice is called *AIDA*[21], emphasizing the four stages of effective advertising:

 - To attract the customer's *A*ttention;
 - To get the customer's *I*nterest;
 - To create a *D*esire;
 - To motivate an *A*ction.

Advertising is considered a non-personal type of communication because the message is presented to the general public. There is a degree of 'dramatization' in the way the message is communicated— different images, colours, pictures and sounds are usually used (if the respective medium allows this). Advertising messages are persistent—repeated many times, without imposing a necessity that the recipient must respond.

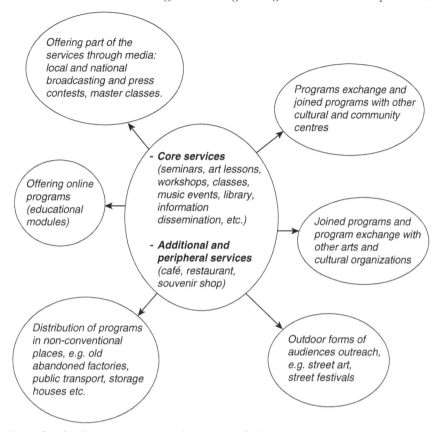

Figure 7.9 Cultural and community centre: diverse channels for widening accessibility

Advertising can be conveyed online, offline and through mobile devices:

- **Offline.** This is conventional advertising mainly through broadcasts and the press (television, radio, magazines, journals, newspapers), print materials (posters, brochures, catalogues) and outdoor signs (billboards).
- **Online.** This type of advertising uses the Internet and can be done through the organisation's website, other websites or online tools (podcasts, videos, blogs, online newspaper, social networking sites and others).
- **Mobile.** This is advertising using mobile (wireless) phones or other mobile devices and is becoming more and more popular, especially among young audiences.

The marketing mix includes setting up an advertising plan as part of the communication strategy. The main steps in elaborating this plan are as follows:

- **Formulating the advertising goals**
 - Choosing the most relevant media channels—press, print materials, broadcasts or online media or mobile devices. The print media and broadcasting are the traditional means of advertising, but in some cases these could be quite expensive. When one is choosing the relevant advertising channel, it is important to analyse existing options and to discuss their pluses and minuses.
 - Evaluating the available budget and the organisation's capacity. It is important to analyse whether the organisation can afford the chosen media or whether there could be a cheaper way of advertising, including using innovative features.
 - Deciding on the format of the message, its frequency and repetition, as well as the exact advertising materials to be prepared.

- Preparing the advertising message(s). This is a creative process which requires considering the recipients—clients, buyers or audiences. The text of the message should be created with simple words, short sentences and active verbs.

The advertising plan has to be synchronized well with other promotional tools and should reflect the overall organisational identity as well as the marketing goals.

- **Public relations (PR)**

Chapter 5 illustrated that an arts organisation is surrounded by different groups and other organisations—business companies, government bodies, competitors, fund-givers, sponsors, and so on. Public relations consists of complex activities with the aim to create, sustain or improve public opinion and trust towards a certain organisation. It is a process of maintaining and developing a mutual understanding between the organisation and its public, which helps to enhance its reputation and set up favourable conditions for future market interactions. Public relations is about the overall impression which an organisation creates in front of its audiences, clients (potential, current and future) and stakeholders. It is not just about selling a concrete product or service. The emphasis in public relations strategies is on attracting new audiences and supporters in the future, as well as keeping the current ones.

The most used public relations tools in the arts are press conferences, online newsletters and bulletins, open educational programmes and seminars, audio-visual materials (films, photos, etc.), press articles, television and radio presentations and interviews, public speeches and special public events. Together with finding the most effective public relations tools for broadcasting, there is also a need to elaborate tools for monitoring and measuring, helping an organisation find out what has happened once the public relations and advertising messages have been spread.

- **Sales promotion**

Sales-promotion methods aim at offering various stimuli to audiences and clients to buy higher quantities during a certain time period (the 'buy-one-get-one-free' concept) or to buy them sooner (for example subscription schemes). Strategies for sales promotion include various methods such as free gifts, discount prices for specific products, merchandising, bonuses or incentive packages, lotteries and prize draws, free samples, vouchers, coupons, involvement of new media (websites and mobile phones that support sales), and many others. The main characteristics of these methods are the following:

- Audiences have an easy way to answer and to participate in the offers.
- Offered benefits are temporary and have an expiration date.
- A lengthy process is needed to prepare and organize the campaign.
- Target groups respond differently to different offers.
- Costs of implementation are low.

There are two main groups of sales-promotion methods commonly used by arts organisations:

- *Methods influencing the purchase price,* for example discount policies and schemes for certain target groups if they buy sooner or buy using a different method of payment (e.g. subscription schemes or memberships). Subscription schemes are very useful in situations where audiences' attendance and participation is very low or when an arts organisation presents new authors, artists, products or programmes. Subscribers should always have the option to choose among several events or products.
- *Methods not directly influencing the purchase price,* for example discussion series, special prize draws and bonuses or incentive packages. Offered benefits could be

 - thematic, in cases where different arts forms are combined but reflect one main theme; or
 - based on audiences' tastes, in cases where clients have the possibility to choose at least one from a variety of arts forms on offer.

In all cases, it is important to keep sales-promotion methods simple and user-friendly. Over-complication is often very frustrating both for the organisation and for its clients.

- *Direct sales*

These are all methods of direct contact between the sales person and the buyer, in which the presented offer aims to provoke an action by the buyer. The rule is that personal interaction cultivates better relationships.

6.5. Planning the Communication Process

Planning of the promotion and overall communication process has several main stages:

- Clarification of target audiences (segments) in relation to marketing objectives.
- Definition of the main communication objectives as a result of the chosen marketing strategies and the marketing mix. These vary for different programmes, projects and products.
- Creative and design process, including writing the advertising message, clarifying the 'unique selling proposition', writing press releases and/or designing brochures.
- Selection of the main communication tools and combining them—online and offline, personalized and non-personalized.
- Designation of the frequency of using different channels (depending on many factors, including the cost for advertising).
- Consideration of budget limitations and calculation of costs.
- Review and feedback.

PRACTICAL RECOMMENDATIONS

When elaborating your communication strategy, answer the following questions:

- Why do you need to communicate?
- To whom? Who are your primary and secondary target groups?
- What kinds of messages do you need to transmit?
- What kinds of responses do you expect?
- What kinds of media (vehicles) are suitable for your organisation, and why?
- What is your communication budget?
- How will you evaluate the results of the communication strategy that you plan?

A classification of the most popular communication tools used in cultural practices is given in Table 7.3.

7. CREATING AND MANAGING AN ONLINE SPACE

The rapid development of online technologies has influenced marketing strategies and methods in the arts greatly. Setting up a website, a blogging space or an online tool for a specific project is sometimes the first step needed to communicate with audiences. There are several important areas to consider when elaborating an online space:

- **The scope and the focus.** What exactly will the website communicate about the organisation and its activities, programmes, products and people?
- **The unique features.** How is this online space different than all others? How does it reflect the organisation's identity?

Table 7.3 Classification of Communication Tools

Type	Tool	Example
Nonpersonalised	Advertising	Advertising through media (traditional and new media[a]): • Television • Radio • Press (print-based publications) • Cinema • Print materials (brochures, posters, catalogues) • Outdoor advertising • New media (Internet, websites, online tools, etc.)
	Sales promotion	• Subscription schemes • Incentive packages • Bonuses • Samples
	Public relations	• Press conferences • Press releases • Public interviews and speeches • Online newsletters
Personalized	Direct sales	• Person-to-person • Telephone
	Sponsorship[b]	
	Direct mail	• Mail and email correspondence
	Mobile devices	• Mobile phones, smart phones, personal digital assistants, and so on
	Public relations	• Targeted specific campaigns and events
	Specialized arts markets[c]	• Showcases

[a] The main distinction between traditional media (film, television, radio, paper-based publications, etc.) and the new media is that the new media allow the creation of content by users and access to content by users at any time, anywhere or on any digital device. New media uses the interactive power of the Internet, digital interactivity and communication tools that also offer the possibility for interactive user feedback.
[b] Sponsorship is a subject of discussion in Chapter 10 of the book.
[c] Examples for arts markets include MIDEM (http://www.midem.com), IAMA (http://www.iamaworld.com) and CINARS (http://www.cinars.org) (accessed March 27, 2012).

- **Profit versus nonprofit.** Will the website also be used for generating revenues from online sales of products, services or advertising space or other methods?
- **Dynamic versus static content.** Will the website be set up as a social networking platform allowing users to upload content (comments, ratings, profiles, etc.) and interact with each other, or will it be mainly a website controlled entirely by the organisation, without user interactions?
- **Technical matters.** What will be the costs and the future maintenance and security issues related to the new website? Would a ready-made software product be preferable to open source software or not? Why?
- **Collaboration.** How could the website be used for joint online advertising and marketing with other organisations in the arts and culture field?
- **Risk factors.** What are the possible risks affiliated with setting up the website (both technical and content-related), and how could they be mitigated?

A successfully elaborated website for an arts organisation or a project contains the following main elements:

- It reflects the organisation's identity while making users feel unique and special.
- It focuses and filters the information, considering targeted customers.

- It shows collaboration and networking with other organisations and with external stakeholders and is not only about presenting the organisation's own image and identity.
- It encouraging online interaction and critical reflections by users—comments on blogs, participation in forums, ratings of art products and services, or other forms.
- It is personalized—it presents people (artists, creative teams, the management team, board members, volunteers, etc.) and not only products and services.
- It contains a lot of visual elements—videos and photos—to animate the content.
- It is updated regularly, with relevant and trustworthy information.
- It contains elements of easy interaction with users—such as online chat between a user and an organisation member in real time, answering requests quickly and efficiently.
- It creates a sense of ownership for the online community of users.
- It is present at several well-known social networking platforms (YouTube, Myspace, LinkedIn, etc.).

Setting up and maintaining a website is only one of the many elements incorporated into the communication strategy of an arts organisation. Online promotional methods are not just about new channels but require a new approach to traditional marketing and the understanding of the customer's behaviour. Creating a website is also about creating an ongoing involvement, awareness and responsiveness by the users and establishing long-term relations with the users in a cost-effective way. This is why a strategic approach to the creation, maintenance and development of online space is essential in the marketing planning process.

The marketing mix, both online and offline, is a practical tool to elaborate the marketing strategy. On one hand, it helps satisfy the needs of audiences and create future needs. On the other hand, it assists the full utilization of the capacity and resources of an organisation and maximizes its performance and as a result, its revenues. The ingredients of marketing mix are adjustable and controllable throughout the process of the plan's implementation, as they constantly change.

PRACTICAL RECOMMENDATIONS

When elaborating the marketing section of a strategic plan, have in mind the following:

- Planning audience development and overall marketing in the arts is to a certain extent about making promises. Implementation of the marketing plan is about keeping the promises that you have made to your audiences, communities and clients.
- The marketing section of the strategic plan provides the main directions for development and also contains key elements of the operational aspects of marketing, especially in the first year of the three- to four-year strategic planning cycle.
- All elements of the marketing mix are co-related and dependent on each other. For example, the choice of communication tools depends on the essence of the creative programming, the targeted audiences, the available budget and the price strategies.
- Competing for audiences' attention, time, and money in the arts should not be done in an aggressive way—you need to pay attention and take care to balance all elements of the marketing mix. It is important to build up trust and positive long-term relationships with your audiences. This is especially important when elaborating subscription schemes and advanced payment for future cultural services and products.
- Public relations and image-building need to emphasize the public visibility of the creative products and programmes, rather than using purely commercial advertising and sales-promotion tools.
- Be creative and innovate when designing your strategic marketing plan. Use unusual forms of matching the right audiences with the right marketing-mix elements (product, price, place and promotion). Go 'beyond the box' and think of cheap and non-conventional methods of marketing and communications.

- Constantly follow up new trends and new methods of marketing in your field. Discuss whether, how and when some of them could be applied by your organisation.
- Keep in mind the power of the Internet and online tools to draw attention, increase visibility, sell products, attract supporters, create and share with your audiences. Be curious and explore.
- Remember that it is always much more difficult (sometimes even impossible) to bring back clients and audiences which have already been disappointed by attending your event or buying your art product, because these did not fulfil the promises you made. In some art forms consumers buy the product or the service before seeing it and experiencing it, for example when purchasing a new book or a ticket for a museum exhibition or a live performance. Therefore, meeting audiences' future expectations is of utmost importance in elaborating the marketing plan. Do not over-promise or under-deliver. Otherwise you might lose your credibility.

8. EXAMPLE OF A 'MARKETING, CREATIVE PROGRAMMING AND AUDIENCE DEVELOPMENT' SECTION OF A STRATEGIC PLAN

Programming, marketing and communications plan

Note: Main strategies, objectives, the focus and milestones are considered for three- to four-year periods in all dimensions of the programming, audience development and communication plan. Other details in the plan, such as detailed programming, prices, promotional tools and communication methods, could be part of the first year of the planning period, but it is difficult to develop these areas for longer periods.

1. **Description and main characteristics of the sector, related to a specific arts field (industry), including:**
 - Competitive advantage and unique selling point of the organisation (as a result of analysis of micro-external environment)
 - Analysis of the main competitors, stakeholders and collaborators
 - General market positioning of the organisation

Note: Synchronise with results from Chapter 5, related to the marketing factors in the external environment, and Chapter 6, related to market strategies.

2. **Market research: rationale and planned methods:**
 - Quantitative
 - Qualitative

Note: In most cases, planning specific research methods is part of a short-term operational plan. Important research directions could be identified for long-term periods.

3. **Segmentation and positioning: marketing segments for different types of products and programs and audience motivation:**
 - Core, peripheral and additional products planned within a time frame
 - Uniqueness and special features of each product
 - Current and desired audiences—main objectives of the audience development strategy

Note: Planning the overall program directions and audience segments is part of the strategic plan. Concrete programs and a more detailed audience profile are part of the operational plan.

Program/product	Desired audience segments (target groups)	Potential reasons for attendance
For each planned program, product or service, outline: • *its unique characteristics, quality and artistic dimensions* • *benefits offered to the audiences* • *core, additional and peripheral products and services (if any).*	*Identify the main audience segments (based on initial internal brainstorming and/ or on results from market research).*	*Answer the question: why would each audience segment (target group) attend the performance, buy the product and/ or participate?*

Programme 1

Programme 2

Product 1

Service 1

Product n..

4. Price strategies:
- Strategic choices in the price policy
- Key factors influencing the choice of price strategies

5. Distribution strategies:
- Place(s) for production, presentation and sale of the key products or services
- Main distribution channels (online and offline) and the rationale for the choice

Note: Concrete distribution tools for each product or service are part of the operational plan. The strategic plan empha-sises the main changes in distribution strategies over a three- to four-year period.

6. Communication strategies and tools:
- Communication objectives (for each of the planned programs, products or services)
- Target groups (for each of the planned programs, products or services)
- Main emphasis in the overall communication strategy, related to the organisation's identity—motto, logo, unique selling proposition, etc.
- Communication tools (different for each program or project): advertising through broadcasting and media (traditional and new media), print advertising, outdoor advertising, online advertising, sales promotions, public relations, sponsorship, personal sales.
- Evaluation of the effectiveness of each communication tool.

Note: Depending on the particular situation, the communication part of the marketing plan can include various aspects. The following is an example.

Program/product	Desired audience segments (target groups)	Communication tools
For each planned program, product or service, outline: • *its unique characteristics, quality and artistic dimensions* • *benefits offered to the audiences* • *core, additional and peripheral products and services (if any).*	*Identify the main audience segments (based on initial internal brainstorming and/or on results from market research).*	*List communication tools planned for each program or project. Where appropriate, include other details related to a specific communication tool (e.g. advertising message, motto, unique selling proposition, etc.).*
Programme 1		
Programme 2		
Product 1		
Service 1		
Product n...		

7. Resources needed for implementation of the marketing and communication plan:
- Expected marketing budget (also as a percentage of the overall budget)
- Human resources involved in the overall marketing and communication strategy
- Other resources

8. Methods of evaluation: success indicators and feedback.

Another possible approach to elaborate this part of the strategic plan is to plan the programmes, products or services in relation to all other elements of the marketing mix and the targeted audiences, as illustrated below.

Programs	Audience segments (target groups)	Price strategy	Distribution strategy	Promotion strategy (communication tools)	Resources required
Core Programme 1 (objectives and focus)	For each program or project identify audience segments (target groups) Examples of audience segments: • students • tourists • art critics • families from the region • curators • journalists • sponsorst • senior citizens (elderly)	For each program or project identify: • the method of setting up the prices • the basic price level • discounts and benefits offered	For each program or project identify: • the place • the main distribution strategy • the distribution channels	For each program or project identify: • communication objectives • the unique selling point • communication tools • the communication message • expected results	For each program or project identify: • the budget • the people • the material resources • the information • other resources
Core Programme 2 (objectives and focus)					
Core Programme 3 (objectives and focus)					
Additional and peripheral products and services: 1. 2. 3. etc.					

9. CASE: EXODOS FESTIVAL (LJUBLJANA, SLOVENIA): MAKING CONTEMPORARY ART ACCESSIBLE

The case was elaborated with the kind assistance of Natasa Zavolovsek, director of Exodos. The case text is based on analysis of primary data from a targeted quantitative research and additional online and offline documents.

9.1. Background

Exodos Ljubljana[22], established in 1994, is a nonprofit, independent theatre and dance production centre. For the past 17 years every spring it has organized the Exodos International Festival of Contemporary Performing Arts, the biggest and oldest international festival of this kind in Slovenia and in this region of Europe. The festival has become a space and a crossroads for European and world cultures, bringing information and joy to audiences and professionals and enabling other cultures to present

and promote themselves in the European cultural scene. The organisation also produces several new productions by young choreographers and directors every yea and promotes them in Slovenia as well as abroad. The Exodos festival also organized the Moving Cake Slovene dance platforms[23]. The newest project of Exodos is the Balkan Dance Platform, organized in 2011.

STUDYING THIS CASE WILL HELP YOU TO:

- Understand the importance of ongoing innovations and advances in artistic programming for an international festival.
- Analyse the specificities of marketing strategies and tools in a nonprofit organisation and the importance of the SWOT (strengths, weakness, opportunities and strengths) analysis for the choice of a relevant strategy.
- Understand practical approaches to the elaboration of a communication and promotion plan for an arts organisation.
- Recognize the elements of the marketing-mix concept in a practical case.
- Discuss the importance of regional and international collaboration and the multiplication effect of a festival's know-how for similar organisations and venues.

Exodos Ljubljana has always reinforced the awareness of the importance of European and world cultural consciousness, their diversity and similarities. Exodos Ljubljana is a member of the International Network of Contemporary Performing Arts (IETM)[24] and the Informal European Theatre Meeting and is a cofounder of the Balkan Dance Platform[25].

- **Team**

 The Exodos team consists of six persons: the director, project coordinator, marketing development director, technical director, web/text editor and public relations officer. The organisation has an international artistic board consisting of four professionals from Slovenia, Belgium and Hungary who play an advising and consulting role in the organisation's development—especially related to the creative programming strategy.

- **Budget Structure**

 The main revenues of the organisation come from the Ministry of Culture of Slovenia, the city of Ljubljana and European Union funding for specific projects. The company Tobacna Ljubljana[26] sponsored an Exodos project for four years (2009–2013): building a garden for smokers in front of the theatre places. The annual turnover of the organisation annually for the period 2009–2011 is 250,000 (on average). The breakdown of income sources is as follows:

 - Support from the city of Ljubljana: 38 per cent
 - Support from the Ministry of Culture of Slovenia: 30 per cent
 - Foundations, sponsors and the European Union: 30 per cent
 - Self-generated income: 2 per cent

9.2. Main Objectives

The main objectives of Exodos are the following:

- To organize a festival that widens the horizon for local, regional and international publics.
- To become an international platform for artists and professionals where they meet, engage in dialogue and exchange ideas and knowledge.

- To support the sustainability of smaller festivals in Europe under the new three-year concept of 'partnership festivals'.
- To internationalize the Slovenian culture sector and facilitate professional artistic contacts between Slovenian artists and artists around the world.
- To discover new Slovenian artists and to present them to the European public and professionals.

The competitive advantage of the festival and its uniqueness lie in three main areas:

- Rich programming and a strong focus on contemporary arts;
- Broad collaboration and visibility on the national and international levels;
- Wide audience outreach.

9.3. Special Projects: Labyrinth of Art

In addition to the festivals, the organisation undertakes special projects. Labyrinth of Art[27] was realized in 2011—a living space for walking and contemplation on the outer edge of Ljubljana. The project was created in the framework of the World Book Capital Ljubljana 2010 project[28] and was dedicated to art, people, ecology and books. The Labyrinth of Art is designed on a space of 100 meters by 100 meters, planted with 297 trees, and in the heart of the labyrinth is the pavilion for reading books. The pavilion is connected with the stone path for reaching it. In the stones are written thoughts and poems about art, life, and so on. The main objectives of the project are

- connecting artistic initiatives with issues around ecology;
- creating a work of art that is capable of changing over time: the form follows its natural development and changes according to the natural changes; and
- creating a place for relaxation and reading within a green space where the public could get rid of stress and refill their bodies with energy.

The Labyrinth of Art has become one of the most popular parks in Ljubljana.

9.4. New Programming Concept

The Exodos festival started a new decade in 2010 and at the same time a new four-year period with a new strategic plan and revised concept, with the following main element: inviting two renowned European artists who are prominent in the field of contemporary arts (Jan Fabre and Tim Etchells) to be associated artists and co-curators of the Exodos festival programme. Both artists are multidimensional and have had a significant impact on artistic communities with their creative practice and artistic visions. The expectation is that this concept will bring a fresh flavour to the festival programming and will include a deeper European perspective in order to attract new audiences and to enhance the professional practice and vision of established and emerging Slovenian artists. This concept will enhance the festival's impact by developing more international co-productions and opportunities to exchange different insights, views and knowledge between participating professionals, the audience and the wider Slovenian culture sector.

The first Exodos festival implementing this new strategy was held in April 2011 and was well received by the public, critics and cultural professionals. In 10 days, the festival presented 33 performances, four workshops, four special evening debates and many other off-programme events. The positive feedback received from artists, audiences and the media demonstrated that Exodos's plans and goals are headed in the right direction.

The support of the European Union's Culture Programme[29] is crucial to enable the festival to realize its strategic ambitions and potential as a European hotspot for exchange, intercultural dialogue and promotion of cultural diversity. It will provide a firm foundation for the festival's collaborations with other cultural actors in other parts of the world and will promote the outcomes within the European

contemporary culture sector. Exodos festival has been asked to take executive production responsibility for the international productions at Maribor, Slovenia 2012.

9.5. Exodos 2012 and 2013

The production of Exodos 2013 will be composed with more layers: Ground 0 and Ground 1 in the period of two years. Each year the organizers plan to implement different projects in the two phases.

- **Ground 0. Warming up: 'Exodos festival on the road'**
 A number of development activities will be undertaken outside of the festival period in order to extend the impact of the festival and to establish new international partnerships that will be taken forward in our new strategy.

 - *Exodos on Xpedition* (April–September 2012) will be realized together with partners from Croatia (POGON[30] and Drugo More[31]) and Sweden (Intercult)[32] and Umea 2014 European Capital of Culture. This will be an 'artistic expedition' from Rijeka to Tirana, with artists and researchers travelling together with the specific objective of engaging in and exchanging artistic experiences and ideas with local artists, associations, students and citizens. The objectives of the Xpedition are to establish new partnerships, to extend collaboration for future long-term projects, to develop new commissions for the Exodos 2015 festival and to facilitate contact between Slovenian artists and local Slovenian organisations with the rest of Europe. 'Exodos on the road' is a 'warm-up' for the Exodos 2013 festival and an efficient way to discover new places and new artists, to open up new collaborations and to promote Exodos's strategic vision among artists and professionals in the region and abroad. 'Exodos on the road' will be presented in Ljubliana for four days, including video and photo documentation, as well as open public debates and sharing by observers, experts and artists.
 - Exodos at a partner festival (LokoMotion Contemporary Dance Festival Skopje, November 2012[33]). As already mentioned, one of the strategic objectives of the Exodos festival is to support the development of and strengthen smaller festivals, which are very important in this part of the European cultural space from the local, regional and national perspectives. The organisation plans to invite and co-finance performances for the LokoMotion festival programme and in so doing help extend the audiences of both festivals.

- **Ground 1. 'Into the fire': Exodos 2013**
 Exodos 2013 will have several important highlights:

 - Presentation of the associated artist Tim Etchells as a multidimensional artist.
 - Preparation of three visual art exhibitions in three galleries: City Gallery, Skuc and Tobacna Gallery, in cooperation with the City Museum of Ljubljana.
 - Presentation of a new theatre piece *The Tick of Things*
 - Publication of the drama work *The Broken World,* in cooperation with the publishing house Studentska založba, as none of his literary works have been translated into the Slovene language yet.

 The aim is to present major European artists to the audience with a 360-degree perspective, examining all aspects of their creative practice.

- **Beyond the Festival**
 Each year the Exodos festival investigates cultures of other corners of the world beyond Europe. Beyond the festival in 2013, the focus will be on the Asia Dance Platform. Exodos festival curators will select and show 16 dance productions by artists from Asia. This focus aims at informing audiences about developments in the field of the contemporary performing arts in different parts

of the world and also to offer artists from these regions a chance to present their art in a Central European context. The Exodos festival aims to promote and establish professional knowledge exchange and artistic collaborations between the cultures of Europe and Asia, which can be sustained through further partnerships and networking that go beyond the festival setting—creating sustainable long-term relationships that will promote greater sharing of practices, techniques, artistic visions and co-productions in order to promote the mobility of artists and their work to and from Europe and Asia.

- **'Brain case': Education and Learning**
 The Exodos festival is an multicultural artistic place where creative and intellectual energies meet, exchange and share. The parallel learning programme usually consists of lectures, discussions, round tables and workshops supplementing the core festival programme. These events are led by prominent professionals in the field and also involve peer-to-peer learning and exchange. Exodos's 2012 festival will have five workshops for dancers, artists and performers, young producers and curators, directors and text writers, and the general audience. The expectation is that these workshops will allow young professionals and artists to acquire new experiences and skills designed to strengthen their future professional career and development and to extend their international network and their technical and practical knowledge.

 Besides the workshops, the Exodos festival will be a platform for daily open discussions about the performances, for lectures, round tables, late long talks that bring together guest artists and audiences. Focused discussions about artistic cooperation between the cultures of Asia and Europe, will host around 30 professionals from both continents. Participants will have the opportunity to learn about partnership opportunities for cooperation. Successful projects and case studies will be presented as well.

9.6. Communication and Promotion Strategy and Tools

- **Audiences**
 The Exodos team is aware that reaching, involving and developing audiences is a core activity when organizing the festival. The communication and promotion strategy is focused on the following *types of audiences:*

 - Media workers (journalists, editors, etc.—particularly those working with popular culture)
 - Artists
 - Cultural professionals and operators
 - Art lovers
 - Students and young people
 - The general public.
 - The audience for the festival numbers approximately 6,500 annually, growing by 20 per cent in the period 2009–2011.

- **Communication Outreach: Approaches**
 The communication and promotion strategy uses several *approaches* to reach the target groups:

 - *Reaching the local population by direct communication.* This approach aims to establish close communication with local associations, networks and schools to present the festival in detail. While team members will contact with the inhabitants of the inner Ljubljana city district, the festival volunteers will also reach regions of the country outside of Ljubljana.
 - *Searching for new audiences and exploring new spaces for advertising.* The festival organizers have reached an agreement with new media sponsors: Najdi.si, *City Magazine, Mladina* magazine, Art Servis and Kolosej multi-cinema[34], where the Exodos video clip will be screened for 10 days prior to the regular film programme. This kind of advertising is aimed at people who do not represent a regular theatre audience.

- *Attracting young audiences and engaging in guerrilla actions.* This is done by advertising through online Internet tools and social media websites. The festival plans to make special eco-tattoos visible throughout the city. These tattoos are eco-signs which will be drawn on the streets and walls around the city and will disappear in a month (as they will be painted using eco-materials). Special tokens are also part of the promotional plan, to make the festival more visible. For example, when one of the editions of the festival was dedicated to disabled people, special small hearts were made—a traditional Slovenian cake—on each of which was written 'more heart' and the logo of the festival. All attendees received a piece.
- *Facilitating the participation of audiences with special needs.* This audience segment is largely deprived of access to cultural events in Slovenia. By securing access to Exodos performances for persons with special needs, the festival aims to attract this special target group.
- *Targeting cultural professionals: artists, directors, producers, curators.* A special approach in the promotional campaign will be to these groups via emails and personalized invitations.

- **Media Mix and Promotional Tools**

 Besides these special promotional actions focusing on specific target groups, the festival organizers intend to reach as wide an audience as possible with a mixed-media approach, aiming

 - to employ mass media to reach the general public;
 - to employ more specific and targeted media to reach art lovers and cultural professionals;
 - to use online media for targeting young audiences; and
 - to select international online and offline media for wider promotion outside Slovenia.

 The promotional plan for the festival includes vast media coverage, involving various types of media—radio, television and print media, as well as web portals and social media (such as Facebook, Twitter and blogs). Media coverage is arranged with local media partners (covering Slovenian regions and cities in Slovenia), as well as with national media partners (covering Slovenia, Croatia and Italy). The role of the media is not only to disseminate information but also to be sponsors or supporters.

 Concrete *promotional tools* for the Exodos 2013 festival are

 - flyers: 15,000 copies sent to cultural centres in Slovenia and to partners throughout Europe (Austria, Belgium, Croatia, France, Great Britain, Italy, etc.), tourist offices, theatres, hotels and airports;
 - posters;
 - billboards;
 - advertisements in Slovenian and international newspapers and magazines;
 - advertisements via radio (Slovenian national radio, Radio Student, local radio stations);
 - advertisements on television;
 - the Exodos festival brochure;
 - Internet website banners;
 - short online video clips about the festival;
 - other promotional or advertising materials such as media releases, articles and newsletters;
 - gadgets and eco-tattoos;
 - Exodos's daily online newspaper; and
 - 'Exodos on the road' warm-up for the Exodos festival in 2013.

- **Main Targeted Media**

 - *Print media (magazines and newspapers)*
 - *Mladina* (weekly magazine targeted at a younger educated audience, 20–45 years of age; reaches approximately 57,000 people): advertising, interviews and announcements
 - *Global* (released every two weeks, targeted at an educated general public, 20–45 years of age; reaches approximately 20,000 people): advertising and interviews

- *Delo Revije*—several magazines: *Stop* (weekly magazine with a music section, targeted at the general public; reaches approximately 60,000 people) and *Obrazi* (weekly magazine, targeted at the general public, reaches 53,000): interviews
- *Lady* (weekly magazine targeted at the general public; reaches approximately 227,000 people): advertising, interviews, news, and so on
- *Žurnal* (weekly edition of a daily newspaper targeted at the general public; reaches approximately 424,000 people): advertising, news, interviews, and so on
- *Revija Študent* (monthly magazine targeted at the student population; reaches approximately 30,000 people), and *Tribuna* (a legendary student magazine with a strong legacy of critical reflections on society): advertising and news
- *Delo* (daily newspaper targeted at the general public; reaches approximately 424,000 people): advertising, news, interviews, and so on
- *Dnevnik* (daily newspaper targeted at the general public; reaches approximately 424,000 people): advertising, news, interviews, and so on.

- *Television channels*
 - POP TV (targeted at the general public; reaches approximately 65 per cent of the population, or 1,300,000 people): advertising
 - TVSLO (targeted at the general public; reaches approximately 85 per cent of the population, or 1,800,000 people): advertising, news and interviews
 - KANAL A (targeted at the general public, reaching approximately 55 per cent of the population, or 1,000,000 people): advertising and news.

- *Radio stations*
 - Radio SI (targeted at a specific audience: foreigners travelling to Slovenia and educated Slovenian audiences fluent in English or German; the fourth-largest national radio station; reaches 50,000 regular daily listeners): advertising, news and interviews
 - Radio Center (targeted at the general public and urban audiences; reaches approximately 100,000 people): advertising, interviews and news
 - Radio Antena (targeted at a younger general audience, 15–40 years of age; reaches approximately 100,000 people): advertising and news
 - Radio KAOS (targeted at a local audience from the region around Ljubljana—Osrednja Slovenija region): advertising, news and interviews
 - Radio SLO2 (targeted at the general public throughout all of Slovenia; reaches approximately 800,000 people): advertising, interviews and news
 - Radio ARS (targeted at a specific audience: people who admire culture; third-largest national radio station; reaches 50,000 regular daily listeners): advertising, news and interviews
 - Radio Student (targeted at a younger general audience, 15–40 years of age; reaches approximately 100,000 people): advertising and news.

- *Web portals*
 - Podnapisi (targeted at the younger population, 14–30 years of age): advertising
 - In Your Pocket (targeted at tourists): advertising and news
 - PodLupo.si (targeted at the general public): advertising, news, interviews, and so on
 - Najdi.si (targeted at the general public; reaches approximately 424,000 people daily in Slovenia and 59,000 daily abroad): advertising
 - Žurnal24.si (targeted at the general public; reaches approximately 369,000 people daily in Slovenia and 27,000 daily abroad): advertising and news.

- *Outdoor advertising*
 - Billboards in larger cities in Slovenia—Ljubljana, Maribor, Celje and Kranj
 - Posters in all larger cities and transport routes in Slovenia
 - City posters in Ljubljana, Maribor and Kranj

- Flyers in all larger cities in Slovenia: Ljubljana, Maribor, Celje, Kranj, as well as larger cities in Croatia such as Zagreb and Trieste
- GEM Ljubljana (part of Planet-siol.net): public multimedia available via 444 digital displays on 124 Ljubljana city buses (digital displays on the public transport and billboards across the city)

- *Social media*
 - Facebook: weekly/monthly updates on project activities (during the festival, daily updates of the programme)[35]
 - Twitter: weekly/monthly updates on project activities (during the festival, daily updates of the programme).

- **Communication and Promotion Plan for Exodos 2013**
 The following provides a short summary of the promotional activities planned for the period May 2012–May 2013:

 - *May–June 2012*

 - Various announcements regarding the progress of the project, with an emphasis on 'Exodos on the road' and the artists involved
 - Establishment of agreements regarding publishing of announcements, newsletters, and so on with various larger web portals, television networks, radio stations and print media
 - Reports from 'Exodos on the road', including photographic material, in the media
 - Active monitoring of media announcements and published materials
 - Announcements through social networks (such as Facebook and Twitter)
 - Visits to primary and secondary schools and academies of art (theatre, visual, design) presenting the Exodos programme, with visual presentation of artists and follow-up debates.

 - *September–December 2012*

 - Active monitoring of media announcements, published material, and so on
 - Announcements through social networks (such as Facebook and Twitter)
 - Presentation of 'Exodos on the road' in Ljubljana with public discussions
 - Updating of website with the whole programme of the Exodos festival
 - Publication of the programme book for the Exodos festival.

 - *January–March 2013*

 - Focus on the Exodos festival with visual presentation of artists and follow-up debates
 - Active monitoring of media announcements, published material, and so on
 - Eco-tattoos on the streets promoting the Exodos festival
 - Posters on walls
 - First press conference
 - Interviews with the organizers focusing on the programme of the festival
 - Announcements through social networks (such as Facebook and Twitter)
 - Activation of volunteers, specifically, seeing to have young people and students become an active part of the Exodos festival (for example, engaging volunteers, organising targeted workshops and debates between artist and students)
 - Coordination between young writers, photographers and the designers of the Exodos festival web page
 - Updates and maintenance of daily publishing on the Exodos website: interviews with artists, guests, evaluation of performances, survey of visitors and a video of each day of the festival.

 - *April 2013*

 - Active monitoring of media announcements, published material, and so on
 - Second press conference

- Additional longer interviews with performers and organizers gradually released in the print media and on television networks, web portals and radio stations
- Coordination between media representatives and the artists and organizers on the festival sites in order to facilitate media exposure (interviews, photographs, videos, etc.)
- Announcements through social networks (such as Facebook and Twitter).

- *May 2013*

 - Press release monitoring and analyses of the promotional impact on the project.

- **Additional Note**

 The festival does not have exact numbers for the audiences attracted by the announcements about the festival through specific media. Instead, general information about media audiences is presented. There is no specific information about how many people are reached via the outdoor media.

QUESTIONS AND ASSIGNMENTS

- Analyse the four Ps of the marketing mix for the Exodos festival. Outline their strengths and weaknesses.
- Identify what kind of general strategy as well as functional marketing strategy the Exodos festival implements. Connect your answer with the main objectives of the festival.
- Elaborate a marketing research plan for the Exodos festival, suggesting concrete qualitative and quantitative methods of research, considering the festival's specificities and the target groups.
- Elaborate a matrix connecting the target groups, their potential motivations to attend the festival and the concrete communication and promotional tools for reaching each one of these targeted segments.
- Analyse Exodos's communication strategy and tools. Extract the priorities and limitations in the communication strategy, considering the organisation's capacity and operations.

 Note: You might need to perform additional online research to compete these assignments. In your answers, apply the theoretical concepts and the methodology from Chapter 6 as well as this chapter of the book.

10. CASE: BELGRADE PHILHARMONIC ORCHESTRA (BELGRADE, SERBIA): REVITALIZATION THROUGH ARTISTIC QUALITY AND MANAGEMENT INTEGRITY

The case was created with the kind collaboration of Ivan Tasovac, general manager of the Belgrade Philharmonic Orchestra and his team. The case text is based on an analysis of primary data from targeted qualitative research and the orchestra's online and offline managerial and promotional materials.

STUDYING THIS CASE WILL HELP YOU TO:

- Understand the importance of management competence and efforts in changing and reshaping the public image and audience development of a music organisation.
- Discuss the practical connections between artistic programming and marketing.
- Analyse the practical implementation of market development strategy and focus strategy.
- Recognize the four Ps of the marketing mix in a real case scenario.
- Study an example of a fundraising strategy through establishment of a foundation for accumulating funds from diverse sources and discuss connections between marketing and fundraising.

10.1. Background Information

The Belgrade Philharmonic Orchestra (BPO)[36], with a 90-year tradition and consisting of 98 musicians with an average age of 35, has had remarkable success and established itself as the leading national orchestra of Serbia over the last decade. The period 2001 to 2011 represents a new beginning for the orchestra as during the tragic events in the Balkans in the 1990s, the orchestra practically stopped working. At the beginning of 2001 there were no subscribers. The whole building and the concert hall were in a terrible condition so that it was impossible to hold a concert. The instruments were in an extremely dreadful state. The majority of the orchestra's musicians were waiting for retirement.

Due to the strong leadership of the orchestra's director, as well as other factors explained in this case, the BPO today, according to diverse media coverage, is 'one of the leading European orchestras' (*The Independent*), 'Serbia's cult orchestra' (the *Financial Times*), 'the most successful cultural institution in Serbia' (the *Morning Paper,* Zagreb) and 'the most powerful PR weapon of Serbia' (*Kvällsposten,* Malmö).

Such a high reputation and public image has quickly attracted a lot of famous names in the field of classical music that have supported the further development of the BPO. In the past few seasons, the orchestra has been cooperating with world-famous conductors and soloists such as Zubin Mehta, Krzysztof Penderecki, Sir Neville Mariner, Mischa Maisky, David Geringas, Julian Rachlin, Sarah Chang, Ivry Gitlis, Barry Douglas and Sol Gabetta. In 2012 the famous Chinese conductor Muhai Tang was appointed as the chief conductor of the BPO, and the renowned Iranian-Austrian conductor Alexander Rahbari was promoted as the principal guest conductor.

Over the last few years the orchestra has organized several successful tours and guest performances in Italy, Austria, Sweden, France, Slovenia, Croatia and other locations. Guest performances at the 2010 Ravello Festival, the first postwar guest performance at the opening of the Julian Rachlin & Friends Festival in Dubrovnik, and a 13-concert tour in Italy in 2011 are just a few of the most recent highlights among the international performances of the orchestra.

The original and unique concept of the New Year's concert cycle, which celebrates the diversity of different ethnic and religious communities, drew significant attention from the domestic and international public and is supported by the European Union. The BPO also initiated long-term regional cooperation by the three national philharmonic orchestras of Serbia, Croatia and Slovenia, with the project Pika-Točka-Tačka ('Dot-Dot-Dot' in the three languages)[37]. This project, intended to improve and promote the collaboration of the three institutions, was supported by the U.S. embassies in the three states and by the U.S. Department of State. One of the most important goals within the five-year plan of the orchestra is to establish and consolidate its position on the international music scene, especially overseas.

10.2. Musicians and Staff

The orchestra managed successfully to engage young musicians who introduced enthusiasm and energy. At present, in February 2012, the orchestra consists of 113 full-time employees averaging 38 years of age. The high reputation and image of the orchestra attracted many well-known names from the world of contemporary classical music who supported BPO's further development by accepting invitations to be visiting maestros, musicians and soloists. Maestro Zubin Mehta, one of the greatest friends of the BPO, performed several times in Belgrade, refusing his fees in favour of the BPO Foundation that today carries his name. Now, with a very limited programme budget of less than 200,000 annually, the BPO collaborates efficiently with many internationally well-known conductors and soloists, as mentioned above.

10.3. Main Audience

Thanks to its creative and often provocative marketing, the BPO has constantly been getting the attention of the public, which has influenced the creation of the orchestra's image as a 'conveyer of social changes'. The audiences have gradually returned to the concert halls owing to the orchestra's high performance quality and programme policy, which follows the latest world trends, and its good image.

According to the results of a marketing survey conducted in 2009, the average BPO subscriber is a highly educated individual between 45 and 50 years old. This age group is a decade younger than the average audience four seasons before 2009. According to an analysis of the age structure, the oldest subscriber was a 100-year-old lady, while the youngest was a 6-year-old girl.

The professional affiliations of the prevailing BPO audiences are doctors, top and middle managers, engineers, members of the diplomatic corps, officers of international institutions, professors and programmers. It is noticeable that music professors and teachers, composers and, generally, people with a background in music are in the minority among BPO subscribers. BPO audiences come mainly from Belgrade, but there are also subscribers who travel to concerts from other regions of the country: Pančevo, Smederevo, Obrenovac, Indjija, Novi Sad and even Kragujevac.

10.4. Basic Financial Figures

The orchestra's overall budget in 2010 was 1,923,398. Of that, 84 per cent was derived from the state and 16 per cent from self-generated income (ticket sales, 34%; touring, 12%; sponsorships, 45%; and rentals, 9%). The main budget costs are for salaries (54%). Direct costs for organizing cultural activities account for 26 per cent. The other 20 per cent of the costs are for operational expenses (heating, electricity, maintenance, scores and performing rights, insurance, etc.) The overall budget in 2011 increased by 7.67 per cent to 2,070,870. Of that amount, 86 per cent came from the state and 14 per cent from self-generated income.

10.5. SWOT Analysis: Main Results

Internal factors	Strengths	Weaknesses
	• High-quality of music programming and well planned season. • BPO is the strongest Serbian brand in the field of music. • Openness for cooperation – locally, regionally and internationally. • High-quality instruments. • Built up a strong brand, image and ongoing media presence • Devotion of the musicians and staff for their work, and a high level of motivation. • Talented and well recognized soloists and conductors. • Good opportunities for the development of the orchestra and artistic advancement. • Strong leadership. • Young staff members. • Excellent working conditions for the staff members. • Professionalism and competence of the production, marketing and technical staff.	• Low salaries. • Lack of internal discipline at work. • Absence of tours bringing additional incomes from revenues. • Unsatisfactory information flow (absence of communication channels) • Working conditions (inadequate concert hall, lack of rehearsal space, old uniforms).[a] • Setting up of sub-groups within the orchestra who sometimes have different needs and expectations and are difficult to manage and moderate. • Internal communication difficulties • Not sufficient use of online technologies and Web 2.0 tools in BPO promotion and marketing. • Trade unions of musicians do not play very active and efficient role
External factors – environment	Opportunities	Threats:
	• General opening of Serbia to the world. • Utilizing better the status of a national orchestra. • Obligations of RTS RTS (Serbian Broadcasting Corporation) as a public broadcasting service towards BPO.	• Absence of a well elaborated and efficient national cultural policy. • No high public attention to the arts and cultural sector in Serbia in the last 10 years..

External factors – environment	Opportunities	Threats:
	• Raising interest to classical music among new audiences. • Exploring new sources of incomes from touring, music recording, new donors, sponsors and patrons. • Possibility of funding coming from the city budget. • Building a recording studio • Increasing role of culture and arts in tourism offers: opportunities to connect BPO programming with cultural tourism.	• Unfavorable political and economic situation in the country. • In some cases political affiliations are placed above professional competences • Lack of adequate legislation for support of classical music and non-profit initiatives in the cultural sector. • Poor educational level of some audience groups. • "Belgradization" of culture – centralization of cultural and artistic life in Serbia in the capital. • Lack of strong professional critics in the music field. • Lack of concert halls for rehearsals and performances. • Absence of regular support from the city authorities. • Absence of competitive environment in the country.

[a]In 2003 BPO building was renovated and now it is a modern one in terms of working conditions. However, this building is too small for the orchestra's programming, and the orchestra performs in a rented concert hall nearby.

10.6. Mission Statement

The BPO aims to create unique experiences for audiences through the highest possible level of performance of symphonic music in order to expand appreciation of classical music among Serbian population, to enrich the social and cultural life, to promote cultural exchange and understanding between Serbia and other countries and to activate public and private interests in order to ensure the orchestra's long-term financial stability.

10.7. Strategic Objectives (2010–2015)

• **New Concert Hall**

In 2002, despite very limited funds provided by the public budget (which was the only financial source for the BPO), a small concert hall with 200 seats was rebuilt. It is used today for rehearsals, while during the concert season performances are still being held in the old hall with 900 seats. This hall is still in very bad shape without adequate acoustics or comfort for the audience. This is why one of the key objectives of the BPO is construction of a new concert hall. So far, this project has met with understanding from the Serbian government and has received significant international support. The donations for the orchestra and its new instruments in early 2012 amounted to 1.5 million. The BPO expects to obtain soon all necessary permissions for the project start-up.

Increasing the number of concerts in a season is also part of the strategic objectives related to increased capacities in the future. Collaboration with the regional philharmonic orchestras in the Balkan region is also envisaged to assist programme expansion.

• **Development of Subscriber Base**

The new management style and approach, started in 2001, helped the BPO to attract ongoing and increasing public and media attention, as it implemented creative and often provocative marketing. The good image and better performance quality contributed to the gradual return of audiences

to the concert halls. Today the BPO has 3,902 subscribers and gives approximately 30–40 regular season concerts a year. This is certainly not a great achievement if compared with the famous European and North American orchestras. But considering that 10 years ago, the orchestra did not have even one subscriber and only four persons were engaged in the orchestra's production, marketing and management, this number is a clear indicator of the efforts made to restore the interest of the audience in classical music in Serbia. Future development of the subscriber base is one of the key objectives for the period 2010–2015 because the orchestra's management and staff believe that this is the only real indicator of the success of any philharmonic orchestra, as well as of its social influence in the society.

- **Tours and Regional Collaboration**
 The comeback on the international scene is another important goal that the orchestra pursues. During the last few years, the BPO has performed in Italy, Austria, Sweden, France, Slovenia, Croatia, Bosnia and Herzegovina and other locations. A matter which the orchestra's management considers of great importance is the recently established regional collaboration with philharmonic orchestras in Zagreb and Ljubljana. During a meeting held in Zagreb on October 19, 2010, three national cultural institutions—the Belgrade, Zagreb and Slovenian philharmonic orchestras—reached an agreement on future cultural and business collaboration. As mentioned above, the joint project is titled Pika-Točka-Tačka. Within the subscription programme, each orchestra will perform in its home city and will also have guest performances with its chief conductor in the other two cities in the region. It was agreed to establish a common programme with the same pieces, soloists and conductors within the regular concert seasons for the next five years, as well as mutual visits by the three orchestras.

 Also, regular management meetings are held to exchange business experience and models of managing philharmonic orchestras. These projects represent the realization of cultural and economic collaboration as a result of the overall European integration process for Croatia and Serbia. At the same time, exchange of experiences will foment business and make possible further reforms in cultural politics, more transparent financing and alignment with European standards for cultural institution management.

The realization of these long-term objectives will be financed by

- the orchestra's strategic partners;
- state financing;
- project financing from state funds and funds for development and improvement of cultural content (e.g. European Union programmes and support from embassies and external funding institutions);
- donations and contributions from citizens; and
- support from business companies and other organisations.

10.8. BPO Foundation Zubin Mehta

As already described, the orchestra's management and staff have set ambitious goals for the upcoming years. These goals largely exceed the current capacities and budget of the BPO. Therefore, further development of the BPO will depend mostly on the ability of the management to attract large donors, especially for the construction of the new concert hall. For that purpose, the BPO Foundation Zubin Mehta was established in June 2004 by the decision of the board of directors of the BPO; it operates under the Law on Foundations and Endowments in the country. The main objectives of the BPO Foundation are

- To raise awareness and funding for the development of the new concert hall;
- To improve the quality of the orchestra's instruments;
- To enlarge international cooperation and project partnership with philharmonic orchestras from the neighbouring countries;

- To make classical music accessible and attractive to the younger population;
- To assist young professionals in acquiring skills and competences in cultural management;
- To improve the orchestra's marketing activities through the development of an information system for booking tickets online, as well as via mobile phones; and
- To develop a special Web TV channel dedicated to culture and social life in the country.

The BPO Foundation was also established to set up an endowment in the United States in order to raise donations from large Serbian diaspora in North America. The BPO is the first national institution with its endowment in a foreign country. The orchestra management believes that this will be a good example of private-public partnership as one of the new models of cultural financing in Serbia, and such an example will be a driving force for positive changes in the tax law related to donations in the country.

To promote the fundraising campaign in the United States, the orchestra plans to organize, by the fall of 2014, a series of concerts in four American cities: Chicago, New York, Washington, D.C., and Pittsburgh. Initial research shows that concerts, expositions and performances by Serbian artists in the United States are usually very well accepted and paid well by the Serbian diaspora.

QUESTIONS AND ASSIGNMENTS

- Elaborate the main driving and restraining forces for the BPO's operations. Elaborate an analysis of the BPO's stakeholders.
- Analyse the four Ps of BPO's marketing mix. Illustrate your answer with examples from the case.
- Analyse the strengths, risks and limitations in the orchestra's current marketing operations and long-term objectives.
- Suggest elements of marketing-related innovations in the orchestra's activities (both online and offline).
- Elaborate ways to gradually transform the BPO into an intrapreneurial arts organisation, emphasizing the diverse options for self-generated income from core and additional services.

Note: You might need to perform additional online research to complete these assignments. In your answers, apply the theoretical concepts and methodology from Chapters 1, 4, 5 and 6 as well as this chapter of the book.

8 Human Resource Management Plan

1. THE HUMAN RESOURCE MANAGEMENT SYSTEM IN AN ARTS ORGANISATION

Elaboration of the human resource management section of a strategic plan requires an understanding of the basic terminology and its application to arts organisations. Human resources in an organisation are the people with knowledge, creativity, professional skills, capacities and personal qualities. As discussed in Chapter 1, this is the most important resource in any organisation, but especially an arts organisation, as creativity cannot be replaced by any other type of resource. Planning human resources helps to prepare people for future changes so that they can obtain the necessary capacity, knowledge and skills to implement strategic programmes and actions. Therefore, the human resource management section of a strategic plan provides an overall evaluation of organisational structures, procedures and peoples' capacities, and includes the best strategies to develop, train and motivate personnel as well as recruit new staff (where required). This part of the strategic plan is tightly connected with the overall strategic framework and long-term objectives for the organisation's development. This is because the people in an organisation are the ones who elaborate and implement the strategic plan.

Planning human resources in an arts organisation requires a good understanding of how the overall system of human resource management operates. There is no single 'correct' way to plan and manage people in an arts organisation. This chapter provides a basic framework and gives ideas on how to create a strategic plan for human resources. The recommended framework is adaptable to individual cases.

There are two levels of planning related to human resources: strategic and operational (see Table 8.1). Strategic planning covers the development of long-term policies and strategies. Operational plans for

> Human resource management (HRM) is an ongoing process for selecting the most suitable people for required positions and tasks, continuously motivating, training and developing them in order to fully utilize their capacity to both achieve the organisation's goals and give people a feeling of satisfaction in their work.
>
> Strategic human resource planning is part of the HRM system that develops strategies on who will realize the strategic plan and how to prepare the people within the organisation for the envisaged long-term changes.

human resources include the design, ongoing monitoring and implementation of concrete activities in all areas of the HRM system.

A well-elaborated and implemented human resource management plan

- helps achieve the main organisational objectives while at the same time optimizing labour costs;
- attracts the right people for the right jobs and keeps them for a long period by monitoring them and improving their competences and skills; and
- generates social effects such as good living standards for employees, fair salaries and benefits, motivation with respect to tasks and jobs, conditions for professional growth and education, and healthy and safe working conditions.

1.1. Elements of a Human Resource Management System

The core elements of a HRM system within an arts organisation are given in Figure 8.1. These elements differ depending on the size of the organisation; for example, in a small organisation very few of these elements are actually present, and usually they overlap. In general, core HRM elements are related to four main areas:

- First, setting up the *structure, regulations and procedures.* Here the emphasis is on

 - evaluating the existing organisational structure and pinpointing ways to improve the workflow and internal decision-making;
 - establishing all internal procedures and regulations in all functional areas that involve personnel;
 - setting up board, committee, and trustees structures and roles;
 - securing the necessary conditions for health and safety at work; and
 - evaluating the potential of the personnel and volunteers and planning their needs for further development.

- Second, identifying mechanisms for recruitment and selection of personnel. This includes

 - attracting the right candidates for vacant positions;
 - selecting and contracting personnel;
 - designing collective agreements and negotiating with professional unions (where applicable);
 - organizing work schedules for all employees and contractors;

Table 8.1 Levels of a Human Resource Management System

Strategic level
- General organisation of human resource management policy and strategy
- Human resource management objectives
- Human resource management strategies
- Organisational structure

Operational level
- Human resource management plans
- Projects and programmes for recruitment, motivation and development of human resources
- Tasks and activities
- Internal procedures and regulations

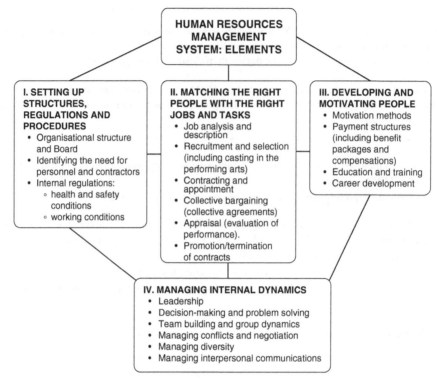

Figure 8.1 Elements of a human resource management system

- evaluating performance and appraisal systems; and
- promoting employees, continuing (or terminating) contracts.

- Third, maintaining and developing the professional qualifications of people. This emphasizes
 - motivating personnel (including through salaries, other forms of payments and benefit packages);
 - providing professional training and education (including lifelong learning modules, qualification and pre-qualification, and special organisational funds for personnel development); and
 - offering individual career development and coaching help.

- Fourth, *managing internal dynamics* related to managing people in teams and their relations to each other (including in situations of conflicts and changes). Important management functions here are
 - leadership and team-building;
 - management of conflicts and changes;
 - decision making and problem solving; and
 - management of diversity and interpersonal communication.

Planning human resources covers the first three aspects of the overall system. The fourth relates to *organisational behaviour,* the way people act within an organisation (as individuals and in groups or teams), and this is a specialized subject in the overall management field.

It is important to emphasize that *motivation* is the core element of any HRM system and all other elements contributing to it. It is impossible to plan and manage any area of human activities without motivating people, without helping them to reach their personal goals and direct their activities and behaviour in this direction, as well as for the benefit of achieving an organisation's objectives. Motivational factors vary a lot and can be related to salaries and fees, the essence of the work (creative or routine), working conditions (including the social atmosphere at work), the leadership style in an organisation, the level of autonomy and self-control, possibilities for professional development, and more.

The connection between the strategic plan of an organisation and the plan for HRM is shown in Figure 8.2. An organisation's general strategic orientation, formulated mission, vision and long-term objectives provide the framework for further elaboration of policies, functional areas, projects and programmes for human resources. Human resource planning is well connected with other functional areas, such as marketing, production, operations, fundraising and financing, and technical aspects.

1.2. Specific Features of Human Resource Management in Arts Organisations

Planning and managing human resources in the field of arts is a process which requires a lot of attention and a high level of competence, especially when engaging people in creative group processes. From the viewpoint of managing people, arts organisations have the following specificities:

- Teams that are engaged in cultural production have very diverse characters—creative, curatorial, technical, administrative, managerial, marketing, and so on. Some of them are involved directly in the creative process, others indirectly. The tasks of all teams contain creative elements as everyone contributes to the final artistic product. It is therefore hard to apply direct norms and indicators for work delivery, as the creative elements cannot be entirely planned (for example, it is impossible to apply formulas on how many paintings a contemporary artist should produce per year or how many performances an actor should participate in annually). Regulation of workflow is an important element of operational planning but cannot be based on strict standards and norms that predetermine the salary range (as it might be possible in other industries). The degree of flexibility in an arts organisation is higher than in many other fields.
- Arts sector has a high level of specialization. There are many types of professions in arts organisations—from very routine to very creative ones. Within each professional art group, there are further sub-specializations that make some personnel 'irreplaceable'. For example, singers could be divided into jazz, blues, folk, world music, opera, pop, and so on, and there could also be separations based on voice range and gender such as soprano, mezzo-soprano, tenor, baritone and bass. High levels of specialization and uniqueness in the voices of 'stars', in certain cases, makes them irreplaceable.
- Recruitment of the right people for creative teams does not always follow general rules for recruitment. It is also a time- and resource-consuming process as, together with other qualities and experience, for the creative team, 'talent' is the most important. In many cases, it is hard to find the right talent for creative production. For example, a casting process in the performing arts field (selection of actors, dancers, singers, etc.) requires the director to also consider the chemistry between members of the creative team.
- Management of creative processes and management of all other supporting, administrative, technical and 'backstage' activities are usually split at the top management level between an artistic leader (artistic director, chief conductor, chief producer) and a general manager (or other titles for these positions that clarify the division of labour between creative processes and all other activities). Decision-making in many cases is difficult, as there are two 'heads' with sometimes conflicting priorities in one organisation. Therefore, it is important to determine how internal rules and procedures are set up.
- Most arts organisations, especially in the nonprofit and government sectors, work with boards (committees, trustees, etc.). Deciding the board's structure is not an easy task, as board members need

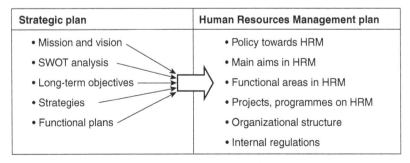

Figure 8.2 Human resource management plan and the strategic plan

to be chosen to have compatible and well-matching competences, as well as to be able to devote sufficient time and efforts to the organisation's development (in many cases on a voluntary basis).

- Many arts organisations have flexible structures and operate on a project basis. For these organisations, HRM is mainly an operational activity rather than a strategic one. This is because after each production, the team dissolves and another team is formed.
- Unusual work schedules in some areas, especially related to the performing arts, music and entertainment industries (evenings and weekends), require a careful consideration of general policies related to working hours and holidays.

Planning human resources in arts organisations as part of a strategic plan includes the three subdivisions and their elements, given in Figure 8.1: setting up organisational structures and procedures, finding the right people, and motivating and developing people. An important step in the planning process is the evaluation of the current human resources potential in an organisation and the identification of future needs.

2. ORGANISATIONAL STRUCTURES AND INTERNAL REGULATIONS

Mapping the organisational structure is a practical way of showing how work in the organisation is formally split between different departments, teams and individuals and what are each one's responsibilities, areas of control and the interrelations between them. An organisational chart (*organogramme*) is the way a structure is described visually. Setting up an organisational structure, analysing the existing structures and finding ways to improve it considering long-term objectives are the first steps in the overall human resource planning process.

An organisational chart consists of several main elements:

- **Management levels.** This shows the management hierarchy. 'Flat' organisational structures have fewer management levels (sometimes with more units or people at one level). 'Fat' structures have more management levels but fewer people or units at each level.
- **Departments and units.** In most organisational structures departments correspond to the main functional areas of management such as production, finances, marketing and innovations.

- **Co-relations between departments and units.** These can involve
 - subordination: between departments and positions from different levels; or
 - coordination: between departments and positions at the same level.

- **Positions** or work posts. Each position is set up for a specific purpose and range of delegated tasks, plays a specific role in the overall process and has concrete rights and responsibilities.

Many factors influence decisions in relation to what kind of structure to choose to support activities in arts organisations. Some of these factors are the cultural and artistic field, the scope of activities, the complexity of the process and the final product or services to be offered, the size and type of the organisation and the balance between creative and supportive teams.

2.1. Types of Organisational Structures

Analysing and improving organisational structures requires a basic understanding of some of the 'classical' types of structures. Here are several examples:

- **Linear Structure**
 This is a simple structure with tight hierarchical connections, constructed in a 'pyramidal' form and strongly centralized. It is suitable for smaller arts organisations (particularly private entities or entrepreneurships and emerging nonprofit organisations). Within such structures, the head of the organisation should be a specialist in all functional areas as he/she is not supported by functional personnel. The only support comes from an office manager or secretary. A linear structure of a small nonprofit arts organisation is presented in Figure 8.3.

EXAMPLE

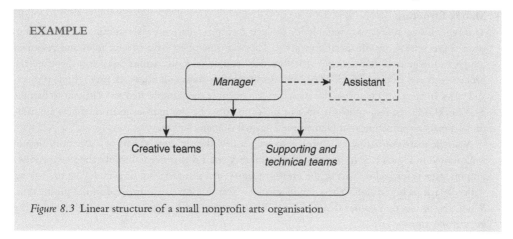

Figure 8.3 Linear structure of a small nonprofit arts organisation

- **Functional Structure**

 This structure is the popular one among middle-sized and large organisations. The work is organized around functional areas (creative production, finances, administration, marketing, etc.) and is led by top management. The advantages are that competences and skills are split, and there are spaces for sharing and collaboration while at the same time the chain of command is clear. On the other hand, if too specialized or too big, a functional structure could become difficult for communication and coordination between the functional units and could slow down the decision-making process. The chart in Figure 8.4 illustrates a functional organisational structure of an art museum[1].

EXAMPLE

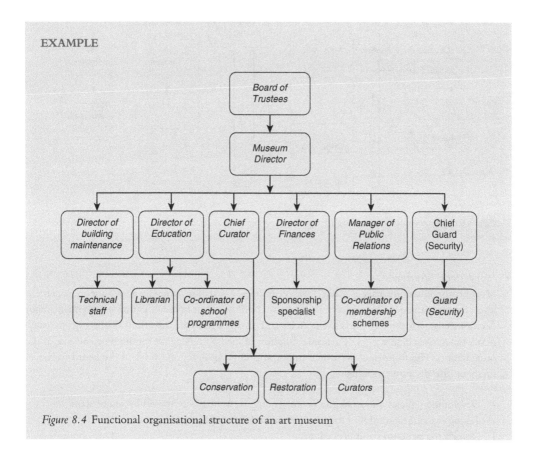

Figure 8.4 Functional organisational structure of an art museum

- **Matrix Structure**

 This type of structure is very suitable for projects or project-driven organisations. The main focus is on teams who work on specific projects. The team members have certain roles and responsibilities in the general management structure. Key people take on various tasks, and therefore the project costs can be minimized. Teams are usually flexible units and can work on multiple projects and tasks. In large organisations, this structure can become too complicated and difficult to handle. The workload if an individual member of the team could be too high, as team members are multifunctional and sometimes simultaneously engaged in many activities.

 A simple matrix structure for a project to stage a new theatre show as part of a repertory theatre is illustrated in Figure 8.5. In this case, the temporary team that is needed to put the new production on stage is formed by part of the creative teams—actors, musicians, singers, and so on—along with selected technical staff. There could also be external contractors involved in the production. When the production comes to an end, the team dissolves, and a new team is established for the next production.

EXAMPLE

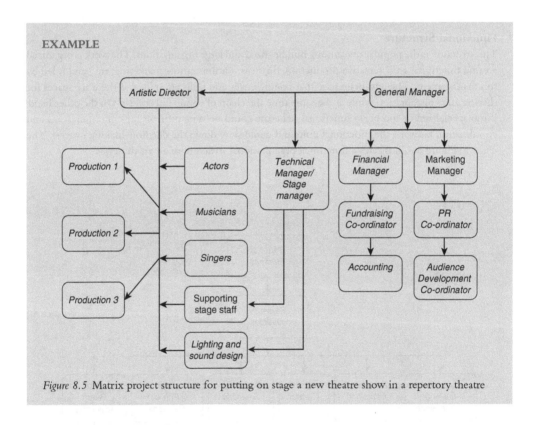

Figure 8.5 Matrix project structure for putting on stage a new theatre show in a repertory theatre

- **'Sand-clock' Structure**

 Most arts organisations have a 'sand-clock' structure—a situation whereby, above the management levels or teams, there is a board (committee, board of directors or board of trustees) who make major decisions related to finances, creative policies and all other strategic directions of the organisation's development (see Figure 8.6.). The exact function of the board depends on the type and size of the organisation. The following are several important responsibilities and roles of the board (some of them are also discussed in Chapter 3):

 - Developing policies and strategies or responding to strategies proposed by senior staff;
 - Taking overall responsibility for an organisation's development;
 - Developing structures and procedures;

- Helping in fundraising and marketing campaigns;
- Maintaining fiscal responsibility;
- Initiating and approving programmes and projects;
- Providing support to key managers to perform their daily tasks;
- Making decisions about the hiring and termination of personnel;
- Implementing assessment and control systems.

In these cases the upper structure is a reverse pyramid, because the decision-making process in the boards and committees is based on representation of the majority of opinions and interests of different stakeholders. The process of coordination and consultation leads to agreed decision-making. These strategic decisions become guidelines in the overall management process.

EXAMPLE

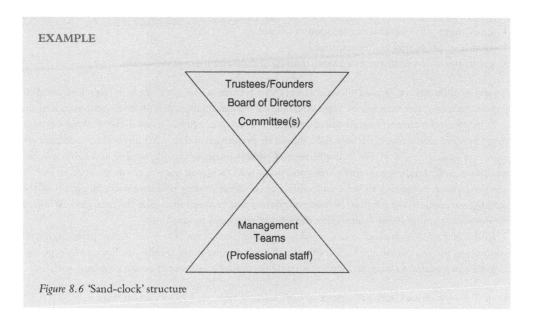

Figure 8.6 'Sand-clock' structure

- **Structure Facilitating Intrapreneurship**
 To be effective and assist in nurturing innovations and seeking additional sources of revenues, an organisational structure has to be created in a way that stimulates an intrapreneurial climate. To achieve that, it is important to do the following:

 - Reorganize the traditional pyramidal structure into a more flexible one where horizontal relations between departments and teams are leading.
 - Provide independence and autonomy to some of the key departments and teams at a lower level in the organisational structure in such a way that they have more responsibilities and decision-making power, especially regarding internal activities and generation of ideas.
 - Set up well-defined objectives, as well as resources as the input of these units. They should result from the main organisational objectives.
 - Establish flexible forms of labour organisation, rotation and exchange (where possible), which requires less specialization and enlarges and enriches job descriptions.
 - Monitor and evaluate the results, including financial ones (achieved independently), from the viewpoint of the overall organisational development as the output of these units.
 - Connect achieved results with a well-elaborated reward system providing financial benefits for people working in the unit.
 - Elaborate an effective strategy for the units to achieve these objectives and maximize the expected results.

An important aspect for the establishment of an intrapreneurial climate is people and their relationships. This is why these units require a strong leadership as well as a team-building approach, decentralization of decision-making, and delegation of tasks. Representatives of intrapreneurial units have to be involved in the overall strategic planning process.

2.2. Internal Regulations and Working Conditions

Internal regulations are documents that help set up the *internal management technology* and operations—in other words, the way things are done in an organisation. Internal regulations and procedures are guidelines for performing certain activities within the overall operational process of HRM system. They define the rules that are the guiding principles on how to act and what to do in specific situations. Such internal regulations could be

- guidelines for the internal organisation of labour;
- guidelines for salaries and benefits; and
- guidelines for recruitment, evaluation, training and development of personnel.

Working instructions are detailed documents on how to perform a concrete routine and repetitive task. Setting up, evaluating and changing or improving internal regulations form part of operational management.

Each position within an organisational structure is situated in a physical and social working environment. Specific requirements on how tasks should be performed and in what physical environment are known as *working conditions*. For example, *physical working conditions* include heating and lighting at the workplace, noise levels, ergonomic work conditions, risks factors in the job, hours of work, degree of repetitiveness or monotony in tasks, and other aspects. *Social working conditions* cover all aspects of the working atmosphere and relations between employees and between them and the managers. Working conditions are important in determining the level of personnel motivation.

Health and safety regulations secure suitable working conditions. There are many professions and positions in the arts containing high levels of risk related to working conditions. For example, people in professions related to stage performances could encounter a number of health problems, such as

- deafness (of various levels) as a result of high levels of noise and vibrations on stage;
- lung diseases as a result of stage dust;
- fractures or bone-related diseases among dancers;
- eye problems as a result of high levels of lighting on stage;
- skin problems from constant use of make-up during performances; and
- health problems, and even heart attacks, due to concentrated levels of intellectual and physical energy on the stage.

Planning for the need to change or improve structures and internal regulations requires a careful consideration of the working conditions of each employee in the organisation. Working conditions, health and safety regulations and social benefits in every sector are usually determined by the national labour legislation in the respective country. However, in many cases, for arts organisations, general legislation is not relevant because artists have distinct work schedules or the retirement age for artists is different than for other people. Artists are a special category that does not conform to mainstream employment characteristics. The unique characteristics of artists' status are not recognized by the general labour legislation in many countries. One of the important aspects of this legislation has to be to offer additional training to artists (e.g. ballet dancers, circus artists) to obtain new qualifications and skills after a certain age.

The unique aspects of artists' working conditions are as follows:

- The unstable nature of work. Many artists are self-employed or participate temporarily in creative teams.
- Fluctuating incomes. Artists who work on contracts receive irregular and unpredictable incomes throughout the year—depending on their engagement in different projects.

- Unusual work schedules (including evenings and holidays).
- Unusual retirement ages (e.g. much earlier for ballet dancers) or no retirement at all in some creative professions.

The preceding characteristics explain why the presence and actions of trade unions of creative workers (actors, writers, musicians, fine artists, etc.) play a very important role in defending the social status of artists and creative professionals. These unions set up the general standards and working conditions for each specific artistic profession. They strive for payments and fees for artists, health and safety regulations at work, members' pensions and insurance schemes, and much more[2].

PRACTICAL RECOMMENDATIONS

Planning an efficient organisational structure and favourable working conditions in the long term requires a careful analysis of several key aspects:

- What are the main problematic areas in your current organisational structure (for example internal workflow, decision-making, coordination, division of work and areas of responsibility)?
- Who does what, why, where and how (in the key positions)?
- Are there clear job descriptions for each position within the organisation?
- What kind of supporting documents regulate internal workflow and working conditions (procedures, rules, regulations)? Are they efficient?
- What is the desired organisational structure in terms of the chosen strategy?
- What are the external and internal driving and restraining forces related to the working conditions?
- What do you need to initiate changes?

3. ANALYSIS AND EVALUATION OF PERSONNEL'S POTENTIAL: PEOPLE AND JOBS

A very important part of strategic planning of human resources is to evaluate how many and what kind of people are needed to achieve the long-term goals of an organisation. This is important because if there are more people working than are required, HRM costs become too high. In an opposite case scenario, pressure at work might be too high, and people working in the organisation become stressed and overloaded as they have to carry out much more work than they are able to perform. Analysis and evaluation of the personnel's potential form the starting point for recruitment of the exact people for the exact jobs: how many people and with what levels of competences and skills are needed. This process has two dimensions:

- Elaboration of future needs of human resources;
- Analysis of the available human resources;
- Identification of necessary changes.

Comparison between these two dimensions yields the additional needs for personnel for implementing the chosen strategy.

3.1. Evaluation of the Personnel's Portfolio

At the core of human resource planning is the evaluation of the personnel's portfolio. This provides results that drive decisions on recruitment, training, development, motivation, repositioning and layoffs. Figure 8.7 gives an example of how to do this using a matrix approach. The method of analysis in this case is carried out based on two main variables: achieved results and compatibility between the employee's qualities and competences and the job requirements. Variables can change from low to

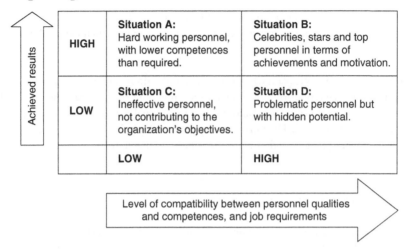

Figure 8.7 Evaluation of the personnel's portfolio

high. As a result of the evaluation based on these two variables, the personnel in an organisation can be grouped and analysed in the following way:

Situation A: These are people who achieve very good final results and fit the expectations of their manager. They work hard and invest a lot of energy and time to perform required tasks. They are responsible and determined to succeed. The problem is that their qualifications, skills or competences are lower than the job requires. It is important in such a situation to find the best way to improve the professional qualifications of these people and to evaluate their willingness to learn. A possible strategy is to invest in education, training or other methods to improve their professional competence.

Situation B: These are the most valuable personnel in the organisation as they match the job description while at the same time achieving high results at work. These people have high competences and contribute well to the objectives of the organisation. When designing a human resource strategy, it is important to design key motivation techniques to keep this group of people within the organisation as long as possible. Options for motivation include involving these people in the governance of an organisation, special benefits, personalized prizes and special public recognition.

Situation C: This group of people do not match the job description and show low results in their work. They are not satisfied in their jobs, and the organisation is not pleased with their productivity and involvement. These people are not motivated to grow, change or improve. Therefore, termination of contracts and development of a strategy for hiring new personnel are the management solutions in this case.

Situation D: These people match the job requirements very well and are extremely competent to do the job. They are keen to learn and develop, but, for hidden reasons, the final results of their work are not satisfactory. These reasons could be absence of satisfaction at work, a difficult social atmosphere and incompatibility with other members of the team, and so on. Other possibilities could be that they are misplaced, lack skills for the job, fear the job cannot be performed at the required level, are emotionally instable or are experiencing poor health or family problems. This reflects frustration and inability to achieve better results at work. It is therefore important to carefully analyse the situation, uncover the hidden problems and try to solve them. Team-building, socializing after working hours, flexible working times, job rotation, enrichment of tasks and other motivation methods could help in such cases. If problems cannot be solved, these people should be replaced with new personnel in the most efficient and least painful way.

This analysis helps an arts manager to evaluate what the human resource potential is and what the needs are for additional personnel to effectively implement the overall strategic plan.

3.2. Job Analysis and Job Description

The chosen organisational strategy requires certain changes in the current working positions and planning of new positions. This requires a job analysis and job description. A *job analysis* is a systematic process that determines the skills, duties and knowledge required for performing the job. Such an analysis is requested when new jobs are created, when jobs are significantly changed, or when there is a need to re-evaluate the current organisational structure. Job analysis provides answers to the following questions.

- Why is the job needed?
- When does the job start and when is it going to be completed?
- When is the job going to be completed?
- Where is the job going to be carried out?
- How should the job be performed?
- What qualifications are needed to perform the job?

There are many practical methods used for analysing jobs:

- Observation of how people perform their jobs;
- Questionnaires (preparation and distribution of a questionnaire among personnel);
- Regular supervision of job performance;
- Individual interviews with personnel;
- Group discussions on job performance and other aspects;
- Recording of job performance (with a hidden or visible camera).

A job analysis helps when writing a job description. A *job description* contains a list of the position's general tasks, duties and responsibilities, as well as the qualifications and skills needed.

PRACTICAL RECOMMENDATIONS

When writing a job description, include the following:

- Position name
- Summary (what is the job about)
- Performance goals and standards to be achieved
- Major duties or tasks performed (essential and complementary)
- Working relations with others in the organisation
- Qualification and skills needed (essential and desirable)
- Working conditions and possible hazards
- Machines, tools and equipment
- Basic salary and benefits.

Job descriptions are used when advertising to fill a vacancy (a new position) and for establishing ongoing performance reviews. They are tailored to the strategic needs of an organisation. An example of a job description for a director of a small library is given in the following example.

To successfully complete an organisation's mission and long-term objectives, an arts manager needs to carefully analyse and evaluate the performance and potential of all people currently working for the organisation, to identify future human resource needs, and to develop an accurate human resource strategy. This analysis can be achieved by considering people's satisfaction, achieved results (quantitative and qualitative), evaluation of the results (by managers, team leaders or heads of units), the professional match between the people and the jobs, and the overall working environment.

EXAMPLE

Job description: Director of a Small Public Library

Title	Library director
Summwary	The director provides the overall leadership and administrative guidance of the library. He/she is the library's main public representative. He/she is expected to develop ongoing relations with the community, create and implement new programmes, keep ongoing connections with other organisations, manage the library's financial matters and facilities, supervise the overall process and develop relations with patrons (readers).
Tasks to be performed	• Assist clients in their use of library resources, including print and non-print materials. Be able to answer questions regarding equipment and technologies, offer basic technical assistance, troubleshoot computer problems, assist with navigation of the Internet, locate databases, request materials through online shared library services, refer clients to external resources and collections and provide information services to them. • Train and supervise volunteers to help with these services. • Develop collections in response to the community's needs, develop purchasing procedures, purchase materials, carry out weeding and evaluate donated materials. • Initiate and coordinate programmes. • Advise the board on pertinent issues by providing monthly reports on the library's operations, attending meetings and participating in fundraising events. • Help the board in the elaboration of the strategic plan.
Working relations with others	The director is responsible for a staff team of four people and manages the overall workflow on a daily basis. The director reports to the library's board and participates in the board meetings. The director also supervises volunteers involved in the library's activities.
Minimum qualifications	• Bachelor's degree in library science or social (humanities) subjects. • Minimum five years of administrative experience, preferably in a top-level position. • Knowledge of public library services and operations and of library collections. • A good understanding of management, administration, operations and finance.
Special working conditions	Work includes prolonged sitting, as well as moderate lifting, carrying, reaching, stooping, pulling and pushing activities. The position requires good communication skills.
Basic salary and benefits	Salary and benefits are in accordance with national or provincial standards for similar positions. Details to be negotiated after interview.

4. FINDING THE RIGHT PEOPLE FOR THE RIGHT JOB: RECRUITMENT AND SELECTION STAGES

To satisfy additional needs for human resources in an arts organisation, it is important to find the right candidates for the right jobs, which is known as *recruitment and selection of personnel*. The existence of various professions and teams in an arts organisation—creative, managerial, technical, production, supporting, and so on—makes it difficult to have a standard procedure and criteria for recruitment. Recruitment and selection of creative team members in the performing arts, movie business and television shows is known as *casting*. This process usually consists of several auditions before a professional casting panel who make the final decision based on preliminary established criteria (depending on the requirements of the show). Artistic jobs and positions do not contain precise requirements for the potential candidate, as the casting process evaluates their talent and artistic skills. For artistic professions, important criteria measuring the professional level are artists' professional image, experience in the field, principal income derived from the arts field, level of public recognition, membership in respective unions, and diplomas (university or other degrees).

Regarding other categories of personnel, procedures for recruitment and selection are formalized.[3] Strategic plans usually cover the main recruitment and selection policy and principles which the organisation intends to implement in the long term, while exact procedures for recruitment are subject to operational HRM. Planning of the main recruitment and selection stages include the following[4]:

- **Preparation.** This stage includes carrying out a job analysis and writing job descriptions and requirements for potential candidates regarding their qualifications, competences and skills, as well as personal characteristics. The preparation period results in the formulation of a vacancy announcement in which the organisation also has to inform applicants about the circumstances and benefits offered to the candidates.
- **Deciding on the procedure of selection.** This stage includes setting criteria to choose the right candidates and selecting a panel.
- **Advertising the vacancy.** It is important to identify the most suitable and cost-effective tools and places for advertising the vacancy (online and offline). Possible places to seek potential candidates are universities, training centres, job-search websites, professional networks, former employees, friends and colleagues, specialized search engines, other websites and online tools.
- **Selection process.** This is the actual process of evaluating applications and conducting the interviews. Usually the selection is divided into three steps:

 - Selection by documents (curriculum vitae, cover letter, references, etc.);
 - Selection by interviews with short-listed candidates;
 - Trial period to assess the qualities and competence of the candidate in a real situation.

 Selection by documents and interviews is the most common method. Other methods of evaluating candidates' competences could be to have them respond to a test, solve a case study, produce a written or oral presentation or participate in a focus group (especially useful for leadership positions). Tests and other written forms of selection are used to eliminate subjective judgements.

- **Ranking and making the selection decision.** This refers to short-listing the final candidates and choosing the most appropriate one based on preliminary defined criteria and the candidate's evaluated qualities and skills.
- **Informing candidates about the final result.** Along with announcing the winner, it is important to inform all short-listed nonselected candidates after finalizing the process.
- **Appointing the new staff person(s).** This includes making an initial job offer, sending a formal letter of appointment, signing the contract, arranging initial job training and providing relevant information necessary for starting the job.

Many organisations, especially large ones, use the services of employment or recruitment agencies to find suitable employees. These agencies play an intermediate role between the job seeker and the employer. Recruitment agencies save administration time, as they are specialized in selection procedures and are dedicated to these tasks. They are especially important for key leadership and management positions within an organisation. Agencies also keep a database of potential candidates. Online job searches have become increasingly popular among both job seekers and organisations offering vacancies[5].

5. INVESTING IN PEOPLE: MOTIVATION, TRAINING AND PROFESSIONAL DEVELOPMENT

5.1. Why Is Motivation Important?

Elaboration and implementation of the strategic plan are almost impossible without personnel's motivation. Motivation is essential for achieving high performance indicators and job satisfaction at work. Situations A and B in Figure 8.7 refer to those people in the organisation who need to be motivated to

stay in the job because they produce very good results and match their job descriptions. These people need to have continual training and development to be able to acquire skills for future strategic changes.

There are many theories on the subject of motivation that attempt to answer the question of why and how human behaviour is activated and how this behaviour can be directed to invest efforts, satisfy needs and reach common goals. The following are the most popular classical theories and models:

- A. H. Maslow's *hierarchy of needs*[6] splits the needs into psychological, safety, love and belonging, esteem and self-actualization.
- C. Alderfer's *ERG theory*[7] emphasizes that to be motivated, human beings seek to fulfil needs for *existence, relatedness* and *growth*.
- David McClelland's *needs theory*[8] outlines the need for power (to influence, lead and control others), the need for affiliation (or desire for interpersonal relationships) and the need for achievements (accomplishment of goals).
- Frederick Herzberg's *motivation-hygiene factors theory*[9] splits motivational factors into two main groups—those leading to dissatisfaction and those leading to satisfaction. Factors leading to dissatisfaction include company policies, supervision, work conditions, salary, and relationships with the boss and colleagues. Factors leading to satisfaction include achievement, recognition, responsibility, advancement and growth. The dissatisfaction factors are called 'hygiene factors' as they are basic but their presence has no perceived effect. 'Motivators' are the factors that determine satisfaction.
- *Cognitive evaluation theory* suggests that there are two groups of motivators: intrinsic—coming from the actual performance of the job (such as achievement, responsibility and competence)—and extrinsic—coming from the environment, controlled by others (such as payment, promotion, feedback and working conditions).

Motivation is not something that is 'done' to other people. It is an internal impulse and state that directs people's behaviour towards achieving certain organisational goals. Reaching and maintaining such a state is a key factor in the strategic planning process. Strategies and tools for motivation aim to understand the motivation of each person (the motivational profile) and, based on this, to direct them towards activities and tasks that further the organisation's objectives.

Artists' motivation is different from motivation in other professions. Many artists create because of their internal impulses and inspiration. Contemporary artists also create to earn their living, but for many of them this is not the primary objective. National statistical data in many countries show that artists have significantly lower annual incomes than the average per country, with the exception of a limited number of 'stars'. This is due to the fluctuating character of their working engagement and other economic factors. Unemployed artists find it difficult to requalify for other professions, and they are not motivated to do so, as they would not receive the same public recognition and public appreciation in other fields of work. This is because artists by nature seek public recognition, approval and acknowledgement.

When one is planning positions and jobs within an organisation, it is important to keep in mind that the jobs have to motivate the people who will perform them. A classical and widely applied theory of what a *motivating job* actually means is Hackman and Oldham's (1976) model[10]. They extracted five characteristics of a motivating job:

- **Skill variety:** the degree to which a job requires a range of personal competences, skills, talents and abilities;
- **Task identity:** the extent to which a job requires completion of a whole and identifiable piece of work;
- **Task significance:** the importance of the job and the substantial impact it has on the lives of other people;
- **Autonomy:** the level of freedom, independence and discretion that the employee has;
- **Job feedback:** direct and clear information about the effectiveness of performance.

An important part of HRM planning is to consider the characteristics of a motivating job when designing work positions and jobs as well as temporary assignments. The process of establishing an intrapreneurial climate requires several of these characteristics, such as

- enlargement of a professional profile through diversification of activities and competences;
- full completion of a product within a unit (and not assignment of a partial activity);
- the level of autonomy given to the team members; and
- feedback from the results achieved by the units.

An important role of arts managers is to constantly evaluate the job positions in an organisational setting and to implement efficient methods to increase motivation at work, as well as create an intrapreneurial climate. The whole strategic management process is based on these two preconditions.

5.2. Methods to Increase Motivation

There are several well-known and widely used management methods for increasing motivation at work. Depending on the type, size and essence of the arts organisation, they can be applied with various level of success.

- **Job rotation.** This refers to the temporary move of a person from one job to another within the organisation. The aim is to allow employees to gain more insights into how other work areas function, as well as a wider view of the overall production and technological process. This method is not applicable for jobs which are too specialized or unique or which involve a high degree of talent and creativity.
- **Job enlargement and enrichment.** This refers to methods that aim to either increase the number of tasks performed or broaden responsibilities and give a higher degree of autonomy in a certain position.
- **Flexible working hours and forms of labour organisation.** This refers to making provision for unusual working hours which better fit a person's habits and daily lifestyle, including part-time work, flexible working time, compressed working hours, partial work from home, and so on. This method is very popular in the arts field.
- **Self-managed work teams.** This refers to giving a heightened degree of freedom and responsibility to an autonomous team without ongoing direct supervision and calculation of exact working hours. This is one of the key characteristic of intrapreneurial units.

Given the unique working conditions evident in the arts and cultural sector, these methods have to be applied selectively.

5.3. Salaries and Fees

Vital motivating factors for staff are salaries and fees because these secure their living standard. Salaries are money remunerations for performing permanent jobs, while fees result from contracted and temporary assignments. Costs for salaries and fees are a key focus in the financial part of the strategic plan of an arts organisation, as it is people-centred and not technology- or machine-driven. In the majority of cases in the arts field, labour costs comprise the highest percentage of the overall expenses. In principle, there are two main salary and fee systems:

- **Closed payment system.** This is a system where the salary and fee levels are based on the financial situation of the organisation, irrespective of the expectations of personnel and contractors and their skills and competences.
- **Flexible (open) payment system.** In this case the organisation considers both its own interests and the interests and expectations of its personnel and contractors.

When one is planning the labour costs, it is important to also calculate allowances (additional payments) for

- work or professional experience;
- higher qualification (higher level of education, e.g. master's degree or doctorate);
- unusual work times (e.g. at night and during weekends and public holidays);
- overtime work; and
- touring.

Bonuses are another monetary motivation and could be calculated

- as a percentage of increased sales or revenues;
- for performing the same amount of tasks in less time;
- for achieving high results at work;
- for innovative ideas and implementation of new projects;
- for effective group work which brings tangible results.

Social security systems require each employer to also pay a certain percentage of the labour costs for full-time personnel to social and health care insurance funds, unemployment schemes and other funds[11]. This is one of the reasons why some organisations prefer contractors rather than full-time employees, as the organisation does not pay additional percentages for health care and social insurance.

Planned costs for labour payments in an organisation have to be distributed based on an internal regulation document. This document sets up the criteria for salary levels for every job related to its specificities and characteristics. In the case of well-functioning intrapreneurial units, decisions on the distribution of salaries and fees should be in the hands of the team leader and the team members and are tightly related to the final results of the unit's activities.

5.4. Professional Development and Learning

The concept of a learning organisation is becoming increasingly popular, especially for the intrapreneurial types of organisations. A *learning organisation* is one that

- acts as an open system and learns from the external environment;
- uses people's mental and creative capacity;
- facilitates people's initiatives and the creation of new ideas and helps people to adapt to the implementation of these ideas;
- not only allows people to learn but stimulates them to do so and rewards them;
- encourages experimentation and a reasonable level of risk and rewards people for risk-taking;
- promotes exchange of information between people and communicates both successes and failures; and
- cares about people, not only about the results.

People's needs for training and professional development are determined by results from periodical appraisals and evaluations of their work. This is part of the strategy for improvement of personnel's capacity and skills within an organisation. *Appraisal systems* evaluate people's achievements, as well as gaps in their work performance and level of adaptability to the changed circumstances. There are many methods to train and develop personnel. Here are a few examples:

- **Introductory training.** In some organisations, HRM planning includes the development of special guidelines for all employees, which help to integrate newly appointed personnel. These provide basic induction information on HRM procedures—internal regulations, benefits, health and safety, performance appraisal methods, training and development, promotion, and so on.

- **On-the-job training.** This method is used in situations where an employee picks up skills whilst working alongside a more experienced employee.
- **Mentorship.** This is a kind of on-the-job training where a close relationship is established between the experienced and less experienced person at work. It is a good method for initial orientation of a new employee.
- **Off-the-job training.** In this case employees are taken away from their usual places of work to be trained somewhere else, such as outside of the city, in a local community centre or in a resort area, e.g. for intensive seminars and workshops.
- **Professional coaching.** This is a method of instructing and training a person, or a group of people, with the aim to help them to achieve their professional goals or to develop certain skills and behaviour at work.
- **Apprenticeship and internship.** These refer to special agreements between a person who wants to learn a specific set of skills and an employer who needs a worker of a certain quality. It usually involves young people who are still studying or have recently graduated. The payment for work is relatively small, because the process allows learning together with performing the tasks In some cases, when both sides are satisfied, internships can continue as full-time employment.
- **Specialized training in health and safety regulations.** This training includes accumulating knowledge on safe working practices, using the equipment in a safe way, and maintaining safe working environment.

5.5. E-learning and Distance Learning

E-learning and distance learning methods have become an integral part of strategic plans in many organisations nowadays, but they are still not very popular in the arts sector. *E-learning* or training involves the use of a computer or an electronic device (e.g. a mobile phone, CD-ROM, audio- or videotape, satellite television) to provide training or educational material. The training or educational programme is delivered electronically, either led by an instructor or without an instructor (*self-supported learning*). *Distance learning* and training methods usually combine e-learning methods with offline seminars and lectures. Course packages are at learners' disposal before the start of the course through online libraries and resources centers, as well as electronic reading rooms where learners can access background materials online. During the course, learners may interact with their tutors (instructors) and with other learners by different media—via the phone or Internet. There are interim and final assignments which can be submitted either by regular mail or electronically via a website. The final decision on whether each student has passed the course is in the hands of an individual tutor, a board or a committee that runs the programme.

There are many advantages of e-learning. It overcomes timing, attendance and travel difficulties and allows easy access from different locations. E-learning eliminates or significantly reduces travel and accommodation costs for the participants, as well as administrative costs for the training organisation. It is suitable for professionals as training can be undertaken at any time and matches people's availability. Another advantage is that the learning modules and materials can be reused and adapted easily.

In spite of these advantages, e-learning platforms and tools are sometimes annoying and not always efficient. The introduction of new methods and technologies might create frustration, especially for people who have more 'conservative' mindsets in relation to training. E-learning requires a higher level of responsibility by the participants to participate in and complete the course. For some e-learning methods which require simultaneous participation, like webinars, online conferences, and so on, it is difficult to synchronize people's schedules so that they can attend at the same time. This is why e-learning has to be included in the strategic plan with care and evaluation of all pluses and minuses. A cost-benefit analysis is a must before deciding on implementing an e-learning module or programme.

Investment in education, training and development is a primary focus of any learning intrapreneurial organisation and requires special attention and careful planning. Strategic thinking and action related to human resources in the arts requires a vision for the future—how the current personnel will change in three to four years' time, how good professionals could be motivated to stay, in what ways people could learn and develop so that their hidden potential would be unlocked, how others could be replaced and compensated, and what kind of recruitment procedures will be implemented.

6. HUMAN RESOURCE MANAGEMENT STRATEGIES: AN OVERVIEW

Figure 8.8 summarizes HRM strategies that could be elaborated in the strategic plan of an arts organisation.

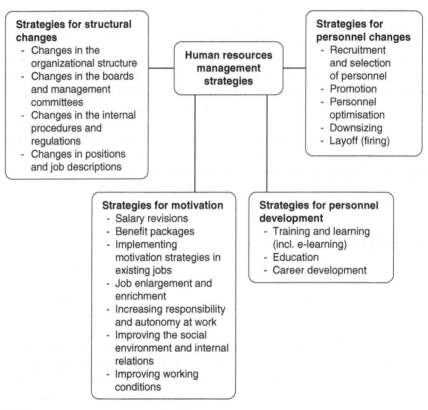

Figure 8.8 Human resource management strategies

PRACTICAL RECOMMENDATIONS

When preparing the human resources section as part of a strategic plan, consider the following:

- Evaluate the current capacity of your personnel.
- Evaluate your organisational structure and identify gaps and overlaps, if any.
- Elaborate a strategy for structural changes needed to reach a desired structure.
- Analyse all internal regulations and working conditions. Think of effective ways to change them (where needed).
- Plan carefully the recruitment and selection process for full-time, part-time and volunteer staff.
- Evaluate to what extent your organisation is a learning organisation.
- Develop concrete strategies for personnel motivation, education and development.
- Calculate the cost-effectiveness of professional development for the current staff members. Find ways to improve their skills and competences, where possible.
- Calculate the cost implications of personnel changes and implementation of planned HRM strategies.
- Synchronize the HRM section with other sections of the strategic plan.
- Suggest ways to secure the necessary financial resources to implement your HRM plan. Connect it with the financial and fundraising section of the plan.

7. EXAMPLE OF A 'HUMAN RESOURCE MANAGEMENT' SECTION OF A STRATEGIC PLAN

1. **Main human resource management strategies and objectives (rationale for the choice and short description).**
 Explain which main strategies and objectives for human resources management you have chosen and why. Give arguments for how they are connected and help in realizing the general organisational objectives.
2. **Main strategic changes planned in the organisational structure (if any).**
 Include here:
 * Problematic areas in the current organisational structure;
 * Organisational chart of a future (desired) structure and approach towards changing it to facilitate an intrapreneurial climate;
 * Job descriptions of the key positions (changes and improvements in the current ones; creation of new positions).
 Note: Pay attention to the current and desired organisational structure. What changes need to be implemented and why? What kinds of new positions are needed (or have to be closed)?
3. **Evaluation, actualization and elaboration of new HRM internal regulations.**
 * Emphasize the key HRM internal regulations (instructions, working conditions, safety regulations, supporting documents regulating internal workflow, contracting procedures in the organisation).
 * Emphasise the need for change over the long term.
 * Elaborate the new internal regulations. (Add as appendices.)
 * Stress the specificity of the working conditions in the organisation.
4. **Analysis and evaluation of personnel's potential.**
 * Analyse the personnel's portfolio.
 * Identify the strategic needs for human resources (quantity of personnel and the skills and competences required).
 * Identify the need for layoffs or hiring.
 * Identify the need and cost for training and development of the new personnel.
5. **Planning the process for recruitment and selection of personnel.**
 Note: In some cases this is part of the operational plan.
6. **Basic human resources (salaries and fees) costs.**

Year	Category of personnel	Number of people	Average salary (on an annual basis)	Social and health care schemes (%)	Total costs
2013	Creative Administrative (Managerial) Technical Production Supportive				
2014	Creative Administrative (Managerial) Technical Production Supportive				
2015 etc.	Creative Administrative (Managerial) Technical Production Supportive				

7. **Schemes and methods for motivation**
 * Monetary (bonuses, allowances)
 * Non-monetary.
 Note: Diverse motivation methods can be implemented gradually over the long term. It is especially important that the motivation process stimulates innovative and entrepreneurial activities within the organisation.

8. **Plan for professional development and training**
 Include here:
 - Evidence or required elements for the organisation to be a *learning organisation*;
 - Planned methods of training, education and requalification;
 - Other methods of personnel development.

 Note: *Make sure that there is an item in the planned budget costs for professional development.*

9. **Main resources needed to implement the HRM strategy and to undertake necessary changes, and assessment of budget implications.**

 Note: *All necessary resources for implementation of the HRM strategy and changes needed should be mirrored in the financial section of the plan (see Chapter 10).*

8. CASE: INTERCULT (STOCKHOLM, SWEDEN): SEEKING A SUSTAINABLE HUMAN RESOURCE STRATEGY IN A COLLABORATIVE CROSS-BORDER ENVIRONMENT

The case was created with the kind assistance of Ida Buren, Vanessa Ware and Chris Torch. The case text is based on analysis of primary data from targeted qualitative research and secondary data derived from Intercult's management documents and promotional materials.

STUDYING THIS CASE WILL HELP YOU TO:

- Understand the importance of the networking and collaboration strategies in the arts.
- Analyse a successful practical example connecting cross-border cooperation with art, research, development, lobbying and partnership.
- Discuss the challenges and opportunities in creating strategic cross-border alliances and creative teams while maintaining ongoing innovation in creative programming.
- Recognize the importance of motivation and development in the HRM strategy of a small organisation with a wide international coverage and a proven methodology of working at an international level.
- Understand the role of personnel's motivation and satisfaction at work.

8.1. Organisational Profile

Intercult[12] was founded in 1996 by Chris Torch as a nonprofit association based in Stockholm, Sweden. The organisation initiates transborder cultural projects and takes an active interest in national and European cultural policy. Since its establishment, Intercult has created and partnered in almost 20 European Union–funded cultural projects. It also runs the European Resource Centre for Culture, sharing the organisation's know-how, expertise and networking[13]. The aim is to internationalize the Swedish cultural sector through training, consultations, conferences and networking.

Since early 2000, Intercult has developed new forms of artistic and cultural collaboration and has initiated and led multilateral platforms connecting European regions, artists, cultural operators and authorities in long-term cross-border collaborations. Examples include CORNERS[14], Black/North SEAS[15], Second Wave and Baltikum/Adriatico.

A main focus in Intercult's work is the connection between local and international initiatives across disciplines and in multiple partnership, bringing together artists, operators and audiences and creating unexpected encounters.

- **Key Current Programmes and Activities**

 - CORNERS is an intercultural arts platform connecting the outer reaches of Europe. Six partners, led by Intercult, work with more than 40 artists and researchers who explore the corners of Europe in search of stories and inspiration for new work.

- In the first phase, CORNERS R&D, four Xpeditions are made by bus to regions far away from the cultural, political and economic centres of Europe, unknown to many. Artists and researchers from different countries in Europe meet engaged citizens and cultural activists who shared with them their stories, thinking and life situations. From these experiences as a guideline, they will make proposals for new artistic work, designed to be presented in unconventional public spaces rather than in theatres or art galleries.
- In the second phase (2013–2017), the proposals for new works of art will be commissioned by the partners in the project and distributed across Europe. Stories heard on the street corners of one part of Europe will be retold on the street corners of another.

- The European Resource Centre for Culture aims to equip Swedish cultural operators with the tools they need to develop and implement international collaborative projects, including cultural management, administration, budgeting, intercultural competence and audience development. The centre organizes courses, debates and an annual international conference on cultural politics, as well as surveys and research work.

Intercult is developing a new model to make the organisation's expertise accessible to the cultural sector. International network engagements are mainly with Culture Action Europe, the International Network for Contemporary Performing Arts (IETM), the Platform for Intercultural Europe, the European Museum Forum, River//Cities and the ARTerial Network (Africa).

- **Management Team**
 The core team consists of senior project managers, including the chief executive officer and communications manager, with different expertise in elaborating projects and partnerships (artistic leadership, creative production, funding and business development, policy development and strategic communication). Artists- and producers-in-residence work on their own projects. The board, with an equal number of representatives from the staff and external professionals, advises and decides on the long-term strategic development of the organization.

- **Financing**
 Intercult's financing model is built on a combination of structural funding[16] from public bodies, project funding for entrepreneurially developed projects in collaboration with interesting partners, and other income. Intercult is supported by the Swedish Arts Council, Stockholm's Culture Committee and the Stockholm County Council[17]. The organisation also develop projects in collaborations where each partner takes on a certain responsibility. The main sources of income for Intercult in the year 2011 are:

 - Structural funding (35% of the total budget);
 - Self-generated income (11%): from lectures, conferences, courses, ticket income, project management, artistic fees, rental of space, and so on;
 - Project funding (54%).

Multilateral projects have been an important part of Intercult's turnover in recent years. A positive trend was the doubled turnover in 2009. Such an achievement demands a great deal of risk-taking considering that 50 per cent of the funding for multi-annual projects come from sources that operate on an annual basis. It keeps the organization flexible but does not further financial stability.

- **General Profile of Clients and Audiences**
 Intercult targets professionals within four overlapping segments tagged by their function: partners, artists, decision-makers and participants. The segments consists of cultural operators, project managers, strategic developers, artists, representatives from key institutions and authorities within all artistic and cultural fields (less frequently from film and literature), politicians and the media. Communication with audiences for artistic work is managed at the project level.

8.2. Unique Features

The main unique features of Intercult relate to its methods of work and programming, as well as its partnership approach:

- Intercult is an idea-based organization, thematically driven by the interconnected aims of an international and intercultural life.
- Expertise, practice and networks are the three equally critical areas for Intercult's work.
- Intercult combines artistic experiences and events with research work, within an overall context of lobbying and advocacy efforts at the European and regional levels.
- The organisation shares its know-how with the cultural sector as a resource model.
- The team has an interdisciplinary approach in all areas of work: artistic projects, research and resource-gathering. It consists of competent professionals with wide international connections.
- Multilateral projects are elaborated in a collaborative mode, with an entrepreneurial spirit, and are process-oriented.

8.3. Main Strategic Directions

- **Mission and Vision**
 Intercult works to internationalize the Swedish cultural sector and beyond. The organisation's vision is arts and culture created across cultural, disciplinary, geographical, structural and mental borders.

- **General Strategy**
 Intercult's main strategy is oriented towards the development of long-term partnerships, strategic alliances and networking based on mutual interests and opportunities rather than just formal connections. Cooperation at the European, regional, national and local levels is a central part of Intercult's projects to create opportunities and secure funding. Networking is an important part of Intercult's strategic development, and the organisation invests considerable resources in networking. Intercult is a member of the boards or advisory groups of international cultural networks, which provides active contacts and knowledge that are fed back into Intercult's development.

- **Strategic Goals (2012–2016)**

 - To develop smart platform structures for projects that engage artists to meet audiences and that lead to innovative forms of collaborative amongst the participating organisations, cultural professionals and artists.
 - To develop and implement CORNERS as a five-year European arts platform.
 - To develop a new model and tools for making Intercult's resource model of expertise, know-how and international networking accessible to the Swedish cultural sectors and players, in a financially sustainable way.
 - To continue to be a strong voice for the development of the cultural and artistic sector on the national and European levels.
 - To act as a consultant and expert on international cultural cooperation for other emerging organisations and institutions.

- **Brief SWOT Analysis**

 - *Strength*. Intercult's visionary yet pragmatic work in the realms of art and politics has always attracted passionate, competent, creative and progressive people with strong ideas. Their resource model combines expertise, practice and networking.
 - *Weakness*. The multifaceted and flexible nature of Intercult's work places high demands on its management.

- *Opportunity.* Intercult's position is unique in Sweden. The world is becoming smaller, and public funding for culture is constantly changing. This requires implementation of new innovative strategies, which the organisation pursues.
- *Threat.* Public funding is in transition in Sweden and internationally. Intercult operates in a politically sensitive sector with limited ability and willingness to self-generate income from service offerings.

8.4. Functional Strategies: Highlights

- **Creative Process and Product/Service Development**
 Project designs and new services are developed by senior project managers. Elaboration of new projects comes from the initiative of team members, in a continuous internal dialogue and in collaboration with strategic partners. Networking and external engagements are important to keep a finger on the pulse.

- *Marketing and Audience Development*
 The marketing strategy focuses on a branded digital platform designed to manage the diverse communication needs of a small organization with a broad and collaborative practice. Content is methodologically shared on an ongoing basis through diverse social media and Intercult's regular newsletters. The digital platform enables cost-efficient and effective communication about both Intercult as an organization, and its projects and services, and also about communicating about events set up in partnership. The people on the Intercult team are continuously communicating about Intercult in their networks and relations.

- **Human Resource Management**
 The main HRM strategy is focused on motivation and personnel development. The staff works in a collaborative networking mode. Individual initiatives and creative inputs are encouraged. In return, the team works with passion and engagement. The organisation recruits new staff members outside of the usual Intercult network, which brings new competences and widens professional contacts.

- **Financing and Fundraising**
 Intercult's fundraising strategy is a mixture of structural funding, project funding and self-generated income. The organisation devotes ongoing efforts to securing funding at the local, regional, national and European levels.

8.5. Intrapreneurial Aspects: From Project to Platform

Intercult has elements of an intrapreneurial organisation. The internal work practice is one of continuous development through dialogue within the team and with external stakeholders and partners. This also signifies a management style which is non-hierarchical and based on trust and a continuous exchange. Informal brainstorming sessions over coffee often turn into more formalized strategic development meetings. The team works in an experimental, laboratory-type climate where each member is encouraged to give ideas as well as suggest ways of implementing them. New ideas are generated by the senior project managers based on their own strong initiative in collaboration with strategic partnerships and impulses through Intercult's wide networks. The unique internal method for exchange of ideas and critical decision-making is called *IC Mapping*. The Intercult mapping session engages the whole team and is designed to discuss a project in relation to Intercult's core values, competences and position.

The organisation has a proven ability for networking and collaboration, constantly seeking expansion and growth through partnership in new regions and new cities across Europe. To be out there (networking) enables Intercult to keep a finger on the pulse of new ideas and financing, and when possibilities

surface they can immediately activate their own network to find the right partners for collaboration. The project design of Intercult's arts and culture collaborations takes the form of a platform that can grow with new opportunities for activities and collaborations. A project development usually starts with a core group of co-organizers and is later extended with hosting partners, co-producing partners and associated partners in different countries and regions. In this way, the project is transformed into a platform with a strong thematic concept and artistic content, which gradually grows with new partners and activities. An example is the multilateral arts platform Black/North SEAS (2006–2010), which involved more than 100 artists and partners from the Black Sea and North Sea regions[18]. Many of the partnerships were cross-border collaborations connecting art collectives, municipal authorities, festival organizations, art institutions, freelance cultural operators and local unconventional venues such as boats, pubs, a flea market, a church and a skateboard club.

All financing for similar projects is done via a mosaic of contributions from the partners involved. The most innovative solutions often involve in-kind support from activists, volunteers, artists and local organizers. This is both necessary and unique: public funding is not sufficient, and private funding is limited and undeveloped in many countries. This is why Intercult relies on innovative actions in partnerships as a way to cover the operational costs for parts of planned events. Many small contributions make a large resource pool. This concept of working as a platform provides the necessary flexibility to identify and seize opportunities and develop new partnerships to realize new ideas.

Intercult's multilateral projects are important to raise funds from diverse European and national sources, which enables the organisation to keep a senior team with strong competences. Such projects also require a great deal of risk-taking as many other funding opportunities work on an annual basis whilst multilateral projects run over several years.

8.6. Lessons Learned

Intercult's team shares three main lessons learned out of their many years of practice in the cultural field across Europe:

- 'Keep your finger on the pulse to understand the relevance of new project ideas and to swiftly act when opportunity arises.'
- 'Always be prepared to rethink your plans and to work hard.'
- 'Keep up the passion in your work by challenging yourself on an ongoing basis and making sure that you collaborate and work with people you enjoy working with.'

QUESTIONS AND ASSIGNMENTS

- Elaborate an efficient HRM strategy for Intercult that helps the organisation to keep a competent core team on an ongoing basis while at the same time expanding its network of collaborators and partners across Europe.
- Draw Intercult's current and future organisational chart, showing also relations with external partners and stakeholders and considering the new programme areas and strategic goals.
- Connect the human resource strategy with the financial/fundraising strategy which helps Intercult to develop concepts, partnerships and projects that are less dependent on ongoing project funding.
- Suggest ways of using online technologies in Intercult's internal management and operations.

Note: You might need to perform additional online research to complete these assignments. In your answers, apply the theoretical concepts and methodology from Chapters 1 and 4 as well as this chapter.

9. CASE: FRAMEWORK (TORONTO, CANADA): EFFECTIVE STRATEGIC MANAGEMENT THROUGH ONLINE SHARING AND COLLABORATION

The case was created with the kind assistance of Dr. Aine McGlynn. The case text is based on Framework's strategic plan, management documents and website and an analysis of primary data from targeted qualitative research.

Studying this case will help you to:

- Understand the importance and challenges of applying online technologies in the strategic management process.
- Explore diverse innovative online tools and techniques in the strategic management process in a nonprofit organisation.
- Discuss practical connections between arts, creativity, volunteering and development of the third sector.
- Understand the importance of investing in the ongoing motivation, research and development of human resources in an organisation.
- Analyse the ingredients of job satisfaction and motivation at work.

9.1. Background

Framework[19] was founded as a nonprofit organisation in 2004 by Anil Patel. When it started, the organisation had a single area of programming only in Toronto. Since then, one of the programmes—the Timeraiser—has grown to 12 cities across Canada, and in the last nine years 32 Timeraiser events have been held. In addition, since 2007 Framework has taken on a leadership role in capacity-building for the nonprofit sector in Canada. Since the first Timeraiser event, the organisation has invested Can$500,000 to assist the professional careers of emerging artists and has raised more than 100,000 volunteer hours. Timeraiser has encouraged more than 6,000 Canadians to pick up a cause and has helped more than 350 nonprofit agencies connect to skilled volunteers.

Framework is committed to the following **principles:**

- Work more collaboratively with like-minded people and organisations over time;
- Become more transparent over time;
- Get really good at prioritizing new ideas against the organisation's existing game plan;
- Become a learning organisation;
- Simplify operations while scaling the organisation's activities.

Mission statement: Framework's creativity connects people to causes and causes to people. This means that the creative work, actions, activities of Framework connect people to causes and causes to people.

9.2. Key Current Programmes and Activities

- **Timeraiser**[20]

 This is still the central area of Framework's programming. Timeraiser connects people to causes and causes to people. Timeraiser events bring together local agencies that are looking for skilled volunteers, while celebrating the work of artists in the community. These events are organized as silent art auctions where participants bid time, not money, on works of art by local emerging artists. Thanks to fundraising efforts and generous corporate partners, Timeraiser artists are paid fair market value for their work.

Timeraiser volunteers, especially those who win art, are encouraged to volunteer with the agencies and organisations who have been invited to attend the Timeraiser. Volunteers spread their hours among several agencies throughout the year. Framework works on the honor system—a part-time member of the staff regularly follows up with art winners to make sure they are able to complete their pledges. Timeraiser participants can create a profile and log their hours using an online portal—Civic Footprint[21]. Planning and tracking civic footprints helps to build a lifetime of civic engagement.

The central quantitative goal for 2013–2015 is to invest Can$500,000 per year in the careers of emerging artists, making the Timeraiser one of the top programmes in supporting creativity, and to raise double the amount of hours annually through this investment.

- **Platformation**[22]
 This is a project-testing tool—an online resource that allows the team to innovate by testing and evaluating different online, mobile and social networking tools for use in the nonprofit sector. The programme started in 2009 with a grant from the McConnell Foundation. Over 200 different tools have been tested in the period of 18 months, and more continue to be tested. Examples include file-sharing, wiki solutions, online idea-sharing and group voting, analytical tools, accounting and finance tools, content management systems, solutions for online surveys, and more. Platformation targets nonprofit and charitable organisations interested in implementing free and low-cost online and mobile technology into their information technology (IT) infrastructure. The Framework team regularly reviews online tools and shares their findings on the website. The Framework team believes that organisational development and programming should come first and that the tools support, but do not lead, the management and creative processes.

- **Sharesies**[23]
 This is a new capacity-building programming stream, started in 2011. Sharesies is a management protocol that encourages organisations to adopt cloud-based tools in order to streamline organisational processes and drive efficiency. It's simple: organisations that share better, both internally and externally, work better and respond quicker. Framework expects to position itself in the nonprofit sector as a leader in technology solutions to management and governance inefficiencies.

9.3. Governance, Management Team and Working Mode

Human resources are the most important asset for Framework. The team is small, consisting of six devoted and motivated professionals working across different programming areas. The team members work quickly, collaboratively and openly. The executive director and founder, Anil Patel, is the driving force behind many of the newer programmes (Sharesies and Platformation), while he plays more of an oversight role in the planning and execution of Timeraiser. Aine McGlynn, resource development coordinator, assists in strategy and business development in all areas of programming and works closely with Patel to reach new audiences and connect with new sources of funding and revenue. Amanda Grainger Munday, manager of communications and marketing, does a great deal of public events wherein she communicates the value of Timeraiser and Framework's other programming streams. She is a talented IT wizard who facilitates many of Framework's internal IT processes. She drafts and disseminates all public relations materials about Timeraiser. Nicole McPhail, the national event and volunteer manager, works most closely with Munday in coordinating agencies, artists, venues, vendors and volunteers for every Timeraiser. Noorin Ladhani is the Platformation testing coordinator and deals with testing and reviewing software programmes that allow running workshops online or using cloud tools to create efficiency.

The team invests efforts to continually make the work space enjoyable, fun, rewarding and meaningful. The organisation invests in people's personal growth, work satisfaction and motivation. While each staff member has specific role and responsibilities, all of them act as customer service representatives, promoters through social media, advocates for engaging volunteers, planners of the Timeraiser and

fundraisers for increasing external incomes. The organisation does not have a hierarchical but a matrix flexible structure. As Framework grows, the goal is to ensure that world-class HRM systems are in place to recruit, train and retain the best candidates from around the world. Framework's human resource management strategy is available online[24].

9.4. Generating New Ideas by Sharing and Collaborating

Framework's team is driven by the philosophy of sharing that motivates their work. The Sharesies model contains four simple components. The first is 'curated sharing'. This builds a new type of organisational muscle that always thinks about sharing useful information with audiences, volunteers, staff, partners, funders and stakeholders. Regardless of whether it is a budget document, policy, procedure or technology review, Framework thinks in the first place about sharing it. This is a very powerful core skill to strengthen over time. A consequence of always thinking about what is being shared, and why, is that Framework team members actually become more agile and responsive. How? Codification of agility and responsiveness is, at the end of the day, a result of being good at change management. For example, everyone on the team knows that to be a learning organisation, there must be a level of comfort with the fact that what might work well today might not work well tomorrow. Therefore, reducing ambiguity about why decisions are being made or how resources are being used helps set the stage for incremental and continuous improvement.

9.5. Financial Resources

Framework has a mixed financial strategy and generates incomes from diverse sources. The overall operational budget for 2011 is Can\$793,289. The main sources of income for 2011, in percentages, are

- Corporate support: 45 per cent;
- Government support: 23 per cent;
- Foundations: 29 per cent;
- Support from individuals: 1 per cent; and
- Earned revenues: 4 per cent.

All financial information is available online on Framework's website and is constantly updated[25].

The strategy for fundraising and increasing sources of income is called the 'Resource Development Strategy'. The main goals for the period 2012–2015 are the following:

- Resource development revenue mix: create and maintain a small but targeted/focused outreach:

 - 40 per cent of the funding coming from corporate partners: in support of Timeraiser and employee volunteerism (mix of money and skilled volunteers);
 - 20 per cent of the funding raised from major gifts and grants and/or strategic partnership funding to support innovative agenda (via Platformation project);
 - 20 per cent of revenues coming from self-generated income;
 - 10 per cent of the funding coming from individual donations, focused on 'new information and communication technologies (ICT) skills' campaign.

- Have an annual operating budget of \$1.5 million by 2013—one-third of which will be invested in supporting emerging artists;
- Increase cash-flow cushion to six months of operating funding[26].
- Create and maintain a small but targeted corporate, foundation and individual outreach strategy. Framework's team updates the current and potential sponsors and supporters of activities and programmes and keeps track of the changes in their priorities, personnel and strategies. The team tries,

as much as possible, to choose key supporters who could invest a lot of time and energy in this activity so that they also become strong advocates for Framework's strategy and programmes.

• Share internally (with staff and board) and externally (with other organisations and stakeholders) all grant applications and/or corporate donations where the funding organisation is interested in collaboration and support.

• Engage the volunteers who want to help engage in outreach within their company or amongst their colleagues.

Framework hopes to build a more stable operating cushion which may include earned-income sources so that the organisation becomes less reliant on donations and grants. This earning potential will come from capitalizing on the substantial knowledge and experience which the team has developed, transformed into consulting and service offers.

9.6. Strategic Goals (2012–2015)

Framework organizes regular internal *Horizon-scanning* exercises. They aim at identifying political, economic, social and technological trends that affect different levels of government, corporations, charities and individual Canadians (PEST analysis). The results are publicly available online[27]. The board, staff and key volunteers have permission to add and comment on the trends that are being captured.

Based on this external analysis and an ongoing analysis of its internal strengths and weaknesses, Framework establishes its strategic goals (see Table 8.2).

Table 8.2 Framework's Strategic Programmes and Goals

Programme	Strategic goalsa
Timeraiser	• Increase payment ceiling for artists and number of works of art available for auction. • Maximise integration of capacity-building technology into Timeraiser programming. • Add 3 to 10 new Timeraiser events, through strong partnership. • Execute 10 to 15 Timeraiser events annually across Canada. • Organise Timeraiser in 15 cities across Canada and 5 cities in the United States. • Incorporate Civic Footprint and Platformation programs into Timeraiser.
Sharesies	• Launch Sharesies Academy for financing the Timeraiser program. • Receive accreditation for the academy. • Migrate all key documents under Sharesies, including monthly financials. • Encourage five organisations to make the pledge to become Sharesies-certified • Attend five conferences where Sharesies is taken into the 'water supply' so that the sector as a whole gets better at working openly and transparently.
Platformation	• Continue testing and prototyping tools while placing a stronger emphasis on creating awareness around data privacy issues associated with using cloud tools. Establish Platformation as the research and development wing of the organisation. • Co-develop Platformation Fund, in collaboration with partners.
Civic Footprint	• Redevelop Civic Footprint strategy so that it is simple, enjoyable and meaningful to plan/track community engagement. • Determine the best approach for Civic Footprint program to meet the needs of the corporate community. • Build and launch Civic Footprint 2.0, which includes a mobile component. • Fundraise to support this relaunch. • Partner with targeted cause-based organisations to promote Civic Footprint concept.

Source: These goals are extracted from Framework's annual report (2011) and Framework's Strategic Directions (2012–2015) documents, both available online at: https://timeraiser.box.com/shared/pxa6fa7yt8 bot1b2dy4u (accessed March 16, 2013).

9.7. Communication and Marketing

Framework is in the process of elaborating a comprehensive Awareness, Communication and Marketing Strategy for 2012–2014. This strategy will cover all Framework programmes, determine the goals, link traditional media and new social media, and include targets and a schedule of activities for each media channel. The strategy is available online.[28]

Framework's main target audiences are related to its programmes and activities. The Timeraiser programme engages mainly (but not exclusively) young professionals aged 20–40. The audience is typically comfortable with social media and uses mobile devices. The agencies and organisations engaged in the Timeraiser fit into four categories: health care, social sciences, art and culture, and the environment. Presented artists are creative young people at the start of their careers.

The target users of the Sharesies programme are mainly young people looking for new competencies in the knowledge economy and nonprofit organisations looking to update the way they think about ITC strategy and implement ITC tools in their programming and operations.

9.8. Innovative and Entrepreneurial Aspects

• Framework focuses on nonprofit capacity-building, raising time and saving time in the way no other organisation of that type does. The Timeraiser programme is about raising volunteer time from people across Canada, while implementation of diverse online tools is about saving management and administration time in running internal operations.
• Framework applies cloud tools to solve fundamental challenges that nonprofits face in their daily work.
• Framework's management and operations are mainly online. The organisation has moved 90 per cent of their key management materials online, and the site is updated in real time. This generates internal efficiency as well as interest from funders and key networks across North America. All budgeting and reporting to funders also happens online. All organisational information is digitalized. Framework's team is vigilant in how they collect, store and share data over the long term
• Through the novel Sharesies methodology, Framework helps nonprofit organisations to think and operate much like the web: open, agile and networked. Framework has established and implemented a number of new tech-savvy approaches to such areas as bookkeeping, board governance, fundraising and impact reporting online and in real time. Framework has documented each of these processes and discovered that they have been four to five times more efficient than the regular workload.
• Framework always innovates, improves and shares. Online tools will be regularly reviewed online, and findings will be shared on the website.
• Framework is about learning. The research conducted through Platformation not only drives other nonprofit organisations' solutions but also helps Framework's team to learn about new ways, new methods and new tools of managing and networking.
• Framework has dedicated research and development resources to making collaboration, transparency and reporting easier for nonprofit organisations of all types and sizes.

9.9. Lessons Learned

Framework's team has the following simple rules for all staff to abide by:

• 'Always think about how to share what we learn with our stakeholders as quickly & simply as possible.'
• 'Always think about how to engage volunteers in our work quickly, meaningfully and deliberately.'
• 'Always look for opportunities to collaborate with other like-minded organisation where there is a fit.'
• 'Always share your ideas with your colleagues by adhering to share-by-default protocols. Use collaborative document crafting, keeping files in the online cloud storage, record contacts and interactions in the internal content management system.'
• 'Be proactive in your work.'

QUESTIONS AND ASSIGNMENTS

- Is Framework an intrapreneurial organisation? Why? Why not? Justify your answer.
- Framework moves quickly and constantly innovates, which might create risks for instability in the strategic planning and plan implementation. What should the organisation do to decrease these risks?
- Elaborate a comprehensive organisational chart for Framework's programmes which could also handle the future strategic objectives. Discuss the type of organisational structure, its main strengths and its possible weaknesses.
- Elaborate a completed framework for a HRM strategy and main tools, considering the programme areas and the main strategic goals.
- Discuss the pros and cons of using online technologies in strategic management and the internal operations of a nonprofit organisation.

Note: You might need to perform additional online research to complete these assignments. In your answers, apply the theoretical concepts and the methodology from Chapters 1, 4 and 6 as well as this chapter.

9 Technological and Production Plan

<div style="border:1px solid">

LEARNING OBJECTIVES

Upon completing this chapter you should be able to:

1. *Elaborate the differences and similarities between the terms technology, production and operations and their relevance to arts organisations.*
2. *Analyse and plan a technological and production process in an arts organisation.*
3. *Elaborate an organisational plan for effective use of material resources, equipment and information resources in an arts organisation.*
4. *Understand what production capacity means.*
5. *Describe why innovation and research and development (R&D) are primary factors for success in an arts organisation.*
6. *Elaborate the technological and production section of a strategic plan.*

</div>

Planning the required resources, as well as the technological and production process, is an important section of the strategic plan. Implementation of this section is done through the operational management. The technology and organisation of production are tightly connected in practice, and it is sometimes not easy to differentiate between them, especially in the area of services.

1. TERMINOLOGICAL ORIENTATION

It might seem very pragmatic to discuss and plan issues around technology, equipment, the production process and operations in an arts organisation. This is because the primary focus in arts organisations is creativity. The actual production process, such as creating an art object, composing a song or writing a book, in some cases happens before the elaboration of the marketing strategy. One of the reasons is that creativity is an impulsive process based on artists' inner motivation and inspiration and is not closely related to market realization of the final creative product. In other cases, especially in commercial art forms and cultural industries, creative production does not start without an estimation of future sales, expected revenues, expected profits and many other marketing and financial indicators.

Knowing what kinds and quantity of materials are required for all 'backstage' processes, what kinds of places and spaces are needed, what the logic and the consequences of activities are in the transformation of the initial resources into goods or services, is an important part of the management practice. All these activities are usually referred to as *management of operations*.

Preparing the production plan, as part of a strategic plan, requires an understanding of specific terminology and its relevance to the arts. The terminology discussed here could have diverse nuances and interpretations in the theory and in management practice.

- **Production process.** In a broader sense, this refers to the overall transformation of inputs into outputs. In common use, it usually refers to the manufacturing of goods and also to the identification of different phases in a process. A production process covers all operations (activities) that transform resources into goods and services which are of use, match market expectations or contribute to solving a problem in society. The production of art involves creativity, imagination and critical thinking.
- **Technological process.** This term refers to the consequences of activities performed to reach a final result. It mainly refers to 'how we do things'. The technological process is usually split into phases. For example, in a repertory theatre the phases are conceptualization, preparation, rehearsals, premiere (first-night show) and continuous performances in front of an audience.
- **Technology.** This term includes machines, equipment, hardware, techniques (methods) and tools. It could also refer to the way resources are combined to produce a product, solve a real problem or fulfil customers' needs. Some arts organisations are more capital-intensive as they require more technological equipment, for example commercial stage musicals, large national museums and libraries. In others, *technology* refers mainly to working methods and creative ways of doing things, rather than the equipment and machines involved in the process. The latter is the case for a small private art gallery, a stand-up comedy show, or a small nonprofit community art centre.
- **Equipment.** These are machines, instruments and tools, computer hardware and software and other information and communication technologies and equipment
- **Logistics.** This term belongs to the terminology related to the *supply chain,* which covers all activities related to the flow of resources, goods and services between the 'point of origin' and the 'point of consumption' and considers the consumers' expectations and needs. *Logistics* in the arts field is applied mainly in the following circumstances:

 - By arts organisations that offer services and programmes where customers' involvement is high and there is a need to *move* customers, either to get them together in one place and time or to organize their access to a cultural place (transportation or accommodation), for example festivals, international events and/or organisations dealing with cultural tourism.
 - In situations where a cultural product changes its place, for example touring music productions, visiting museum exhibitions, on-the-move libraries and others.
 - By arts organisations where storage space for keeping arts objects is required. These are often objects that are not yet sold, are not yet ready to be seen or are waiting to be exhibited. This is common in the case of libraries and museums.

- **Operations.** This term refers to activities performed during the process of transformation from inputs to outputs. In the arts and culture sector the term is not widely used as it usually refers to routine activities rather than to creative or complex ones.

2. MATERIAL RESOURCES, EQUIPMENT AND INFORMATION

As already discussed in Chapter 1, every cultural organisation requires human, material, financial and information resources for its operations. The core of all internal processes is the people in the organisation as well as the creative and unique nature of the product and services produced and/or offered. Arts organisations also need to secure financial resources for their operation[1]. Planning of the required venues, materials and equipment is an important part of the overall resource planning process. It is predetermined by the production and marketing plan, which answers the questions: 'How many programmes, projects, performances, exhibitions or workshops?' and 'For whom and at what quality and scope?' This part of the strategic plan is very specific and requires a deep knowledge of the concrete arts field in terms of exact technological processes, internal operations and final outcomes. There are many professionals and teams in an arts organisation who have supporting and technical roles. They help in the process of purchasing, maintaining, using or repairing equipment, for example stage managers and technicians, sound and lighting engineers, specialists in conservation and protection of cultural heritage

sites, specialists in restoration of art objects, specialists in printing and digitalization, software engineers and technicians for audiovisual equipment. The list is long as every field of arts and culture is highly specialized.

2.1. The Venue

A cultural venue can include many different spaces (places), some of them internal (not visible to the audience) and others external (where meetings with audiences and clients take place). Here are examples of types of venues:

- External: spaces open to the public. These are concert halls, theatres, exhibition rooms, library reading rooms and educational workshop spaces. Other external spaces are for supporting activities, not for creativity, such as parking spaces and gardens.
- Internal: closed to the public, that is, spaces directly connected with preparation and production, such as rehearsal rooms, a library's internal archives, museum conservation rooms, spaces in the theatre to store properties and costumes, and storage and transportation spaces. Other internal spaces are for supporting activities, such as administrative offices, storage spaces and parking.

When considering a place for setting up a new arts organisation, it is important to answer the following questions:

- What are the pluses and minuses of the location?
- What would be the additional costs to bring the audiences to this place?
- Do the buildings (or the premises) contain enough space to accommodate the planned needs, for all the planned processes?
- Will the building bring additional costs for repairs, improvements or construction of additional rooms?
- Is the building user-friendly and accessible, and how could it be improved to fit the customer's perspective?
- How are issues related to humidity and security of the space sorted out?
- Who are the owners, and how might they use the property (sale, rent, privatize, etc.)?

PRACTICAL RECOMMENDATIONS

Here is an example of some technical questions which you have to address if you are looking for an appropriate space for your new art gallery:

- Where will you locate the gallery? The choice of the place (region, city and neighbourhood) depends on important factors such as the mission and aims of the future gallery, available budget for investment, type and size of art objects to be exhibited or sold, and potential clients. It is important to consider the balance between the investment, the operational costs and the plan for *return on the investment*.
- What is the size of the space you need? You may need to consider both an exhibition space and spaces for storage and office. Remember that an exhibition space includes the walls, the floor and the ceiling (in case of sculptures and installations) and excludes windows.
- What lighting is available? Organizing the exhibition space depends much on the natural and artificial lighting.
- How could you maintain the required temperature and air humidity? Preservation of arts objects requires maintenance and certain air conditions.
- How will you deal with security issues? Artworks are expensive and need insurance policies. Security is an important area to consider when opening a gallery and organizing exhibitions.
- How would you furnish and decorate the interior of the gallery? For a small gallery, the interior should be simple, elegant and minimal. You need to carefully consider in advance the possible ambience that could be created[2].

2.2. The Equipment

The equipment required to perform activities in an arts organisation depends on many factors. Planning of the materials and equipment needed for facilitating a creative process includes the following key stages:

- Clarifying the production plan;
- Preparing a list of quantitative, qualitative and technical specifications for the necessary equipment;
- Evaluating the options to purchase, rent or lease the necessary equipment;
- Evaluating various suppliers' offers for equipment and materials, in terms of the price range, quality, technical specifications, options for a supply of spare parts, maintenance policy, and other factors;
- Contacting suppliers and selecting the most efficient option;
- Purchasing the equipment;
- Learning to use the equipment and to maintain it.

In many countries there are specialized companies that take care of finding the most appropriate equipment for specific arts organisations—museum equipment, stage equipment and others.

EXAMPLE

Planning the Equipment for a Museum Collection

Museum equipment should be chosen to answer the following main criteria:

- To facilitate the storage of specific shapes and sizes of materials;
- To protect the integrity of collections;
- To ensure conservation;
- To offer accessibility;
- To optimize use of space;
- To consider safety features (for the audiences and the collections).

There are several key stages in planning the equipment needed for exhibiting a museum collection (art objects, manuscripts, photographs, sculptures, cultural historical objects, etc.):

- Evaluation of the art collection in terms of the necessary materials—types, quantities and sizes;
- Consideration of the exact requirements for exhibiting and storing each object;
- Listing of the type of equipment needed to store and exhibit the collection;
- Calculation of additional equipment needed for further growth of the collection;
- Research on potential suppliers of materials and equipment;
- Evaluation of offers and negotiations with selected suppliers until the final purchase is complete;
- Installation and maintenance of equipment.

2.3. Informational Resources

Information is an essential resource in the overall management process as well as in the process of developing an efficient strategic plan. To be useful in management decision-making, the collected information should be adequate, actual, trustful, useful and sufficient.

Information and communication technologies (ICTs) have become widely used by arts organisations in the overall process of converting, storing, processing, transmitting and retrieving information. To sustain a consistent and long-term workflow in an arts organisation, a plan for purchasing, using and maintaining ICTs also has to be included in the strategic plan. Some ICT examples include computer software and hardware; electronic and telecommunication equipment such as telecommunication networks and telephones; security systems; and audio and video equipment. ICTs could be of use for different purposes and in different phases of a technological process in an arts

organisation, such as facilitating core creativity, helping conduct market research and/or assisting a promotional campaign. ICTs are also widely used in other internal processes such as transmitting and processing information between departments and teams, developing and maintaining internal databases and performing certain management functions such as analysing, researching, coordinating and controlling.

The estimated costs for information and telecommunication equipment to be included in the financial forecast include purchase costs, system integration and deployment costs, ongoing maintenance costs, repair costs, consultant costs (external help for the integration of the equipment and the pilot phase) and training costs (courses and workshops for people who will use the ICTs).

3. TECHNOLOGICAL AND PRODUCTION PROCESSES IN AN ARTS ORGANISATION

The key technological phases of the production process for a material object are storage, production, assembly, completion, control and packaging. These phases are modified in arts organisations. In cases where the creative production process happens within the organisational setting, like in a repertory theatre, music recording studio or opera house, the production process is a combination of creative, technical and supplementary processes to create and produce a final artistic product—a theatre performance, music album or opera performance. In other cases, the actual creative production process happens outside of the premises of an arts organisation, and after the product is ready, the organisation takes the responsibility to exhibit it, sell it, or lend it to clients, for example in the case of a museum, a library or a music venue that hosts external bands. In these cases the organisation deals mainly with marketing, administrative, technical and support services, but not with the core creative process.

From a theoretical viewpoint, a creative production process can be

EXAMPLE

Technological Process and Operations in a Public Library

There is no actual creative production process in a public library. Several service-oriented, research, technical and additional processes are happening simultaneously, many of them not visible to the clients (readers):

- *Reference desks.* This unit provides help to the readers. In larger libraries, public service librarians are specialized in periodicals, scientific literature, kid's books and other thematic collections.
- *Educational services.* This section of the library works with regular readers, with schools and universities, with the general public, with underrepresented groups (such as seniors, the homeless, rural communities, culturally diverse groups and people with disabilities) to promote books and to advocate for literacy or other social causes.
- *Research and development services for collections.* This area deals with ongoing research (both online and offline) to acquire books on specific subject areas and of a required quality level. Many libraries have specialized research departments to follow recent trends in library services and improve the organisation of collections.
- *Electronic services.* This unit manages the resources and databases online, and the ones that libraries license from third-party vendors.
- *Technical services.* These are 'behind the scenes' operators who order library materials and database subscriptions, computers and other equipment and supervise cataloguing and physical processing of new materials. Computer network maintenance is an important part of the technical services.
- *Archive services.* These are also 'behind the scenes' personnel responsible for archiving manuscripts, documents, books and audio materials, as well as digitalizing material sources of information.
- *Support services.* These include cleaning and maintenance of basic equipment and other services.

- individual, for example writing a song, a book or a film script;
- product-oriented, for example when all departments, groups and units are connected in relation to phases in the production of the final result, such as a production in a repertory theatre; or
- service-oriented, for example when all departments and teams are mutually connected to serve clients and those that have direct access to the client are the most visible, such as a library, a museum or a cultural and community centre.

The planning of all necessary materials and equipment needs careful consideration of all internal processes and phases, as well as research on future trends in the specific field. The following example illustrates a service-oriented process in a public library.

EXAMPLE

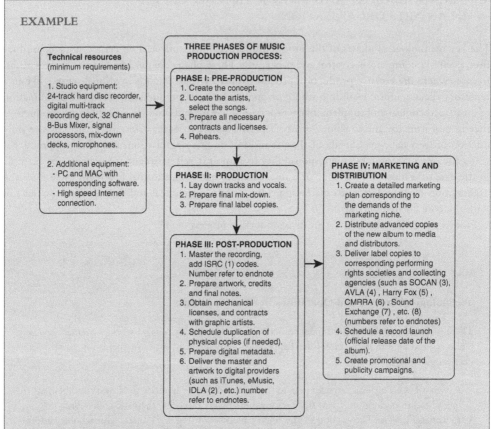

Figure 9.1 Production and distribution process for a music album

[1] An International Standard Recording Code (ISRC) uniquely identifies sound and music video recordings and is used on CDs that will be commercially distributed.

[2] Independent Digital Licensing Agency (IDLA) website: http://www.idla.ca (accessed April 9, 2012).

[3] Society of Composers, Authors and Music Publishers of Canada (SOCAN) website: http://www.socan.ca (accessed April 9, 2012).

[4] Audio Video Licensing Agency in Canada (AVLA) website: http://www.avla.ca (accessed April 9, 2012).

[5] Harry Fox is a mechanical licensing, collection and distribution agency for music publishers in the United States. Website: http://www.harryfox.com (accessed April 9, 2012).

[6] Canadian Musical Reproduction Rights Agency (CMRRA) website: http://www.cmrra.ca (accessed April 9, 2012).

[7] SoundExchange is a nonprofit performance rights organisation that collects statutory royalties from satellite radio, Internet radio, cable television music channels and similar platforms for streaming sound recordings. Website: http://www.soundexchange.com (accessed April 9, 2012).

[8] *Note:* These examples relate to North America (excluding Mexico).

Sometimes the production process is visualized by a flow chart which shows the algorithms of the process, usually in a diagram format where each step in the process is represented by a box of a different kind and contains a short description of what the respective step in the process is about. Flow charts help to provide a visual overview of the whole process—from the resources to the outcomes—and to determine vulnerable or inefficient stages which require special management attention.

Figure 9.1 illustrates an example of the production and distribution process of a music album and the basic technical resources required for a recording studio. In this case, the actual creative production process (CD recording), the manufacturing (mass production of the CD) and the marketing activities (distribution and sales) are split and performed by different teams of professionals.

Understanding technological and production processes assists strategic planning, especially in the preparation of specific operational and action plans for various teams and departments.

4. PRODUCTION CAPACITY

Production capacity is the maximum possible quantity of products (services) which an organisation can produce based on a certain structure, by the most effective use of its facilities, implementation of the best technology and the most effective organisation of production. This definition is about the maximum capacity in an organisation, which in reality cannot be achieved. This is why in the process of strategic planning it is important to also elaborate the *real capacity* as an important indicator in the strategic management. Real capacity depends on a variety of factors. For example, in a theatre organisation it is related to

- the percentage of attendance at a theatre performance;
- the number of performances in a time period (day, week or month); and
- the limited insensitivity of the creative labour (impossibility of performing more than a certain amount of shows in a time period).

Production capacity relates to the securing of material and technical resources which are considered as investment costs in the strategic plan. The return on these investments is part of the financial plan.

An important aspect of managing of an arts organisation is determining how to diversify the utilization of the production capacity—using the venue not only for a core artistic activity but for additional and peripheral services as well. For example, an art gallery could rent the space to other companies, or it could organize concerts, educational programmes and other events. In the field of the live performing arts, the capacity creates a limit for audiences, because the number of seats in a hall is limited. This is why cross-connections between the performing arts and new media arts provide additional opportunities for overcoming these limitations, for example live streaming of a concert or an opera performance, either online or in another distantly located venue. Expansion of capacity through the use of new technologies results in higher revenues for an arts organisation, along with higher visibility and attendance. As analysed in Chapter 1, this is one of the characteristics of an intrapreneurial arts organisation.

5. INNOVATIONS, RESEARCH AND DEVELOPMENT IN THE ARTS

The primary function of a research and development (R&D) unit in a business company is to develop new products which are profitable and could be well accepted by future buyers. The key responsibilities of the R&D team are to make sure that the new product is developed and produced in an efficient manner, on time, within the available budget, under all regulatory requirements and at the requested quality level. The Organisation for Economic Co-operation and Development (OECD) defines R&D as 'creative work undertaken on a systematic basis in order to increase the stock of knowledge (including knowledge of man, culture and society), and the use of this stock of knowledge to devise new applications. R&D covers three activities: basic research, applied research and experimental development'[3].

R&D is essential for increasing productivity. It plays an important role in any innovation process, as it results in bringing new products and services to the market. As discussed in Chapter 6, innovation is one of the possible main strategies in the development of an arts organisation. An innovation strategy could help a team to find the best way to perform, operate, deliver or communicate. Innovations result in high-quality jobs, successful businesses, better goods and services and more efficient processes. The emphasis in arts innovation strategies is not necessarily on productivity or the implementation of a new technology, but these strategies could cover all aspects of an organisation's development. Innovation could be implemented in production and technological processes, in the structuring and utilization of various resources, and in marketing and communication processes. Today's digital era requires each organisation, including those operating in the arts and culture sector, to implement R&D functions— either in one separate department or integrated within the activities of all teams and departments.

There are two strategic alternatives for implementing an innovative product or service. The first is through an R&D department within the organisation which works on the creation, design and implementation of new products and technologies. The second option is when an organisation acquires a new product or technology from external know-how through contracts, cooperation agreements, patent rights, franchising or other methods.

There is no exact definition of what R&D in the arts means. It is also difficult to measure how much arts organisations invest in innovation and to estimate the return on investment. The art sector still lacks tools both to identify market failures and to undertake policy measures to address R&D development, although there have been some new attempts to create a partnership between the three sectors in support of R&D in the arts[4].

Many large companies in the arts and culture sector have R&D departments (or activities related to R&D)—for example the big festival centres, large distribution chains for music, large performing arts venues, major arts museums and national and international libraries. Small and middle-sized arts organisations, or nonprofit ones, rarely deal with research, development and innovations as part of their strategic plans. Some of the reasons for a lack of awareness of the importance of R&D in the field of arts and culture are the following:

- R&D creates a competitive advantage or a new potential for an organisation to conquer the market and thus increase sales and profit. These are not always the primary objectives of an arts organisation.
- R&D requires significant investments, and arts organisations operate with scarce funding. The need to constantly fundraise from external sources makes it difficult to secure additional funds for R&D on a long-term basis, especially when the forecasted budget is not securely balanced.
- R&D is an activity with a high level of risk. The risky investment could be returned later by the revenues generated when an innovative product is commercialized. Cultural processes contain, by default, a high percentage of risk and uncertainty. Adding more risk by implementing R&D activities is not a preferred option by arts managers.
- There could be bureaucratic obstacles and barriers to implementing R&D in the arts sector because of legislative acts or internal organisational regulations.

PRACTICAL RECOMMENDATIONS

When working on the technological and production plan as part of a strategic plan, answer the following questions:

- How would you describe your current production and technological process, and how could it change in the next three to four years?
- What would be the main equipment and materials needed in the long term, considering the strategic objectives and programmes?
- Do you plan any changes in your current suppliers of materials and equipment? If yes, what are they?

- How do you plan to use the spaces for all your activities in the long term (changes, reconstruction, purchases, etc.)?
- Do you need to consider any specific industry-related standards, safety regulations and quality-control characteristics for specific equipment (for example for lighting or sound equipment)?
- What is your maximum capacity, and what is the level of its utilization? How would this change in the future considering your strategic objectives?
- What are the alternative ways to expand the utilization of a limited facility, including through the use of new technologies?
- Do you plan any technical and technological innovations and, if yes, in which areas? How would you cover the cost for these innovations?

A careful consideration and evaluation of possible R&D product and technological innovations should be part of the strategic planning process for every arts organisation. This is because R&D results in valuable innovations, ideas and designs which can be a very good source of potential value and can bring revenues, facilitate operations and increase supporters and recognition. From a pragmatic point of view, it is also important to envisage legal protection of intellectual property through available legislative mechanisms.

6. EXAMPLE OF THE 'TECHNOLOGICAL AND PRODUCTION' SECTION OF A STRATEGIC PLAN

Technological and production plan

1. Key objectives of the technological and production strategy
- Key areas and aspects;
- Long-term objectives.

2. A short description of the main technological and production process (phases and elements)
- Current process. Flow chart: current and desirable;
- Changes to be undertaken (if any).

3. Plan for equipment and material resources
- Main equipment required;
- Information and communication technology equipment required;
- Benefits of the chosen technology, including ecological aspects, economic aspects, quality, technological levels and others;
- Major long-term needs for materials, as well as general specifications of the main materials planned;
- Main suppliers for equipment and materials, changes in the current suppliers and planned negotiation stages with the new ones (if any);
- Detailed action plan for the first year (purchasing of equipment, maintenance, etc.).

4. Plan for spaces and capacity
- Evaluation of the current capacity;
- Long-term objectives for better use of the current space (reconstructing, enlarging, changing, buying, etc.);
- Plan for acquiring a place (if needed);
- Plan for implementation of online technologies and new media for enlarging of the current capacity
 Note: Synchronise this with the marketing plan.

5. Plan for innovations, research and development
- Sources of innovation;
- Innovation capacity of the organisation and evaluation of the intrapreneurial level of the organisation in terms of technical innovations;
- Main areas of technical/technological innovation planned for the long term;
- Resources required for research and development activities in the long term;
- Risk factors and contingency plan related to innovations, research and development.

6. Quality control
Note: This subsection applies if there are any specific objectives, standards and/or requirements in the respective art field or industry branch.

7.　CASE: CARAVANSARAI (ISTANBUL, TURKEY): SUCCESS FACTORS AND SUSTAINABILITY ISSUES IN AN ARTIST-RUN SPACE

The case was created with the kind assistance of Julie Upmeyer, cofounder of Caravansarai. The case text is based on Caravansarai's initial strategic plan, management documents and results from targeted qualitative research.

STUDYING THIS CASE WILL HELP YOU TO:

- Discuss entrepreneurial aspects in the strategic management of an artist-run organisation.
- Analyse the strengths and weaknesses of managing a small arts organisation that has its own space.
- Understand different types of resources and the capacity limitations involved in the daily management of an artist-run space.
- Recognize the importance of building a strong network of partners, stakeholders and audiences for the successful running of an arts organisation.
- Discuss the success factors for efficient strategic management of an artist-run space.

7.1.　Background

Caravansarai[5] began in 2007 as a hybrid arts-production space and arts consultancy in Istanbul, Turkey, and in New York, United States. Having developed social and professional networks in past career incarnations, the two founders, Julie Upmeyer and Anika Weshinskey, established Caravansarai to expand on and profit from services they were already offering informally. With their background in the arts, education and business, they had a strong desire to open a studio where they could work in a creative environment and involve other artists. They strive to satisfy the same needs for the art world as provided by the historical 'caravansarais'—roadside marketplaces which supported the flow of commerce, information and people along trade routes throughout Asia, North Africa and South Eastern Europe. The two American women pooled their creative and financial resources and bought a building in which they could produce their own work, as well as provide space for other artists.

Two of the most intimidating obstacles for most artists in urban environments in many cities across the world are lack of space to create and lack of time to focus on creative endeavours (as a result of having to work other 'paying' jobs). Artist residencies and project spaces like Caravansarai are created to redress this problem. In Istanbul artists encounter the lack of mobility as an obstacle, along with other issues. Because the Turkish contemporary art world is still developing an infrastructure, a company like Caravansarai, which was developed and run by American artists, is a unique solution for the specific problems of this region.

Through conducting artist-in-residence activities, acting as a physical and virtual information hub, packaging artist exchanges and cultural events and providing space for collaborative efforts, Caravansarai seeks to encourage intercultural interaction. Utilizing the diverse experiences and international connections of the two founders, Caravansarai hosts collaborations between visual artists, performers, film-makers, musicians, circus performers, choreographers, curators, writers, administrators and all manner of creative people. Caravansarai today is an artist-run production space supported solely through income-generating activities and based on a solid business plan, elaborated in 2009, and adapted dozens of times since then.

7.2.　The Founders' Profiles

- Julie Upmeyer, co-owner of Caravansarai, is an artist and initiator based in Istanbul. Her professional experience in the arts business began when she was an 11-year-old entrepreneur in Detroit, Michigan, selling handmade art and handicrafts at fairs and festivals. After graduating with a

bachelor of fine arts from Grand Valley State University, she began her affiliation with Res Artis, the international network of artist residencies. Thus she began a nomadic life of working as a consultant setting up and running artist communities in India, Germany, Austria, the Netherlands and Greece. She continues to work as the web editor for Res Artis. Having first been invited to Istanbul as an artist in residence in 2006, she found it an advantageous location to establish her own profitable artistic community as well as to pursue her artistic endeavours.

- Anne (Anika) Weshinskey, the other co-owner, has a background that is simultaneously academic and artistic. As a lifelong performer, Weshinskey attended the University of Michigan, initially as a music major, but graduated with a master's degree in anthropology/ethnomusicology. In high school she had begun her own housekeeping business, which continued in various capacities until she graduated with a master's in library science from the University of Texas. Having worked in major urban and small rural libraries for over 15 years, Weshinskey acquired experience in marketing materials as well as grant writing. While attending the Circus Center San Francisco, she worked not only as a circus performer but also as the office assistant and production assistant, and she served on the board of directors. Producing, teaching, researching, and performing have taken her around the world, eventually landing her in Asia, Western Europe, the Balkans and ultimately Turkey, where she and Upmeyer have combined their talents and professional experiences to establish Caravansarai. Weshinskey is based in New York City and Istanbul.

7.3. Key Current Programmes and Activities

Caravansarai currently works in the following main directions:

- **NOKTA: Project in Residence**
 Nokta is the Turkish word for 'point', 'dot', 'period' or 'spot'. Many people think of Caravansarai's building as a spot for individuals and organisations that have ideas for projects (artistic or otherwise) in, around and about Istanbul. The NOKTA residency is for artists and collectives with funded projects in Istanbul. For example, if an artist is already invited for an exhibition, is creating a work for a festival, or is part of an exchange programme, he/she could use Caravansarai's facilities[6].

- **Live-Work-See Residency Programme**
 This programme is open to artists, creators and researchers (over 26 years of age) interested in living and working in Istanbul for periods of a minimum of one month and up to three months. Residents are responsible for their own financial support. The programme offers
 - comfortable and convenient living quarters equipped with bathroom and full kitchen, in a building dedicated to creative energy;
 - shared work space and/or studios in which residents can pursue their individual work; and
 - local guidance and access to a wide network of resources and people in Istanbul by virtue of living within an artistic meeting point.

- **Events and Consultancy**
 Caravansarai organizes on a regular basis performances and parties for and with friends and residents, as well as classes, circus workshops and private instruction sessions. It also consults on project management, events management, artists management for cultural organisations, individual artists, researchers, curators, arts organisations and networks.[7]

7.4. Management and Facilities

The two founders are the only managers, and they do practically everything. Each of them manages separate aspects of running the company, but they also overlap in the management of creative and collaborative projects. No additional staff are involved, except a translator who helps with the Turkish language on the website. Weshinskey and Upmeyer generate ideas by having their own 'summits'. These are times away from the space and computers, often in some sort of beautiful and/or special

environment, to talk about ideas, the future and their assessment of how things are going. These summits have names and have become an important part of their working practice.

Weshinskey and Upmeyer have interests of their own, and they sometimes develop these ideas as their own projects with other collaborators and partners. Everything that happens within the building and the organisation is run past the other partner. Risks are shared, and responsibilities delegated according to ability. Organisational tasks are split up: Weshinskey, for example, excels at content development, while Upmeyer does the graphic design.

Caravansarai's production space is strategically located in Istanbul, at the nexus of Europe, Asia and the Middle East; it also has an office and operations in New York. In Istanbul it has a 55 square meter, six-floor building in Perşembe Pazarı, a hardware district along Karaköy's waterfront in the Beyoğlu area of the city. The production space is the main working space for all those using or staying at Caravansarai. It is used for cutting, gluing, practicing, painting, talking and debating. It is also used for workshops, meetings, special events, small performances and presentations. This space is not a gallery, as Caravansarai does not host exhibitions. Caravansarai also has a library, which serves as a knowledge-exchange meeting point—it contains an eclectic collection of books and magazines, with cushions, couches and tables where readers can enjoy them. Other areas in Caravansarai's possession are two residency bedrooms, office space, two working studios, a kitchen and a terrace.

7.5. Finances

The projection of incomes set up in the business plan was that approximately 95 per cent of Caravansarai's annual revenues will be generated by a combination of leased space, paid services, memberships and related activities. The rest of the income is generated through project grants from external funders and a variety of small-scale activities. The major current source of income for Caravansarai is the rental of bedrooms through the 'Live-Work-See' residency programme. A small amount of income also comes through project management of outside projects and the rental of the Caravansarai production space to external organisations and individuals for organizing events. The initial research shows that the demand for such living and working spaces in Istanbul will only grow for the next several years, so Caravansarai is in a good position to keep such a financial structure in the future.

7.6. Marketing Approach and Client Profiles

Caravansarai has been developed with a market-driven approach. The two founders and managers use their vast professional network of international colleagues and customers. Istanbul has an emerging international contemporary art scene. One of the greatest opportunities for Caravansarai results from its unique position—being run by American entrepreneurs in a cosmopolitan city with a developing arts business infrastructure.

- **Target Audiences**
 The three main target groups envisaged in Caravansarai's strategic business plan are the following:

 - *Individual artists and cultural producers.* These are professionals in the field of the arts who are looking for space in which to produce work or a studio space to rent, or who have in mind a project they want to develop and need a consultant. Caravansarai receives at least three requests per month from international artists. Caravansarai receives at least three requests per month from international artists. Usually these are artists who either have access to funding for international residences or artists who have enough income to support their residency fee. This is the main target group for Caravansarai. The 'Live-Work-See' programme (November 2010–February 2012) had a broad international coverage and involved 27 artists coming from Germany, Norway, Spain, Indonesia, the United States, Australia, Netherlands, the United Kingdom, Iceland, Denmark, Canada and Italy.

- *Arts and cultural organisations.* This target group is important for Caravansarai's collaborative projects and initiatives, as well as for securing external support for specific projects. Some of these organizations are the Turkish-American Society, European Cultural Foundation, and the Istanbul 2010 European Capital of Culture Agency. Organisational customers are foundations, galleries, cultural institutions, governments, regional arts councils and other entities who would like to support or be involved in Caravansarai's projects, as well as arts councils and foundations across Europe.
- *Public and events audiences.* These are attendees at diverse Caravansarai events and those who make use of the services offered, such as exhibits, classes and workshops. They include tourists and visitors to Istanbul interested in culture, Istanbul citizens, and friends and supporters of Caravansarai.

Marketing tools used to reach audiences are mainly word-of-mouth, local and international networks such as Res Artist (Worldwide Network of Artist Residences)[8] and IETM (the International Network of Contemporary Performing Arts)[9], as well as Caravansarai's home page and Facebook profile. As stated in the strategic business plan, the web presence, advertising and alliance-building are the three main focuses of the marketing and promotional campaign.

- **Competitors**
 There are several other entities with services similar to Caravansarai. Comparable Turkish organisations are funded with personal financial support, local sponsorship and intermittent project grants. Similar U.S. organisations are almost entirely nonprofit cultural institutions with artist support being just one of their programming aims. Most of these organisations depend on external grants, donations, government subsidies and the like, while Caravansarai considers external funding as less important in the overall financial structure, emphasizing the self-generated revenues from its core and peripheral activities.

 As a for-profit arts business, Caravansarai targets working with partnering organisations rather than competing against them. These entities, which from the outside would appear to be competitors, are actually collaborators, involved in projects and exchanges of services. Additionally, individual artists wanting to work with Caravansarai are responsible for their own funding from granting institutions, donors or self-financing to cover their residency fees.

7.7. Unique Characteristics: Differentiation Points

Caravansarai has the following unique characteristics which differentiate it from other similar organisations:

- **Independency and autonomy.** Caravansarai is an independent organisation and does not rely on a sole external source of funding. The two founders own and are in control of the overall programming, the building and the management operations. The two of them make the artistic, strategic, financial and managerial decisions.
- **Original programming and high-quality unique services.** As artists themselves, the two founders understand and anticipate the needs and desires of the customers and audiences. Having launched their own artistic careers in these environments, they are confident in their ability to run and offer projects, space and services differentiated from those of their competitors.
- **Personal attention and small organisation.** Caravansarai's direct competitors often operate on a scale that does not allow adequate personal contact with the artist or the integration of artists into a community. Because Caravansarai is an artist-run business, with both founders having a hands-on approach to management of the company and its services, the organisation is able to offer a more personalized experience.

- **Fine reputation within the artistic field.** Caravansarai has been approached for training and consulting by organisations and individuals in the artistic and cultural communities in Turkey and abroad. Organisations such as freeDimensional[10] and the Netherlands Foundation for Visual Arts, Design and Architecture (Fonds BKVB)[11], among others, have pinpointed Caravansarai's projects as worthy of attention and development.
- **Location.** Caravansarai is located in Persembe Pazarı, a hardware district along Karaköy's waterfront in the Beyoğlu area of Istanbul. In this neighbourhood one can find the materials and services to produce almost every sort of artwork. The location is a 10–15-minute walk from most of the city's galleries and art spaces.

7.8. Strategic Plan: Main Elements[12]

- **Vision Statement**
 To serve as an indispensable platform for connecting individuals from a wide spectrum of cultures and traditions by inspiring and supporting the creation and presentation of collaborative art.

- **Mission Statement**
 Caravansarai is a hybrid arts-production space and arts consultancy based in Istanbul and New York. By conducting artist-in-residence activities, acting as a physical and virtual information hub, packaging artist exchanges and cultural events and providing space for collaborative efforts, Caravansarai seeks to activate artistic intercultural interaction. Utilizing the founders' diverse experiences and international connections, the organisation hosts collaborations between visual artists, performers, film-makers, musicians, circus performers, choreographers, curators, writers, administrators and all manner of creative people.

- **Value Proposition**
 Caravansarai serves as an indispensable platform for connecting cultures, neighborhoods, countries, ethnicities and religions by facilitating the creation and exhibition of collaborative art and the formation of a local and global hybrid art community.

- **Strategic Goals (2012–2015)**
 After one and a half years of active operation, Caravansarai's founders are clearer now about what they do, what has worked well and what has not, and where the new focus should be. The main goals for 2012–2015 are defined as follows:

 - To keep and develop Caravansarai's competitive advantage—a combination of unique services, outstanding location and a personal touch.
 - To focus on creative work and projects within the Caravansarai context and explore them further.
 - To meet customers' expectations and provide an inspirational environment as well as project management consulting for organisations and individual artists and professionals in case the projects fit Caravansarai's team competences and interests.
 - To develop further the trust-building with external stakeholders and funders and constantly improve Caravansarai's local, national and international reputation.

Caravansarai also faces challenges in its current activities. The space is often not filled with the type of energy and creativity that the founders seek. They are also not paid for their time hosting and taking care of artists in residence, so they continue to work their other jobs. This leaves very little time for their personal projects and art practice. Another challenge is that when artists and people in residence change often, they sometimes do not have time to actually create something in the space, instead having time only to act as tourists and do research. This makes the building feel empty and un-inspirational.

QUESTIONS AND ASSIGNMENTS

- Elaborate the strengths and weaknesses of Caravansarai's current venue and management performance.
- Are the two Caravansarai founders effective entrepreneurs and/or managers? Are they innovators? Why? Why not?
- Elaborate a flow chart of the organisation's resources, processes, phases and outcomes.
- Analyse Caravansarai's current stakeholders and external partners. How could they assist the organisation's strategic development and animate the building to become a more efficient social and creative space?
- Does Caravansarai need further investment in research and development? Why? Why not?

Note: You might need to perform additional online research to complete this assignment. In your answers, use the methodology and theoretical concepts from Chapters 1, 4, 5 and 8 as well as this chapter.

8. CASE: MORAL FIBERS (MONTREAL, CANADA): ETHICAL BRAND HELPS ARTISTIC COMMUNITIES IN DEVELOPING COUNTRIES

The case was created with the kind assistance of Matthew Brightman and Martin Weiss. The case text is derived from Moral Fibers business plan and an analysis of primary data from targeted qualitative research.

STUDYING THIS CASE WILL HELP YOU TO:

- Understand the practical aspects of a social entrepreneurial company.
- Analyse the elements of arts, creativity, manufacturing, operations and business in a social entrepreneurial process.
- Understand the importance of elaborating a strategic plan for a start-up organisation.
- Elaborate on the operational and R&D aspects of an internationally established production process and sales of sustainable clothing with artistic elements.
- Discuss the importance of helping communities in developing countries through a concrete business and financial model.

8.1. Background

Moral Fibers[13] is a business organisation with a social mission. The organisation is a sustainable clothing brand, emphasizing the connection between art and education as a powerful tool to assist artists, grow talents and build financial sustainability in the poorest communities in the world. Moral Fibers was founded by Matthew Brightman and Martin Weiss and is incorporated in Vermont in the United States, as well as in Canada. There is also a pending incorporation in Haiti.

The company's philosophy is that the distinction between nonprofit and for-profit does not affect the amount of 'good' a company can do. The company represents the forefront of a new breed of ethical brands that do not exploit their employees in the developing world but rather work with them over the long term to develop their skills and talents as artists. The business model provides sustainable human capital–developing jobs in the developing world by focusing on art as a high-return technology.

In June 2011, Moral Fibers' business plan won first prize and Can$15,000 from McGill University's Dobson Cup, an annual opportunity for budding entrepreneurs to showcase their business ideas and not-for-profit start-ups[14]. This event propelled Brightman and Weiss to fast-track Moral Fibers into a rapidly expanding, full-time enterprise. By July, Moral Fibers employed 10 artists and one local manager in Haiti, and by August the Moral Fibers team absorbed a full-time marketing specialist, a graphic designer and a fashion designer, in addition to keeping a web developer on retainer. Moral Fibers' early success factors are clear and professional branding, unique products, a concrete market niche, and a strong focus on fashion, arts and education.

8.2.　The Concept

Moral Fibers produces clothing with artistic elements in Montreal and Port-au-Prince, Haiti. T-shirts and dresses are made in Montreal, while light jackets and button-down shirts are made in Haiti. Moral Fibers expects to prove a smarter, more effective method of international development by focusing on 15 individuals from Haiti. The people chosen were living on the ragged edge of poverty—tent-camp residents struggling to feed themselves and their families. They were all instructed and trained by artists to provide Moral Fibers 10 paintings per month, for which they receive a monthly salary of US$150—higher than the average in the country. They are also required to volunteer for 20 hours each month in their community, and they are required to go to school. When an artist's painting is featured on a production-clothing item, the artist receives a US$250 bonus, which provides the artist with an incentive to create high-quality artwork. This means that with the sale of just one line, the artist receives almost four times Haiti's national average salary—enough money for them to support their families and focus on creating art as a full-time job. Moral Fibers artists also receive a US$400 yearly stipend to purchase art supplies in Haiti, which allows them to choose their own materials and boost the local economy. As a result, these Haitian artists have come together, moving from tents to homes, to learn to paint—to express themselves.

Moral Fibers artists are considered contractors who work with Moral Fibers Company in the United States. The management of Moral Fibers intends to form an independent Haitian entity to formalize the relationship and reduce any potential liability for Moral Fibers Company. Additionally, there are morale-boosting benefits in having Moral Fibers artists be legally employed in their home countries. All Moral Fibers artists receive a Moral Fibers identification card upon employment, which also boosts morale.

Moral Fibers' model is based around the models of micro-financing popular in the developing world. Self-helped groups of 15–20 people have been formed to encourage "solidarity lending"—a lending practice where small groups borrow collectively and group members encourage one another to repay. Playing off the social dynamics of a small group to encourage positive results has shown incredible reliability. Playing off the social dynamics of a small group to encourage positive results has shown incredible reliability. The important aspect of Moral Fibers' model is that the buyer of a T-shirt knows exactly who they are helping and exactly how they are helping. Partnering with governments, nonprofits, socially conscious consumers and businesses is essential.

Moral Fibers plans to apply its artist model to other countries once the model proves to be financially profitable, developmentally beneficial, repeatable and scalable.

8.3.　Management Team and Idea Generation

Moral Fibers' key managers are Brightman (chief executive officer and cofounder) and Weiss (chief operating officer and cofounder). Other members of the team include Ben Gruber (chief financial officer), Trevor Stanhope (system administrator) and Erick Frazier (local manager in Haiti). Brightman and Weiss are the sole decision-makers, but every financial decision is run by Gruber. At the end of the day the Brightman has the final say, but both Brightman and Weiss lead the company.

The team has maintained relatively consistent responsibilities over the one year of operation. The chief financial officer oversees and monitors the finances and budget and ensures that the two founders as well as others follow the agreed procedures. The budget is updated regularly, via consensus.

A local manager handles all on-the-ground operations and communications. The local manager receives the same benefits as the company's artists, as well as a base salary of US$350 per month. The local manager is responsible for communicating the company's vision and requirements to the artists, communicating responsibilities to the artists, paying the artists, shipping art to Moral Fibers and recruiting artists. Currently, Frazier holds this position in Haiti and has the title of 'Haiti boss-man'.

The company is still very small and young. The two founders generate new ideas all the time. They have realized the importance of learning from past ideas, and they take failures in their work as ways to increase the potential success. Brightman and Weiss meet every Friday for updates, reports and planning of the next steps. They believe that constant improvement comes from financial and analytical rigor, paired with a thirst for experimentation. The company has only three full-time employees in Montreal, and this gives them enormous autonomy, as well as a large responsibility. The team still strives for consensus on the delegation of responsibilities and projects.

8.4. Uniqueness and Competitive Advantage

Moral Fibers currently has a catalogue with 15 T-shirts that are adapted from original artwork from artists in Haiti. These T-shirts are printed on a blended NAFTA-approved poly-cotton fabric in Montreal via a process called dye sublimation, which allows putting a unique QR code on each shirt for customer tagging and a node-based referral sales network. The technology of dye sublimation, when compared to traditional screen-printing, has many advantages. Dye sublimation leaves no hand on the shirt, and due to the chemical processes of the printing, the ink will never fade. Additionally, dye sublimation allows for an allover printed look with an infinite amount of vibrant colors.

Moral Fibers' unique advantage is the established community in Haiti. In the process of working with artists, the company elaborates a real, gripping, personal story of international development that logically ends with the creation and distribution of a product. These stories, combined with the mission of linking arts and education, define the company as a social entrepreneurship.

8.5. Operational and Technical Aspects

Currently, it costs us Can$19 to print each shirt, which limits Moral Fibers' ability to be profitable at the wholesale cost that large retailers require.

The company works with INDEPCO, a nonprofit atelier networking and training facility[15]. They train rural Haitians at the factory in Cite Soleil. Upon completion of the training, each participant receives an industrial sewing machine. INDEPCO then finds orders, cuts the fabric centrally, and ships the cut fabric out to the rural groups for sewing. The finished products are checked for quality control centrally in Cite Soleil, and the workers are paid accordingly.

8.6. Profile of Clients, Marketing and Promotion

Moral Fibers sells men's and women's artistic clothing to customers who are typically between 18–44 years of age and have higher household incomes. The company is an 'affordable luxury' brand, positioned for affordable luxury retailers. Anticipated customers include private fashion boutiques, Macy's, Dillard's, the May Company, Bloomingdales, Parasuco, Lord and Taylor, Nordstroms, Neiman Marcus, Holt Renfrew, and others.

Management also plans to build a retail distribution network over the course of 2012, initially targeting boutiques in Montreal as a retail foundation and then scaling to larger retailers by traveling to tradeshows across New England in the United States. Management anticipates the acquisition of 15 retail or boutique contracts in the greater Montreal area in 2012.

The company website represents both a significant investment and a significant avenue for sales. Between June 2011 and January 2012, the site received 279,358 page views, from 15,870 unique visitors. Between June 2011 and December 2011, the site accounted for US$9,538.25 in revenue, which accounts for 29.3 per cent of Moral Fibers' revenue during that same period (including prize revenue).

The main directions of Moral Fibers' promotional campaign include

- targeted paid Facebook advertising campaigns;
- Google Ad-words campaigns;
- remarketing campaigns;[16]
- unpaid promotion on fashion or ethical fashion blogs;
- paid advertisements in college newspapers nationwide;
- paid advertisements in magazines or newspapers; and
- Moral Fibers' placement in fashion shows.

The overall marketing strategy is still under consideration.

8.7. Entrepreneurial and Financial Aspects

Moral Fibers was built from the ground up as an engine for revenue generation, just like every for-profit business. The only difference is that the founders place a higher value on investing in people, as well as in a social cause. Moral Fibers is built to meet market demands, but it is also exceptionally conscious of and communicative regarding the social impact of its activities and actions.

Over the course of 2012, Moral Fibers' revenue streams will come from two main sources: e-commerce sales and retail contracts. The management of Moral Fibers anticipates that 20 per cent of total revenue will come from e-commerce B2C sales[17] and that 80 per cent of revenue will come from retail contracts with retailers and boutiques.

The company is currently in a process of raising US$300,000 in convertible debt to accomplish these goals and sustain business operations for 18 months without revenue. Currently, they have raised US$75,000 in convertible debt, in addition to a US$50,000 capital contribution at founding.

8.8. Mission and Strategic Goals

- **Mission Statement**
 Moral Fibers is a sustainable clothing brand with a strong commitment to artists in developing countries. The company uses art and education as tools to grow talent and build financial sustainability in the poorest communities in the world.

- **Main Strategic Goals**
 Moral Fibers' current milestone is to sign US$1,000,000 in retail contracts by December 31, 2012. To reach that milestone, the company has to accomplish four goals, which the founders refer to as the 'four 50's':

 - **Building a catalogue of 50 products.** To be attractive to large-scale retail buyers, Moral Fibers has to diversify its catalogue and to prove it is strong in its diversification. Instead of just being a 'T-shirt brand', Moral Fibers plans to expand its product catalogue to include jackets, raincoats, leggings, sweaters, pants, dress shirts, accessories, and so on. To accomplish this goal, Moral Fibers is working with prominent designers to develop new products.
 - **Establishing 50 retail accounts.** Moral Fibers aims to establish a retail network of 50 accounts from small- to medium-sized retailers in order to build a reputation as a respectable wholesaler who can follow through on contract details, order specifications and delivery times. Additionally, smaller retail accounts will help Moral Fibers reach its goal of US$1 million in revenue from retail contracts. To accomplish this goal, Moral Fibers plans to travel to tradeshows to meet with potential buyers.
 - **Reducing production costs by 50 per cent.** Since Moral Fibers is aiming to get retail contracts, the company's current cost of production has to be lowered by 50 per cent in order to achieve a 30–40 per cent profit margin at wholesale pricing. For this reason, INDEPCO took over the textile manufacturing and training of local people.

- **Gaining 50,000 brand fans.** To achieve large-scale retail contracts, Moral Fibers needs to prove to buyers that it has a significant social impact. Additionally, a large social following will increase organic traffic to Moral Fibers' website and therefore will increase online sales. To accomplish this goal, Moral Fibers aims to expand its 'Artists Helping Artists' campaign, where musicians support Moral Fibers by hyping its products and wearing them while performing.

Upon achieving these goals, Moral Fibers will make a strong case to buyers from large retailers, as already mentioned, during fall of 2012 for the spring of 2013 season (as retailers tend to buy their merchandise two seasons early). The management is confident that achieving US$1 million in retail contracts before December 31, 2012, is an aggressive yet attainable goal. Given Moral Fibers' strong social model, and the combination of the preceding goals, the management believes that there will be no other new fashion brand with a comparable success rate for a retail expansion like that of Moral Fibers.

8.9. Lessons Learned

Brightman and Weiss share the following lessons learned as a result of their social entrepreneurial activities and management competence:

- **Business Lessons**
 - 'Learn from your mistakes and successes. Learn from everything you do and everyone you meet, every day.'
 - 'Get out of your "comfort zone".'
 - 'Balance everything: the budget, your time, commitments, emotions, and actions.'
 - 'Be clear, concise, and record your requests and process.'
 - 'Measure your impact, define success and failure clearly.'
 - 'Remember that transparency can't get you in trouble.'
 - 'Trust your gut, and follow up on your first instincts. If there's a problem, address it sooner.'
 - 'Problems don't fix by themselves, they require leadership.'

- **Humanitarian Lessons**
 - 'Think of those who are less fortunate than yourself.'
 - 'Ask communities: "What do you need?" as opposed to stating: "This is what we are going to give you."'
 - 'Teach a man to fish. Education is the silver bullet for poverty.'
 - 'Promote a society of equal opportunity, and equality will follow.'
 - 'Be kind. You'll never know the whole situation, but you always know enough to help.'

QUESTIONS AND ASSIGNMENTS

- Outline the elements of innovation and R&D in Moral Fibers' activities.
- Identify the main resources which Moral Fibers requires to continue operations. Split them into groups, such as material, technical, human, financial and informational.
- Elaborate an operational flow chart of the technological and production process in phases and including the partners involved.
- Does the company need to invest in R&D in the future? Justify your answer. If yes, provide concrete suggestions of how this would be possible in terms of operations and financing.
- What would be your suggestion for using all the art objects submitted by artists that are not included in the T-shirt production process? How would this help increase the company's revenues?

Note: You might need to perform additional online research to complete the assignment. In your answers, apply the theoretical concepts and methodology from Chapters 1 and 8 as well as this chapter.

10 Financial and Fundraising Plan

LEARNING OBJECTIVES

Upon completing this chapter you should be able to:

1. *Understand the main elements in a financial planning process.*
2. *Describe the main sources of external financial support for an arts organisation.*
3. *Explain why a fundraising planning is important and describe the process of applying for external sources of funding.*
4. *Elaborate a project proposal for applying to a foundation.*
5. *Understand the overall sponsorship process.*
6. *Plan a charity event for raising funds from external sources.*
7. *Understand the differences between the three key financial statements in the strategic planning process.*
8. *Elaborate the structure and content of the financial and fundraising section of a strategic plan.*

1. BASICS OF FINANCIAL PLANNING

Elaboration of the financial and fundraising section of a strategic plan requires an understanding of the basic terminology in this field, as well as the specificities of applying it to the arts and culture sector. Gathering, analysing and using financial information is central to the success of any planning process. The financial plan is a key section of any type of plan—business, operational, entrepreneurial or strategic.

Financial resources are basic for the functioning of any arts organisation. *Strategic financial planning* is about securing funding for the investment phase of a new venture or organisation, projecting the future revenues, calculating the costs of each type of resource, summarizing financial data to create financial statements, discovering efficient and optimal ways to spend the money, and analysing possible financial risks.

Many cultural managers and artists are afraid of dealing with finances because mathematics, accounting or financial analysis is not their strength. Financial information is quantifiable and thus provides measurements for things which otherwise could be difficult to compare or combine. The general rule is that the financial information has to be

- accurate and consistent, as it has to allow comparisons between the reporting periods;
- gathered and processed on time for each period (months, quarters, year); and
- relevant and a reflection of the reality.

An important thing to realize is that financial information is like a universal language as it is recognized internationally and can overcome language barriers. Financial plans are not just about tables and figures. They are about people and are created by people, which makes them interesting and dynamic. It is impossible to run any organisation without being able to prepare, understand and analyse financial statements.

Thinking carefully about the financial future of an organisation is a critical point in the overall strategic management process. Financial planning aims to determine how an organisation can achieve its mission and objectives in monetary terms. The main aims of the financial plan are to

- identify the necessary investment costs related to expansion, growth, modernization and implementation of new technologies;
- identify the necessary resources for the planned innovations;
- identify as precisely as possible the financial resources necessary for the implementation of all functional strategies;
- consider all potential revenues and sources of external funding (financing);
- discover the most efficient ways to utilize financial resources;
- secure sustainable liquidity (ability to pay debt);
- provide clear, regular and special attention to the flow of financial resources in a given period of time, especially the cash flow; and
- consider financial ratios, including the ratio between investment costs and operational costs and the critical point of return on investments.

A *financial strategy* is a way to secure the necessary financial resources for the realization of the strategic plan and utilization of these resources in the most effective way within a time frame. The *financial plan* is a tool for realizing the overall financial strategy of an arts organisation.

When elaborating the financial section of a strategic plan, it is important to

- choose the most effective financial model, structure and conditions;
- identify priority areas for future capital investments and innovative projects that might require major financing;
- optimize the budget to secure a balance of expenditures with expected incomes;
- secure stable and long-term relationships with sponsors, foundations, donors and other external support structures;
- procure a positive cash-flow balance and account liquidity at all times; and
- secure management of the organisation without a deficit and with a financial surplus or profit.

Financial documents are a mirror image of any organisation as they provide an overview of how an organisation functions, where the major problematic areas are and how the future might look in a monetary terms.

2. BUDGETING

An important role in the financial planning process is *budgeting*. Budgeting is the calculation of planned expenses (costs) and revenues (incomes). Budgets provide a clear and easy-to-understand forecast of how much money is needed for a certain period and from where it will be secured. They translate the strategic plans into financial numbers to ensure financial viability. This is the background for making important decisions on how resources will be allocated to accomplish the organisation's short-term objectives. Budgets are also helpful for monitoring performance progress and evaluating final results after the process is finalized.

Subsidized and nonprofit organisations in the arts work with annual budgets which have to be approved by a governing body—a board, a committee, or the trustees. In these cases the budget plays the role of an annual financial plan. In business arts organisations, budgeting is important for identifying the financial resources of the key departments. Budgets are very important for intra-preneurial units within an organisation, as they provide the overall financial framework and the

limits within which units work. Intrapreneurial activities aim to increase the final result in the most effective way.

Every budget for an arts organisation aims on the one hand to maximize sources of support and revenues and on the other to keep expenses at a rational level or reduce them, so that the programmes are conducted according to the organisation's overall strategic plan. The preparation of budgets for the next planning year is based on the previous fiscal year's actual expense information and financial statements (see later on). Art managers need to carefully estimate the costs of any potential new programmes, projects and events.

Every budget consists of two parts: revenues (incomes) and expenses (costs).

- **Revenues**[1]

 Revenues could be classified in different groups depending on the type of organisation and the respective accounting system. For example, they could be grouped into the following categories:

 - Revenues from sales of goods or services (self-generated incomes or earned revenues).
 - Revenues from additional and peripheral activities with innovative elements.
 - Support from outside sources such as foundations, sponsors, individual donors and international or national programmes. This part of the budget is especially important for subsidized arts organisations.
 - Financial revenues such as results from financial partnerships, bank interest, investments in mutual funds, government bonds and others.
 - Other revenues, for example from intangible assets such as patents, licenses, trademarks and copyrights.

- **Expenditures (costs)**[2]

 Costs can be separated into different groups based on diverse criteria, as well as the respective accounting system. For example:

- *Investment costs,* needed for starting up an activity, expanding an activity, implementing a new product or service, realizing an innovation or purchasing a new equipment.
- *Operational costs,* needed for running the activity. Operational costs can include costs for salaries and fees, costs for additional services, depreciation of equipment, material costs, and the like. They are divided into direct and indirect costs.
 - *Direct costs* are expenses directly associated with the main production process. For example, the direct costs for organizing an exhibition in a gallery would be the artist's fees (in the case of commissioned works), insurance for the artworks, transportation costs and costs for printing catalogues related to the exhibition.
 - *Indirect costs* are costs which do not change based on the production volume; they include costs for administration, gallery maintenance, electricity and heating costs, rent (if any), and so on. They are sometimes called 'overheads'.
- *Financial costs* include the payment of interest on debts, currency losses and bank charges, and so on.

The final financial balance between revenues and expenditures is the planned operating profit (or financial surplus) of an organisation for a given period. Business organisations in the arts always plan a profit in their budget, which comes from diverse methods of expansion and growth. Net profit is the operating profit, after expenses and taxes are deducted. The net profit is used for reinvestment and dividends for the owners, shareholders or co-partners of the organisation. Nonprofit arts organisations plan their budgets to equalize incomes and expenses at the end of the financial year. In some cases, if the respective national legislation allows, they can plan a surplus—when revenues exceed expenses. The surplus is not distributed among the owners or the managers but instead must be left as a reserve or reinvested during the next planning period with the intention of achieving the organisation's aims. State-subsidized arts organisations follow certain budget regulations, predefined by the government,

as most of their budget is based on government subsidies. Usually they also equalize the revenues and expenditures.

The budget is further broken down into periods, corresponding to periodic financial statements—normally on a monthly or quarterly basis. In addition to the budget, a fundraising plan is developed to help alleviate the organisation's cash-flow difficulties and to fill the gap between expenses and revenues in the case of nonprofit arts organisations. Examples of budget and fundraising plans are given at the end of this chapter.

When the budget is prepared it needs to be reviewed and approved by the board, financial committee and/or trustees—depending on the organisational structure. Once it is accepted and becomes a working document, it needs the commitment of all staff members, the management body and stakeholders to be implemented.

3. MAIN FINANCIAL SOURCES FOR ARTS ORGANISATIONS

Preparing budgets and other financial documents as part of the strategic plan requires careful consideration of all potential sources of income and support for an arts organisation. The nature and legal status of an organisation predetermine its financial structure. In a general framework, there are two main groups of revenue and income sources for an arts organisation: external and internal.

3.1. External Sources

External sources can be split into two subgroups: institutional support from government bodies, business corporations, foundations and funding institutions as well as individual support.

• *Direct state (public) support* for the arts usually takes the form of a *subsidy*. Subsidies for arts organisations are provided at the national, regional or local levels by the ministries of culture, national arts councils, city councils, municipalities and national and/or regional state cultural foundations. Subsidies could be distributed by several means, including on a permanent annual basis (budget subsidy), for a specific project on a competitive basis (project subsidy), for construction of a new cultural venue (capital subsidy), or for supporting individual artists (grants, bursaries, etc.). While budget subsidies are allocated primarily for state-subsidized arts organisations, project subsidies are given on a competitive basis for projects and could be granted to any type of organisation—private or nonprofit—depending on other predetermined criteria, such as the project quality and final results. Subsidies are usually given by the government to help certain sectors by reducing the market prices. Subsidies promote a public objective and are in favour of societal aims.
• *Support from foundations, funds and trustees* is another institutional type of support for nonprofit organisations and individuals. It usually comes in the form of a *grant* and is awarded for a specific project and rarely for the overall organisational development. It is possible for a foundation to provide support to individuals as well as organisations, in the form of bursaries, travel grants, scholarships, fellowships and more. Each foundation has its own priorities, programme areas, guidelines for applications and grant policies. Foundations usually prefer to support innovative artistic and cultural projects that contribute to a specific social cause. The usual procedure for applying to a foundation is submission of a *project proposal*.
• *Business-sector support for the arts* is usually known as *corporate support* or *corporate philanthropy*. It includes support through corporate foundations or funds, sponsorship (monetary and/or 'in-kind'[3]) and different forms of corporate donations. The most visible form is *sponsorship*, which is part of the marketing and communication strategy. This type of support is usually given for visible outcomes, for example publicly visible projects such as festivals, performances, concerts, educational programmes, exhibitions and broadcasts of live artistic events.

- *Financial instruments and support from financial institutions* are known as *alternative financial instruments* when used by nonprofit and subsidized arts organisations, as they are an unusual form of financial management. External financing is widely used by business organisations, and in these cases external financing is rarely a grant, subsidy or donation. It is of two main types—debts and equities—known as *borrowed capital:*
 - *Debt instruments* include bills, bonds, notes, loans, and the like. They represent a written promise to repay the debt and require a fixed payment to the holder, usually with interest. They are 'asset-based', which means that a business or personal asset has to be pledged as collateral[4]. The most commonly used debt instrument is the bank loan.
 - *Equity financing* occurs in cases where a company decides to raise money by selling the company's stocks to investors. In return for the money paid (the financial contribution) the investors receive ownership interests in the company. Equity financing is therefore an exchange of money for shared ownership.
 - *Angel investors* are usually retired executives or entrepreneurs who invest their own funds in a start-up business with high risk and require a high return on the investment. They bring their expertise and know-how to an emerging business and seek an equity position in return[5].
 - *Venture capital* is provided by investors for start-up businesses with high potential for growth and high risk. It is attractive for new companies in rapidly developing industries.

 Because the arts sector and creative industries involve a high degree of risk and not fully predictable markets, and many arts organisations have few tangible assets to pledge as collateral, external investors are usually reluctant to lend money or to buy equities. To be able to apply for bank loans, an organisation needs to write a strong business plan and follow the loan guidelines. For example, they may be required to show a strong financial record and be able to provide guarantees that the loan will be repaid after a certain period. Nonprofit and state arts organisations rarely use such instruments, although there are examples of banks providing loans for social, educational, cultural or other nonprofit purposes. In these cases, the payback guarantee on loans is usually covered by a bank venture capital, a foundation or a specially established government fund.

 Another example of support from a financial institution is the national lottery system. In this case, part of the lottery revenues are accumulated in a state fund and distributed (although rarely in the form of direct funding).

- *Individual donations* (individual giving) are different types of donations from individuals given for a specific cause. Small donations are most often given during specific charity events devoted to a solving a social problem. Larger donations from wealthy individuals can sometimes be left as a legacy. In countries where donors are entitled to tax rebate certificates, individual donations are the fastest-growing level of support.

3.2. Internal Sources

Self-generated revenues in an arts organisation usually come from the following sources:

- *Sales of core products and services* (e.g. artworks, books, music CDs, entrance tickets and admission fees). Increases in sales result from increases in the volume of products sold, larger audiences, higher prices and other methods. They result from effective marketing activities and improvements in the quality of the product and services offered. Diverse entrepreneurial and innovative projects and activities could also increase the self-generated revenues.
- *Sales of additional and peripheral products and services* (for example renting of studios and equipment, revenues from restaurant activities, babysitting offered during events, parking services and merchandising activities[6]).
- *Subscription and membership schemes.* They are especially important in the arts field because of the need to keep and develop regular audiences. Subscription is a payment for consecutive issues of programmes (e.g. performances, exhibitions) over a specified period of time. It is a popular method in marketing and fundraising in the arts.

3.3. Methods Using Digital and Online Technologies

The rapid development of new technology and the Internet is opening new opportunities for on-line sales and fundraising. These methods can generate significant revenue in a very short time by mobilizing a vast number of potential donors or customers. Online fundraising is known also as *e-philanthropy* and provides a number of benefits, for example easy publicity through social networks, cost-effective solutions for collection of money, flexibility in changing the online content and convenience in collecting funds—immediate receipt of the transaction and acknowledgement of the donation.

- *Crowdfinancing (crowdfunding)* is a collective way to support or to invest in a project where users are invited to donate a certain amount of money in a limited time frame. The project is implemented only if the funding target is achieved. Crowdfinancing is usually for start-up projects, as well as for a variety of social causes and purposes. The supporters get certain benefits in return, for example subscription discounts or a copy of the art object (music album, book, painting, etc.). They get regular updates on the progress of the project. Crowdfinancing is a way of marketing and promoting an artistic project online while it is still in the making[7].
- *Crowdculture*[8] is a new innovative model where the mission is to open up a cultural space for wider participation and to set up multiple regional funds in geographically dispersed places, encouraging grass-roots exchange between these places. The funds are initiated by either a local or regional authority or a strong private actor. The model works like a regular crowdfunding model, except that cultural workers can also seek financing from public funds through the system. The money pool contains both private money (members) and public money (part of the cultural budget). It is the members' voices that control where the public money goes. The equity of the fund can only be co-invested in a project if a crowd decides to invest. Thus the public entity can give guidelines as to what they are ready to invest in but not determine exactly what project they put the money into. The system eventually aims at opening up cultural resources and gives more people a chance to affect the cultural offerings as well as find support for their own projects. It could be seen as crowd-sourcing investment decisions, thus letting citizens participate in the definition of quality. This model operates in the borderlands between the public and private sphere.
- *Online fundraising through social networks and mobile devices* is a method for raising external support using the power of social networks such as Facebook, Twitter, and others, as well as organizing fundraising campaigns through customers' mobile devices.
- *E-commerce* (electronic commerce, online sales) refers to the buying and selling of products and services online (usually via the Internet)[9]. It is becoming widely used because of its many advantages. E-commerce allows the overcoming of the barriers of time and distance and the opportunity to reach global markets. From an operational viewpoint it helps to reduce both the time and the personnel required to complete a transaction and lower both labour and transportation costs. E-commerce is a flexible and efficient method of sales as it can handle complex transactions and product ranges via a well-developed content management system on the website. It also allows expansion to new geographical locations in a fast way. Artists and arts organisations also use e-commerce—selling art objects or tickets for events via websites, blogs, online galleries, online stores or social networking sites. One of the disadvantages of using e-commerce in the arts is the loss of personalized contacts with audiences and buyers.

Table 10.1 gives an overview of the main financial sources for an arts organisation.

State-subsidized arts organisations rely mainly on government support. They could also receive support from individuals and businesses for specific projects. It is rare for these organisations to apply to foundations given that in most cases foundations support organisations with a nonprofit status. A relatively small portion of a state arts organisation's budget is based on self-generated income.

Business organisations in the arts and culture sector rely mainly on revenues from selling core, peripheral and additional products and services. They also look for external financing (debts and/or

Table 10.1 An Overview of Financial Sources for an Arts Organisation

Main groups of support	Type of support/financing	Forms of support/financing (examples)
EXTERNAL: from the state sector	Direct government support	• Budget subsidy • Project subsidy (grant programs) • Investments (capital subsidy) • Fund development • Grants for individual artists
	Indirect government support	• Income tax and other taxation benefits • Labour law, social benefits for artists and artistic professions • Regulation of imports and exports of cultural goods and services • Legislative protection of cultural heritage • Other legislative mechanisms
EXTERNAL: from the business sector	Corporate support (corporate philanthropy)	• Grants and support from corporate foundations • Sponsorship • Material support of all kinds • 'In-kind' support • Corporate subscription schemes
EXTERNAL: from the third sector	Support from foundations, funds and trustees	• Grants for nonprofit organisations • Grants for projects • Grants for individuals • Material or technical support • Support for innovative initiatives • 'Seed money' (start-up support)
EXTERNAL: from individuals	Individual support and donations	• Charity events of all kinds • Annual fundraising appeals • Subscription schemes • Memberships • Bequests (legacy)
EXTERNAL: from financial institutions and wealthy individuals	Financial instruments	• Debt instruments • Equity instruments • Lottery systems • Angel investors • Venture capital
INTERNAL (self-generated)	Sales revenues	• Revenues from core creative products and services • Revenues from peripheral and additional products and services (renting of studios, equipment and properties, merchandising, etc.)
EXTERNAL AND INTERNAL	Methods using online technologies	• E-commerce • Crowdfinancing (crowdfunding) • Crowdculture • Online fundraising

equity). The profit raised by a commercial company as a result of its overall operations is distributed among shareholders and owners in the form of dividends, and/or it can be reinvested for further growth and operations. Additional self-financing could be achieved by the sale of some of the company's assets, by depreciation, by bootstrapping[10], or by other methods. Business organisations could organize charity events and other forms of gathering support from individuals for a specific cause, but this is usually done in partnership with other arts organisations and is not their primary activity.

Effectively operating nonprofit organisations have diverse financial structures, including support coming from foundations, state subsidies for projects, donations and charity events, subscription schemes and innovative fundraising methods. Sponsorship support is usually for specific events, particularly those that have large media coverage. In some countries nonprofits are also allowed to sell goods and services, as long as the revenues received are counted as a financial surplus and not as a profit.

4. THE FUNDRAISING PLAN: AN OVERVIEW

The overall process for identifying, approaching, applying to and gathering support (mainly, but not only, financial support) from external sources (government agencies, businesses, foundations and/or individuals) is known in the cultural practice as *fundraising*[11]. The general rule is that *people always give to people;* therefore, fundraising is about building up friendships, not just financial relations. It is a very important part of the strategic planning process, mainly for nonprofit arts organisations. In some cases it refers also to the identification and solicitation of external capital for business organisations. Recognition of fundraising needs is part of budgeting, whereby the aim is to reach equilibrium between expected expenses and expected revenues. In the case of subsidized and nonprofit organisations, when self-earned revenues cannot cover all planned expenses, there is a need to elaborate a separate fundraising plan to fill the envisaged financial gap. The main stages in the process of raising external funding and financing are summarized in Figure 10.1.

PRACTICAL RECOMMENDATIONS

When preparing a fundraising plan, answer the following questions:

- How much do you need? What is your goal? Provide a quantifiable breakdown of all necessary potential resources.
- What kinds of programmes, projects and events are you planning, and at what cost?
- Clarify why you need external support: why do you deserve it? Identify the cause and the social aspect of the programmes and projects for which external support will be requested.
- Why would someone support you? If you apply to foundations and government programmes, carefully consider their criteria and application requirements.
- What are the sources of information on possible institutional and individual support? Find out how to select available sources of support and how to contact relevant institutions and individuals.
- Who from your organisation will be in charge of fundraising? Who will prepare the project proposals and sponsorship packages?
- Who will be dealing with the overall fundraising campaign in the organisation?

There are hundreds of online and offline sources on fundraising, which give an orientation and practical tips on how to be successful in the overall fundraising process and on how to approach foundations, government programmes, sponsors and individual donors[12]. To better plan the overall fundraising process, it is important to understand and recognize the differences between various possible sources of external support, the motivation of people and organisations that give money, their criteria for support and the ways to approach them most effectively. Success (or failure) in fundraising depends on many factors. Some of them are

- the popularity and public image of the organisation;
- the quality of the project and the the strengths of the cause;
- the team's previous experience in fundraising;
- the overall team commitment;

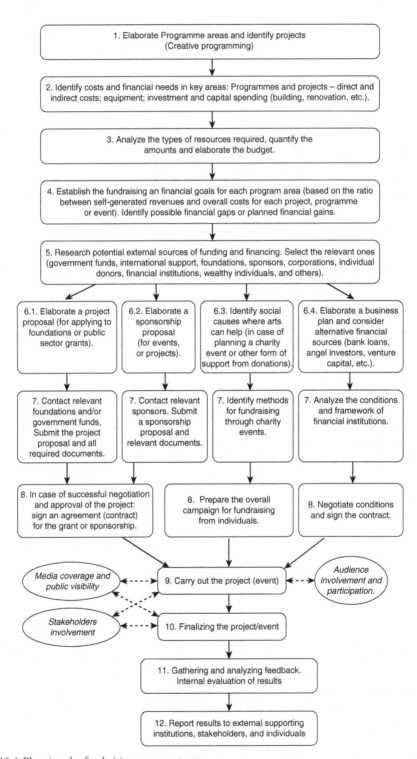

Figure 10.1 Planning the fundraising process: stages

- the efficiency of the fundraising methods used;
- the degree of involvement by the board, staff and volunteers in the fundraising process;
- the overall media and public visibility of the fundraising campaign; and
- the charisma, enthusiasm and personal qualities of the people leading the campaign.

This chapter provides a general framework and practical recommendations on how to plan the overall fundraising process, especially related to raising money from foundations, sponsors and charity events. It also gives an orientation on the preparation of the financial and fundraising section of the strategic plan, based on key financial documents.

5. FUNDRAISING FROM FOUNDATIONS: PROJECT PROPOSAL

A foundation is an entity that exists to accumulate assets from a variety of sources in diverse ways and distribute them in the form of grants to other unrelated organisations or individuals for educational, cultural, social, scientific, environmental or other charitable purposes. There are also foundations that do not distribute grants to external applicants but mainly organize their own programmes (operational foundations).

5.1. Foundations' Criteria

When one is planning to approach foundations, it is important to understand how they function. Foundations can be classified in several groups, depending on various criteria—their ownership, main aims or the ways they structure their activities. A broad classification splits them into private and public foundations. Private foundations accumulate funds from part of the annual profit of a family, a company or a corporation. Public foundations are set up by public authorities and accumulate funds on national, regional or municipal levels from government money or diverse public-private financial schemes, as well as other sources under state supervision. These are the state, national or community foundations. Table 10.2 gives an overview of various types of foundations, based on diverse criteria.

There are hundreds of thousands of foundations around the world and plenty of online and offline databases to search and decide which one to approach and how. Therefore, it is important to carefully plan the process of seeking the right foundation to apply to, as fundraising is also *fund-spending* activity: it requires time, money and patience to write and submit applications. Research on potential foundations and selection of the right one to apply to (stages 5, 6.1 and 7.1 in Figure 10.1) is crucial, as the more effectively it is done, the less money and time are wasted sending proposals to foundations without positive results.

Table 10.2 Types of Foundations, Based on Diverse Criteria

Criteria	Types of foundations
Ownership and main source of funding	- State and public foundations: set up by government funding with a separate organisational structure or under a government institution. - Corporate foundations: set up by a business company, usually having the same name as the company. Their main aim is to improve the public image of the company by contributing to diverse social causes. - Community foundations: set up as a result of a collective will, usually functioning on a regional or local level. Usually they have flexible grant-giving policies and distribute funds for organisations and individuals living in a specific region or city. - Private or family foundations: set up as a result of a will which predetermines the program areas or for tax purposes. In this case strategic decisions are made by the family, family members or a board of trustees appointed by them.

Table 10.2 (*Continued*)

Criteria	Types of foundations
The ways foundations establish their policy and grant programs	• Grant-giving • Operational • Mixed
Aims	• Multipurpose or general. These are large foundations with diverse grant policies and programs. • Specific. These are foundations that support projects in a very concrete area only, such as the performing arts, literature or archaeology.
Geographical coverage	• International • National • Regional • Local

PRACTICAL RECOMMENDATIONS

When selecting a foundation to apply to, consider the following:

• What are the foundation's goals and programme areas, and what is the geographical scope of the foundation's grant policy? They have to be relevant to your idea or project and the place where you would like to produce it.
• What are the types of grants available, and what are the grant limits? Some foundations provide support exclusively for artists' fees, for equipment or for travel-related expenses. Therefore, it is important to match the foundation's guidelines with the costs in your budget. In most cases, foundations clearly state the exact budget they might be willing to cover. A general rule is that foundations never support 100 per cent of the budget's costs, as they would like to encourage the organisation to also invest in the project. Most foundations prefer to be one of several supporters of a project or to leverage government funding.
• What are the application procedure and deadline? Application procedures vary; in some cases foundations have precise application forms which have to be filled out. In other cases, they require a complete project proposal to be submitted. In a third case scenario, they may first require an initial letter of inquiry explaining the idea, and then if they agree in principle, the application process begins.
• For what kinds of activities, projects, organisations or geographical areas does the foundation not provide support? It is important to know the limitations in a foundation's grant-giving policy in order to not lose time applying to foundations where the chances of success are few or none.

Foundations normally announce in advance their criteria for selection for each specific programme area and the precise guidelines. The process of evaluation of applications is usually in the hands of a board of experts, or selection committee, whose members are chosen on a mandate principle. Table 10.3 summarizes the common criteria for evaluation of project proposals by foundations.

5.2. Elaborating a Project Proposal

Writing a project proposal is a process which needs a sufficient level of competence and experience[13]. It is important to keep in mind that a project proposal is not just the presentation of an idea but a well-thought and well-structured persuasive instrument. It is also a justified and strong statement as to why financial support is needed and why the applicant organisation is the one which deserves support. A well-structured project proposal contains the following main sections:

Table 10.3 Common Criteria used by Foundations when Evaluating a Project Proposal

Criteria	Questions asked by the foundation's experts when evaluating project proposals
Match of the project to the foundation's mission and priorities	Does the project fit well with the foundation's program areas?
Social significance and usefulness	Why is the project needed? Who are the beneficiaries? What kinds of social problem (or problems) will it solve or contribute to solving? What would be the social consequences if the project is not realised?
Uniqueness and innovative characteristics	Is the project original? What distinguishes it from other projects in the same field? What are its innovative characteristics? Has there been a similar project in the same city, region or country?
Feasibility and practicability	Are the stated objectives actual and real? Are the planned resources sufficient? Is the time frame rational? Are all the project components well elaborated?
Organisation's (team's) reliability	Do the people who will carry out the project have the necessary skills, experience and competences? Is the organisation reliable and credible? What kinds of projects has the team done in the past? Who else has supported this organisation before?
Requested amount	Is the budget realistic and sufficient? Does it cover all necessary resources and planned activities? Is it detailed enough? Who else supports the project? What is the percentage of self-earned revenues in relation to the financial external support?
Results	What are the concrete qualitative and quantitative results of the project? How will these results be measured?
Public visibility and impact	How will the results be publicly disseminated (online and offline)? Is there any multiplication effect planned?
Sustainability of the project	Is there evidence that the project will continue after the grant is spent? How will the project be sustainable? What is the long-term continuity plan?

- **Résumé.** This is a very important part of the project proposal. It includes a short explanation of the project idea, the main objectives, the problem which the project hopes to address, the time frame, the main phases of the creative production and other supplementary processes, target groups (beneficiaries), expected results, overall costs for realization of the project and the sum of money requested from the foundation.
- **Context.** This section provides a brief description of the overall framework and circumstances in which the project will be realized. This is a situational analysis and rationale for what inspired the project and how it would contribute to the specific cultural development of a city, region or country.
- **Target groups.** These are the market segments to which the project is targeted. They can be classified based on different variables such as professional affiliation, location, age, gender and other characteristics[14].
- **Action plan.** This includes all activities related to the project and set within a given time frame, with specific deadlines and interim results. It demonstrates the relations and coexistence of different activities and operations, from the inputs to the final results.
- **Project team.** This section provides a description of the competences, skills and experience of the people involved in the project's implementation. It is useful to outline who will do what during the project's development. It is important to also emphasize the past achievements of the team.
- **Collaborators and partners.** This is an important part of the project proposal as fund-givers are encouraged to give grants to projects which provide evidence of partnerships and collaboration with other organisations (in the form of consortiums, co-production, co-organisation, or others). Partners could be directly involved in the project's activities and receive part of the project's funding or could be indirect collaborators. Collaboration could also be a source of additional income, for example by delivering free services, providing premises or securing volunteer work.

- **Project budget.** The budget explains the whole project in figures and contains all the expected expenditures and revenues, as well as outlining the support requested from the foundation. Past financial statements of the organisation (from previous years) could supplement the project proposal as an appendix.
- **Expected results.** The results can be qualitative and quantitative, as well as results from different areas of the project—creative programming, marketing, management, financial and organisational. The project could be evaluated in different ways such as feedback from experts, clients or audiences. It is much easier to evaluate the success of a project that has concrete tangible and quantitative results than one that has primarily educational or social objectives.
- **Project sustainability.** It is important to indicate how the project could continue after the grant period is completed—what the further self-financing methods would be. The project proposal should also suggest multiplying effects and the impact on other organisations after the project's realization.
- **Appendices.** They could include a short history of the organisation, legal-status documents, curricula vitae of the team involved, publicity materials, evidence of prizes or awards, recommendations, financial statements from previous year(s) and a list of project partners.

Preparing project proposals is a time-consuming activity and requires patience and devotion. It is especially complicated when two or more partners apply for a project grant in a collaborative mode. There are plenty of suggestions in the literature and online resources on fundraising regarding what to do and what not to do when elaborating a project proposal[15].

PRACTICAL RECOMMENDATIONS

When elaborating a project proposal, keep in mind the following:

- Have a good understanding of the foundation you are applying to and preselect the most appropriate foundations (as explained earlier). Try to find out what projects and areas the foundation(s) has supported in the past.
- Follow the foundation's guidelines and overall application procedure. In many cases the cover letter is crucial to introduce the organisation and set the tone.
- Make sure that the project résumé is written well and gives a brief but clear picture of the whole project. In many cases the foundation's expert who evaluates projects reads the résumé first before exploring the rest of the application package.
- Emphasize the problem(s) which your project will address and why this project is needed in the specific context of the city, region or country where it will be realized. Provide sufficient information about the local and regional context where the project will operate.
- Emphasize the uniqueness of the project, its innovative characteristics and differences from other similar projects in the field.
- Make sure that the target groups are well defined and give evidence of how the project meets their needs and expectations, as well as how it creates future needs.
- Do not ask the foundation to cover all project costs. Be rational and always find ways to invest in the project and to generate revenues and support from other fund-givers.
- Develop a contingency plan in case things do not go as planned during the realization of the project.
- When writing the project, show a personal style and express clearly your viewpoint. Avoid jargon and complicated explanations. Write in simple and understandable language, in a logical and structural framework.
- Give concrete facts, and do not forget to include exact references and sources of information.
- Do not make promises that you might not be able to fulfil.
- If you use an outside consultant to write the project proposal, make sure that you are also involved in the process at all its stages, and do not leave the whole project proposal in his/her hands.

An example of an application form for a foundation's international artistic mobility project grants is given below. It provides a general guideline on how a project proposal should be elaborated.

EXAMPLE

Application Form for a Foundation's International Artistic Mobility Project Grants
(Please complete the form in five pages maximum, plus the budget.)

1. Résumé

- Project title
- Organisation applying, country and city
- Location(s) of the project
- Project summary (abstract of the action plan, including the means and goals, in max. 200 words)
- Project period
- Total budget of the project
- Requested amount from the foundation
- Previous applications or grants received by the foundation (type, years, amounts).

2. Situational analysis and rationale (What is the situation in the region/country related to the project? Why is the project needed? What kind of problem does it aim at solving? Answer in max. 300 words.)

3. Project objectives

4. Project team—applicant (organisation/institution which will realize the project)

- Name, address and type of the organisation (state, private, nongovernmental organisation, association, etc.)
- Major activities, programmes, achievements and further plans of the institution
- Names of the project leader and the project team (curricula vitae, qualifications, delegation and separation of tasks).

5 Collaborators and partners (direct and indirect)

- Names of partners and their involvement in (or support for) the project
- Responsibilities of the applicant and its partners in the realization of the initiative, reflecting the division of labour.

6. Summary of the project

- What are the objectives of the project in the short and long term?
- What are the problems to be resolved and the needs to be met?
- How will the project be realized? (the choice of methodology, methods, main phases of the action plan)

7. Target groups or project beneficiaries. Who will be influenced and affected by the realization of the project? Who are the direct and indirect beneficiaries? What is their profile?

8. Promotional and communication plan

9. Action plan (What are the main project activities?)

Activities	Deadline	Interim results
Including contents of the programs (titles, topics, methodologies, repertoires of an event, training seminar, research, conference, etc.)		

10. Expected results (quantitative and qualitative)

11. Evidence for sustainability and further development of the project

12. Additional information

13. Budget

Expenditures (expected)

Budget item	Amount (in Euros)	
	Requested from the foundation	Matching funds from other sources
Programming and production		
Personnel (salaries and fees)		
Travel and accommodation		
Equipment and rent		
Administrative		
Marketing and public relations		
Other (please specify)		
Total costs		

Income (expected)
(Please provide letters of confirmation for all secured external support.)

Sources of incomes	Amount (in Euros)	Percentage of the overall budget
External funding:		
• From sponsors (names of companies and contact addresses)		
• From other foundations (names and contact addresses)		
• From government institutions (names and contact addresses)		
• From international funds		
Revenues from sblales		
Other (please specify)		
Requested grant from the foundation		
Total		

INSTRUCTIONS FOR FILLING OUT THE APPLICATION FORM

Project title. If the title consists of terms which are difficult to understand in English, please provide more explanation.

Location of the project. This is the situation(s) where the project will take place.

Summary of the project (200 words). Please write this part only when you have already completed the whole project proposal and have a clear vision about what exactly you are going to do, why and what you are going to achieve. The project summary is an extract explaining the major need for the project, the project's objectives, the overall concept (project contents), the main phases in the project's realization and the expected results.

Situation analysis and rationale (200–250 words). This also includes how the project would contribute to regional networking and cultural cooperation and what kinds of problems the project solves. A profound and clear assessment of the need for such a project proposal is appreciated.

Objectives. Try to link the long-term and short-term objectives with ways and means of solving concrete problems.

Project team and organisation. Please attach any important information relevant to the major achievements of your organisation, as well as short professional CVs from the project's team. You may wish to draw an additional organisational structure as well.

Partners of the project. These can be regional, national or international institutions which will be directly involved with the project or are ready to provide help and assistance for its realization. Please attach letters of agreement or confirmation.

Target groups or project beneficiaries. Please explain who they are and how they are going to benefit from the project. Connect the project objectives and activities with the needs and priorities of your direct and indirect target groups. You might consider providing the results of some marketing surveys, if available. Include a brief media mix (public relations) plan where appropriate.

Action plan. List the major and minor activities which you plan to realize during the project period in order to achieve your objectives. Include the titles, programme topics, seminars and conferences. You may consider splitting the action plan into a preliminary preparatory period, actual project period and a final period for evaluations and feedback.

Expected results. If possible, include evaluation indicators. Try to be as precise as possible.

Sustainability. Explain how you are going to continue the project after spending the grant. What will be the further reflection of the project results on the target groups, your organisation, your region or your country? What are the chances for sustainable development of the project in the future?

Budget. Be careful when preparing your budget and consult with financial experts, if necessary. The budget has to be realistic and linked with the overall costs of living in your country. Calculate the expected expenditures and incomes. Add sufficient additional explanation (breakdown) for every budget item. Indicate clearly the total budget of the project and the amount requested from the foundation. Consider the grant limitations, matching funds from sponsors, other foundations and government authorities, and remember that self-generated income is required. Letters of potential or already confirmed funding should be included.

Additional documents. Any supplementary information which you find appropriate and relevant to the successful implementation of the project will be considered: illustrations, letters of recommendation and other materials, letters of interest from potential 'implementers' of the project—ministries, municipalities, universities, the media, cultural institutions, associations, and so on.

6. GAINING SUPPORT FROM SPONSORS

Sponsorship is a different concept from subsidizing, donating or grant-giving. Sponsors always expect something in return for their support, either directly or indirectly, such as increased media coverage, the possibility of attracting potential buyers and client, an improved corporate image, and tax or other financial benefits.

6.1. Mutual Benefits

Sponsorship is part of the promotional strategy of a company and is related to business goals[16]. It is a kind of a partnership—a mutually beneficial process for both the sponsor and the sponsored organisation or project. The sponsored organisation receives money or 'in-kind' support, and the sponsor receives in return certain promotional, public relations and marketing benefits. Sponsorship is not a gift and is not eligible for a tax rebate certificate. In some countries sponsorship is eligible to be counted as a cost in the accounting system and may decrease the corporate tax due. Business companies may also support arts organisations and projects by giving corporate gifts or grants.

Table 10.4 provides an overview of possible benefits for both the sponsoring company and the arts organisation. Depending on the level of sponsorship and other factors, one or another benefit prevails.

Table 10.4 Sponsorship as a Mutually Beneficiary Process

Benefits for the sponsor	Benefits for the sponsored art organisation
• Increased media coverage • Cheaper and easier access to a range of media • Cheaper advertising • Attraction of potential buyers and clients • Improved image and visibility (online and offline) • Sales promotion • Prestige and recognition • Use of the results of market research • Financial gains • Informal contacts with artists and art professionals • Insight into the 'backstage' of the artistic process • Benefits for the sponsoring company's personnel and their families	• Financial support • Material support (equipment, products and services received, etc.) • Gaining information and knowledge on business matters • Experience in business management • Increased contacts with the business world • Attraction of new regular subscribers • Opportunity to learn to look at the project from the eyes of businesses • 'Business-like' thinking • Prestige and image

6.2. Reasons for Sponsoring and Differences from Foundations' Support

Sponsorship is a process and not a single transaction. Planning the sponsorship process requires an understanding of the different reasons that lead potential sponsors to support an artistic event or a project. Here are the most common questions which a potential sponsor might ask before deciding to get involved:

- **Main reason.** Why should the business company sponsor this event or project? Why is it of benefit for the company?
- **Similarities.** How far does the artistic project or event complement the products or services of the sponsor?
- **Professionalism and artistic quality.** Is the team professional, and how does this match the level of professionalism of the sponsoring organisation? Are the artistic results of a high quality? How is this evident?
- **Market coverage (participation).** How many people will participate in the event? What is the profile and size of the expected audience?
- **Media coverage (visibility).** How and by whom will the event be broadcast? What kind of traditional and new media will the project (event) involve?
- **Scope.** What exactly would be supported—an event, a project or an artist?
- **Location.** Where will the project (event) take place? Will there be multiple locations?
- **Frequency.** How often will the event (or the activity) take place? Will it be repeated (e.g. on an annual basis)?
- **Time frame.** How long would the sponsorship last, and how would it match the short-term and long-term strategic objectives of the business?
- **Financial planning.** How does the sponsorship fit into the overall financial and marketing plan of the company? How much would it cost? Is it cost effective?
- **Reliability.** How capable, skilful and competent is the management team of the sponsored organisation? What is their marketing knowledge and capacity?

When one is planning and preparing a sponsorship proposal, it is important to keep in mind the *difference between the criteria of potential sponsors and the ones of foundations.* Business companies regard sponsorship and philanthropy as additional activities, while foundations exist to accumulate funds and distribute grants. Business companies rarely sponsor innovative, risk-related or emerging activities. Sponsors focus primarily on their own marketing benefits and only indirectly on the social aspects of the project and related social causes. While most foundations ask questions such as 'What is the social value of the project, and what kind of problems will it solve in society?', business companies focus on questions such as 'How

will this project benefit our company, and what would we gain by supporting it?' Sponsors are interested in events that have wide media coverage, while foundations tend to be more interested in the uniqueness and innovative characteristics of the project. Business companies prefer to sponsor an event by providing a product, a service, equipment or space, rather than money. 'In-kind' sponsorship is much more popular than direct financial support. On the other hand, foundations usually provide grants in the form of monetary support. Commercial companies are less likely to understand the precarious budget-balancing of arts organisations, whereas foundations are much more aware of the objective financial deficits in the nonprofit arts sector. Foundations normally publish information about their programmes and application procedures, while sponsors rarely have a systematic way of presenting their sponsorship policy. Finally, both commercial companies and foundations regard artistic quality as an important criterion for support.

6.3. Sponsorship Proposal

Elaborating a sponsorship proposal is part of the overall fundraising plan of an arts organisation. The proposal has to be short, attractive and understandable. It has to grab attention. There is no set formula on how to elaborate the proposal, as the content depends on the sponsorship subject—supporting an event, a chain of events, a project or an individual artist. Sponsorship is rarely given for substantial operational support.

PRACTICAL RECOMMENDATIONS

Here are a number of elements to consider including in a sponsorship proposal:

- Who are we? A short description of the arts organisation: its mission, programmes, activities and creative teams.
- What is our concrete project or event? A short description of the main purpose of the event, the artistic quality, the planned activities and outcomes. State the date and time of event(s).
- Who is going to come to our event or see the event? A short description of the target groups and the audience profile. What kind of media coverage have you planned? Connect this with your market research and target groups.
- What are our concrete promotional offers and other benefits for the sponsor? This is the most important part of the sponsorship proposal. It contains all services and benefits which an arts organisation can offer, including promotion, advertising and media coverage, as well as group benefits, benefits for the company's personnel and guests, joint initiatives, and so on. Sponsorship levels or the amount a sponsor might wish to contribute are quite often closely related to the number of services and benefits that the sponsor receives in return. Outline the respective benefits for each sponsorship level.
- How much would it cost? This is the 'price' of the sponsorship. The answer to this question will depend on the following:
 - How much will it cost for the sponsor (not only how much do we need)? How much will the business save by sponsoring you, that is, instead of organizing the same media and advertising campaign on its own?
 - What is the overall reputation of our organisation in the region? Is it well known and respected?
 - What are the financial and marketing policies of the targeted businesses? As sponsorship is part of the marketing and communication strategy of a company, it is important that the sponsorship proposal considers the company's overall strategy and especially its marketing priorities.
- What are the indicators for success? How would we identify that we have succeeded (e.g. media coverage, profit gained, number of participants involved, new supporters attracted)?
- What/who is the contact address/person from our organisation?
- Additional information, for example evidence from successful past events and projects; a list of other supporters; and video, audio and print materials that can effectively demonstrate the organisation's success. Corporations would also like to know what the other external sources of support for this event or project is.

An example of a sponsorship proposal prepared by a theatre company is illustrated below. The list of benefits for the sponsor is split into four main groups: direct benefits related to ticket sales and booking, entertainment and peripheral services offered, person-to-person benefits, and marketing and promotional benefits. The greater the sponsorship support is, the more benefits are offered to the sponsoring company. The list is flexible and optional, one or another benefit could be chosen, depending on the amount of the sponsorship.

EXAMPLE

Example of a sponsorship proposal of a theatre company

Benefits and services offered by the theatre to a potential sponsor	Platinum sponsor	Golden sponsor	Silver sponsor
Direct benefits related to ticket sales and booking			
• Provision of a certain amount of free tickets for regular performances	★	★	★
• Provision of a certain amount of free tickets for first-night shows	★	★	★
• Selection of best seats in the theatre hall	★		
• Priority booking for specific events	★		
• Provision of a certain amount of tickets with a discount	★	★	
• Simplification of the booking process	★	★	
Entertainment and peripheral services			
• Special premium treat for a certain amount of sponsor's guests during the break and/or before the performance	★	★	★
• Special cocktail after the performance for the sponsor's guests	★	★	★
• Spaces in the building for selling or advertising the sponsor's products (if appropriate)	★		
• Free parking spaces	★	★	
• Free babysitting facility during the performances	★		
• Promotion of sponsor's products during the event (if applicable; for example food, drinks, etc.)	★		
People-to-people benefits (benefits for the guests of the sponsor or the company's personnel, related to people working in the theatre organisation)			
• Meetings and discussions with the actors	★	★	★
• Participation at theatre rehearsals	★		
• Backstage tours	★		
• Photos with theatre celebrities	★	★	
• Organisation of joint events and programs on the occasion of national and other holidays for the sponsoring company's personnel	★		
• Membership benefits	★	★	★
• Organisation of special business meetings at the theatre premises	★	★	
• Joint receptions on specific occasions	★		

Note: The stars in the table mark the co-relation between the services offered and the level of sponsorship. In actual sponsorship packages it is important to also include the range of financial support in monetary values, differentiated between the platinum, gold and silver sponsorship levels.

Benefits and services offered by the theatre to a potential sponsor	Platinum sponsor	Golden sponsor	Silver sponsor
Marketing and promotional benefits			
• Advertising space for the sponsor in the evening program	★	★	★
• Advertising space for the sponsor in the annual publicity materials of the theatre	★		
• Advertising space for the sponsor at the theatre venue (temporary or permanent)	★		
• Provision of free programs and other print materials for the sponsor and the sponsor's guests	★	★	★
• Various cheaper forms of media advertising—easy access to the media	★	★	
• Production of a special video to promote the sponsor, using the theatre actors	★		
• Outdoor advertising of the sponsor	★	★	★
• Online advertising of the sponsor at the theatre website	★	★	★
• Promotion of the sponsors products through the theatre actors (if suitable)	★		

6.4. Planning the Approach to Potential Sponsors

Planning the overall sponsorship process requires answering the following questions:

- How well does the sponsorship match the organisation's aims and objectives?
- For which programmes and events could sponsorship be an effective way of gaining additional support? Why?
- Why do the event and the arts organisation deserve sponsorship?
- What are the size and the reputation of both the arts organisation and the potential sponsors, and how do they match?
- What is the 'benefits package' provided in return for the sponsor's financial and in-kind support?
- How will the overall visibility and media coverage of the project or event attract potential sponsors?

Effective sponsorship planning requires a careful selection of suitable business companies. The proposed planning scheme provides a general framework which needs to be adapted to each specific case.

PRACTICAL RECOMMENDATIONS

When deciding which company to approach for sponsorship and how, consider the following:

- Learn as much as possible about the company and its key managers before approaching it. Neutral letters starting with 'Dear sir …' rarely succeed.
- Your chance of success is much higher when you approach companies with a history of sponsoring cultural and/or nonprofit organisations.

- Companies are keener to offer sponsorship locally, that is, in the area where they operate.
- A good match between the sponsor's products or services and the cultural event is always a plus.
- Companies who are launching a new product onto the market are always more eager to sponsor, especially in situations when the product can be used during the cultural event or when the profile of the participating audience matches that of the potential buyers of the new product.
- Sponsors are more willing to support your organisation if they already know you and your reputation is good.
- Elaborate well the online marketing and promotional offers to the sponsor.
- Prepare quantitative indicators to prove the size of the target groups and potential audiences—numbers of attendees, participation, sales, online viewers, and so on.
- Sponsorship decisions are often made by the head of the marketing or public relations department in a company. The personal preferences of the key corporate decision-makers towards a specific art form may also weigh on the final decision to sponsor or not.

It often happens that a company refuses sponsorship not because the proposal is not well elaborated but for other reasons, such as

- inappropriate timing of the application;
- a lack of available personnel or a policy in the company dealing with sponsorship;
- a lack of compatibility between the project and the company's targeted market;
- a company's wish not to be seen as sponsoring many projects or organisations, especially in times of financial difficulties; and
- an absence of favourable legislation for sponsorship in the country.

An arts organisation may also decide to refuse offered sponsorship money. This could happen because the sponsor has a bad reputation, the company seems unreliable, the sponsor's product is inadequate or inappropriate (e.g. a dangerous product for human health) or the sponsor would like to interfere too closely in the creative processes.

Keeping a sponsor is as important as finding a sponsor. Sponsorship is a process, not a single act, and it requires careful planning, rational spending of the sponsorship money, constant involvement of the sponsor in the planned activities, regular reporting, feedback by participants and involvement of the media before, during and after the event. Nurturing sponsors and keeping long-term relations is a time-consuming business.

7. FUNDRAISING THROUGH CHARITY EVENTS AND INDIVIDUAL DONATIONS

A key element in the fundraising plan is planning charity events where individuals, external stakeholders, or organisations donate certain amount of money for specific social causes. Several important factors predetermine the successful planning and organisation of a charity event:

- **Defining and explaining the cause.** The case statement clearly states the social cause and the reason for a potential donor to make a contribution to the event.
- **Understanding the potential motivations of individual donors.** People have different motivations to donate money. Some of them are psychological, for example a wish to help, philanthropic feelings, guilt, sorrow, regret, compassion and/or fear. Others are social reasons, such as a feeling of patriotism, humanitarian reasons, commitment to the cause, desire for prestige and social recognition, solidarity and/or a need to belong to an organisation); financial reasons (tax deductions); and many others. Finding out the motivations of the potential donors is a key to organizing a successful charity event.

- **Securing visibility and media coverage.** This is equally important before, during and after the event.
- **Building transparency, public accountability and trust.** This is a key to the success of any charity event.
- **Involving volunteers during the event.** This contributes to the overall operational budget which in case of organizing a charity event should be kept as low as possible.
- **Including elements of fun and amusement.** Where this is possible—depending on the social cause—this could be an important element, as potential donors would like to be assured that the event is going to be entertaining and worth attending.

Charity events have several benefits for an arts organisation. They increase public recognition, help improve audience relations (current and future) and provide opportunities to gain supporters and make new friends. On the other hand, they require a lot of organisation and are time-consuming. As a result, they might raise insufficient funds, especially when done for the first time. To be successful, charity events need to be carefully planned to involve as many donors as possible and not look like as 'begging'.

The most effective fundraising methods are based on direct contact with potential donors. Table 10.5 suggests several popular methods used by arts organisations to raise money. Individuals can help an arts organisation not only by donating money but also by donating services, equipment or materials, for example transportation vehicles, spaces for rent, office equipment, second-hand items needed for the creative process, technical support, print and telecommunication services and consultations (financial, legal, marketing, etc.).

The effectiveness of a charity event can be measured by several indicators:

- The sum of money collected as a result of the event;
- The time, money and efforts invested versus the results achieved;
- The number of individual donors attracted to the event;
- The increase in the number of supporters and friends as a result of the event;
- The number of articles, press interviews or broadcasted announcements that result from the event;
- The number of online users (in the case of online fundraising tools).

The choice of specific indicators depends on the type of the event, its scope, the objectives of the fundraising campaign and the overall strategic objectives of the organisation. These indicators should be included in the fundraising plan.

Table 10.5 Methods of Fundraising from Individuals

Methods for raising money from the general public	Methods for raising money from the organisation's members
• Personal contact with potential donors in public places	• Direct mailings
• 'Door-to-door' fundraising	• Membership schemes
• Fundraising in the workplace	• Cocktail gatherings and receptions
• Telephone fundraising	• Fashion shows
• Television and radio call-in programs	• Auctions
• Lotteries	• Balls and dance parties
• Carnivals and parades	• Home parties
• Street shows	• Tours
• Bazaars, flea markets and sales	• Excursions
• Special games	• Team games
• Targeted parties for children, the elderly or other groups	• Special celebrations with a fundraising element
• Online fundraising (crowdfunding and others)	• Targeted weekend gatherings (cultural retreats)
	• Online community spaces
	• Fundraising through mobile devices

PRACTICAL RECOMMENDATIONS

When planning a charitable event it is important to think strategically and to connect the campaign with the overall strategic objectives of the arts organisation, especially the objectives related to the external environment[17]. There are several key issues to consider:

- Set up a fundraising committee whose members have credibility and are personally committed to the project.
- Involve actively the organisation's board, committees and volunteers in all stages of the process: preparation, the actual event and post-event activities.
- Train your volunteers, and provide them with regular updating sessions.
- Set up payment procedures for giving donations easily, such as bank deposits, credit cards, cheques sent by post and online payment methods.
- If possible, announce the sum of money collected at the end of the event, thus giving everyone a sense of accomplishment.
- Keep records of donors and send them letters of acknowledgement and thanks.
- Keep records of all procedures related to financial matters.
- List the names of all key donors in the programme.
- Cooperate with other organisations to lobby decision-makers at all levels in relation to the social cause you are fundraising (where relevant).

As already mentioned, there are other potential sources of external funding such as government grants, foundations, international bodies, membership schemes and alternative financial methods (bank loans, debt instruments). Partnership, networking and cooperation are powerful in-kind support mechanisms for artistic initiatives and projects. Co-organizers and partners could contribute a great deal to an art event or a project, providing free premises, free transportation services, joined advertising and PR campaigns and volunteers.

Putting together, analysing and approaching all possible sources of external support requires a strong fundraising plan, as well as commitment and shared responsibilities by the board, managers and staff. In some cases a special *fundraising team* or *fundraising committee* could be established to deal with the overall process of planning, budgeting, monitoring and reporting the funds raised.

8. ACCOUNTING PROCESS: AN OVERVIEW

When the budget and the fundraising plan have been prepared and the organisation is in the phase of implementation, there is logically a need to monitor and record all financial transactions and communications. *Accounting* is a set of activities which involve gathering, processing, recording, analysing and summarizing transactions and events from a financial point of view and in a way that meets legal regulations, restrictions and rules (see Figure 10.2). The accounting process serves as a background for elaboration of the financial plan and facilitates the prognosis of the future financial results. Accounting also helps in the overall process of the plan's monitoring, implementation and final reporting.

Data gathering and processing, as well as principles of accounting for business and nonprofit organisations, differ for each country depending on the national or regional legislation. There are several commonly accepted *accounting methods* for recording and reporting financial information:

- The *accrual method* of accounting recognizes revenues at the moment they are earned and expenditures at the moment when the materials or services are received, whether or not they are paid for.
- *Cash basis* accounting recognizes revenues and expenditures at the moment when cash is received (cash receipts) or is paid out (cash payments).

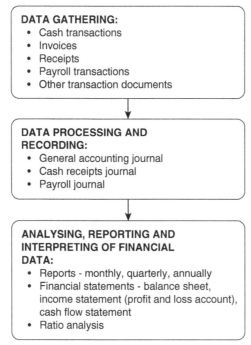

Figure 10.2 The accounting process: an overview

- *Depreciation* accounting is a method to spread the costs of a tangible capital asset (e.g. buildings and/or equipment) over a span of several years, which is the estimated useful life of the asset, if it is used in a rational and systematic manner. This in fact is a way to gradually reduce the value of an asset due to its usage, wear, technological outdatedness or other factors related to time. Artworks, cultural and historical heritage sites and treasuries do not depreciate.
- A *double-entry* accounting system is a way of recording each transaction in two accounts which are affected by the exchange process. Simply put, this method of accounting helps to track where the money comes from (a source account) and where it goes (a destination account).

Subsidized arts organisations usually receive external support through grants, subsidies, sponsorship and donations. The transfer of money is always agreed by a contract or an agreement stating the terms of how the funds are to be used. These funds should be registered separately and in many cases these funds need separate bank accounts to be maintained and to ensure that all the restrictions, requirements and limitations of the fund-givers are met.

Drawing up a budget at the beginning and analysing the data at the end of the financial process are managerial jobs and part of the overall strategic planning process. Data gathering, processing and recording are accounting activities and are performed at the operational level. In order to secure smooth coordination between creative and financial activities in an organisation, an ongoing relation between the top managers (directors) and accountants is required. This is certainly one of the pitfalls in the cultural practice, as artistic directors in some cases are not able to understand and analyse financial statements. On the other hand, financial managers and accountants are often unable to fully understand the complexity and uniqueness of artistic and cultural processes.

9. MAIN FINANCIAL STATEMENTS

The three main financial documents which form the basis for analysis of the organisation's performance and also serve as the basis for the next period of financial planning are the

- balance sheet;
- income statement (profit and loss account); and
- cash-flow statement.

Information gathered and processed in these three financial statements is used by the internal management and external stakeholders to determine the overall financial position of an organisation, the profit (or loss) and the financial surplus (or deficit) in a particular period, as well as the day-to-day cash management.

In the business practice, the term *financial reporting* usually refers to preparation and submission of the three statements: balance sheet, income statement and cash-flow statement. In the strategic planning process, these statements are elaborated as a prognosis for the future and become the core of the financial plan.

Preparation of the financial statements is based on several important milestones: the chosen organisational strategy and long-term objectives, the accumulated experience from previous years (in the case of an existing organisation), benchmarking in the respective industry branch (sector), gathered information from all functional parts of the strategic plan and the overall prognosis for the next planning period.

9.1. Balance Sheet

This financial statement provides information about the economic potential of an organisation: the original structure and transformation of its capital. It also gives an orientation on the organisation's financial stability and liquidity and its level of financial independence. The balance sheet, as a financial document, mirrors the financial relationship between the organisation and its economic environment—suppliers, clients, creditors and others. This is a static document, as it shows the financial situation of an organisation at a particular moment (a certain date, usually on December 31 each year). It can also be used for internal purposes, or for external stakeholders. In the first case it is detailed; in the second it is developed in an aggregated (summarized) format. The balance consists of two main parts: *assets* and *liabilities.*

- *Assets* show all financial and material resources (anything having an economic value) which are at disposal of the organisation and can be activated for realization of the organisation's goals. Assets can be split into different categories depending on the accounting system of a country, for example tangible, intangible and financial; or long-term investments and current assets. Long-term assets are investments which participate in the organisation's activities for a longer time period—over one year. The long-term assests transfer their value partially and gradually on the product's costs. Current assets are crucial for the functioning of an organisation as they show its *liquidity,* which is an essential aspect in any financial partnership. At the start up, an organisation obtains its assets from two main sources: internally (from capital raised by shareholders or from self-invested capital) and from external sources (funds, loans and other financial instruments). In the case of a business company, the external capital needs to be repaid after a certain time. In the case of a nonprofit or state-owned organisation, the support is given as grants, subsidies and donations which are not returned to the fund-giver.
- *Liabilities* in the accounting framework show all obligations or legal debts that arise over time during business operations. Liabilities, as a sum of self-invested capital and investments by creditors, show the sources of financing in an organisation. In the case of external financing, liabilities show from whom the resources (assets) are taken and/or to whom they belong.

 Current liabilities are those expected to be payable within one year. These usually include wages, taxes, accounts payable and short-term obligations. Long-term liabilities are debts payable over a longer period such as bonds, long-term leases, obligations for paying pensions and others.

Table 10.6 Example of a Balance Sheet Structure

Assets	Liabilities
Non-current (fixed) assets: • Material assets (property, plant, equipment) • Intangible assets (patents, copyrights, trademarks, know-how) • Financial assets (excluding investments accounted for using the equity method, accounts receivable, cash and cash equivalents) Current assets: • Cash and cash equivalents • Accounts receivable • Inventories • Prepaid expenses	Non-current (long-term) liabilities: • Long-term loans • Issued debt securities • Deferred tax liabilities Current liabilities: • Accounts payable • Current income tax payable • Current portion of loans payable • Other current liabilities Shareholders' equity: • Owners' equity: paid-in capital • Retained earnings • Treasury stocks

Assets and liabilities are two forms of one and the same value, and in the process of an organisation's activities they are transformed from one to the other. The balance sheet must follow the following formula: Assets = Liabilities + Shareholders' (Owners') Equity[18]. An example of an assets and liabilities structure (without monetary values) is given in Table 10.6[19].

9.2. Income Statement (Profit and Loss Account)

This financial statement is a historical record or a summary of business transactions over a given period (usually a year) and shows whether an organisation has made a profit or loss at the end of a financial period. It shows the difference between the organisation's total revenues and total costs. It indicates how a business has performed and enables comparison with other similar organisations. The main principle for preparing this statement is to group the costs and revenues based on their nature and source. The income statement is an important document for tax authorities, as it follows the legislative framework of the relevant country, especially in relation to the expenses which can (or cannot) be recognized as valid. As already mentioned, this financial statement is a basis for preparing budgets and financial plans. The prognosis of the income statement have to correspond with all other parts of the strategic plan.

9.3. Cash-Flow Statement

This is an important financial statement, as it follows the money coming into the organisation, the money going out and the money which is available in cash or in the bank account(s) of the organisation during a certain period of time (day, week, month, quarter or year). A cash-flow statement is a dynamic document as it shows the actual 'money in' and 'money out', as well as 'money net'. It is a dynamic document, compared with the profit and loss account, which represents the revenues and expenditures in a static way at the end of a financial period. In the accounting practice, there is a difference between revenues as a value and revenues as real money coming into the bank account. An organisation could have a good financial status in general but at the same time might not be able to pay clients and suppliers at a certain moment in time because of a lack of cash. Such a situation could occur as most of the payments and investments are done at the beginning of the year while revenues arrive later in time.

Cash management is a crucial part of the financial management in any organisation, particularly for arts organisations, as cash is required for

- transactions—to meet obligations, for example personnel salaries and fees and payment to contractors;
- risk and safety—to meet unexpected situations;
- investment—to be prepared for opportunities if they arise; and
- discrepancies—between the date of the event and the date the funds from a subsidizing organisation arrive (e.g. from a government programme, foundation or sponsor).

Cash is the most vulnerable of all assets, and because of its liquidity it can be easily misused. That is why establishment of effective controls over all cash assets is a must, for example, requiring dual signatures for taking cash, enforcing accountability on all cash items, separating cash-related functions from the accounting functions (if possible) and setting up one account for cash in order to limit thefts or loss.

There are several important differences between the last two statements. The income statement does not show the real financial status in terms of cash available but shows the gross and net profit (or loss) from activities. This is because it registers only revenues resulting from all the organisation's activities, and not all inflow of money. For example, a bank loan is included in the cash flow as *money in* but is not an income source in the income statement. The income statement registers the amortization expenses on acquired equipment, while the real expenses for purchasing of this equipment are *money out* in the cash-flow statement. The income statement registers a situation in a certain moment and does not consider the exact time frame when these expenses occur or when revenues are received during the year. The cash-flow statement is a dynamic document and registers the exact moment when money comes into and goes out of the company.

10. INTERPRETING FINANCIAL INFORMATION

Financial statements and reports are the wheels for driving any organisation efficiently and effectively. They provide facts which are interpreted by managers, boards and external stakeholders, as well as tax and other financial authorities, who use them as a measure to judge performance and to make decisions about further development. The indicators of a business company's financial health and performance are called *financial ratios*. They are calculated from the financial statements. In the planning process, ratios are indicators for both past performance and future projections, especially related to envisaging potential problematic areas and making investment decisions. Financial ratios are widely used as a forecast as they predict future trends—growth, expansion, stabilization or even bankruptcy.

The technique for interpreting and comparing financial ratios is called *ratio analysis*. It is useful because it summarizes and compares the results of activities and business transactions and relationships between different variables. Ratios give comparisons internally and externally. The internal comparison could consider the following:

- *Different time periods of an organisation's own history.* For example, comparing data from the last period with the current period and making a future prognosis.
- *Budgets and targets.* These are 'subjective standards' as they are prepared in advance. During the realization of a planned budget, there are many external and internal factors influencing and causing changes in the planned figures.
- *The organization's internal departments and units.* This is especially important if an organisation has several intrapreneurial units working on projects.

Ratios also help for external comparison with other similar organisations or with accepted average standards in the respective field or industry[20]. Comparative statistics may be obtainable from the financial statements of other companies (if published officially), from trade chambers and associations or from third parties such as consultants, economists and others. External users of financial reports and ratios are normally investors, banks and other lenders, suppliers and tax and other government authorities.

There are different categories of financial ratios used in business arts organisations, depending on what they measure and what they aim to achieve. Several examples are given here:

- *Liquidity ratios* show the ability of an organisation to pay its short-term debts—bills, payrolls and other cash-related expenses.
- *Profitability ratios* focus on the ability of a company to utilize its resources in generating profit and shareholder value.
- *Financial leverage ratios* indicate the extent to which the business relies on debt financing.
- *Debt ratios* are about a general picture of the organisation's overall debt and the mix between equity and debt instruments used in its financial operations. They determine the overall risk level, as the greater the amount of debt, the greater the financial risk.
- *Operating ratios* show management efficiency.

Ratio analysis applicable to businesses is only partially applicable to nonprofit organisations. Here are examples of the most commonly used *ratios and financial indicators in nonprofit arts organisations:*

- *Ratio of net assets to expenses* is often called an 'operating reserve' and indicates the extent to which an organisation has a reserve for taking advantage of new opportunities or facing unexpected problems. If it is too low, an organisation may not have enough working capital.
- *Excess of overall expenses over revenues ratio* indicates the need for external financial support.
- *Ratio of expenses on all fundraising campaigns and methods to the amount of money gathered as a result* gives an indication of the effectiveness of the fundraising methods.
- *Ratio of expenses for creative programming to total expenses* is important as it gives an orientation regarding the extent to which an arts organisation helps the communities and is oriented to external goals[21].
- *Ratio of operational costs to total costs* shows that the more a nonprofit organisation spends on internal operations, the less efficient it becomes[22].
- *Ratio of debt to assets* is the extent to which activities are financed by borrowing money. High values indicate future liquidity problems or reduced capacity for future borrowing.
- *External contribution ratio* gives an orientation as to the percentage of the total revenues that comes from a source of external financial support. For example, the government grants ratio measures the composition of an organisation's funds coming from government sources and is useful to determine the strategic dependency of an organisation on government funding.

Financial ratios are useful but have also several *limitations*. For example, different choices of accounting methods may result in different ratio values, and changes in the ratios may result from changes in the accounting techniques used, not in the company's performance. It is important to underline that ratios should be analysed together and not separately from one another. In this way they can give a full picture of the organisation's financial situation; otherwise, they could be misleading. Ratios do not answer why this or that happens; they only state facts and point out a current or potential problem. Therefore, they require management analysis and interpretation. Another limitation is that a ratio can look good or bad over time when examining and considering the inflation factor.

Ratios are only one of the many management methods and tools for monitoring a company's performance and forecasting the future. They highlight in a quick and snapshot manner important financial information and make financial statements more 'digestible'. Sound strategic management in an arts organisation requires accurate and complete financial information. Continual monitoring and control of all financial aspects of an organisation's performance ensures sustainability in a long-term period. It is also important in terms of maintaining efficient relationships with all external stakeholders, including banks and other financial institutions, foundations, government institutions and suppliers. The role of the board in the overall financial management is of utmost importance. In nonprofit arts organisations, its responsibilities, among others, include accountability and transparency of financial information to ensure that the social objectives are met.

PRACTICAL RECOMMENDATIONS

When preparing the financial and fundraising sections of a strategic plan, consider the following:

- The financial plan is the 'mirror' of all other parts of the plan. It is the 'financial reflection and evaluation' of all your planned activities and areas of production, innovations, marketing, human resources, and so on.
- The financial plan results from the chosen strategies, creative programming and long-term objectives.
- The projected three financial statements (balance sheet, income statement and cash-flow statement) form the core of your financial plan for the next three to four years.
- Each specific project in your strategic plan could have a separate 'project budget', planned for a shorter period, usually one year. This is especially important for organisations whose structure is project-based.
- The fundraising plan is an important part of the strategic plan for nonprofit and subsidized organisations because there is usually a discrepancy between expected earned revenues and projected expenditures.
- Financial statements and financial ratios for the past reporting period form a rational background for extrapolation of financial figures for the next planning period. They are not enough for elaboration of a thorough financial plan, therefore all other influencing factors and results of the analysis should be considered as well.

11. EXAMPLE OF A 'FINANCIAL AND FUNDRAISING' SECTION OF A STRATEGIC PLAN

1. Main objectives of the financial strategy. Argumentation.
The main financial objectives reflect the main strategic directions and conclusions made in all other parts of the strategic plan. The informational and analytical basis for setting up the financial strategy should also be attached to the financial plan for argumentation—for example key financial documents, financial statements, statistical figures.

2. Priority needs for financial resources
- Crucial areas for the organisation's development in the next four years
- Programming and functional areas that need major investments

Note: This part of the financial plan corresponds to the production and investment plan.

3. Budget forecast

Option I: Example of an art organisation working on a project-to-project basis

Expected expenses (costs) Program/project-related costs Plan the cost items separately.	In the respective currency (and/or as a percentage of the overall budget)	Expected revenues (incomes) Plan the expected revenues and funding separately for each program, project or event.	In the respective currency (and/or as a percentage of the overall budget)
Project 1:			
Personnel (salaries and fees, including necessary social insurance and other personnel benefits)		**Government support:** • National • Regional • Municipal	
Direct programming and production costs *Include here expenses linked directly with the realisation of the final event, artistic work or cultural product.*		**Foundations grants:** • Foundation 1 • Foundation 2 • Foundation 3	
Equipment and housing Include here costs for renting or buying technical and electronic equipment related to the project, renting spaces for the events, and so on.		**International support:** (European Union programmes international funds)	

Administrative costs
Include all indirect costs related to the project.
• Telephone
• Email
• Postal expenses
• Office supplies
• Maintenance of spaces (heating, lighting)
• Office rent

Marketing and communication costs
• Media advertising
• Design
• Branding
• Print materials
• Online promotion (website, online tools)
• Public relations campaigns
• Direct mail

Travel and accommodation
List here international and domestic travel expenses, accommodation and per diems for specific artistic mobility programs or touring.

Miscellaneous (other) costs
(e.g. bank interests due on accounts and investments)

Contingency costs

Total costs for the project (program)

Project 2 (program, event):

Similar cost structure to the preceding

Project 3 (programme, event):

Similar cost structure to the preceding

Sponsorship and other types of corporate support
(money, services and 'in-kind support' estimated monetary value):
• Sponsor 1
• Sponsor 2
• Sponsor 3

Revenues from subscriptions and membership schemes

Revenues from charity events

Revenues from other fundraising campaigns

Revenues from sales of core products and programs
(e.g. artistic works, services, entrance fees, ticket sales and others)

Revenues from peripheral and additional products and services
(e.g. sales of drinks and food, restaurant business, revenues from a shop or parking, contract services, merchandising, and others)

Other incomes
(e.g. from lottery funds, financial revenues from bank interest, major donations, legacies, bequests, intellectual property and copyright income)

Other incomes based on partnership and cooperation (e.g. estimate of the monetary value of voluntary and free services)

Total incomes and revenues for the project (program)

Project (program, event) 2:

Similar revenue/income structure to the preceding

Project (programme, event) 3:

Similar revenue/income structure to the preceding

Project ... *Similar cost structure to the preceding*	Project ... *Similar revenue/income structure to the preceding*
TOTAL COSTS	**TOTAL REVENUES / INCOMES**

Option II: Example of a budget for an art organisation with relatively stable operations, structures and programming

Expected expenses (costs)	**In the respective currency (and/or as a percentage of the overall budget)**	**Expected revenues (incomes)**	**In the respective currency (and/or as a percentage of the overall budget)**
Investments costs (e.g. costs for starting a new organisation or activity)		**External support:** • **Government support** • **Corporate support** (sponsorships, in-kind support, corporate foundations) • **Third-sector support** (from foundations and other funding organisations)	
Operational costs, including **Personnel costs** • Salaries and fees for creative, administrative, technical, production and other teams, including social and health insurance and other benefits • Costs for training and education • Costs for social activities and human resource development		**Self-generated revenues:** • **Sales of products and services** • **Sales of property and other assets**	
Material costs • Costs for buying technical and electronic equipment, as well as spare parts; for repairing and maintaining equipment; for purchasing materials used directly in the creative production process		• **Membership schemes** • **Charity events and other fundraising campaigns** • **Major gifts and bequests**	
Costs for external services • Costs for consulting, transportation services, accounting, financial experts, lawyers, accommodation for visiting contractors, membership in networks, insurance, advertising and public relations agencies' services		**Financial revenues** • **External services to other organisations** (consulting, organising of events, public relations campaigns) • Bank interest on investments • Interest from mutual funds and other investment schemes.	
Depreciation costs (applicable to long-term assets) **Financial costs** • Various types of taxes and licences, interest due on debts, costs occurring as a result of currency rate changes		**Other revenues**	

Costs related to intellectual property and copyrights	Revenues from intellectual property and copyrights
Costs for research and development (innovations)	Revenues as a result of research and development (innovations)
Contingency costs or other costs • Penalties, complaints and costs occurring due to unexpected circumstances	
TOTAL COSTS	**TOTAL REVENUES**

Option III: Example of a budget for an organisation having both permanent operations and project-based activities

(In this case the budget is a combination of the two preceding options.)

Forecast for expenses and revenues

Note: The expense/revenue structure is the same as in the preceding but is based mainly on forecasted percentages for each budget item and for each year, considering the trends highlighted in the SWOT analysis, economic factors, the inflation rate and other factors.

Fundraising plan

• Main objectives, approach and fundraising methods

Program/project where external support will be requested (For what?)	Sources of support (From where?)	Expected support (How much?)	Deadlines (By when?)	Responsibilities (Who is in charge?)
List the programs, projects and events for which external financial support will be requested.	*For each program, project or event, register possible external sources of support (foundations, sponsorships, government programs, international support, individual donations, alternative financial support and others).*	*For each source, identify the target amount to be obtained (match with the budget).*	*Mark here the deadlines for application to specific foundations and funds, organisation of charity events and others.*	*Delegate responsibilities among the management, staff, board or a special fundraising committee.*

4. **Financial statements** (forecast for the next four years)
 • Balance sheet
 • Income statement (profit and loss account)
 • Cash flow statement

5. **Major ratios and analytical summary. Strategic ratio prognosis.**

12. CASE: *BIRTHMARK ON THE MAP* (NOVOSIBIRSK, RUSSIA): TELLING STORIES ABOUT RURAL RUSSIA. LOCAL BRANDING IN AN INTERNATIONAL CONTEXT

The case was created with the kind assistance of Valery Klamm and Lada Urchenko. The case text is based on an analysis of primary data from targeted qualitative research, online promotional materials and internal management documents.

ANALYSING THIS CASE WILL HELP YOU TO:

- Recognize the necessity for arts entrepreneurs and project managers to elaborate strategic plans.
- Understand the importance of partnership and collaboration for the sustainability of an innovative artistic project.
- Understand the importance of balancing external fundraising with self-generated revenues for an artistic project.
- Consider financial strategies and methods for increasing self-generated revenues.
- Be aware of the mix between online and offline tools in building a local and international brand for a project.

12.1. Background

Birthmark on the Map (BOM)[23] is a Siberian-based photo blog and documentary project featuring rural lifestyles from around the world. Valery Klamm, photographer, cultural entrepreneur and writer, began this photo blog in 2009, in collaboration with the Agency for Regional Marketing (ARM)[24]. The initial idea of the project was to tell about the daily life of the people in the Novosibirsk region through the language of photography. The project was initially launched at the Novosibirsk regional business portal Newsib.ru, supported by the regional government via the ARM as a web resource dedicated to the 'daily life of small local communities in the region'.

Klamm uses the language of photography to tell stories of ordinary people living outside of big cities. Initially aimed at capturing daily life in the Novosibirsk region, Klamm uses the language of photography to tell stories of ordinary people living outside of big sites and to capture small points on the map—villages and little towns. The project aims to become a lively visual archive of rural Russia. *'We want to show regular provincial life of the countless "small motherlands" which form our great country. Everyday life in its beauty and majesty'.*

The subject matter proved to be important and interesting for many, and the blog quickly expanded to include participants from other regions with their stories about Russian provinces. The new subsection 'Birthmarks on the Globe' became the virtual place where professional photographers, enthusiasts and students capture rural-life moments and scenes aiming at building up 'photo bridges' with other countries. As of 2010 the movable exhibition 'Birthmarks on the Map' has been shown in local museums in the Novosibirsk region. The project had a multimedia presentation in Yekaterinburg (Ural) and Moscow at anthropological conferences and ethnic film festivals. In April 2011 BOM was short-listed as one of the four nominees for Best Russian Blog for the Deutsche Welle Blog Awards[25]. In 2012 BOM was presented at the Head On Photo Festival in Sydney, Australia[26].

12.2. The Entrepreneur's Profile and Partnership

BOM is expanding internationally while remaining a 'home-based' projects, operated by Valery, who is the key photographer and a social entrepreneur. He has analytical abilities, such as identifying and exploiting a new opportunity, seeking international visibility and creating a collaborative online platform. He is a social leader with a strong sense of social responsibility, connectedness and networking skills. Together with being a strategic thinker with a vision, Valery has project management competences, and he is both the artist and also the manager of his projects. He has the basic traits of an entrepreneur, such as the ability to tolerate and manage risks, adaptability to changes and coping with uncertainty, and ongoing motivation and enthusiasm in his professional work. His photographic works and projects are recognized internationally as innovative and creative, transforming photographs into storytelling artistic tools visually representing rural Russia.

The key entrepreneur has a service agreement with the ARM, established on a yearly renewable basis. The ARM provides the project's financing from the regional budget, which covers the main

operational, administrative and technical expenses. The ARM hosts also the Newsib portal[27] and assists the entrepreneur in promotional activities across the region, for example the presence of BOM at the Shanghai Expo 2010. All contributions to the blog and peripheral activities from photographers are on a volunteer base.

12.3. Profile of Users

BOM's viewer (user, reader, guest) is described by the entrepreneur as 'someone who has a rough rural life, who have a strong feeling of existence, who obtains an inner wisdom and is interested in people's daily lives'. This is someone who lives outside of big cities—or struggles with being inside of them—regardless of the exact place on the globe; someone who wants to understand better his/her own country and local history, or who is curious about other countries and places and accepts the world as a whole, without clichés and stereotypes, but discovering similarities and differences.

12.4. The Project's Innovative Aspects

The project has the following innovative features:

- Unusual form of state-private partnership.
- Focused creative approach to the daily life of the Russian provinces: exploring and visualizing simple stories of simple heroes in simple circumstances—warmly, sincerely, with sympathy.
- Development of the territory's image by expanding the locally based cultural brand across borders.
- 'Online-offline' circle—producing offline exhibitions and multimedia presentations, as well as elaborating online coverage and following up users' traffic.

12.5. Main Mission and Objectives

BOM is a 'photo-bridge' to mutual understanding. The project aims to produce, present and promote sincere and humane visual material from the Novosibirsk region and provincial Russia as a whole. It focuses on a documentary and lyric archive of rural life that tells simple stories to help people better understand themselves as well as their neighbourhoods (village-region-country-globe).

BOM's long-term objectives are

- to become a visual and cultural Novosibirsk-based brand that is well recognized nationally and globally and a lively visual archive of the Russian provinces—the 'non-capital Russia';
- to develop as a platform for cooperation between photographers and other professionals in the fields of photography, science, education and the media (editors, curators, publishers, anthropologists, movie-makers, teachers and professors) from Russian regions and the rest of the world;
- to grow as a place of interactions with the Russian diasporas and a virtual meeting point for anyone interested in the contemporary life of Russia 'off the news';
- to broaden the online community around the blog and the territory of coverage, involving new authors and implementing 'BOM-branded' joint projects with partners, both interregionally (Siberian regions, Central Asia, Ural Mountain region, etc.) as well as internationally; and
- to expand BOM's partnerships by involving companies, institutions and individuals in an international think tank having an advisory role.

12.6. Brief SWOT Analysis

Strengths

- Targeted and focused project.
- Reputation of the project in Russia and among photography communities.

- Strong competences and traits on the part of the main entrepreneur and author of the project.
- Well-established professional connections around the world.

Weaknesses

- Complete reliance on two leaders' personal involvement and devotion: Lada Urchenko, director of ARM, and Valery Klamm.
- Full dependency on state financing and at the same time lack of financing for dynamic development of the project (e.g. for more staff, web platform, upgraded equipment or bilingual presentation of the project).
- Dependency on the priorities of the regional marketing, predetermined by the local policy.
- Possibility of losing one of the two main project leaders because of shifting to other fields.

Opportunities

- Good positioning on the national and international levels as a local Russian project that has discovered a new angle on the daily life of the country.
- Possibility of raising support from new sources at the regional and municipal levels in the Novosibirsk region (e.g. the Ministry of Culture and district administration, local and national corporate sector, charity organisations).
- Fast growth in terms of authors, audience, geographical coverage, upgrade of the blog's design and web engine as a whole.

Threats

- Possible cancellation of the support from the local government.
- Competitive environment: launching of similar projects in other regions with more sources involved.
- Decreased audience interest because of relatively slow project development.

12.7. General Directions of the Functional Strategies

- **Creative Process and Product/Service Development**

 - Applying more Web 2.0 tools on the website and uploading more multimedia content in the blog: audio podcasts, photo-films.
 - Implementing bilingual content in the project's promotion, both online and offline.
 - Collaborating with photographers on an assignment basis by suggesting to them both general creative themes as well as administrative and financial support.
 - Attracting new authors and new themes in the project development.
 - Implementing *photo-radio* and *photo-cinema* in the project—podcasts with Skype-based interviews with photographers and other professionals, photo-films and videos produced by the photographers[28].

- **Marketing, Audience Development and Public Relations**

 - *Online:* Implementing professional Internet-based marketing tools on an outsourcing basis; initiating and monitoring discussions that can attract public attention.
 - *Offline:* Increasing BOM's promotional trips aiming at presentations and exhibitions in other regions and countries; involving youth as well as state corporations (e.g. Russian Post).
 - Focusing on the cooperation between photo-blogging and science—involving anthropologists and ethnographers as consultants and partners in the image-capturing and storytelling process[29].
 - Involving local museums as well as local media to reflect on the local reality and its heroes, using the know-how of the project.
 - Involving young people in the project as both viewers and active participants.

- Engaging audiences outside of the Novosibirsk region and across the country's borders.
- Using the photographers and partners as ambassadors of the project through their presentations at public events and conferences, their own publications and websites and other promotional tools.

- **Human Resources**

 - Gradually transforming the 'solo' management into a small BOM team, with the technical support provided by the Newsib web portal's programmers and other resources.
 - Increasing the remuneration for the people involved in the project to a level matching their time, efforts and level of professionalism.

- **Financing and Fundraising**

 - Focusing on seeking new sources of fundraising among corporate sponsors, charitable organisations and private donors.
 - Implementing crowdfunding tools.
 - Actively engaging the board in the fundraising campaigns, both online and offline.
 - Encouraging partners (local museums and media) to gather financing from district sources.

- **Collaboration and Partnership**

 - Seeking targeted forms of collaboration with scientific and educational institutions, international and national festivals, and the Russian diasporas worldwide.
 - Increasing contacts with the business sector and seeking mutual benefits.
 - Brainstorming about unusual forms of collaboration, aiming at synergies.

12.8. Lessons Learned

Valery shares his professional values and lessons learned as follows:

- 'Stand on the "crossroad of interests" and be flexible in your collaboration with partners. Find the points of crossing between different intentions, expectations, competences and experiences.'
- 'Remember that your project or initiative never exists in an empty space, and there is a need for a constant deeper understanding of the changing context. The balance between leading and adapting to this context is never easy.'
- 'Believe that there are and there will be many people that are ready to share with you and support you. Sharing will make your life worthy and will help you to never be alone.'

QUESTIONS AND ASSIGNMENTS

- Are there any elements of social entrepreneurship in this case? Justify your opinion. Discuss elements connecting the creative artistic concept with a social cause.
- What is the main strategy used by the entrepreneur in the project's growing phase?
- How could the strategy of constant international growth in content and visibility be connected with a strategy of fundraising from diverse external sources?
- What are the possible ways for this project to generate revenues by offering both online and offline products and services?
- Elaborate a basic sponsorship proposal for the project and suggest key benefits for potential sponsors, for both online and offline presentation.

Note: You might need to perform additional online research to complete these assignments. In your answers, apply the theoretical concepts and methodology from Chapters 1, 6 and 7 as well as this chapter.

13. CASE: AUDITORIUM PARCO DELLA MUSICA (ROMA, ITALY): OPPORTUNITIES AND CHALLENGES IN MANAGING A LARGE VENUE

The case was created with the kind assistance of Carlo Fuortes (chief executive officer) and Alessandra di Michele Bragadin (responsible for fundraising and international development). The case text is based on an analysis of primary data from targeted qualitative research, internal management documents and other promotional materials.

STUDYING THIS CASE WILL HELP YOU TO:

* Analyse the challenges and opportunities in managing a large venue in the field of the arts.
* Understand the connections between cultural programming, marketing and financial strategy for an art venue.
* Discuss the importance of a mixed fundraising strategy for an organisation aiming at sustainability.
* Discuss changes in the cultural demand and supply factors based on the establishment of a large venue in a city.
* Understand the importance of the space's architecture and facilities for attracting sponsors and audiences.

13.1. Brief History

Auditorium Parco della Musica[30] is a multifunctional complex dedicated to music, culture and art, placed in the centre of Rome. In 1993 an international competition was announced for the construction of a new Auditorium in Rome, which was won by the architect Renzo Piano. He started building the Auditorium in 1995, choosing as its location the area between the Parioli district, the Flaminio district, the Olympic Village and Villa Glori in Roma. The whole complex opened in December 2002.

The organisation Musica per Roma was created in 1999 as a joint-stock company to manage the Auditorium Parco della Musica. Five years later it was transformed into a foundation to continue managing the complex and taking care of its arts and cultural programming, as well as additional business activities. The founding members are the city of Rome (which has granted the foundation the gratuitous loan of the Auditorium facility for 99 years), the chamber of commerce of Rome, the province of Rome and the Lazio region (an important region in Italy). The Auditorium hosts the Accademia Nazionale di Santa Cecilia[31], which has its own choir and orchestra producing series of classical music concerts, as well as the Fondazione Cinema per Roma, which organizes the International Film Festival in Rome.

In the last 10 years, the Auditorium Parco della Musica has become a consolidated reality on the cultural scene of both the city of Rome and the entire country, a resounding success in terms of the quality of its programmes and the consistently high audience attendance. Every year there are over 1,100 events presented in the Auditorium, visited by over two million people.

13.2. Facilities

The Auditorium consists of five main multipurpose performance spaces:

* Santa Cecilia Hall (2,742 seats)
* Giuseppe Sinopoli Hall (1,133 seats)
* Goffredo Petrassi Hall (673 seats)
* Theatre Studio (300 seats)
* Amphiteatre Cavea (3,000 seats), for summer performances.

There are also several rehearsal spaces:

- The Choir Studio (350 square meters)
- Studios 1, 2 and 3 (120 square meters each).

A virtual tour on the Auditorium's website gives a visual impression of the facilities[32].

13.3. Key Current Programmes and Activities

The organisation works in six main programme areas, as follows:

- **Music.** Auditorium Parco della Musica presents exclusive international musicians and some of the best Italian artists. Through new projects, it explores all kinds of music, such as contemporary, jazz, rock, world music, pop and Italian music.
- **Performing arts.** The Auditorium presents some of the most interesting and attractive performances in the field of contemporary dance, theatre and contemporary circus.
- **Art.** The Auditorium's cultural and artistic offers also expand into the fields of painting, photography and the visual arts through the organisation of exhibitions on a regular basis.
- **Culture.** The Auditorium hosts public events and meetings in diverse areas such as history, science, literature, journalism, art history, music history and more. For its special attention to such events, the Auditorium is sometimes called a 'University'.
- **Parco della Musica Records.** This record label was created with the aim of introducing a larger public to the best concert performances held at the Auditorium or made by musicians with very close ties to the venue.
- **Corporate events.** The Auditorium is also a space where leading Italian businesses and multinational companies organize their corporate business events, such as conventions, conferences, forums, trade fairs, product launches and business meetings.

13.4. Management Team

Auditorium Parco della Musica is run by a chairman and a managing director. The board of advisors is composed of 15 members, including the chairman. Advisors are nominated by the foundation's founding members and consist of

- eight advisors (including the chairman) nominated by the municipality of Rome;
- four advisors (including vice chairman) nominated by the chamber of commerce of Rome;
- one advisor nominated by the province of Rome; and
- one advisor nominated by the Lazio region.

The 15th advisor is the president-superintendent of the Accademia Nazionale di Santa Cecilia, who is ex officio member of the board.

The executive management team covers the following areas:

- Marketing, fundraising and international development office
- Commercial office (rental) and external relations
- Merchandising, new publishing initiatives and new commercial products
- Logistics
- Legal issues
- Purchasing office, general affairs, and management control
- Special projects and youth policy.

Other departments and areas of management are as follows:

- Stage management
- The events production department (musical events and festivals)
- The exhibitions department
- The audiovisual and productions department
- The technical office (maintenance and architectural projects)
- The communication department
- The press office
- The administration, finance and budget department
- The human resources department and auditing
- Public and institutional relations department
- The ticket office and promotion.

The decision-making is in the hands of the president, the board of advisors and the chief executive officer (CEO). All of the preceding departments and offices, including artistic experts and the budget office, refer to the chief executive officer for their activities and decision-making matters.

13.5. Basic Financial Figures

The total revenues of the Auditorium Parco della Musica for 2010 were 29,888,308 euros. Public support accounts for 33.66 per cent of the budget structure and comes mainly from the city of Rome (76 per cent), as well as from the Lazio region (20 per cent) and the province of Rome (4 per cent). Musica per Roma does not receive funding from the Ministry of Culture or any national institution.

Self-generated income and self-financing account for 66.34 per cent of the overall budget structure and come from the following internal and external sources:

- Ticket sales: 29.6 per cent
- Sponsorship: 25.9 per cent
- Other revenues: 12.5 per cent (mainly income from private or public contributions dedicated to single events that cannot be acknowledged as corporate sponsorship)
- Commercial royalties and merchandising: 5 per cent
- Chamber of commerce contribution: 5 per cent
- Interest deriving from an endowment fund: 0.9 per cent
- Guided tours and exhibitions: 0.2 per cent.

Sponsorship accounts for around one-fourth of all revenues and income. The Auditorium Parco della Musica works with business companies and offers sponsorship packages with the following aims:

- To offer to the public cultural and educational programmes with innovative elements;
- To contribute to enhancing the musical and artistic culture in the city of Rome;
- To gain wide international visibility;
- To be a leader in offering high-quality cultural and artistic programming.

The Auditorium's sponsors have an opportunity for their brand and activities to be promoted among around 1.5 million people a year.

13.6. Marketing, Promotion and Audience Development

The Auditorium's audience is extremely diversified due to the variety in programming and variety of events offered. The paying audience in 2010 was 1,050,844 people, while the total number of Auditorium visitors was 2,339,800. The audience is mostly composed of people between 30 and 40 years old, most of them from Rome. Another target group is children, especially during the Christmas Festival when the Auditorium becomes the Children's House. Elderly people aged 60–80 are also regular audience members, especially for the classical music concert series. The variety of the audience

is connected to the diversification of the programme—ranging from people who love electronic music or big pop-star concerts to people interested in history, the arts or science and those attending lectures organized at the Auditorium. The Auditorium Parco della Musica has a list of almost 30,000 people registered for the website newsletter.

The admission for attending an event ranges from free admission and low price tickets for low-cost events (for example between 2 euros and 5 euros) with educational or other purposes, to expensive tickets for very famous pop concerts (where the tickets are up to 220 euros). The price of the ticket also diversifies the audience.

For all events Musica per Roma provides a 20 per cent discount for people over 65 years old as well as for young people and students under 26. At the same time, on the basis of a quite diversified programme in terms of cultural and musical genres, Musica per Roma offer discounts on selected events or festivals for specific target groups—such as families and school groups, in particular. These offers are delivered directly and/or through partners—for example other cultural organisations, arts associations and specialized outlets—in order to maximize participation and word-of-mouth advertising. The Auditorium organizes diverse events in different artistic fields in collaboration with many partner organisations.

The communication department elaborates the whole promotional strategy and tools for the creative programming that takes place at the Auditorium. Several important promotional tools are used most often:

- The website, where visitors can find free podcasts (audio and video);
- The monthly magazine, more than 50,000 copies of which are printed and distributed at the venue, as well as through libraries, bookshops, hotels and tourist information meeting points around Rome;
- Advertising through daily newspapers, such as *La Repubblica, il Messaggero* and *Corriere della Sera,* and weekly magazines, such as *Trovaroma,* as well as monthly magazines;
- Outdoor posters, especially for festivals and key events;
- Word of mouth, through other partner organisations and audience members.

13.7. Strategic Goals

The main strategic goals pointed out in the bylaws of Musica per Roma are

- to promote the Auditorium as a venue for concerts and other cultural and artistic events;
- to promote the Auditorium as an attractive international venue through the organisation of cultural events (music, theatre, multimedia shows and others) according to the cultural, social and economic needs and development in the city of Rome, the Lazio region and the whole country; and
- to assist the development of a rich and diversified music culture and the promotion of research in the music field through research on and investigation of new types of music, unknown and original music instruments and in that way to help in the development of musical expressions that usually aren't played in the common circuit.

The strategic goals of Musica per Roma for the next four years are

- to offer original and new program, including innovative artistic events;
- to commission new, contemporary and innovative works of art;
- to tour with the successful events across the country as well as internationally;
- to developing a music label; and
- to develop a web radio and web TV.

13.8. Unique Characteristics and Success Factors

The Auditorium's reasons for success may be identified in a very special and innovative mixture of three main elements: the uniqueness of the facility, the extraordinary richness and variety of the cultural and artistic programming and the original economic model, based on entrepreneurial and profitable projects.

- **Space and Architecture**

 The architectural complex is one of the greatest strengths of the Auditorium Parco della Musica. It is one of the first world-class examples of contemporary architecture among the European Union countries in the last 20 years. The place has an extraordinary symbolic value for the city of Rome. Parco della Musica is a very large complex—spanning more than 90,000 square meters and consisting of four big concert and theatre halls, four rehearsal rooms and a large number of spaces for services and amenities. All spaces together can host 5,000 spectators (the amphitheatre Cavea alone hosts 3,000 spectators).

 For far too long, the city of Rome rested on its laurels. Though it is true that the city's matchless cultural heritage is 'hard to compete with', Rome ran the risk of forgetting that it is not possible for a city to prosper without paying close and critical attention to the present and, more important, the future, not least its baggage of new genres and forms of cultural expression.

 From its opening, the Auditorium's mission has been to create a permanent venue in Rome to foster and host a diverse range of international artistic and cultural genres—not only in the field of music—and to attract both Roman citizens and tourists on an ongoing basis. The Auditorium helps improve the city of Rome's image as not only being an attractive tourist destination because of its historical and cultural heritage but also paying attention to all forms of contemporary art and cultural expressions and offering quality artistic programming to diverse audiences.

- **Cultural and Artistic Programming**

 The second factor for success is the highly diversified multicultural planning approach adopted by the venue. The space is so big that in fact it could easily contain all the concerts in Rome—the potential capacity of all indoor and outdoor public spaces is 1,500 performances per year. The initial fears were that the Auditorium would 'swallow up' the city's spectators and would reduce the audiences for other cultural organisations in the city. This has not happened because the wide range of the Auditorium's programming has increased the city's overall demand for music and cultural events, ranging from jazz, pop, rock and world music to contemporary dance, cinema and literature. Many of the Auditorium's programmes—in the traditional as well as contemporary art forms—are done in partnership and collaboration with other external organisations. This is proof that the demand for culture can be stimulated when the supply is increased and that cultural demand is highly elastic.

 The Auditorium has held major international festivals on science and philosophy, book fairs, the world's first festival of mathematics, as well as a conference cycle on history, journalism, logic and the law. This is perhaps one of the areas where Parco della Musica is the most innovative venue internationally.

 The Auditorium has become a focal point for contemporary art forms and building audiences around it. More than anything, it is one of the most original experiments in what it means to 'purvey' culture today in a major city. The Auditorium helps shape the city's identity and contribute to its vibrant, contemporary, vivid artistic image.

 The general statistics concerning cultural events in Rome show that over the last few years the number of spectators in the whole city has increased more than the number of spectators at the Auditorium. The effect has thus been the one of multiplication rather than substitution. This is achieved by working on the strategy and building capacity to attract new audiences. The Auditorium has become an ideal place for serendipity, where a spectator may encounter multiple, and sometimes unexpected, experiences, for example coming to the Auditorium to listen a concert but then finding another interesting event happening.

- **Economic Model**

 A primary factor for success is the achievement of a high degree of self-financing. This level was attained through financial diversification of revenues: tickets, subscriptions and prepaid cards, sponsors, conference services, catering, bookshop sales, and merchandising as well as incomes from capital funds.

 For a cultural institution, it is as important to have financial autonomy as it is to have programming autonomy. A high degree of independence with respect to public funding makes it possible

to embark on multiyear planning with no fear of being affected by fluctuations in government funding and to enjoy great freedom of action as regards artistic choices and policies for prices and services as well as a high degree of accountability for the results achieved.

QUESTIONS AND ASSIGNMENTS

- Discuss the strengths and weaknesses of the organisation's current performance. Analyse the types of general and functional strategies used by the Auditorium.
- Does the Auditorium have a sustainable financial strategy? Why? Why not?
- Suggest innovative online and offline methods of increasing external and internal sources of revenues, considering the Auditorium's current programmes and target groups.
- Elaborate a basic sponsorship proposal for some of the Auditorium's current programmes and offers.
- Suggest a strategy for several charity fundraising events which the Auditorium could organize. Elaborate a plan for these events and suggest relevant local and international partners, considering the causes of the events.

Note: You might need to perform additional online research to complete this assignment. In your answers, use the methodological background and theoretical concepts from this chapter of the book, as well as chapters 5, 6 and 7.

11 Implementation, Monitoring and Strategic Reflection

LEARNING OBJECTIVES

Upon completing this chapter you should be able to:

1. *Understand what a successful implementation process requires.*
2. *Discuss what 'performance indicators' are about and why they are important in a plan's implementation.*
3. *Elaborate a contingency plan and risk-mitigation plan.*
4. *Understand the role of volunteers and ways to recruit and work with them.*
5. *Consider sustainability issues in a plan's implementation.*

1. IMPLEMENTATION AND MONITORING

The last two stages of the strategic management process are implementation and monitoring, and strategic reflections—measurement of results, overall evaluation and corrective actions for the next strategic planning cycle[1]. Implementation of the strategic plan is a key phase, as this is the actual work that transforms a concept into real actions. Strategic documents are useless if they are not implemented. The fit between implementation and strategy is never perfect as there are always many factors that influence the process and constantly change over time. This makes it necessary to tweak and adapt the plan during the implementation. Some of the methods used for monitoring the plan include ongoing internal flow of information between teams or departments, regular meetings, personal interviews with the staff, constant review of data, personal observations and experts' opinions. A successful implementation process requires that the following activities are completed:

- *Translation of long-term objectives into operational objectives* so that they are understood by all members of the personnel and other parties involved in the project.
- *Preparation of operational plans and project plans* throughout in order to achieve long-term objectives. This may require subdividing tasks and responsibilities between different teams in a synchronized and well-coordinated manner.
- *Outlining of individual assignments,* including the goals and objectives of all team members, thus clearly defining individual roles.
- *Ongoing monitoring* of all activities and constant checks to see if they match the preliminary plan. Monitoring requires the use of key performance indicators and the setting of targets, as well as deadlines, in order to control the process and manage changes. Adjustments need to be made if the strategy implementation does not follow the plan.

The strategic plan's implementation is performed through the main management functions: organisation, coordination, motivation, delegation, decision-making and control. The main responsibility for

the plan's implementation is usually in the hands of the general manager and/or artistic director. All other managers and project leaders share roles and responsibilities as well. The main focus in the process of the plan's implementation is to make everyone in the organization believe that the strategic plan is not just a document but helps in the daily work as it provides the direction and the means to perform activities. A good sign of personnel commitment is if everyone in the organization can explain the key elements of the plan, the mission statement and/or the strategic objectives. The issue of *ownership* of the strategic plan is crucial, as people are committed and motivated to do something if they feel that it belongs to them (and is not 'done' to them). This is why it is important to implement an inclusive approach from the very first draft of the strategic plan to the last phase of evaluation and control[2].

2. PERFORMANCE INDICATORS

Implementation of the strategic plan needs constant monitoring to assess progress and evaluate results and, based on this, to do the strategic reflection and the necessary correcting measures. This is normally done in time periods, for example daily, weekly, monthly, quarterly and annually. It is also important to have a good reporting system that is consistent with the financial and other reporting documents. The monitoring process is based on preliminary established *key performance indicators*—financial and non-financial. They are quantifiable and measure the progress throughout the process versus the preliminary established objectives in key areas, such as creative advancement, market positioning and share, labour effectiveness, innovative actions and financial performance. There are many reasons why performance should be measured, for example to learn from mistakes and improve further, to report to external stakeholders and comply with reporting regulations or to monitor people's behaviour and actions.

The difficulty of setting performance indicators in an arts organisation is that indicators are quantifiable and measurable, while many aspects of processes and results in the arts cannot be clearly defined in quantities and figures. An example of possible performance indicators for a public library is given below.

EXAMPLE

Performance indicators for a public library

Area	Indicators
Building and developing of the collection	• Number of new entries in the collection annually • Percentage of unique titles in the collection • Percentage of titles in the national language(s) • Percentage of spending for acquisition of foreign collections • Percentage of rare materials catalogued • Total cost of materials
Accessibility of the collection	• Average time to process an inquiry and deliver it to a client • Accuracy in shelving the collection • Number of content units available for download • Number of content units available in another format, such as CDs • Percentage of virtual visits to the library
Cooperation	• Number of annual interlibrary loans • Percentage of staff involved in international projects
Users	• Total online and offline visits for a certain period • Total loans for a certain period • Frequency of visits • Membership contributions • Contributions based on donations
Efficiency	• Costs per catalogued unit • Costs per loan • Costs per visitor (online and offline)

Many nonprofit organisations prepare their strategic plans based on projects which help to form proposals to external funders and also to generate revenues where possible[3]. Once the project is in the operational (realization) phase, it needs to be monitored, based on preliminary defined key indicators. This helps the project realization to meet the preliminary established objectives, as well as the main organisational objectives. Indicators cover the main areas such as evaluation of the project's phases from inception to completion, partnership and collaboration, target groups, promotion and outreach, management aspects, financial aspects and the overall project's sustainability. The following is a suggested system of project-monitoring indicators which can be adapted to different types of projects and organisations in the arts:

- **Indicators for Artistic Quality**

 - Artists' opinions and satisfaction. Are the creative teams satisfied by the process? What do they find the most valuable in the project? What is their feedback?
 - Media reflections. What are the numbers and the content of the critics' reviews on the project (e.g. art critics and music critics)?
 - 'Newness' and innovation in artistic programming. Does the project implement all elements of programme innovation which were initially elaborated? Does it exceed the promises or under-deliver?
 - Audiences' reactions and satisfaction. What is the general level of satisfaction of audiences participating in the project? How is this measured?
 - Stakeholders' opinions. What are the reflections of different key external groups and individuals on the project's quality? How is this measured?

- **Indicators for the Project's Implementation Stages**

 - The extent to which activities are performed as planned and described in the application documents.
 - The extent to which the project's implementation stages (phases) fit to initial project proposal and the expectations of the funder(s).
 - The level of innovation and originality in the project's implementation.
 - The evolution of the project from the inception to the final outcome. Was there a difference between the starting and the ending phase? Did the project goals shift in the process of realization? Did partners change? Did target groups change? Are the changes positive or negative?

- **Indicators for Partnership, Collaboration and Networking**

 - Partnership dynamics. Is there a clear structure of responsibilities and roles between partners during the project's implementation? What is the level of trust and understanding between the project partners? Are the partners actively involved? Are they performing effectively in accordance with the initial agreement? Are there any problems during the project realization and, if yes, did the partners help solve them?
 - The level of improvement of professional networking and collaboration. Was the project realized in a networking and collaborative mode? Does the project gradually lead to the setting up of a new network or new collaborative entity? Did the project improve the professional competences of people related to networking and collaboration?

- **Indicators for Target Groups/Outreach**

 - Planned and actual target groups. Does the project reach the planned target groups?
 - Tracking and measuring of audience feedback. What are the tools used by the project's organizers to measure and gather audience feedback, such as questionnaires, online surveys, focus groups with experts, phone surveys, critical reviews in the media, informal conversations with audience members and stakeholders, or others?

- Outreach. Is the project targeting young people and other key groups of the population?
- Community involvement. Does the project consider working with, encouraging, engaging and empowering communities and/or new audiences?

- **Indicators for Promotion and Communication**

 - Communication and promotional tools. What are the main promotional and public relations tools used in the project's realization? Which ones are effective? Why? How do they help in communicating to the target groups?
 - Online communication and promotion. Are any online tools used in the project's realization? If yes, what kind and in which areas—promotion, visibility, sales, feedback, managing internal operations, or others? Are they effective? Why? Why not?

- **Indicators for Organizational/Managerial Aspects**

 - Managerial capacity. How have the competences and skills of the management team changed during the project's realization?
 - Do the managers and team members acquire new skills, new methods of work or new capacities during the process? If yes, what kind, and by what means?

- **Financial Indicators**

 - Budget implementation. What are the most problematic budget items in the realization of the project? Why?
 - Cost structure. What are the planned and actual percentage of programming and administrative/operational costs in all project costs? Does this change throughout the project's implementation?
 - Revenue structure. What is the planned and the actual percentage of the overall budget generated from external sources (foundations, government programmes, sponsors)? How does this change throughout the project's implementation?
 - Other indicators[4]
 - New sources of financing and fundraising. Are new sources of funding and financing being identified during the project's implementation?

These performance indicators are important also for interim and final reporting on the project's realization to external financial institutions, such as foundations or government programmes, as they compare the initial indicators stated in the action plan of the project's proposal with the interim results during the project's implementation.

3. RISK MANAGEMENT

The strategic plan's implementation is influenced by many unpredictable factors which create uncertainty during the process. When the plan is transformed into actions, things can go wrong in directions which might have a negative or unfavourable impact on the initially established objectives. The analysis of the external and internal environment in Chapter 5 envisages the risks and threats from a strategic viewpoint. In the process of the plan's implementation it is important to also manage operational risks. Anticipating in advance what could go wrong and why, and trying to prevent that or to decrease the consequences if it does happen, is part of the plan's implementation process. There are several important areas to consider:

- **Anticipating the risks.** This means answering the question 'What if?' (i.e. what could happen differently than planned, and how likely is it to happen?).
- **Clarifying the necessary management and other tools needed to diminish the risks.** This means eliminating or reducing the risks' impact and preparing a *risk-mitigation plan*.

- **Solving the problems when they occur.** Management should have the ability to solve sudden problems, and situations or emergencies, even if they are not part of the risk-mitigation plan.
- **Preparing a contingency plan.** This is a secondary plan, a 'plan B', in case the primary plan does not work for one reason or another.

Risk management is a systematic way of forecasting, identifying, assessing, prioritizing and mitigating potential risks which might occur during the implementation of a plan. The example below possible risk situations and risk-mitigation tools during the plan-implementation process in an arts organisation.

EXAMPLE

Risks and risk-mitigation tools

Possible risks which might occur	Risk-mitigation tools
• Scope of activities defined in the plan is too wide and complicated.	• Narrow and clarify individual tasks.
• Planned schedules for different activities seem too short.	• Revise deadlines.
• Team productivity is low, and there are insufficient interim results.	• Implement team-building activities and motivational strategies.
• Key people who are involved in the main processes cannot perform their assigned activities.	• Develop a backup plan for replacement of staff (where possible).
• A key partner or key shareholder withdraws from a major project, which causes serious financial problems.	• Prepare a partnership agreement in advance, covering a wide range of options and compensations in case of withdrawal. • Prepare a backup plan for distributing the partner's activities among others.
• Audiences' satisfaction is much lower than expected.	• Ensure a higher degree of information given to audiences and involve audiences in the preparatory process.
• The public is not informed enough and not engaged in a fundraising event.	• Make sure that the level of communication and public visibility is high, that the cause is clear and that the potential motivation of donors is clear in advance. • Plan the event in an attractive entertaining style.
• There is a problem occurring due to limited knowledge transfer in an organisation.	• Prepare and distribute materials on best practices.
• Implementation of a new security system for entering the building causes fears and resistance by the personnel.	• Secure sufficient information before the implementation and stress the benefits for staff members. • Train personnel in how the new system works.
• The only sponsor of a project withdraws support because of bankruptcy.	• Secure matching funds and several sources of support from the beginning of the event.
• New or unproven technology is defective at key moments (e.g. stage lighting or sound equipment during a concert).	• Test the reliability of the technical equipment in advance. • Ensure that the staff is experienced and trained to cope with the defects.
• There is a sudden need to decrease the price of a key cultural product (art work) due to unexpected economic circumstances.	• Ensure in advance a backup business plan for survival in critical circumstances, including setting up of a fund for covering key expenses in crisis situations.
• An unexpected weather change (i.e. rain, wind or snow) in the case of an outside event makes the concert, festival or exhibition impossible to hold.	• Prepare in advance a clear plan to hold the same event indoors. • Sign an agreement with the venue in advance to move the event indoors.

- A key artist (musician, dancer, actor) cannot participate in the show due to sickness or other unexpected circumstances.

- Content of the website was built up as static but is no longer liked by users, who are accustomed to dynamic social networking sites.

- Number of website visitors is much lower than planned.

- Sign in advance a detailed agreement with the artist, covering opportunities to change the scenario of the event in the last moment in case of emergency and have someone double the role.

- When elaborating information and communication technology (ICT) strategy, use a flexible technical solution for building your website, one that can accommodate future applications as online technology develops rapidly.

- Emphasise online promotional tools and ethods in the plan and evaluate options. Use online link campaigns with other organisations' websites, as well as the power of social networks to promote your website. Update content on an ongoing basis, and make it interactive for users.

In the process of anticipating possible risks, it is important to get inputs from the staff, board, stakeholders, experts, clients and volunteers by organizing brainstorming or other feedback sessions. This can also be done by bringing together colleagues, managers and friends who have been working on similar projects and could be familiar with similar risky situations. Sharing lessons learned is a powerful tool in risk management. This is the way to suggest valuable ideas on what could happen, how to help prevent it and what to do if it does happen. 'Out of the box' thinking helps to generate more ideas on how to cope in risky situations.

4. WORKING WITH VOLUNTEERS

Implementation of the strategic plan happens when projects, activities and operations are carried out in a logical manner. As discussed in Chapter 10, when preparing budgets, arts managers have to be conscious about costs and keep them as low as possible. One of the ways to decrease labour costs is to use volunteers for selected activities.

Working with volunteers has its pros and cons. The benefits for engaging volunteers are as follows:

- Volunteers are usually enthusiastic and willing to learn.
- They do the job for fun, contacts and image.
- They use it as a learning experience.
- They have fewer demands and expectations.
- They cost less money for the organisations, although might require more coordination and training.

Volunteers might not feel adequately committed and responsible because of the unpaid nature of their work. Therefore, it is important that the organisation be prepared if they suddenly leave. To avoid such situations, it is important for the management team to find ways to increase their commitment, for example by providing detailed and structured explanations about the expected work commitment and by organizing motivation sessions. Constant encouragement is a must as volunteers need to feel needed, useful and appreciated. It is important to note that it is not volunteers but the managers who take the responsibility for an event or a project. Volunteers only help, and they should not be expected to make decisions or deal with problems and risks that might occur.

Possible benefits for a person who becomes a volunteer are the following:

- To develop professionally and gain working experience which helps on any future job applications;
- To learn new skills and competences in a specific area;
- To have an insider's perspective into the 'backstage' artistic processes;
- To gain visibility among the community and society as a whole;
- To increase professional contacts;
- To have fun, meet new people and socialize.

Volunteers are usually attracted to programmes that focus on positive, honest and enthusiastic appeals and engaging social causes. Volunteers can perform practically any job or duty in an arts organisation—from low- to high-skilled jobs related to supporting, administrative and technical activities. Volunteers could also be involved in functional areas, such as marketing, fundraising, financial operations or the production process. These volunteers are usually students who are studying in these fields or people interested in obtaining training.

EXAMPLES

Functions Performed by Volunteers

Volunteer support during a music concert

Volunteers could help before, during and after the concert in the following ways:

- Selling tickets
- Disseminating information about the event
- Updating information on the organisation's website
- Seeking sponsors for the event
- Contacting the media
- Guiding guests in the hall before the concert
- Keeping track of the guest list and the membership list
- Helping the musicians with the backstage preparations
- Serving food and drinks during the event
- Photographing musicians and guests
- Engaging in follow-up activities with the media
- Cleaning and tidying up after the event.

Volunteer support for a marketing campaign

In a marketing campaign or an audience survey, volunteers could help with the following:

- Preparing a mass mailing
- Distributing posters, brochures, samples and test products
- Disseminating questionnaires
- Gathering responses from a survey
- Processing the data and developing a database of clients and audiences
- Creating a website or helping with website development and content.

Finding the right volunteers, training them and involving them is a time-consuming job that has a number of stages:

- Identifying the volunteers' tasks and activities and preparing short task descriptions.
- Developing applicable procedures for attracting volunteers.

- Recruiting volunteers.
- Providing orientation and training sessions for volunteers.
- Informing and training the staff in the organization about how to involve and motivate volunteers.
- Supervising volunteers in their work and securing a system for mentoring.
- Performing a brief evaluation at the end of the volunteering services.
- Recognizing and thanking volunteers for their services at the end.

Places to look for volunteers are usually schools, colleges and universities, specific associations, social networking sites, friends and colleagues and announcements for volunteer recruitment on the organization's website and other online platforms. When one is recruiting volunteers, it is important to understand volunteers' motivations. Elderly volunteers have mainly moral, ethical, patriotic and other emotional and psychological motivations, while younger generations of volunteers seek to acquire professional skills and competences necessary for their future professional development as a result of the volunteering process. Some people become volunteers in the arts because these activities are related to certain hobbies and to the way they spend their free time in a more attractive and joyful way.

If an organization regularly uses volunteers to perform activities, the evaluation of the volunteer process can be done using several indicators, such as

- the number of volunteers;
- the number of volunteer hours/days;
- the percentage of increase/decrease in voluntary participation; and
- feedback from the volunteers about their satisfaction and learning during the services performed.

Working with volunteers is an important economic aspect of the plan's implementation in non-profit and subsidized arts organisations because it decreases labour costs. Volunteers are a powerful asset as they bring a fresh spirit and enthusiasm and new working styles. Volunteering is a phenomenon of the third sector. Business companies rarely use volunteers, and if they do it is only in some specific cases when they are organizing a charity event or special fundraising campaigns devoted to social causes.

5. FINAL EVALUATION

As discussed in Chapter 2, strategic management is an ongoing process and not a one-time spontaneous activity. Every strategic plan has an expiry date after which the planning cycle starts again, taking into consideration all necessary changes. Evaluation of success in implementing a plan and achieving final results can be done based on many methods. Some of them are

- Compare preliminary established indicators with the initial set of objectives;
- Process and analyse client, audience, stakeholder and community feedback;
- Perform observation and monitoring by managers; and
- Use of consultants and external experts who are invited to analyse and evaluate the final results.

The final evaluation of the strategic plan in an arts organisation is based on the following key indicators:

- The extent to which the project helps in the realization of organisation's strategic objectives.
- The level of achieved functional objectives.
- Improvement of the artistic quality and the creativity of the core teams.
- The level of development of innovative activities in an organisation and the level of increase in innovative potential.
- The level of intrapreneurial climate achieved.

- The level of effective use of resources (money, people, equipment, facilities).
- The level of satisfaction and involvement of audiences, clients and customers, including new target groups.
- The level of satisfaction of funding bodies (foundations, government authorities, sponsors), including improved connections with local authorities and funders.
- The level of self-generated revenues.
- The level of improvement in the organisation's image and reputation in the society and among the immediate community.
- The increase in the visibility of the creative production and project results.
- The level of improvement in the organisational and managerial capacity.
- The level of professional collaboration and networking.
- The level of the arts organisation's engagement in solving social and ecological problems.
- The level of sustainability achieved in all aspects: financial, environmental, community, and so on.

Table 11.1 gives a possible scale for evaluation of these indicators.

Table 11.1 Scale for Evaluation of Indicators

Indicator	Excellent	Satisfactory	Good	Unsatisfactory	Poor
Contribution to strategic objectives					
Goals achieved					
Artistic quality and creativity					
Innovative activities					
Intrapreneurial climate					
Resources used:					
• Material					
• Human					
• Financial					
• Informational					
Involvement of audiences (clients)					
Satisfaction of stakeholders and funding bodies					
Increased self-generated revenues					
Improved overall organisational image					
Improved visibility of projects and people					
Increased management capacity					
Networking and collaboration					
Social engagement					
Level of sustainability					

6. SUSTAINABLE APPROACH TO PLAN IMPLEMENTATION

Strategies are about securing future sustainability, and this is why an efficient strategic management is always directed towards an organisation's sustainable development. The Sustainability Report (out of Canada) defines that 'sustainability is about living and working in ways that meet and integrate existing environmental, economic and social needs without compromising the well-being of future generations'[5]. The *four pillars of sustainability* model incorporates culture as a fourth dimension of sustainability, together with environmental responsibility, economic health and social equity[6]. This model recognizes

that culture and the arts contribute immensely to building liveable cities and communities where people want to stay, live, work and visit and that this plays a major role in supporting social and economic health in a sustainable mode.

Therefore, sustainability is not just a goal but should be naturally incorporated in the overall process of strategic management and planning in the arts sector. A sustainable approach to a strategic plan's implementation considers the following factors and trends:

- **Arts organisations as open systems of interactions.** As already discussed in Chapter 2, strategic management regards an organisation as an open system, constantly interacting with the external social, economic and political environment. In the implementation of strategic plans, artists and arts managers nowadays are more conscious about how their work reflects the broader context and has an impact on social systems, ecology, economic development and more. Art is becoming more and more interactive and engaging by different means: artists involve audiences in their interactive projects. Artists are leaders, and they shape public opinion, and therefore they are in a great position to provoke people to rethink the future of their planet.
- **Arts organisations as 'messengers' of sustainability.** There is an increased awareness of artists, arts entrepreneurs and managers nowadays about global issues, including sustainability, the environment and climate change. Artists have a special ability to discover and explore what other people do not see. They inspire, provoke and bring to the surface our emotions; they shake us and make us think and change. Sustainability is about the need for a global positive change. This is why incorporation of sustainability into strategic plans and their implementation is crucially important.
- **Interdisciplinary aspects.** Arts organisations today develop interdisciplinary and transdisciplinary projects—not only between art disciplines but also between arts and other areas of society such as the environment, health care, education and the social area. This cross-collaborative commitment is an important focus in a well-elaborated strategic plan. Implementation of such a plan is possible only by broad collaboration and partnership between arts organisations and others from different sectors.
- **Sustainable art.** Individual artists are addressing more and more the issue of sustainability in various ways by creating artworks and projects that consider the wider impact of their work in relationship to the environment—social, economic, historical and cultural[7]. Creative programming concepts consider more and more aspects of sustainability in art and involvement of diverse stakeholders and supporting organisations in this process, such as foundations, government funds, sponsors and individual donors.
- **Global connectivity.** Artistic communities worldwide combine efforts and form their own networks and coalitions. These artistic gatherings aim at raising public awareness about climate change and the environment, encouraging the implementation of environmentally friendly projects. They are engaged in advocacy-based actions to catalyse changes among the general public. Some of these networks bring together landscape architects, artists, engineers, ecologists and educators who are passionate about improving and sustaining the quality of our urban and natural environment, including through artistic means. Many online platforms and international organisations have been created in recent years to assist these efforts[8].
- **Sustainable operational management.** Managing artistic operations and projects in a sustainable mode is not new but is a gradually developing practice worldwide. Examples include being conscious of electricity and water consumption during large events, using stage equipment that meets energy-efficiency standards, using organic cleaning products, printing promotional materials on recycled paper, harvesting rainwater to water plants, composting and recycling garbage, using ecological clothing and accessories, and more.
- **Support of communities through the arts.** Sustainability in a plan's implementation also means caring about the community's cultural development, for example supporting local artistic talents, empowering communities to be engaged in artistic programming in one way or another and involving volunteers in artistic projects and events.

- **Financial sustainability.** Incorporating entrepreneurial and innovative elements in the strategic plans of arts organisations is a way to make them financially sustainable by securing a mixture of self-generated income and outside financial support.

Sustainability should not be regarded as a separate dimension in a strategic plan for an arts organisation. It should be naturally embedded in all its parts. Performance indicators for a plan's implementation should also consider sustainability in all aspects of creative programming, marketing, human resource management, financial management and others.

7. COMMUNICATING RESULTS

A very final stage in the plan's evaluation process is to report and communicate evaluation results to the organization's board, funding bodies, government officials, audiences, partners and key stakeholders. Evaluation reports are usually completed in two versions:

- One for internal use: prepared for the board, trustees, committees, managers, staff, partners and contractors;
- Another for external use: for wide media coverage, informing audiences, communities and the general public.

Final reporting in an arts organisation is rarely done for internal purposes only, as arts always need public recognition, approval, ongoing public involvement and support. Therefore, wider communication of the results of the strategic plan's implementation is important for informing others what has happened, why, what resources were used and what results were achieved and what the multiplication effects and public benefits are. Consideration of feedback and critical reflections from diverse internal and external groups is an essential stage at the end of the planning cycle. It is especially important to inform those who provide ongoing support, make key decisions, help with public visibility and image-building, volunteer their time or might be future supporters of the organisation.

After a period of strategic reflection (evaluating results and capturing feedback), another planning process begins by taking corrective actions and setting up the new strategic goals, as planning is a process in a loop. Managing an arts organisation based on a well-designed plan is the first basic ingredient for success. It is important to emphasize that strategic management is always a 'situation-based' collective and comprehensive exercise and that there are no ready recipes and formulas—each case is different and unique. Strategic planning is a creative process which requires selection of methods and tools which have to be adapted to the uniqueness of each arts organisation considering the specific context. It also has to reflect to the needs of the teams and the expectations of the audiences in the long term. A complete structure for a strategic plan and its content items at a glance is given at the end of the book. It is elaborated as a result of the theoretical concepts, targeted research that has been conducted and the practice of arts management. This is not a ready-to-use model and needs adaptation to each specific case.

This book offers a general methodological framework and instruments for strategic management and planning in the arts, considering innovative thinking and entrepreneurial actions during all phases of this process. If elaboration of a strategic document seems too complicated and overwhelming for you, do not give up—just construct it piece by piece, like a puzzle, so that at the end you construct the whole picture of how you want your organisation to look in the long term. Planning will make your daily management much easier and more efficient, because you will have something concrete and solid to guide you in the future—your strategic document. As stated at the beginning of the book, creating tomorrow today might not be easy, but it is certainly possible—by investing collective efforts, ongoing learning and mutual inspiration.

8. CASE: LOKOMOTIVA CENTRE FOR NEW INITIATIVES IN ARTS AND CULTURE (SKOPJE, MACEDONIA): COLLABORATIVE CONTRIBUTION TO SOCIOCULTURAL CHANGES IN A COUNTRY

This case was created with the kind assistance of Biljana Tanurovska and Violeta Kachakova. The case text is based on an analysis of internal management documents, promotional materials and primary data from qualitative research.

STUDYING THIS CASE WILL HELP YOU TO:

- Understand how a small creative nonprofit organisation runs its programmes and influences socio-cultural changes in a country.
- Understand the importance of connecting artistic programmes' implementation with lobbying and advocacy efforts for cultural policy development.
- Discuss the need for strategic professional development and capacity-building in the culture sector, especially related to innovation and entrepreneurship.
- Analyse the benefits and challenges in strategic management of a small organisation having rich programming and working in a wide partnership context.
- Analyse performance indicators for a nonprofit organisation.

8.1. Brief History and Achievements

Lokomotiva Centre for New Initiatives in Arts and Culture[9] was founded in 2003 in Skopje, Macedonia, as a nonprofit organisation playing the role of a multipurpose platform for education, reflection, discussions, creative projects and critical thinking. It is a small organisation but is a very active participant in the building and development of the democratic sociocultural space in Macedonia and the former Yugoslavian region. Through its activities, Lokomotiva aims to widen the access of citizens to arts and cultural events and projects and to influence the development and support of contemporary, dynamic art and culture as an incentive towards the development of a democratic society.

Lokomotiva is one of the most reputable nonprofit organisations in the field of the arts and culture in the former Yugoslavia region as well as in Europe. Its reputation is due to its development and successful implementation of many projects, such as films, performances, training programmes, debates, discussions and more. In their realization, regional and international cooperation has always been a priority. Lokomotiva is a cofounder of the Nomad Dance Academy project network[10] and the Loco-Motion festival for contemporary dance and performance. Since its establishment, the organisation has been very active in the development of local cultural policy.

8.2. Key Programmes

Lokomotiva is dedicated to the creation of a new and dynamic civil environment in Macedonia through opening a space for the development of new sociocultural discourses and ideas, education, reflection, discussion, critical thinking and creation, where the needs of the actors on the scene and citizens are articulated in new contemporary arts and cultural practices that influence the development of the new social values and are initiating sociocultural developmental changes on the national level. Through attentive affirmation these sociocultural changes are then presented in a wider regional and international context.

Lokomotiva programmes are structured under an interdisciplinary principle and cover diverse areas such as: education, creation and production, artistic exchange, diffusion, research and debates about cultural policies, and opening a space for debating, critical thinking, networking, and so on.

The main programme directions are the following:

- **Contemporary performing arts.** Long-term projects are the Nomad Dance Academy, Loco-Motion festival for contemporary dance and performance, and Jardin d'Europe—European project for contemporary dance development[11].
- **Cultural policy.** Long-term projects are a project for decentralized cooperation between the Region of Lower Normandy (France) and Macedonia, the development of the networking and advocacy capacities of the independent cultural scene in Macedonia and the development of the advocacy platform for contemporary performing arts within Nomad Dance Academy.

8.3. Management Team and Organisational Structure

Lokomotiva's core team consists of

- a programme and organisation manager (full-time employee);
- a project manager (full-time employee);
- an office assistant (part-time employee);
- a financial officer (outsourced);
- several programme coordinators for contemporary dance and visual art, paid on an honorarium basis; and
- other collaborators: a web administrator, public relations and media specialist, technical and stage coordinator, and assistants in organisation and guest coordination when festivals and other public events are organized.

Team members have split up the tasks for projects in different arts and culture fields: one is responsible mainly for programmes in the contemporary performing arts, and another for programmes related to film, video and the visual arts. Cultural policy development is an issue which is embedded in almost all programmes and projects.

Lokomotiva does not have its own studio or performing space but owns only technical equipment that it shares with independent artistic organisations. Since there is no developed art market in Macedonia, the need for such technical facilities is low, and the organisation cannot rent them to others or charge for their use. Lokomotiva rents its office space.

8.4. Idea-Generation Methods

Lokomotiva members are professionals with different backgrounds, knowledge, skills and affiliations with arts and culture. Ideas generated by Lokomotiva's team are not oriented only towards programming and project development. They also cover internal matters, such as team-building and development, research and preparatory work for a project and ways to gather new knowledge and experiences in the field of arts and culture. Some ideas are generated in a collaborative context—with participation of representatives of external artists, experts, stakeholders and organisations. This is a great motivator as it makes the external partners feel involved in Lokomotiva's activities.

One of the factors that has a negative influence on the process of idea generation is the very small core team of Lokomotiva. Team members are preoccupied with project implementation and have little time left for brainstorming and enhancing creativity at work. Application procedures for and reports to external funders and donors have become increasingly complicated in the last years, and team members spend a lot of time on applications and reports. This is why little space is left for reflections and generation of new ideas.

8.5. Financial Structure

All Lokomotiva income by now comes from external donors and supporters on a project basis. Therefore, most of the public events organized by Lokomotiva are free of charge for the audiences. Audience development and the creation of cultural needs for contemporary artistic creations are additional reasons for offering free events. If tickets are sold, the revenues received are considered as income for paying the rent for the space, usually provided by a public institution. Sometimes revenues are split

between the public institution and Lokomotiva. Monthly honorariums and salaries for Lokomotiva's team vary depending on the scope and funding of the project which is being realized.

Basic financial figures related to external sources of income for the 2011 budget are given in Table 11.2. The total budget of Lokomotiva for 2011 was €106,770 and was lower than that in 2010. The main reason for this is the income generated by the Nomad Dance Academy activities. In 2010 the three-year regional funding for the Nomad project from the Swiss Cultural Programme in the Western Balkans finished. Also, in 2009 and 2010 the first two installments that brought the biggest part of the funding from European Union's Culture Programme 2007–2013 for the Nomad part of the Jardin d'Europe project were transferred to Lokomotiva. This increased the average income part of the yearly budget. Lokomotiva was coordinating the activities of the Nomad Dance Academy partners within Jardin d'Europe; therefore, funds distributed to Lokomotiva's account were not used exclusively for Lokomotiva activities but for the activities of the network partners as activities within the project.

8.6. Profile of Audiences

In relation to the projects of the organisation and the scope of activities within a project, different target audiences are being addressed and involved, for example:

- Projects dedicated to, or involving, programme lines for cultural policy research and development are addressed to decision-makers in the field of culture, representatives of the cultural institutions, the nongovernmental organisation sector working in culture, and freelance artists.
- Projects and programme lines dedicated to education have as their main beneficiaries young artists, professionals or academics. They obtain new knowledge and practical methods in subject areas different from the one in the universities' curricula.
- Projects and programme lines for arts and cultural production and dissemination of cultural and artistic content have as the main beneficiaries students and young practitioners of art, art lovers and the general audience.

8.7. Success Factors and Uniqueness

- **High reputation.** Since its establishment in 2003, even though it is a small organisation, Lokomotiva has managed to sustain its reputation and be one of the leading and most active representatives of the independent culture sector on the national level. Furthermore, the organisation is regionally

Table 11.2 Lokomotiva's Budget for 2011

External sources of income	Percentage
Swedish Institute through partner Hybris, Sweden (Workshop/collaboration Nomad—Hybris and Inpex)	3.8
European Cultural Foundation (Woodstock of Knowledge Project)	19.7
Swedish Institute through partner Intercult, Sweden (Fast Forward Laboratory)	10.0
Prohelvetia through partner Stanica, Serbia (LocoMotion festival)	5.6
European Union's Culture Programme (2007–2013), through main partner Dance WEB, Austria (project Jardin d'Europe)	17.2
Swiss Cultural Programme in the Western Balkans (Nomad Network, preparatory grant)	3.2
Swedish Institute through partner Hybris, Sweden (LocoMotion festival)	6.5
Macedonian Ministry of Culture (co-financing for project Jardin d'Europe)	9.1
City of Skopje (LocoMotion festival)	1.5
Association of Local Democracy Agencies and the region of Lower Normandy (project for decentralized cooperation between the Region Lower Normandy (France) and Macedonia)	23.4
Total income (grants)	100.0

Source: Lokomotiva Annual Report 2011, p. 3.

and internationally recognized and acclaimed for its unique and well-realized projects and collaborative initiatives. Lokomotiva is working in a situation characterized by a turbulent sociopolitical context, ongoing changes in funding policies and the withdrawal of many donors and funders from Macedonia in the last five years. Such negative external factors have led many other similar non-profit organisations in the country to close or decrease their scope of work.

- **Professionalism.** The sustainability of Lokomotiva is mostly due to good strategic management and planning, as well as to the professionalism and enthusiasm of the team members, who constantly create and implement new ideas.
- **Wide partnership.** Lokomotiva's efficient work is also a result of being proactive with other arts organisation and public institutions on the national, regional and international levels. Relations with partners are established through different projects and networking events over the years.
- **Involvement in cultural policy development.** Lokomotiva is the first organisation in Macedonia that initiated work on the creation of a strategy for development of culture on the regional level (in the Pelagonija region of Macedonia), based on the method of participation and a bottom-up approach in the creation of public cultural policy, in collaboration with the Centre for Development of the Pelagonija region.

8.8. Results of the SWOT Analysis

Strengths	Weaknesses
People's creativity, engagement and devotion to their workExperience in contemporary arts, networking, partnership and cultural policy developmentKnowledge and capacities in project managementProfessional management teamConsistency at workSense of ownership in the organisationGood understanding of the local and regional cultural scene and the overall contextOngoing collaboration with diverse organisations on the local, regional and international levels: arts organisations, government authorities, arts and cultural networks	Absence of own space for production and creativityOverloading of team members with work—small team and huge demands for project realisationLack of focus and wide diversification due to monitoring and managing a wide range of different activities and programsLack of sufficient and trustable contacts with the business sector
Opportunities	**Threats**
Better opportunities for international cooperation for Macedonian organisationsImproved regional networking on the Balkans in the last years.Creation of lobbying and advocacy networks in the field of arts and culture in the countryCheap and easy-to use information and communication technologies (Web 2.0 tools, online social networks, etc.)	Turbulent overall political situation in the countryDysfunctional public institutions due to a level of political control and employment policyLack of government support for contemporary arts and the independent cultural sectorInefficient legislative mechanisms in the field of culture, especially related to motivating individual donations and corporate philanthropyNo university education or specialised training in arts managementLack of educated and knowledgeable arts managers in the country and low credibility of the professionMissing links between the government, business and the nonprofit sector

8.9. Strategic Directions

- **Mission**
 Lokomotiva directs its practice towards the creation of a new dynamic civil environment and a space for reflection, creation and discursive practice that advocates for the needs of the cultural actors and articulates them into relevant project activities.

- **Vision**
 Lokomotiva is to be dynamic and open platform for creation, an information resource and a place for the development of new ideas and discourses and innovative contemporary works, which will imply social and cultural changes on the national, regional and international levels.

- **Main Strategic Goals for the Next Three to Five Years**

 - Encourage the development of civil society in the field of culture—the creation of a new and dynamic civil society in Macedonia that will participate in the process of creating public cultural policies.
 - Initiate and encourage partnership and collaboration between central, regional and local authorities and institutions on the one hand and civil society on the other.
 - Facilitate and support capacity-building of cultural professionals in the civil sector and public cultural institutions.
 - Create and implement new models of education and knowledge-sharing in the field of contemporary art practice and theory, which are not represented in the formal education system in the country.
 - Stimulate contemporary artistic production.
 - Encourage critical thinking and the development of cultural needs.
 - Educate, develop and engage the audience.
 - Network at the national, regional and international levels.

- **Main Strategic Programmes**

 - *Reflections:* a programme for research and development of cultural policies and advocacy for the communities' needs.
 - *Platform for Professional Development (Arts and Culture):* a programme for lifelong learning and development of professional capacities in the field of art, designed for artists, art critics, sociologists and cultural workers coming from the independent culture sector.
 - *Art for Sociocultural Change:* a programme that aims to visualize and produce a free, democratic civic space through different art and cultural practices and productions.

8.10. Innovative Aspects

- **Audiences' Engagement in Artistic Processes**
 As part of every project (festival, workshop, lecture, etc.) Lokomotiva develops interactive methods of audience participation: by art professionals and the general audience. An example is the Loco-Motion contemporary dance festival. The performance *Still Lives* in 2009, choreographed by Isabelle Shad, was a result of one week of pre-performance research on public opinions and comments on a photograph by Jeff Wall, taken from people passing by on the city's streets. These comments formed the dramaturgy of the performance. Afterwards, the choreographer held a two-week workshop with non-professional dancers (ordinary people). All the people included in the workshop were participants in the final performance, which opened the festival edition in 2009[12]. Another example is the Fast Forward Laboratory on dance and dramaturgy (2010–2011), including participants from Macedonia, other Balkan countries and Sweden. The results of this workshop were also presented as part of the festival. In 2011 the Curatorial Programme was open for participation by

the public[13]. This programme consists of different forms of lectures, workshops and presentations. The purpose of this format is to create a space that will be nurturing for both the artistic communities and the public, as well as for the discourses that Lokomotiva develops, in partnership, on what the performing arts could do today and become in the future.

- **New Methods of Collaboration**
 Lokomotiva constantly initiates new cooperative projects with the same partners and networks where new partners and network members are invited to participate. This is an important mechanism for introducing new organisations and artists and empowering less visible organisations in the field of art. Moreover, the increased number of partners and collaborators influences the wider development and visibility of the contemporary art practices as well as advocacy actions on the local and regional levels for better policy development in the cultural field, especially related to the independent culture sector and specific art domains.

 Another focus of collaboration is the establishment of regional networks and a focus on events bringing together diverse players: artists, cultural managers, policy-makers, academics, experts, curators, and so on. Lokomotiva aims at building up collaborative mechanisms to enhance the lost connections between cultural policy, academic research and artistic practices. New models of education and knowledge-sharing, especially in relation to the arts and creativity, are also widely embedded in partnership projects.

8.11. Lessons Learned

Lokomotiva's team believes that in order to deal with arts and culture, arts managers must really love the work they are doing, be passionate and highly motivated and believe that arts and culture are a catalyst for significant changes in a wider sociocultural context. Art contributes to increasing the quality of life and communication in a region, enhancing social cohesion and improving the democratic rules for living within the society.

QUESTIONS AND ASSIGNMENTS

- Does Lokomotiva manage its programmes, operations and people in an effective manner and in a sustainable way? Why? Why not?
- Considering the past achievements, current programmes, strategic goals and situational analysis, elaborate the general strategy (or set of strategies) suitable for Lokomotiva to become more innovative and entrepreneurial in the future.
- Suggest strategies and tools for self-generated income, both online and offline, considering Lokomotiva's current programmes and SWOT analywsis.
- Elaborate the main performance indicators for Lokomotiva's interim and final reporting on its projects.
- What kind of concrete managerial actions would you recommend for improvement of Lokomotiva's plan-implementation process?

Note: You will need to perform additional research to complete these assignments. In your answers, apply the theoretical concepts and methodology from Chapters 6 and 10 as well as this chapter.

9. CASE: MAXGUIDE.ORG (METRO VANCOUVER, CANADA: A COLLABORATIVE STRATEGY TO COMMUNICATING ARTS AND CULTURE ACROSS THE REGION

The case was created with the kind assistance of Judy Robertson, communications specialist at Metro Vancouver. The case text is based on MAXguide.org's business plan, management documents and targeted qualitative research.

STUDYING THIS CASE WILL HELP YOU TO:

- Understand the practical connection between a feasibility study and a plan for implementation of a long-term online project in the field of the arts and culture.
- Evaluate the strategy, objectives, performance indicators and risk factors of an online project.
- Discuss the connections between content, technical, operational and marketing issues in the conceptualization and development of a web-based tool.
- Discuss the importance of collaboration between the state, nonprofit and business sectors for supporting arts and culture events and initiatives in a region.

9.1. Background

Metro Vancouver[14] is a political body and corporate entity operating under British Columbia's provincial legislation as a 'regional district' and 'greater boards' that delivers regional services, planning and political leadership on behalf of 24 local authorities[15]. Metro Vancouver has a vision to achieve what humanity aspires to on a global basis—the highest quality of life, embracing cultural vitality, economic prosperity, social justice and compassion, all nurtured in and by a beautiful and healthy natural environment.

Since 2002 Metro Vancouver has formally put the concept of sustainability at the centre of its operating and planning philosophy and has advanced its role as a leader in making the region one which is explicitly committed to a sustainable future. This comprehensive endeavour has become known as the Sustainable Region Initiative (SRI). This initiative is driven by the following overarching imperatives necessary for creating a sustainable future:

- Have regard for both local and global consequences and long-term impacts.
- Recognize and reflect the interconnectedness and interdependence of systems.
- Be collaborative.

These lead to three sets of sustainability principles for decision-making:

- Protect and enhance the natural environment.
- Provide for ongoing prosperity.
- Build community capacity and social cohesion.

In 2010 Metro Vancouver elaborated a feasibility study and a business plan to assess the viability of setting up a web-based Arts and Culture Regional Calendar that would synchronize and promote regional arts and culture activities across the region. The aims of the feasibility study were to analyse the provision of information regarding arts and cultural events in the region, to identify the main gaps, to examine experts' opinions and arguments, and to suggest elements of the framework for the business plan as well as concrete actions for implementing the project. The feasibility study was based on the following main methods:

- An online survey of targeted individuals
- Focused in-depth telephone interviews
- An online survey and assessment of about 100 websites
- Comparative analysis of technical options
- A literature review and desk research.

The following main gaps were identified as a result:

- Absence of one comprehensive calendar/information hub where residents and visitors could easily access the range of cultural and artistic offers across the region;

- A discrepancy between the visibility of cultural organisations located in the city of Vancouver and those located in the rest of the region;
- Missing online connections between the municipal websites (events calendars) and the events calendars of key cultural organisations and online platforms in the region;
- Missing content: under-represented and invisible cultural events and initiatives of small scale, located in the 'peripheries';
- Missing connection between the cultural and educational sectors (e.g. art events at schools).

The feasibility study confirmed that the Metro Vancouver region needed a comprehensive online calendar (information hub) where residents and visitors could easily access the range of cultural and artistic organisations and events across the region. Further investigation confirmed that as a host organisation, Metro Vancouver was best positioned with respect to its capacity and ability to undertake the implementation and development of a web-based Arts and Culture Regional Calendar 'in-house'. Subsequent meetings with stakeholders and media outlets confirmed regional interest and support for a collaborative approach to communicating arts and culture across the region.

9.2. MAXguide.org: General Concept

Metro Vancouver took the lead in developing a simple, easy-to-use and up-to-date web-based calendar for detailing and promoting the range of cultural and artistic events—professional and community-based—available on an ongoing basis. The new online arts and culture calendar is called MAXguide. org (an acronym for Metro Arts Xperience)[16]. It provides free listings of arts and cultural events for arts organisations, individuals and arts and culture businesses in the fields of dance, festivals, film and media art, literature, museums and heritage, music, theatre and the performing arts, the visual arts, lectures and classes.

MAXguide.org features a clean design and easy-to-use interface, advanced search capabilities, images and videos, all having links to social media (Facebook, Twitter, YouTube). MAXguide.org provides easy access to links to tickets, reviews, professional associations and volunteer opportunities and in the future will also host an archive of past events. It links to the existing web calendars of municipalities, cultural organisations and arts and entertainment venues throughout the region.

9.3. MAXguide.org Strategy: Highlights

- **Objectives**

 MAXguide.org is an effective communication tool that highlights the full range of arts and cultural events available across the region and can enhance cultural tourism as an economic driver in Metro Vancouver. The plan, elaborated in 2010, outlined the following objectives:

 - To *improve intercultural interactions* and ongoing information-sharing related to the culture sector among the municipalities;
 - To bring *'added value' to the region,* becoming a definite asset for regional cultural activities;
 - To *promote widely* cultural, artistic and community events and activities throughout the whole region;
 - To achieve much *higher visibility* for the overall regional cultural infrastructure located outside the city of Vancouver while at the same time increasing the sense of 'regional services' for cultural organisations located in the city of Vancouver;
 - To serve as an *'online cultural resource center',* accumulating and disseminating information on arts and culture events, activities, organisations and individual artists;
 - To have a *special emphasis on young audiences* and connections with schools and universities across the region.

In the long term, MAXguide.org aims to assist in fostering connections and encouraging collaboration between

- citizens of different municipalities, who will be better informed about what's going on 'next door';
- cultural producers/organisations and cultural offers in all municipalities;
- different arts and culture forms and categories (a 'cross-fertilizing', 'cross-sectoral' approach);
- the cultural and educational sectors, with a special focus on youth; and
- the culture sector and the overall economic development of the region.

- **Content**
 The business plan outlines the two major parts of MAXguide.org's website content:

 - Dynamic core content on ongoing culture and arts events and activities. This content is being updated on an ongoing basis by the members. Events coordinators or publicists apply for memberships with MAXguide.org and are responsible for the input of their own events[17]. The MAXguide.org administrator approves each membership, adds additional events and keeps the featured events and videos on the home page current.
 - Static content: comprehensive lists of the websites of municipalities, networks and associations, organisations, venues and local cultural facilities. New listings are added by the MAXguide.org team on an ongoing basis.

 Each event on the website is presented with a short summary; details about the date, time and venue; options to share the event through social media; the option to buy a ticket online; and in some cases videos and images. All ticket sales are done through the event site and not through MAXguide.org. However, it should be noted that the online user will go to the event site to purchase tickets or view a video, but once they close that window they are still on the MAXguide.org site. MAXguide.org features on an ongoing basis volunteer opportunities for a variety of arts and cultural events across the region. The website also offers an advanced search option to find an event based on an arts and culture category, name of the venue, specific time period, location using advanced search or the map search, and keywords.

- **Technical Options Review**
 As part of the research into the feasibility of the calendar, a comparative analysis of five technical options was undertaken. The comparative criteria related to the technical solutions for setting up and maintaining the calendar included the following:

General Criteria

- Technology: off-the-shelf products versus open software options.
- Stability of the content management system (CMS): ability of the technology to cope with large amounts of data and user contributions, constant transfer of data and backup of data.
- Flexibility of the system: ease of integration of future extensions and applications.
- Ease of maintenance: level of collaboration between the technical company and the client after launching the website, and resolution of bugs.

Specific Criteria

- User-friendly and technically advanced search engine.
- Effective options for setting up user-generated content.
- Options for export and import of content between websites (synchronisation).

- Company's competence and experience in general, especially experience with online calendars and user-generated content.
- Past products and current clients of the company.
- Hosting and maintenance solutions.
- Costs for development and maintenance: price packages, hourly rates for technical development, maintenance and further applications.

The comparative analysis based on these criteria showed that Metro Vancouver's in-house solution was the least expensive and most viable option. The software SharePoint 2007[18] is already owned by Metro Vancouver. There is a knowledgeable technical team within Metro Vancouver—this is a core competency as demonstrated by the successful product Metro Vancouver Recycles[19], and there will be no additional costs for hosting the website. This solution is also more reliable as there will be no long-term dependency on an outside company. The only outside help required was a contractor to collaborate with Metro Vancouver technical staff on the content development.

- **Collaboration**

 MAXguide.org provides a foundation piece for smaller arts and culture organisations, strengthens municipal websites and provides the much-needed linkages between municipalities, their arts and culture producers (professional and amateur), media outlets, tourist bureaus, boards of trade, chambers of commerce, and so on. It is set up on a broad collaborative basis between Metro Vancouver and its member municipalities as well as regional culture stakeholders. Advertising and promotion of the calendar are accomplished through an existing distribution system and close collaboration with municipalities through the Regional Culture Development Advisory Committee.

- **Budget**

 The total budget to build the calendar was Can$69,000. Costs to further refine and enhance the functionality of the calendar, based on users' feedback, along with ongoing maintenance, are estimated at $32,000 annually. Efforts will also be undertaken to secure corporate support from the business sector. Later in 2012 the staff will undertake a review to assess the long-term viability and financial structure of the calendar.

- **Promotion and Users' Feedback**

 The MAXguide.org team has just completed a user assessment survey. The results are still under processing and analysis. A preliminary look shows the members are very pleased with the online calendar. Membership uptake has been very efficient, and the current focus is on making MAXguide.org *the* 'go-to' site for arts and cultural events.

 Marketing and promotion have been through word of mouth, trade show participation as one of the online services provided by Metro Vancouver, Twitter, Facebook and presentations to various municipal councils and arts organisations. The local *24 Hours* magazine culls the listings to use for its 'Events around Town' segment on Fridays. The page has the QR code[20] for MAXguide.org, which brings users directly to the site. This is at no cost to Metro Vancouver. The 2012 marketing plan will be developed following the results of the user survey. An iPhone application will be developed in September 2012.

- **Benefits**

 The initial plan highlighted the main qualitative and quantitative benefits as a result of MAXguide.org's implementation:

 - *Qualitative Benefits*

 - Increased engagement of citizens and visitors in events across the region (outside the city of Vancouver).

- Increased collaboration between 24 local authorities in the culture sector.
- Increased involvement of young people in cultural and artistic events across the region.
- Higher visibility of small, emerging and less known cultural organisations.
- Higher visibility of school and university art forms.
- Heightened awareness of the economic potential of culture and arts across the region.

- *Quantitative Benefits*
 - Relatively small budget for initial technical set-up (in the case of the preferred in-house technical development).
 - Relatively small budget for management and operation (due to efficient technical solutions and user-generated content).
 - Low budget for online visibility and promotion due to existence of powerful social networking tools in the field of the arts and culture.
 - Increased percentage of collaborative cross-sectoral and 'cross-municipality' projects in the region.
 - Increased number of media responses (traditional media and online media) to regional arts and culture events, activities, organisations and artists.
 - Increased number of people attending cultural events as a result of using the calendar (can be tracked online and through targeted marketing surveys).

- **Performance Indicators**
 To secure achievement of long-term objectives, the following performance indicators were envisaged in the plan for measuring the progress of the plan's implementation in key areas:

 - Users' website statistics in all parameters (unique visitors, pages opened/downloaded, frequency of visits, average length of visits, etc.).
 - Number of pages in other social networking platforms targeting issues related to regional arts and culture.
 - Number of websites and online tools linked with the calendar.
 - Feedback (both offline and online).
 - Number of user uploads in a certain period of time (monthly).
 - Number of cultural organisations and venues actively using the calendar.
 - Number of collaborative projects realized because of the calendar's interactive options.
 - Efficiency parameters, measured by cost per user.
 - Amount of matching funds attracted by other partners and funders after the launch.
 - Other quantitative evidences of effective partnership.
 - Assessment of access from Google analytics on how the site is being accessed: Facebook, Twitter, the QR code, and so on.

9.4. Implementation and Results

Important factors for the successful implementation of the elaborated strategic business plan for MAX-guide.org are

- the competent, skilful and highly motivated team;
- event administrator testing throughout the development;
- the ongoing strategic partnership;
- well-elaborated coherent and synchronized content development; and
- an active ongoing promotional campaign at all levels.

Throughout the development of the back end of the site, member administrator testing was conducted. Over a period of six months a total of 15 one-on-one tests were conducted to ensure

the back end was working for the new members. Ongoing changes were made to the system prior to its launch. Once the site was live but not yet publicly launched, one month was dedicated to inputting data with member administrators, and a comprehensive user guide was developed. This diligence is critical to the uptake of the site. It is easy to use, and there is a direct phone line for members if they are experiencing problems in setting up a membership or events. The administrator can work through the issue remotely. The average troubleshooting session lasts under three minutes. Since the launch on February 25, 2011, there have been no major programming or user issues.

The calendar is populated by members and administered by Metro Vancouver. Since its launch, membership in MAXguide.org has expanded from the original 90 members to 400. The number of organisations presented online has grown from 160 to over 500. Venue listings went from 187 to well over 400. Event listings have increased dramatically from 178 to over 1,500. The numbers in each of these categories continue to increase daily and are beyond anticipated target numbers for the first year.

MAXguide.org continues to receive positive feedback from members indicating that it is a very user-friendly tool that is more than meeting their expectations. In a number of cases, members have noted an increase in their audience numbers and plan to include MAXguide.org listings in their promotional plans for 2012 and beyond. As previously mentioned, the MAXguide.org administrative team conducts surveys to capture the performance indicators and find ways to improve.

The most important tasks for the team are to keep culture and arts on the agenda of the Regional Board, as well as to show the directors and management how MAXguide.org contributes to the long-term vision of Metro Vancouver and that there is sufficient capacity to maintain and develop the calendar further.

Another long-term goal is to sell MAXguide.org as a complete package to other regions and municipalities who then could implement and manage it on their own—a concept similar to that of the Artsopolis network model[21]. The Niagara region has expressed interest in purchasing the product (discussions are ongoing).

The future financial sustainability of MAXguide.org also depends on balancing sources of income and the need to incorporate targeted paid advertising in the overall marketing strategy, as well as the use of a variety of online tools and mobile technologies.

QUESTIONS AND ASSIGNMENTS

- Analyse MAXguide.org's performance indicators, considering the current objectives and the theoretical framework.
- Elaborate potential risks related to information-gathering, content development, potential users, the technical platform and other aspects. Suggest possible risk-mitigation actions.
- Suggest marketing and promotional strategies and concrete tools to improve MAXguide.org's visibility and to also generate additional revenues through the website.
- In which part of MAXguide.org's operations can volunteers help? How would this reflect on the overall project's implementation?
- What are the success factors to consider when developing an online project in the field of the arts and culture? List and prioritize them.

Note: You will need to perform additional research to complete these assignments. In your answers, apply theoretical concepts and methodology from Chapters 6 and 7 as well as this chapter.

Appendix 1

Strategic Plan at a Glance: Structure and Content

A. INTRODUCTION

Cover Page

- Organisation's name, logo and contact details (postal address, website, email)
- Title of the strategic plan and time period
- Team (or person) who elaborated the plan
- Date of completion and approval of the plan (in some cases also the signature of the manager/director)

Content Page

Résumé (Executive Summary)

- Rationale for writing the strategic plan (Why is it needed?)
- Organisation's mission and strategic objectives
- Brief results of the external and internal analysis
- Main set of chosen strategies and rationale
- Main highlights from the functional parts of the plan (Emphasis on the financial plan)
- Time frame and expected results
- Evidence for sustainability

Organisation's Profile

- Brief history
- Legal status
- Main principles (values)
- Brief overview of people (teams) involved
- Organisation's business model (general financial structure)
- Brief characteristics of the sector where the organisation operates

B. STRATEGIC PART

1.	Vision
2.	Mission (Purpose)
3.	Logo and slogan (optional)

4. Strategic objectives:
• Main
• Functional

5. Specific (operational) objectives (for the action plan in the first year)

6. Values (optional)

7. Other key elements of organizational identity and culture (optional)

Section II: **Analysis of the External and Internal Environment (SWOT Analysis): Results and Conclusions**

1. **Results of analysis of the macro-eternal factors influencing an art organization and its activities (opportunities and threats)**
• Economic
• Political/legislative (including analysis of cultural policy trends in a country/region/city)
• Social
• Technological
• Informational and digital
• Global
• Other
Opportunities **Threats**

2. **Result of analysis of the micro-external environment of an arts organisation**
• Creative (cultural) or entertainment industry: situational analysis and trends
• Potential market (size, growth, segmentation)
• Main trends in consumers' behaviour including spending, preferences and needs, especially related to free time and leisure activities
• Potential market and projected revenues
• Competitors (direct and indirect), and their strengths and weaknesses
• Stakeholders
• Collaborators and other key organisations and groups

3. **Results of analysis of the internal environment: main factors influencing an arts organisation's internal activities and performance (strengths and weaknesses)**
• Resources.
• Processes and activities.
• Structures, people and procedures.
• Performance and visibility.
Strengths **Weaknesses**

4. **SWOT analysis: a summary overview (relationships between strengths, weaknesses, opportunities and threats)**
• Driving forces
• Restraining forces
• Limitations and risks

5. **Basic rationale for further choice of a strategy (or set of strategies). Final conclusion of the SWOT analysis**

Section III: **Strategies: Options and Choices**

Strategy	Rationale	Key elements	Objectives	Expected results
List the strategies you have chosen.	*List the main reasons for selecting the strategy (results of analysis).*	*Point out the main focus, key elements and priorities in each strategy (using a time period based on months or years).*	*List the key objectives and the specific objectives for each strategy.*	*Envisage expected results from the implementation of each strategy. (Results are very tightly connected with objectives but have a more 'visible' format—quantitative and/or qualitative characteristics.)*
Main strategies: • Strategy 1 (for example strategy for integration and partnership) • Strategy 2 (for example product-market strategy) • Strategy 3 (for example innovation strategy) Functional strategies: • Marketing strategy • Human resources strategy • Financial strategy • Other				

C. FUNCTIONAL PART

Section IV: **Strategic Directions in Creative Programming: Key Artistic Programmes and Projects**

Section V: **Marketing, Creative Programming and Audience Development Plan**

1. Description and main characteristics of the sector, related to a specific arts field (industry)
 - The competitive advantage and unique selling point of the organisation (as a result of analysis of micro-external environment)
 - An analysis of the main competitors, stakeholders and collaborators
 - The general market positioning of the organisation

Note: Synchronize with results from Chapter 5 related to marketing factors in the external environment and Chapter 6 related to market strategies.

2. Market research: rationale and planned methods
- Quantitative
- Qualitative

Note: In most cases, planning specific research methods is part of an operational short-term plan. Important research directions could be identified for long-term periods.

3. Segmentation and positioning: marketing segments for different types of products and programmes and audience motivation
- Core, peripheral and additional products planned within a time frame
- Uniqueness and special features of each product
- Current and desired audiences—main objectives of the audience development strategy

Note: Planning the overall programme directions and audiences' segments is part of the strategic plan. Concrete programmes and a more detailed audience profile are part of the operational plan).

Programme/product	Audience segments (target groups)	Potential reasons for attendance
For each planned programme, product or service, outline: • *its unique characteristics, quality or artistic dimensions;* • *benefits offered for the audiences; and* • *core, additional and peripheral products and services (if any).*	*Identify the main audience segments (based on initial internal brainstorming and/or results from market research).*	*Answer the question: why would each audience segment (target group) attend the performance, buy the product and/or participate?*
Programme 1		
Programme 2		
Product 1		
Service 1		
Product n...		

4. Price strategies
- Strategic choices in the price policy
- Key factors influencing chosen price strategies

5. Distribution strategies
- Place(s) for production, presentation and sale of the key products or services
- Main distribution channels (online and offline) and rationale for the choice

Note: Concrete distribution tools for each product or service are part of the operational plan. The strategic plan emphasizes the main changes in distribution strategies over a three- to four-year period.

6. Communication strategies and tools
- Communication objectives (for each of the planned programmes, products or services)
- Target groups (for each of the planned programmes, products or services)
- Main emphasis in the overall communication strategy, related to the organisation's identity: motto, logo, unique selling proposition, and so on
- Communication tools (different for each programme or project): advertising through broadcasting and media (traditional and new media), print advertising, outdoor advertising, online advertising, sales promotions, public relations, sponsorship, personal sales
- Measurement of the effectiveness of each communication tool

Note: Depending on the particular situation, the communication part of the marketing plan can include various aspects. The following illustration gives just possible examples.

Programme/product	Audience segments (target groups)	Communication tools
For each planned programme, product or service, outline: • *its unique characteristics, quality or artistic dimensions;* • *benefits offered for the audiences; and* • *core, additional and peripheral products and services (if any).*	*Identify the main audience segments (based on initial internal brainstorming or results from market research).*	*List communication tools planned for each programme or project. Where appropriate, include other details related to a specific communication tool (e.g. advertising message, motto or unique selling proposition).*
Programme 1		
Programme 2		
Product 1		
Service 1		
Product n...		

7. Resources needed for implementation of the marketing and communication plan
- Expected marketing budget (also as a percentage of the overall budget)
- Human resources involved in the overall marketing and communication strategy
- Other resources

8. Methods of evaluation: success indicators and feedback

Another possible approach to elaborate this part of the strategic plan is to plan the programmes, products or services in relation to all other elements of the marketing mix and the targeted audiences, as illustrated below.

Programs	Audience segments (target groups)	Price strategy	Distribution strategy	Promotion strategy (communication tools)	Resources required
Core Programme 1 (objectives and focus)	For each program or project identify audience segments (target groups) Examples of audience segments: • students • tourists • art critics • families from the region • curators • journalists • sponsorst • senior citizens (elderly)	For each program or project identify: • the method of setting up the prices • the basic price level • discounts and benefits offered	For each program or project identify: • the place • the main distribution strategy • the distribution channels	For each program or project identify: • communication objectives • the unique selling point • communication tools • the communication message • expected results	For each program or project identify: • the budget • the people • the material resources • the information • other resources
Core Programme 2 (objectives and focus)					

Programs	Audience segments (target groups)	Price strategy	Distribution strategy	Promotion strategy (communication tools)	Resources required
Core Programme 3 (objectives and focus)					
Additional and peripheral products and services: 1. 2. 3. etc.					

Section VI: Human Resource Management Plan

1. Main human resource management strategies and objectives (rationale for the choice and short description)

Explain which main strategies and objectives for human resources management you have chosen and why. Give arguments on how they are connected and help to realize the general organisational objectives.

2. Main strategic changes planned in the organisational structure (if any)

 Include here:
 - Problematic areas in the current organisational structure;
 - Organisational chart of a future (desired) structure and approach towards its change to facilitate an intrapreneurial climate;
 - Job descriptions of the key positions (changes and improvements in the current ones; creation of new positions).

 Note: Pay attention to the current and desired organisational structure. What changes need to be implemented and why? What kinds of new positions are needed (or have to be closed)?

3. Evaluation, actualization and elaboration of new human resource management internal regulations
 - Emphasize the key human resource management internal regulations (instructions, working conditions, safety regulations, supporting documents regulating the internal workflow and contracting procedures in the organisation). Emphasize the need for change over the long term.
 - Elaborate the new internal regulations.
 - Stress the specificity of the working conditions in the organisation.

4. Analysis and evaluation of personnel's potential
 - Analyse the personnel's portfolio
 - Identify the strategic needs for human resources (quantity and skills and competences required).
 - Identify the need for layoffs or hiring.
 - Identify the need and cost for training and development of new personnel.

5. Planning the process for recruitment and selection

Note: *In some cases this is part of an operational plan.*

6 Basic human resources costs (salaries and fees)

Year	Category of personnel	Number of people	Average salary (on an annual basis)	Social and health care schemes (%)	Total costs
2013	Creative Administrative (Managerial) Technical Production Supportive				
2014	Creative Administrative (Managerial) Technical Production Supportive				
2015 etc.	Creative Administrative (Managerial) Technical Production Supportive				

7. Schemes and methods for motivation

- Monetary (bonuses, allowances)
- Non-monetary

Note: *Diverse motivation methods could be implemented gradually over the long term. It is especially important that the motivation process stimulates innovative and entrepreneurial activities within the organisation.*

8. Plan for professional development and training

Include here:
- Evidence or required elements for the organisation to be a *learning organisation*
- Planned methods of training, education and requalification
- Other methods of personnel development

Note: *Make sure that there is an item in the planned budget costs for professional development.*

9. Main resources needed to implement the human resource management strategy and to undertake necessary changes; assessment of budget implications

Note: *All necessary resources for implementation of human resource management strategy and necessary changes are mirrored in the financial plan (see Chapter 10).*

Section VII: **Technological and Production Plan**

1. Key objectives of the technological and production strategy
- Key areas and aspects;
- Long-term objectives.

2. A short description of the main technological and production process (phases and elements)
- Current process (flow chart: current and desirable);
- Changes to be undertaken (if any).

3. Plan for equipment and material resources
- Main equipment required;
- Information and communication technology equipment required;
- Benefits of the chosen technology, including ecological aspects, economic aspects, quality, technological levels and others;
- Major long-term needs for materials and general specifications of main materials planned;
- Main suppliers for equipment and materials, changes in the current suppliers and planned negotiation stages with the new ones (if any);
- Detailed action plan for the first year (purchasing of equipment, maintenance, etc.).

4. Plan for spaces and capacity
- Evaluation of the current capacity;
- Long-term objectives for a better use of the current space (reconstructing, enlarging, changing, buying, etc.);
- Plan for acquiring a place (if needed);
- Plan for implementation of online technologies and new media for enlarging of the current capacity (*Note: synchronize this with the marketing plan.*).

5. Plan for innovations, research and development
- Sources of innovation;
- Innovation capacity of the organisation and evaluation of the intrapreneurial level of the organisation in terms of technical innovations;
- Main areas of technical/technological innovation planned for the long term;
- Resources required for research and development activities in the long term;
- Risk factors and contingency plan related to innovations, research and development.

6. Quality control

Note: This subsection is needed in case there are any specific objectives, standards and/or requirements existing in the respective art field or industry branch.

Section VIII: **Financial and Fundraising Plan**

1. Main objectives of the financial strategy: Argumentation

The main financial objectives reflect the main strategic directions and conclusions made in all other parts of the strategic plan. The informational and analytical basis for setting up the financial strategy should also be attached to the financial plan for argumentation—for example key financial documents, financial statements and statistical figures.

2. Priority needs for financial resources
- Crucial areas of organisation's development in the next 4 years
- Programming and functional areas that need major investments

(Note: This part of the financial plan corresponds to the production and investment plan.)

3. Budget forecast

Option I: Example of an art organisation working on a project-to-project basis

Expected expenses (costs) Programme/project-related costs Plan the cost items separately.	In the respective currency (and/or as a percentage of the overall budget)	Expected revenues (income) Plan the expected revenues and funding separately for each programme, project or event.	In the respective currency (and/or as a percentage of the overall budget)

Project 1

Personnel
(Salaries and fees, including necessary social insurance and other personnel benefits)

Government support
• National
• Regional
• Municipal

Direct programming and production costs
(Include here expenses linked directly with the realisation of the final event, artistic work or cultural product)

Foundation grants
• Foundation 1
• Foundation 2
• Foundation 3

Equipment and housing
(Include here costs for renting or buying technical and electronic equipment related to the project, renting spaces for the events, etc.)

International support
(European Union programmes, other international funds)

Administrative costs
(Include all indirect costs related to the project)
• Telephone
• Email
• Postal expenses
• Office supplies
• Maintenance of spaces (heating, lighting)
• Office rent

Sponsorship and other types of corporate support
(Money, services and 'in-kind support' estimated monetary value)
• Sponsor 1
• Sponsor 2
• Sponsor 3

Marketing and communication costs
• Media advertising
• Design
• Branding
• Print materials
• Online promotion (website, online tools)
• Public relations campaigns
• Direct mail

Revenues from subscriptions and membership schemes

Revenues from charity events

Revenues from other fundraising campaigns

Travel and accommodation
(List here expenses for international and domestic travel and accommodation and per diems for specific artistic mobility programmes or touring)

Revenues from sales of core products and programmes
(e.g. artistic works, services, entrance fees, ticket sales and others)

Miscellaneous (other) costs
(e.g. bank interest due on accounts and investments)

Revenues from peripheral and additional products and services
(e.g. sales of drinks and food, restaurant business, revenues from a shop or parking, contract services, merchandising, and others)

(Continued)

Expected expenses (costs) Programme/project-related costs Plan the cost items separately.	In the respective currency (and/or as a percentage of the overall budget)	Expected revenues (income) Plan the expected revenues and funding separately for each programme, project or event.	In the respective currency (and/or as a percentage of the overall budget)
Contingency costs		Other incomes *(e.g. from lottery funds, financial revenues, major donations, legacy, bequest, intellectual property and copyrights incomes)*	
		Other incomes based on partnership and cooperation *(e.g. volunteer and free services, estimated in money value)*	
Total costs for the project (programme)		Total income and revenues for the project (programme)	
Project 2 (programme, event) *(Similar cost structure to the preceding)*		*(Similar revenue/income structure to the preceding)*	
Project 3 (programme, event) *(Similar cost structure to the preceding)*		*(Similar revenue/income structure to the preceding)*	
Project n *(Similar cost structure to the preceding)*		Project n *(Similar revenue/income structure to the preceding)*	
TOTAL COSTS		**TOTAL REVENUES/ INCOME**	

Option II: Example of a budget for an art organisation with relatively stable operations, structures and programming

Expected expenses (costs)	In the respective currency (and/ or as a percentage of the overall budget)	Expected revenues (income)	In the respective currency (and/ or as a percentage of the overall budget)
Investments costs *(e.g. costs for starting a new organisation or activity)*		External support: • **Government support** • **Corporate support** *(sponsorship, in-kind support, corporate foundations)* • **Third-sector support** *(from foundations and other funding organisations)*	

Operational costs, including:	Self-generated revenues:
Personnel costs: • Salaries and fees for creative, administrative, technical, production and other teams, including social and health insurance and other benefits • Costs for training and education • Costs for social activities and human resource development	• **Sales of products and services** • **Sales of property and other assets**
Material costs *Costs for buying technical and electronic equipment, as well as spare parts; for repairing and maintaining equipment; for purchasing materials used directly in the creative production process*	• **Membership schemes** • **Charity events and other fundraising campaigns** • **Major gifts and bequests**
Costs for external services *(Costs for consulting, transportation services, accounting, financial experts, lawyers, accommodation for visiting contractors, membership in networks, insurance, advertising and public relations agencies' services)*	**Financial revenues** • **External services to other organisations** (consultation, organisation of events, public relations campaigns) • Bank interest on investments • Interest from mutual funds and other investment schemes
Depreciation costs *(Applicable to long-term assets)*	
Financial costs *(Various types of taxes and licences, interest on due debts, costs occurring as a result of currency rate changes)*	**Other revenues**
Intellectual property and copyright–related costs	**Revenues from intellectual property and copyrights**
Costs for research and development (innovations)	"Revenues as a result of research and development (innovations)"
Contingency costs or other costs *(Penalties, complaints, costs occurring as a result of unexpected circumstances)*	
TOTAL COSTS	**TOTAL REVENUES**

Option III: Example of a budget for an organisation having both permanent operations and project-based activities

Note: *In this case the budget is a combination of the two preceding options.*

Forecast for expenses and revenues

Note: *Expenses/revenue structure is the same as in the preceding but is based mainly on forecasted percentages for each budget item and for each year, considering trends highlighted in the SWOT analysis, economic factors, inflation rate and other factors.*

Fundraising plan

• Main objective, approach and fundraising methods

Programme/project for which external support will be requested (For what?)	Sources of support (Where from?)	Expected support (How much?)	Deadlines (By when?)	Responsibilities (Who is in charge?)
List the programmes, projects and events where external financial support will be requested.	For each programme, project or event, register possible external sources of support (foundations, sponsorship, government programmes, international support, individual donations, alternative financial support and others).	For each source, identify a target amount to be obtained (match with the budget).	Mark here the deadlines for applying to specific foundations and funds, organising charity events and others.	Delegate responsibilities among the management, staff, board or a special fundraising committee.

4. Financial statements (forecast for the next three to four years)
 • Balance sheet
 • Income statement (profit and loss account)
 • Cash-flow statement

5. Major ratios and analytical summary. Strategic ratio prognosis.

Section IX: **Contingency and Risk Plan (anticipation of possible risks and strategies for mitigation)**

CONCLUSION

• Final wrap-up of key strategic priorities
• Final remarks
• Acknowledgements (if relevant)

Note: Acknowledgements can be placed also at the beginning of the planning document.

D. APPENDICES

1. Legal documents
2. Media coverage and visual materials
3. Financial documents
4. Supporting documents
5. Any other important and relevant documents

Appendix 2

References and Recommended Readings

STRATEGIC MANAGEMENT AND PLANNING
(BUSINESS AND NONPROFIT)

Abraham, Stanley (2006). Strategic Planning: A Practical Guide for Competitive Success. Thomson South-Western, USA.

Allison, Michael & Jude Kaye (1997). Strategic Planning for Nonprofit Organizations: A Practical Guide and Workbook. New York: John Wiley.

Amara, Roy (1983). Business Planning for an Uncertain Future: Scenarios and Strategies. Oxford: Pergamon Press.

Amason, Allen C. (2011). Strategic Management: From Theory to Practice. New York: Routledge.

Ansoff, Igor (1965). Corporate Strategy. New York: McGraw-Hill.

Ansoff, Igor (1957). Strategies for Diversification. Harvard Business Review. 35 (5) (Sept.–Oct.), 113–124.

Ansoff, Igor (1990). Implanting Strategic Management. Upper Saddle River, NJ: Prentice Hall.

Barney, J. B. & W. S. Hesterly (2010). Strategic Management and Competitive Advantage (3rd ed.). Upper Saddle River, NJ: Pearson Prentice Hall.

Barrow, Paul, Richard Branson, & David Storey (2001). The Best-laid Business Plans: How to Write Them, How to Pitch Them. n.p.: Virgin.

Barry, Bryan (1997). Strategic Planning Workbook for Non-profit Organisations. St. Paul, MN: Amherst H. Wilder Foundation.

Bennis, W. & R. Townsend (1995). Reinventing Leadership: Strategies to Empower the Organisation. New York: Morrow.

Bertocci, David (2009). Strategic Planning and Management: A Roadmap to Success. Lanham, MD: University Press of America.

Bilton, Chris & Stephen Cummings (2010). Creative Strategy: Reconnecting Business and Innovation. West Sussex, UK: John Wiley.

Bryse, Herrington (1999). Financial and Strategic Management for Nonprofit Organizations: A Comprehensive Reference to Legal, Financial, Management, and Operations Rules and Guidelines for Nonprofits. San Francisco: Jossey-Bass.

Bryson, John (1995). Strategic Planning for Public and Nonprofit Organizations: A Guide to Strengthening and Sustaining Organizational Achievements. San Francisco: Jossey-Bass.

Bryson, John & Farnum Alston (2004). Creating and Implementing Your Strategic Plan: A Workbook for Public and Nonprofit Organizations. Hoboken, NJ: John Wiley.

Burkhart, Patrick & Suzanne Reuss (1993). Successful Strategic Planning: A Guide for Nonprofit Agencies and Organizations. Thousand Oaks, CA: Sage.

Byars, Lloyd L. (2002). Strategic Management: Formulation and Implementation, Concepts & Cases (3rd ed.). New York: Harper Collins.

Carpenter, Mason & William Gerald Sanders (2009). Strategic Management: A Dynamic Perspective, Concepts and Cases. Upper Saddle River, NJ: Prentice Hall.

Catanese, Anthony & Alan Walter Steiss (1970). Systematic Planning: Theory and Application. Lexington, MA: Heath Lexington Books.

Chandler, Alfred (1962). Strategy and Structure: Chapters in the History of Industrial Enterprise. New York: Doubleday.

Chesbrough, Henry (2007). Business Model Innovation: It's not Just About Technology Anymore. Strategy & Leadership 35 (6), 12–17.

Coke, Al (2002). Seven Steps to a Successful Business Plan. New York: AMACOM.

Cooke, Tim & Guy Braithwaite (2000). A Management Companion for Voluntary Organisations. London: Directory of Social Change.

Cornforth, Chris (ed.) (2003). The Governance of Public and Non-Profit Organisations: What Do Boards Do. London: Routledge.

Coulter, Mary (2002). Strategic Management in Action (2nd ed.). Upper Saddle River, NJ: Prentice Hall.

Cummings, Stephen (2002). ReCreating Strategy. Thousand Oaks, CA: Sage.

Cummings, Stephen, & David Wilson (2003). Images of Strategy. In: Images of Strategy. Malden, MA: Blackwell.

Davenport, Thomas, Marius Leibold, et al. (2006). Strategic Management in the Innovation Economy. New York: Publicis/Wiley.

David, Fred (1993). Strategic Management. New York: Macmillan.

David, Fred (2011). Strategic Management Concepts. Upper Saddle River, NJ: Prentice Hall.

DeKluyver, Cornelis (2000). Strategic Thinking: An Executive Perspective. Upper Saddle River, NJ: Prentice Hall.

Drucker, Peter (1974). Management: Tasks, Responsibilities, and Practices. New York: Harper & Row.

Drucker, Peter (1985). Innovation and Entrepreneurship: Practice and Principles. New York: Harper & Row.

Drucker, Peter (1990). Managing the Nonprofit Organization: Principles and Practices. New York: Harper Collins.

Drucker, Peter (1993). The Five Most Important Questions You Will Ever Ask about Your Nonprofit Organization. San Francisco: Jossey-Bass.

Drucker, Peter. (1998). Excellence in Non-profit Leadership: Facilitator's Guide. San Francisco/New York: Jossey-Bass (Foundation for Non-profit Management).

Drucker, Peter (2008). The Essential Drucker: The Best of Sixty Years of Peter Drucker's Essential Writings on Management. New York: HarperCollins.

Fayol, Henri (1916). Administration Industrielle et Generale—Prevoyance, Organisation, Commandment, Contrôle. (Unfinished work.)

Fitzroy, Peter, Peter Hulbert & Abby Ghobadian (2012). Strategic Management: The Challenge of Creating Value. London and New York: Taylor and Francis.

Grant, Robert (2002). Contemporary Strategy Analysis. Oxford: Blackwell.

Grünig, Rudolf & Richard Kühn (2011). Process-based Strategic Planning. (Translated by Anthony Clark.) New York: Springer.

Gupta, V. & I. C. MacMillan (2002). Entrepreneurial Leadership: Developing a Cross-cultural Construct. Proceedings from the Academy of Management Science, Denver, Colorado.

Hatch, Mary Jo & Majken Schultz (eds.) (2004). Organizational Identity: A Reader. Oxford Management Readers. New York: Oxford University Press.

Jane, Henry (ed.) (2001). Creative Management. Thousand Oaks, CA: Sage.

Joyce, Paul (1999). Strategic Management for the Public Services. Buckingham and Philadelphia: Open University Press.

Kaiser, Michael (1995). Strategic Planning in the Arts: A Practical Guide: http://artscene.org/uploaded/Pages/ArtistResources/StrategicPlanninginteArts-APracticalGuide.pdf

Kaufman, Roger, Hugh Oakley-Browne, Ryan Watkins & Doug Leigh (2003). Strategic Planning for Success, Aligning People, Performance and Payoffs. San Francisco: Jossey-Bass/Pfeifer.

Kelly, Louise & Chris Booth (2004). Dictionary of Strategy: Strategic Management A–Z. Thousand Oaks, CA: Sage.

Kim, Chan & Renee Mauborgne (2005). Blue Ocean Strategy: How to Create Uncontested Market Space and Make Competition Irrelevant. Boston: Harvard Business Review Press.

Lawrie, Alan (2001). The Complete Guide to Business and Strategic Planning for Voluntary Organisations. London: Directory of Social Change.

Learned, Edmund P., C. Roland Christiansen, Kenneth Andrews & William D. Guth Business Policy, Text and Cases. Homewood, IL: Irwin, 1969.

Markides, Constantinos (2000). All the Right Moves—A Guide to Crafting Breakthrough Strategy. London: Harvard Business School Press.

Mintzberg, Henry (1992). Five Ps for Strategy. In: H. Mintzberg & J. B. Quinn (eds.), The Strategy Process. Englewood Cliffs, NJ: Prentice-Hall International Editions,.

Mintzberg, Henry (1993). The Pitfalls of Strategic Planning. California Management Review, 36 (Fall), 32–47.

Mintzberg, Henry (1994). The Rise and Fall of Strategic Planning: Reconceiving Roles for Planning, Plans, Planners. New York: Free Press/Toronto: Maxwell Macmillan Canada.

Mintzberg, Henry (2005). Strategy Bites Back: It Is Far More, and Less, than You Ever Imagined. Upper Saddle River, NJ: Prentice Hall.

Mintzberg, H., B. Ahlstrand & J. Lampel (1998). Strategy Safari. Upper Saddle River, NJ: Prentice Hall.

Mintzberg, H., J. Lampel, S. Ghoshal & J. B. Quinn (1995). The Strategy Process: Concepts, Context and Cases. Upper Saddle River, NJ: Prentice Hall.

Oster, Sharon (1995). Strategic Management for Nonprofit Organizations: Theory and Cases. New York: Oxford University Press

Osterwalder, Alexander & Yves Pigneur (2010). Business Model Generation: A Handbook for Visionaries, Game Changers and Challengers. Hoboken, NJ: John Wiley.

Palmer, Derrick & Soren Kaplan (2007). A Framework for Strategic Innovation: Blending Strategy and Creative Exploration to Discover Future Business Opportunities. San Francisco: Innovation Point. http://www.innovation-point.com/Strategic%20Innovation%20White%20Paper.pdf (accessed February 2, 2012).

Peters, T. J. & R. H. Waterman (1982). In Search of Excellence. New York: Harper & Row.

Pettigrew, Andrew, Howard Thomas & Richard Whittington (2002). Handbook on Strategic Management. London: Sage.

Porter, Michael (1990). The Competitive Advantage of Nations. New York: Free Press.

Porter, Michael (1996). What Is Strategy? Harvard Business Review, 74 (2) November/December, pp. 61–78.

Porter, Michael (1998). Competitive Strategy: Techniques for Analyzing Industries and Competitors. New York: Free Press.

Schendler, Dan & Charles Hofer (1978). Strategy Formulation: Analytical Concepts. Eagan, MN: The West Series in Business Policy and Planning.

Selznick, Philip (1957). Leadership in Administration: A Sociological Interpretation Evanston, IL: Row, Peterson.

Senge, Peter & A. Kleiner (eds.) (1994). The Fifth Discipline Field Book: Strategies and Tools for Building a Learning Organization. New York: Doubleday.

Stacey, Ralph (2003). Strategic Management and Organisational Dynamics: The Challenge of Complexity (4th ed.) Upper Saddle River, NJ: Prentice Hall/Financial Times.

Steiss, Alan Walter (2003). Strategic Management for Public and Nonprofit Organizations. New York and Basel: Marcel Dekker.

Taylor, Frederick (1910). Principles of Scientific Management. New York and London: Harper & Brothers.

Thompson, Arthur & A. Strickland III (1996). Strategic Management: Concepts & Cases. Boston: Irwin/McGraw-Hill.

Tregoe, B. & J. Zimmerman (1980). Top Management Strategy. New York: Simon & Schuster.

Varbanova, L. (2010). Strategic Planning for Learning Organizations in the Cultural Sector. Chisinau, Moldova: Soros Foundation and European Cultural Foundation, Amsterdam and Soros Foundation.

MANAGEMENT IN THE ARTS AND CULTURE SECTOR

Bilton, C. & Leary, R. (2002). What Can Managers Do for Creativity? Brokering Creativity in the Creative Industries. International Journal of Cultural Policy 8 (1), pp. 49–64.

Bowen, W. & W. Bowen (1968). Performing Arts—The Economic Dilemma. Cambridge, MA: MIT Press.

Brindle, Meg & Constance Devreaux (eds.) (2011). The Arts Management Handbook. New Directions for Students and Practitioners. New York: M. E. Sharpe.

Byrnes, William (2003). Management and the Arts. Waltham, MA: Focal Press.

Chong, Derrick (2002). Arts Management. London: Routledge.

Cliche, Danielle, R. Mitchell & A. J. Wiesand (in cooperation with I. Heiskanen & L. dal Pozzolo) (2002). Creative Europe: On Governance and Management of Artistic Creativity in Europe. Bonn: ARCult Media.

Davis, Howard & Richard Scase (2000). Managing Creativity: The Dynamics of Work and Organization. Buckingham and Philadelphia: Open University Press.

Dewey, Patricia (2004). From Arts Management to Cultural Administration. International Journal of Arts Management 6 (3) Spring. pp. 13–22.

Dragićević Šešić, Milena (2009). Educational Programmes in Strategic Cultural Management within the Regional Context. In: Cultural Policy and Management (KPY) Yearbook. Amsterdam: Boekmanstudies, Culture Resource (Al Mawred Al Thaqafy) and European Cultural Foundation (ECF).

Dragićević Šešić, Milena (2010). Opening Horizons: The Need for Integrated Cultural Policies in Arab World. In: Cultural Policies in Algeria, Egypt, Jordan, Lebanon, Morocco, Palestine, Syria and Tunisia: An Introduction. Amsterdam: Culture resource, European Cultural Foundation, Boekmanstudies.

Dragićević Šešić, Milena & Sanjin Dragojević (2004). Intercultural Mediation in the Balkans. Sarajevo: OKO.

Dragićević Šešić, Milena & Sanjin Dragojević (2005). Arts Management in Turbulent Times: Adaptable Quality Management. Amsterdam: European Cultural Foundation and Boekmanstudies.

Dragojević, Sanjin (1993). How to Establish New Theatre Management in Central and Eastern European Countries. Ekonomski pregled, No. 11–12, 1993, pp. 820–834.

The European Task Force on Culture and Development (1997). In from the Margins: A Contribution to the Debate on Culture and Development in Europe. Strasbourg: Council of Europe.

Fitzgibbon, Marianne & Anne Kelly, (eds.) (1997). From Maestro to Manager: Critical Issues in Arts & Culture Management. Dublin: Oak Tree Press.

Frey, Bruno & Werner Pommerehne (1989). Muses and Markets (Exploration in the Economics of the Arts). Cambridge: Basil Blackwell.

Hagoort, Giep (2003). Art Management: Entrepreneurial Style (3rd ed.). Delft, The Netherlands. Eburon.

Hudson, Mike (2005). Managing at the Leading Edge: New Challenges in Managing Nonprofit Organizations. San Francisco: Jossey-Bass.

Kast, Fremont & James Rosenzweig (1979). Organization and Management. New York: McGraw-Hill.

Kay, Sue (2011). Grand Narratives and Small Stories: Learning Leadership in the Cultural Sector. London: Cultural Leadership Programme, p. 16. http://www.culturalleadership.org.uk/345/.

Kay, Sue & Katie Venner (with Susanne Burns and Mary Schwarz) (eds.) (2010). A Cultural Leadership Reader. London: Cultural Leadership Programme/Creative Choices. http://www.culturalleadership.org.uk/uploads/tx_rtgfiles/A_cultural_leadership_reader.pdf.

Klaic, Dragan (2007). Mobility of Imagination: A Companion Guide to International Cultural Cooperation, Budapest: Central European University, Center for Arts and Culture. In conjunction with Euclid, UK and the Budapest Observatory., p. 120.

Mitchell, Ritva & Rod Fisher (1992). Professional Managers for the Arts and Culture? The Training of Cultural Administrators and Art Managers in Europe, Trends and Perspectives. CIRCLE, Council of Europe and the Arts Council of Finland, Helsinki.

Negus, Keith (2006). Rethinking Creative Production Away from the Cultural Industries. In: James Curran & David Morley (eds), Media and Cultural Theory. Abingdon: Routledge.

Pick, John & Malcolm Anderson (1996). Arts Administration. London: E & FN Spon.

Reiss, Alvin (1992). Arts Management: A Guide to Finding Funds and Winning Audiences. Marion, IL: Taft Group.

Relais Culture Europe (2010). A European Manual for Cultural Operators: How to Develop a European Cultural Project. Relais Culture Europe. http://www.relais-culture-europe.org/fileadmin/fichiers/4_Monter_son_projet/manuel2-E-BD.pdf (accessed April 9, 2012).

Renard, J. (1998). The Administration of the Arts or the Art of Administration. In: D. Bogner et al., Management of Change. Vienna: KulturKontakt Austria.

Robertson, Iain (2005). Understanding International Arts Markets and Management. New York: Routledge.

Schwarz, I. & Varbanova, L. (2000). Linking Cultural Management to Local Development: The Role of Trans-national Cultural Networks. In: INCLUDE—The Cultural Management as Key Agent for Local Development. Barcelona: INTERARTS, pp. 42–55.

Staines, Judith, Sophie Travers, & M. J. Chung (2011). International Co-production Manual. Korea Arts Management Service, Seoul and International Network for Contemporary Performing Arts, Belgium.

Summerton, Janet & Sue Kay (1995). Through the Maze: A Do-It-Yourself Guide to Planning in the Arts. Devon, UK: South West Arts.

Suteu, Corina (2006). Another Brick in the Wall: A Critical Review of Cultural Management Education in Europe. Amsterdam: Boekmanstichting

Throsby, D. & G. A. Withers (1979). The Economics of the Performing Arts. London: Edward Arnold.

Tobie, Stein & Jessica Bathurst (2008). Performing Arts Management: A Handbook of Professional Practices. New York: Allworth Press.

Towse, Ruth (ed.) (1997). Cultural Economics. Cheltenham: Edward Elgar.

Varbanova, L. (1997). Arts Management. Sofia, Bulgaria: University of National and World Economy, University Press.

Varbanova, L. (1997). The New Role of Cultural Administration in the Emerging Democracies. In: Professionalization of Public Servants in Central and Eastern Europe. Ottawa: SIGMA/University of Ottawa.

Weeda, Hanneloes, Corina Suteu, & Cas Smithuijsen (eds.). The Arts, Politics and Change: Participative Cultural Policy-making in South East Europe (2005). Amsterdam: Boekman Foundation.

CREATIVITY AND INNOVATION

Bakhshi, H. & D. Throsby (2010). Culture of Innovation: An Economic Analysis of Innovation in Arts and Cultural Organizations. London: National Endowment for Science, Technology and the Arts (NESTA).

Bakhshi, H. & D. Throsby (2012). New Technologies in Cultural Institutions: Theory, Evidence and Policy Implications. International Journal of Cultural Policy 18 (2), pp. 205–222.

Bilton, Chris (2007). Management and Creativity: From Creative Industries to Creative Management. Oxford, UK: Blackwell.

Castaner, X. & L. Campos (2002). The Determinants of Artistic Innovation: Bringing in the Role of Organization. Journal of Cultural Economics 26, pp. 29–52.

Chapain, Caroline, Phill Cooke, Lisa De Propris, Stewart MacNeill & Juan Mateos-Garcia (2010). Creative Clusters and Innovation: Putting Creativity on the Map. London: National Endowment for Science, Technology and the Arts (NESTA).

Christensen, Clayton (1997). The Innovator's Dilemma: When New Technologies Cause Great Firms to Fail. Boston: Harvard Business School Press.

Davis, Howard & Richard Scase (2000). Managing Creativity. Milton Keynes: Open University Press.

Drucker, Peter (2002). The Discipline of Innovation. Harvard Business Review, August.

Fitzgibbon, Marian (2001). Managing Innovation in the Arts: Making Art Work. Westport, CT: Greenwood Press.

Foster, Richard & Sarah Kaplan (2001). Creative Destruction. New York: Currency/Doubleday.

Gartner, William B. (1985). A Conceptual Framework for Describing and Classifying the Phenomenon of New Venture Creation. The Academy of Management Review 10(4), pp. 696–706.

Goldenberg, Mark (2004). Social Innovation in Canada: How the Non-profit Sector Serves Canadians—and How It Can Serve Them Better. Ottawa: Canadian Policy Research Network.

Handke, C. (2008). On Peculiarities of Innovation in Cultural Industries. Paper presented at the 15th International Conference on Cultural Economics, Northeastern University, Boston, June 13–15.

Johnson, Steven (2011). The Innovator's Cookbook. New York: Riverhead Books.

Kelley, Tom (2005). The Ten Faces of Innovation: IDEO's Strategies for Defeating the Devil's Advocate and Driving Creativity throughout Your Organization. New York: Currency/Doubleday.

Krinsky, Robert & Anthony Jenkins (1997). When Worlds Collide: The Uneasy Fusion of Strategy and Innovation. Strategy & Leadership, July/August.

Leifer, Richard et al. (2000). Radical Innovation. Boston: Harvard Business School Press.

National Endowment for Science, Technology and the Arts (NESTA) (2007). Hidden Innovation: How Innovation Happens in Six 'Low Innovation' Sectors. London: NESTA.

Palmer, Derrick & Soren Kaplan (2007). A Framework for Strategic Innovation: Blending Strategy and Creative Exploration to Discover Future Business Opportunities. San Francisco: Innovation Point. http://www. innovation-point.com/Strategic%20Innovation%20White%20Paper.pdf (accessed April 8, 2012).

Utterbach, James (1994). Mastering the Dynamics of Innovation. Boston: Harvard Business School Press.

ENTREPRENEURSHIP IN THE ARTS AND CULTURE SECTOR

Abbing, A. (2002). Why Are Artists Poor: The Exceptional Economy of the Arts. Amsterdam: Amsterdam University Press.

Bakr, A. Ibrahim & Ellis H. Willard (2002). Entrepreneurship and Small Business Management: Text, Readings, and Cases (4th ed.). Dubuque, IA: Kendall Hunt.

Baron, Robert, Scott Shane & Rebecca Reuber (2010). Entrepreneurship: A Process Perspective. Toronto: Nelson Education.

Barringer, Bruce & Duane Ireland (2008). Entrepreneurship: Successfully Launching New Ventures. Upper Saddle River, NJ: Pearson Education.

Brinckerhoff, Peter (2000). Social Entrepreneurship: The Art of Mission-Based Venture Development. West Sussex, UK: John Wiley.

Brooks, Arthur (2009). Social Entrepreneurship: A Modern Approach to Social Value Creation. Upper Saddle River, NJ: Prentice Hall.

Burke, Andre E. (ed.). (2006). Modern Perspectives on Entrepreneurship. Dublin: Senate Hall.

Burton, Chris (2003). Scoping the Challenge: Entrepreneurial Arts Management in Times of Uncertainty. Journal of Arts Management, Law and Society 33 (3), pp. 185–195.

Chell, E., J. Haworth & S. Brearly (1991). The Entrepreneurial Personality: Concepts, Cases and Categories. London: Routledge.

Freytag, Andreas & Roy Thurik (2009). Entrepreneurship and Culture. New York: Springer.

Galenson, D. W. (2006). Analyzing Artistic Innovation: The Greatest Breakthroughs of the Twentieth Century. Working Paper 12185. Cambridge, MA: National Bureau of Economic Research. http://www.nber.org/ papers/w12185 (accessed April 8, 2012).

Hagoort, Giep (2007). Cultural Entrepreneurship: On the Freedom to Create Art and the Freedom of Enterprise. Utrecht, The Netherlands: Utrecht University.

Hagoort, Giep & Rene Kooyman (eds.) (2009). Creative Industries: Colourful Fabric in Multiple Dimensions. Utrecht, The Netherlands: Utrecht School of the Arts.

Hisrich, Robert, Michael Peters, Dean Shepherd & Peter Mombourquette (2009). Entrepreneurship (2nd ed.). Toronto: McGraw-Hill Ryerson.

Ibrahim, Bakr & Ellis Willard (2002). Entrepreneurship and Small Business Management (4th ed.). Dubuque, IA: Kendall Hunt.

Martins, E. C. & F. Terblanche (2003). Building Organisational Culture That Stimulates Creativity and Innovation. European Journal of Innovation Management 6, pp. 64–74.

McGrath, Rita & Ian MacMillan (2000). The Entrepreneurial Mindset: Strategies for Continuously Creating Opportunity in an Age of Uncertainty. Boston: Harvard Business School Press.

Meyer, Dale & Kurt Heppard (2000). Entrepreneneurship as a Strategy: Competing on the Entrepreneurial Edge. Thousand Oaks, CA: Sage.

New York Foundation for the Arts (2011). The Profitable Artist: A Handbook for All Artists in the Performing, Literary and Visual Arts. New York: ARTSPIRE and New York Foundation for the Arts.

Paton, Rob (2003). Managing and Measuring Social Enterprises. Thousand Oaks, CA: Sage.

Philips, Ronnie (2011). Arts Entrepreneurship and Economic Development. Hanover, MA: Now Publishers.

Rauch, A. & M. Frese (2000). Psychological Approaches to Entrepreneurial Success: A General Model and Overview of Findings. In: C. L. Cooper & I. T. Robertson (eds.), International Review of Industrial and Organizational Psychology. Chichester: Wiley, pp. 104–142.

Rentschler, Ruth (2002). The Entrepreneurial Arts Leader. St. Lucia, Queensland, Australia: University of Queensland Press.

Roberts, Joseph & Clark Greene (2004). Arts Entrepreneurship: The Business of the Arts. London: United Press Service.

Sexton, David & John Kasarda (1992). The State of the Art of Entrepreneurship. Boston: Pws-Kent.

Slaughter, A. (2004). Art That Pays: The Emerging Artist's Guide to Making a Living. Los Angeles: National Network for Artist Placement (NNAP).

Thomson, John (1999). A Strategic Perspective of Entrepreneurship. International Journal of Entrepreneurial Behaviour & Research 5 (6), pp. 279–296.

Timmons, Jeffrey, Stephen Spinelli & Prescott Ensign (2010). New Venture Creation: Entrepreneurship for the 21st Century. New York: McGraw-Hill Ryerson.

Wilson, N. C. & D. Stokes (2005). Managing Creativity and Innovation: The Challenge for Cultural Entrepreneurs. Journal of Small Business and Enterprise Development 12 (3), p. 366.

Winkleman, Edward (2009). How to Start and Run Commercial Art Gallery. New York: Allworth Press.

CULTURAL INDUSTRIES AND CULTURAL POLICY

Adorno, Theodor (2001). Culture Industry: Selected Essays on Mass Culture. London: Routledge.

Andrew, C., M. Gattinger, S. Jeannotte & Will Straw (eds.) (2005). Accounting for Culture: Thinking through Cultural Citizenship. Ottawa: University of Ottawa Press.

Bonet, L. (2011). Trends and Challenges of Observing Cultural Industries. In: C. Ortega (ed.), New Challenges of Cultural Observatories. Documentos de estudios de Ocio no. 45. Bilbao: University of Deusto, pp. 49–65.

Boorsma, Peter B., Annemoon van Hemel & Niki van der Wielen (eds.) (1998). Privatization and Culture: Experiences in the Arts, Heritage and Cultural Industries in Europe. CIRCLE Publications, no. 10. Boston, Dordrecht and London: Kluwer Academic.

Caves, Richard (2000). Creative Industries. Cambridge, MA: Harvard University Press.

Council of Europe (1997). In from the Margins: A Contribution to the Debate on Culture & Development in Europe. Strasbourg: Council on Europe.

D'Angelo, M. (1999). Cultural Policies in Europe: A Comparative Approach. Strasbourg: Council of Europe.

D'Angelo, Mario & Paul Wesperini (1999). Cultural Policies in Europe: Method and Practice of Evaluation. Strasbourg: Council of Europe.

Dorland, Michael (ed.). (1996). The Cultural Industries in Canada: Problems, Policies and Prospects. Toronto: James Lorimer.

Duxbury, Nancy & M. Sharon Jeannotte (guest eds.) (2011). Culture and Sustainable Communities. Ottawa, Culture and Local Governance / Culture et Gouvernance Locale: Special double issue: 3 (1–2), 1–2.

Duxbury, Nancy et al. (2004). Creating Economic and Social Benefits for Communities. Vancouver, BC: Creative City Network of Canada.

Garham, Nicholas (2004). Afterword: The Cultural Commodity and Cultural Policy. In: Sara Salwood (ed.), The UK Cultural Sector. London: Policy Studies Institute.

Hesmondhalgh, David (2002). The Cultural Industries: An Introduction. Thousand Oaks, CA: Sage.

Landry, Charles (2000). The Creative City: A Toolkit for Urban Innovators. London: Earthscan Publications

Lewis, Justin & Toby Miller (2002). Critical Cultural Policy Studies. Hoboken, NJ: Wiley-Blackwell.

Matarasso, Francois & Charles Landry (1999). Balancing Act: 21 Strategic Dilemmas in Cultural Policy. Strasbourg: Council of Europe.

Mercer, Colin (ed.) (2002). Convergence, Creative Industries and Civil Society: The New Cultural Policy. Zagreb: Culturelink/Institute for International Relations (IMO).

Miller, Toby & George Yudice (2002). Cultural Policy. London: Sage.

Reeves, Michelle (2002). Measuring the Economic and Social Impact of the Arts. London: Arts Council of England.

Roberts, Ken (2004). The Leisure Industries. Basingstoke: Palgrave Macmillan.

Ryan, Bill (2002). Making Capital from Culture. Berlin and New York: Walter de Gruyter.

Schuster, J. M. (2002). Informing Cultural Policy: The Research and Information Structure. New Brunswick, NJ: Centre for Urban Policy Research

Scott, Allen & Dominic Power (eds.) (2004). Cultural Industries and the Production of Culture. New York: Routledge.

Steinert, Heinz (2003). Culture Industry. London: Polity Press and Blackwell.

Varbanova, Lidia (2005). Mind the Financial Gap! Rethinking State Funding for Culture in South-East Europe. In: H. Weeda, C. Suteu & C. Smithuijsen (eds.), The Arts, Politics and Change: Participative Cultural Policy Making in South-East Europe. Amsterdam: Boekman Foundation.

Varbanova, Lidia (2007). The European Union Enlargement Process: Culture in between National Policies and European Priorities. Journal of Arts Management, Law and Society, May, 48–64.

Varbanova, Lidia & Aneliya Dimitrova (2002). Is There Any Social Cohesion in the Bulgarian Multicultural Society? Making Connections: Culture and Social Cohesion in the New Millennium. Canadian Journal of Communication, 27 (2–3), 153–162.

Vogel, Harold (1998). Entertainment Industry Economics. Cambridge: Cambridge University Press.

Wallinger Mark & Mary Warnock (2000). Art for All? Their Policies and Our Culture. London: Peer.

Wesner, Simone & Adrian Palka (1997). Challenges for Cultural Policy and Management in Central and Eastern Europe. Strasbourg: Council of Europe.

Wolf, Michael J. (1999). The Entertainment Economy. London: Penguin.

MARKETING IN THE ARTS, CULTURE AND THE NONPROFIT SECTOR

Andreasen, Alan & Philip Kotler (2007). Strategic Marketing for Nonprofit Organizations (6th ed.). Upper Saddle River, NJ: Pearson Prentice Hall.

Bennett, Peter D. (ed.) (1995). Dictionary of Marketing Terms (2nd ed.). Chicago: American Marketing Association.

Cashman, S. (2003). Thinking Big: A Guide to Strategic Marketing Planning for Arts Organisations. London: Arts Marketing Association in association with Arts Council England.

Colbert, Francois, Jacques Nantel, Suzanne Bilodeau, & J. Dennis Rich (1994). Marketing Culture and the Arts. HEC Montreal: Chair in Arts Management.

Cross, Rob, Andrew Parker & Robert L. Cross (2004). The Hidden Power of Social Networks: Understanding How Work Really Gets Done in Organizations. Boston: Harvard Business School Press.

Dibb, S. (1996). The Market Segmentation Workbook: Target Marketing for Marketing Managers. London: Routledge.

Filli, Ians (2002). Creative Marketing and the Art Organisation: What Can the Artist Offer? International Journal of Nonprofit and Voluntary Sector Marketing 7, no. 2 (May 1), pp. 131–145.

Hill, Liz, Catherine O'Sullivan, & Terry O'Sullivan (2003). Creative Arts Marketing. Oxford: Butterworth Heinemann.

Kerrigan, Finola, Peter Fraser, & Mustafa Ozbilgin (2004). Arts Marketing. Amsterdam: Elsevier.

Kinnel, M. (1997). Marketing in the Not-for-Profit Sector. Butterworth.

Kotler, Philip (1967). Marketing Management: Analysis, Planning and Control. Upper Saddle River, NJ: Prentice-Hall.

Kotler, Philip (1994). Marketing Management, Analysis, Planning, Implementation and Control. Upper Saddle River, NJ: Prentice Hall.

Kotler, Philip & Alan Andreasen (1975). Strategic Marketing for Nonprofit Organizations. Upper Saddle River, NJ: Prentice Hall.

Kotler, Philip & G. Armstrong (2003). Principles of Marketing. Upper Saddle River, NJ: Prentice Hall.

Kotler, Philip & Sidney Levy (1969). Broadening the Concept of Marketing. Journal of Marketing, 33 (January), pp. 10–15.

Kotler, Philip & J. Scheff (1997). Standing Room Only: Strategies for Marketing in the Performing Arts. Boston: Harvard Business School Press.

Kotler, Philip & Gerald Zalman (1971). Social Marketing: An Approach to Planned Social Change. Journal of Marketing, 35 (July), pp. 3–12.

Lovelock, Christopher & Charles Weinberg (1984). Marketing for Public and Nonprofit Managers. New York: John Wiley.

Macdonald, M. (1999). Marketing Plans: How to Prepare Them & How to Use Them. Oxford: Butterworth-Heinemann.

Maitland, H. (2000). The Marketing Manual for Performing Arts Organisations. Cambridge, UK: Arts Marketing Association.

McCarthy, K. F. & K. Jinnett (2001). A New Framework for Building Participation in the Arts. Santa Monica, CA: Rand Corporation.

McNichol, T. (2005). Creative Marketing Strategies in Small Museums: Up Close & Innovative. International Journal of Nonprofit & Voluntary Sector Marketing 10 (4), pp. 239–247.

Melilo, J. V. (1983). Market the Art! New York: Foundation for the Extension and Development of the American Professional Theatre.

Mokwa, Michael, William Dawson, & Arthur Prieve (eds.) (1980). Marketing the Arts. New York: Praeger.

Perry, Matt (2004). Marketing Your Creativity: New Approaches for a Changing Industry. Worthing, UK: AVA.

Plattner, Stuart (1996). High Art Down Home: An Economic Ethnography of a Local Art Market. University of Chicago Press.

Porter, Michael (1985). Competitive Advantage. New York: Free Press.

Porter, Michael (1998). Competitive Strategy: Techniques for Analyzing Industries and Competitors. New York: Free Press.

Porter, Michael (1990). The Competitive Advantage of Nations. New York: Free Press.

Rentschler, Ruth (1999). Innovative Arts Marketing. Sydney, Australia: Allen & Unwin.

Robertson, Iain (2005). Understanding International Art Markets & Management. New York: Routledge.

Sargeant, Adrian (1999). Marketing Management for Non-profit Organizations. Oxford: Oxford University Press.

Shapiro, Benson (1973). Marketing for Nonprofit Organizations. Harvard Business Review, September/October, 123–132.

Stern, Gary (1984). Marketing Workbook for Non-profit Organisations. New York: ACA Books.

Varbanova, Lidia (2005). Managing Information Flow through Cultural Portals. In: N. Svob-Dokic (ed.), The Emerging Creative Industries in Southeastern Europe. Zagreb: Institute for International Relations, pp. 157–167.

Varbanova, Lidia (2007). Our Creative Cities Online. In: N. Svob-Dokic (ed.), The Creative City: Crossing Visions and New Realities in the Region. Zagreb: Institute of International Relations, pp. 9–18.

Wymer, Walter, Patricia Knowles & Roger Gomes (2006). Nonprofit Marketing: Marketing Management for Charitable and Nongovernmental Organizations. Thousand Oaks, CA: Sage.

HUMAN RESOURCE MANAGEMENT IN THE ARTS, CULTURE AND THE NONPROFIT SECTOR

Alderfer, C. (1969). An Empirical Test of a New Theory of Human Need. Organizational Behavior and Human Performance 4 (May 1969) 142–175.

Barbeito, Carol (2004). Human Resource Policies and Procedures for Non-profit Organization. Hoboken, NJ: John Wiley.

Cliche, Danielle (1996). Status of the Artists or of Arts Organisations? Canadian Journal of Communication 21, pp. 197–210.

Devanna, M. A., C. J. Fombrun, & N. M. Tichy (1981). Human Resource Management. A Strategic Perspective. Organizational Dynamics (Winter), 51–64.

Feist, A. (2000). Cultural Employment in Europe. Strasbourg: Council of Europe.

Fraser, Joost & Ursula Fraser (2002). Recruiting Volunteers: Attracting the People You Need. London: Directory of Social Change.

Hackman, J. R. & G. R. Oldham (1976). Motivation through the Design of Work: Test of a Theory. Organizational Behavior and Human Performance 16, pp. 250–279.

Herzberg, F., B. Mausner, & B. B. Snyderman (1959). The Motivation to Work. New York: John Wiley.

Maslow, A. H. (1943). A Theory of Human Motivation. Psychological Review 50 (4), pp. 370–396.

McClelland, David (1961). The Achieving Society. New York: Free Press.

Schuler, Randal & Susan Jackson (1987). Linking Competitive Strategies with Human Resource Management Practices. The Academy of Management Executive, 1 (3)(August), 207–219.

Sparrow, P. & J. M. Hiltrop (1994). European Human Resource Management in Transition. Upper Saddle River, NJ: Prentice Hall.

Taylor, Gill & Christine Thornton (1995). Managing People. London: Directory of Social Change.

Towse, R. (1996). The Economics of Artists' Labour Markets. London: Arts Council of England.

Wilmot, Hannah (1996). The Work Experience Handbook: A Guide for Arts Organizations. n.p.: East England Arts.

FUNDRAISING AND FINANCING IN THE ARTS, CULTURE AND THE NONPROFIT SECTOR

Baguley, John (2000). Successful Fundraising. Stafford, UK: Bibliotek Books.

Benedict, Stephen (2002). Public Money and the Muse: Essays on Government Funding for the Arts. New York: W. W. Norton.

Bodo, Carla, Christopher Gordon, & Dorota Ilczuk (eds.) (2004). Gambling on Culture: State Lotteries as a Source of Financing. Amsterdam: CIRCLE, Associazione per l'Economia della Cultura & Boekmanstudies.

Bonet, L. & F. Donato (2011). The Financial Crisis and Its Impact on the Current Models of Governance and Management of the Cultural Sector in Europe. Encatc Journal of Cultural Management and Policy 1, pp. 4–11. http://www.encatc.org/pages/fileadmin/user_upload/Journal/JOURNAL_VOL1_ISSUE1_DEC2011.pdf.

Botting, Nina & Michael Norton (2001). Complete Fundraising Handbook. London: Directory of Social Change.

Daellenbach, K. (2006). Understanding Sponsorship & Sponsorship Relations: Multiple Frames & Multiple Perspectives. International Journal of Non-profit & Voluntary Sector Marketing 11 (1), pp. 73–87.

Dolphin, R. (2003). Sponsorship: Perspectives on Its Strategic Role. Corporate Communications 8, (3): pp. 173–186.

Fitz Herbert, Luke (2004). Effective Fundraising: An Informal Guide to Getting Donations and Grants. London: Directory of Social Change.

Fondazione Fitzcarraldo (2003). Cultural Cooperation in Europe: What Role for the Foundations? Brussels: Network of European Foundations for Innovative Cooperation.

Forester, Susan & David Lloyd (2002). Arts Funding Guide. London: Directory of Social Change.

Fredman, Carolyn & Karen Hopkins (1996). Successful Fundraising for Arts and Cultural Organizations. Phoenix: Oryx Press.

Ginsburgh, Victor & David Throsby (2006). Handbook of the Economics of Art & Culture. Amsterdam: Elsevier.

Greenfield, James (2002). The Nonprofit Handbook: Fundraising. West Sussex, UK: John Wiley.

Lloyd, T. (2006). Cultural Giving: Successful Donor Development for Arts & Heritage Organisations. London: Directory of Social Change.

Mullin, Redmond (2002). Fundraising Strategy. London: Directory of Social Change.

Norton, Michael (2003). The Worldwide Fundraiser's Handbook: A Guide to Fundraising for Southern NGOs and Voluntary Organisations. London: Directory of Social Change.

Rectanus, Mark. (2002). Culture Incorporated: Museums, Artists, and Corporate Sponsorships. Minneapolis: University of Minnesota.

Reiss, Alvin (2000). CPR for Non-profits: Creative Strategies for Successful Fundraising, Marketing, Communications and Management. San Francisco: Jossey-Bass.

Reiss, Alvin (2000). Don't Just Applaud—Send Money! The Most Successful Strategies for Funding and Marketing the Arts. London: Nick Hern.

Sargeant, Adrian & Elaine Jay (2004). Fundraising Management: Analysis, Planning & Practice. New York: Routledge.

Sayer, Kate (2002). A Practical Guide to Financial Management for Charities and Voluntary Organisations. London: Directory of Social Change.

Shaw, Phyllida (2001). Creative Connections: Business and the Arts Working Together to Create a More Inclusive Society. London: Arts & Business.

Skildum-Reid, Kim & Anne-Marie Grey (2007). Sponsorship Seeker Toolkit. Sydney: McGraw-Hill Australia.

Varbanova, Lidia (1997). Sponsorship and Donations for the Arts. Sofia, Bulgaria: University of National and World Economy, University Press.

Varbanova, Lidia (2001). Challenges and Opportunities in Fundraising through Networking. In: The Role of the Arts in Process of Social Change, Sabine Shaschl and Janos Szabo, eds. Bucharest: Arts and Education Network, pp. 13–21.

Varbanova, Lidia (2008). The Online Power of Users and Money: Can Culture Gain? In: Digital Culture: The Changing Dynamics. Zagreb: Culturelink, 167–181.

Warwick, Mal, Ted Hart & Nick Allen (2002). Fundraising on the Internet: The ePhilanthropy Foundation.org's Guide to Success Online. San Francisco: Jossey-Bass.

Young, Heather (2005). Finance for the Arts in Canada. Toronto: Young Associates.

RESOURCE CENTRES AND VIRTUAL LIBRARIES

Alliance for Non-profit Management, Resource Library: http://www.allianceonline.org/content/index.php?pid=172

Creative Choices. Developing Your Career in the Creative and Cultural Industries: http://www.creative-choices.co.uk/

Europa Glossary: http://europa.eu/legislation_summaries/glossary/

European Foundation Center Resources: http://www.efc.be/NewsKnowledge/Pages/NewsKnowledge.aspx

European Institute for Progressive Cultural Policies (eipcp): http://eipcp.net/publications

The European Library: http://search.theeuropeanlibrary.org/portal/en/index.html

Foundation Center: http://foundationcenter.org/

Free Management Library: http://managementhelp.org

Hill Strategies Research, Canada—http://www.artsresearchmonitor.com/

IFACCA Research Assistance: http://www.ifacca.org/research_assistance/

Imagine Canada's Non-profit Library—http://library.imaginecanada.ca/

Impact Database: http://www.impact.arts.gla.ac.uk

KEA European Affairs Research and Reports: http://www.keanet.eu/en/report.html

LabforCulture.org: http://www.labforculture.org

NetMBA—Business Knowledge Center, the Strategic Planning Process: http://www.netmba.com/strategy/process/

NonProfit Expert: http://www.nonprofitexpert.com

On-the-Move Cultural mobility information network: http://www.on-the-move.org

QuickMBA, Strategic Management: http://www.quickmba.com/strategy/

Welcomeurope (Monitoring, Training, Consultancy on European Funding and Public Affairs): http://www.welcomeurope.com

WEBSITES REFERENCED IN THE TEXT

Ashoka Canada: http://canada.ashoka.org/

Association of Canadian Women Composers: http://www.acwc.ca

Audio Video Licensing Agency in Canada (AVLA): http://www.avla.ca

Battersea Arts Centre: http://www.bac.org.uk

Canada Business Network: http://www.canadabusiness.ca/eng/125/141/

Canadian Equity Association, Canada: http://www.caea.com

Canadian Musical Reproduction Rights Agency (CMRRA): http://www.cmrra.ca

Cape Farewell: http://www.capefarewell.com

Centre for Social Innovation, Canada: http://socialinnovation.ca/about/social-innovation

Chartered Institute of Marketing: http://www.cim.co.uk/home.aspx

Compendium of Cultural Policies and Trends in Europe: http://www.culturalpolicies.net

Crowdculture: http://www.crowdculture.eu

Culture: The Fourth Pillar of Sustainability: CECC—Cultural Research Salon: http://www.cultureandcommunities.ca/downloads/Salons/Salon3-handout.pdf

Culture Action Europe: http://www.cultureactioneurope.org

Culture 21: Agenda 21 for Culture: http://www.agenda21culture.net/

David Suzuki Foundation: http://www.davidsuzuki.org

Department for Culture, Media and Sport, United Kingdom, Creative Industries Section: http://www.culture.gov.uk/what_we_do/creative_industries/default.aspx

Deutsche Welle Blog Awards: http://thebobs.com/english

Eco Street Blog: http://www.ecostreet.com

eMusic: http://www.emusic.com

Equity Association, UK: http://www.equity.org.uk.

Europa Nostra Website: http://www.europanostra.org

European Cultural Foundation (ECF): http://www.eurocult.org

European Trade Association for Business Angels, Seed Funds, and Other Early Stage Market Players: http://eban.org/

Europe Jazz Network website: http://www.europejazz.net

Facebook: http://www.facebook.com

Ford Foundation: http://www.fordfound.org

Grameen Bank: http://www.grameen-info.org/

Green Muse Art: http://greenmusearts.com/

Green Museum: http://greenmuseum.org/

Green Theatre Initiative: http://www.greentheaters.org/

Harry Fox Mechanical Licensing, Collection and Distribution Agency for Music Publishers, USA: http://www.harryfox.com

Imperial War Museum: http://www.iwm.org.uk

Independent Digital Licensing Agency (IDLA): http://www.idla.ca

International Federation of Arts Councils and Culture Agencies (IFACCA): http://www.ifacca.org

International Network of Contemporary Performing Arts (IETM): http://www.ietm.org

Investopedia: http://www.investopedia.com

iTunes: http://www.apple.com/itunes

Julie's Bicycle: http://www.juliesbicycle.com

Kickstarter: http://www.kickstarter.com

LabforCulture: Research in Focus: Climate Change: Artists Respond: http://www.labforculture.org/en/home/contents/climate-change-artists-respond

LabforCulture: Research in Focus: Social Entrepreneurship: http://www.labforculture.org/en/resources-for-research/contents/research-in-focus/social-entrepreneurship

LinkedIn: http://www.linkedin.com

London Symphony Orchestra: http://lso.co.uk

Myspace: http://www.myspace.com

National Angel Capital Organization Canada: http://www.angelinvestor.ca

New Art Exchange: http://www.thenewartexchange.org.uk

OECD Library: http://www.oecd-ilibrary.org

oneVillage Foundation: http://www.onevillagefoundation.org/

Orchestras Canada: http://orchestrascanada.org

Society of Composers, Authors and Music Publishers of Canada (SOCAN): http://www.socan.ca

SoundExchange: http://www.soundexchange.com

The Sustainability Report, Canada: http://www.sustreport.org

TakingITGlobal: http://www.tigweb.org

Tipping Point: http://www.tippingpoint.org.uk

Twitter: http://twitter.com

UNESCO Convention on the Protection and Promotion of the Diversity of Cultural Expressions (2005): http://portal.unesco.org/en/ev.php-URL_ID=31038&URL_DO=DO_TOPIC&URL_SECTION=201.html

Vancouver Foundation: http://www.vancouverfoundation.ca

WEBSITES REFERENCED IN THE CASE STUDIES

Academia Nazionale di Santa Cecilia: http://www.santacecilia.it/en/index.html

Agency for Regional Marketing (AOM), Novosibirsk: http://sibarm.com/

Arts Council of Mongolia, Ulaanbatar: http://www.artscouncil.mn

Artsopolis: http://www.artsopolis.net/

Auditorium Parco della Musica, Rome: http://www.auditorium.com

Balkan Dance Platform: http://www.balkandanceplatform.net/

Belgrade Philharmonic Orchestra: http://www.bgf.rs/

Birthmark on the Map (BOM): http://rodinki.newsib.ru/

Black/North SEAS: http://www.seas.se

Caravansarai: http://www.caravansarai.info/

Centre in the Square: http://www.centre-square.com/

Civic Footprint: http://www.civicfootprint.ca/

CORNERS: http://www.cornersofeurope.org

Cultural Rights: http://www.culturalrights.net

Deutsche Welle Blog Awards: http://thebobs.com/english

Dobson Cup: http://www.mcgill.ca/desautels/research/centres/dces/dobsoncup

Drugo More: http://www.drugo-more.hr/wordpress/

European Expert Network on Culture: http://www.eenc.info

European Resource Center for Culture (ERC): http://www.intercult.se/european-resource-center

European Union Culture Programme: http://ec.europa.eu/culture/our-programmes-and-actions/doc411_en.htm

Exodos, Ljubljana: http://www.exodos.si

Focus for Ethnic Women: http://few.on.ca/

Framework, Toronto: http://www.frameworkorg.org

Framework of the Promotion of Cultural and Creative Industries (FOMECC): http://www.fomecc.org

freeDimensional: http://freedimensional.org

Head On Photo Festival, Sydney: http://headon.com.au/

Imperial War Museum, UK: http://www.iwm.org.uk

Institut National pour le Developpement et la Promotion de la Culture (INDEPCO): http://www.indepco.org.ht/welcome/index.php

INTERARTS, Barcelona: http://www.interarts.net

Intercult, Stockholm: http://www.intercult.se

International Council of Museums (ICOM): http://icom.museum.com

Jardin d'Europe: http://www.jardindeurope.eu

Kitchener-Waterloo Art Gallery: http://www.kwag.ca/en/

Kitchener-Waterloo Multicultural Centre: http://www.kwmc.on.ca/

Labyrinth of Art: http://www.labirint-umetnosti.si/engf

LokoMotion Contemporary Dance Festival: http://www.lokomotiva.org.mk/Material_2009/HTML_2009/ProgrameLokomotion.html

Lokomotiva, Skopje: http://www.lokomotiva.org.mk

London Symphony Orchestra: http://lso.co.uk

MAXguide.org, Vancouver: http://www.maxguide.org

Metro Vancouver: http://www.metrovancouver.org

Mongolian Tourism Board: Official Tourism Website of Mongolia: http://www.mongoliatourism.gov.mn/

Moral Fibers: http://www.moralfibers.co

MT Space, Kitchener: http://www.mtspace.ca

Multicultural Cinema Club, Kitchener: http://www.kwmcc.org/

The Netherlands Foundation for Visual Arts, Design and Architecture (Fonds BKVB): http://www.fondsbkvb.nl/

Newsib Portal, Novosibirsk: http://newsib.ru/

Nomad Dance Academy Network: http://www.nomaddanceacademy.org

ODA Theatre, Pristina: http://www.teatrioda.com

Open Society Foundations: http://www.soros.org

Pika-Točka-Tačka: http://pikatockatacka.net/

Platformation: http://www.platformation.ca/

POGON Zagreb Center for Independent Culture and Youth: http://www.upogoni.org/en/

Res Artist: http://www.resartis.org/en/

Sharesies: http://www.sharesies.com

Stratford Shakespeare Theatre Festival: http://www.stratfordfestival.ca/

Timeraiser, Canada: http://www.timeraiser.ca/

Tobacna Ljubljana: http://www.tobacna.si/en

Tuguldur Foundation, Mongolia: http://www.tuguldursan.mn/main/?f=gallery&vlang=en&Itemid=497

Vishtynetsky Ecological and Historical Museum, Kaliningrad Region: http://www.wystynez.ru/

Vladimir Potanin Foundation: http://eng.fund.legein.ru

World Expo 2010: http://icom.museum/what-we-do/activities/2010-world-exposition.html

Waterloo Public Interest Research Group (WPIRG): http://wpirg.org

Notes

1. INNOVATION AND ENTREPRENEURSHIP IN THE ARTS: A STRATEGIC APPROACH

1. In: UNESCO Universal Declaration on Cultural Diversity (2001): http://portal.unesco.org/en/ev.phpURL_ID=13179&URL_DO=DO_TOPIC&URL_SECTION=201.html (accessed March 29, 2012).
2. In the remainder of the book an 'organization in the arts and culture sector' is referred to as an *arts organisation*.
3. Example: In Canada a major advantage of obtaining charitable status is that the organisation is able to issue receipts to donors for income tax purposes. This can be a major advantage when soliciting donations. In addition, charities receive certain tax exemptions.
4. The term *third sector* is used with the connotation that the other two sectors of the economy are state (governmental) and private (business/commercial).
5. Example: There are four main types of business structures in Canada: sole proprietorships, partnerships, corporations and cooperatives. Source: Canada Business Network: http://www.canadabusiness.ca/eng/125/141/ (accessed January 30, 2012).
6. The separation between *subsidized culture* and *commercial culture* is used by many authors. *Subsidized culture* refers to 'art', while *commercial culture* refers to 'entertainment'. See: Scott, Allen & Dominic Power (2006). Cultural Industries and the Production of Culture. New York: Routledge, p. 48.
7. These aspects are discussed further in Chapter 5.
8. For different forms of mobility and collaboration, see: Klaic, Dragan (2007). Mobility of Imagination: A Companion Guide to International Cultural Cooperation. Budapest: Central European University, Center for Arts and Culture. In conjunction with Euclid, UK and the Budapest Observatory, pp. 51–66.
9. The terms *online* and *offline* have a meaning in relation to the use (or non-use) of the Internet and World Wide Web. The influence of these new technologies and global connectivity on the arts and cultural sector is discussed in Chapter 5.
10. Ryan, Bill (2002). Making Capital from Culture. Berlin and New York: Walter de Gruyter, pp. 64–65.
11. Diverse sets of strategies in arts organisations are discussed in Chapter 6.
12. Chapter 8 provides samples of different organisational structures in arts organisations.
13. Chapter 11 discusses plan implementation and performance indicators.
14. Bilton, Chris (2007). Management and Creativity: From Creative Industries to Creative Management. Malden, MA: Blackwell.
15. Fitzroy, Peter, Peter Hulbert & Abby Ghobadian (2012). Strategic Management: The Challenge of Creating Value. London and New York: Taylor and Francis, p. 400.
16. Meyer, Dale & Kurt Heppard (2000). Entrepreneurship as a Strategy: Competing on the Entrepreneurial Edge. Thousand Oaks, CA: Sage.
17. Drucker, Peter (1985). Innovation and Entrepreneurship: Practice and Principles. New York: Harper & Row, p. 33.
18. Kim, Chan & Renee Mauborgne (2005). Blue Ocean Strategy: How to Create Uncontested Market Space and Make Competition Irrelevant. Boston: Harvard Business Review Press.
19. Kotler, Philip & Alan Andreasen (1975). Strategic Marketing for Nonprofit Organisations. Upper Saddle River, NJ: Prentice Hall, p. 456.
20. Drucker, Peter (1985). Innovation and Entrepreneurship: Practice and Principles. New York: Harper & Row, pp. 179–180.
21. Drucker, Peter (1990). Managing the Nonprofit Organisation: Principles and Practices. New York: Harper Collins, pp. 11–14.
22. Definition provided by the Centre for Social Innovation, Canada: http://socialinnovation.ca/about/social innovation (accessed January 29, 2012).

23. Chesbrough, Henry (2007). Business Model Innovation: It's not Just about Technology Anymore. *Strategy & Leadership* 35 (6), pp. 12–17.

24. Osterwalder, Alexander & Yves Pigneur (2010). Business Model Generation: A Handbook for Visionaries, Game Changers and Challengers. Hoboken, NJ: John Wiley, p. 138.

25. Bilton, Chris & Stephen Cummings (2010). Creative Strategy: Reconnecting Business and Innovation. West Sussex, UK: John Wiley, p. 65.

26. Bakhshi, Hasan & David Throsby (2010). Culture of Innovation: An Economic Analysis of Innovation in Arts and Cultural Organisations. London: National Endowment for Science, Technology and the Arts (NESTA), pp. 16–24.

27. An example is New Art Exchange: http://www.thenewartexchange.org.uk/ (accessed April 10, 2012).

28. London Symphony Orchestra is testing such mobile marketing for students; see their website: http://lso.co.uk/ (accessed April 10, 2012).

29. Battersea Arts Centre pilots a programme allowing audiences to intervene in the theatre performance. Their mission is 'to invent the future of theatre'. The work that is programmed at the centre is now 95 per cent new work. See their website: http://www.bac.org.uk/ (accessed April 10, 2012).

30. An example is the Imperial War Museum in the United Kingdom, which has developed a new system to enable visitors to interpret and share opinions and spread them through social media. The project was developed in collaboration with University College London, Salford, Nottingham and Exeter universities and MTM London. See their website: http://www.iwm.org.uk/.

31. Markides, Constantinos (2000). All the Right Moves—A Guide to Crafting Breakthrough Strategy. London: Harvard Business School Press.

32. Hagoort, Giep (2003). Art Management: Entrepreneurial Style. Utrecht, The Netherlands: Utrecht School of the Arts, p. 22.

33. Amason, Allen C. (2011). Strategic Management: From Theory to Practice. New York: Routledge, p. 260.

34. Chapter 9 discusses the importance of research and development (R&D) in an organisation's strategy.

35. Chapter 5 provides arguments why arts organisations are regarded as open systems.

36. The word *entrepreneurship* derives from the French and German languages and means 'undertaking'.

37. McClelland, David (1961). The Achieving Society. New York: Free Press.

38. Gartner, William B. (1985). A Conceptual Framework for Describing and Classifying the Phenomenon of New Venture Creation. The Academy of Management Review 10(4), 696–706.

39. Chell, E., J. Haworth & S. Brearly (1991). The Entrepreneurial Personality: Concepts, Cases and Categories. London: Routledge.

40. Bilton, Chris & Stephen Cummings (2010). Creative Strategy: Reconnecting Business and Innovation. West Sussex, UK: John Wiley.

41. Rauch, Andreas & Michael Frese (2000). Psychological Approaches to Entrepreneurial Success: A General Model and Overview of Findings. In: C. L. Cooper & I. T. Robertson (eds.), International Review of Industrial and Organisational Psychology. Chichester: Wiley, pp. 104–142.

42. Drucker, Peter (1985). Innovation and Entrepreneurship: Practice and Principles. New York: Harper & Row.

43. Gupta, V. & I. C. MacMillan, and Surie, G. (2002). Entrepreneurial Leadership: Developing and Measuring a Cross-cultural Construct. Proceedings from the Academy of Management Science, Denver, Colorado.

44. Bilton, Chris & Stephen Cummings (2010). Creative Strategy: Reconnecting Business and Innovation. West Sussex, UK: John Wiley, p. 110.

45. Thompson, John (1999). A Strategic Perspective of Entrepreneurship. International Journal of Entrepreneurial Behaviour & Research 5 (6), pp. 279–296.

46. Meyer, Dale and Kurt Heppard (2000). Entrepreneurship as Strategy: Competing on the Entrepreneurial Edge. Thousand Oaks, CA: Sage.

47. McGrath, Rita & Ian MacMillan (2000). The Entrepreneurial Mindset: Strategies for Continuously Creating Opportunity in an Age of Uncertainty. Boston: Harvard Business School Press.

48. Hagoort, Giep (2003). Art Management: Entrepreneurial Style. The Netherlands: Eburon.

49. Fitzgibbon, Marian (2001). Managing Innovation in the Arts: Making Art Work. Westport, CT: Greenwood Press.

50. Klaic, Dragan (2007). Mobility of Imagination: A Companion Guide to International Cultural Cooperation. Budapest: Central European University, Center for Arts and Culture. In conjunction with Euclid, UK and the Budapest Observatory, p. 120

51. Hagoort, Giep and Rene Kooyman (eds.) (2009). Creative Industries: Colourful Fabric in Multiple Dimensions. Utrecht, The Netherlands: Utrecht School of the Arts, p. 21.

52. Philips, Ronnie (2011). Arts Entrepreneurship and Economic Development. Foundations and Trends in Entrepreneurship. Hanover, MA: Now Publishers.

53. Kay, Sue (2011). Grand Narratives and Small Stories: Learning Leadership in the Cultural Sector. London: Cultural Leadership Programme, p. 16. http://www.culturalleadership.org.uk/345/ (accessed April 9, 2012).

54. In economics and business studies the break-even point is the one at which expenses and revenues are equal and there is no loss or profit.

2. STRATEGIC MANAGEMENT: ESSENCE, ROLE AND PHASES

1. Fayol, Henri (1916). Administration Industrielle et Generale—Prevoyance, Organisation, Commandment, Contrôle. (Unfinished work.)
2. Taylor, Frederick (1910). Principles of Scientific Management. New York and London: Harper & Brothers.
3. Selznick, Philip (1957). Leadership in Administration: A Sociological Interpretation. Evanston, IL: Row, Peterson.
4. Ansoff, Igor (1965). Corporate Strategy. New York: McGraw Hill.
5. See Chapter 6.
6. Chandler, Alfred (1962). Strategy and Structure: Chapters in the History of Industrial Enterprise. New York: Doubleday.
7. Porter, Michael (1998). Competitive Strategy: Techniques for Analyzing Industries and Competitors. New York: Free Press.
8. See Chapter 7.
9. Catanese, Anthony & Alan Walter Steiss (1970). Systematic Planning: Theory and Application. Lexington, MA: Heath Lexington Books.
10. Bryson, John (1995). Strategic Planning for Public and Nonprofit Organizations: A Guide to Strengthening and Sustaining Organizational Achievements. San Francisco: Jossey-Bass.
11. Schendler, Dan & Charles Hofer (1978). Strategy Formulation: Analytical Concepts. St. Paul, MN: West Publishing, p. 11.
12. Meyer, Dale & Kurt Heppard (2000). Entrepreneneurship as a Strategy: Competing on the Entrepreneurial Edge. Thousand Oaks, CA: Sage.
13. Palmer, Derrick & Soren Kaplan (2007). A Framework for Strategic Innovation: Blending Strategy and Creative Exploration to Discover Future Business Opportunities. n.p.: Innovation Point. http://www.innovation-point.com/Strategic%20Innovation%20White%20Paper.pdf (accessed February 2, 2012).
14. Bilton, Chris & Stephen Cummings (2010). Creative Strategy: Reconnecting Business and Innovation. West Sussex, UK: John Wiley.
15. Amason, Allen C. (2011). Strategic Management: From Theory to Practice. New York: Routledge, pp. 2–7.
16. The first arts management programmes in Europe started at City University, London, United Kingdom, and the University of Arts, Belgrade, Serbia.
17. Pick, John (1980). Arts Administration. New York: Spon.
18. See suggested readings on arts management at the end of the book.
19. See suggested readings on creative (cultural) industries and cultural policy at the end of the book.
20. Kaiser, Michael (1995). Strategic Planning in the Arts: A Practical Guide. http://artscene.org/uploaded/Pages/ArtistResources/StrategicPlanningintheArts-APracticalGuide.pdf (accessed June 20, 2012).
21. Dragićević Šešić, Milena & Sanjin Dragojević (2005). Arts Management in Turbulent Times: Adaptable Quality Management. Amsterdam: European Cultural Foundation and Boekmanstudies.
22. The choice of strategies discussed in Chapter 6.
23. See also the references and suggestions for further reading on strategic management at the end of the book.
24. David, Fred (1993). Strategic Management. New York: Macmillan, p. 5.
25. Thompson, Arthur & A. J. (Lonnie) Strickland III (1996). Strategic Management: Concepts & Cases. Boston: Irwin/McGraw-Hill, p. 3.
26. Kaufman, Roger, Hugh Oakley-Browne, Ryan Watkins & Doug Leigh (2003). Strategic Planning for Success, Aligning People, Performance and Payoffs. San Francisco: Jossey-Bass/Pfeifer, p. 16.
27. Steiss, Alan Walter (2003). Strategic Management for Public and Nonprofit Organizations. New York and Basel: Marcel Dekker, p. 1.
28. Grünig, Rudolf & Richard Kühn (2011). Process-based Strategic Planning. (Translated by Anthony Clark.) New York: Springer, pp. 5–19.
29. The spiral shape of strategic management is explained in Chapter 3.
30. Mintzberg, Henry (1994). The Rise and Fall of Strategic Planning: Reconceiving Roles for Planning, Plans, Planners. New York: Free Press/Toronto: Maxwell Macmillan Canada.
31. David, Fred (2011). Strategic Management Concepts. Prentice Hall, p. 6.
32. Baumol and Bowen were the first to point out that the nonprofit arts face problems if relying only on self-earned revenues from admissions and ticket sales. They pointed out that the labour-intensive nature of the performing arts makes it difficult for them to increase productivity and gain benefits from economies of scale. There are limits to raising prices to cover the increasing costs. This ongoing discrepancy results in a chronic gap between expenses and self-earned revenues, which they call the 'income gap'. See Baumol, W. & W. Bowen (1968). Performing Arts—The Economic Dilemma. Cambridge, MA: MIT Press.
33. Again, see: Bowen, W. & W. Bowen (1968). Performing Arts—The Economic Dilemma. Cambridge, MA: MIT Press.
34. Analysis of stakeholders is part of Chapter 5.
35. Chapter 6 discusses competitive advantage in arts organisations' strategies.
36. Milena Dragićević Šešić and Sanjin Dragojević's book *Arts Management in Turbulent Times: Adaptable Quality Management* (2005) provides an in-depth theoretical framework and analytical approach to managing arts in turbulent social, economic and cultural contexts.

37. Bryson, John (1995). Strategic Planning for Public and Nonprofit Organisations: A Guide to Strengthening and Sustaining Organisational Achievements. San Francisco: Jossey-Bass, p. 105.

38. The SWOT framework was described in the late 1960s by Edmund P. Learned, C. Roland Christiansen, Kenneth Andrews and William D. Guth in Business Policy, Text and Cases (Homewood, IL: Irwin, 1969).

3. STRATEGIC PLANNING PROCESS, METHODS AND TYPES OF PLANS

1. Kast, Fremont & James Rosenzweig (1979). Organisation and Management. New York: McGraw-Hill, pp. 416–417.

2. Kaufman, Roger, Hugh Oakley-Browne, Ryan Watkins & Doug Leigh (2003). Strategic Planning for Success, Aligning People, Performance and Payoffs. San Francisco: Jossey-Bass/Pfeifer, p. 41.

3. Grünig, Rudolf and Richard Kühn (2011). Process-based Strategic Planning. (Translated by Anthony Clark). New York: Springer, p. 8.

4. Bryson, John (1995). Strategic Planning for Public and Nonprofit Organisations: A Guide to Strengthening and Sustaining Organisational Achievements. San Francisco: Jossey-Bass, pp. 5–31.

5. Bryson, John & Farnum Alston (2004). Creating and Implementing Your Strategic Plan: A Workbook for Public and Nonprofit Organizations. Hoboken, NJ: John Wiley.

6. Allison, Michael & Jude Kaye (1997). Strategic Planning for Nonprofit Organisations: A Practical Guide and Workbook. Hoboken, NJ: John Wiley.

7. Kaiser, Michael (1995). Strategic Planning in the Arts. n.p.: Kaiser/Engler Group. http://artscene.org/uploaded/Pages/ArtistResources/StrategicPlanningintheArts-APracticalGuide.pdf (accessed June 20, 2012).

8. In some countries nonprofit organisations are allowed to develop activities which generate incomes, as long as the financial surplus is reinvested back in the organisation's activities.

9. Relations between programming and marketing are analysed in Chapter 7.

10. Chapter 1 discusses the characteristics of an intrapreneurial arts organisation.

11. Klaic, Dragan (2007). Mobility of Imagination: A Companion Guide to International Cultural Cooperation. Budapest: Central European University, Center for Arts and Culture. In conjunction with Euclid, UK and the Budapest Observatory.

12. See recommended readings on strategic planning at the end of this book.

4. STRATEGIC THINKING: VISION, MISSION AND OBJECTIVES

1. Drucker, Peter (1974). Management: Tasks, Responsibilities, and Practices. New York: Harper & Row, p. 61.

2. Burkhart, Patrick & Suzanne Reuss (1993). Successful Strategic Planning: A Guide for Nonprofit Agencies and Organizations. Thousand Oaks, CA: Sage, p. 73.

3. Kaiser, Michael (1995). Strategic Planning in the Arts: A Practical Guide. http://artscene.org/uploaded/Pages/ArtistResources/StrategicPlanningintheArts-APracticalGuide.pdf (accessed June 20, 2012).

4. Bryson, John (1995). Strategic Planning for Public and Nonprofit Organisations. A Guide to Strengthening and Sustaining Organisational Achievements. San Francisco: Jossey-Bass, p. 65.

5. Joyce, Paul (1999). Strategic Management for the Public Services. Buckingham and Philadelphia: Open University Press, p. 22.

6. Allison, Michael & Jude Kaye (1997). Strategic Planning for Nonprofit Organisations: A Practical Guide and Workbook. Hoboken, NJ: John Wiley, p. 68.

7. Dragićević Šešić, Milena and Sanjin Dragojević (2005). Arts Management in Turbulent Times: Adaptable Quality Management. Amsterdam: European Cultural Foundation and Boekmanstudies, p. 53.

8. Grünig, Rudolf, and Richard Kühn (2011). Process-based Strategic Planning. (Translated by Anthony Clark.) Springer, p. 90.

9. David, Fred (2011). Strategic Management Concepts. Upper Saddle River, NJ: Prentice Hall, p. 51.

10. See also Chapter 6's discussion of networking strategies in the arts, among others.

11. Culture Action Europe website: http://www.cultureactioneurope.org (accessed March 30, 2012).

12. Europa Nostra Website: http://www.europanostra.org (accessed March 30, 2012).

13. Europe Jazz Network website: http://www.europejazz.net (accessed March 30, 2012).

14. International Network of Contemporary Performing Arts (IETM) website: http://www.ietm.org (accessed March 30, 2012).

15. International Federation of Arts Councils and Culture Agencies (IFACCA) website: http://www.ifacca.org (accessed March 30, 2012).

16. Canadian Conference of the Arts (CCA) website: http://ccarts.ca/ (accessed March 30, 2012).

17. Association of Canadian Women Composers website: http://www.acwc.ca (accessed March 30, 2012).

18. Orchestras Canada website: http://orchestrascanada.org(accessed March 30, 2012).

19. A domain name is a way to identify and locate computers and resources connected to the Internet. It gives every Internet server on which a website is located a memorable, unique and easy-to-spell online address.

20. European Cultural Foundation (ECF) website: http://www.culturalfoundation.eu/ (accessed April 12, 2012).

21. David Suzuki Foundation website: http://www.davidsuzuki.org (accessed April 12, 2012).

22. Vancouver Foundation website: http://www.vancouverfoundation.ca (accessed April 12, 2012).
23. oneVillage Foundation website: http://www.onevillagefoundation.org/ (accessed April 12, 2012).
24. Ford Foundation website: http://www.fordfound.org (accessed April 12, 2012).
25. Ashoka Canada website: http://canada.ashoka.org/ (accessed April 12, 2012).
26. TakingITGlobal website: http://www.tigweb.org (accessed April 12, 2012).
27. Cape Farewell website: http://www.capefarewell.com (accessed April 12, 2012).
28. Julie's Bicycle website: http://www.juliesbicycle.com (accessed April 12, 2012).
29. Tipping Point website: http://www.tippingpoint.org.uk (accessed April 12, 2012).
30. Grameen Bank website: http://www.grameen-info.org/ (accessed April 12, 2012).
31. In English, different terminology exists to reflect different levels and scopes of objectives as well as different levels of implementation. These include aims, objectives, goals and targets. They all have different connotations which are not easy to translate and interpret into some other languages. The term *objective* throughout this book is used in the framework of the hierarchy of objectives.
32. See Chapter 6 on the choice of strategies.
33. International Council of Museums (ICOM) website: http://icom.museum/ (accessed March 18, 2012).
34. Read more about the 2010 World Expo here: http://icom.museum/what-we-do/activities/2010-world-exposition.html (accessed March 18, 2012).
35. Read the *ICOM Code of Ethics* here: http://icom.museum/what-we-do/professional-standards/code-of-ethics.html. Also see the Red Lists Database by countries: http://icom.museum/what-we-do/resources/red-lists-database.html (accessed March 18, 2012).
36. Read more about the Red Lists here: http://icom.museum/what-we-do/programmes/fighting-illicit-traffic.html (accessed March 18, 2012).
37. For more information, visit the UNESCO-ICOM Museum Information Centre: http://icom.museum/what-we-do/resources/unesco-icom-museum-information-centre.html (accessed March 19, 2012).
38. Read more on ICOM members' benefits here: http://icom.museum/where-we-work/join-us/benefits.html (accessed March 20, 2012).
39. Download ICOM's strategic plan here: http://icom.museum/fileadmin/user_upload/pdf/Strategic_Plan/Strategic_plan.pdf (accessed March 19, 2012).
40. INTERARTS website: http://www.interarts.net (accessed March 20, 2012).Legally, INTERARTS is a private foundation. Its legal name in Spanish is Fundació Interarts per a la cooperació cultural internacional. However, as its brand, it uses only the name Interarts. The organisation also has nongovernmental organisation status, granted by the Ministry of Foreign Affairs of Spain.
41. For more information on current and past projects, refer to http://www.interarts.net, where the yearly activity reports are published.
42. See European Expert Network on Culture website: http://www.eenc.info (accessed March 22, 2012).
43. Read about the European Arts Education Monitoring System here: http://www.interarts.net/en/encurso.php?p=375 (accessed March 20, 2012).
44. A specific website for the Euro-American campus is at http://www.campuseuroamericano.org (accessed August 10, 2012).
45. See: Derechos Culturales, http://www.culturalrights.net; Fomento de Empresas Culturales y Creativas, http://www.fomecc.org; and European Expert Network on Culture, http://www.eenc.info (accessed March 22, 2012).

5. STRATEGIC ANALYSIS: THE ARTS ORGANISATION AND ITS ENVIRONMENT

1. The choice of strategies is discussed in Chapter 6.
2. Kaiser, Michael (1995). Strategic Planning in the Arts: Practical Guide. http://artscene.org/uploaded/Pages/ArtistResources/StrategicPlanningintheArts-APracticalGuide.pdf (accessed June 20, 2012).
3. In the literature on strategy and planning, they are also referred to as PESTEL factors—political, economic, social, technological and legal factors.
4. Investopedia defines *inelastic* as an economic term used to describe the situation in which the supply and demand for a good are unaffected when the price of that good or service changes: http://www.investopedia.com/terms/e/inelastic.asp#axzz1m0joiNaI (accessed February 10, 2012).
5. Cultural heritage is divided into tangible (such as buildings, monuments, works of art and artefacts) and intangible (such as folklore, traditions, language and knowledge).
6. *Consumer behaviour* refers to the selection, purchase and consumption of goods or services that satisfy the consumer's needs and wants.
7. *Web 2.0 tools* is an umbrella term including social networking sites, blogs, user-shared content on wikis, video-sharing websites and much more. These tools transform users from passive viewers to active participants who can change online content.
8. See also: Varbanova, Lidia (2008). The Online Power of Users and Money: Can Culture Gain? In: Digital Culture: The Changing Dynamics. Zagreb: Culturelink, pp. 167–181.
9. Chapter 7 provides an orientation on considering new technologies and digitalization in the process of strategic planning of marketing.

10. Social networks allow an unlimited number of users to interact via the Internet and create online communities to share ideas, attitude, opinions, events, activities, and so on.
11. Innovative ways of fundraising and financing art projects are discussed in Chapter 10.
12. E-commerce (or electronic commerce) covers all options for buying and selling of products or services via the Internet and other computer networks.
13. Klaic, Dragan (2008). Mobility of Imagination: A Companion Guide to International Cultural Cooperation. : Central European University, Center for Arts and Culture. In conjunction with Euclid, UK and the Budapest Observatory.
14. See results of collective research on LabforCulture (2010) on Artists Respond to Climate Change: http://www.labforculture.org/en/home/contents/climate-change-artists-respond (accessed February 12, 2012).
15. See the Research in Focus on Social Entrepreneurship on LabforCulture (2009), devoted to the essence and characteristics of social entrepreneurship in the arts sector: http://www.labforculture.org/en/resources-for-research/contents/research-in-focus/social-entrepreneurship (accessed February 12, 2012).
16. The sustainability issues in plan implementation are discussed in more detail in Chapter 11.
17. The term *cultural policy* is most often associated with governments, but it is important to note that other decision-makers could strongly influence policies such as corporations, community organisations, foundations or networks.
18. See the references and recommended readings at the end of this book.
19. Compendium of Cultural Policies and Trends in Europe website: http://www.culturalpolicies.net (accessed February 10, 2012).
20. Culture 21: Agenda 21 for Culture website: http://www.agenda21culture.net (accessed February 10, 2012).
21. Department for Culture, Media and Sport, United Kingdom: http://www.culture.gov.uk/what_we_do/creative_industries/default.aspx (accessed February 12, 2012).
22. UNESCO Convention on the Protection and Promotion of the Diversity of Cultural Expressions (2005): http://portal.unesco.org/en/ev.php-URL_ID=31038&URL_DO=DO_TOPIC&URL_SECTION=201.html (accessed February 12, 2012).
23. See the references and recommended readings at the end of the book.
24. Scott, Allen & Dominic Power (eds.) (2004). Cultural Industries and the Production of Culture. New York: Routledge.
25. Roberts, Ken (2004). The Leisure Industries. Basingstoke: Palgrave Macmillan.
26. *Leisure* refers to the free time spent away from work, while *entertainment* is a subset of leisure and also provides enjoyment and satisfaction of a person's hobbies or interests.
27. Note that activities such as shopping and cooking are excluded from this definition of the entertainment industry.
28. Kaiser, Michael (1995). Strategic Planning in the Arts: A Practical Guide. http://artscene.org/uploaded/Pages/ArtistResources/StrategicPlanningintheArts-APracticalGuide.pdf (accessed June 20, 2012).
29. See further Chapter 6.
30. Traditional media include television, radio, newspapers and magazines. New media include the Internet, Web 2.0 tools, mobile technologies and devices, digital forms of advertising, live streaming, podcasting and many others.
31. See Chapter 7.
32. Burkhart, Patrick & Suzanne Reuss (1993). Successful Strategic Planning: A Guide for Nonprofit Agencies and Organisations. Thousand Oaks, CA: Sage, p. 2.
33. Bryson, John (1995). Strategic Planning for Public and Nonprofit Organisations: A Guide to Strengthening and Sustaining Organisational Achievements. San Francisco: Jossey-Bass, p. 27.
34. Allison, Michael & Jude Kaye (1997). Strategic Planning for Nonprofit Organisations: A Practical Guide and Workbook. West Sussex, UK: John Wiley, p. 42.
35. Bryson, John (1995). Strategic Planning for Public and Nonprofit Organisations: A Guide to Strengthening and Sustaining Organisational Achievements. San Francisco: Jossey-Bass, p. 28.
36. Joyce, Paul (1999). Strategic Management for the Public Services. Buckingham and Philadelphia: Open University Press, p. 32.
37. Vishtynetsky Ecological and Historical Museum website: http://www.wystynez.ru/ (accessed March 14, 2012).
38. Website of Vladimir Potanin Foundation: http://eng.fund.legein.ru (accessed March 14, 2012).
39. MT Space website: http://www.mtspace.ca (accessed March 17, 2012).
40. MT Space received the following awards: two KW Arts Awards (2008 and 2009) and the Ontario Trillium Foundation's Great Grant Award, Arts and Culture category (2007). MT Space was also short-listed for the Volunteer Impact Award in 2007.
41. Kitchener-Waterloo Multicultural Centre website: http://www.kwmc.on.ca/ (accessed March 29, 2012).
42. Multicultural Cinema Club, Kitchener website: http://www.kwmcc.org/ (accessed March 29, 2012).
43. Focus for Ethnic Women website: http://few.on.ca/ (accessed March 29, 2012).
44. Waterloo Public Interest Research Group (WPIRG) website: http://wpirg.org (accessed March 29, 2012).
45. Stratford Shakespeare Festival website: http://www.stratfordfestival.ca/ (accessed March 29, 2012).

46. Centre in the Square website: http://www.centre-square.com/ (accessed March 29, 2012).
47. Kitchener-Waterloo Art Gallery website: http://www.kwag.ca/en/ (accessed March 29, 2012).

6. CHOICE OF STRATEGIES

1. Tregore, Benjamin & John Zimmerman (1980). Top Management Strategy. New York: Simon & Schuster, p. 17.
2. Amara, Roy (1983). Business Planning for an Uncertain Future: Scenarios & Strategies. Oxford: Pergamon Press, p. 5.
3. Mintzberg, Henry (1992). Five Ps for Strategy. In: H. Mintzberg & J. B. Quinn (eds.), The Strategy Process. Englewood Cliffs, NJ: Prentice-Hall International Editions, pp. 12–19.
4. Porter, Michael (1996). What Is Strategy? Harvard Business Review **74** (2) November/December, pp. 61–78, pp. 61–78.
5. Bryson, John (1995). Strategic Planning for Public and Nonprofit Organisations: A Guide to Strengthening and Sustaining Organisational Achievements. San Francisco: Jossey-Bass, p. 32.
6. DeKluyver, Cornelis (2000). Strategic Thinking: An Executive Perspective. Upper Saddle River, NJ: Prentice Hall, pp. 3–5.
7. Byars, Lloyd L. (2002). Strategic Management: Formulation and Implementation, Concepts & Cases (3rd ed.). New York: HarperCollins, p. 13.
8. Coulter, Mary (2002). Strategic Management in Action (2nd ed.). Upper Saddle River, NJ: Prentice Hall, p. 7.
9. Cummings, Stephen & David Wilson (2003). Images of Strategy. In: Images of Strategy. Malden, MA: Blackwell, p. 1.
10. See Figure 2.1.
11. The characteristics of an intrapreneurial art organisation are discussed in Chapter 1.
12. Boorsma, Peter B., Annemoon van Hemel & Niki van der Wielen (eds.) (1998). Privatization and Culture: Experiences in the Arts, Heritage and Cultural Industries in Europe. CIRCLE Publications, no. 10. Boston, Dordrecht and London: Kluwer Academic.
13. These strategies are analysed in the book *Arts Management in Turbulent Times: Adaptable Quality Management* (2005), by Milena Dragićević Šešić and Sanjin Dragojević. The two authors regard strategic management in Central, Eastern and South Eastern Europe as a key factor in the process of capacity building and organisational development in the region. The book provides practice-based management tools and hands-on solutions for arts management working internationally and in turbulent contexts.
14. An *in-kind contribution* is a non-cash input which can be given a cash value.
15. Porter, Michael (1990). The Competitive Advantage of Nations. New York: Free Press.
16. See: Chapain, Caroline, Phill Cooke, Lisa De Propris, Stewart MacNeill & Juan Mateos-Garcia (2010). Creative Clusters and Innovation: Putting Creativity on the Map. London: National Endowment for Science, Technology and the Arts (NESTA).
17. The book by Dragan Klaic entitled *Mobility of Imagination: A Companion Guide to International Cultural Cooperation* (2008) offers basic instruments for cross-border international project management including networking, co-production, partnership and others. It is a systematic guide to purposes, instruments, models, benefits, success factors, risks and strategic issues in international cultural cooperation.
18. Source: Ansoff, I. (1957). Strategies for Diversification. Harvard Business Review, 35 (5) (Sept.–Oct.), 113–124.
19. *Benchmarking* was first used as a term in 1972 at the Institute for Strategic Planning in Cambridge, Massachusetts.
20. Porter, Michael (1998). Competitive Strategy: Techniques for Analyzing Industries and Competitors. New York: Free Press.
21. See Chapter 10 for more details on the *bootstrapping* strategy.
22. ODA Theatre website: http://www.teatrioda.com (accessed March 13, 2012).
23. This statement is based on the statistics that each cultural institution in Kosovo (including movie theatres) publicly declares at the end of each year.
24. See: http://www.teatrioda.com/?cid=2,32 (accessed March 13, 2012).
25. This programme has been recently launched in collaboration with the IN SITU network (the European Network for Artistic Creation in Public Space).
26. Note that the figures are provided by the Arts Council of Mongolia based on statistics in 2011.
27. Arts Council of Mongolia (ACM) website: http://www.artscouncil.mn. See also ACM on Facebook: http://www.facebook.com/artscouncilmongolia; ACM on Flicker: http://www.flickr.com/photos/artscouncilmongolia; and ACM on Twitter: http://twitter.com/#!/acmongolia (accessed March 12, 2012).
28. Open Society Foundations website: http://www.soros.org (accessed March 12, 2012).
29. Tuguldur Foundation website: http://www.tuguldursan.mn/main/?f=gallery&vlang=en&Itemid=497 (accessed March 12, 2012).
30. See team members here: http://artscouncil.mn/new/index.php?option=com_content&view=article&id=66&Itemid=49&lang=en (accessed March 12, 2012).
31. Ministry of Education, Culture and Science, Mongolia. (1996). Government Policy on Culture, p. 1.

32. Ministry of Education, Culture and Science, Mongolia. (1996). Government Policy on Culture, p. 2.
33. Mongolian Tourism Board: Official Tourism Website of Mongolia: http://www.mongoliatourism.gov.mn/ (accessed March 22, 2012).

7. MARKETING, CREATIVE PROGRAMMING AND AUDIENCE DEVELOPMENT PLAN

1. See references and suggested readings on marketing at the end of the book.
2. Bennett, Peter D. (ed.) (1995). Dictionary of Marketing Terms (2nd ed.). Chicago: American Marketing Association.
3. Chartered Institute of Marketing website: http://www.cim.co.uk/home.aspx (accessed March 24, 2012).
4. Kotler, Philip (1994). Marketing Management, Analysis, Planning, Implementation and Control. Upper Saddle River, NJ: Prentice Hall.
5. Drucker, Peter (2008). The Essential Drucker: The Best of Sixty Years of Peter Drucker's Essential Writings on Management. New York: Harper Collins.
6. Kotler, Philip and Sidney Levy (1969). Broadening the Concept of Marketing. Journal of Marketing, 33 (January), 10–15.
7. Kotler, Philip and Gerald Zalman (1971). Social Marketing: An Approach to Planned Social Change. Journal of Marketing (July). 3–12.
8. Shapiro, Benson (1973). Marketing for Nonprofit Organisations. Harvard Business Review, September/October, 123–132.
9. Kotler, Philip (1967). Marketing Management: Analysis, Planning and Control. Englewood Cliffs, NJ: Prentice-Hall, p. 628.
10. Kotler, Philip & Sidney Levy (1969). Broadening the Concept of Marketing. Journal of Marketing, 33 (January), p. 10.
11. Mokwa, Michael, William Dawson,& Arthur Prieve (eds.) (1980). Marketing the Arts. New York: Praeger.
12. Melilo, Joseph & Patricia Lavender (1983). Market the Arts! New York: Foundation for the Extension and Development of the American Professional Theatre.
13. Colbert, Francois, Jacques Nantel, Suzanne Bilodeau, & J. Dennis Rich (1993). Marketing Culture and the Arts. HEC Montreal: Chair in Arts Management, p. 14.
14. Dragićević Šešić, Milena & Sanjin Dragojević (2005). Arts Management in Turbulent Times: Adaptable Quality Management. Amsterdam: European Cultural Foundation and Boekmanstudies, p. 124.
15. The term *buzz-marketing* originally referred to word-of-mouth marketing but is often applied nowadays to the use of social media and consumers' exchange of opinions in an informal way.
16. Internet marketing is also known as *web marketing, e-marketing* or *online marketing.*
17. In 1953 the president of the American Marketing Association, Neil Borden, used the term *marketing mix* for the first time. Jerome McCarthy was the first to use the term *four Ps of marketing* in 1960, suggesting that the four most common variables used in constructing a marketing mix are the product, place, price and promotion
18. See Chapter 10 for suggested ways to raise funds online, such as crowdfinancing.
19. Organisational identity was discussed in Chapter 4.
20. See Chapter 10 for different types of costs and cost structures in the organisation's budget.
21. Some theoretical sources add the word satisfaction to this model, making the acronym *AIDAS.*
22. Exodos website: http://www.exodos.si (accessed March 13, 2012).
23. The first GIBANICA (Moving Cake) was organized in 2003.
24. International Network of Contemporary Performing Arts (IETM) website: http://www.ietm.org/ (accessed March 13, 2012).
25. Balkan Dance Platform website: http://www.balkandanceplatform.net/ (accessed March 13, 2012).
26. Tobacna Ljubljana is part of the major international tobacco company Imperial Tobacco Group; its website is http://www.tobacna.si/en/ (accessed March 13, 2012).
27. Labyrinth of Art website: http://www.labirint-umetnosti.si/eng (accessed March 13, 2012).
28. Since 2001 UNESCO has been nominating cities to be the annual World Book Capital City, and the city of Ljubljana was the 10th. World Book Capital Ljubljana 2010 was launched on April 23, 2010.
29. The European Union's Culture Programme (2007–2013) has a budget of €400 million for projects and initiatives to celebrate Europe's cultural diversity and enhance the European shared cultural heritage through the development of cross-border cooperation between cultural operators and institutions. Website: http://ec.europa.eu/culture/our-programmes-and-actions/doc411_en.htm (accessed March 13, 2012).
30. POGON Zagreb Center for Independent Culture and Youth website: http://www.upogoni.org/en/ (accessed March 13, 2012).
31. Drugo More website: http://www.drugo-more.hr/wordpress/ (accessed March 13, 2012).
32. Intercult website: http://www.intercult.se (Accessed April 9, 2012).
33. Website of LokoMotion Contemporary Dance Festival: http://www.lokomotiva.org.mk/Material_2009/HTML_2009/ProgrameLokomotion.html (accessed March 13, 2012).

34. Kolosej multi-cinema website: http://www.kolosej.si (accessed March 13, 2012).
35. Exodos festival on Facebook: http://www.facebook.com/profile.php?id=1579864063 (accessed March 22, 2012).
36. Belgrade Philharmonic Orchestra website: http://www.bgf.rs/ (accessed March 12, 2012).
37. Pika-Točka-Tačka website: http://pikatockatacka.net/ (accessed March 22, 2012).

8. HUMAN RESOURCE MANAGEMENT PLAN

1. Not all possible functions and positions are listed in the organisational chart—only examples.
2. Examples: The trade union for professional performers and creative practitioners in the United Kingdom is called *Equity*; it has over 5,000 members and has existed for more than 80 years. Its website is http://www.equity.org.uk. The Canadian Actors' Equity Association represents more than 6,000 professional artists engaged in theatre, opera and dance in British Canada, including performers (actors, singers, dancers), directors, choreographers, fight directors and stage managers; its website is http://www.caea.com (accessed April 4, 2012).
3. Categories of personnel are discussed in Chapter 1.
4. Legislation in different countries and regions of the world applies different procedures, stages and criteria for recruitment and selection of personnel.
5. LinkedIn is the world's largest professional network on the Internet with more than 150 million members in over 200 countries and territories. It is a powerful tool for job searches and recruitment of personnel. LinkedIn website: http://www.linkedin.com (accessed April 4, 2012).
6. Maslow, A. H. (1943). A Theory of Human Motivation. Psychological Review 50 (4), pp. 370–396.
7. Alderfer, C. (1969). An Empirical Test of a New Theory of Human Need. Psychological Review.
8. McClelland, D. (1961). The Achieving Society. New York: Free Press.
9. Herzberg, F., B. Mausner & B. B. Snyderman (1959). The Motivation to Work. New York: John Wiley.
10. Hackman, J. R. & G. R. Oldham (1976). Motivation through the Design of Work: Test of a Theory. Organizational Behavior and Human Performance 16, pp. 250–279.
11. Social security systems are regulated by national labour legislation and are different for different countries. This book provides only general rules.
12. Intercult website: http://www.intercult.se (accessed March 22, 2012).
13. European Resource Center for Culture (ERC) website: http://www.intercult.se/european-resource-center/ (accessed March 22, 2012).
14. CORNERS website: http://www.cornersofeurope.org (accessed March 22, 2012).
15. Black/North SEAS website: http://www.seas.se (accessed March 22, 2012).
16. *Structural funding* is an annual investment in an organization's infrastructure, such as salaries, offices and equipment. This funding can also go to activities.
17. See details about funding organisations here: http://www.intercult.se/financing/ (accessed March 22, 2012).
18. The legacy of Black/North SEAS is shared online at http://www.seas.se/ (accessed March 22, 2012). The website provides information about the project, lessons learned, evaluations and perspectives, video and photo archives, and much more.
19. Framework website: http://www.frameworkorg.org (accessed March 16, 2012).
20. Timeraiser website: http://www.timeraiser.ca/ (accessed March 16, 2012).
21. See Civic Footprint website: http://www.civicfootprint.ca (accessed March 16, 2012).
22. Platformation website: http://www.platformation.ca/ (accessed March 16, 2012).
23. Sharesies website: http://www.sharesies.com (accessed March 16, 2012).
24. Framework's human resource management strategy: http://www.frameworkorg.org/hr-best-practices.html (accessed March 16, 2012).
25. Framework's financial and fundraising strategy: http://www.frameworkorg.org/resource-development.html (accessed March 16, 2012).
26. This operating budget strategy means that the needed funds will be raised well ahead of the project expenditures.
27. Horizon Scanning: http://www.frameworkorg.org/horizon-scanning.html (accessed March 16, 2012).
28. Framework strategy: http://www.frameworkorg.org/awareness-strategy.html (accessed July 29, 2012).

9. TECHNOLOGICAL AND PRODUCTION PLAN

1. Planning of budgets and fundraising is discussed in Chapter 10.
2. Alternative ways of selling an art object (outside of a conventional gallery space) are illustrated in Chapter 7.
3. Source: OECD Library: http://www.oecd-ilibrary.org (accessed April 6, 2012).
4. An example of a fund to support research, development and implementation of new technologies is the Digital Research & Development Fund for Arts and Culture. It is a partnership between the Arts Council England, Arts & Humanities Research Council (AHRC) and NESTA to support arts and cultural organizations across England who want to work with digital technologies to expand their audience reach and engagement and/or

to explore new business models. Areas of support include social media and user-generated content, distribution, mobile apps and gaming, data and archives, education and learning, and resources. The fund supports arts and culture organisations that want to experiment and does not intend to just promote novelty in art forms. Website: http://www.nesta.org.uk/areas_of_work/creative_economy/digital_rnd (accessed April 12, 2012).

5. Caravansarai website: http://www.caravansarai.info/ (accessed March 18, 2012).
6. See the list of past artists in residence: http://www.caravansarai.info/index.php?/library/past-artists-in-residence/ (accessed March 18, 2012).
7. Download Caravansarai services: http://www.caravansarai.info/index.php?/library/past-artists-in-residence/ (accessed March 18, 2012).
8. Res Artist website: http://www.resartis.org/en/ (accessed March 18, 2012).
9. International Network of Contemporary Performing Arts (IETM) website: http://www.ietm.org// (accessed March 18, 2012).
10. freeDimensional website: http://freedimensional.org (accessed March 22, 2012).
11. The Netherlands Foundation for Visual Arts, Design and Architecture (Fonds BKVB) website: http://www.fondsbkvb.nl/ (accessed March 22, 2012).
12. The vision and mission statement of Caravansarai were written in late 2010 as part of the overall process of strategic business planning performed by the two founders.
13. Moral Fibers website: http://www.moralfibers.co. See also Moral Fibers' Facebook profile: http://www.facebook.com/MoralFibers, and Moral Fibers on Twitter: http://twitter.com/#!/moralfibers (accessed March 15, 2012).
14. Dobson Cup website: http://www.mcgill.ca/desautels/research/centres/dces/dobsoncup (accessed March 15, 2012).
15. INDEPCO website: http://www.indepco.org.ht/welcome/index.php (accessed March 15, 2012).
16. A *remarketing campaign* is a kind of marketing campaign that targets repeat users or customers who have already purchased a product from the company (i.e., follow-up emails or specific online advertising).
17. '*B2B*' indicates sales made from businesses to businesses rather than to individuals. The latter is known as 'business to consumers' (*B2C*) sales.

10. FINANCIAL AND FUNDRAISING PLAN

1. *Revenues* are income received, usually from the sale of core goods and services to customers. These are all earnings before expenses are subtracted. In some countries revenue is referred to as *turnover*. In nonprofit organisations revenues include donations and subsidies and other forms of external support. *Income* refers to the total earnings from diverse sources. *Net income* is the amount that remains after adding together all revenues and subtracting all expenses, including the cost of goods sold and income taxes.
2. There is a slight difference between expenditures and costs. Both are related to the money outflow. Costs are a cash flow that may bring benefits, while expenditures will only cost money but not necessarily bring benefits in return.
3. 'In-kind' support is any type of non-monetary support: providing goods, services, information, equipment or spaces instead of money.
4. *Collateral* is a borrower's pledge (property or assets) to secure repayment of a loan or other credit.
5. For further information see National Angel Capital Organisation Canada (http://www.angelinvestor.ca/) and the European Trade Association for Business Angels, Seed Funds, and Other Early Stage Market Players (http://eban.org).
6. *Merchandising* is a marketing practice in which the brand or image from one product or service is used to sell another. It makes the products appealing and available to the target market.
7. One of the many examples is Kickstarter—the largest online funding platform for creative projects, at the intersection between commerce and arts patronage: http://www.kickstarter.com (accessed April 6, 2012). It gives people the freedom to create however and whatever they want. Project creators always keep full ownership and control of their work and in the process gain direct access to an audience deeply connected to their efforts. Kickstarter is about enabling creativity outside of the constraints of traditional systems. If a project is successfully funded, Kickstarter charges a fee of 5 per cent of the total amount raised.
8. Crowdculture website: http://www.crowdculture.eu (accessed April 9, 2012).
9. Electronic commerce between businesses is known as B2B transactions.
10. *Bootstrapping* is a way to run a business based on little or very minimal outside capital by using personal financing, operating revenues and other internal methods.
11. Sometimes fundraising is called *fund development*—to recognize the process of development of donor relations and the cultivation of mutual trust.
12. See the references and recommended readings at the end of this book.
13. The differences between projects and plans are elaborated in Chapter 3.
14. Chapter 7 gives an overview of market segmentation and target groups.

Index

Strategic Management in the Arts

Strategic Management in the Arts looks at the unique characteristics of cultural organizations and shows readers how to tailor a strategic plan to help these organizations meet their objectives.

Strategic management is an essential element that drives an organization's success, yet many cultural organizations have yet to apply strategic thinking and action within the management function. Varbanova reviews the existing theories and models of strategic planning and then relates these specifically to cultural organizations. Also included are sections on entrepreneurship and the concept of a 'learning organization'—an organization able to adapt its strategy within a constantly changing, complex environment. The book is structured to walk the reader through each element of the strategic plan systematically.

With key questions, examples, cases to connect theory with practice and suggestions for further reading, this book is designed to accompany classes on strategic planning, cultural management or arts management.

Lidia Varbanova is a faculty member of the Department of Management at John Molson School of Business, Concordia University, Canada.